Monet

JACKIE WULLSCHLÄGER

Monet

The Restless Vision

ALLEN LANE
an imprint of
PENGUIN BOOKS

ALLEN LANE

UK | USA | Canada | Ireland | Australia
India | New Zealand | South Africa

Allen Lane is part of the Penguin Random House group of companies
whose addresses can be found at global.penguinrandomhouse.com.

Penguin
Random House
UK

First published in Great Britain by Allen Lane 2023
001

Copyright © Jackie Wullschläger, 2023

The moral right of the author has been asserted

Set in 10.5/14pt Sabon LT Std
Typeset by Jouve (UK), Milton Keynes
Printed and bound in Great Britain by Clays Ltd, Elcograf S.p.A.

The authorized representative in the EEA is Penguin Random House Ireland,
Morrison Chambers, 32 Nassau Street, Dublin D02 YH68

A CIP catalogue record for this book is available from the British Library

ISBN: 978-0-241-18830-9

For William

Contents

CONTENTS

Introduction and Acknowledgements

Like many people who love Monet's paintings, I hardly remember a time when they were not part of my visual imagination. But I recall very clearly the moment I started thinking about the relationship between his life and work: it was in Paris in 2016, at the Fondation Vuitton's exhibition *Icons of Modern Art: The Shchukin Collection*. Loaned from Moscow, *Le Déjeuner sur l'Herbe*, [Plate 2] the large oil sketch of 1866 for a yet larger, never completed picture of eleven pic-nickers in a forest, stopped me in my tracks. Its context at the exhibition was unusual: Sergei Shchukin collected predominantly Matisse and Picasso. In their company, *Déjeuner*, spectacular and odd, held its own as aggressively modern. In 21st century Paris it looked as alive as if it had been painted yesterday: the dramatic action of light beating through trees, the strange artificial tableau of figures around the chicken and wine picnic. All the women were modelled by Monet's 18-year-old girlfriend, holding five different poses, her expression a curious mix of warmth and neutrality. I wondered who she was, this teenager offering an outstretched arm to welcome the viewer into the scene, pulling us into the feast of Monet's painting. In appreciation, Monet carved a heart with an arrow into the bark of the oak tree in the foreground – his signature as a lover.

Monet the lover was to me an unfamiliar figure, refreshingly unlike the white-bearded sage serene by his pond, gazing out from the famous late photographs. *Déjeuner* made me want to know more about his character, life, the people in it, how they determined his art, and about the social currents informing his thinking – the triumph of French secular culture in an era marked by wars, political unrest, concern about man's relationship with nature, and changing roles for women.

Although he has been exceptionally well served by art historians, I could find little about Monet's interior life. Daniel Wildenstein's catalogue raisonné includes a documentary account, which I read initially in the one-volume English version. Then I discovered the magnificent five-volume French edition of the catalogue raisonné, published by the Wildenstein Institute between 1974 and 1991, which includes, collected at the end of each volume, some three thousand letters by Monet. Very few have ever been translated into English. I set out to write a full personal biography based on this rich untapped source. My approach stems from the belief that painters transform the raw material of experience into art; that, as the artist Sean Scully once said to me, "painting will always reflect your nature without mercy", and that understanding something of this creative process enhances our enjoyment of looking at pictures.

Wildenstein's work is foundational for all Monet studies, and I am immeasurably indebted to him and to the generations of outstanding scholars, above all Meyer Shapiro, John Rewald and John Stuckey, who have defined the history of impressionism. I have also benefitted from studying material which has surfaced since the catalogue raisonné was completed, in the Cornebois collection of letters to Monet sold by Artcurial auctions in 2006, and in unpublished documents in private French archives. I am deeply appreciative of all those who granted me access, beginning with the leadingMonet scholar Marianne Matthieu, head curator until 2022 of the Musée Marmottan Monet. She guided me through the archives there and inspired me throughout by her erudition and acuity. I am exceptionally grateful for her unstinting generosity and energy in sharing her knowledge and wisdom. I would also like to thank Aurelie Gavoille and Manon Paineau at the museum, and director Erik Desmazières. At the Fondation Custodia, the late Ger Luijten warmly hosted me, and I thank Mariska de Jonge and Marie-Claire Nathan for helping find material, and art historian Jean-Paul Bouillon for answering questions about Manet's letters held there. Flavie Durand-Ruel and Paul-Louis Durand-Ruel made my visit to the Archives Durand-Ruel, headquarters of Monet's dealer, pleasurable and profitable. Hugues Gall, president of the Fondation Claude Monet, was the perfect guide to Monet's house, garden and more in Giverny.

As Monet left no direct descendants, surviving family documents are in the hands of his step-children's heirs. The late Claire Joyes, widow of Jean-Marie Toulgouat, Monet's step-great-grandson, welcomed me to her home on rue Colombier in Giverny, invited me to examine letters and photographs, and gave me the benefit of her vivid grasp of Monet family identity. My friends Francis and Christine Kyle kindly introduced me to Claire. I am also grateful to art historian Philippe Piguet, another Monet step-great-grandson, for showing me further material, help with photographs, and for his illuminating observations.

I am much indebted to the staff of the British Library, especially for tracking down obscure French volumes, and to the expertise of curators of recent exhibitions. Over many years I have appreciated stimulating conversations with Ann Dumas; her *Painting the Modern Garden, Monet to Matisse* at the Royal Academy was the exhibition which stayed most in my memory while writing. Anne Baldessari kindly gave me a tour of *Icons of Modern Art* at the Fondation Vuitton, and Roya Nasser hosted my return there to see *Monet Mitchell.* I learnt more about *Women in the Garden* from its restoration at the Musée d'Orsay in 2022 under the guidance of director Sylvie Patry. Her show on Berthe Morisot in 2019, and that at Dulwich Picture Gallery in 2023, curated by Lois Oliver, cast light on one of Monet's important friendships. Cecile Debray widened my thinking with *The Water Lilies, American Abstract Painting and the Last Monet* at the Musée de l'Orangerie, and I enjoyed Richard Thomson's *Monet and Architecture* at the National Gallery. My understanding of Monet's admiration and support of Cezanne was strengthened by the Cezanne exhibition, which arrived in summer 2022 at Tate Modern from Chicago, curated by a team led by Gloria Groom and Natalia Sidina, and above all by the landmark study appearing at the same time, *If These Apples Should Fall* by T. J. Clark, greatest living writer on art, from whom I have been gratefully learning since the 1980s.

At Penguin, my huge thanks to Stuart Proffitt, peerless editor, for commissioning the book, allaying my anxieties, and vastly improving the manuscript by his fine judgement and knowledge. Everyone at Penguin made the book far better. Alice Skinner was an astute editor of the second draft and I greatly appreciate her lively engagement

with the text and her help smoothing the book's production. I was extremely fortunate to work with Claire Peligry, eagle-eyed, sensitive copy-editor supreme, whose command of French history and language helped at every turn, and Cecilia Mackay, queen of picture researchers, who brought her flair and expertise to bear on the text too; each meeting with her sparked fresh thoughts. My warmest thanks for their time, patience and good humour extends also to Anna Wilson, who supervised the copy-editing, Matt Young for his imaginative cover design, publicity manager Matthew Hutchinson, and Francisca Monteiro. I am grateful to my editor in New York, Shelley Wanger, for additional careful editing, fruitful questions and for her enthusiasm. Remaining mistakes are of course my fault.

I thank my agent Carol Heaton for her commitment to the project; as ever she was a rock, giving me confidence, encouragement and easing many paths. At the *Financial Times*, Jan Dalley was crucial: for her advice as a writer and her intellectual discernment, for allowing me to balance my efforts between journalism and biography, for her kindness as a friend. I would also like to thank Raphael Abraham and Josh Spero at the *Financial Times*. As a critic covering contemporary art on a daily newspaper, I have also benefitted from conversations about painting and about Monet with Frank Auerbach, David Hockney, Bridget Riley, the late Howard Hodgkin and the late Leon Kossoff.

While I was working on *Monet*, four of my oldest friends were also engrossed in writing long books: Deborah Steiner and Alastair Macaulay in New York, Elizabeth McKellar in Oxford and Michael Kerrigan in Edinburgh were the best of fellow travellers, sharing ideas and troubles, unfailingly supportive and sympathetic. In London, with me every step of the way, were Aline de Bièvre, Louise Gale and Andy Stern, friends who have come to feel like family.

My children Naomi, Zoë and Raphael contributed more to the book than they could imagine, by their interest, fresh perspectives, willingness to challenge my opinions, affectionate moral support, practical help, and by the happiness they and their partners Michael, Thomas and Evelina always bring.

This book is dedicated to my beloved husband William Cannell. For nearly four decades, he has shaped my endeavours, encouraging me by his expansive vision and integrity to think more broadly and

deeply than I would have otherwise dared. I rely on his comments on every page, and our looking at and talking about painting together is a consistent joy. I no longer know the boundary between his and my thoughts, but I do know that without his love and conviction I wouldn't write at all. To express my love and thanks, I fall back as before on Dante: *l'amor che move il sole e l'altre stelle.*

Prologue:
'The Throb of One Happy Moment'

During the overcast summer of 1879, in the riverside village of Vétheuil halfway between Paris and Rouen, a restless painter paced his garden, waiting for an hour's sunshine. When the cloud lifted, he slipped through his gate bordering the Seine, made rapid sketches of the water and the reflections of its grassy islets, and returned home fast to be at his sick wife's bedside. Camille 'had been, and still was, very dear to me', Monet said,[1] but he was falling in love with someone else. Alice, hot-tempered, highly strung and married to one of Monet's collectors, was close by. Bankruptcy had lost this once gilded couple their paintings, their Paris apartment and their country chateau, and they were sharing the Monets' cramped terraced house. While devotedly nursing Camille, Alice became fascinated by Monet.

Camille died on 5 September and Alice described her last day. 'The poor woman suffered horribly, it was a long and terrible agony, and she remained conscious until the last minute. It was heartbreaking to see her say her sad goodbyes to her children.'[2] Alice did not allow herself to relate what happened next. Monet seized a canvas and sketched his dead wife. 'I found my eyes fixed on the tragic countenance, mechanically trying to seek the sequence, the degradation of the colours that death had just imposed on the motionless face. Shades of blue, yellow, grey, and I don't know what ... My automatic instinct was first to tremble at the shock of the colour.'[3]

But *Camille Monet on her Deathbed* [Plate 25] is about far more than the play of colours: the quick, coarse bluish-violet-white marks veiling the pallid face unfold Monet's blizzard of grief. A torrent of slashing horizontal strokes rushes along the lower part of the canvas,

as if submerging and carrying away the body. It is a portrait of Camille disappearing.

Monet had made his reputation painting Camille. She features in fifty pictures, strolling in gardens, relaxing on a river embankment, windswept on the beach – images forever connecting Impressionism with everyday happiness. But after her death, he hardly depicted a figure again. In a winter that came early in 1879, he went back to the Seine and, a hot-water bottle in each pocket to warm his hands, stood on its now frozen surface, painting frost, ice floes, snow-covered fields lit by a pale sun: nature transformed, on a gigantic scale, into a shroud of mourning. Monet was thirty-nine, almost halfway through his life, and at its turning point.

In Vétheuil he developed a fresh way of working – to trap the same scene at different seasons, hours, to paint time passing. 'Monet is only an eye, but what an eye,' was Cézanne's famous, deprecating praise.[4] It has distorted interpretation of Monet ever since. Cézanne admired his friend's unerring, nuanced vision, rapture at the visible, directness in translating that delight into pictorial fact, but he defanged him into emotional neutrality and implied an intellectual void. Giving primacy to what was seen, to the shimmering surfaces of his canvases, the remark underplays the roles in Monet's painting of feeling, thought and memory.

This book attempts to tell Monet's life as he felt it: his joys and sorrows, loves and disappointments, what he read, his connections to cultural currents, and how all this, and especially his closest relationships, inspired his choices of what and how to paint.

Three times, Monet's art changed decisively when the woman sharing his life changed. To excavate the unrecognized contributions and the voices of Camille Doncieux, Alice Raingo and Blanche Hoschedé, the special atmosphere with which each surrounded him, the extent to which they curated the milieu of his paintings, is not to diminish the force of Monet's originality, but to rethink how he worked, and how his paintings work on us, to enlarge 'only an eye' to admit heart, soul and mind.

Monet himself talked little of these things. 'Monet the Taciturn' is the title of Thadée Natanson's affectionate memoir. Natanson's Monet was a 'raptor' with a devouring gaze who sat silent, as in a trance, in

his wide-brimmed straw hat, watching his water lilies. If he opened his mouth, it was to puff on a Caporal cigarette, from which 'scrolls of smoke climbed and renewed themselves around him'.[5] Vanishing into his garden, into his paintings, Monet, one of the most popular artists of all time, became what Degas aspired to be: illustrious and unknown.

Discretion and reserve were elements of his character. A decade after becoming Alice's lover, Monet was still writing to her as 'chère Madame' and using the formal 'vous' pronoun. His adored younger son could not bring himself to address his father by the familiar 'tu'. And Monet never painted a nude, the only great artist from the Renaissance to the early twentieth century not to do so.

Yet his paintings are the opposite of restrained. They embrace sensual experience, and are built on what Meyer Shapiro called 'the fury of the brush'.[6] His letters reveal his voracious appetite, for art and life: 'I work in the rain, in the wind. I gorge myself on it'; 'I have a terrible thirst to be near you'.[7] He is always hungry, always greedy, 'j'ai grand faim'; 'I will spoil myself like the big mouth I am'.[8] Painting both answered an emotional need – 'it was a joy for me to see this furious sea, it was like a nervousness' – and drove introspection – 'I plunge back into examining my canvases, that is to say, continuing my tortures. Oh, if Flaubert had been a painter, what would he have written?'[9]

Impressionism, with its breezy brilliance at fixing the artist's sensation, inevitably led towards interiority: to painting suggesting mutability, memory; to brushstrokes eloquent for their own sake rather than strictly representational; eventually to forms of abstraction. Monet made the full journey in a single lifetime – the sole Impressionist to push the movement's implications through to the end. He began rendering broad, busy scenes and people, steamships in port, crowds on the boulevards – the sociable existence shared with Camille in the 1860s–70s. He refined his observations in compositions emptied of people: the unsettled seascapes of the nomadic 1880s, then the series paintings launched in the security of Giverny in 1890 with *Haystacks* [Plates 34 and 35] ,which slow down time to catch 'the luminous atmosphere that brings dazzle to our ordinary lives', as his friend Georges Clemenceau said.[10] Finally, in the seclusion of his

garden, Monet in the twentieth century turned the relationship between painting and nature inside-out: he constructed his own landscape to provide motifs against which he could record his minute-by-minute perceptions, and in his *Water Lilies* series [Plates 46 and 49], he painted the surface of his little pond to reflect the infinity of the sky.

Painting is always an expression of personality; with Monet it went further. Only a man of tremendous self-belief could hold his nerve while transforming his private, fleeting impressions, which to audiences at the time looked like mere sketchy improvisations, into defining, iconic images – dawn breaking in Le Havre in *Impression, Sunrise* [Plate 16] – his wife and son wandering through a meadow hazy in summer heat in *The Poppy Field* [Plate 17].

In youth, struggling against near-destitution, mockery and misunderstanding, Monet built Impressionism on his confidence in the authority of a painter's direct perception. His independence, and his intense reactions, were fundamental to the project he set himself: his painting would be, he decided aged twenty-eight, 'the expression of what I myself will have experienced, I alone'.[11] At fifty, inaugurating Gafter another – light falling thirty times on Rouen cathedral, poplars quivering by a stream from dawn to dusk – he reiterated the same impulse: 'I am more than ever wild with the need to put down what I experience.'[12]

As the frontier of his painting moved inward, Monet insisted that his method remained unchanged: obsessive attention to nature, stalking transient effects. But by 1920 the Duc de Trévise described his pictures as abstractions: 'skeins of kindred shades that no other eye could have unravelled, bizarre assortments of immaterial threads'.[13] Few artists have lived and been productive for so long, and only Matisse has equalled Monet in producing late work which radically departed from his early manner, yet consistent with and developing inevitably from its first aims.

The distance from young to old Monet is shown by the gulf between his literary champions. In the 1860s Zola praised Monet through the prism of his own vigorous realism: 'oh yes, here is someone with a temperament, here is a *man* among all those eunuchs . . . I congratulate him for having an exact and candid eye, for belonging to the great school of naturalists.' Zola was especially drawn to the figure paintings, for

Monet 'loves our women, their parasols, their gloves, their lace, even their false hair and their face powder – everything that makes them the daughters of our civilization'.[14] But as Monet's path diverged from Zola's, the novelist betrayed the friendship. His scathing novel *L'Œuvre* (1886) stars an impassioned painter who, bereaved, cannot stop himself seizing a canvas and depicting a corpse.

Thirty years later, in the first volume of *À la recherche du temps perdu*, Proust alludes to Monet's water lilies. On a walk, the narrator watches the river Vivonne 'choked with water plants', ugly and disordered, 'suggesting certain victims of neurasthenia ... and ... those wretches whose peculiar torments, repeated indefinitely throughout eternity, aroused the curiosity of Dante'. Then comes a property whose owner 'made a hobby of aquatic gardening, so that the little ponds into which the Vivonne was here diverted were aflower with water lilies'. In the depths, the narrator now sees 'a clear crude blue verging on violet, suggesting a floor of Japanese cloisonné. Here and there on the surface, blushing like a strawberry, floated a water-lily flower with a scarlet centre and white edges.'[15] The gardener/artist has spun beauty and meaning from the chaos of nature and the mind. For Proust, Monet's lilies symbolized the transformation of life into art.

The painter Elstir in *À la recherche du temps perdu* is partly based on Monet. In one of his seascapes, Proust writes, the artist 'had felt so intensely the enchantment that he had succeeded in transcribing, in fixing for all time upon his canvas, the imperceptible ebb of the tide, the throb of one happy moment'.[16] It is a description of the new painting which Monet inaugurated – painting which is expansive, fluid, and never stales because it is fed by the flux of so rich an inner life.

PART ONE

Voyaging Out

I

The City and the Sea, 1840–57

Monet's life began in Paris in 1840, but the imprint of memory came with the river and the sea. The Monet family moved to Le Havre when he was four years old. The railway to Rouen had just opened; the first line out of the capital to the provinces, it was extended in 1847 to the coast. The train leaves the Gare Saint-Lazare, close to Monet's birthplace on rue Laffitte, and soon crosses the Seine at Asnières, then a tiny village named for breeding donkeys. The route winds back and forth over the looping, slow-flowing river and its fertile valleys before reaching the chalky Pays de Caux plateau and descending to the huge port of Le Havre, on the right bank of the broad estuary. Along this journey were most of Monet's subjects: 'I have painted the Seine all my life, at every hour, at every season. I have never tired of it: for me the Seine is always new.'[1]

At one end of the itinerary, Monet depicted the Channel coast in some 300 seascapes. At the other, the Gare Saint-Lazare inspired a dozen smoke-filled pictures [Plates 21 and 22] celebrating the dynamic industrial era into which he was born. 'Our artists have to find poetry in train stations as their fathers found it in the forests,' wrote his contemporary Émile Zola, born seven months earlier.[2] For Monet, the station facilitated an existence divided for the whole of his life between the capital and Normandy, between aggressive commerce and opportunity in the modern metropolis, and retreat and freedom to roam and paint by the water.

Only a single eye-witness report of Monet, other than his own, survives from before the age of seventeen, and it places him happy in Le Havre on the high plateau above the ocean. His friend Fernand Bidaux recalled this scene, 'where we two adolescents, drunk en plein

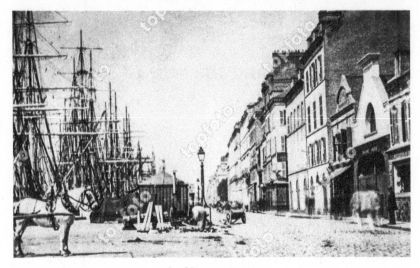

Le Havre, 1860s

air, lost in the mass of rocks, injured by the brambles and asperites which we braved so brazenly, clambered up the cliffs at La Hève, surprising those tumultuous heaps, seeking a motif that you liked . . . Do you remember my sketches, so flat and dull next to your divinely excavated drawings?'[3] The recollection came when Bidaux, who had not seen Monet for forty years, walked into a Paris exhibition of his Channel seascapes in 1897 and was inspired to write to remind him of 'beautiful days forever gone'.

Monet talked rarely about his childhood. 'Apart from my date of birth, I hardly see what information I can give you except that from my most tender infancy I already had a passion for drawing', he told the journalist François Thiébault-Sisson irritably, ahead of his first major biographical interview, in 1900.[4] He relented to add a single expansive description, which accords with Bidaux's – he was always outside 'when the sunshine was inviting, the sea smooth and when it was such a joy to run about on the cliffs, in the free air, or paddle around in the water'.[5]

He was an unruly child, the competitive second son of a second son, born to a father whose livelihood as a ships supplier depended on movement and travel – servicing people and vessels arriving and departing Le Havre's quays. Before that, Adolphe Monet had tried a

4

career as a sailor, crossing the Atlantic. At least since the French Revolution, when the Monets begin to be clearly documented, the family survived by being on the move, and moving on fast when disaster struck. Unsentimental, they did not keep mementos or dwell on the past; no photograph or portrait of Monet as a child is known. 'If he had good memories of his family, he never talked of them. So I think we can say that he hardly had any,' his stepson suggested. 'I never heard him make any reference to a tender childhood memory concerning his parents.'[6] From the same reticence, Monet's friend and first biographer Gustave Geffroy concluded that 'he had a happy childhood', and closed the subject in a sentence.[7]

Monet introduced himself to Thiébault-Sisson of *Le Temps* in six words: 'I am a Parisian from Paris'.[8] He was proud of his roots in the capital, which went back two generations; his Monet grandparents settled there in the 1790s, joining the swell of migrants from the provinces who made up 70 per cent of the city's population at the time. The artist's father was born there, in the parish of Saint-Eustache, close to the food market at Les Halles, on 3 February 1800. A few months before, in November 1799, Napoleon had staged the coup that overthrew the revolutionary government, established himself as First Consul, and set France on the path to empire.

Adolphe was his mother Catherine Chaumerat's third and last child, and the only one born legitimate. Catherine, the illiterate daughter of a postman, was used to being pregnant in turbulent times. She came from Lyon, France's second city and Europe's silk capital. Her parents were Gaspard Chaumerat, a Lyon hat-maker's son, and his third wife, Jeanne Marie Mera, a native of Quincié-en-Beaujolais, a village in the nearby wine-making region. Catherine was sixteen when she began a romance with an Italian tailor, Isidore Gaillard, or Gaiardi, born in Rome. It was the summer of 1789, the season of plunder and riots known as 'La Grande Peur' (The Great Fear) – Lyon's equivalent of the disturbances in Paris which culminated in the storming of the Bastille. In Lyon tension between silk weavers and silk merchants was long established, and unrest continued to flare. In February 1790 there was the pillage of the Lyon Arsenal, and in June 1791 a mob attacked the castle of a retired colonial officer, who was lynched and dismembered by a butcher; his heart served up in a nearby *auberge*.

In a city in turmoil, Catherine gave birth to her daughter Marie-Jeanne Gaillard on 13 March 1790, and married Isidore on 7 November. She was quickly widowed and, still a teenager, as quickly found a new partner: in 1792 she had another illegitimate baby, Claude Pascal Léonard Monet. Now Lyon was firmly in the throes of revolution. In the uprising known as the *septembrisades lyonnaises*, officers and priests in the fortress of Pierre Scize were decapitated, their heads paraded round the city and then displayed by torchlight to terrified audiences at the Théâtre des Célestins. The silk industry, the chief source of employment, stagnated. Workers struggled; counter-revolutionary sentiment rose and was snuffed out by republican forces, who bombarded and laid siege to the city. Lyon surrendered in 1793.

Tough and young, Catherine got herself and her two babies through the siege, and survived the 'liberation' of 1793–4, a year of denunciations and mass trials. Two thousand Lyon citizens were killed, some guillotined on the Place Bellecour, others shot by firing squad, the notorious *mitraillades,* on the Des Brotteaux plain across the Rhone. It was among the worst atrocities of the revolution and, after the fall of Robespierre, answered with reprisals – the 'white' terror, including massacres of Jacobin prisoners and those suspected of sympathizing with them. Women too were shot on the street; mutilated bodies flung into the river were a common sight. Lyon was in a state of more or less civil war until 1798. The population plummeted.

Catherine at least gained security by marriage, in 1795, to her son's father, Léon Pascal Monet, known as Pascal, also widowed. Cited in official documents as an 'agent de commerce ', he had come north to Lyon from Avignon, a papal enclave when he was born there on 17 December 1761, the son of another Claude Pascal Monet and grandson of a Pascal. His first marriage, in Avignon in 1779, was to a lawyer's daughter, which implies he came from a higher social class than Catherine. He did not stay long in Lyon: on the eve of the new century Pascal and his wife, son and stepdaughter made the intimidating journey, four days and nights by stagecoach, to Paris. Adolphe was the child who completed the family in their new home. He, and subsequently his sons, would win the unquestioned, lifelong devotion of his half-sister Jeanne. She was nearly ten when her baby brother was baptized Claude Adolphe on 9 February 1800 at the grand Gothic

Saint-Eustache church – where Cardinal Richelieu and Molière had been christened – in the first arrondissement. The building, desecrated and looted during the revolution, remained damaged and had not yet been formally returned to the church, but Saint-Eustache was on its way to stability and peace and so were the Monets.

Resourcefulness, adaptability, robust health and a resolutely urban outlook were the legacy of these grandparents, with whom Monet grew up. Having endured and escaped fanaticism, Pascal and Catherine brought up children indifferent to politics, and in the entrepreneurial spirit of the times. The sons followed the rise of industry and international commerce, which made the north the beating heart of modernizing nineteenth-century France, while slow southern towns such as Avignon lagged behind. The older boy married at eighteen and moved to Nancy; he described himself as a 'négociant', a term covering every sort of trade. At the same age, in 1818, the apprentice seaman Adolphe Monet boarded the merchant ship *Constantia*, bound for San Domingo, at Le Havre. He returned from the Caribbean a year later as a passenger, disembarked at La Rochelle and never went to sea again. Another 'négociant', and also referred to on official documents by the equally vague 'propriétaire', he developed business interests between Paris and Le Havre. He was helped by an industrious, generous brother-in-law: in 1823 Jeanne Gaillard, at thirty-three, made a brilliant match to Jacques Lecadre, whose grocery and ships' supply stores and warehouses were prominent in the thriving port city.

Nothing about this thoughtful, refined and dignified woman suggested the turmoil of her first years, although Adolphe later insisted that 'my sister must not be disturbed in her inner tranquillity'[9] – the disturber being her rowdy nephew. Jeanne was an amateur painter and her husband built her a studio. The couple's summer villa, Le Coteau, route des Phares, at the resort of Sainte-Adresse, was a haven where Jeanne cared for her mother and step-father, shielded from continuing political upheavals. When Pascal Monet died at the villa in his ninetieth year, he had lived through three revolutions, in 1789, 1830 and 1848, and, since leaving Lyon, five regimes in as many decades: the First Republic; Napoleon's rule during the Consulate (1799–1804) and as emperor (1804–15); the restored Bourbon constitutional monarchy (1815–30); the so-called July Monarchy of the Orléanist rival

king Louis-Philippe (1830–48); and the Second Republic led by Napoleon's nephew Louis-Napoleon (1848–51).

In the early 1830s, Louis-Philippe, known as the Citizen King, dressed like a banker and carrying an umbrella, brought hopes of growth and prosperity, and Paris was calm when Adolphe Monet married Louise-Justine Aubrée there on 20 May 1835. She was born in the capital on 31 July 1805, one of the last dates to be recorded according to the revolutionary calendar – 11 Pluviose, year XIII – and her family and circumstances suggest spirit and independence. François Aubrée, her father, a civil servant in Louis-Philippe's finance ministry, was separated from her mother, Marie-Françoise Toffard – rare at a time when divorce was not possible in France. As a young woman Louise, unusually, did not live with either of her parents in the period before she married the wealthy Emmanuel Despaux in 1831. She was widowed in 1834, and within a year became Madame Monet. The couple's son Léon Pascal, the artist's only brother, was born in 1836.

The first Monet images appear in 1839, suggesting a degree of bourgeois comfort. Adolphe and Louise were sufficiently well off to commission wedding portraits, each showing off a prominent ring, though they waited until a few years after their marriage, and were not affluent enough to ask an established society artist: they chose a foreign adventurer. Adolphe Rinck, an academic painter trained in Berlin, was in Paris en route to America and a flourishing career in antebellum Louisiana. Rinck depicted Monet's father as handsome, with regular features and thick chestnut hair, and somewhat bland, eager to appear correct; a man who would insist that 'there is only one route to success: to progress resolutely on the path of work and order' and set no store by the imaginative life, believing of his son that 'only his actions, his behaviour, are favourable or unfavourable'.[10] Louise – oval face, big eyes, luscious chignon and a slick of dark hair playfully framing her cheek – is more of a performer, coquettishly dangling a jewel, décolleté in fashionable off-the-shoulder ivory silk, lace-trimmed bodice tapering to a point, ribboned short sleeves in little puffs. Her expression is vivacious, mischievous, composed, but there is also something elusive, or distant, in her gaze.

The Monets moved between various rented flats before settling in an apartment on the fifth floor of a newly built block at 45 rue Laffitte in

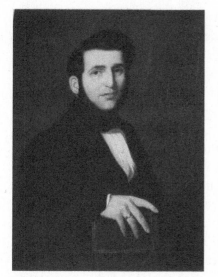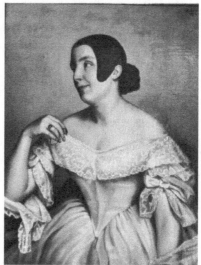

Adolphe and Louise Monet, the artist's parents,
portrayed by Adolphe Rinck in 1839

the ninth arrondissement. Here Adolphe and Louise's second son was born on 14 November 1840, and outlandishly named Oscar Claude, an outlier from Monet family tradition. And unlike his staid brother, this younger son was born at a fancy address to go with his fancy name: rue Laffitte in the 1840s was on its way to becoming *la rue des tableaux*, the street of pictures. In 1842 Adolphe Beugniet arrived at number 10, setting up a restoration business and then a gallery selling the work of artists such as Camille Corot, Eugène Delacroix, the orientalist Eugène Fromentin and the Barbizon landscapist Charles-François Daubigny, later Monet's supporter. Further galleries, stationers and specialists in drawings joined Beugniet; in 1844 *Les rues de Paris* described rue Laffitte as a place of 'trade, arts and pleasure'.[11] By the early 1850s it was commonly referred to as 'la rue des tableaux', the magazine *L'Artiste* even proclaiming it, by 1854, a street museum.

Monet's friend Georges Clemenceau called rue Laffitte an omen, but family agency helped coincidence. The Monets' choice of a smart street on the Right Bank declared cultural ambition, an instinct to be close to the action, characteristics inherited by their second son. Although social classes were jumbled within streets and also within

9

buildings in nineteenth-century Paris – ample apartments on the lower floors, smaller ones such as the Monets' higher up – the location in this animated *quartier* was significant. A neo-classical ensemble of stone town houses, some with shop fronts, most divided into apartments, plus some elaborate *hôtels particuliers* opening on to inner courtyards, rue Laffitte had just been extended to run from Boulevard des Italiens, the most prestigious of the café-lined *grands boulevards*, to the new church of Notre-Dame-de-Lorette.

Here, in a gold-frescoed chapel, at a font adorned with a bronze St John, Oscar Monet was baptized on 20 May 1841; his uncle and aunt from Nancy were godparents. A year before, the composer Georges Bizet, born a few streets away to another ambitious father, a wig-maker turned singing teacher, had been christened at the same font. Notre-Dame-de-Lorette, today dwarfed by the massive Sacré-Coeur on the hill of Montmartre behind it, was considered at its completion in 1836 to be controversially lavish, almost unspiritual; the carved tympanum and Corinthian columns inspired by Roman basilicas certainly aggrandized the worldly rue Laffitte. The Bourse was within comfortable walking distance, and it was in order to be near it, and to woo the new money on the Right Bank, that the dealers came here, deserting their former haunts around the official Académie des Beaux-Arts and the aristocratic Faubourg Saint-Germain on the Left Bank. More notorious residents in the area were the 'lorettes', the demi-mondaine prostitutes maintained by several lovers, who took their nickname from the church. Thus *L'Artiste*, noting the seductive gallery windows, called rue Laffitte 'the valley of temptation'.

Lifestyle and aspiration were on display and for sale. Rue Laffitte was a fashion destination – Madame Guichard's hats, dresses at Madame Palmyre's, couturier to royalty – and a cultural gathering place. It was home to Balzac's friend the romantic poet Marceline Desbordes-Valmore, to the polemical journalist Émile de Girardin, publisher of the pioneering mass-market newspaper *La Presse*, and to the opera singer Rosine Stoltz, a sensation as Léonor in Donizetti's *La Favorite*, which premièred a fortnight after Monet's birth. At number 2, the other end of the street from the Monets, Lord Hertford was amassing the paintings which would become the Wallace Collection in London. At number 19, banker James Rothschild had reconstructed his

neo-Renaissance *hôtel particulier*, which Heinrich Heine called a financier's Versailles. At number 27 lived the banker Jacques Laffitte, who gave his name to the street. Previously it had been rue d'Artois, after the Comte d'Artois, with a brief period from 1792 as rue Cerruti, commemorating a Revolutionary journalist.

The renaming in Laffitte's honour, in recognition of his manoeuvres in ensuring the throne for Louis-Philippe, signified the rise of the financial class. Under the July Monarchy, commented Stendhal, 'the bankers are at the heart of the State. The bourgeoisie has taken the place of the Faubourg Saint-Germain, and the bankers are the nobility of the bourgeoisie.'[12] Physically, Paris at Monet's birth was still the city of Balzac – picturesque and filthy, with its twisting alleys, cramped pavements, poor lighting and stench of sewage – but new social and financial structures were ushering in great change. In 1837 Jacques Laffitte founded Paris's first business bank, the Caisse Générale du Commerce et de l'Industrie. Thanks to speculative investment, industry and technology boomed, and railways were built. '*Éclairez-vous, enrichissez-vous*, improve the moral and material condition of our France, *voilà* the true innovations,' Louis-Philippe's foreign minister François Guizot told the French people in 1843.[13] It was only a street, but rue Laffitte in the 1840s represented the alliance of middle-class money and culture evolving from the upheavals of the last half-century, which in turn laid the ground for the intellectual and artistic innovations of the next generation. No less than the Lyon postman's illiterate daughter who made a life in Paris, and her children who went on to acquire solid wealth and cultural capital, Monet's life was shaped by these forces.

They were at work in his favour when they swept the young family up to Le Havre in 1845. Standing between the mouth of the Seine and soaring cliffs, France's biggest northern port was noisily responding to expansion in transatlantic transport and trade. The cranes of its shipbuilding yards were gigantic, its basins were built deeper and deeper to accommodate the new vessels, its quaysides bursting with exotica, yelping monkeys and jabbering parrots alongside coconuts and chinoiserie. Le Havre was, according to Jules Janin in the mid-century, 'the warehouse of the whole world'.[14] It boasted 'des rues toutes parisiennes'; the activity, movement, passions of a great city. Completely modern, it [was] a town of zeal, work, active industry, storms which

grumble and pass, boats which arrive and depart again', where everyone was in a hurry, everyone needed 'to produce, exchange, sell, buy, create, fill and empty this port'.[15] Wholesaler Jacques Lecadre, trading cotton, rope, wool, indigo, resin, oils, candles, spices and wine from 17 quai d'Orléans and rue Fontenelle, had more business than he could manage. His nephew and partner Arthur Lecadre died unexpectedly in 1843, making an opening for his brother-in-law, Adolphe Monet.

The Lecadre-Monet business flourished in a city which absorbed every regime change in its rush to profit, and benefited from each one. The February 1848 uprising in Paris which deposed Louis-Philippe stirred riots in industrial cities, including neighbouring Rouen, and also Lyon, but in Le Havre it provoked only sporadic chanting of the Marseillaise. The *Courrier du Havre* hoped that trouble in Paris 'would not take on the character of an insurrection, still less that of a revolution'.[16] Le Havre's expansion, begun during the July Monarchy, gathered pace under the Second Republic from 1848, and flourished still more following Napoleon III's coup in 1851, which established the Second Empire. The new boulevard Impérial linked station and port; the rail speculators Émile and Isaac Pereire branched out to launch the Compagnie Générale Transatlantique; the quai d'Orléans abandoned a name with royalist allusions to become, briefly but aptly, the quai du Commerce. As the merchant Frédéric de Coninck said, 'Le Havre would be nothing without its commerce, and no serious commerce is possible without confidence in the stability of government and the maintenance of peace.'[17]

The tourist Stendhal described a place where adventurers from across the world sought to 'smack' a fortune; it operated to the rhythms of the Bourse as well as to the tides. The marine insurers lining the port had names like 'Les Deux Mondes' and 'L'Espérance'; vistas were global and optimistic: vessels arrived from Constantinople, Odessa and New Orleans and there were regular sailings to Southampton, Liverpool, Hamburg, Rotterdam and New York. Sixteen-year-old Manet passed through in 1848 to sail on the *Le Havre-et-Guadeloupe* for Rio de Janeiro. Pissarro, disembarking after a voyage from his native Danish Antilles in the 1840s, first set foot on French soil at Le Havre. 'C'est peu esthétique,' he would tell his son Rodolphe, 'but you get used to it and end up discovering great character there.'[18] That hard-edged, teeming character and modernizing

impetus were part of Monet's childhood, and the directness and rough handling of his painting has something of Le Havre's upstart brashness. 'The water is acrid, and the horizon extends with harshness,' wrote Zola of Monet's early depictions of the port. 'We are facing the ocean; before us is a ship smeared with tar; we hear the muffled, gasping cry of the steamer filling the air with its sickening fumes.'[19]

Profits made from these ships enabled Le Havre's merchants to live away from the smoke, in the airy upper town, the *ville haute*. Adolphe Monet settled his family in a large house in Ingouville, at 30 rue Eprémesnil. In his *Excursions in Normandy* of 1841, the German traveller Jacob Venedey singled out the heights of Ingouville: 'the wealthier merchants of the wealthy commercial town have here built a number of palaces, where they enjoy themselves in summer after the toils of the day. Many English live in those which the owners are willing to let, that they may thus make money even of their villas.'[20] Others, including the Monets, took in paying holiday guests to supplement their income. Among the summer lodgers at rue d'Eprémesnil were a family of aristocratic foreign office civil servants, the Beguin-Billecocqs, who began visiting in 1853; two sons, Ernest and Théodore, became friends with the Monet boys. An older cousin, Count Théophile Beguin- Billecocq, kept a diary of his holiday, and thanks to him is preserved this sole vignette of Monet domesticity: 'I found this short holiday very pleasant. During the day there were walks and sea-bathing, in the evening improvised concerts and balls; everything conspired to make the house cheerful, and the hosts were ready to enjoy life to the full.' Madame Monet sang, he added, and had 'an exceptional voice'.[21] Monet did not inherit his mother's talent, but he did enjoy singing and in his seventies he could still sing the baritone part of a Mozart duet from memory, on pitch.

The Billecocqs would have found themselves in the heart of genteel Le Havre society. Through the connections of Jeanne Lecadre, the Monets' friends included the Delaroches, relatives of a former mayor and owners of the most imposing estate in Ingouville, and the engineer Alfred Bodson de Noirfontaine, designer of the harbour's new fortifications, and his wife Pauline, a local author who in her Paris days had hosted a salon. Monet's famous youthful picture *Terrace at Sainte-Adresse* [Plate 2] was painted on a visit to the Noirfontaine

beach house, looking out on a regatta. Lecadre cousins are depicted there too.

The Lecadres were eminent locally, and a street commemorates another of Jeanne's nephews, Dr Adolphe Lecadre. He served the poor, led the local *société savante*, and pioneered research into cholera and demographics, comparing the decrepit lower town with the salubrious residential heights, where he was bringing up three dainty daughters. The Monet boys acquired a gang of quasi-cousins: the doctor's girls and Arthur's two orphaned sons, whom the childless Jacques and Jeanne had adopted. Suave Eugène Lecadre, aged thirteen in 1845, was a natural businessman, and was being trained to run the enterprise. His older brother would become another doctor. Léon Monet, nine, was destined for science; as a chemist, his knowledge of how synthetic dyes widened the possibilities for oil paint would be a point of connection with his brother. For now the little Oscar, youngest of the quartet, chose as his role 'essentially that of a vagabond', he later remembered.[22] It distinguished him from the others, and particularly from steady Léon. While Léon studied, Oscar roamed the town and the seashore. In middle age Monet was still mocking his sedate, less agile older brother as he struggled on a cliff walk, and Monet had to help him down the cliff, holding his hand 'like a lady's'.

Oscar was a short, dark-haired, spirited boy who found school 'a prison, I could never make up my mind to stay there, not even for four hours a day'.[23] This was the Collège du Havre, where, after a private primary school, Monet was enrolled on 1 April 1851, remaining there until 1857–8. A liberal, secular establishment of some 200 pupils, the school did not use corporal punishment and seems to have been indulgent towards Monet, who brightened lessons – two hours in the morning, two in the afternoon – 'with distractions. I made wreaths on the margins of my books; I decorated the blue paper of my copybooks with ultrafantastical ornaments ... deforming ... as much as I could, the face or the profile of my masters'.[24] François Ochard, the patient middle-aged drawing teacher, left no opinion of his disruptive pupil, who did not choose to attend Ochard's additional classes offered at the municipal drawing school. Monet played down his schooling, which however equipped him as an adult to keep his own business accounts, bargain with dealers, build his own library replete with the

classics – from Homer and Tacitus to Voltaire and Molière – and become a lifelong devoted reader and friend of poets and novelists.

His memory was that he was 'naturally undisciplined' and 'the worst pupil' in his class, 'since all [he] did was sketch', but he was well liked.[25] 'Your success … can't have altered the qualities of the generous nature that I knew,' wrote Fernand Bidaux wistfully.[26] Abbé Antihaume, collating evidence for a history of the school in 1905, recorded that Monet was remembered for 'an excellent nature, very sympathetic to fellow students'. He had 'a remarkable disposition for drawing, enjoyed sketching in pencil or making ink portraits, which he offered very cordially to his friends in the school. We know of some of his efforts, which his childhood friends are carefully preserving.'[27]

The first extant mark of Monet's hand dates from the age of fifteen: a pair of sketchbooks from summer 1856, their pages meticulously annotated. They trace his wanderings near his home and, as remembered by Bidaux, around the Cap de la Hève, close to the Lecadre villa Le Coteau. Monet gives a glimpse of Ingouville's bourgeois houses, set in parks with paths framed by yuccas and umbrella pines, suggesting already the appeal of gardens, of nature tamed, enclosed and decorative, as a counterpart to the attraction of the open sea. A drawing which lays claim to be Monet's first seascape is dated 11 July 1856: the water calm on the wide bay of Sainte-Adresse, a distant schooner making for the port. Another focuses on three boats stranded on the

Monet, *Villa in a Park in Ingouville*, drawing from the 1857 sketchbook

Monet, *Cliffs at Sainte-Adresse*, drawing, 1 October 1857

Le Havre shore, their sails drying in the wind. There are pages and pages of detailed studies of the 'divers bateaux', which held Monet's interest so much more intently than his classes.

The Collège du Havre stood on rue de la Mailleraye, which ran down to the outer port – an attraction for all the boys and the professional destination of most of them, Monet to an extent included. It offered a thrilling spectacle at a particular historical moment, when the age of sail and wood was giving way to steam and metal. Monet the artist kept a child's sense of wonder at the turmoil and energy. In *The Grand Quay at Le Havre* [Plate 1], the basin is vibrant and unpredictable, packed with majestic three-masters and puffing steamships. On the embankment glittering hay bales are unloaded and, reduced to small flecks, a maritime cast – travellers, sailors, dockers, crane operators, customs officials, port agents were always on the quays – rushes around between the bureaux of the shipping lines. *The Port of Le Havre* and *Fishing Boats Leaving the Harbour* [Plate 15] depict the curve of the harbour, its front line of tall narrow houses grey in the smog, the action all in the swarm of graceful schooners and hard-working rowing boats.

In these vigorous, affectionate paintings, from the 1870s, the brushwork is improvisational, fast and loose, but the compositions are monumental and architectonic. Monet takes command of the town developed by the mercantile elite to which his family belonged, but always gives primacy to the water. *The Museum at Le Havre* features

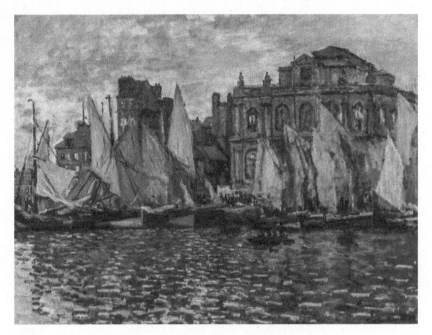

Monet, *The Museum at Le Havre*, 1873

the impressive municipal building, which was erected on the quayside the year the Monets arrived: Monet painted it as if from a boat on rippling water, with oversize sails obscuring the façade of arched windows – the sea triumphant. He would write of his 'passion for the sea', once joking that he wanted to be buried in a buoy.[28]

Monet's three intimate writer friends each documented the impact of the sea on his art. Watching the 'stirrings of the tumultuous ocean', wrote Clemenceau, his eye grew familiar with 'the luminous gymnastics of the mad atmosphere which hurls all its nuances and all its tones to the reckless waves and winds. From childhood, Monet loved the huge horizons of the sea.'[29] Gustave Geffroy believed that 'there stayed with him, from this handsome commercial city, the ineffaceable impression created by the roads opening on to the sea.'[30] And Octave Mirbeau thought the port inflected Monet's very brushstrokes:

> automatically the movement of the boats on the sea, of the sea against the jetties, the rhythm of the swell, the entry of ships into the harbour, the fluctuation of the pent-up masts which relates to the loose curves of

the ropes, the fleeting sails which dance and fly, the spirals of smoke, all the silhouettes of the teeming quaysides, teach him better than a professor the elegance, the suppleness, the infinite variety of shapes.[31]

Monet painted more than a thousand works where water is the main motif, and returned to Le Havre all his life. Jacques-Émile Blanche's description of Monet in a November storm in the 1920s, 'old but still very handsome, getting out of a powerful car, enveloped in a sumptuous fur' to sit on a dike 'in a bitter west wind which ruffled his long white beard, mingling it with the foam of the waves', closes the circle of Channel coast sightings begun with Bidaux's recollection from the 1850s.[32]

Manet, attempting simultaneously to confine and acknowledge his rival, called Monet 'the Raphael of water', but the reach of Le Havre went beyond his subject matter. Impressionism is a northern art, forged from the experience of movement and change in a place where everything is in motion – weather and light, tides and gusts whipping the water, the shifting reflections of sails, buildings, clouds, the sombrely nuanced grey-blue-brown tonalities of sea and sky. Monet the northerner ignored French classical tradition, the heritage of Claude Lorrain and Nicolas Poussin, who both lived extensively in Italy. Among nineteenth-century artists, it was Paul Cézanne the southerner, painting in the constant luminosity of Aix-en-Provence, its fountains and avenues of plane trees preserved since the *ancien régime*, who pursued the aim of 'making of impressionism something solid, like the art of the museum'.[33]

Monet's exceptionally intense experience of seeing was innate, but the transparency of water and the blur of fog in Le Havre played their part in training his eye: the mist above the port hid then revealed objects and elements, so that the act of looking was itself a quest. Stendhal, at the window of Le Havre's Hôtel de l'Admirauté in 1837, described an atmosphere dense with black-brownish smoke from the steamers, mingled with jets of white steam whistling from the industrial buildings. Monet, from a window of the same hotel in 1873, reconsidered the view he had seen every morning as a schoolboy, and painted winter dawn over the smoky port: the harbour at first hardly perceptible in its shroud of mist and steam, then forms – docks, cranes,

chimneys – heaving into view. The grey sea and sky are tinted rose by the rising sun, whose reflection, applied in a thick orange-red paste, wet on wet, is cursory and dashing. A diagonal of three sculled boats punctuates the water surface; their dark silhouettes are almost filmic, as if Monet shows the same slowly progressing boat at different moments. This painting, *Impression, Sunrise* [Plate 16], gave impressionism its name, made Le Havre an icon of modern art, and memorialized Monet's connection to the port city.

What we know of his first decade there, aged four to fourteen, suggests a child outward bound, curious, stimulated by his surroundings, and secure within a nurturing extended family of characterful women. Oscar and Léon grew up under the gaze of a lively, sociable mother, of sensitive Aunt Jeanne, attentive to everyone's needs, and of Catherine Chaumerat, the sturdy grandmother from Lyon, who lived on at Le Coteau into her eighties. Until this point, Monet's happy childhood, fortunate in its uneventful ordinariness, as mentioned by Geffroy, rings true.

Then catastrophe struck. Catherine's death at Sainte-Adresse in September 1855 marked a turning point for the Monets, the end of a

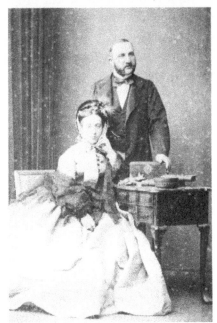

Adolphe and Louise Monet, *c.*1855

long period of comfort and upward mobility. In 1856 it became obvious that Louise's health was failing. The only known photograph of Monet's parents dates from around this time. His mother, seated, demure and neat, looks resigned – far from the lively hostess described by Théophile Billecocq and painted by Rinck. Adolphe stands protectively, anxiously, behind his wife, with a bewildered, almost vacant look. Another Billecocq visitor is the witness to this period: the diplomat Hippolyte, father of Ernest and Théodore, recalled Adolphe's concern for his wife, and 'the care with which he surrounded her during that cruel illness'.[34]

Adolphe and the Monets' maid, Célestine Vatine, became Louise's nurse. Jacques' nephew, Adolphe-Aimé Lecadre, was her doctor. Monet kept out of the way. His sketchbooks trace his wandering by the water almost every day in summer 1856. On 17 July he drew eleven different boats, their riggings and sails precisely detailed, on a single sheet, plus studies of trees in Ingouville on two further pages. The next morning he was back on the beach, then he went east to Harfleur, where the little river Lézarde meets the Seine; here Monet drew his first bridge, and its reflection in the water – a motif that would hold a lifelong attraction. He slipped into the Delaroche property to sketch the gardens, and into the orchards of a neighbouring farm to draw apple trees. In a second summer sketchbook began on 13 August, on the pebbled slopes of Bléville, he noted 'the storm of 21 August' with a tempest-tossed canoe, and trees whipped by the wind. Every page shows the fifteen-year-old's power of concentrated observation, his easy touch, what Bidaux called his 'divine' drawing.

Towards the end of the summer Monet found two little boys to pose, one sitting cross-legged with a doll, the other, named – Édouard Perdrieux – standing solemnly in knee-length trousers, oversized jacket and a cap, hands in his pockets, a tiny figure in the middle of the page. Monet's sympathy for children is well documented, but in 1856 he was not much more than a child himself, and perhaps felt lonely or lost. He concluded the sketchbook on 10–12 September with a pair of melancholy spectacles: a tumbledown cart marooned in long grass, and a gnarled broken tree trunk inscribed 'aux phares' – the twin Sainte-Adresse lighthouses which guided the way into Le Havre, and gave their name to the route des Phares, where Le Coteau

stood. Then he returned to school and to autumn and winter evenings in a darkening house.

Louise Monet died at home at one o'clock in the morning on Tuesday 28 January 1857. At 11 o'clock, Jacques Lecadre registered the death at the town hall. He himself had only a year to live, and without his protection Adolphe's professional position was vulnerable. For now Jacques offered a last gesture of help to his brother-in-law: an escape from the house on the heights, too large to manage without Louise, to an apartment on the harbour at the Lecadre business headquarters, at 13 rue Fontenelle. The widower relocated with his sons to the quayside, and Monet lost Ingouville as well as his mother.

Her death could not take away the advantages of passing his youth in Le Havre. The city imbued Monet with a love of movement, a delight in the materiality and texture of things – impressionism's secular pleasures and extroversion. But a childhood awareness of loss, burning deep into Monet's psyche, may also have had a bearing on paintings which so determinedly celebrate the fleeting moment, and therefore say too that each will inevitably pass.

'Painters in the past attempted to separate the eternal from the transitory. They distinguished elements, bodies, substances in an effort to be specific about volumes and planes,' wrote the critic Roger-Marx in the early twentieth century. 'M. Claude Monet belongs to a quite different age, in which dizzying speed is the rule' and in his painting 'the question is no longer a matter of fixing what is there, but of seizing what is going by'.[35]

Son of energetic Le Havre, Monet, even in the shock of grief, was ready to seize the moment, in art and in life.

2

Trembling Laughter, 1857–9

A fortnight after Louise's death, Monet climbed the hill overlooking Graville, where a Romanesque abbey stands behind yew trees, and sharp gusts blow off the Channel. He began a fresh sketchbook with the drawing of a crooked covered gate entrance to a farm, the little roof damaged but still supported on uneven brick pillars, the portal swung back and a bare tree sprouting in the opening. It an image of man-made shelter amid nature such as would appeal to Monet all his life – cabins on the cliffs, haystacks in the fields. Already, in this 1857 sketchbook are depictions of the distinctive *caloges*, the covered boats resting onshore through the winter, which would recur in his 1880s paintings of nearby Étretat.

On 22 February, Monet was out again, 'sur le bord de la mer', as he recorded beneath his sketches, drawing a tousle-haired, dark-eyed, full-lipped youth. It was not a self-portrait, although the expression, sombre, pained, withdrawn, is that of a grieving adolescent. Another tumbledown lonely building, a thatched grange several kilometres inland, was his subject a week later.

Then suddenly a new sort of drawing appears in this sketchbook: monstrous caricatures with huge heads, pronounced, hideous noses and small bodies. By the summer, when he gave the loyal visitor Ernest Billecocq a batch of funny, savage cartoon-portraits, Monet had refined the drawing and added colour highlights. He was on the quays, satirizing the arrivals and departures. A fashionable young man squints through a monocle, a traveller in tartan sports an over-sized moustache, a staring boy in a too tight jacket is entitled 'progéniture anglaise'. Among these characters, a benign, larger personage, long-haired, bandy-legged, bright with a big red bow tie and a pointed hat, is an artist, carrying his case of paints.

These figures represent the launch, within months of his mother's death, of the caricaturist signing himself 'O. Monet'. He quickly made progress and as quickly became known across the town. Monet recalled circling the rue de Paris in the centre of Le Havre so that he could repeatedly walk past the stationer and framer Gravier, at number 104, where his caricatures of the town's notables were on show in the window, in an arrangement renewed every Sunday. 'My caricatures arrogantly displayed themselves five or six in a row, framed in gold and glazed, like highly artistic works, and when I saw the loungers crowd before them in admiration and heard them pointing them out, say "That is so and so," I nearly choked with vanity and self-satisfaction.'[1]

Some of these have survived. Each is carefully worked, executed with fluent economy of line and tender-cruel attention to facial detail and to insect-like shadows thrown by the tiny legs. Monet learnt his grotesque style by copying examples from the popular 'portraits-charges' (caricatures) by illustrators such as Étienne Carjat, in the newspaper *Le Gaulois*, and Nadar, in his satirical 'Panthéon' and in *Le Journal amusant*. His own subjects came from the Lecadre-Monet

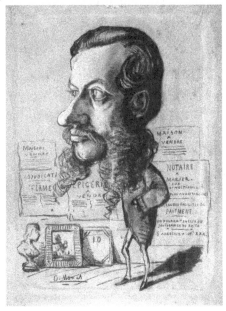

Monet, *Léon Manchon*, c.1858

business circle, such as the 'courtier de commerce' Adolphe-Victor Coesmo with his flamboyant curly coiffure. Lawyer Paul Boudereau, sharp-eyed behind his pince-nez, thin and menacing, is depicted in pugnacious cross-examination, while his colleague Léon Manchon, out-size side-whiskers trailing halfway down the page, is set against posters mockingly advertising his trade – 'Notaire à marier, aux conditions plus avantageuses'. Manchon was treasurer of the Société des Amis des Arts du Havre, and Dr Lecadre also sat on the board. A big-nosed disaffected character is the elderly picture framer and gilder 'grand-père Lebas'; a wily-looking man fingering a snuff box is an auctioneer; and Monet inscribed a portrait of a lugubrious middle-aged grocer 'à mon ami Dermit'. These macho distortions flattered big egos. Monet's harsh contours matched his subjects' thrusting personalities.

How much the aggressive productions of the precocious teenager owed to the rage and loneliness of the bereaved child is hard to say. In his analysis of caricature in *De l'essence du rire*, written in 1855–7, Baudelaire declared that 'le sage ne rit qu'en tremblant'– the wise man does not laugh without trembling.[2] Baudelaire situated caricature as an urban, edgy form, revealing and representing alienation. The ambitious Monet seized it to situate himself socially and professionally, but it was for him also an expressive outlet; drawing was a refuge from the gloomy household.

The only written record of the Monet family in the months after Louise's death come from the Billecocq visitors. 'I'm not at all surprised at the demoralized state in which you have found the worthy Monsieur Monet,' Hippolyte told his son Ernest. 'I knew too well the affection he had for his regretted wife . . . For the poor husband, it's a broken existence, a void that nothing can fill.'[3] But Adolphe did soon fill it, in secrecy and shame: with the maid Célestine Vatine, who would give birth to his daughter Marie in January 1860. Adolphe did not reveal the child's existence to his sons. Confronted some years later with the news that Monet's lover was pregnant, Adolphe closed his ears. He expected, he said, that 'these things' remained unspoken, 'restent dans le silence'.[4]

Monet too kept things *dans le silence*. For forty years, no one recalled him talking about his mother, and never in his voluminous

correspondence is she mentioned. When eventually he did refer to her, under pressure from interviewers after 1900, he was wilfully misleading. Once he predated her death, claiming that she died when he was only twelve but 'had already urged him to draw'.[5] On another occasion he extended her life to his student days in Paris when 'my mother in secret sent me small sums of money'.[6] That fantasy carried some emotional truth about his behaviour at the time, for in his letters until the mid-1860s, describing current events and interactions with his father, Monet repeatedly referred not to 'mon père' but to 'mes parents'. Although this can mean 'my relatives', Monet's use of the phrase, long after his mother's death, allowed him at least not to admit her absence from his life. If the deliberate vagueness was a defence, he may have uttered no happy recollection of his mother not because he had none, but because he found strength by refusing to look back and accept that she was gone.

Monet's stepson said that his aunt was 'the only person from this time of whom he talked with affection'.[7] Adolphe, sneaking off to visit his 21-year-old mistress in the bustling rue Pincette, a few minutes' walk from rue Fontenelle, was distant from his sons. Léon was absorbed in his studies. The brothers were never close and, according to family memory, a lifelong antagonism existed between them. But there is an implication of common experience in a gift made much later. One week after Léon himself was widowed, Monet gave him an 1856 landscape drawing signed 'à mon frère, souvenir de notre jeunesse', dated 20 September 1895 – a condolence gesture which recalled their shared difficult year, 1856–7. Léon, in the family tradition, remarried quickly, and in his sixties became father to a daughter, whom he named Louise Monet, after his mother.

'Certainly life has its sad moments, but if you let yourself continue like this, you are lost' was Monet's advice, many decades on, to an inconsolably bereaved woman whom he loved.[8] It was given from his own experience of resilience and recovery. As an adult, he was explicit about attempts to sublimate unhappiness in painting: 'I have to be able to work to conquer my grief.'[9] At sixteen, he was already doing so. On the one hand, he was out with his sketchbook on the cliffs, heralding the habits of a lifetime – Geffroy asserted that Monet was predominantly 'a man of solitude' for whom 'nature has been the

most splendid refuge'.[10] On the other, he threw himself into the busy sociability of making caricatures, and an enterprising marketing of them.

With his *portraits-charges*, Monet steps out of the childhood mists of Le Havre, and begins to forge an identity. He received commissions, he boasted, and 'according to the appearance of my clients, I charged ten or twenty francs . . . the scheme worked beautifully. In a month my patrons had doubled in number. I was now able to charge twenty francs in all cases.'[11] These caricatures link the provincial adolescent to metropolitan modernity, to a genre inherently rebellious – even if his bourgeois subjects treasured the results enough to pay for and keep them. Their aggression is also defensive, for distortion deflects the threat of another's subjectivity. They were an assertion of power at a time of vulnerability. In them, little Oscar got the better of 25-year-old Eugène, his smooth, complacent, hook-nosed cousin, top hat to hand, who was rising in the Lecadre business. And Monet was ruthless with a rival young aspiring artist, Henri Casinelli. Renamed 'Rufus Croutinelli' (a *croûte* is a sketch), he was depicted with his shoulders

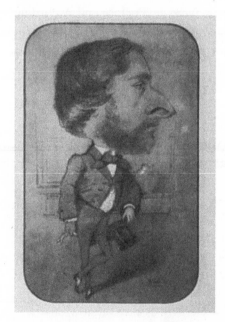 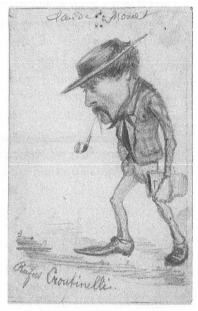

Monet, *Eugène Lecadre*, c.1858; Monet, *Rufus Croutinelli*, 1858–9

hunched, downcast and hindered by too-large shoes, staggering une-
venly along the street, as if Monet hoped he would trip up.

Why are we amused at 'the spectacle of man who falls ... who
stumbles at the edge of the pavement', Baudelaire asked in *De l'essence
du rire*. 'One finds at root, in the thinking of he who laughs, a certain
unconscious pride: me, I don't fall; me, I walk straight.[12] The carica-
turist Oscar Monet seventeen was walking straight – towards Parisian
modernity. He was also expressing something indomitable in his rela-
tionships to others: that he would accept them only on his own
terms. He would carry elements of his *portraits-charges* into the
painting of Claude Monet, in his hard emphatic touch, and in his
stark, anonymizing way of engaging with the human figure. From the
eleven picnickers in *Le Déjeuner sur l'herbe* in 1865 to the pictures of
girls in boats from 1887–90, whoever he depicted was playing a part
in a composition, not a psychologically considered or independent
person.

This is one reason that Monet became primarily a landscape artist.
Another was the painter Eugène Boudin. Monet met this tall, slow-
moving, good-natured sailor's son, sixteen years his senior, in the
framer's shop when he was crowing over his display of caricatures.
Boudin's pictures were also on show, and did not sell. Self-taught and
self-doubting, Boudin, with his inquisitive eyes, domed forehead and
fan-shaped beard, was a familiar but mostly scorned figure in Le
Havre. Born in Honfleur and apprenticed at twelve to a printer, he
had met the Barbizon realists Charles-François Daubigny and Jean-
Francois Millet when he worked in a stationery shop, and following
their example he began to paint informal, non-academic seascapes
and landscapes en plein air.

In 1854 he was thirty, lived in an attic and told his diary: 'I'm only
too aware of my unimportance ... I have not a penny in the world, I
have absolutely nothing.' Two years later, things had slightly improved
when he noted: 'people are beginning to visit me and I'm no longer
treated like a miserable failure.' In December 1856 he set down his
quest for the new year: 'to breathe in the depths of the sky, to express
the gentleness of clouds, to balance these masses far, far away, from
the grey mist, to set the blue of the sky alight, I can feel all this within
me, poised and awaiting expression.'[13] He was trying to make it

happen when he encountered the audacious young caricaturist who thought himself 'an important personage in the town',[14] enjoyed drawing as an instinctive pleasure, but 'had never seen a canvas being covered' in paint.[15]

'I remember our meeting as if it were yesterday,' Monet recounted to Boudin's biographer Georges Jean-Aubry. Monet had until then shared Le Havre's prejudice against Boudin. His 'expansive and generous personality was already apparent', he recalled, but

> I had seen his work on several occasions, and must admit I thought it was frightful. 'These little things are yours, are they, young man?' he asked. 'It's a pity you don't aim higher, for you obviously have talent. Why don't you paint?' I confess the thought of painting in Boudin's idiom didn't exactly thrill me. But when he insisted I agreed to go painting in the open air with him. I bought a paintbox, and we set off to Rouelles, without much enthusiasm on my part. I watched him rather apprehensively, and then more attentively, and then suddenly it was as if a veil had been torn from my eyes. I had understood, I had grasped what painting could be. Boudin's absorption in his work, and his independence, were enough to decide the entire future and development of my painting. If I have become a painter, I owe it to Eugène Boudin.[16]

The fateful meeting took place in 1857, and Monet was soon following Boudin. 'Together we went on long walks during which I never stopped

Eugène Boudin

painting from nature. That's how I understood it and got to love it pas-
sionately.'[17] His attraction to Boudin was instinctive: a teacher with
untiring kindness guided him to a stage beyond drawing. It helped that
Boudin was temperamentally his opposite – mild, moderate, mod-
est. Monet would probably have resisted a more forceful personality.
As it was, he learnt plein air painting from a teacher in the vanguard,
and at a propitious moment. Plein air painters had been significantly
helped by John Rand's invention, in 1841, of the collapsible paint tube,
light and portable, and the Impressionists would further exploit its
bright new synthetic colours, made possible as chemistry advanced.

'How long is it since we set out to try ourselves out on the landscape
of the Rouelles valley?' Boudin asked decades later, recalling 'our years
as beginners'.[18] The recollection is of a parallel endeavour rather than
mentor and pupil. Rouelles, in the valley of the river Lézarde, was a
fifteen-kilometre hike from Le Havre through forests and villages.
View of Rouelles is Monet's first known painting, and his first to be
exhibited, at Le Havre's Société des Amis des Arts show in August–
September 1858. Monet had positioned his easel next to Boudin, who
depicted the same scene in *Norman Landscape*, but to different effect.
Boudin's rural idyll balances river, trees, farmhouse, the roofs of a
hamlet and cattle grazing in a pasture. The drifting clouds imbue the
scene with life, but at ground level everything is static. Monet cut most
anecdotal detail – no houses, no animals, only a lone fisherman – and
simplified the scene to emphasize a row of poplars reflected in the river,
which opens up in the foreground into a pool of light.

Boudin's is a work of careful naturalism, Monet's a schematic, com-
posed picture. Executed in a higher colour key, more imbued with the
effects of light and air than Boudin's, and harmonious in the equilib-
rium between water, sky and the fisherman's blue shirt, his little
landscape anticipates a lifetime's concern with weighing fidelity to
observed nature against the demands of pictorial construction. He
surveyed the scene, and concentrated on what gave structure and
luminosity: the poplars and the pool of water. Both became favourite
motifs when he was rethinking what landscape could be in Giverny in
the 1890s and 1900s. Aged seventeen and out with Boudin, 'my eyes,
finally, were opened' to nature, he said, then, 'I analysed it in its forms
with a pencil, I studied it in its colorations.'[19] With him for the whole

of his life was Boudin's conviction that 'anything painted directly from nature and on the spot has always a force, power and vivacity of touch that one cannot find in the studio. Three brushstrokes painted from nature are worth more than two days' work at the easel.'[20]

In 1858 this was eccentric, and Boudin's was the opposite of a successful career. He was so poor that he burnt his furniture to keep warm, but he was slowly gaining respect from somewhat like-minded, more famous peers. Corot, acclaimed painter of Arcadian, silvery landscapes, begun in the open air but finished in the studio, called Boudin 'the king of the skies'. Gustave Courbet, the pioneer of realism, saw a Boudin picture in 1859 and demanded an introduction. Boudin kept his head, noting 'he is a really vigorous man ... his approach is broad ... at the same time I find it very coarse, and his attention to detail very summary and rather styleless. I feel that there is a truer and surer way to paint.'[21]

Boudin's loose connections with the celebrated realists of the age alerted Monet to a cultural scene beyond Le Havre. By the time he was eighteen, Monet was giving promotional advice to his teacher, declaring, 'There is a total lack of marine painters, and it's up to you to set off on the road which will lead you far.'[22] Monet would follow that advice himself, overtaking Boudin, who never sought prominence and whose career unfolded gradually. Once he had taken what he needed, Monet did not always repay Boudin's kindness. 'I have many causes to reproach myself as far as you're concerned, and I very often do,' he wrote in 1889, 'but don't let this make you less certain of the friendship I feel for you, nor of my gratitude for the advice you gave me, advice which made me what I am.'[23]

The teenage Monet was bold enough to ask Boudin for the gift of a sketch. In turn, asking sadly years later for a 'keepsake', Boudin wrote, 'If I have one regret on seeing myself growing old, it's that among my souvenirs I have not the tiniest little bit of a painting by you. I once had a very beautiful one, without a circumstance of which I don't have to remind you, it would still be on my wall.'[24] The implication is that Monet took advantage of Boudin's good nature. The gap widened quickly. Boudin in his forties was still warning himself, 'I must work to eliminate a certain timidity, which is a long-cherished provincial habit.'[25] Monet was a provincial in a hurry not to be one. Six

Monet's portrait of his father, Adolphe Monet, 1865

months after meeting Boudin, he had made his decision: 'I announced to my father that I wished to become a painter and that I was going to settle down in Paris to learn.'[26]

Adolphe Monet had more pressing concerns. After Jacques Lecadre died, in 1858, Hippolyte Billecocq noted, 'M. Lecadre's death should have the effect, it seems to me, of dissolving the business which he directed: what will happen to M. Monet père? Will he continue to preside alone, or will he have to find another position? The prospect of a legacy coming to his sons would be sweet, but it in no way ensures his livelihood now.'[27] The worldly Billecocq had observed Adolphe Monet through the 1850s, and his lack of confidence was justified. Adolphe did not stay long at the company, retiring in 1860. His widowed sister, for whom Jacques had ensured a comfortable private income, welcomed his company at Le Coteau and helped support him. His own funds were channelled, secretly, to Célestine Vatine after the birth of Marie. Monet's depiction of his father in 1865 suggests Adolphe did not age happily, nor win his son's sympathy. The profile portrait shows a heavy-lidded, morose figure with turned-down

mouth and half his face shaded – a descendant of the harsh caricature mode.

It is hard not to see Boudin in 1858 fulfilling a nurturing paternal role for Monet that was absent at home. It may have been to this period, and to summers at Sainte-Adresse, that Monet referred, in a rare throwaway remark, 'I learnt gardening in my youth, when I was unhappy.'[28] His room was on the second floor at Le Coteau, and from it he depicted the wooded valley with the towers of the churches Saint-Denis at Sainte-Adresse and Saint-Vincent at Le Havre, fog rising from the estuary, sky and water tinted pink: *View of Sainte-Adresse from Aunt Lecadre's House*, a picture belonging to his brother Léon. A corner of the white house with green-grey shutters, and Monet's window, peer out from his painting *Garden in Flower*. Eugène, who married his Lecadre cousin Marguerite, a Havrais doctor's middle daughter, inherited Le Coteau in 1871 and demolished it in favour of a turreted Anglo-Norman pile. But for Monet the dappled park, abundant and multi-hued with its tall rose bushes darting up from bright flowerbeds, its curving gravel paths and the sheltering screen of hedges and trees, was the prototype for all future gardens, first in paint, then in fact when he created his own. In the mid-1860s he made a group of scintillating garden paintings led by *Woman in a Garden* [Plate 6], where Marguerite Lecadre with her parasol strolls past flowers in a sunlit glare. Eugène and Marguerite acquired this major painting,* then swapped it with a Havrais collector for a pair of Chinese vases.

In adolescence Monet basked in Lecadre largesse. As Adolphe's means were reduced, Jeanne's fortune and the estate at Le Coteau kept the Monets in bourgeois style. *Peaches in a Jar*, the clove-studded bottled fruit reflected on a glassy surface, depicts the pride of Jeanne's greenhouse – she would send her nephews gifts of peaches – and distil the indulgence and taste of childhood. Without a husband to care for, this fragile, determined woman, nearly seventy, concentrated her affection on her nephew. She got little thanks. She allowed Monet to use her studio, and made him a present of a landscape painting. Monet claimed she had failed to recognize it as by Daubigny, the Barbizon

* It is now at the Hermitage in St Petersburg, and was the catalogue cover image for the Monet retrospective at the Grand Palais in Paris in 2010.

Jeanne-Marie Lecadre

plein-air painter; he identified it and sold it. That she did not under-
stand what she was giving him seems unlikely, as the Barbizon artists
were well known by the 1850s, and Jeanne had connections with real-
ist painters through a friendship with the painter Armand Gautier, a
disciple of Courbet and frequent visitor to Le Havre. She and Gautier,
a fervent republican and a generous man, kept up a regular corres-
pondence. Jeanne was well informed, cultured and smart. Monet
seems to acknowledge her qualities in a caricature of an elderly
woman whose features, affable intelligent expression, wide-mouthed
yet reserved smile and old-fashioned Norman pleated headdress all
resemble Jeanne Lecadre in a photograph. This was one of the few
caricatures Monet neither sold nor gave away.

Of Adolphe, Monet spoke only with derision. His father 'opposed
him vigorously'[29] from the outset, he said, and never gave him a franc.
The paintings depicting him disprove this – Adolphe, after all, posed
for them – and so do Le Havre's archives. On 6 August 1858 Adolphe
Monet applied to the municipality for a grant for his son to study art
in Paris; the city ran a competition to help promising candidates
embarking on their careers. The attempt was unsuccessful, and
Adolphe applied again on 21 March 1859. Between these dates
Monet, out of school, drifted. In the summer he was steadied by

Boudin. In the winter he hung out downtown, making 'drawings from the theatre, on separate sheets, portraits-charges of all the artists in the troupe and several musicians from the orchestra'.[30]

These were displayed in 1859 at the Place de l'Hôtel de Ville in the shop of a photographer called Lacourt, and were still remembered in Abbé Antihaume's gathering of recollections *Le Collège du Havre* in 1905. We can trace a connection, arising in the 1850s–60s, between the virtuoso speed of caricature and the flash of photography. The caricaturists Carjat and Nadar both became celebrated photographers.* Monet said that he also made portraits, for 5 francs a head, of sea captains coming off the boats. He was thus in direct competition with the Macaire-Warnod brothers, who set up their photo booth on the Le Havre quay in 1851, and in 1858 netted as a customer, among numerous other travellers, Elizabeth Barrett Browning. She was a fervent admirer of photographs: 'I would rather have such a memorial of one I dearly loved than the noblest artist's work ever produced,' she wrote.[31] Already, in 1851, the *Revue du Havre* reckoned the brothers' photographs had 'a truthfulness which would be the despair of the most skilful pencil'.[32] In Le Havre, contest between the media heightened when the Macaire-Warnods appeared in the 'drawings' section of Le Havre's Société des Amis des Arts exhibition in 1858, with 'portraits et marines instantanés, non retouchés'.

Louis Daguerre had announced the invention of the daguerreotype in 1839. Quite soon it became clear, to thoughtful artists, that photography would make painting's documentary function obsolete, and technical virtuosity at rendering reality became ever less important – expressive content, inventive composition and colour more so. Monet, and his friends born at the time – Cézanne and Sisley in 1839, Renoir and Berthe Morisot in 1841 – belonged to the first generation of painters challenged at the outset of their careers by photography's *instantanéité* and objective eye. Monet competed with the first, and developed painting which declared its own subjectivity – a response to the second.

* Monet would come to know both: Carjat was the first to photograph him, in 1865; Nadar lent his premises for the first Impressionist exhibition in 1874, and later made famous images of the elderly Monet.

His display at Lacourt's drew attention from the committee considering grant applications. There were six candidates in spring 1859, reduced to five when Casinelli, aka Croutinelli, was disqualified because he was not French. The case of 'Monnet (Oscar)' intrigued the municipal board: 'we all know ... his remarkable natural disposition for caricature' but 'is there not in this precocious success, in the direction so far towards this facility of drawing, a danger, one that will keep the young artist away from more serious studies?'[33] The sketchy virtuosity of his *portraits-charges* was too easy. Monet's paintings would meet similar criticism for the next quarter century.

At rue Fontenelle, Monet's future was also unclear, but he was on a loose leash. While Léon was taken on by the Swiss firm Geigy and began a successful career as a chemist, and Eugène thrived in the family company, developing a profitable specialism in wool, Oscar drew, painted, studied illustrations in Parisian journals and dreamt of going to Paris. Later Monet claimed his father was biding his time, allowing him freedom only to 'catch' him at twenty, when the lottery for conscription took place. Under the Second Empire, military service was a seven-year stint, avoidable only by paying a substitute; thus an 'unlucky number' gave wealthy parents bargaining power over recalcitrant sons. When Monet was eighteen, this was a far-off prospect, but, like many uneasy teenagers, he began to resent the milieu on which he depended. Le Havre, he told Boudin, was philistine, a cotton town, 'this dirty city'.[34], this cotton town Gautier concurred that 'the city is so commercial and the museum so neglected that exhibitions are rare.'[35] Monet, at least in retrospect, unfairly tarred his family with the same brush: 'I was born in a circle entirely given over to commerce, where all professed a contemptuous disdain for the arts.'[36]

Unfolding his biography to Thiébault-Sisson, Monet skirted the two years in Le Havre following his mother's death by pretending that he had simply not been there. He did not want to dwell on them. His version was that, against the will of his parents, he lived in Paris for four years, from the ages of sixteen to twenty, funded by an unlikely 2,000 francs earned from his caricatures. He told Geffroy too that he went to Paris in 1857. This is an invention: he is documented as living in Le Havre until 1859. In his legend of independence, Monet also cast his mother, dead before he set eyes on Boudin, as the

Charles Lhuillier's caricature of Monet aged eighteen

opponent of the man he believed his saviour. Louise Monet disapproved of Boudin, he claimed, and 'thought me lost in the company of a man of such bad repute'.[37]

Louise shifts in her son's memories between adversary and secret ally, probably reflecting the ambivalence with which the adolescent Monet thought about her. But his living family was supportive. In spring 1859 Monet told Boudin that he had persuaded his father 'to let me stay a month or two' in Paris 'to work firmly at drawing'. He was to search out a teacher and an art school. Following this initial foray, he was expected back for summer 1859 in Sainte-Adresse to paint 'good studies in the country', then in the autumn he would return to the capital 'to settle definitively. That is accepted by my family.'[38] It was also funded by them.

The earliest known depiction of Monet comes at this time, appropriately, a caricature by Charles Lhuillier, who had trained with

Ochard in Le Havre, and was Boudin's contemporary. He delineated a teenager with a dramatic quiff, dressed up in a too-large suit, a little foppish with his sharp lapels and bright neck-tie, the pose confident-casual, one hand shoved in a pocket, legs crossed. The high brow, strong-willed features, piercing eye, and a face steadily composed yet pushing forward, suggest an uncontainable force, yet there is also a hint of apprehension in the expression of this eager young man leaving home for the first time.

On 18 May 1859 the municipal authorities declared their decision. Alert to civic relevance, they awarded grants to an architect, Anthime Delarocque, a pupil of Gothic revivalist Eugène Viollet-le-Duc, and to a sculptor, and rejected Monet. He had not bothered to wait for news of his application. The day after the result was announced, he was already installed at the Hôtel du Nouveau Monde, Place du Havre, close to the Gare Saint-Lazare. From here he wrote his first letter home, breathlessly unfolding to Boudin 'every beautiful thing I see in Paris'.[39]

3

Oscar in Paris and Algiers, 1859–62

Disembarking at the Gare Saint-Lazare in spring 1859 was to walk into a city that was a building site, but one touched with fantasy. Paris was then in the throes of the most ambitious physical transformation in its history as Baron Haussmann, Napoleon III's prefect of the Seine, turned the capital into the radiant, cohesive city which became the Second Empire's great legacy: wide tree-lined avenues, scintillating gas lamps, landscaped parks. A contemporary American visitor described a French Babylon in which 'magic palaces rise, glittering promenades are thronged, where of late stood only mean and narrow streets'.[1] On a former swamp in the centre, and funded by the speculators the Pereire brothers rose in 1859 the foundations of the majestic Grand Hôtel, which would later gleam on the corner of Monet's painting *Boulevard des Capucines* [Plate 18]. From the graceful paths fringing the lawns and flowerbeds of the Parc Monceau to the stark iron trusses of the Pont de l'Europe spanning the enlarged Gare Saint-Lazare, the buildings and pleasure sites which would feature in Monet's cityscape paintings were conceived, planned and begun within a few years of his arrival, and were part of the urban boom of his youth.

The teenage Monet called his new home 'this stunning Paris'.[2] His first lodgings were at rue Rodier, in the ninth arrondissement of his birth. Subsequently he rented nearby a sixth-floor attic room from a landlady called Madame Houssmène at 18 rue Pigalle on the borders of Montmartre. Originally a village in open country, with vineyards and windmills, Montmartre was developing into an entertainment attraction and was incorporated into Paris as the eighteenth arrondissement on 1 January 1860. The city was expanding on all sides, and the ninth arrondissement benefited from investment moving

north. Writers and artists followed. An irresistible modernizing impulse, Haussmann's new-look Paris would be backcloth and accomplice to a new way of painting.

Napoleon's instructions were to 'aérer, unifier, embellir': to make the city airy, unified and beautiful, a statement of empire to rival London and evoke Rome. In 1859 the gutting of old Paris and the building of the 'grande croisée' connecting the major central boulevards were complete, and phase two was beginning. This was the project for networks of new straight thoroughfares, lined by smart apartment blocks in pale stone, their window sizes, cornice heights, balcony railings, decorative ironwork all regulated – proud symbols of civic cohesion and industrial achievement, and still the core of the city today. Renoir's father, a tailor with five children on rue de la Bibliothèque, in the first arrondissement, was among the thousands of artisans evicted in the mid-1850s from insalubrious working-class housing to make way for clean, geometrically organized, well-lit boulevards.

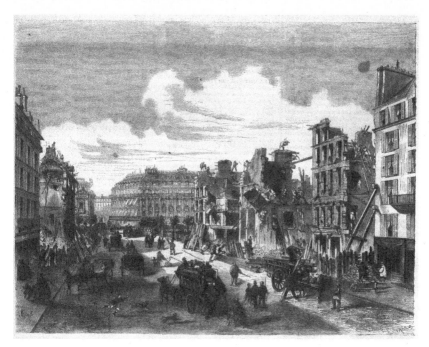

Demolition of the rue de la Paix for the opening of rue Réaumur, Paris, as part of Baron Haussmann's transformation of Paris, 1860s

Social and economic progress was Hausmann's mantra, but what also mattered was the dazzle of prosperity. To bribe people into accepting an authoritarian government, 'the empire must be a succession of miracles', Napoleon's minister of the interior, the duc de Persigny, advised.[3] Louis-Napoleon, elected President of the Second Republic in 1848 after the revolution against King Louis-Philippe, seized absolute power in 1851, won approval under a constitutional referendum and founded the Second Empire in 1852, proclaiming himself Napoleon III. To a growing urban middle class, he brought security and the prospect of wealth. Paris became a platform for conspicuous consumption, speculation soared, fortunes were won, a fifth of workers were employed to build this fresh city representing a fresh regime.

The atmosphere of construction, dynamism, optimistic possibility caught up even those opposed to Haussmann, or Napoleon. Renoir, nostalgic for the medieval winding Paris, thought Haussmann's uniform buildings as coldly ordered as a row of soldiers, but he depicted them as a blaze of light and elegance. Zola, who arrived from Aix and was a committed republican, wrote home in 1860 that 'Paris is the star of intelligence, sending its rays to the most distant provinces.'[4] It was the only place to be, and through the 1860s he insisted that 'to live away from Paris at this time of struggle is criminal'.[5] Walter Benjamin famously named Paris the capital of the nineteenth century. Its citizens at the time already believed it. A fashion magazine in 1854 praised a 'paradise of luxury and pleasure, the capital par excellence of the fashionable world, the queen of civilization. Above all Paris amuses itself.'[6]

Monet amused himself, and tried to position himself. He arrived with a few letters of introduction. His first call was to Aunt Jeanne's friend Armand Gautier, who was welcoming, then to the genre painter Charles Monginot, who offered Monet the use of his studio, and to Constant Troyon, a Barbizon artist enjoying success with his animal paintings. Boudin, for a fee, painted Troyon's skies for him, and he sent Monet to his friend for appraisal. Troyon studied Monet's canvases and, like the Le Havre committee, judged him gifted but facile. He recommended study with Thomas Couture, a dedicated teacher – Manet was his pupil for six years – but a dry academician whom Monet quickly dismissed as a bad painter. His taste honed by Boudin's naturalism, the young arriviste was not afraid to be critical. He

did not rate Monginot either, though he seized the chance to paint still lifes in his studio, and while there occasionally glimpsed Monginot's friend Manet. There was no contact: a gulf of social class and education separated the urbane Parisian and the Le Havre provincial. Monet had to find his own way.

From rue Pigalle it was a brisk half-hour walk, skirting the rue Laffitte, now well established as the *rue des tableaux,* across the fashionable boulevard des Italiens, past the Louvre, over the Seine at the Pont Neuf, lined with its grotesque stone heads, the *mascarons,* to the Île de la Cité. This was the heartland of authoritarian Paris, where Haussmann was

The Académie Suisse, seen from the Pont St-Michel, *c.*1865, Monet's first drawing school in Paris

redeveloping the Palais de Justice, the site of revolutionary tribunals and the guillotine still within living memory, and adding a Prefecture of Police. In its shadows stood, at 4 quai des Orfèvres, a dirty red building housing a vintner, a barometer-maker and a pewter shop and, above them, the Académie Suisse. 'I am very content here, I am steadily drawing figures,' Monet told Boudin in February 1860.[7]

The Suisse was a bohemian legend. Eighty stools were crammed between nicotine-stained walls in a second-floor studio with two windows, one overlooking the Seine, the other a courtyard. In summer the school opened at six in the morning, and there was an evening class from seven to ten. A nude model posed daily, male for three weeks, female for one. 'Sabra, Dentist to the People', occupied premises on the same floor and, after climbing the narrow wooden staircase, new recruits to either establishment sometimes wandered, appalled, into the wrong one. Both institutions attracted the impoverished – charges at the Suisse were only 25 francs a month, to cover the cost of the model – and neither were quite what they said, the dentist being a cheap tooth-puller with no qualifications, and the Académie the opposite of academic. It offered no formal tuition or supervision or programme; students came and went as they chose, any medium or style was acceptable.

The liberal instinct which led Monet to Boudin similarly took him to this informal drawing school. Founded in 1815 by Martin-François Suisse, a model for Eugène Delacroix, to offer opportunities for drawing and painting from life, the Suisse had originally been conceived not as an alternative to the rigorous École des Beaux-Arts but as a complement to it. It was as such that many significant French artists, including Ingres, Daumier, Corot and Courbet had passed through; they continued to look in to size up the talent. Monet just missed Suisse himself, who retired in 1858 and died in 1859. His nephew ran the establishment unaltered, but its role in the art ecosystem was evolving, reflecting changing attitudes to the venerable École des Beaux-Arts. In the early nineteenth century, political revolution and upheaval had not detracted from the status of this *ancien régime* institution founded by Cardinal Mazarin in 1648, and to study there was still considered essential grounding. Thus many who made use of the Suisse did so before, during or after their training. Admission to the rigorous Beaux-Arts was by selective exam; years were spent there pursuing

anatomy and perspective, drawing ideal forms from plaster casts, and only then from the live model.

In Monet's time, the classically inclined continued to favour the Beaux-Arts – Edgar Degas enrolled there in 1855, and John Singer Sargent as late as 1874. But less conservative hopefuls no longer did, and the Suisse was a haven for those who wanted an art school without the conventions of academic practice. Monet was at the extreme edge of these, as his lack of interest in historic art was exceptional. It was standard for Paris art students to register as copyists at the Louvre – Manet and Degas met while copying there in 1859; their friend the realist painter Henri Fantin-Latour called the Louvre a second home; and eighteen-year-old Renoir, employed decorating blinds and screens on rue du Bac, acquired his first pass in January 1860. Monet did not register at all during his first period living in Paris.

The Suisse in the 1860s was harmonious in its diversity. 'Colourists, Ingrists, traffickers in chic, realists, Impressionists – the word had not yet been invented, but several of the founders of the new school that bore that name were there – everyone was on good terms, with a few rows here and there between the fanatics,' recalled Anatole Gobin in the story *Fernande, histoire d'un modèle*. 'You could spoil the paper or the canvas, without too much fuss, as long as you were careful to pay the monthly charge.'[8] Students came from across France and beyond, and went on to wide-ranging careers.

Among Monet's early friends there were Pissarro, son of a hardware store owner from St Thomas in the Caribbean, and Charles Durand, a Lille hotel owner's son reinventing himself as flashy portraitist Carolus-Duran. Pissarro, the softly spoken future anarchist with a long beard and tender face, was 'not then posing as a revolutionist, and was tranquilly working in Corot's style', in Monet's reminiscence.[9] Although he had grown up thousands of miles away, Pissarro was, like Monet, a child of a port and the sea, passionate about nature, and from a similar mercantile background. Older, collegial, endlessly curious and patient, he became a lifelong friend and Impressionist comrade. By contrast Carolus-Duran took a mainstream path, quickly achieving success while circling Monet and the future Impressionists, and learning from and depicting them. He

would write half a century later to Monet that 'although life has separated us, I can't forget our youth where we were united in heart and spirit'.[10]

The Suisse stood just before the Pont St-Michel, the bridge to the Latin Quarter on the Left Bank, where Georges Clemenceau, a medical student dabbling in anti-imperial journalism, observed Monet.

> He could be seen from time to time, hunting down 100 sous to buy paints. I reserved the memory of him as a spirited character, with large fiery eyes, a curved nose that looked slightly Arabic, and an unkempt black beard . . . We caught a fleeting glimpse of one another and did not see each other again for a quarter of a century. We were far too self-centred and preoccupied with our own interests to become attached to one another . . . We had nothing at all in common. Only politics mattered to me and Monet lived solely for art.[11]

Clemenceau eventually became Monet's closest friend.

In 1861 the future prime minister was working at the student newspaper *Le Travail* alongside Zola, whom the young Clemenceau thought hopeless: 'Do anything you like. Sell mustard or women's hats. But give up literature. You will never be a writer.'[12] Zola was grateful to get a job packaging books at the publisher Hachette. Clemenceau's ambitions stalled when he was jailed for affixing political posters. Zola's schoolfriend Cézanne, who arrived at the Suisse in 1861, lasted a mere five months in his initial attempt at living in the capital, then fled home to work in his father's bank.

Born within a few months of each other, Monet, from Normandy, Zola and Cézanne, from Provence, and Clemenceau, from Vendée, were part of the ferment of bourgeois youths up from the provinces in the early 1860s, aspiring artists, writers and politicians, taking the first steps of their careers, measuring themselves against the age. Outside the Suisse, Monet tried to make his mark as a caricaturist, with some success when his *portrait-charge* of the Comédie-Française actor Adolphe Laferrière in military garb, clutching a flagpole, against a poster advertising his roles, appeared in the journal *Diogène* on 24 March 1860: Monet's debut in the press. The best of his Paris caricatures, such as a depiction of the painter Jules Didier with wings, as a butterfly held on a leash, are imaginative and accomplished. They

Monet, *Louis Laferrière*, published
in *Diogène*, 24 March 1860

Monet, *Jules Didier with Wings*,
c.1860

place him on the boulevards, at the theatre, exploring the city beyond the Suisse.

Clemenceau noted from afar that Monet was inseparable from Théodore Pelloquet, the radical journalist. Monet in Le Havre had copied Nadar's caricature of the spiky-haired, glaring Pelloquet. The pair were often spotted together at the Brasserie des Martyrs, at 9 rue des Martyrs, close to rue Pigalle. Monet said that this brasserie 'lost me a lot of time and did me the greatest harm'.[13] The regret casts light on Monet's early days in Paris and his attempts to get his bearings. He chose older friends from whom he could learn – in 1860 Pelloquet was forty and nearly an alcoholic, Pissarro was thirty. Although Monet told Boudin that at the Suisse he was surrounded by a group of young landscape painters, he had not yet made close ties, or recognized kindred spirits, among anyone his own age. He pestered Boudin to leave Le Havre and keep him company in the capital. After a year away, he still loyally signed himself 'your pupil and friend'.[14]

For a young man in Paris, frequenting a familiar café was the heart of his social existence, and reflected class sensibilities, the construction of identity and a statement of allegiances. Forty-year-old Courbet,

large, loud, gregarious, presided at the Martyrs. He had just moved his headquarters there from the Andler, a brasserie on the left bank – part of the migration of artists northwards to the up-and-coming ninth arrondissement. The Martyrs was big, rustic and generous, like Courbet himself. It had several floors of smoke-filled, echoing salons, a covered courtyard, plenty of billiard tables, and a clientele consisting of 'the weavers of rhymes, the poetasters still damp from the nest, the penniless philosophers indifferent to money, the hunters of pictures, the chasers of words, the roving artists of pen or brush, nearly all of them suffering more or less acutely from Panurge's disease: lack of money'.[15] This was the journalist Firmin Maillard's recollection, in 1874, in *Les derniers bohêmes*, his nostalgic memoir of this period. Clemenceau recalled among Monet's friends there the young poet-performer Albert Glatigny, who improvised verses on rhymes suggested by his audiences and was always accompanied by his dog. Non-bohemians, the better-heeled artists and writers, patronized the Café Tortoni on boulevard des Italiens, where Manet was often seen lunching with Baudelaire. Tortoni was famous for its ice creams, a luxury dessert, the Martyrs for serving beer, popular in Paris since the 1848 revolution as the drink of the people.

Courbet was a divisive figure, for his convergence of politics and aesthetics, for his struggle against institutional convention, for his belligerence and self-promotion. He lived and worked under the banner: 'I am not only a socialist but a democrat and a Republican as well – in a word a partisan of all the revolutions and above all a Realist.[16] His 1849 depiction of a rural funeral, *Burial at Ornans*, was, he boasted, the burial of Romanticism, ousted by his own robust realism. Courbet attracted a range of liberally inclined young artists concerned with everyday subjects and a naturalist approach. Zacharie Astruc, starting out as a critic in 1859, wrote that Courbet was 'the first champion of this new art who will perhaps be the curiosity of future centuries'.[17]

Monet was on the fringes of this circle, and had much to observe and absorb. He had landed in Paris when the progress of painting was uncertain, for although the city supported the careers of 4,000 artists during the Second Empire, no young name stood out. People had been talking about this vacuum for years. Baudelaire, the leading critic of the age, already lamented in 1846 that 'the great tradition has been

lost, and . . . the new one is not yet established'.[18] Courbet attempted to fill the gap. Baudelaire thought him tangential, prominent only for lack of competition. By 1859, the giants who occupied the two poles of French painting, the neo-classical Ingres and the romantic Delacroix, were both elderly. The consensus was that no successor of comparable strength had emerged and the field was wide open, as proved by the year's disappointing Salon, the massive government-sponsored art exhibition at the Palais de l'Industrie.

Baudelaire saw in the 1859 show only craft and technique, commenting: 'mediocrity has dominated.'[19] Alexandre Dumas summed it up as '1500 completely worthless paintings'.[20] A newcomer's perspective was different. This was Monet's first Salon. He visited the sprawling makeshift rooms beneath the vast glass cage of the Palais many times, and found plenty to like, gravitating to the names he knew from Boudin. He enjoyed Troyon's dog devouring a partridge, admired Corot, and singled out Daubigny's view of Villerville, across the estuary from Le Havre.

Any aspiring artist in France had to grasp the workings of the Salon, then attempt to make his reputation there. There was no other route to a successful career, and those turned down by the generally narrow-minded juries came back year after year to try again. Manet, rejected in 1859, insisted that 'the Salon is the real field of battle, it is there that one must take one's measure', and fought on for acceptance within its walls.[21] 'I believe that there the best is truly to be found, because there every taste and every style meet and collide,' wrote the young Cézanne.[22] Monet in the 1860s was as accepting of the Salon as everyone else.

Founded in the seventeenth century, the Salon, which went through annual and biennial phases, was a grand society event. It gave painting a public arena at the forefront of culture as nowhere else in the world, and encouraged ambition by its size, status and the prospect of prizes and state purchases. The rewards were such that some artists worked for a year on their submissions. The Salon was more than a platform for painters; it was also the stage for writers interpreting them, from Diderot in 1759 – 'people think it's only about arranging figures . . . the first point, the important point, is to find a great idea'– to Baudelaire, who wrote in 1859 that there is 'no great painting without great ideas'.[23]

The clash between conservatism and innovation was time-honoured,

but against the odds originality could eventually pierce through. The Salon's very existence conferred a belief in art's social function, the status of artists, the value of their contribution, continuous since the *ancien régime*. Thus the paradox that, attracting the best talents, the tradition of the Salon was a reason why modern art was born in mid-nineteenth-century Paris – despite the conservatism of the juries, and when painterly revolution was the last thing the government wanted.

Napoleon III appointed as superintendent of the arts a reactionary, Count Nieuwerkerke, who did his malevolent best to keep out anything subversive. It was a losing battle. In the 1850s–60s, as social structures were changing, and the legacy of revolution remained unfinished, painting and commentary on it were vehicles for the bigger question of what sort of country France could be. Political censorship channelled intellectual talent towards the arts. Although few artists apart from Courbet were directly political, art's broad political undercurrents were unmistakable. Nieuwerkerke himself acknowledged them when he called the Barbizon landscapes 'the painting of democrats, those who wash their linen in public'.[24] The pleasure of landscape was democratic, available to all, carrying no hierarchies. Imperial preference was naturally for the epic, the classical, the grandiose, the so-called *pompier* art,* slick, polished and expensive, of historicists such as Alexandre Cabanel and Jean-Léon Gérôme. Enlightened commentators saw these painters as vacuous and moribund. Monet simply ignored the *pompiers*.

What delighted Monet at the 1859 Salon was the strong showing of landscape. The tilt from classical and historical subjects confirmed the rise of realism, and that the ground was being prepared for landscape to become, within a decade, a focus for a radicalism which would finally undo the Salon itself. None of this could have been predicted at the time. Ingres and Delacroix had made their reputations with history paintings. Even the anti-classicist Baudelaire denigrated landscape as an inferior genre, not personal enough, not offering imaginative scope.

* The pejorative term derived from a resemblance between the helmets of firemen (*pompiers*) and those of soldiers in paintings of classical narrative; there was also an association with pomp.

Monet would annul the charge, but not yet. He was painting very little. Only three canvases, a still life, a studio interior and an atypical factory scene, survive from 1859–61. These years chiefly afforded him the chance to look. He scoured commercial galleries, which displayed changing stock; 400 of them had opened in Paris between his birth and his return in 1859. They served the growing number of middle-class collectors, products of Second Empire wealth and ostentation, creating a flourishing market. The Hôtel Drouot auction house, launched in 1852, was an entrepôt for pictures which made the relationship between economics and taste very public. It was a stimulating, confusing milieu. We can see retrospectively that a platform was slowly being built for artists beyond the Salon, preparing the ground for the Impressionists to develop their careers outside the establishment in the 1870s.

One name continued to dominate in progressive circles: ageing, lofty, romantic Delacroix. 'For a number of years the whole genius of the French school seemed to be concentrated [in this one man],' said Baudelaire in 1862.[25] There was no Salon in 1860, and the year's significant exhibition was a retrospective of the 'École de 1830', on boulevard des Italiens, starring more than a dozen Delacroix which Monet described as splendid; *The Shipwreck of Don Juan* especially fascinated him. In 1860–61 Delacroix was at work on his final major piece, the murals of saints and angels at the baroque Saint-Sulpice church. It would be a legacy to the Impressionists of sumptuous colour, surging movement, large, separate brushstrokes which blended at a distance.

Since the 1830s Delacroix had developed a vein of French art which put classicism to one side. The first major French painter not to study in Rome, he had made instead a journey of cultural formation to Morocco and Algeria, where exceptionally he gained access to a harem. The light, chromatic brilliance and exotic subjects of that trip (*Women of Algiers*, *Arab Horses Fighting*, *Jewish Wedding*) sustained his painting for the rest of his life, and appealed to a romantic element in the young Monet's personality. The lesser orientalists Prosper Marilhat and Théodore Frère also caught his interest, but Delacroix, Monet said, 'is one of my idols'.[26] When he became rich enough to build his own collection of paintings, the earliest artist he included

was Delacroix: two watercolours of the Norman coast and the quixotic ink drawing *Tiger Frightened by a Snake*.

It was some months after he had seen the Delacroix exhibition that the twenty-year-old art student travelled home to Le Havre to join the class of 1840, Le Havre, south canton, for the military lottery at one o'clock on Saturday 2 March 1861. He drew a low number from the urn – an unlucky number, which made it almost certain he would be called up. In early April it was announced that of the 228 men of the south canton contingent, the first seventy-three would enter the army. Monet chose to enlist in the First Regiment of the African Chasseurs. After less than two years in Paris, and with nothing concrete to account to his family for his time there, he prepared to sail for Algeria.

Monet said he chose to go to Algeria for its skies, as 'my family refused to pay for a substitute'.[27] In 1861 the cost of a substitute was 2,500 francs – more than twice a working man's annual wage. In 1900 Monet told Thiébault-Sisson that his father and aunt would pay it only if he would accept a career in business, but, by the time he related his biography to Geffroy in 1920, the story was that 'they let him go because he would not become an artist *selon la norme*'[28] – according to convention. This is more convincing; Monet's problem in the early 1860s was not a family opposed to art, as he complained, but one that presumed an informed interest. In 1861 Marie Lecadre, one of Jeanne's great-nieces, married Auguste Toulmouche, whose 'dolls', as Zola called his limp portraits of upper-class women, were popular at the Salon and with Napoleon III. Toulmouche's view of art and the route to success was more persuasive to Aunt Lecadre than the caricaturist Oscar's. Monet struck out for independence, and went to the Mediterranean, as far as possible from the Atlantic, source of the Lecadre fortune.

To sign up for seven years in Algeria was an extreme move for a young painter. Cézanne – who the year before had also drawn a bad number, and was bought out by his banker father – discussed the call-up of his less fortunate painter friend, Numa Coste, in terms of mitigation. 'What can I say about your unhappy lot, a great calamity has befallen you ... come to Paris to join a corps here ... where even a recruit would have more advantages of all sorts, be it leave or light duties, so that you could still devote yourself to painting.'[29] This sort

of compromise was not for Monet. He was excited by the stories of a friend who had served in Africa, stating: 'Nothing attracted me as much as the endless cavalcades under the burning sun, the razzias, the crackling of gunpowder, the sabre thrusts, the nights in the desert under a tent.'[30]

Orientalism was in its heyday, and consciously or unconsciously underwrote the imperial colonial agenda. Delacroix was the leading exponent in painting, and by the 1840s–50s there were tourist guides and memoirs. Théophile Gautier's *Picturesque Journey in Algeria* (1845) was popular, and Eugène Fromentin's *A Year in the Sahel*, published in 1858, described Algiers's ramparts, minarets, white houses between the sea and hills as 'this paradise built by voluptuaries', at sunrise taking on 'the light and colour from the vermeil ray that every morning comes to it from Mecca'.[31] In Rouen, in 1861, Flaubert was writing his novel set in Carthage, *Salammbô*, opening with a feast in the gardens of the general Hamilcar where cross-dressing men in gold earrings shriek like jackals, and drink like camels at a watering hole. Crucified lions, child sacrifice, the heroine writhing with a python and sliding into an army tent for lust at midnight, follow. *Salammbô* was a bestseller.

Between Delacroix's visit in 1832, accompanying a French diplomatic mission to the Sultan of Morocco, and Monet's recruitment in 1861, France had completed the conquest of Algeria initiated in 1830. It was under military occupation, ruled by a governor-general, Marshal Pélissier, appointed the year before Monet arrived. A veteran of wars in the Crimea and Algeria, he had supervised atrocities including gassing the Ouled Riah tribe hiding in caves in the Dahra mountains in 1845. Louis-Philippe's men had been thugs. 'In order to banish the thoughts that sometimes besiege me, I have some heads cut off, not the heads of artichokes, but the heads of men,' Lucien de Montagnac, one of the king's lieutenant-colonels, explained.[32] A scorched-earth policy delivered full victory in 1847, when Algeria was declared part of France.

Napoleon III inherited the colony. No longer fighting a war, he pursued a 'civilizing mission' for the Arabs. This was described by the historian and political scientist Alexis de Tocqueville as French rule for the conquered that would be 'a power that guides them, not only towards our interest, but in theirs ... that works ardently for the

continual development of their imperfect society ... that does not restrict itself to exploiting them.'[33] Napoleon III visited Algeria in 1860, admired the tribal chiefs, deplored the greedy settlers, the *colons,* and dreamed that Algeria could function simultaneously as Arab kingdom, European colony and French military camp, with an assimilated Muslim population owning and working the land. This alienated the settlers, without winning the battle for hearts and minds among the Muslim population, who were 'subjects', not citizens of France, and had no intention of giving up their religion or culture.

If Napoleon III muted the viciousness of Louis-Philippe's conquering army, the emperor was hardly enlightened. Like any nineteenth-century European colonialist, his aims in Algeria were exploitation of resources and labour, prestige and power, a gateway to further expansion in Africa, and keeping out rivals, especially the British. Unsurprisingly, the British media had been overwhelmingly critical throughout the conquest of what *The Times* headlined 'French Atrocities in Algeria':

> the struggle which had been going on ... in the north of Africa is not war – it is a contest between armed invaders and a whole people. War has its conventional rights and laws of mercy, but in Algeria it is waged within discriminating licence against the private possessions and the lives of every native tribe which still dares to feed its flocks in freedom amongst its native mountains.[34]

Even enlightened French commentators were pessimistic about Algeria's future. De Tocqueville concluded that the country was 'a closed field, a walled arena, where the two peoples would have to fight without mercy, and where one of the two would have to die'.[35]

Between 1830 and 1860, almost a million Arabs died, in the conflict and through disease and famine, and 100,000 French soldiers lost their lives. 'The new regiments above all pay a large tribute to the climate, to the insalubrity of the Metidja [sic], and to the miseries of the African war ... they die there without glory, killed by fever, by dysentery and by nostalgia,' wrote Corneille Trumelet, a colonial officer in Algeria from 1851 to 1875.[36] Colonel Montalembert, commander of the First Regiment of the African Chasseurs, died of cholera during his troops' expedition to Morocco in 1859. His replacement, Monet's

commander, was Colonel Reinaud de Lascours, who served five years. For Europeans, 'death comes quickly in Algeria', warned a doctor there in the 1850s.[37] Louis-Joseph de Colomb, a French explorer, whose *Les Oasis du Sahara* appeared in 1860, thought that if Dante had seen the blankets of burning sand in the Algerian desert he would have made this the entrance to his gates of Hell.

Did Monet know or care about any of this? A curious link between Saint-Adresse and Algeria was a little known volume, *Un Regard écrit: Algérie*, written by the Lecadres' friend Pauline de Noirfontaine, and published in Le Havre in 1856. Pauline had accompanied her husband, Alfred Bodson de Noirfontaine, lieutenant-colonel of the Engineers Regiment, to Algeria in 1849–51. Subsequently de Noirfontaine was in charge of the fortifications of Le Havre from 1853, retiring in 1861 and remaining in the city. Pauline's impressions were far from the rose-tinted orientalist school, and closer to de Tocqueville's.

She observed with discomfort that the settlers and the Arabs were separate and unequal, judged the former as rapacious, driven by 'speculative ambition ... to plant the banner of colonization on African soil' and the latter as lazy and wretched. She was horrified by a cholera epidemic, watching plague convoys from her window, and cast a critical eye on everyone, from Spanish immigrants who 'bask in historic filth' to Jewish traders manifesting 'hereditary disloyalty'. Her summing up was that the native population would never accept French 'religion, tastes, customs ... in a word Algeria is defeated but not conquered'.[38] It is unlikely that Jeanne would not have read her friend's book, and Monet himself, joining in the social rituals of middle-class Le Havre, is documented as a visitor to the Noirfontaines. If he had not come across *Un Regard écrit*, his aunt would probably have mentioned it now, as a warning. Did he read it and thrill to the exotic allusions, or opt for Algeria in defiance?

Monet formally entered the army on 29 April. The army roll recorded that he was 1.65m tall, had brown hair, chestnut eyes, and was in good health. Algeria 'appealed to my sense of adventure. In any case the uniform was elegant,' was one laconic recollection.[39] Monet was always a glamorous dresser: his 'thin, fine-boned hands' emerging from the cuffs of fancy shirts in 'a filmy cloud of ruffed tulle' still drew

Charles Lhuillier's portrait of Monet
in the uniform of the African
Chasseurs, 1861

attention in old age.[40] In 1861 Charles Lhuillier was pressed into ser-
vice for another portrait, the first known painting of Monet, in the
splendid Chasseurs uniform. This was a formalized version of North
African dress: open-fronted blue jacket with gold brocade, voluminous
red trousers, a sash and a fez, worn at a jaunty angle. In Lhuillier's
rendering, the costume is superb but the face in shadow, bearing an
uncertain expression; the uneasy pose, one hand on his hip, the other
slipped into the sash, in a forced casualness, suggest that Monet was
nervous. In June 1861, when he crossed the Mediterranean and after
a thirty-hour voyage disembarked in Algiers to join his regiment, a
hundred men in the 2nd Chasseurs squadron, at the mud-brick bar-
racks at Mustapha, Monet had never so much as sat on a horse, or
previously travelled further from Normandy than Paris.

De Tocqueville, arriving at the port of Algiers in the 1840s, was
stunned by the 'prodigious mix of races and costumes, Arab, Kabyle,
Moor, Negro, Mahonnais, French. Each of these races, tossed together
in a space much too tight to contain them, speaks its language, wears
its attire, displays different mores. This whole world moves about
with an activity that seems feverish.'[41] This would have been the first

impression of most European travellers. Monet talked of the delight with which 'I incessantly saw something new.'[42]

In summer 1861 the military situation was relatively calm and the Chasseurs' duties were mostly ceremonial. They chiefly consisted of escorting Marshal Pélissier on his tours of the county, showing off French power and organization in their riding columns. Whether Monet was a sufficiently competent horseman to take part is doubtful, but he had aimed high. The Chasseurs d'Afrique, founded in 1832, was the mounted equivalent of the Zouaves, an elite infantry regiment raised in Algeria at the beginning of the French invasion. The name derives from the Zouaoua (Zwawa) tribe of Berbers, legendary fighters whose assistance the French initially sought. The Chasseurs, launched with 300 men from various cavalry regiments and 120 Arab riders, had been acclaimed for service in North Africa, the Crimea and Solferino in Italy. Recruitment from the native population soon ceased; in the 1860s the regiment, divided into six squadrons, comprised mostly French volunteer soldiers (not conscripts) and French settlers in Algeria doing military service. Monet, with no experience, said his own insistence had won him a place in this distinguished regiment.

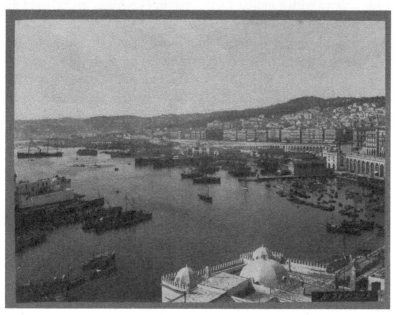

Algiers, the port, c.1860

Of all Monet's recollections, those about Algeria are the most shifty, contradictory and unsubstantiated. In one interview with Thiébault-Sisson he enthused about Algeria's benefits to his painting: 'You cannot imagine to what extent I increased my knowledge, and how much my vision gained ... the impressions of light and colour that I received there were not to classify themselves until later; but they contained the germ of my future researches.'[43] A few works were documented in Monet's lifetime, though nothing survives. A Norman friend from the army, Pierre Benoît-Delpech, who after military service settled in Algeria as a *colon*, remained in contact and, having purchased some of Monet's watercolours and drawings of Algeria, brought them with him on a visit to Giverny in 1919. Around this time Monet mentioned that Clemenceau owned his watercolour of the Spanish gate at the casbah of Oran, and that he himself had conserved two Algerian landscape drawings.

What he did not keep was a signed *Algerian Scene*, executed in Fromentin's style. When a dealer discovered and bought it cheaply, and presented it to Monet, he at first denied authorship – 'it's not by me, I've never done any camels' – and then was eager to have it, proposing a swap with a more valuable work. The dealer understood that 'at the time of his military service ... needing money, he had done a kind of fake Fromentin, but he had failed to sell it, and had signed it.'[44] Monet made the exchange in order to destroy it and erase the record of a youthful flirtation with orientalism. According to Clemenceau, 'Africa was forgotten. The artist thought the landscape was admirable, but he couldn't catch its colours on the palette, as Delacroix had done.'[45] In a different interview Thiébault-Sisson quoted him as denying that he made any works at all there: 'I had not even thought of painting for an instant' in 'a country that left me with so many awful memories'.[46]

Reading between these scanty lines, it seems that Monet hated army service in Algeria, though there is no evidence he questioned colonial policy. He would have found, as Flaubert did when he visited in 1858, a place with a strong military character, smelling, he said, of absinthe and the barracks. This was the reality for which orientalist painting and literature had not prepared Monet. Following nine or ten months

in training, in spring 1862, according to Thiébault-Sisson's account published after Monet's death, Monet recounted:

> It seemed so wearisome to be confined to the barracks or the camp until such time as I became a skilled cavalier that, finally, one fine day, I just exploded. Noticing one of the pack mules straying into the court-yard, I caught the animal by surprise, heaved myself quickly on to its back and urged it into a quick gallop by kicking it hard in the sides with my heels . . . The mule thundered out of the camp and we escaped through the olive groves of Sidi-Moustapha.

Here Monet was thrown off, fainted, and discovered by a search party, 'my uniform . . . in shreds and my entire body covered with cuts and bruises'. He was imprisoned for 'desertion and destruction of military property'.[47] A diagnosis of typhoid fever saved him from military tribunal, and got him sent home.

An alternative version, recounted to another journalist, André Arnyvelde, in 1913, was that 'being in uniform wasn't too bad', and was mitigated by 'some favours' gained by giving sketches to the offic-ers, but then, 'I fell ill and was granted sick leave. Once I was home again it seemed terrible to go back, especially because a tour was for seven years . . . but my family hardly wanted to pay for a replacement' so he returned, 'fell ill again before long, determined to go home on sick leave – and never come back'.[48] Army records disprove this: they show Monet had only one stint in Algeria, and make no mention of the runaway mule and imprisonment. Did Thiébault-Sisson invent it as lively copy, did Monet dream it in the fever of a real illness, or did it serve as an emblem for the horrible memories of confinement and discipline?

The common feature of all Monet's reports is his illness. The most straightforward account was:

> I fell ill . . . and quite seriously. They sent me home to recuperate. Six months of convalescence were spent in drawing and painting . . . seeing me thus persisting, worn as I was by the fever, my father became con-vinced that . . . no ordeal would get the better of so determined a vocation. [Partly] from fear of losing me, for the doctor had led him to expect this, should I return to Africa, he decided, towards the end of my

furlough, to buy me out. 'But it is well understood,' he said to me, 'that this time you are going to work in dead earnest. I wish to see you in an atelier, under the discipline of a well-known master ... Is it a bargain?'[49]

Monet told the story as if his father had seen the light, but, chastened by his experience of Algeria, he was also in meek mood.

His account distorts a crucial detail: Adolphe could not afford to buy him out. Such a decision and generosity would be Aunt Lecadre's. 'Don't you think my nephew should return to Paris to study under the direction and advice of the masters?' she asked her painter friend Armand Gautier in October. It was in Le Coteau at Sainte-Adresse that Monet recuperated, under his aunt's care. 'My nephew Oscar has stayed here with me while waiting for the annulment of his enlistment in the African Chasseurs,' she continued. She commented on the French army's deficiencies in Africa as another justification for rescuing Monet, at the cost of 550 francs for each of the seven years unserved. She paid 3,025 francs, more than the original price of a substitute. Nevertheless, she 'trembled to give him his freedom', but 'by liberating him,' she said, 'I thought less about his own satisfaction than of almost personal considerations. I didn't want to reproach myself for having hindered his artistic career and leaving him too long in a bad school; he would have ended up utterly demoralized.'[50] Aunt Lecadre does not mention his illness, or fears for his health, which Monet may have exaggerated then or later.

At any rate, he was sufficiently recovered to be out painting in summer 1862. He was at a farmyard near his old haunt at the Cap de la Hève, trotting after a cow in an attempt to depict it, when an English visitor, watching and laughing, offered to hold the beast still. The animal was uncooperative, and it was Monet's turn to laugh. The Englishman offered to introduce him to a plein air artist staying nearby, the Dutch painter Johan Jongkind. More vigorous in manner than Boudin, and a more clamorous personality, this 'simple good-hearted man, murdering French atrociously' invited Monet to work with him outdoors and 'thereby completed the teachings that I had already received from Boudin ... it was to [Jongkind] that I owed the final education of my eye.'[51]

The Dutchman, invited to dinner at Le Coteau, appeared with his companion Madame Fesser, failed to introduce her, and roared, when Jeanne asked Monet to pass a dish to 'Madame Jongkind', that she was not his wife, but an angel. Aunt Lecadre, embarrassed, did her best with 'a very great artist and above all a really good man'; she was ashamed that his eccentric appearance and louche ways upset her. She was seventy-two, protective, concerned, wanting to believe in Monet, accommodate his peculiar companions, understand his work. 'His studies are still sketches ... but when he wants to finish, to make a picture, they become the most awful *croûtes*, which he admires himself, and finds imbeciles who congratulate him'. As she was not 'at his level', she said, she kept quiet. '[H]owever I want at all costs to get him out of this and put to good use his very real talents, and force him to work seriously. He has to make a position for himself because I won't always be there.[52]

On 21 November 1862, a week after his twenty-second birthday, Monet received a good-conduct certificate and was released from the army. Algeria left conflicting memories, of enchantment and intense luminosity, of confusion and humiliation. He always insisted he had been there two years; the reality was no more than twelve months, and some of those in the sick bay. Recounting his life to Geffroy, in 1920, Monet was careful to give Algeria a role, that the watercolours he made there were lessons in rendering light. He kept a group of photographs of Algiers until his death: faded sepia images of the casbah, the old city with its domes; a mosque; a stony slope in Bouzareah on the hilly outskirts; a path through a parched landscape. And when, from the 1890s, he was affluent enough to buy pictures, he outmanoeuvred friends to acquire Renoir's paintings with Algerian connections: *Mosque. Arab Festival*, depicting the old Turkish ramparts of Algiers, and *The Algerian Woman*, in a gold headscarf, an Impressionist descendant of Delacroix's *Women of Algiers*. And he likened Spain enthusiastically with Algeria on his only trip there, in 1904.

But he never revisited Algeria, and his actions from the 1870s onwards are his verdict on military life. He left France to avoid call-up when Napoleon III went to war with Prussia, and he pulled every possible string, from Clemenceau down, to extricate his own sons

from military service. Aunt Lecadre's conviction that 'all the misery that he endured has transformed him and prepared him for work'[53] suggests that Algeria was a torment. Monet did not see the Mediterranean again for more than twenty years, and reoriented himself and his art firmly towards the Atlantic of his childhood.

At Sainte-Adresse Jeanne rejoiced that 'he works, uses his time well, stays here contentedly with us, and seems happy'; he was more graceful, his 'behaviour ... infinitely better than in the past'.[54] This supports another account, published by his stepson, in which Monet admitted that Algeria 'did me the greatest good, morally and from all points of view, putting some sense into my head. I set myself thinking only about the return and work.'[55] A large autumn canvas, *Hunting Trophy*, depicting a dog sniffing at a dresser laid out with dead bird and guns, is the most substantial piece surviving from the period following his return. Dated 1862, it is his last painting signed 'O. Monet'.

Docile and trapped, the prodigal nephew had no choice but to follow his aunt's instructions for his return to Paris. He duly trotted off to see Toulmouche, appointed guardian – or spy – in the capital, with the more sympathetic Gautier also asked to keep an eye on him. Monet took, as an example of work to show Toulmouche, *The Cutlet*, a luscious chop placed with a dish of butter, shiny kidneys and smooth eggs. It was correct, uncontentious, a demonstration of still life as a touchstone of painting. Toulmouche thought it flashy, and like the Le Havre committee and Troyon before him, declared Monet gifted but undisciplined. He recommended his own teacher and neighbour, the Swiss-born Charles Gleyre, a classical painter tinged with romantic nostalgia, so painstaking and self-critical that since 1849 he had ceased to exhibit.

Nearing sixty, lean, long-faced, quietly spoken and an earnest, unassuming teacher, Gleyre preached the value of line over colour, but he was relatively tolerant, and generous. Asking only 10 francs a month, for the cost of the model, he was even cheaper than the Suisse. In his twenty-year teaching career he had instructed pupils as diverse as Gérôme and, recently, the bohemian provocateur James Whistler. His school was at 70 bis rue Notre-Dame-des-Champs in the sixth arrondissement, a lane curving from rue Vaugirard up to the Notre-Dame

church, then a wooden chapel, an earlier building having been destroyed during the Revolution. The school occupied one of seven studios set back from the street around a courtyard and garden, all owned by Toulmouche's father. Toulmouche worked in one, Gérôme in another.

Toulmouche's suggestion was reasonable and Monet knew he had to accept. Mutiny was expressed in a single initial: *The Cutlet* is his first painting signed 'C. Monet'. When he arrived at Gleyre's, in December 1862, Monet set out to make his reputation with a name by which his family did not know him, which distanced him from Le Havre and from the Algerian debacle. Oscar returned to Paris as Claude.

Monet in 1864, by the celebrity photographer Étienne Carjat

4

Bazille, 1862–5

Gleyre interviewed three candidates at the end of 1862: Alfred Sisley, twenty-three, a British silk manufacturer's Paris-born son: Frédéric Bazille, twenty, from a wealthy wine-growing family in Montpellier; and Monet. Bazille recorded the process. Gleyre 'looked me up and down from head to toe, but did not say a word; it seems he's like that with everyone, out of timidity.'[1] All three entered the school and found themselves a place in the crowded classroom of young men at easels, seated on low stools, facing a model – male one week, female the next – perched on a platform next to a stove. Tasked with drawing a nude, Bazille was relieved to find 'many students as good as me, or rather as bad'.[2]

Walls and floors were encrusted in paint, but novices rarely got to hold a paintbrush. Drawing from life was the core of the instruction, though Gleyre occasionally suggested a subject for composition. He appeared at the school weekly, on a Monday, moving noiselessly round the studio, stopping at each student to offer a few words of suggestion, in muted tones, so the neighbour at the next easel could not overhear. The winter of 1862–3 was severe and to save fuel the school opened only four days a week. The hours were from 8 a.m. to noon, when for 15 sous *rapins*, a lunch of a chop and a bowl of soup with bread, was offered, followed by an afternoon session. Nick-named after their meagre meal, the students themselves were known as *rapins*.

At the back of the class, weighing up the newcomers, was 21-year-old Renoir, who had been there a year. The tailor's son was a close sartorial observer. He was immediately drawn to mild, silky Sisley. He reckoned Bazille, exceptionally tall, well-groomed and attired in

Renoir, by Bazille, 1867

tartan trousers, as 'the sort who gives the impression of having his valet break in his new shoes for him'.[3] And at least in nostalgic memory, he lionized Monet, who had exchanged his Algerian uniform for frills and tulle. 'Everyone . . . was impressed,' said Renoir, 'not only by his virtuosity but also by his worldly manner. When he first came to the school, the other students were jealous of his well-dressed appearance and nicknamed him "the dandy". He was penniless, and he wore shirts with lace at the cuffs!'[4]

Renoir's more sober recollection was about 'being a group of friends who were able to benefit from each other's research. It is good to work in art classes, because when one works alone, one ends up believing everything one does is good. In an art school, one sees what one's neighbour does. As a result, one benefits from what the neighbour did better than you.'[5] A loose alliance developed among the students whose inclinations went against academic convention. Within the decade, the partnership of Monet and Renoir would produce Impressionism, but at first each paired off with a gentler, less ambitious personality. Renoir, thin, fair, a lively, light spirit and a fast thinker, befriended the slower, more restrained Sisley, and Monet was immediately drawn to the gregarious and courteous Bazille.

From an upper-class background, Bazille initially formed an easy bond with the school's aristocratic newcomer, Viscount Lepic, son of the emperor's aide de camp. 'This young man and another from Le

Havre, called Monet, are my best friends among the *rapins*,' Bazille told his parents. The one gave him a tour of 'his rooms in the Louvre itself, where his father has set up a splendid studio for him', the other took him to paint in the countryside.[6] Here 'Monet, who is rather good at landscape ... gave me some advice that was very helpful to me.'[7] So a deal between the short, stocky northerner and the lanky six-footer from the south evolved. Monet woke Bazille up every morning, got him to an easel, and advised on his compositions, while Bazille served as echo chamber for Monet's developing sense of himself and his painting.

Bazille was also custodian, preserving his friend's letters. Monet's voice in his twenties is known chiefly as he addressed himself to Bazille: impulsive, high-spirited, demanding, commanding in his declaration of vulnerability – 'I have only you'[8] – yet exuberant in the friendship. 'Are you dead?' he asked, awaiting a visit from Bazille to Normandy. 'I hope not, but you are the most ignoble, laziest person I've ever met. It's only a question of writing a few words. Every day I go to meet the evening train, and the Le Havre boat. Please write quickly ... and just come, you big hound. If I don't get a reply, I don't know any more which saint I'll swear to.'[9] Through the 1860s, the pair grew up together, began their careers in parallel, competed at the Salon, found their place in the Paris network of artists and writers, negotiated relationships with women, struggled against paternal authority. If Monet was dominant, he was also the one longingly pacing the station and the port.

He makes his first appearance, anonymously, in Bazille's letters in January 1863, when Frédéric apologizes for not sending studies home to Montpellier because 'they are covered in caricatures made by my neighbours'.[10] Bazille next explained that he still could not draw properly, and had not yet touched a paintbrush, then, in March, 'M. Gleyre said I was making progress ... I like my work in the studio more and more; it will be, if not the honour, at least the happiness of my life.'[11] Bazille's letters home are our chief source about life at Gleyre's. They are detailed, cheerful and charged with a mission – to convince his parents of his vocation.

Born in December 1841 into a prominent Protestant Languedoc family, Bazille was, according to Zola's description of a character to be modelled on him,

blond, tall and slim, very distinguished. A little the style of Jesus, but virile. A very handsome fellow. Of fine stock, with a haughty forbidding air when angry, and very good and kind usually. The nose somewhat prominent. Long wavy hair. A beard a little darker than the hair, very fine, silky, in a point ... All the noble qualities of youth: belief, loyalty, delicacy.[12]

Bazille's father Gaston, an innovator in saving French vines from the mid-nineteenth-century blight of phylloxera, worked as an agronomist and lawyer. Méric, the family's country estate, was a pink villa with broad terraces set in ten hectares of Mediterranean gardens and wooded slopes, with a vista down to the river Lez. In Paris Bazille was homesick for his family, and for the *clapas*, the boulder fields of the south. 'I would really love to see you and my friends, and the countryside; I am suffering from a surfeit of long walls and streets,' he told his parents.[13] He also missed his piano, which was sent north, together with reams of sheet music.

Bazille's parents were affectionate, indulgent, and had high expectations. Frédéric had been a dreamy child who loved butterflies and birds, and Gaston had urged him towards medicine, until Courbet got in the way. Bazille had spent long days at the home of the family's Montpellier neighbour Alfred Bruyas, Courbet's collector and friend. Bruyas is one of the two figures meeting the artist on the road in the painting *Bonjour Monsieur Courbet*. Bazille was hooked. The compromise with his parents was that he could attend a teaching studio in Paris if he also continued his doctor's training begun in Montpellier. So every day, after drawing the human form, Bazille spent afternoons dissecting corpses and snoozing through anatomy lectures. He was thus at medical school at the same time and place as Clemenceau – the two men, both cool rationalists able to withstand their friend's emotional outbursts, who would bookend Monet's career with their support and adulation.

Arriving in Paris with inclinations towards Courbet's realism, Bazille was committed to painting 'the modern era because I understand it best and find it most alive for most living people', without being sure how to do this.[14] Unlike Monet, attending resentfully, Bazille was keen to learn from Gleyre and excited to be at the school at all. He was ecstatic when Gleyre praised him, and sympathetic

when the teacher was ill: 'it seems the poor man is in danger of losing his sight, all his students are very affected, for he is loved by everyone who knows him.'[15]

Renoir too spoke warmly of Gleyre. Monet, in contrast, was unwaveringly hostile: 'The first week I worked there most conscientiously on a nude drawing,' he said. On his Monday rounds, Gleyre

> sat down, and solidly planted on my chair, looked attentively at my production. Then – I can see him yet – he turned round, and leaning his grave head to one side with a satisfied air, said to me, 'Not bad! Not bad at all . . . but it is too much in the character of the model – you have before you a short thickset man, you paint him short and thickset – he has enormous feet, you render them as they are. All that is very ugly . . . when one executes a figure, one should always think of the antique. Nature is all right as an element of study but if offers no interest.'

So, Monet said, 'I saw it all, Truth, life, nature, all that moved me . . . did not exist for this man. I no longer wished to remain under him.'[16]

Bazille, modest, uncertain, and Renoir, who revered the Old Masters, were more inclined to trust Gleyre's teaching. Monet, having worked with Boudin and Jongkind, brought an alternative experience, and influenced the others. Renoir said Monet 'had so much self-assurance' that he was a natural leader.

> Monet began by refusing to use the stool which was assigned to him when he first entered the classroom. 'Only fit for milking cows.' Gleyre had the habit of getting up on the little platform on which the model posed and giving advice from that vantage point to this or that novice. One day he found Monet installed in his place. Monet's explanation was that he needed to get nearer the model in order to examine the texture of the skin. Except for his friends in the 'group', he looked down upon the rest of his fellow students as a sort of anonymous crowd – 'just a lot of grocers' assistants', he called them.[17]

If these are legends conjured in old age, Monet's early antagonism to Gleyre is securely indicated. When, eventually, Monet registered to draw at the Louvre – copyist number 922 – on 5 March 1863, he called himself a pupil of Armand Gautier rather than Gleyre. More public snubs came with his Salon submissions. Custom was to name

a teacher, and Bazille, Renoir, Sisley all listed Gleyre. Monet did not. 'I preached rebellion to them,' he boasted.[18] Nevertheless, he was careful, initially, to affect compliance to Aunt Lecadre. 'This child, so long lost on a bad path, who gave me such torments, now admits his mistakes,' she informed Gautier on 20 March 1863.[19] Monet had written to her, thanking her for buying him out of the army and letting him leave Le Havre. 'All that is said simply and I feel that he is telling me what he thinks, and I am as happy about it as his father is.'

Her reassurance was short-lived. As she wrote, Monet, with Bazille in tow, was already plotting his first escape. On Easter Sunday, 5 April, the pair were at the Auberge du Cheval Blanc in the village of Chailly in the forest, where Bazille was learning plein-air painting, under Monet's guidance making oil sketches of the trees: 'in Montpellier we just have no idea of oaks like these.'[20]

The Fontainebleau forest, Barbizon territory, was the riposte to Gleyre's 'nature offers no interest', and the trip took on a privileged place in Monet's retelling: At the school, 'after a month, I said to myself, "What they do here is stupid."' He led his friends out of the door. 'I took them with me, I said, "Let's go and paint outdoors." But when my family found out that I'd quit ... it was quite simple, they cut me off.'[21] Since Monet is recorded still at Gleyre's in December 1863, and his allowance continued until the mid-1860s, the story is false in the facts. Rather, Monet was remembering how he felt, his relief in the country, after a pent-up studio winter. And there was a family tiff. While Bazille returned to Gleyre's later in April, Monet stayed in Chailly for much of May. 'I went intending to stay only a week, but then in the spring it's so beautiful, everything burst into green, the weather turned fine ... I found a thousand charms which I couldn't resist. I've worked a great deal and you will see, I think, that I have looked harder than usual.'

This was addressed to Armand Gautier, and intended for his aunt. Toulmouche had reported Monet's absence from Paris to the Lecadres and he was instructed to return. He played contrite, ending: 'I have in no way abandoned the studio ... and now I'm going to go back to drawing. I haven't at all given it up.'[22] This was true only in so far as he had never accepted it. His attention to the forest was part of a strategy independent of Gleyre, and it bore fruit in several large

paintings in 1864, including *The Bodmer Oak* and *The Pavé de Chailly*. These in turn would be preparations for the picture intended as his showpiece, *Le Déjeuner sur l'herbe*, in 1865 – his eventual response to the scandalous new canvas which Manet unveiled in spring 1863. Manet's work, under its initial title *Le Bain (The Bath)*, was on everyone's lips when Monet returned from Chailly to Paris and discovered the Salon des Refusés.

It was Monet's and Renoir's good fortune to be students at the moment of the Refusés, launched on 15 May 1863. Legitimizing the avant-garde by giving it a place for the first time in the prominent Palais de l'Industrie, the Salon des Refusés was a turning point in art history, and immediately stirring for young dissenters. This was the very opposite of what the organizers intended. The Refusés was prompted by an outcry at the restrictive Salon jury. Napoleon III, wanting to appear liberal, allowed the rejected paintings to be exhibited in their own pavilion, expecting them to be jeered. They were, but the Salon des Refusés also received enormous critical and popular attention.

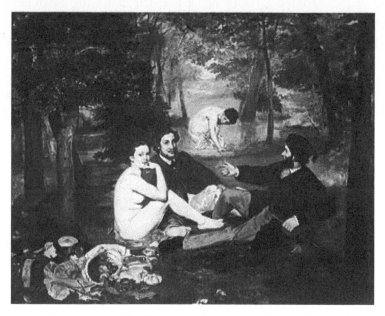

Manet, *Le Déjeuner sur l'herbe*, 1863, the painting that starred at the Salon des Refusés. It was then known as *Le Bain*; Manet changed the title in response to Monet's *Le Déjeuner sur l'herbe*.

Its 'brilliance, inspiration, powerful flavour, surprise', reported Zacharie Astruc, was Manet, and especially *Le Bain*.[23] Parodying figures from Raphael's *Judgment of Paris*, Manet depicted a woman, scantily clad, a Parisian variation on a nymph, by the side of a stream, while in the foreground a nude, her clothes piled in a heap along with a basket of food, sits casually with two male companions in contemporary dress and stares belligerently at the viewer. Its disturbing psychological charge owed something to secrets in Manet's personal life. In 1863 he married Suzanne Leenhoff, his former piano teacher, who had been not only his mistress but probably also his father's, a situation reflected in the painting of the naked woman shared by two upper-class men. Suzanne's child Léon, born in 1852, was either Manet's son or his half-brother, but acknowledged as neither, and told, until his fifties, that he was Suzanne's younger brother.

The painting surprised even as advanced a critic as Théophile Thoré, who regretted that *Le Bain* was 'of a very risky taste': 'The nude woman does not have a beautiful figure, unfortunately ... and you cannot imagine anything uglier than the man lying down next to her ... I cannot guess why an intelligent and distinguished artist chose to paint such a preposterous composition.'[24] Conservative commentators, meanwhile, contrasted Manet's figure with a celebrated bather in the official Salon, Cabanel's *Birth of Venus*, which Napoleon III bought. The opposition between these two erotic paintings was plain. Manet's defiant naked woman and modern setting, stark in contrasts of light and shade, visible brushstrokes, rough finish, looked like a declaration of war on the antique style represented by Cabanel's placid idealized goddess, glossed with an opalescent sheen.

Bazille, who visited the official Salon twenty times that year, was disappointed that 'there are very few painters who are truly in love with their art. Most of them are only out to make money by flattering the taste of the public, which is usually false.'[25] The dull academicism of the 1863 Salon helped the Refusés, which was a *succès de scandale*, attracting audiences of 4,000 a day, and offering undreamt of visibility to artists struggling against Salon constraints. 'My pictures are among those refused and I have some success,' Jongkind told Boudin.[26] A critic congratulated Pissarro for his contribution to the Refusés. Whistler made his Paris reputation there with *The White Girl*. Despite

mockery from many visitors, the Refusés was thus an own goal for the imperial administration. When in subsequent years there was clamour for further displays of rejected paintings, an official noted, on a letter by Cézanne making such a request, 'We have come to realize how inconsistent with the dignity of art the exhibition of the Refusés was, and it will not be repeated.'[27] It was too late. The Refusés ushered Manet into the national conversation and heralded the end of the neo-classical paradigm.

Three months after the Salon des Refusés opened, Delacroix's death in August 1863 brought an epoch of history painting to a close. Manet and Baudelaire walked together at his funeral, and in the winter Baudelaire published *The Painting of Modern Life*, a clarion call for the artist to concentrate on his everyday existence, to 'extract from fashion whatever element it may contain of poetry within history, to distil the eternal from the transitory' and depict the 'gait, glance and gesture' of his own period. 'By modernity, I mean the ephemeral, the fugitive, the contingent,' Baudelaire wrote.[28] The hinterland was *Les Fleurs du Mal* of 1857, where Baudelaire consecrated the romantic idea of self-expression in a modern urban context, that an artist speaks for his society yet exists in opposition to it. The poet likens himself to an albatross, captured by mocking sailors, 'exiled on earth, amid the jeering crowd,/With giant wings that will not let him walk'. Monet loved Baudelaire's poetry. For his generation, Baudelaire's positing of reality as ever-fluctuating and ambiguous was a pervasive influence. 'The Impressionists proceed from Baudelaire,' the critic Jules Claretie explained in the mid-1870s.[29]

Baudelaire is seated next to Manet in Fantin-Latour's *Homage to Delacroix*, a group portrait painted in 1864. Fantin-Latour positioned Manet and Whistler on either side of Delacroix's portrait, signalled as his descendants, and haloed Manet in a luminous glow. The vacancy lamented since the 1840s for an innovative visionary was filled. *Le Bain* and another work first shown in 1863, *Music in the Tuileries*, depicting a top-hatted crowd of recognizable characters at the weekly summer concert, cemented Manet as pioneer of a new approach: formally audacious, cool, witty, engaged with urban life, employing sketchy strokes, and disturbingly *flat*, as if the figures were pasted on, their artifice flagrant. This went beyond and challenged Courbet's

Édouard Manet

brash naturalism. 'With Courbet it was still the tradition, with Manet it was a new era of painting,' summed up Renoir.[30]

It was ironic that, unlike Courbet, no one wanted to be or to be seen as a revolutionary less than Manet. The son of a judge, descended from magistrates, diplomats and army officers, he was distinguished-looking and with exquisite manners, and although a republican, craved official respect, a place in the Salon proper. Knowing this, a friend, Commandant Hippolyte Lejosne, a member of Napoleon's imperial guard but a collector of taste, consoled him for the scandal surrounding *Le Bain* by holding a banquet in his honour. Manet thanked Lejosne with the gift of a reduced-scale version of the painting (now at the Courtauld). While this hung at the Lejosne apartment on avenue Trudaine, Bazille had the opportunity to examine it repeatedly. Commandant Lejosne was married to Valentine, one of his Montpellier relatives. She is the prominent figure seated in the foreground of Manet's *Music in the Tuileries*, and it was at the Lejosne salon that Manet had been introduced to many allies, such as Baudelaire and Astruc, represented in the painting.

Bazille became a regular at the Lejosne salon, and met there the friend, another southerner, who best understood him and became an antidote to Monet's fierceness. Edmond Maître, an amateur musician and collector from Bordeaux, was in Paris studying law, but wanted only 'to cultivate in secret and away from the crowd the beloved

studies that make the charm and as it were the essence of my soul'.[31] When Bazille's piano arrived, he and Maître played four-hand pieces late into the night. Maître was Bazille's companion in evenings at the opera and theatre, a luxury (7 francs for a seat, 9 francs for gloves, 5 francs for a carriage) beyond Monet's reach. Bazille's other life in Paris, the milieu of top-hatted, frock-coated Manet, who loved parties, widened Monet's social horizons, and Bazille's connections provided his first Paris buyer when Maître bought one of his still lifes.

Gleyre faded into the background. His health was failing, as were his finances, though after the summer break Bazille reported the students greeting each other with shrieks of joy when they returned in October. Pestering his parents for his own studio, Bazille got it in January 1864, at 115 rue Vaugirard, sharing with another wealthy student from Montpellier, Louis-Émile Villa. There was even a small garden, which 'will be very pleasant for us in the summer to paint figures in the sunshine'.[32] Monet, on more modest means, growled that Bazille would get no work done in the company of a lightweight like Villa. Gaston Bazille could not bear to refuse his son the studio, but warned, 'You are putting a considerable strain on my poor wallet; examination fees, furniture for the studio ... this year you have to be careful', and told him to sit his first medical exam in January.[33] Bazille delayed, did not prepare and in March admitted, 'My dear father, I have just heard that I have failed my examination, which I am very upset about, especially for having let you down ... I flunked my dissection ... I have only one regret, and that is having lost all this time that I really needed to devote to my painting.'[34]

Monet, living in a tiny room on the fifth floor at 20 rue Mazarine, a small street winding down from the Latin Quarter to the Seine, and often in the company of a girlfriend, 'ma petite Eugénie', was also in trouble with his family. Summoned in March 1864 after a long absence to show his work to Armand Gautier, Monet dawdled along the Seine, turned up late and had to grovel, fearing reports sent on to Aunt Lecadre. In his attempt to apologize, his ebullience burst out anyway:

You would not believe how sorry I was the other day ... because I saw that you weren't at all satisfied and that I had lost your good esteem,

without knowing exactly what I had done. Sorry. That day I arrived in such a good mood. I had got up early; on the way to you I took a delicious walk along the river and the Tuileries, it was lovely and I was absolutely happy . . . I work very hard, and the more I do, the happier I am.[35]

Then Monet fled to Fontainebleau, leaving Gleyre's for good some months before the school closed permanently that summer. Bazille was again with him, and probably other Gleyre students. 'I used to go to Fontainebleau with Sisley with my paintbox and a painter's shirt. We would walk until we found a village, and sometimes only come back a week later when we had run out of money,' Renoir recalled. Around this time, the roots of Monet's most important artist friendship, an unalterable bond, were planted when, under his influence, Renoir began to paint outdoors, and his palette brightened. According to his son, 'Even before he left art school, Renoir was faced with the dilemma of his whole existence . . . The choice was between the excitement of direct perception and the austere ecstasy found in the study of the Old Masters.' Gradually, Renoir was swayed towards the former, driven by 'his love of life, his need to enjoy all the perception registered by his senses, as well as the talents of his comrades', without giving up respect for tradition.[36] The first crisis came with *Esmeralda Dancing*, which Renoir submitted to the 1864 Salon. It was accepted; however, so quickly did Renoir change tack that on the picture's return from the exhibition he destroyed it.

Monet did not enter a Salon picture in 1864, but he studied the exhibition closely, and was impressed most by Daubigny's *Cliffs at Villerville-sur-Mer*, depicting a stretch of coast he knew well. In May he took Bazille, who had never seen the North Sea, by boat up the Seine to Honfleur, with a stop at Rouen where, three decades before he painted it, Monet's encounter with the cathedral is recorded – Bazille enthused, 'we were able to see the Gothic marvel of this large city'.[37] They also admired the collection of Delacroix in the museum.

Monet stayed in Normandy for the next six months, Bazille for some weeks. Monet imposed the discipline of working hours from 5 a.m. until 8 p.m. Every day the two painted side by side outdoors in the field of a seventeenth-century thatched farmhouse, Saint-Siméon, whose orchards and gardens ran down to the Seine estuary. Once a

refuge for sailors, the inn on the heights of Honfleur had long wel-
comed painters – Corot, Boudin – attracted by its open views, modest
rates and easy hospitality. Boudin and Jongkind came again in 1864.
'Mère Toutain', the owner's wife, was generous with credit and food,
and served them lunch – mackerel with sorrel was the house
speciality – and cider under the apple trees.

'The countryside is a paradise. One couldn't see richer meadows
with more beautiful trees,' Bazille told his mother. 'The sea, or rather
the Seine broadening out, gives a delightful horizon to the masses of
green. We are staying in Honfleur itself, at a baker's, who has rented
us two small rooms; we eat at the Saint-Siméon farm, situated on a
cliff a little above Honfleur; it's there that we work and spend our
days.'[38] The pair had visited Monet's family, whom Bazille found
charming; everyone was presumably on their best behaviour.

Monet acknowledged he needed to be in Sainte-Adresse to please
his family, but was reluctant to stay. Tensions mounted, as they did
between Bazille and his parents. For better or worse, Gleyre's students
were launched. Their next challenge was to sell their work, make a
name, yet most were still humiliatingly dependent on their relatives.
The exception was the poorest, Renoir, who had to pay his way; he
spent summer 1864 on a portrait commission from Sisley's father.
Sisley had a generous allowance. Bazille, still a medical student, was
more circumscribed, but broke free. He did not turn up for his exams
in July. 'Papa is going to be very annoyed with me, I have spent too
much money and did not sit my medicine examination; I am counting
on forgiveness for my progress in painting and most of all on the
goodness of his heart.'[39] Monet's sympathetic portrait of Bazille at the
farm, his features in shadow, his long head cast down, marks a
moment of their unity against pressurizing families.

Bazille left Honfleur with no work to show for the stay. His tall
story that a box of pastels overturned and ruined his paintings masked
a crisis of confidence trying to keep pace with Monet, who quickly
produced the sparkling, twilit *The Beach at Sainte-Adresse*. The coast
sweeps towards Le Havre, a rowing boat is close to the shore, the
day's last sailing vessels are coming in and the atmosphere of a tran-
quil evening is pervasive. Bazille was thus witness to the creation of
the first painting devoted to Monet's lifelong theme of the effects of

light on water, executed with precision and a rush of excitement in calligraphic, darting brushstrokes.

Bazille copied the painting when it returned with Monet to Paris. Bazille needed Monet, but he also needed to get away from him. In his studio on rue Vaugirard, he began a large nude, a genre of no interest to Monet. *Reclining Nude* took two months and Bazille hoped his parents would appreciate his effort, telling them: 'I admit it's pretty bad, but taking its difficulty into account, you will find that I have made progress.'[40]

While he struggled, Monet campaigned to get him to come back: 'My dear Bazille, I wonder what you can be doing in Paris in such lovely weather, for I suppose it must also be lovely over there. Here, my dear friend, it's adorable, and every day I discover still more beautiful things ... Goodness, it's already the 16th, grab your things and come here ... it would be the best thing you could do, it can't be easy to work in Paris.'

These are the first surviving words Monet wrote to Bazille. If the superior tone grated, there is no record of it: while Bazille kept Monet's letters, Monet threw Bazille's away. But in his stifling Paris studio, a return to Honfleur was the last thing on Bazille's mind. He needed to finish his nude to prove mastery to his disappointed parents. Monet's letter made it clear that it had never occurred to him that Bazille might have different aims or desires from his own. The young Monet was a problematic companion. Beneath his encouragement – 'Are you making progress? I'm sure you are, but I'm also sure you don't work hard enough and in the right way' – was Oscar the caricaturist, imposing the force of his own personality.[41]

At home for the summer, Monet was in his element, and the haul from his trip was twenty paintings. Following *The Beach at Sainte-Adresse* came a group of Norman seascapes, which were the basis for his inaugural Salon attempt to be developed during the winter. Another repeated subject was the tree-lined stretch of the road from Honfleur to Trouville, sometimes with a corner of the Saint-Siméonfarm just visible, recording the shift from summer brightness to muted autumn tones, when the trunks cast long shadows and the leaves began to thin out. It was the beginning of a lifetime's working in situ before the motif, in bouts of extreme concentration and mostly

alone. 'It makes me feel I'm going mad, how much I want to do everything, my head is bursting,' he wrote, pouring it all out to Bazille:

> It's terribly difficult to do something complete in all aspects, and I think most people are content with approximations. Well, my dear friend, I intend to fight, scrape off, begin again, because one can produce something from what one sees and what one understands, and it seems to me, when I see nature, that I can do everything, write it all down, and then, when you're working, nature drives you – it says: go!

Bazille is co-opted into Monet's project: 'all this shows that one must think of nothing else. It's by force of observation and reflection that one gets it. So let's sweat and sweat, continually.' Yet Monet ends, 'it's better to be completely alone, and yet even all alone, there are things that one can't fathom. Ultimately all this is terrible . . . I am thinking of amazing things. When I go to Sainte-Adresse and then Paris in the winter, it's scary what I see in my mind.'[42]

In high season the Saint-Siméon inn filled with painters, most of them 'very poor . . . a bunch of jokers', apart from Boudin and Jongkind, with whom Monet played dominoes in the evening. He wanted Bazille. 'Nature is beginning to grow beautiful, it's ripening and becoming more varied, in short it's marvellous . . . Come back and rejoin me, the countryside is really at its loveliest, there's wind, fine clouds, storms, it's a wonderful moment, there are many more effects.'[43] He broke off the letter when Mère Toutain announced lunch. 'J'ai grand'faim,' he scrawled, and the hunger of ambition sounds throughout this summer too: 'I'm desperate to make enormous progress before returning to Paris.'[44] Eugénie was reminding him that she had not forgotten him; her letter made Monet so joyful, he told Bazille, that he could have leapt all the way to Paris – yet he did not move.

Monet, once absorbed in a place, was always hard to shift. By October he couldn't leave: he owed Mère Toutain 800 francs. Without paying, he slipped home, seeking funds, but stayed less than a week and on 15 October was expelled and asked 'not to return any time soon'.[45] Monet's disruptions were familiar occurrences. Jeanne was in her seventies and 'at her age, must not be disturbed in her inner tranquillity, as has already happened several times,' Adolphe would write a couple of years later.[46]

There was no question where to turn. 'I never doubted that you would put yourself out to help me,' Monet explained to Bazille.[47] His claims that 'my rupture with the family will happen any day . . . I even fear I won't get any more money'[48] were probably exaggerations to win sympathy. The pair now concocted an unrealistic scheme by which Monet, entirely unknown, would send three canvases to Montpellier and Bazille would sell them to his collector friend Bruyas. Monet went to considerable effort in selection and presentation, trying to develop more finished paintings, as collectors expected, but he was proudest of a freer *Saint-Siméon*. 'Among these three canvases is a simple study . . . entirely done from nature, perhaps you will find a certain relationship with Corot, but it's without any imitation . . . The motif and above all the calm and misty effect are the only reason. I did it as conscientiously as possible without thinking of any painting. Anyway, you know that's not my system.'[49] This description crystallizes his early aims, methods, sincerity and conviction.

'Your three pictures' – a pronoun shifted responsibility to Bazille – departed in a crate sent express a thousand kilometres south on 17 October. Monet was respectful enough, apologizing for bothering Bazille's father in his demands, but the undercurrent was that Bazille was there to service Monet. As his importuning letters, always unfranked, multiplied, Bazille's defence was passivity: he no longer answered. Bruyas declined the canvases. Bazille had his own battle, making paintings which reasserted family connections: his hunting dog, a cousin looking out on the village of Castelnau-le-Lez.

Marooned at the inn with his debts, Monet was still waiting in November. 'I can't stay here for ever, until eternity,' he told his friend, as if his departure were Bazille's problem.[50] Honfleur and the other coastal towns were deserted. He made the best of it, continuing to paint outdoors. *Horses at the Pointe de la Hève* depicts a shingle beach off-season, in a crisp atmosphere, bright, the air turning colder, a few workers and their horses and carts the only activity. 'It is so beautiful at the moment that I must take advantage of it. I'm completely alone now and frankly I work the better for it.'[51]

His luck turned with the interest of the Gaudiberts, Le Havre shipping insurers and patrons of Armand Gautier. Louis-Joachim Gaudibert, two years older than Monet, had just married a Havrais

lawyer's daughter and set himself up on boulevard Impérial. Monet painted decorative panels for the apartment, and the Gaudiberts purchased a Saint-Siméon canvas. The money paid Mère Toutain, and Bazille and Monet returned to Paris at the same time. Bazille was at once the grateful pupil: 'at the moment I am working every day at Monet's', and Monet as soon was back in debt.[52] 'You think the way I spend my money is idiotic,' he acknowledged, just before asking Bazille for more. 'I'm sorry, could you once again be my saviour? ... This morning I've had a disagreeable surprise ... I need 10 francs. Forgive me for asking you so often, I am really very grateful, during the coming week I'll repay you 20 francs.' This request ended with the promise of another extravagance: 'tomorrow morning we're going to be photographed at Carjat's, Eugénie and me – come with us.'[53]

Carjat had set up a photography studio at 56 rue Laffitte, and was popular for flattering his subjects with the pronounced theatrical outline that he had refined as a caricaturist. He posed the young men carefully, in three-quarter-length format, each with a hand slipped into a pocket, a deliberate off-hand stance. Monet, long hair brushed back, emphasizing his broad forehead, and wearing a coat fastened

Bazille in 1864, by Étienne Carjat; Monet and Bazille went together to Carjat's studio to be photographed

only by a top button, in imitation of a cape, and a cravat with floppy ribbons, affects the fluid silhouette of a bohemian dandy. Intense eyes staring into the distance, strong lips and jaw, a smooth young face, all mark determination, assertiveness, curiosity. The effect in this first known photograph is dashing yet reserved. Bazille in his tight double-breasted waistcoat, high-collared shirt and neat short haircut, attempts to ape his friend's casual-cool look, but the effort makes him appear the more awkward. You worry for this affable giraffe, head tilted back uneasily, expression benign, open to the world, seeking affection, but suggesting a wistful lack of resolve.

'Unfortunately I don't see enough of the sacred fire in you, and you retreat from difficulties instead of knowing how to overcome them through patience and energy,' Gaston wrote to his adored son.[54] But Gaston sensed Monet's galvanizing influence, and agreed to a plan for the friends to take lodgings together in the new year. The Gaudibert connection meanwhile worked wonders at Sainte-Adresse, for in December Adolphe visited Paris and gave Monet 250 francs for his part in the rent.

'My bedlinen arrived ... and is now on my iron bedstead fitted with a base and a mattress, the blankets will be ample for me even though it does get very cold. All I need now are curtains over the window and I can move in, they are coming on Monday. So from today, you can write to me at 6 Place de Furstenberg,' Bazille informed his father on 6 January 1865. These premises, one floor up from Delacroix's final studio, gave the pair an illustrious Left Bank address, on an attractive, tree-lined road which half way along opens into a square (the official name is rue de Furstenberg). Bazille provided a sumptuous green armchair as the luxury. In a bitter winter, so cold that the Seine froze over and 'you could have walked across on the ice', Monet's contribution, Bazille explained, was to 'wake me up every morning' and urge him into the studio. He promised his father 'to work my heart out and show you next year how much greater progress I have made than I did last year'.[55]

Monet and Bazille had opposite relationships to the studio. Monet used it in winter to work from summer sketches, but for him nothing rivalled being outside, confronting the subject. Bazille fetishized his *ateliers*, creating elaborate portraits of each one which form an

The first known painted portrait of Monet, by Gilbert de Séverac, 1865

extended autobiography, documenting his paintings, taste, interests, friends. He made Monet omnipresent in *Studio in the Rue de Furstenberg*: Bazille's chair and the pot-bellied stove are the star props, but the paintings dominating the walls are Monet's road to Saint-Siméon and a seascape. Hanging beneath them is Gilbert de Séverac's portrait of Monet of 1865. The pose is as bold as in Carjat's photograph, and more unruly. Seated the wrong way astride a chair, arms folded across its back, as if it is an effort to keep still, Monet in a striped tunic has a piercing look, resolute, impetuous, unquiet.

He spent the first months in this studio on his Salon submissions, seascapes developed from Honfleur and Sainte-Adresse oil studies which are factual, descriptive, carefully constructed and planned to be complementary in tone and subject. *La Pointe de la Hève at Low Tide*, based on the autumn's beach scene with horses and carts, is a harmony of greys, blues, whites, the shingle and rippling shallows delicately coloured, the textures of crisply dabbed pebbles, wet sand, weathered wooden posts, rocks, precisely observed. The atmosphere

Bazille, *Studio in the rue de Furstenberg*, 1866:
a portrayal of the studio he shared with Monet

owes something to Boudin's and Daubigny's seascapes, but Monet is
stronger. Courbet's vigour is recalled in the ribbons of sun breaking
through an overcast sky, and in the powerful diagonal of cliff and
shoreline. The brushstrokes are lively, there is no smooth finish as in
academic paintings, but *La Pointe de la Hève* remains comfortably
within 1860s realist mode. Accepted by the jury, it was a safe route to
the Salon for a debut, with a piquancy which attracted attention.
'Monet. The author of a seascape the most original and supple, the
most strongly and harmoniously painted, to be exhibited in a long
time,' commented the anonymous Pigalle in the broadsheet review
L'Autographe au Salon. 'M. Monet, unknown yesterday, has at the
very start made a reputation by this picture alone.'[56]

La Pointe de la Hève invites slow looking, as if the viewer is stroll-
ing along its beach. The second Salon picture, *The Mouth of the Seine*

The Mouth of the Seine at Honfleur, one of the pair of seascapes which
were Monet's first paintings exhibited at the Salon, in 1865

at Honfleur, facing the harbour where the river empties into the
Channel, a blustery sea and sky within a stable structure, is more the-
atrical. The lighthouse is a vertical anchor in a flow of horizontals, the
fishing vessel tilting its mast anchors the bottom of the canvas, even
the seagulls are carefully placed between billowing sails.

The painting did not start that way. Monet based it on a serene
Honfleur sketch, then he whipped the wind, added more boats whose
sails swell in the gusts, stiffened the waves, and sent huge light-
streaked clouds rushing across the canvas. He did so after seeing, at
the Galerie Martinet in February 1865, Manet's *The Battle of the
Kearsage and Alabama*, the imagining of an American Civil War skir-
mish which took place in summer 1864 off the coast of Cherbourg,
when the Union corvette *Kearsage* sank the Confederate raider *Ala-
bama*. Manet had hastened to Boulogne to survey the *Kearsage*
anchored, and produced an unorthodox, turbulent seascape with high
horizon line, where the viewer feels immersed in rising waves.

Monet's *Mouth of the Seine* was not as daring, but late in the day
he stirred up the composition to suggest the exhilaration of being on

the open sea, borrowing Manet's tilting sailing ship, which gives a dynamic charge. A Manet-like starkness is balanced by Monet's pearly luminous atmosphere. *L'Autographe au Salon*, which reproduced notable Salon works, commissioned a drawing. 'Mouth of the Seine abruptly stopped us in passing and we shall not forget it,' wrote conservative critic Paul Mantz. 'The taste for harmonious schemes of colour ... the striking point of view of the whole, a bold manner of seeing things and of forcing the attention of the spectator, these are qualities which M. Monet already possesses in high degree.'[57] Monet's first Salon pictures were thus idiosyncratic enough to be noticed, but assimilated approaches of his two major contemporaries, Courbet and Manet. It was a smart beginning. 'Monet has had a much greater success than expected,' Bazille told his parents.[58]

In an effort to be fairer, the 1865 Salon was hung alphabetically. Monet found himself in a room with Manet, his seascapes installed either side of *Olympia*, featuring Victorine Meurent as an aggressive-looking, sickly prostitute, posed after Titian's reclining Venus. The cold realism of the radical *Olympia* sparked even more outrage than Manet's *Le Bain* had in 1863, and the painting was openly jeered. Since their names were similar, however, casual viewers thought all three works were Manets. Even some of Manet's friends, embarrassed by *Olympia*, did not look too closely at the signatures and went out of their way to congratulate him instead on the marines. Manet was furious, and declined when Astruc offered to introduce him to the young upstart. Weary of Paris, he left for Spain.

Days after the Salon opened on 1 May, Monet had sold his two pictures to the dealer-printer Alfred Cadart for 300 francs each and immediately spent the money. He took the train, then a carriage, to Chailly, where he established himself at the Lion d'Or inn. Here he began to devise his new picture for the 1866 Salon – one to prove that he was more than a marine painter and, looking back to the Salon des Refusés, could challenge Manet on his own turf. From Chailly he wrote to Bazille:

> You know that this time I'm waiting for you, no excuses, Saturday evening for dinner. If not, write to me so that we don't wait to eat. The young Gabrielle arrives on Monday during the day, it won't be any fun

if you're not here. You're wasting time in Paris, here everything is superb; you ought to take advantage of these lovely days, there are enough bad ones during which you can work in your room on your panels. Be so good as to bring paper and pencils. I have absolute need of them, and there's something I need even more – a bit of money, you must make every effort to find some. Above all, come on Saturday. I really want you to be here: I want your opinion on the choice of my landscape for my figures, I'm sometimes frightened to throw myself into it.[59]

In the forest, Monet stood on the verge of a project so grandiose that it alarmed as well as enthralled him. 'My figures' were to be a dozen life-size picnickers, staged across a canvas six metres wide – three times larger than Manet's *Le Bain*. Bazille was supposed to model for most of the men, but he vacillated – neither Monet nor Gabrielle could tempt him away from Paris, where he had three paintings on the go, there was a reading of a play he had composed, and he was sailing. In July his boat *La Cagnotte* won first prize at the Bougival regatta. 'As you can see, I am working nicely in many genres (I can hear you from here saying, too many),' he wrote home. 'Rest assured, dear father, with these appetizers I am not forgetting painting is my only main course . . . a grill-room owner is perfectly entitled to try his hand at an egg soufflé now and again.'[60]

Monet grew frantic. 'You seem to have completely put me aside . . . I beg you, my dear friend, don't leave me in the lurch . . . You can't have anything very serious keeping you in Paris . . . I know how capricious you are.'[61] Eventually he was disbelieving. 'If you don't reply by return post as soon as you get my letter, I will think that you refuse to write to me or help me out. I am in despair, I am afraid that you will make me lose my picture and that's very bad of you after having promised to come and pose . . . *Pick up a pen and reply*,' he pleaded on 16 August.[62]

Monet awaited him 'like the Messiah' Bazille told his parents drily.[63] He stirred himself to go later in August, but the painting sessions were held up initially by rain, then by a minor accident when Monet injured his leg protecting some children in the forest from a discus thrown by English tourists. Enraged, he could not stand and it was Bazille, in a

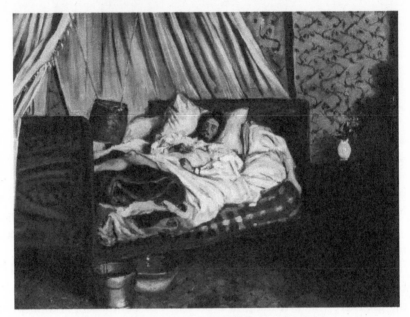

Bazille, *The Improvised Ambulance,* depicting
Monet in bed with a leg injury, 1865

rare position of power in the relationship, who painted his bedridden
friend. *The Improvised Ambulance,* his most assured work so far,
depicts Monet propped up on a large canopied double bed, his blood-
ied leg elevated on a blanket, surrounded by an arrangement of
buckets and bowls of water to keep the wound clean, a system devised
by former medical student Bazille.

The painting of the invalid in the bedroom does not include his
companion, but Monet was not alone at the Lion d'Or. While waiting
to depict the men, he had spent the previous three months on studies
of the five female figures, which 'are going marvellously', he told
Bazille.[64] All of them were modelled by his new girlfriend, eighteen-
year-old Camille.

5
Camille, 1865-7

'Henceforth Camille is immortal,' wrote the cheerleader of young painters Théophile Thoré on encountering Monet's first exhibited painting of his new love, *Camille, or The Woman in a Green Dress* [Plate 5].[1] At life-size, it was the largest picture Monet had completed to date, and anostentatious introduction to the woman whom for the next decade he would show off to the world, yet, through different guises and disguises, as intensely keep private, rarely even depicting her frontally unless masked into anonymity. Camille balanced a quality of display – sinuous poses, graceful bearing, the ability to hold static a lively gesture or movement – with an aura of inwardness, discretion and subtlety. A fresh daring entered Monet's work when she came into his life, and his first wide acclaim was achieved through her image.

In *The Woman in a Green Dress* he portrays her from the back, body slightly arched, just turning, head tilted to show a pale, oval face framed by raven hair in half-profile, with high cheekbones, prominent nose and chin, thick eyebrows. Wearing a fur-trimmed jacket over an absurdly opulent green and black striped dress dragging behind her, Monet's teenage girlfriend progresses haughtily across the canvas. 'Camille: Parisienne, ô reine – ô noble creature,' proclaimed the journal *L'Artiste*.[2] A woman on the go, on the rise, hard to pin down, a figure of verve and enigma: in review after review, men swooned over this Camille as Monet rendered her – at 'the provoking way in which she tramps the pavement', how 'she passes proudly, protected by both her vices and her elegance'.[3] 'The dress, how supple it is, how solid,' wrote Zola. 'It trails softly, it is alive, it declares loud and clear who this woman is.'[4]

Actually, Monet made sure the picture did no such thing. The dress was his camouflage for Camille as well as a triumph of paint and fashion. 'It is indeed Mme Monet ... who served me as model, though it was not necessarily my intention to do a portrait of her, but merely of a Parisian figure of that time. The likeness to her is exact,' Monet explained forty years later.[5] He seldom spoke of Camille, and never in detail. On canvas she is as elusive. In the split-second image of a woman adjusting the ribbon of a small bonnet as she walks away from us, Monet created a fleeting presence, an intrigue, a sweep of green satin. 'The beautiful creature passes by, appears, is about to disappear, with an allure full of power and grace ... Her expression is untranslatable, a sort of disdainful coquetry, marked in the lowered eyelids, and in the corner of the mouth ... a moment of perfection,' wrote Geffroy.[6] In his melancholy poem 'À une passante' (To a Woman Passing By), Baudelaire described a figure 'Stately yet lithe, as if a statue walked / ... Lovely fugitive/Whose glance has brought me back to life'. *Camille, or The Woman in a Green Dress* calls to mind such an ephemeral exchange on a Paris street.

The painting's first owner was magazine proprietor and speculator Arsène Houssaye, who saw *The Woman in a Green Dress* at an exhibition in Le Havre, paid Monet 800 francs and promised to donate the painting to the Musée du Luxembourg, in Paris. Houssaye was fascinated by Second Empire women who 'emancipated themselves ... knew the power of money, used it to the hilt ... They light your cigar; they let you smoke only because they smoke themselves. One has to see them making fun of women as they used to be: obedient, servile, in the shadows. Those days are over.' Camille flaunting the latest fashion embodied for Houssaye the modern Parisian woman, for 'there are only two ways to be a Parisienne – by birth or by dress'.[7]

Camille Léonie Doncieux was almost the former – her family moved to Paris in her childhood – and, with her flair for fashion, determinedly the latter. She was born in Lyon on 15 January 1847, first daughter of Charles-Claude, then aged forty, and his seventeen-year-old wife Léonie, née Manéchalle. On documents Charles-Claude described himself as a *négociant*, the broad term similarly used by Adolphe Monet. Doncieux may have been employed selling textiles, Lyon's staple and booming industry. The Doncieux and Monet

families had in common an older father, a mercantile background, and a link to France's second city. The Doncieux left for Paris in the 1850s. A second daughter, Geneviève, was born in 1857 when they were living at rue Neuve-des-Poirées, on the Left Bank, near the Sorbonne. A curiosity about this sole sibling is a will of 1866 by François de Pritelly, a 68-year-old widower, retired tax collector and property owner, leaving all he owned to Geneviève and disinheriting his two sons. He may have been no more than a bountiful friend; if he was Geneviève's father, then Camille, like Monet, had an illegitimate younger half-sister, and the Doncieux home may have been fraught.

Whatever Claude-Charles Doncieux's trade, he was successful enough for his daughter to bring an extensive, up-to-date wardrobe to Fontainebleau. 'Lyon offers us its *fayes* and its failles, its *poults-de-soie*, its satins, its velvets comparable to no others, its gauzes and its tulles, its crepes de chine. What should one make of these materials? Above all, masterpieces,' suggested Stéphane Mallarmé.[8] The poet, who wrote an entire fashion journal, *La Dernière Mode*, under pseudonyms such as 'Satine', was one of many artists and writers fixated on fashion, its innovations and possibilities for a modern idiom, connected to mass markets and consumer culture. The first department stores were recently launched – Le Bon Marché in 1852, Le Printemps in 1865. Baudelaire was asking painters to 'extract from fashion whatever poetry it might contain'.[9] Even Cézanne, shyest and least Parisian of the avant-garde, copied costume plates from *La Mode illustrée* as paintings.

In 1860s Paris, these interests affected relationships between artists and their models, and increasingly empowered the women, as female subjects were shifting from the academic nude to the contemporary Parisienne. Their personal styles were treasured expertise for a painter of modern life, and the girls inspired with their arrangements of colours and textures, making them almost co-creators of the compositions. 'The satin corset may be the nude of our era,' said Manet.[10] Hippolyte Taine claimed in 'Notes sur Paris' in 1867 that 'a perfect toilette is equal to a poem. There is a taste, a choice in the placing and shade of each satin ribbon, in the pink silks, in the soft silvered satin, in the pale mauve ... this is the only poetry left to us, and how well they understand it!'[11] Camille opened this milieu to Monet. No painting by

him of the female figure pre-dates his relationship with her. Most artists varied their models: Manet with Victorine Meurent (*Olympia*), his wife Suzanne, sister-in-law Berthe Morisot (wife of his brother Eugène), pupil Eva Gonzales, the courtesan Henriette Hauser (*Nana*), actress Ellen Andrée (*La Parisienne*), for example. Monet worked only with Camille.

Like almost everything about her, how Camille met Monet and threw in her lot with him is mysterious. As the daughter of a *négociant*, she came from a family more comfortable than the girls of her age who were the lovers of Monet's friends such as Lise Tréhot, a tobacconist's daughter, and a seamstress when she met Renoir, or Cézanne's Hortense Fiquet, also a dressmaker, living alone in Paris. On the other hand, an inventory in 1873 valued the contents of the Doncieux household – furniture, jewellery, silverware, clothes – at a modest 3,196 francs. They owned no property. Camille's social position is unclear. Her paternal grandfather was a baker, her maternal grandfather a cavalry captain. Never in the financial crises of her life with Monet was there any help from her family, and the dowry they eventually provided was small: 1,200 francs. Yet she had beautiful clothes, she was educated enough to give French lessons when living abroad, and she would move easily with Monet in bourgeois and even aristocratic company. Renoir and Manet competed to paint her. At eighteen, her gift for posing was pronounced; she may have been a semi-professional model, recruited to the shared studio on rue de Furstenberg where Bazille frequently worked from paid models.

The home Camille left to go to Fontainebleau with Monet was at 14 rue Truffaut, a street lined with shops and a washhouse in the Batignolles quarter in the north-west of Paris. The Doncieux had moved to take advantage of Haussmann's new apartment blocks in this expanding area, recently incorporated as the seventeenth arrondissement of Paris, and attracting a wave of bourgeois and bohemian residents. Manet took an apartment at boulevard des Batignolles in 1864, and became so identified with the area that the term Batignolles School was used for the group formed around him in the later 1860s. Zola followed, moving to 23 rue Truffaut, directly opposite the Doncieux, and Bazille later justified a vast studio in the area because it was quiet and cheap. Perhaps Monet introduced himself to Camille in the

Batignolles, in a café or on the street. Her looks were distinctive; more than that, her dark hair with the loop of a curl framing an oval face, big dark eyes, and an animated yet enigmatic expression, bear a similarity to Louise Monet as a young woman in Rinck's portrait.

A single clue about Camille's background exists. In 1923 Monet subscribed to a farewell performance for comedy actress Marie Samary, whom he recalled as Camille's 'intimate friend . . . of whom I have always retained fond memories'.[12] Samary, born 1848, was the longest lived of a performing dynasty. Her grandmother was a famous *comédienne* during the July Monarchy, her siblings including actress Jeanne, Renoir's model and lover, and actor Henri, painted by Toulouse-Lautrec. Marie was a star at the Vaudeville, the Gymnase and the Odéon, all venues patronized by Bazille, an avid theatregoer and one of the gentleman-admirers who loved to pay homage backstage, though he tried to sound blasé about it: 'I can tell you I have become a regular behind the scenes . . . it is not at all a delightful place to stay, it is rather chilly, you see some very dirty stage hands, some very stupid musicians . . . sweaty dancers . . . I have talked with the dancing girls, who told me how much rent they have to pay, about their dog or their cat . . . '[13] Bazille, as well as writing plays, was an amateur performer – a dancing girl in a farce-version of *Macbeth* at Gleyre's, a lead in Victor Hugo's *Ruy Blas* at the Lejosnes'.

There is a record of Monet and Camille participating in amateur dramatics: they played in Eugène Labiche's dark, absurdist vaudeville *L'Affaire de la rue de Lourcine*, written in couplets, interspersed with songs and a strangled cat. The only female character is a bourgeois wife transformed into a screaming harridan in response to her husband's misdemeanours. The performance took place in April 1866, just after the completion of *The Woman in a Green Dress*, at the home on rue du Bac of Théophile Beguin-Billecocq, cousin of Monet's friend from his teenage years Théodore Billecocq, and Camille was presented as Monet's wife. 'We set up our theatre in my salon, Monsieur and Madame Monet (friends of Théodore) invigorated our troupe,' Beguin-Billecocq noted in his journal.[14] Ten years later, wigged and donning a kimono in *La Japonaise* [Plate 20], Camille was still performing in fancy dress. A love of theatre is clear from the books – recent editions of Shakespeare in translation, Alfred de Musset's play

Le Caprice, sumptuously bound Garnier Frères volumes of the 'Théâtre de Corneille' and Sainte-Beuve's 'Théâtre de Beaumarchais' – which she and Monet had acquired by 1872, when they had their first permanent home. They appear to be Camille's choices, for Monet's library included only one work of drama published after her death.

So it may be that overlapping groups of artists, actors and models brought Camille and Monet together, and that Bazille was the agent. At any rate, Camille and Bazille shared a talent for striking postures, and a playfulness – swapping outfits, rearranging themselves around trees and picnic props. When Bazille, having relented, turned up in Chailly, together they entered the drama of the creation of *Le Déjeuner sur l'herbe* [Plate 3]. in August 1865. Monet posed them, repeated but varied, for the picture's three rhythmically linked couples. At the back, entering the forest in a sunny clearing, Bazille stands diagonally behind Camille, leaning forward towards her. In the centre, he throws his head back, looking beyond her as she partly covers her face with her arms. A third pair is Bazille stretched along the ground, not quite facing a seated Camille in flowing white. Each pair enacts a small vignette of closeness yet detachment. Bazille's gawky posture and gestures are exaggerated, enhanced by his unusual height. Camille manages to be both impassive and lively, her expression either obscured, or marked by that blend of withdrawal and insolent blankness with which Monet would habitually characterize her. For the seated figures, her twinned radiant faces, framed by dyed reddish gold hair – henna and rhubarb – are fixed, stagy as masks, yet pivotal to *Déjeuner*'s atmosphere of warmth and well-being. Both Camilles stretch out an arm in an open movement which pulls us into the painting. There is a glimpse of her flesh beneath the gauzy semi-transparent frocks, a shiver of sex.

The joy of role-playing comes across in the breezy oil sketch *Bazille and Camille*, a study for the left-hand pair, painted outdoors. Bazille, in a dark open suit jacket, shirt with stiff cuffs, loud cravat and melon hat, acts the country gentleman who he naturally was. The folds of Camille's promenade dress, a tight-fitting short jacket and skirt worn without crinoline, turn grey in the shadows. The dark soutache embroidery imitates military trimmings, lending a toughness that contrasts with the soft polka-dot and green-striped white dresses of the seated Camille.

Monet painted a quarter-size oil version of the complete composition, at the time considered a sketch but by the early twentieth century, when the Russian modern art collector Sergei Shchukin bought it, recognized as a masterpiece anticipating Impressionism. In this painting Monet achieved his aim of merging figures with setting, and of rendering light as the action of the painting, beating through the trees, fragmenting the scene into contrasting patches of brightness and shade. Russet leaves carpet the ground, and as the sun glints through the canopy of branches on to the picnickers, the painting shines with chromatic highlights from Camille's wardrobe – the gold dress, the rippling green muslin, a red shawl crumpled on the grass. In the pattern of inclining heads and exchanged glances, the harmonizing skeins of line and gesture, there is in an easy animation, as if Camille and Bazille's laughter, carried over the forest clearing, echoes across the canvas. Carved into the bark of a tree, the heart pierced by an arrow is Monet's lover's signature.

The picnic is a subject through French painting from Antoine Watteau's *Embarkation for Cythera*, which Monet said was his favourite painting in the Louvre, to Courbet's *Repas de Chasse* and Georges Seurat's *La Grande Jatte*. Monet, following Manet, was claiming his place in the canon. Although Watteau's gracefully mannered couples at the party in an imaginary forest landscape by the sea are aristocrats in theatrical costumes, *Déjeuner*, shares with *Embarkation* the motifs and mood of a *fête galante* set in idyllic countryside where ornamental couples in a glade talk and flirt. Monet, with his chicken picnic, bottles of wine and eager sniffing dog, claims the site of pleasure for middle-class life. *Déjeuner* is a democratic painting, and, in the casual poses and relationship between figures and forest, celebrates freedom in nature. 'The gesture and the bearing of the woman of today,' advocated Baudelaire, 'give to her dress a life and a special character which are not those of the women of the past.'[15] Camille interpreted by Monet was the emblem of that modernizing process, enhanced by the open-air setting. If Monet had been considering a composition of large-scale figures in nature since he saw Manet's *Le Bain* in 1863, it was Camille who made *Déjeuner* happen in 1865 – their first collusion.

After Bazille departed for the south, Monet recruited other painters

to pose for his men, including Sisley, who was working nearby in the village of Marlotte with Renoir, also attempting figures in a landscape. Monet boasted, 'Everyone knows what I'm doing and greatly encourages me.'[16] The attention continued when he took his sketches back to the rue de Furstenberg in October to complete the full-scale painting. He had the studio to himself; Bazille, stalling over his own Salon attempt in Montpellier, sent neither word nor the rent. 'I really don't know what to think of you, on all sides I see people complaining about your silence,' complained Monet.[17] When Bazille did turn up, he was generous, excited that Courbet 'came to visit us to see Monet's picture, which delighted him. More than 20 other painters have come to see it, and all admire it greatly, although it's far from finished . . . This picture will make a huge stir at the exhibition.'[18]

In truth, the more experienced visitors were circumspect. Courbet offered himself as a model, and he is in the picture, with twirling moustache, long beard and an exaggerated air of bonhomie. But he was competitively discouraging, telling Monet that even he would not be able to finish such a large picture in time for the Salon. Boudin wrote enviously, 'I have seen Courbet and others daring to paint large canvases, the happy men. Young Monet has twenty feet to cover,' but added that the effort was costing Monet 'the eyes in his head' and 'every penny he has'.[19] 'I think only about my picture, and if I knew I wouldn't pull it off, I think I'd go mad,' Monet wrote, but in Paris he grew increasingly frustrated, unable to recapture at monumental scale the liveliness of the sketch.[20]

His slim chance of finishing before the Salon deadline disappeared in January, when he and Bazille quit the rue de Furstenberg, going their separate ways. Monet said they were evicted for being too raucous, after a masked party in which Bazille, in a last outburst of reverence, dressed up as Monet, and Monet was a Honfleur fisherman. More likely, Bazille had had enough, and chose not to renew the lease. He explained to his father that he wanted to work more quietly. Gaston was sceptical: 'I'm sorry about your separation from Monet. It seems he was a real worker who must have made you blush at your own laziness quite often; and when you're alone, I very much fear that you'll pass a great many mornings and even entire days in a *dolce farniente* that won't serve to advance your paintings for the exhibition.'[21] Bazille did soon tire of solitude, and

invited Renoir to share his studio at the rue Visconti, also on the Left Bank. Appeasing his father, Bazille described Renoir as 'a real worker, he takes advantage of my models and helps me pay for them. It's very pleasant for me not to spend my days completely alone.'[22]

Monet's new studio, on the third floor of 1 Place Pigalle, rented from a friend of Gautier's, was less desirable, and too small to hold the giant canvas. The little portrait *Camille with a Small Dog* [Plate 4], painted there in early 1866, bears testimony to domestic anxiety. Everything feels restricted, compressed and cropped – head, hand, dog. Camille's features are taut and she appears worried, tired. Just turned nineteen, she looks older. The big eyes and thick eyebrows are given weight, and Monet does not flatter: her face is harshly illumined, accentuating her angular profile and prominent chin, her sharpness contrasting with the docile, softly drawn animal. This picture was never exhibited or sold in Monet's lifetime. Its frankness is intimate, and the familiarity of Camille's bright red scarf is touching: it is the wrap which lies discarded in a heap of accessories, including a dashing white feather, beneath the tree in the corner of *Déjeuner*. Here, held in Camille's arms against the scarf, the white Maltese, depicted with fluffy strokes, imitates the feather – a wintry recollection of the couple's happy complicity in the arresting summer painting.

Monet suspended his heroic effort, and had landscapes to submit to the Salon instead. He chose a Fontainebleau painting, *The Pavé de Chailly*, but he was determined to show a large-scale figure painting too. Bazille and Camille were again the means. All winter, struggling with *Déjeuner*, Monet watched Bazille grapple with a more modest attempt at half-life-size figures, a man reclining on a sofa listening to a female pianist. 'The terribly difficult part is the woman,' Bazille told his mother. 'There is a green satin dress, which I hired, and a blond head that I am really afraid of not doing as well as possible.'[23] While Bazille was filled with doubt, Monet grabbed the gown, put Camille in it, and painted her life-size. Monet worked quickly, bringing to bear months of study for *Déjeuner*. The insouciant pose he and Camille devised now combined elements of all three standing Camilles, the two seen from the back and the one adjusting her hat, refreshed for winter in fur, heavy fabric, dark colours. Monet finished the picture fastidiously, with bravura brushwork.

Bazille expected his *Young Woman at the Piano* to be turned down by the 1866 Salon, warning his parents that 'had I painted Greek or Roman women, I would have nothing to worry about, because that is where we are still at ... but I am afraid they are going to reject my satin dress in a sitting room.'[24] His painting was refused, but the satin gown entered the Salon without him: *Camille, or The Woman in a Green Dress* was accepted. The news came in early April, just in time to pacify Aunt Jeanne, who was considering ending Monet's allowance in response to Toulmouche's reports of her nephew's vainglorious ambition and expense.

Gautier intervened on Monet's behalf and his aunt softened. 'This poor boy, gentle as a lamb' got his monthly money, and although she did not go so far as paying off his creditors, she inclined to blame them, not him: 'if we were in Paris, his father would inquire and try to reason with these gentlemen, since I can't and don't want to pay his debts.'[25] Monet ran up unpayable bills with grocers and butchers ('one had to stay fed, and I was a real gourmet')[26] and stories of his huge appetite and tastes beyond his means abound from this period. Stick-thin Renoir, who ate little, approved that 'Monet was able to wangle a dinner from time to time, and we would gorge ourselves on turkey with truffles, washed down with Chambertin.'[27]

In spring 1866 the lamb was boldly out and about, exploiting on behalf of *The Woman in a Green Dress* the attention that *Déjeuner* had garnered him. He encouraged the rumour, circulated by Théophile Thoré, that the new picture was painted in four days. 'When you're young you don't stay cooped up in a studio, you go out gathering rosebuds,' wrote Thoré. 'The deadline to submit to the Salon was approaching. Camille was there, fresh from gathering violets in her lawn-green train and velvet jacket ... a magnificent green silk dress, fully as dazzling as the fabrics painted by Veronese.'[28] *The Woman in a Green Dress*, Bazille reported, was a 'succès fou',[29] and *The Pavé de Chailly* was also accepted. Renoir's picture from the Fontainebleau summer, *Landscape with Two Figures*, was not. He was so nervous that he waited at the door of the Palais de l'Industrie to find out the jury's verdict at the earliest moment, pretending to be 'a friend of Renoir' to inquire shyly about the fate of his own submissions.

Monet was ahead of the pack. 'I confess the painting that held my

attention longest is *Camille* by M. Monet,' opened Zola's review, entitled 'The Realists at the Salon', in *L'Événement*.

> Here was a lively energetic canvas. I had just finished wandering through those cold and empty rooms, sick and tired of not finding any new talent, when I spotted this young woman, her long dress trailing behind . . . I don't know M. Monet, I don't even think I've seen a single canvas of his. Yet I almost feel like one of his old friends, and that's because his painting speaks whole volumes to me about energy and truth.[30]

Zola saw in Monet parallels with the robust naturalism to which he aspired as a novelist. Still unknown, he had just left Hachette after publishing his first, unsuccessful novel, *La Confession de Claude*, about prostitutes in the Latin Quarter, which had drawn attention only from the imperial censor. In 1866 he was beginning his career as a reviewer for the daily *L'Événement*. The writer Armand Sylvestre described him at this time as 'still in the period of full struggle, but the conviction of a not too distant victory was plainly visible in the serenity of his gaze and the quiet firmness of his speech . . . It was impossible not to expect from him something strong, wilful, bravely opposing conventions, something personal and audacious.'[31] Zola saw the same fire in Monet. This overture to their long relationship had an immediate impact. Four people sent copies of his review to Aunt Lecadre, who found herself widely congratulated.

Camille, or The Woman in a Green Dress was a picture, moreover, which Jeanne Lecadre, could understand. Although only historical or state figures, not an emerging artist's teenage girlfriend, traditionally received life-size treatment, it was close enough to fashionable society portraits to be uncontroversial, while Monet and Camille gave it individuality. Like the 1865 marine paintings, fell within convention, but was different enough to excite. And flagrantly, by calling the picture *Camille* – 'Portrait of Mlle Doncieux' would have been appropriately respectful – Monet both separated himself from standard Salon bourgeois portraiture, and claimed Camille as his in public. On the way he risked her good name. As one reviewer wrote, 'From Camille's gait . . . one has no trouble guessing that Camille is not a woman of the world, but [just] a Camille.'[32]

Thus, slightly errant, Camille entered the popular imagination. Cartoonists in three journals seized on her image, including the widely read *La Vie parisienne*, where a suggestively altered drawing was titled 'Camille. Happy in her striped dress without crinoline, sucks her thumb contentedly'.[33] The connotations are sexual, and of childlike delight in dressing up. Second Empire men took voyeuristic delight in women's sensual engagement with fashion. Zola in his novel *Au Bonheur des Dames* imagined a department store decked out like a huge white altar, where women swooned with desire for damasks, lace, silks and velvets.

This was Manet's territory. *La Vie parisienne* mistakenly ascribed the painting to Manet. André Gill, caricaturist of *La Lune*, captioned his cartoon : 'Monet or Manet? – Monet. But it is to Manet that we owe this Monet. Bravo Monet! Thank you Manet!'[34] If Monet's name in the 1865 Salon had irked Manet, *Camille* in 1866 challenged him directly as chronicler of Parisian women. All around Manet heard the comparisons. 'Claude Monet, more fortunate than his near-homonym Manet,' Thoré's review began. Manet was rejected from the 1866 Salon. 'Manet is very tormented by his rival Monet,' the critic Edmond Duranty wrote in the autumn. 'He says that, having Manetized him, he would like to de-Monetize him' (*'après l'avoir manétisé il voudrait bien le démonétiser'*).[35]

Far from being 'de-Monetized', Monet was riding high. Following

Caricature of *Camille, or The Woman in the Green Dress*, in *La Vie parisienne*, 5 May 1866

his Salon success he sold 800 francs of paintings, and received a commission for a reduced-size copy of *Camille* to be sent to America. He and Camille rented a little house with a garden close to the station at Ville-d'Avray, a suburban village west of the capital, home to Corot. Here, carefree and jubilant, they began work together on an enormous painting, the four-metre square *Women in the Garden* [Plate 7], which would combine the fashionable appeal of *The Woman in a Green Dress* with *Déjeuner*'s ambition.

Women in the Garden was a key staging post towards Impressionism. Pushing further than *Déjeuner* the rendering of figures in direct light, Monet depicted Camille on a single canvas four times in different summer dresses on a series of bright afternoons. He had learnt his lesson from the failure to complete *Déjeuner*. This time he would renounce the studio altogether, paint the whole thing outdoors, and fix in a Salon-scale painting the spontaneity, appearance of the passing movement, atmospheric and light effects, of a sketch. He would rely only on Camille and her gowns, dispensing with the dithering Bazille and other models.

'I threw myself body and soul into the plein air,' Monet remembered.[36] *Women in the Garden*, he insisted, was 'not the same thing' as the works he, or anyone else, had done before. 'This picture was actually painted from nature, right then and there, something that wasn't done in those days. I had dug a hole in the ground, a sort of ditch, in order to lower my canvas into it progressively as I painted the top of it.'[37] The trench assured his stability of viewpoint and constancy of light across the picture, on which he worked only on sunny days; the canvas moved up and down rather than the artist changing his perspective by climbing a ladder to reach the top.

Light, a diagonal bar of sunlight striking the garden, shapes the painting, dividing the path into bright rose-pink and violet shadow, and illuminating two of the Camilles: the turning redhead (more henna) in the spotted dress and the seated woman whose skirt spreads across the grass, covering half the width of the canvas. The women standing at the left are partly in shadow, but their outfits bask in vibrant reflections from the path and from the brilliant white expanse of the skirt. The heightened contrasts achieved by working outdoors, directly on the canvas with quick, broad strokes, were startling in the

1860s. Baudelaire had called for rapid brushwork, appropriate for depictions of fast-changing reality, but the sun had never shone so brightly in a painting, and it bewildered even advanced artists. Courbet visited Ville-d'Avray on a cloudy day and asked why Monet was idling. Monet replied that there was no sun; Courbet suggested he therefore work on the landscape. Monet enjoyed retelling this exchange. Courbet's incomprehension underlined the uniqueness of his project of integrating figures within what he later called the 'envelope' of light and air.

The implication of a neutral eye, according all parts of the composition equal value, and the flattened space evoke a snapshot, giving a modern detached look. The closeness, in placement of the figures and sunlit versus shady areas, to photographs taken by Bazille of women in pale dresses with parasols in the leafy part of the Méric estate in 1865, is notable, and suggests that discussions with Bazille played a part in Monet's conception for his painting. Zola relished the contemporary element: 'no effect could be stranger. An unusual love for one's time is required to risk such a tour de force, with these fabrics divided into sunny and shady halves, and these ladies placed in a garden plot well-groomed by a gardener's rake.'[38]

Camille, as before, contributed her fashion expertise. Reusing a trio of her dresses from *Déjeuner*, she varied them with new accessories and different poses. Updated with a wide-bowed yellow hat, the scalloped dress worn by a standing Camille in *Déjeuner* forms the outspread skirt of the seated figure in *Women in the Garden*. The striped and dotted muslins of the seated Camilles in *Déjeuner* now clothe standing figures. The smoothed triangular silhouettes of the skirts, flat at the front, swaying out at the back, represent the latest mid-1860s fashions.

The painting's sartorial newcomer, the sand-coloured cone-shaped suit with big buttons, is another allusion to Watteau – to his figure *Pierrot* (1718–19). Camille, peering out mischievously from above her bouquet, acts up to it. The mask face and slits of eyes of the seated Camille enhance the touch of *commedia dell'arte* in a painting whose paradox is artifice enacted in a natural setting. For the scene in *Women in the Garden* never happened, the four figures make no connection with one another, there is none of the conviviality of *Déjeuner*. Rather,

it is echoes between embroidered fabric arabesques and patterns of flowers and foliage – dots, stripes, petals, leaves – which build a dizzy mood of light, heat, fragrance. The psychological isolation of the figures is underlined by Monet's imitation, in stiff, distancing effects, contrasting back and frontal views of the gowns, of the commercial style of fashion engravings. Camille brought her ingenious combination of showiness, devising and sustaining elegant but strenuous poses, with interiority and self-absorption. This was a gift to a painter who was voracious for public success yet intensely private. Camille on canvas is delicious, ornamental, but emotionally and sexually out of the viewer's reach.

Women in the Garden is discreet yet outlandish, infused with a young artist's sense of fun working with his lover in a secret garden. The couple lived well, though their money ran out soon enough and in a begging letter in June, bemoaning that 'all my big canvas has done is cover me in debt', and probably lying about lack of family support, Monet invited Courbet to view the picture and advance a loan. 'I would be very glad to see you again. La Monette is asking for you too . . . My family don't want to give me anything, and at this moment I haven't any money, not even enough to frank this letter . . . If you have confidence in me, lend me something . . . Monette sends you her best wishes, and is counting on you to come and sample her cooking.'[39] The letter exudes domestic intimacy, a young man's proprietorial pride in his girlfriend. The nickname Monette, jarring to 21st-century ears, probably came from Courbet; it is not used elsewhere. Monet was calling on Camille's charms to help them in what was becoming the feckless adventure of a wandering year away from Paris.

At the end of the summer, the couple fled Ville-d'Avray in arrears – the first of several occasions – and Monet slashed many canvases to prevent their seizure to pay their debts. They moved on to Deauville, where Courbet in September encountered 'Monet and his lady' at the Casino and invited them to dinner, along with Boudin and his wife, with his host the Comte de Choiseul at his summer chalet. The Count, Monet's age, was rich, well connected, open-minded in his taste in art and fashion, which included cross-dressing, and of scandalous background, as his father's murder of his mother in 1847 had contributed to the discrediting of the July Monarchy. Courbet was making

portraits of the Count's favourite companions, his greyhounds, and, for a slice of aristocratic attention, Monet did too. The Count bought, among other paintings, a Fontainebleau landscape and a still life. Meanwhile, from a comfortable distance, Monet fought off his creditors at Ville-d'Avray and in Paris. In December Bazille was instructed to employ delaying tactics and to send quickly to Honfleur, at his own expense, a failed Salon-size canvas, *Femme blanche*, which Monet would scrape down to use for a sea painting.

The address was the Hôtel du Cheval Blanc on the waterfront. Here Monet and Camille established winter quarters and he concentrated on his Salon pictures, working on *Women in the Garden* and beginning a huge *Port of Honfleur*, towering sailing boats disconcertingly thrust forward at the viewer as a pattern of triangles and diamonds, part of a panorama of vessels old and new, commercial steamers, fishing craft, tourist rowing boats. Sometimes Monet wandered alone down to the Saint-Siméon farm and worked there outside in the snow. He did not leave Honfleur until just before the Salon deadline in March, when, Bazille informed his mother, there was 'news from the rue Visconti: Monet has fallen on me from the skies with a collection of magnificent canvases which are going to be a huge success at the exhibition. He'll be sleeping at my place. With Renoir that makes two impecunious painters I am putting up. It's a veritable infirmary, which I find enchanting.'[40]

Also back in Paris was Camille, who was ill, distraught, and pregnant. The baby, Monet told Bazille, was due on 25 July. Camille's life and prospects were changed unalterably, Monet's hopes and freedom as a painter were threatened, and they could not decide or agree about what to do. Camille's family was hostile, he did not dare tell his, as she 'hasn't a sou and nor have I'.[41]

Monet was weighing up a standard option. 'I don't know, Bazille, but it seems to me very bad to take a child away from its mother. This idea upsets me,' he confided.[42] Nearly half of unmarried mothers in Paris in the 1860s abandoned their babies. Zola's wife Alexandrine Méley, for example, before she met the writer in 1865, gave up her daughter at birth, later searching vainly for her – the infant had died. Camille was hysterical at the thought of giving up her baby, though during her difficult pregnancy she came to appear more resigned. 'She

is very sweet, a very good child, and has become reasonable, and by that she makes me more sad,' Monet wrote.[43] But he could not commit to the baby. With Bazille as his counsellor suggesting a 'wait-and-see' approach, Monet questioned the degree of support he was able or willing to offer, and together the men seemed to put Camille on trial. 'I intend to do for this child and Camille as you advised me,' he told Bazille, 'according to the mother's behaviour and appearance, I will see what I will do.'[44]

In 1867–8, three of the gang of four from Gleyre's became fathers. As his friends paired off, the fourth, Bazille, was lonely enough to ask his parents to arrange a marriage for him. The plan failed: 'Papa's last letter made me very unhappy, even more than you can imagine ... Any ideas of marriage in me have received a severe jolt. Maybe it is better that I should be completely free to work as and when I please.'[45] Thus independent and well-funded, Bazille was the steady point in a maelstrom as Sisley, Renoir and Monet faced their dilemmas.

Sisley's partner was Marie Lescouezec, a florist from a genteel family fallen on hard times. Admitting the relationship to his wealthy father, Sisley fought to maintain his allowance, and William Sisley, stern and unwelcoming to Marie, did not in the end cut his son off. Marie gave birth on 19 June 1867 to Pierre, a gentle dreamy boy, painted by his father and by Renoir. Thirty years later Pierre Sisley, still a dreamer, would fall in love with one of Monet's stepdaughters and, in a scenario unimaginable in 1867, Monet would refuse him as a suitor – because Pierre was an impecunious painter.

Renoir's girlfriend Lise also had a boy named Pierre. This impoverished couple did not give their names on his birth certificate and left him at a foundling hospital. Weeks before the birth, Renoir pointedly asked Bazille, 'If you have some money, it would be good if you would send it to me immediately, so that you won't spend it. You needn't worry about me since I have neither wife nor child and am not ready to have either one or the other.'[46]

Monet was not ready either. He was poorer than Sisley, not as poor as Renoir. 'I don't know what to do,' was his refrain to Bazille.[47] Monet and Camille pinned their hopes on *Women in the Garden*: if it triumphed at the Salon, he could hold his head high while admitting his plight to his father. So the stakes were high at the shared studio as

Monet applied the finishing touches to the painting. Bazille and Renoir were also submitting figures in landscape to the Salon. Bazille had painted his cousins in Méric, Renoir a realist nude, modelled by Lise, perched on rocks. Renoir added a dead deer and gave her a bow, transforming her into the goddess Diana and the picture into a classical narrative. Each painting represented many months of work, emotional engagement and money for materials – a gamble because, as Bazille explained to his parents, an emerging painter needed to present 'rather large pictures demanding very conscientious studies, and therefore a great deal of expense, otherwise you take ten years to get talked about, which is discouraging'.[48]

On 29 March the residents of 20 rue Visconti learnt the Salon's verdict. All were rejected. So were Sisley, Pissarro and Cézanne. The 1867 jury was exceptionally conservative. The world fair, the Exposition Universelle, a showcase for Napoleon's Second Empire, opened on 1 April, and the government, concerned about any whiff of subversion, left nothing to chance. One jury member, Jules Breton, explained that he refused Monet 'precisely because he is making progress': his influence on young artists was pernicious and 'it is high time to protect them and to save art.'[49] Zola said that the jury 'gated all those walking down the new path'.[50] To his mother, Bazille claimed rejection as a badge of honour, 'You mustn't get too upset about this, it is not at all discouraging, just the opposite, in fact. I share this fate with everything that was any good at this year's Salon.'[51] He dreamt instead of an independent group show for which 'we shall invite painters whom we like, Courbet, Corot, Diaz, Daubigny ... with these people, and with Monet who is stronger than all of them, we are sure to succeed. You shall see that we'll be talked about.'[52] It did not happen immediately, but Bazille's idea was the seed of the Impressionist exhibitions in the 1870s.

Monet had a harder case to explain, to a less indulgent parent. Adolphe saw not 'Monet who is stronger than all of them' but a headstrong liability bringing home debt, disturbance and dishonour. A Salon failure tied to a pregnant model, the pair of them spendthrifts, confirmed 'the bad path that he has followed for a long time with culpable energy', that he 'must give up his extravagant ideas and behaviour', for 'serious, sustained work, as useful to advance on the

path of progress as to produce financial results, of which he has not achieved enough at the moment, knowing however the importance and use of money'.

This piece of banality, exasperation and satire was addressed on 11 April to Bazille, who intervened on Monet's behalf. It is Adolphe's only surviving letter. 'I was very surprised by this confidence, these things usually remain unspoken,' Adolphe continued,

> but as I have said to him, he alone is competent to know what he has to do: he pretends that this woman has rights because she will become a mother in three months. Obviously, she can only have those rights which he wants to give her, and in this regard, he must know more than me what she is worth and what she deserves ... One sees all the time people well and truly joined by law who separate; that is yet more frequent and easy in Oscar's case, without his needing either to hide or extricate himself.[53]

Did Adolphe really expect Monet to desert Camille? The hypocrisies were manifold. Adolphe was supporting his own mistress, herself illegitimate, and their daughter Marie. Adolphe's sister Jeanne was also born illegitimate; their mother Catherine had given birth to two children out of wedlock. Adolphe's own irregular arrangement, still concealed from his sister – he would wait until Jeanne died before marrying Célestine and legitimizing Marie – probably made him more intransigent. His offer was that if Oscar 'is really repentant and inclined to take a good path to redeem his disastrous past', he must return home alone. 'I am sure I can persuade my sister to welcome him at Sainte-Adresse ... if I manage to get Oscar to come here, that would be a good place of refuge for him.'[54]

Refused at Sainte-Adresse, Camille was also banished from rue Truffaut. For the Doncieux, shame trumped loyalty or compassion. A wealthy friend, Alfred Hatté, came to the couple's rescue and provided a room on the ground floor at 8 impasse Saint-Louis in the Batignolles area. Monet recruited a 25-year-old medical student from Gascony, Ernest Cabadé, to 'care for and deliver' Camille, and told Bazille, 'this already makes me feel calmer.'[55] Cabadé's payment was a still life and his portrait: a clear-eyed, kindly, reassuring youth. In an ironic twist, Cabadé, returned to Gascony, eventually sold these

paintings to fund the dowries of his daughters, for, he explained to Monet, 'I have only these assets, tell me that you won't be angry with me ... you have become what ... I always predicted, the leading painter of the age, and I am a poor devil of a doctor.'[56]

With no hope for now of a dowry for Camille, Bazille stepped forward. In the absence of other offers, he bought *Women in the Garden* for 2,500 francs, to be paid over four years in monthly instalments of 50 francs. Effectively he was giving Monet an allowance, and preventing him blowing a larger amount at once. The money went straight to Camille, to prepare for the baby's needs; though not lavish, the sum was equivalent to a worker's standard wage of 2 francs a day. In exchange, Bazille got a landmark painting of the 1860s. At the rue Visconti, *Women in the Garden* was already decisive for Renoir, who abandoned goddesses and depicted Lise in rustic attire, outdoors, with light bouncing off her white muslin dress, tinged with green reflections from the foliage. In Méric, *Women in the Garden* helped Bazille create his best work. His outdoor piece of summer 1867, *The Family Gathering*, was an attempt to transpose Monet's plein-air influence onto the evenly lit Mediterranean terrace at Méric, where eleven of Bazille's family posed as static, Ingresque figures. The solemn picture evokes what Maître wistfully called 'that delightful world that has made you who you are, and which all too soon, I fear, will take you away from Paris and your friends.'[57] Both *The Family Gathering* and *Lise* would be accepted at the 1868 Salon, proving Breton right about Monet's influence, wrong about being able to prevent it.

Before it went to Méric, *Women in the Garden* spent the spring in the window of the dealer Hagerman's shop on rue Auber, off the chic boulevard des Italiens, gathering interest from more of Monet's peers, and especially Manet. Monet claimed that at the Café Tortoni Manet 'pretended not to know I was there and said to a friend, "Have you seen that picture that's exhibited on rue Auber which makes it seem the Old Masters were thinking of painting in the open air?"'[58] A variation was Monet overhearing Manet sneer: 'I've just seen a picture by Monet entitled "Femmes en Plein Air". Can you imagine? Whoever heard of painting *en plein air*?!'[59]

The mockery stung, at a moment when Monet felt vulnerable. The

simmering rivalry of the last two years was in the open. Monet was thrusting forward, getting noticed; Manet was waspish, proud yet defensive. Scenting the mood of the 1867 Salon, Manet had not submitted any works. Instead, he used part of his inheritance to have his own pavilion constructed on the Place d'Alma, close to the Exposition Universelle. Courbet built a private pavilion there too, and declined to visit Manet's because 'I should be obliged to tell him that I don't understand anything about his painting and I don't want to be disagreeable to him.'[60] From afar, Monet watched Manet 'in dreadful trances' over his exhibition: 'God it's stupid that he lets himself run after praise like that, because he could do really good things.'[61] It was a difficult time for Manet. Anxious not to appear a dissenter, he pinned a caveat at the entrance to his exhibition, worded by Astruc, insisting 'Monsieur Manet has never desired to protest. On the contrary, it has been against him, who did not expect it, that there has been protest . . . It is sincerity which endows works of art with a character that makes them resemble a protest.'[62] It did not help. Manet's

Carolus-Duran, *Monet*, 1867

pavilion was a big disappointment: few visitors came, and most of them laughed.

Monet and Manet each had their portrait painted in 1867, by friends more conventional than themselves. Carolus-Duran depicted Monet as a handsome fop with an extravagant quiff, sturdy, direct, determined. Fantin-Latour's worshipful *Manet* is a laconic, patrician flâneur with silky beard and bright features, elegant in gait, one hand gloved, with his props of cane and top hat. 'Naturally ironical in his conversation and frequently cruel', Manet was, said Armand Sylvestre, 'the strangest sight in the world, his elbows on a table, throwing about his jeers with a voice dominated by the accent of Montmartre ... unforgettable with his irreproachable gloves and his hat pushed back to the neck'.[63] Zola admired Manet's 'quick and intelligent eye' and described 'a mobile mouth, sometimes a little mocking; the whole face irregular and expressive, with an I-don't-know-what expression of sensitiveness and energy'.[64] Renoir liked his 'gaiety maintained even in the midst of injustice'.[65] At thirty-five Manet, adulated by critics and artists, was frustrated and uncomprehending that establishment approval was withheld, and with it a wider audience.

His notorious *Le Bain*, the sensation of the Salon des Refusés, reappeared in his pavilion under its new name, *Le Déjeuner sur l'herbe*. Manet changed the title specifically to assert priority over Monet's *Déjeuner*, which had acquired legendary status among young artists. In 1867 Manet was claiming pre-eminence as the painter of modern life. Degas put the record straight that 'Manet wasn't thinking about plein air when he painted *Déjeuner sur l'herbe*. He never thought about it until he saw Monet's first paintings.'[66]

Monet too insisted that in 1867 Manet's painting 'was still very classical'.[67] He criticized his renamed *Déjeuner*, painted in his studio, as illuminated by the light of the atelier. While admitting that his own *Déjeuner* was 'done after Manet's', the point was the difference: he had worked outdoors for months before attempting the full composition at rue de Furstenberg, recalling, 'I proceeded bit by bit with studies done from nature, which I would then put together in my studio.'[68] *Women in the Garden* was the breakthrough to plein-air painting as monumental composition. 'The dream of all painters: to place life-size figures in a landscape,' Zola declared in 1867.[69]

Although the first was incomplete and the second a Salon reject, Monet's two paintings starring Camille, his *Déjeuner* and *Women in the Garden*, set the agenda for new painting.

Thanks to Astruc, the introduction between Manet and Monet took place around spring 1867, and wariness started to yield to fondness and loyalty. 'As Édouard loved to repeat, Monet is a genius,' Mallarmé would recollect.[70] But Manet never liked *Women in the Garden*, and later regretted that, via a swap with Bazille's family, he became its owner. Not for long. 'You have no idea how irascible nice old Manet could be,' Monet recounted. 'He said to me, "You have a small study of mine at your place; give it back to me. I'll have that large picture of yours taken back to you, as I don't want anything of yours!"[71] Monet then kept the painting close, and in old age enjoyed showing it off in his Giverny studio. What *Women in the Garden* meant to him was demonstrated when he chose it of all his works as the one to be purchased by the French state. Aged eighty, he watched the canvas being packed into a crate, walked it to the lorry and supervised its 'bon placement'. It was a moment of 'heartbreak', he wrote. 'The departure of this painting leaves a great emptiness in my heart, because of the many memories it contains for me.'[72]

Women in the Garden entering the Musée du Luxembourg in 1921 was long delayed justice for Camille. In spring 1867, while the four life-size Camilles shone at the rue Auber, Camille herself was 'la misérable'.[73] Hidden away at impasse Saint-Louis, she was ill and penniless. Monet needed to produce small, marketable pictures fast. Excluded from the Salon, he would conquer Paris another way. He requested permission to set up his easel inside the Louvre 'to make views of Paris' from the second-floor balcony. Literally turning his back on tradition, he made his subject the living city outside. The paintings kept pace with the current mood, as the spectacle of the Exposition Universelle sharpened appetites for celebrations of Paris on canvas. Alongside Monet, Renoir addressed similar motifs – their first shared campaign. Both produced light, airy cityscapes. Renoir's are crisper, more topographical. Monet's three vistas are studies of coloured shadows and atmospheric excitement, held within architectonic compositions, ordered by symmetries of domes, fences, massed rooftops.

Suffused with Paris's moist, grey, soft luminosity, the trees in fresh

leaf, these paintings imbue the city with wonder. The strange construction of the vertical *The Garden of the Infanta*, with its tilted lawn floating off the picture's edge and the Seine funnelled into the centre, already demonstrates an awareness of the stylized, dynamic compositions of Japanese prints by Hiroshige and Hokusai, on show at the Exposition Universelle Japanese pavilion. It was too innovative to sell, but the other two paintings found buyers quickly. Astruc acquired *Saint-Germain l'Auxerrois*, dominated by the façade of the recently restored Gothic church, rendered precisely and accentuated by dark shadows, with rows of blooming chestnuts in small dabs. The decorative *Quai du Louvre*, depicting the Seine with crowds and carriages as dots and dashes, and a red-edged advertising banner rising above the bridge, sold to the dealer Latouche, which, Monet wrote, 'gave me great pleasure because I have been able to help poor Camille'.[74] His painting was going so well, he told Bazille, that 'if it weren't for this birth, I could not be happier'.[75]

Adolphe offered 'Oscar' a bait to leave Camille and come to Le Coteau, to 'work there calmly and fruitfully if he wanted'. He knew his son. It was easy to make excuses to go: the opportunity to produce saleable seascapes, to live cheaply at home, not to cut Lecadre purse strings definitively. Six weeks before the baby was due, Monet returned to Sainte-Adresse, fleeing a reality he could not accept, and leaving Camille alone in the impasse Saint-Louis.

6

'Painter on the Run', 1867–9

'I am here in the bosom of my family . . . as happy and well as possible. My family is being charming to me and *voilà*, they admire every brushstroke,' Monet wrote scornfully to Bazille at the end of June. 'I have some twenty paintings under way, stunning marines and some figures and gardens, in short, everything. I am doing the regattas at Le Havre with lots of people on the beach and the harbour covered with little sails. For the Salon, I'm doing an enormous steamship. It's very curious.'[1]

Every anxiety is sublimated in the glistening, supremely calm paintings made by the sea in summer 1867 – as magnificent a crop of pictures as Monet ever achieved in any single season. The regattas are maritime cousins of the spring's Paris vistas, vibrant contrasts of light and shade. Vessels glide smoothly across the water, well-dressed onlookers survey the scene. There were also pictures done at Le Coteau, including *Adolphe Monet Reading in a Garden*: his father, obscured by shadow, seated on a bench amid agaves, arums, begonias, beds with red flowers trained on poles.

Monet could not lose himself entirely in these scintillating paintings. 'My anxiety is visible at home,' he told Bazille.[2] Camille was not mentioned at Sainte-Adresse, and maybe Adolphe believed Monet had left her, or he witnessed his son's discomfort and suspected the deceit. Either way, the strain took its toll and Monet was hit where it hurt most. A week after arriving at Le Coteau, he had problems with his eyes and feared he was going blind. 'I am very unhappy. Can you believe that I'm losing my sight? I can hardly look for more than half an hour at a time. The doctor says I have to give up painting outside. What will become of me if this doesn't go away?'[3]

Absent from Camille, his concern for 'ce petit' grew. 'I would be horribly unhappy if she gave birth without what is necessary, without care, without this little one being properly clothed. I don't want to have anything to reproach myself for,' he told Bazille. 'Forgive me the fury with which I address you, always in my worst moments.'[4] On 16 July he wrote twice to Bazille. In the morning he was aggressive, irritable – 'These 50 francs won't go far, and I haven't got anything for my departure' – and domineering: 'It seems to me you're hardly moving fast on your big picture. Be very careful, especially with the proportions and the *mise en place*.' In the afternoon the power was Bazille's as Monet beseeched, 'My dear friend, send me immediately 150 or 200 francs as fast as possible and especially reply as fast as possible ... Please think about me. I beg you, I absolutely need that money. After this, I will leave you in peace, but at least this child won't come into the world in misery and will have what's needed.'[5] Monet was stuck. He had promised to return to Paris for the birth, but he could not afford the fare; his family would give him nothing.

A serenity so determined that it seems to declare itself artificial pervades the greatest painting of 1867, *Terrace at Sainte-Adresse* [Plate 2]. It was begun on 21 July, four days before the baby was due, when Monet, his father, his cousins Eugène and Marguerite, and Marguerite's mother Sophie Lecadre visited the Noirfontaines' beach chalet, to watch a regatta. Monet depicted the visitors on the terrace, with its fluttering *tricolore*, surveying a festive scene emblematic of Le Havre's maritime prosperity. A throng of boats line up on the water, new steamers alongside old sailing ships and a local fishing vessel.

From an elevated viewpoint, Monet commands the scene, looking down on figures fixed within formal strips of colour: sandy flower-filled terrace, sea, sky. Flagpoles unite top and bottom, forming a rectangle with the fence, like a picture frame. Seated, Adolphe and Sophie survey a picture-within-a-picture: the young couple at the water's edge, the panorama of ships and ocean. Seen from the back – Monet refused to face him directly – Adolphe, rigid, heavy, cane between thrusting legs, shiny black shoes stamped on pale ground, is set against the lively open sea. Monet's freedom of looking out in this

picture is an answer to his family's strictures, and he controls in paint those who tried to control him in life. The surface dazzle celebrates visual sensation as paramount.

Glittery, compressed and enchanting as a stage set, stark in its geometry, *Terrace* owes much of its allure to Monet's risk with brutal contrasts: slashing bands of light and shade; clashing vermilion gladioli, orange nasturtiums, green leaves; sunlight on dark water; abrupt shifts in scale from the people, hats, parasols, wicker chairs to tiny distant boats. Scattered notes of brilliant colour, yellow, lemon, midnight blue dots and curls, are applied straight from the tube on white ground. Irreconcilable is the split perspective between the flat sea and the plunging space of the terrace. The encounter between surface and depth unsettles. The sea appears to rush up to the fence, as if the terrace bobs on the water.

Monet modelled the composition, high angle, figures on a platform before a landscape, on Hokusai's *The Sazaido of the Gohyaku Rakanji Temple*. Especially after the Exposition Universelle, Japanese ukiyo-e woodcuts, ('pictures of the floating world', depicting the landscapes and affluent society in the city of Edo, as Tokyo was known until 1868), were revelatory. Their sharp contours, planes of vivid colour, odd perspectives, and favouring of bold, and formal composition over naturalistic representation were inspirationalto French artists striving against the academic manner. Monet loved Japanese prints, and would collect many examples as soon as he could afford them. Although *The Garden of the Infanta* already suggested the impact of seeing them at the Exposition Universelle, *Terrace*, fantastically bringing the floating world of Edo to Normandy, was the real pioneer, and was referred to by Monet and his friends as the 'Japanese' painting. The speed with which Monet assimilated the fashion for *Japonisme* testifies to his ambition and rapacious eye, grasping Hokusai as a route to modernity, taking him far from his naturalistic seascapes admired at the Salon just two years earlier.

If *Terrace* was begun in a flight from anxiety, it was completed in joy. At six o'clock in the evening of 8 August 1867 Camille gave birth to Jean-Armand-Claude Monet, 'a big beautiful boy whom, in spite of everything, I feel that I love'.[6] Camille had a long labour, and charmed the doctor. 'Be sure to tell Madame Camille that I remember the

adventures of her delivery at the Passage Saint-Louis des Batignolles ...
Make lots of pictures like your 'Camille' of 1866!' Cabadé later wrote
to Monet.[7]

Acknowledging paternity, Monet gave his name on Jean's birth cer-
tificate, thus agreeing to support the child. It was reasonably common
in nineteenth-century France for fathers to accept a child in this way,
subsequently legitimizing the birth by marriage. Sisley, Pissarro,
Cézanne, all did so. Monet went further. He persuaded Astruc and
Hatté, when they took Jean to be registered on 11 August, to perjure
themselves by declaring him the legitimate child of Claude Monet and
his spouse Camille Doncieux. It was impulsive proof of his commit-
ment to and rush of feeling for his baby and Camille.

She was alone again the following day, and Monet was back at
Sainte-Adresse, complaining that he had to borrow the fare 'to return
so as not to upset the family'.[8] It was hardly a dignified position for a
new father, and he took it out on Bazille: 'I've had to ask strangers for
loans and people have insulted me. Oh, I really blame you, I never
thought you'd abandon me like this ... I waited for the post and every
day the same ... Come on, Bazille, there are things which one can't
put off till tomorrow.'[9] An ultimatum followed on 20 August. 'I no
longer dare to believe in your friendship. If you don't answer me,
everything will be over between us, I will never write to you again.'[10]

Monet, *Jean Monet Asleep*, 1868

At Jean's baptism at Sainte-Marie-des-Batignolles, Bazille stood as godfather. Julie Vellay, Pissarro's (unmarried) partner, who already had two children with the painter, was godmother. Monet was an atheist; this was one of the rare occasions when he was sighted inside a church.

He was not the first or last young father reluctant before the birth and devoted afterwards. *Jean Monet in his Cradle*, the earliest depiction of the baby, shows a rosy-cheeked, plump infant, with pristine toys and draperies around his crib. In *Jean Monet Asleep*, a couple of months older, he is as fashionable as his parents in his embroidered smock, and clutches a doll. He looks calm, though life was not. Monet was commuting between Jean and Camille at impasse Saint-Louis, rue Visconti *chez* Bazille, and his father and aunt in Le Havre. Here he was painting his Salon submission, a furious winter storm, *The Jetty at Le Havre*, surely underlined with his own anger. From Paris, in November, Bazille told his parents, 'At the moment Monet is staying with me, and he's more wretched than ever. His family is shamefully stingy with him, he's probably going to marry his mistress. Does this woman have parents sufficiently accommodating to see her again and assist her if she marries? Not exactly cheerful, but their child will have to eat.'[11]

Marriage would yield a dowry from the Doncieux, but risked alienation from Le Havre; that Monet was considering it shows his difficulties. He could not afford coal, there were days without fire, and creditors at the door. One from 1867 was still pursuing him in 1882.

On the evening of 1 January, Monet, anticipating 1868 'without a sou', raged once more to Bazille: 'I have a lot to pay out tomorrow and afterwards, so you need to find a way to give me some money. I never harass you,' he began, unbelievably,

> [but] if you give me 20 or 10 sous at a time, we won't be done with it until the end of the world; however, when you bought my picture you agreed to give me 100 francs each month [the agreed sum was 50] . . . You seem to think you bought the painting from me out of charity, and when you give me money, you have the air of lending it to me . . . If you had to pay 1,000 francs or more you'd find it; for me that is more impossible than ever and I can't go on like this. So see that you get it

for me. My position is critical enough for you to trouble yourself with me a bit.[12]

One has to hear a screaming baby in the background, the misery of a new parent unable to support his beloved son, to understand the ingratitude. Bazille forgave it. 'If I didn't know how unhappy you are, I certainly wouldn't bother to reply to the letter which reached me this morning,' he began.

> You set out to show me that I'm not keeping my promises, but you succeeded only in proving to me your ingratitude. I have never, as far as I know, had the appearance of giving you charity. On the contrary, I know better than anyone the value of the painting which I bought from you, and I very much regret not being rich enough to offer you better terms. However bad they are for you, I'm the only one, nevertheless, to have offered anything, and I beg you to take that into account.[13]

A summary of their financial transactions followed: Monet had received 980 francs from him since the start of their friendship, and Bazille had never failed once to give him the agreed monthly 50 francs. Now, too, Bazille leapt into action, persuading Lejosne to buy a Monet still life.

The gap between Bazille's lifestyle and Monet's had never been wider. Bazille began 1868 relocating to 9 rue de la Paix, 'a vast studio in the Batignolles quarter. It costs 200 francs more, but I can handle the extra expense. I've paid for all my meals and I'm getting to the end of the month despite splashing out a couple of times, like on a dinner with a whole evening at the Théâtre des Italiens.'[14] The green armchair, the piano and the permanent house guest, Renoir – on familiar 'tu' terms with Bazille as Monet never was – went with him. Nearby was the Café Guerbois at 11 Grand Rue des Batignolles (now avenue de Clichy), Manet's headquarters from 1868. Almost daily Bazille and Renoir joined the regulars there – Degas, Fantin-Latour, Antoine Guillemet, a landscapist proudly describing himself as a 'Batignolles painter', Zola, Astruc. Monet went occasionally, and talked warmly in old age of the discussions at the Guerbois, but in 1868 he said 'I hardly miss the reunions.'[15] Renoir noted his withdrawal from the shared studio: 'Monet has taken his large pictures, it leaves a great void.'[16]

All the group had good news in the spring when a more liberal jury promoted what the critic Jules-Antoine Castagnary called 1868's 'Salon of the Young'. The admission of his *Family Gathering* so surprised Bazille that he thought it was a mistake. His father was bursting with pride: 'You are too modest in thinking that your painting slipped through the net; for my part, I do not accept that is how it was, I do not put this down to chance.'[17] Monet had mixed fortunes. The summer's *Boats Leaving the Docks* was accepted, causing, said Boudin, 'a great scandal among people who are wrong', though he added soon afterwards that Monet was 'beginning to be admired by everyone'.[18] Not however in the press, where *Boats* drew indignant commentary. The *Journal amusant*'s caricature, resembling a child's drawing, inscribed, 'M. Monet was four and a half years old when he painted this picture', was an early iteration of the 'my child could do this' complaints about modern art. The painting was subsequently confiscated from the exhibition by Monet's creditors, and disappeared, a significant financial loss.

Monet's second submission, *The Jetty at Le Havre* came up for consideration after *Boats Leaving the Dock*, but 'We don't want any more of that sort of painting,' Count Nieuwerkerke insisted.[19] The refusal squashed hopes of a sale. Gaudibert in Le Havre had promised to buy *Jetty* on condition that it was shown at the Salon, a common approach among all but the most enlightened collectors. Zola fought the convention, provocatively concentrating on the rejected painting in his Salon review, entitled 'The Actualists'. 'The long narrow jetty juts out into the grumbling sea, lifting against the pale horizon the thin dark silhouettes of a row of gas lamps ... a bitter harsh wind is blowing ... buffeting skirts, ploughing deep furrows into the sea ... these are the dirty waves, these surges of grubby water, which no doubt frightened members of the jury.'

Zola hailed Monet as 'a temperament ... an exact and candid eye ... belonging to the great school of naturalists" like himself.[20] It was already a misreading. In the spring Monet and Zola stayed together at the Auberge de Gloton at Bennecourt, a village of yellow-stone houses on the river opposite Bonnières-sur-Seine, two hours' train ride north-west of Paris. Zola detailed the place in his novel *L'Œuvre*: the trip from Bonnières on a creaking ferry, the calm waters

Monet, *On the Bank of the Seine, Bennecourt*, 1868

for swimming and rowing under willows, the little inlets, their quiet only disturbed by a blacksmith's anvil and church bells. But Monet in *On the Bank of the Seine, Bennecourt* was already abstracting from reality. His subject is the village reflected in the river, with the façade of the Gloton inn, concealed by trees, seen only as a reflection. This was the first of a lifetime's compositions showing the world mirrored in water.

Monet reclaimed Camille pictorially in *Bennecourt*. She sits on the riverbank, contemplating the view, directing our gaze towards the reflections. Despite the tranquil subject, the composition is awkward. There are discernible, messy adjustments in her figure; Jean, originally on her knee, was scrubbed out, and there are signs of tears and punctures. The painting was roughly handled, because Monet left

Bennecourt in a hurry, before the canvas did. On 28 June, 'naked as a worm', and in arrears as usual, he was shown the door of the inn: 'I don't know where I'm going to sleep tomorrow . . . I was definitely born under an evil star.'[21] In a postscript recounting his misfortunes to Bazille, he added, 'I was so upset yesterday that I was stupid enough to throw myself into the water; fortunately, nothing bad happened.' As Monet describes it, relegated to a PS, this sounds impulsive and desperate, but not suicidal – and Monet was a strong swimmer, unlikely to come to harm in the Seine on a summer's day. He proceeded to Le Havre, his sights set on the Gaudiberts. Remaining at Bennecourt were Camille, Jean, a heap of unpaid bills, unpacked trunks, unfinished canvases.

Zola had already gone, but his friend Guillemet was there, and recounted Camille's part in the story with relish:

> Get yourself [to the station] . . . at 10.15 to meet the Bonnières train, and you'll again find the bird [he told Zola excitedly on 17 July]. It will be the Monet bird. I'm hurrying to send her to you . . . Trouble at Bennecourt where an *actualiste* is in a difficult position. When you left here, you left me with *la femme* Monet. I sent the husband an emotional letter . . . He wrote to the wife that things were sorting themselves out and that they would all be together. The wife is overjoyed. We wait several days. The husband's letters become less urgent. The word 'be patient' appears 71 times in the same letter. The poor Batignolles painter who dares to call himself your friend [Guillemet himself] is drowned in the tears of the forsaken spouse and deafened in one ear by the child's crying . . . At last, a letter [from Monet] . . . exhorts patience and reports superb parties by the sea and bull runs . . . The Batignolles painter takes the part of the deserted wife, who produces a cataract, a waterspout, a torrent etc. The *Batignollais* gives advice in a feeble voice to the poor abandoned woman. That she should rejoin the unfaithful husband at Le Havre. This advice is favourably received . . . They're leaving on Wednesday and arriving at 9 p.m. at Le Havre. Imagine the astonishment and *joy* of the painter on the run.[22]

This slice of malice and class snobbery is the longest extant written description of Camille; there are no others more than a phrase or two. Guillemet's account chimes with Monet's own 'very good child' to

diminish and infantilize her. But if the direct target is Camille, a poor young mother with good looks and no social status, the problem is Monet. Guillemet, a modest talent, jealously watched a rival boldly doing what he liked, as painter and lover, and getting away with it.

Monet got away with it once more in Le Havre. The Gaudiberts came to his rescue. He showed five works at the city's International Maritime Exhibition in July; as happened at the Salon, they were sequestered and sold to pay his creditors. Gaudibert purchased them at rock-bottom prices and returned them to Monet. Bazille was instructed to round up all the paintings in Paris, including *Terrace at Sainte-Adresse*, similarly at risk of being seized, and to dispatch them frameless to Jeanne Lecadre. She would guard them zealously. 'I've lost so many that I hold dear the ones that remain,' Monet said.[23]

Jeanne Lecadre was willing to receive the paintings, but not Camille and Jean. Neither his aunt nor his father had relented in their hostility on learning of the birth of the baby. Monet, talking proudly of 'toute ma petite famille', refused to hide them, and installed 'Madame Monet' in a hotel up the coast at the fishing port of Fécamp. Subsequently he found at rue des Coudriers in Le Havre 'a very cheap small furnished house, where I would be already if it weren't for your procrastination,' he told Bazille.[24] He had not definitively broken with his family at Sainte-Adresse, but they provided no assistance for Camille and the child, and Monet had to accept, resentfully, that his allowance had ended. Boudin noted in 1869 that Monet 'still claims that his aunt is very severe towards him, and withholds his pension from him'.[25]

Survival now depended on sales, yet Monet continued to play the *enfant terrible* to the Havrais bourgeoisie. A commission from the Gaudibert parents for a portrait of their son Louis-Joachim was a disaster; the Gaudiberts refused it. 'One can't deny that this boy is noted for his audacity as an original painter,' Boudin's friend Martin wrote on seeing the painting in October, 'but in execution it's diabolically vulgar and has neither delicacy of flesh nor finesse ... It's a picture, it's not a portrait.'[26] Louis-Joachim himself, more tolerant, gave Monet another chance, and commissioned him to paint his wife Marguerite and little son, at their castle, Château des Ardennes-Saint-Louis, outside Le Havre. Camille was not invited, and before going Monet had to decide whether to leave the few coins in the house for

her and arrive penniless, or take the cash and rely on sending her the first payment.

'How all this will end: I lose my head when I think about it,' Monet told Bazille. Looking back on his painting from the first year of Jean's life, he mourned that he had achieved 'absolutely nothing', his 'old ardour' had gone, 'everything bores me as soon as I want to work: I see everything in black ... disappointments, insults, hopes and again disappointments, that's it ... painting's not going well, and certainly I no longer count on achieving glory.'[27]

At the castle he struggled with a subject for which he had no feeling. He took elements of *The Woman in a Green Dress* as a model, portraying Marguerite Gaudibert in profile turning away, and emphasizing the overflowing train of a burnished silk crinoline. But Marguerite was not Camille – she appears provincial and frumpy. He did better with Louis-Eugène, a grinning three-year-old with a shock of blond curls, the first of a score of informal portraits capturing the ebullience and spontaneity of childhood. Monet's portraits of his own children are different – their keynote is vulnerability. *Child with a Cup*, Jean as an infant with big worried eyes, and *Portrait of Jean Monet in a Pompom Hat*, from the winter 1868–9, are fervent and frank, full of the young father's concerns, and contrasts with the gleeful Gaudibert toddler.

Gaudibert approved the portraits of his family, and created a small allowance for Monet; his support ended only with his premature death in 1870. Thanks to him, the family moved once more, in

Monet, *Jean Monet in a Pompon Hat*, 1869

October, to a house on the main road at coastal Étretat, Monet's fifth address in as many months. Here everything changed. Off-season, tourists had deserted the resort, and the winter's seascapes had an exhilarating freedom and immersion in weather and light. By the sea, reunited with Camille and Jean, Monet's spirits soared, and the year that had opened with despairing accusations to Bazille ended with a letter, ecstatically pronouncing new-found stability

> I am very contented, very happy. I am like a pig in clover, surrounded by everything I love. I spend my time in the open, on the shingle beach ... or in the countryside, which is very beautiful here. I find it perhaps even more lovely in winter than in summer, and of course I work all the time ... And then in the evening, my dear friend, I find a good fire and a happy little family in my little house. If you could see how lovely your godson is at the moment. My dear, it's enchanting to watch this little being grow, and goodness I'm very happy to have him.

Monet's first plan for the next Salon were two figure paintings, sailors en plein air, and sixteen-month-old Jean, 'painted with other figures around him as is right ... and I want to do it in a sensational way'.[28]

On the back of the canvas depicting Madame Gaudibert, Monet had sketched a figure composition featuring Camille – the germ of *Luncheon*. Pictorially and psychologically peculiar, this genre scene disconcertingly enlarged to Salon scale compresses four figures into a confined space so that they appear over-large. A warm glow bathes Camille and Jean, who is brandishing a silver spoon. The other protagonists are cramped. Awkwardly perched against the window is a visitor, also posed by Camille, with her aloof mask face, veiled, while a maidservant is half crushed into a cupboard. None of the women engage or make eye contact, a lack of connection enhanced by the precariousness of objects as the bread, newspaper and napkin tip over the table's edge. The picture reveals Monet's feelings about his domestic life – his pride in his companion and child; sensual delight focused on food and drink and the pleasures of smell, taste, touch; aspirations for abundance and prosperity; actual constrained conditions; and a shutting out of the world beyond.

The golden light surrounding Camille and Jean extends across the table to Monet's place setting and his empty chair. That chair is a key

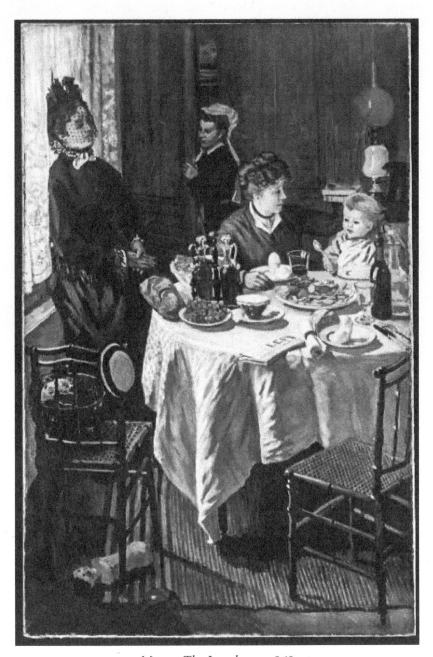

Monet, *The Luncheon*, 1868

to the painting: it insists on Monet's subjective reality, that the viewer read the scene of these enclosed women from the patriarch's position. It is also an absence, a question mark. Monet, at the end of a turbulent year, was asserting to himself who he was, or wanted to be. It is a fraught picture, and was difficult to finish. Thus Monet changed tack for the Salon to a twilit Étretat seascape, *Fishing Boats at Sea*, with flattened planes and bold contrasts, and *The Magpie* [Plate 8], the winter's masterpiece.

Monet out around the Norman coast in snow was a familiar figure. Walking across white fields on a day 'cold enough to split rocks' Le Havre critic Léon Billot reported glimpsing 'a little heater, then an easel, then a gentleman swathed in three overcoats, with gloved hands, his face half-frozen. It was M. Monet studying an aspect of the snow.'[29] Monet had painted descriptive snowscapes for several years, but *The Magpie* was an advance. It reproduces the experience of the cold, stillness, muted sounds of being solitary in snow, watching the play of shadows acquire colour in changing light. The snowy landscape in the afternoon sun becomes a harmony of whites, silver, pinks, yellows, cobalt blues, cast with long lavender, lilac and indigo shadows, contrasted with a warmer reddish sky behind the trees. *Terrace at Sainte-Adresse* is recalled in the calligraphic sharpness, the shadows' rhythmic patterns, and the geometric elements bisecting the composition horizontally – the tightly drawn wattle fence laden with snow, through which lighter patches of snow on the other side of the field are seen. But while the immediate effect of *Terrace* is pleasure in a stage set, in *The Magpie* it is feeling. The bird just landed, a restrained note animating the composition with a living presence, balances artifice with spontaneity.

'The further I go, the more I regret even the small amount of knowledge that I have, it's certainly that which cramps one the most,' Monet told Bazille in December 1868. 'The further I go, the more I notice that one never dares to express frankly what one experiences.'[30] With *The Magpie*, he dared. The painting's focus is not the bird but Monet's experience, his visual thrill, of the play of the purple shadows, which would become a hallmark of Impressionism.

This was baffling at the time. But if it is hard to understand today why *The Magpie*, a destination picture at the Musée d'Orsay and a

Christmas card favourite, dismayed the 1869 Salon jury, that is because the triumph of Impressionism has accorded landscape painters ever since the right – eventually the necessity – to make their own felt experience of a scene their subject.

'I would like to stay like this for ever, in a calm corner of nature as here. I assure you I don't envy your being in Paris,' Monet continued to Bazille from Étretat. 'Frankly I think what one does in such a milieu is very bad: don't you think that alone in nature one does best?' He knew that, to sell, he must keep a presence in the capital, hoping now to only come for a month each year, for 'one is too preoccupied with what one sees and hears in Paris, however strong one is, and what I will do here will at least have the merit of not resembling anyone, at least that's what I believe, because it will be simply the expression of what I myself will have experienced, I alone.'[31]

The paradox was his need to say it. Bazille's role as listener was to hear how little he mattered. Monet continued to make practical demands, but emotionally he had wrung his friend dry. For Bazille, a tendency to inertia and melancholy, which had both maddened Monet and been alleviated by his presence, came to the fore in 1869. 'If you need to feel sorry for me in order to undertake to write, let me tell you that for a while I have been ill. I have almost constant headaches, complicated by all kinds of aches and pains. Also I am going through a moment of deep discouragement . . . Things are not good and I don't know who to be furious with,' he wrote to Maître.[32] Doubts closed in. Bazille told his mother, 'I feel a violent love for no one.'[33]

In contrast, Monet's manifesto of subjectivity and self-reliance, 'what I myself have experienced', emerged as his emotional life was opened and deepened by fatherhood. Evolved through the vicissitudes of 1868, his resolution bore fruit the following year, when he laid the foundations of a way of painting by setting down on canvas, with a confidence, directness and conviction, as if they were facts, his own impressions. It made possible his breakthrough at La Grenouillère in 1869, and determined his art for the rest of his life.

7

La Grenouillère, 1869–70

In spring 1869 Monet moved his family to a small rented house at Saint-Michel in the hills above the river at Bougival, twenty minutes by train from the capital. It was the first of his five homes on the Seine as it loops around Paris and then flows north into Normandy. From now on, Monet would live nowhere else in France, and four of these places – Bougival, Argenteuil, Vétheuil and Giverny – are inescapably connected with the staging posts of Impressionism. The move to Bougival distanced Monet from Bazille the southerner, and brought him closer to Renoir, who was economizing by staying with his parents at the nearby village of Voisins, and to Pissarro, also local at Louveciennes.

All were broke and selling cheap, if at all. 'This price of a hundred francs is the most difficult thing imaginable to raise. If you accept it, you can never get out of that price range. If you refuse it, you never catch sight of the dealers again,' was Boudin's assessment in April 1869. He was cheered that one of Monet's seascapes was displayed at the dealer Latouche's, 'which the entire artistic world rushed to see. There was a crowd outside the window as long as the exhibition was on, and in the young people this unexpected and violent painting stirred up fanaticism.' But Monet himself he described as 'famished and with his tail between his legs' after the Salon rejection.[1]

'This fatal refusal has almost taken the bread from my mouth, and although my prices are not high, dealers and collectors turn their backs,' Monet wrote in June to Arsène Houssaye, the buyer of *The Woman in a Green Dress*, to whom he was trying to sell again.[2] Houssaye was setting up the summer fair at his Château de la Folie in Breuil: a quarter-mile of roasting pits of whole oxen, sheep, pigs,

partridges, hare, quail, fountains flowing with wine, a thousand bottles of champagne – a last breath of Second Empire decadence. He did not reply to Monet.

Without Aunt Lecadre's allowance, and having used up Gaudibert's money in the move to Bougival, Monet hardly knew where to turn. Renoir brought the Monets food from his parents' table. For the first eight days of August, they had 'no bread, no wine, no fire to cook on, no light. It's dreadful.'[3] Monet pleaded to Bazille, 'I'm telling you, we are starving. May you never know such moments of misery ... You do me wrong by your extreme insouciance towards the misery of others.'[4] But although Monet was now hungry, he had cried wolf too often. His letters went unanswered. Renoir, no more successfully, tried a laconic approach to Bazille: 'I am at my parents' house and almost always at Monet's where, between parenthesis, they can't hold out much longer. We don't eat every day. But all the same I am pleased because, as far as painting goes, Monet is good company. I am doing next to nothing because I have very little paint. Things may get better this month. If it's the case I'll let you know.'[5]

The saint of Méric snapped, and suggested Monet walk to Le Havre and earn money chopping wood. Bazille, cossetted in luxury, failed to grasp his friends' privations. He was also depressed about his own painting. His harsh words shook Monet into dignity. 'This is to inform you that I did not follow your advice (inexcusable) and walk to Le Havre,' he answered Bazille on 25 September. 'I reread your letter, my dear friend: it is really very funny, and, if I did not know you, I would take it for a joke ... If you were in my position, you would be more disturbed than I am. It's harder than you could imagine.'[6] Unrepentant, he added: 'It's absurd to have a friend in Montpellier and not be able to get a crate of wine from him. Come on, Bazille, this is a moment when wine can't be lacking in Montpellier. Couldn't you send me some ... ? At least we wouldn't drink water so often.' Apart from a brief note cancelling a meeting, this is Monet's last known letter to Bazille.

It was probably to this period that Monet referred when in old age he remarked, 'the young painter must expect to eat tough meat (and he may be glad to have that)', but 'if he has fire in his belly, he will find the means'.[7] In the midst of deprivation, 'furious against everyone',

Monet found the means. 'I have indeed a dream, a picture, the bathing place at La Grenouillère, for which I've done some bad sketches, but it's a dream,' he wrote. 'Renoir ... also wants to do this picture.'[8]

La Grenouillère, the frog pond, was a bathing establishment run by a Monsieur Seurin, who in July 1869 was proud to give a tour to the Emperor himself. Built on a pair of barges moored on banks where the river coils between Bougival and Le Croissy, La Grenouillère was popular for swimming, boating, drinking, dancing and pick-ups. The frogs referred to the prostitutes leaping from one man to another. A narrow footbridge – from which drunken revellers often fell into the water – linked the café, a wooden shack, to a small round island known as the 'Camembert'. Here crowds gathered under the trees, and another small bridge led to the shore where rowing boats were lined up. It was a place lively with natural and human incident; the light on the river filtered through the overhanging branches as changeable as the parade of day-trippers and bobbing swimmers. The bridges provided structure for compositions whose subject was flux and movement.

In September, with Renoir at his side, Monet began in broken brushstrokes to depict the reflections in the water, rippling in metallic tones and vibrant hues, casting coloured shadows. Rapid small marks, specks, blots of bright pigment suggested indistinct forms of promenaders, swimmers, foliage, the edges dissolving into blurs of light and colour on fluttering surfaces. The two works described by Monet as 'bad sketches' are to today's audiences shimmering, unified paintings: *Bathers at La Grenouillère* at the National Gallery in London, and *La Grenouillère* at the Metropolitan Museum [Plate 9]. In the version in New York, focused on the Camembert island, with the floating café on the right, light effects streak across the water in long, flat strokes of greenish-black, olive-brown and bluish-white in the foreground. A third, larger *La Grenouillère* was intended for the Salon. Framed by branches, and dotted with sailing boats, this composition was more formal and decorative, but still the exposed brushwork and fleeting effects were those of a sketch. In the 1900s, in the burst of German enthusiasm for Impressionism, this larger version went to Berlin. It was destroyed during the Second World War and is known only by photographs.

The impact of the Grenouillère paintings, though, was indestructible. In the experimental fusion of light, reflections and movement on the Seine, in the watery world at once vividly rendered and abstracted, in the decomposition of the image through abrupt, accented brushstrokes, beginning to be independent of representation, they contained the elements determining the rest of Monet's art. Five years before it acquired its name, Impressionism was launched on the banks of the Croissy island, in paintings celebrating everyday leisure and pleasure, by a pair of penniless artists.

Renoir's three Grenouillère paintings have a feathery softness, and details of people, costumes, anecdotal incident. Monet's figures are mere silhouettes, and he uses a more restricted palette, more assertive handling, bolder geometry. Each kept his own identity yet learnt from the other. Monet was liberated by Renoir's sparkle and decorativeness, Renoir was carried forward by Monet's interpenetration of light, surface, atmosphere, and by his drive and decisiveness. 'There are few things more refreshing in art than the sense of delight in a newly acquired mastery,' Kenneth Clark wrote in *Landscape into Art*. Monet 'contributed his complete confidence in nature as perceived through the eye and his remarkable grasp of tone; while Renoir contributed his brilliant handling and rainbow palette'[9] – that came from his training of painting in crystalline, unmuddied colour on porcelain.

It was a collaboration which changed the history of art, and marked the consolidation of an unalterable friendship, beyond rivalry or judgement. Renoir liked to affect helplessness: 'I never had the temperament of a fighter and I would many times have given up altogether if my old friend Monet, who did have the temperament of a fighter, hadn't given a hand and lifted me back up.'[10] Cézanne thought that 'unlike Monet, Renoir doesn't have a consistent aesthetic; his genius makes it difficult for him to find a way of working. Monet sticks to a single vision of things; he gets where he's going and stays there.'[11] Looking back, he told the painter Maurice Denis, 'Monet around 1869, he struck the great blow' to forge a new way of painting for the 1870s.[12]

In the winter Monet returned to his experiments with shadows on snow, this time with Pissarro in Louveciennes. The menacing *Head of a Boar*, a severed furry head resting on a table with a large hunting

Monet, *Head of a Boar*, 1870

knife, was painted on 4 January 1870. Dead beast and gleaming blade, seeming to jut out of the canvas, confront the viewer directly. It is a violent picture carrying an awareness of singularity, as if Monet had shocked himself with the implications of the 1869 paintings. Numerically, it had been a lean year: only thirteen works were completed, but they were fundamental and uncompromising, as was felt at the time. The large *La Grenouillère* was submitted to the 1870 Salon and rejected. *Luncheon* was also refused. Renoir, more flexible, submitted not his Grenouillère works but traditional figures, the classically inspired *Bather with a Griffon Dog* and an orientalist *Algerian Woman*, which were accepted. The dealer Paul Durand-Ruel, who later adored Renoir as artist and friend, commented that these 'already displayed chromatic qualities, but had a dryness and hardness that reeked of the studio'.[13]

'Do you know that they pitilessly refused Monet? One asks oneself with what right,' Boudin wrote in May 1870 to his friend Ferdinand Martin.[14] Daubigny and Corot resigned from the Salon jury in protest at Monet's exclusion. Not only Renoir but Bazille, Pissarro, Sisley, Manet, Degas were all admitted. Also there was Fantin-Latour's *A Studio in the Batignolles*, the portrait memorializing the group's life in the last days of the Second Empire. It stars Manet at his easel, painting a portrait of his spokesman Astruc. Bazille, taller than everyone

Fantin-Latour, *A Studio at Les Batignolles*, 1870. Left to right: German painter Otto Scholderer, Manet at his easel, Renoir (wearing a hat), Zacharie Astruc (seated), Zola, Edmond Maître, Bazille, Monet

else, looks admiringly at Manet's picture across the heads of the others. Renoir, Zola, Maître, Fantin-Latour's friend Otto Scholderer all crowd around, chatting, each depicted in sharp focus. Blurred, wedged between Bazille's back and the corner of the canvas, and shut out from the conversation, stands Monet. He looks out darkly, smouldering, like an uninvited guest who has gate-crashed the party. He was the only artist whom Fantin-Latour could not convincingly portray as an acolyte of Manet.

The Salon rejection, signalling Monet as the most radical of his generation, was a turning point in a year of finales. Boosted by the sale, through Bazille's agency, of *Terrace at Sainte-Adresse* to a young Montpellier doctor for 400 francs, Monet accepted that the Salon offered no outlet for his energy and ambition, and he began working in the mode he would adopt throughout the next decade, producing smaller paintings, bypassing the Salon, aiming to sell directly to collectors. There was, it turned out, no Salon in 1871 anyway. The 1870 exhibition was

hardly hung before rumours circulated of impending war. France had been alarmed for some years by the gradual unification of a militarily powerful Germany under Bismarck, who in turn was convinced that a war with France was needed to instil a spirit of German nationalism. At the same time Napoleon III's popularity was declining; though overall successful, his government had suffered at the 1869 parliamentary elections, and there had been riots in Paris. He was pressured, especially by Empress Eugénie, to believe war might prop up his regime. In 1870 rival French and Prussian interventions into the Spanish succession fanned the flames, and conflict looked inevitable. 'In France there seemed to be bands and banners on military display almost every day,' an English observer, Charles Oman, wrote of the period. 'The soldier was everywhere, very conspicuous because of his various multicoloured and sometimes fantastic uniform' – horsemen in bright blue, grenadiers in bearskins, and most striking the 3rd Zouaves' 'floppy tasselled headgear and immense baggy breeches, with yellow lace upon their absurdly small cut-away jackets'.[15] *Infantry Guards Wandering along the River* was one of Monet's first paintings of 1870.

The prospect of war brought Monet the threat not only of increased poverty but of conscription. He painted the elegiac *The Train in the Country*, divided into horizontal bands of grassy meadow, dense woodland and carriages on the Saint-Germain line to Bougival, with a locomotive suggested only by puffing smoke into a cloudy grey sky, and a larger view of the bridge at Bougival, acquired by the paint dealer Père Martin for 50 francs. This was negotiated down from 100 francs, with Monet accepting a Cézanne picture (even less saleable than his own) in part payment. Monet now tried to set his affairs in order, garnered what funds he could, took steps to avoid call-up, and considered the possibility of leaving France.

On 28 June, in the town hall of the seventeenth arrondissement, the wedding took place between Claude Monet, resident of Saint-Michel, Bougival, and Camille Doncieux, of 17 boulevard des Batignolles – her parents' home, though this address was merely a convention. The witnesses were Courbet, Manet's younger brother Gustave, a lawyer, Antoine Lafont, a journalist and politician, and Paul Dubois, a doctor. As Bazille predicted, the Doncieux accepted a married Camille, and offered 500 francs for her trousseau and a small dowry of 12,000

francs, to be paid after her father's death. Until then she received annual interest on the sum, plus two years' interest payable immediately, at 5 per cent – 1,200 francs. None of Monet's family was present, though his father sent written approval through a lawyer. Both Adolphe and Aunt Lecadre were ill; she died, aged eighty, a week after the wedding, on 7 July. There had been no reconciliation. 'Friends are worth more than family,' Monet would often say.[16]

Monet was indifferent to marriage as an institution, 'a pure formality', he called it. Jean's birth certificate already claimed the couple as married, and he and others habitually referred to Camille as 'Madame Monet'; his commitment to her was not the question. What was at stake was conscription, from which married men were exempt. Monet, even married, had reason to be alarmed. Officials at his wedding questioned him about his position as a reservist, having done military service.

France mobilized on 15 July, and declared war on Prussia on 19 July. The excuse was a diplomatic insult to the French ambassador, orchestrated by Bismarck to ensure France appeared the aggressor. He thus roused the south German states to join Prussia, giving it numerical superiority. The Emperor fell, reluctantly, into the trap, urged on by a bellicose press and patriotic advisers blindly adhering to a faith that Napoleonic mystique and pomp outweighed German military strength and organization.

Republicans were the dissenters, and included most of Monet's friends. Fantin-Latour was among those who saw the war as the last irresponsibility of the imperial regime, from which defeat would liberate France – republicans should therefore wish the enemy at their gates. 'Remember, France has sown the world with far-flung cemeteries,' Zola wrote on 25 July; 'from China to Mexico, from the snows of Russia to the sands of Egypt, there isn't an acre under the sun that doesn't cradle some slaughtered Frenchman.'[17] For pronouncing France's real enemy to be Napoleon III, he was charged with 'inciting hatred and scorn of the government'.[18] The regime fell before he could be tried. From Méric, Bazille told Maître on 2 August, 'I occasionally snap, out of the exasperation I feel about people like Bonaparte and Bismarck. These perfected throat-cuttings horrify me. I will definitely never be shouting long live any war.'[19]

Two weeks later, on 16 August, Bazille enlisted with the colourfully

dressed 3rd Zouaves, an elite, high-risk unit. Nothing predicted this. His father had paid for a substitute to avoid him, at twenty-one, doing military service. He had reason to have confidence in his painting. *Summer Scene*, a group of male bathers 'in the fun-loving heat of a fine summer's day', as Astruc praised, was acclaimed at the 1870 Salon. These clearly outlined swimmers on the river Lez were far from what was happening in the ruptured brushstrokes at Bougival: Bazille was evolving as a realist Mediterranean painter, returning to his family background, distinguishing himself from Monet. Yet the long-term effects of Monet's tremendous personality on Bazille as he tried to shape his identity cannot be ruled out as a factor in his impulse to assert himself, and sail to Algeria.

Bazille would have been drafted anyway, as a law of 10 August conscripted unmarried men aged 25–35, with those who had done military service required to report to their battalions.[20] This would have trapped Monet had he not married, and it caught Renoir, who reported for military duty on 26 August, a month after Lise had given birth to their second child, also given away. Renoir was assigned to a cavalry regiment, and did not see active combat. Bazille, by contrast, chose a deliberately dangerous war. Maître, on hearing the news, wrote to his 'dear and only friend': 'you are mad, stark raving mad, my heartfelt hugs; may God protect you ... Why not talk it over with a friend? You have no right to make this commitment.'[21] Renoir entered the room as Maître was writing, and scrawled a postscript: 'Break a leg. Arch-brute.'

Bazille joined his regiment for combat training in Algeria on 30 August. By the time he returned, ready for action in France, he was already partly disillusioned: 'this life of a brute is the death of me.'[22] But his letters never again referred to painting, and he engaged enthusiastically in army life. 'Being so tall, I am the best-known man in my regiment. The officers are charming with me. I take a lot of meals at their table ... this morning I led a large party reconnoitring the forest where it was our misfortune not to sight a single Prussian.'[23]

No ripple from these momentous events disturbed Monet's summer canvases depicting Camille on the beach at Trouville in a white frock, windswept, her face in the shadow of a parasol. The only disruptions were some grains of sand attaching themselves to the surface, proving the pictures' plein-air credentials. Camille's dress blends into the sand

in one of these gusty pictures, in another, *Camille on the Beach at Trouville* [Plate 10], she leans back as if to tip into the waves. Seeking motifs to please an upmaket clientele, Monet had chosen for his honeymoon the cream of Norman resorts. The grand seafront Hôtel des Roches Noires was four years old. Monet painted it in a picture where everything soars – flagpoles, lamp-posts, columns, a crenellated tower, slashing blue verticals carving long window shapes out of the hotel's sand-coloured façade, and the statue of Neptune on the roof as a baroque squiggle twisting into the sky. It is a vision of carefree flickering elegance. A couple look out from a balcony, men in pale suits and women with parasols stroll on the terrace, a group gather on the steps at the entrance. Proust stayed at the hotel in the 1890s and described arriving, and the excitement of watching the pounding sea, in *Jean Santeuil*. Monet did not stay there. He was at the backstreet Hôtel Tivoli and as usual left without paying the bill. Boudin, who joined the Monets in August, took care of the stranded Camille and Jean. 'I can still see you with that poor Camille in the Hôtel Tivoli ... I've even kept a drawing showing you on the beach ... Little Jean is playing in the sand and his papa is sitting on the ground, a sketch in his hand.'[24]

On 2 September Napoleon III was defeated at Sedan, and the Second Empire ended. A provisional government of national defence, led by Léon Gambetta, was proclaimed as the Third Republic, and vowed to continue the war. Many but not all republicans became more engaged with a cause which had originally been perceived as imperial folly. Manet was commissioned a lieutenant in the 350,000-strong National Guard set up to defend Paris, and found himself under the command of the academic painter of battle scenes Ernest Meissonier. Zola fled Paris to L'Estaque, in the south, where Cézanne, a draft dodger, sat out the war.

Monet, who was making a last visit to his ailing father, acted quickly. He acquired a passport on 5 September, noting that the boats from Le Havre to England were all full. On the evening of 9 September, he was sad to see 200 passengers waiting on the quay. Boudin, leaving Trouville for Brittany, saw people 'carrying a few clothes and a little food tied up in bundles ... fleeing from the departments of Seine-et-Oise and Marne. It was heartrending ... they were all mixed up among thousands of soldiers, cavalry and volunteers coming and

going in all directions.'[25] Boudin was among many artists trying to leave the country; he found a safe haven in Brussels.

On the Norman coast it was chaos, and the Monets, trying to sail for England, had no idea that close friends – Pissarro and Sisley and their families – were attempting the same voyage. The refugees cut across artistic allegiances, ranging from Monet's supporter Daubigny to Salon traditionalist Jean-Léon Gérôme. Also making the journey was Count Nieuwerkerke, ill and fearing arrest under the new republic; he travelled alone to Boulogne-sur-Mer, collapsed and was discovered unconscious in a train compartment, his suitcases crammed with small antiques to sell in London.

A huddled, uncertain family among many, Monet, Camille and Jean reached England in late September. Monet spent his thirtieth birthday, on 14 November, in lodgings at 11 Arundel Street, Piccadilly (now Coventry Street), then the family moved to 1 Bath Place, Kensington. What Camille thought of London is suggested by her bleak gaze and hunched body in the subdued *Meditation, Madame Monet Sitting on a Sofa*, Monet's first London picture, a gloomy interior with chintz decor. The book Camille holds is closed, normal life is shut down.

The French émigrés quickly formed a community, and exile tightened

Monet, *Meditation: Madame Monet Sitting on a Sofa*, 1871

solidarity. Daubigny sent Monet to a gallery in New Bond Street, where the dealer Paul Durand-Ruel had migrated from the rue Lafayette, with the message, 'This young man will surpass us all. You must buy. I promise to take any you can't get rid of in exchange for my own work.'[26] Durand-Ruel saw 'a tough, strongly built man who looked to me as if he would go on painting tirelessly for much longer than I myself expected to live'.[27] Monet saw a staid, courteous gallerist, nearly forty, impeccably dressed, hand resting on his lapel with a reserved manner, steely features and bright piercing eyes announcing a steady nerve. Each man responded to the other's determination.

Before the war, Durand-Ruel had sent his stock of pictures to London for safekeeping; he followed with his wife Eva and family, and set up home in Brompton Crescent, close to the Monets. A monarchist and a devout Catholic who attended mass daily and had his five children tutored by a priest, he favoured neither the Second Empire nor the Third Republic. He had dreamt of a military career; duty led him instead to his father's stationery and print shop. He expanded it to sell paintings – Delacroix, Millet, Corot, Courbet, Daubigny. The rise of a contested avant-garde, combined with Salon restrictiveness, created the opportunity for a visionary with a 'rash tendency to gather up anything beautiful I come across'[28] and 'an upbringing that taught me to ... respect people who fought for their beliefs. I wanted to become a missionary or a soldier. I found myself on a different field of battle. The weapons were less deadly but the battles were every bit as relentless, harsh and exciting.'[29]

Durand-Ruel had not been unaware of Monet in Paris, but being thrown together in exile in London accelerated their bond, as the dealer started on a fresh path, linking his business irrevocably with his own taste. His daring sat oddly with his conventional persona and downright reactionary beliefs, including a hatred of the Enlightenment and a conviction that Voltaire was 'one of most criminal writers of all time'.[30] Renoir reckoned that 'we needed a dyed-in-the-wool reactionary to defend our work, which the salonards were calling revolutionary,' though it took years of risk before the gallerist could persuade his clients that he was not a flighty madman.[31] A superb businessman, Durand-Ruel eventually became very rich, but not before 'making several enormous business mistakes ... I increasingly indulged in purchases disproportionate to my means.'[32] This was to

Monet's advantage. 'Without Durand-Ruel we would have died of hunger, all of us Impressionists. We owe him everything,' he would sum up. 'He was stubborn and relentless, risking bankruptcy a dozen times in order to support us.'[33]

Durand-Ruel bought Monet's Trouville and first London pictures for 300 francs each. The price distinguished Monet from the other London Parisians hastening to New Bond Street. Pissarro, always impoverished, and with a growing family, and Sisley, newly poor because war had bankrupted his father, each received 200 francs per canvas. London audiences showed no interest. 'It is only abroad that one feels how beautiful, great and hospitable France is. What a difference here! One gathers only contempt, indifference, even rudeness,' Pissarro wrote.[34] The Pissarros became the Monets' closest friends in exile, sharing political and artistic sympathies, homesickness, books, and visits to the National Gallery. Pissarro said they were impressed by the Turners, by which he meant the highly finished pictures; the sketchier ones dissolving into sheens of light were at that time despised and banished to the cellars. Monet refuted Pissarro's account and denied any influence from Turner on nascent Impressionism. Unpatriotic about the defence of France in 1870, he was patriotic about the Frenchness of French art.

Neither Monet nor Camille spoke English, and the scramble from Le Havre, and the devastation in France, left them out of touch with home. From 19 September Paris was under siege, as Prussia set out to starve its citizens into surrender. Battles raged around its outskirts. From the shuttered city, post came rarely, by homing pigeon, or balloon, and few people in Paris even knew where Monet and Camille were; Pissarro's painter friend Édouard Béliard, rounding up information on the painters, wrote that they were in Dieppe.

They did not therefore receive immediate news of the battle of Beaune-la-Rolande, where Prussian brigades were holed up to guard the flanks and rear of the forces besieging Paris. General Crouzat launched an assault here on 28 November, opening with an attack by the 3rd Zouaves. Bazille, charging forward to defend fleeing civilians who came too close to the firing line, was gunned down by shots from the 16th Westphalian regiment. His fellow soldiers watched as, hit twice in the stomach, his tall frame fell to the ground.

Bazille's last correspondence with his parents was dated 25 November. On the 27th, he was promoted to the rank of sergeant-major, and in the celebrations that evening declared, 'I know for myself I won't get killed; I have too many things to do in life.'[35] The next morning he was dead. 'Half of my life has gone. No one in the world will ever fill the void that he has left in my life,' wrote Maître, who took on the task of sending to Montpellier his friend's belongings from Paris.[36] Among others mourning 'the fate of poor Bazille' was Scholderer – 'I remember his feelings of desperation as to the success of his paintings; this again is truly related to his death'[37] – and Manet. He had bought a portrait of Bazille by Renoir and later arranged for it to hang in the second Impressionist exhibition so that 'the modest and likeable hero' could stand among his friends, 'still present in their midst'.[38] Monet's response to Bazille's death at the time is not recorded, but he remained loyal to his memory and to his art; thirty years later, in 1900, he insisted that Bazille 'would have become noted had he lived', and in 1910 he visited Bazille's first retrospective, accompanying the artist's brother Marc Bazille.[39]

Gaston Bazille heard initially only that his son had been wounded, and set off at once for the war zone in the north-east, making enquiries from town to town – Gien, Bellegarde – amid scenes of devastation, before reaching Beaune-la-Rolande, where a priest escorted him. Bazille's cousin, the painter Eugène Castelnau, recorded the return to Montpellier on 14 December:

> Gaston Bazille arrived this morning with the body of his son Frédéric, killed in the battle of Beaune-la-Rolande. A tall, handsome boy full of spirit . . . His father was looking for him for eight days, showing, in his determination to reach the side of his son, already dead and buried on the field of battle, invincible courage and energy, having obtained a Prussian safe-conduct. After a thousand difficulties and hardships, a thousand dangers, he obtained the melancholy satisfaction of rescuing from an unmarked grave the remains dear to myself and to France.[40]

Close to the grave, this Priam of the Franco-Prussian War noticed a juniper bush, from which he took a cutting, planting it on the terrace at Méric.

8

The Bridge to Argenteuil, 1871–3

Through the long winter of 1870–71, the Monets and their little band of exiles the Pissarros and the Durand-Ruels worried and waited. Monet's London paintings from this period are among the most subdued of his career. Trying to grasp unfamiliar subjects in an unsettled time, he painted wet fields and muddy paths in *Green Park* and *Hyde Park*, desolate beneath overcast skies on short days, and views shrouded by fog in *Boats in the Port of London* and *The Thames below Westminster*. Although the forms are solid and directly representational, the misty atmosphere streaked with light, and the Houses of Parliament, river and bridge as entities here unified by light and colour, signal the attractions that would bring him back to paint the city in the 1900s. The London pictures of 1870–71, however, are muted, lonely, frozen. And there were very few – seven paintings in a nine-month stay.

The war and siege of Paris ended on 28 January 1871, with an armistice by which France ceded Alsace-Lorraine and agreed to an indemnity of 5 billion gold francs. Many wealthier Parisians left the city, for there were already concerns that worse would come. French peace negotiator Jules Favre feared that militant, working-class parts of the National Guard in republican Paris would rebel – at France's defeat after so much hardship, at the monarchist majority on the newly elected National Assembly. Nevertheless, when it happened the insurgence was a surprise. On 17 March, 'believing that calm had returned to Paris', Durand-Ruel 'set off to find out for myself how my business stood'. His gallery had become a field hospital, 'everything was in disorder'[1] and the morning after his arrival, crowds lynched two generals in Montmartre, during riots which Clemenceau, the

mayor, tried unsuccessfully to calm. Durand-Ruel immediately returned to London, bringing terrible news.

Paris now tore itself apart. The Communards established a rule of terror, hostage-taking and executions within, the army bombarded the city with shells from outside. On 19 March the red flag of socialism, replacing the tricolour of the fledgling Third Republic, was hoisted over the Hôtel de Ville, and to the sound of 'La Marseillaise' began what socialist journalist Jules Vallès, Courbet's friend, celebrated as a revolutionary festival. 'Citizen Courbet', an elected Commune member, was implicated in an act of symbolic destruction. He had demanded the dismantling of the Vendôme column, Napoleon I's monument to victory at Austerlitz, and on 16 May it was torn down and Communards rushed through smoke and dust to gather mementos of broken stone and clay.

The Commune lasted until 28 May. It concluded in *la semaine sanglante*, the Bloody Week, when government troops, temporarily based in Versailles, massacred civilians as they stormed the barricades held by Communards, who responded with a frenzy of killings and torching of public buildings. The former imperial palace the Tuileries burnt for two days. Thousands of Communards were arrested and held in torturous conditions in the stables at Versailles. Many were summarily shot in groups of twenty and buried in mass graves. Courbet was among the prisoners, and initial false news was that he had been executed. 'All this is dreadful and makes me ill. I haven't the heart to do anything. After the current state of things, total discouragement ... You've no doubt learnt about the death of poor Courbet, shot without trial. What ignoble conduct from Versailles ... All this is disgusting,' Monet wrote to Pissarro on 27 May.[2]

Manet sketched soldiers from Versailles cold-bloodedly executing a Communard on a street corner in *The Barricade*. There were corpses strewn around the sixth arrondissement near the apartment Renoir shared with Maître. The journalist and collector Théodore Duret informed Pissarro in London at the end of May that 'dread and dismay are still everywhere in Paris. Nothing like it has ever been known. I have only one wish and that's to leave ... Paris is empty and will get still emptier.'[3]

Duret had just escaped with his life. He was wandering the

bullet-strewn streets with Henri Cernuschi, owner of the republican newspaper *Le Siècle*, when Versailles troops mistook them for Communards and led them to a cul-de-sac running with blood. As they were lined up and about to face a firing squad, an officer recognized the upper-class Duret, heir to a firm of Cognac dealers, and released them. *Le Siècle*'s editor, Gustave Chaudey, was less fortunate: he was killed by Communards by order of their bloodthirsty 25-year-old leader Raoul Rigault. Renoir, while painting in Fontainebleau, had once met Rigault, then a rebel on the run, and helped him hide in the forest. Rigault repaid the favour by giving Renoir, still weak after a nearly fatal attack of dysentery in the army, a safe-conduct to leave Paris; he escaped to his parents in Voisins. Shortly afterwards Rigault was shot dead on the street, shouting 'Vive la Commune'.

No one in Paris was immune from the effects of the Commune. The trauma, on individuals and in shaping conservative politics in reaction, endured for the rest of the century. There was scant sympathy for the Communards. Courbet, sentenced to six months in gaol at Sainte-Pélagie in Paris, was deserted by almost all his friends. 'Measures taken against fugitive insurgents are more and more severe,' Zola approved on 2 June. 'People entering or leaving the city will need safe-conducts . . . Given the heinous crimes that have just been perpetrated, every decent citizen should support this search for the guilty.'[4]

Monet stayed away another half-year, travelling home via an extended visit to Zaandam in Holland. Durand-Ruel's purchases paid for the journey, Monet painted landscapes of canals with reflected buildings, Camille gave French lessons. They bought big Delftware pots for the garden they did not yet have, and had their portraits taken by Amsterdam photographer Albert Greiner. The sense is of a close family group putting a strong face to the world. No expense was spared for the outfit of four-year-old Jean, smiling shyly at the camera in his patterned coat and big hat. Monet at thirty exhibits his usual robust demeanour, but looks sober and worn, almost middle-aged. Camille, in the only surviving photograph of her, also seems older than her twenty-four years, tired, with a resigned air, and a sympathetic, sorrowful gaze.

In November 1871 the family took the train to Paris and moved into a room at the Hôtel de Londres et de New York by the Gare

Monet and Camille photographed in Amsterdam by Albert Grenier, 1871. This is the only known photograph of Camille

Saint-Lazare. Monet rented Armand Gautier's studio nearby, and worked regular hours there, from ten to four. Camille and Jean came at the end of the day, sometimes with Boudin, who was fond of the little boy. The first painting Monet made on his return, *The Pont Neuf*, is austere and grey. Figures scurry across the bridge in the rain, their reflections faintly rendered on the damp pavement, with steam rising from tugboats below – a picture of mourning. The Monets' friends back from London were all in distress. Durand-Ruel's pregnant wife Eva died suddenly of pneumonia on 27 November, leaving three sons and two daughters – an 'irreparable loss', Durand-Ruel said. 'I felt the effects all my life. My children also suffered greatly because, despite my efforts to fill the gap for them, I was never able to fulfil that difficult role for them as my wife would have done herself.'[5] He survived Eva by fifty years and never remarried. The Sisleys had a new sickly baby, who lived only three months. Pissarro returned to Louveciennes to discover that Prussian troops had commandeered his house and destroyed his paintings – over a thousand works.

One of Monet's earliest outings, accompanied by Boudin and

Armand Gautier, was to visit Courbet, ill and transferred from prison to a clinic at Neuilly. They found him feeble, despondent, pathetically grateful for their concern, quietly trying to complete still lifes of apples and pears, which were rejected from the 1872 Salon on political grounds. Courbet was ruined by his participation in the Commune, and died in obscurity and poverty in Switzerland in 1877. Gautier, associated with him during the Commune, was similarly ostracized and hardly sold anything again. Courbet's militant agenda had no place in the Third Republic, focused on healing and reconstruction.

Monet began 1872 with a pair of paintings registering loss and suggesting recovery. *Argenteuil, the Bridge under Repair* and *The Wooden Bridge* depict the road bridge across the Seine blown up by the French army in retreat from Prussian troops occupying the small town of Argenteuil, twenty kilometres north-west of Paris. The first features the bridge under reconstruction, the reflection of the timber scaffolding lending faint warmth to the murky river. The second, conjuring a moment of evening light as people and a carriage hasten home across the half-repaired bridge, takes a viewpoint through a single arch;

Monet, *The Wooden Bridge*, 1872

144

Monet frames the river by the interlaced scaffolding and its mirror image. It is an odd herald of the circular reflective pools framed by the Japanese bridge in Giverny. In its musing on the nature of images, framing, looking, its embrace of modernity – the building site, the steaming factory chimney – and the nuances of light and weather conditions, *The Wooden Bridge* laid out parameters for Monet's work in the 1870s.

Manet bought this painting in a gesture of greeting and acceptance. He no longer resisted or resented Monet: his status as a leader of the avant-garde was too clear to contest, while his over-riding concern, since 1869, with landscape, made him less threatening to Manet, primarily a figure painter. Manet could still occasionally consider him a rival, but more strongly, he admired and liked him. And there was no friction between Manet and Renoir, who had stayed, and Monet, who had fled Paris in 1870: rather, camaraderie after separation quickened. Manet found the Monets a home, at 2 rue Pierre Guienne, close to Argenteuil's station; they rented it for 1,000 francs a year from the widow of former mayor Louis-Eugène Aubry, a lawyer friend of Manet's father. It was a modest, recently built house, painted cream with blue shutters, with a fenced garden and a small lean-to studio offering a glimpse of the Seine. After the house-warming party on 2 January 1872, lasting several days, Renoir took up part-time residence, coming and

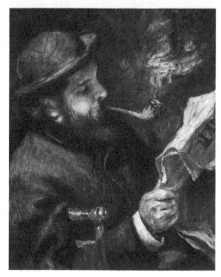

Renoir, *Monet Reading*, 1872

going freely for the next few years, and set about recording what he perceived as his friend's charmed life in Argenteuil.

He caught Monet by gaslight in winter, reading, puffing on his pipe, and again in bowler hat and overcoat, a serious urban type, keeping up to date with *L'Événement*. In summer, in *Monet Painting in his Garden at Argenteuil*, Renoir depicted his host as a man of the outdoors, rough and ready, at his easel in the heart of his terrain, amid a profusion of dahlias, geraniums and gladioli. Renoir's portraits of Camille in 1872 place her in lilting rhythm with the exoticized interior. Wearing an embroidered sky-blue peignoir, she is engrossed in a paperback, propped on cushions with peacock motifs against a wall hung with Japanese fans in *Madame Camille Monet*. In the same glamorous dressing gown, she reclines on a white sofa, dark hair heaped high, lips on the verge of a smile, in *Madame Monet Reading 'Le Figaro'*.

Camille is everywhere in Monet's pictures of their home and garden in 1872–3. In *The Reader* [Plate 13], she stretches out on the grass beneath a tree, illuminated as sunlight creates brilliant patches on the ground and on her pink muslin dress. Under blossom in *Lilacs, Grey Weather* and *Lilacs in the Sun*, she is almost obliterated by the glare in the brighter picture. These were Monet's first paired works depicting the same scene in different light. There are memories of *Women in the Garden*, but now Camille is decorously placed and at modest

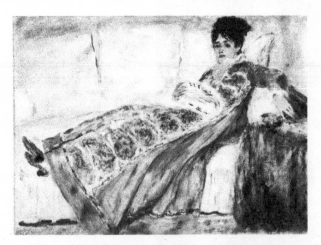

Renoir, *Madame Monet Reading 'Le Figaro'*, 1872

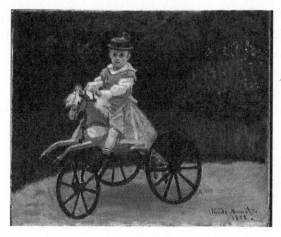

Monet, *Jean Monet on his Horse Tricycle*, 1872

scale, the dignified married woman in her protected domain. After five years shuffling between some dozen addresses, the family found peace at rue Pierre Guienne. Jean started at a private school, his fees paid by the portrait *Mademoiselle Bonnet*, of the director's granddaughter. In *Jean Monet on his Horse Tricycle* the five-year-old, with feathered cap, gallops around the gravel paths, a little prince on horseback, Velázquez's Infante in the riding school transposed to suburban Argenteuil. Monet 'has settled in comfortably and seems to have a great desire to make a name for himself', Boudin reported on 2 January 1872. 'He is destined to fill one of the most prominent positions in our school of painting.'[6] Monet's earnings that year were 12,100 francs, mostly from Durand-Ruel's purchases.

There is a sense, in the first Argenteuil paintings, of Monet seizing possession of happiness. He takes the measure of his new milieu in small, considered canvases: the town unfolding beneath pink skies in *View to the Plain of Argenteuil*; its rural peace in *Path through the Vines*; twilight falling on the day's last pleasure boats and also on factories lining the shore in *Argenteuil, Late Afternoon*. These indicate the range of Argenteuil's attractions. One of the ribbon of Seine settlements lifted to prosperity by the railway, Argenteuil was distinguished from similar places by a long straight stretch of river, a haven for sailing and regattas, and a wide embankment. A small town of 8,000 people when the Monets arrived, it was rapidly expanding, as a suburb and a day-tripper's resort, though it was not quite picturesque. There

were vineyards and fields, and also the Joly ironworks and other factories. The split rural/modernizing identity suited the balance of elements determining Monet's art. He looked outward, painting everyday suburban life from the security of a self-enclosed world built around Camille, their home, their garden and the idyll of the river.

In summer Monet set his easel on the embankment to depict the expansive vista *The Port at Argenteuil*: the broad bank, with strolling crowds between long shadows of trees reaching towards the water's edge, yachts with white sails scudding on the still river, bulky clouds, and in the distance the bridge, now repaired, glowing in afternoon sunlight. It is Monet's fresh, assured statement of what he felt about his new home, and in its authority of vision and composition, its thrill of looking and rapid notation, the painting is a beacon of the first Impressionist moment. Unified, every part equal to every other, inviting the eye to enter and linger anywhere, satisfying in its decorative assembly of forms, the arabesques of trees echoing the cloud shapes, it evokes a harmonious atmosphere quite different from the harsh depictions of the broken bridge a few months before.

In 1873 Monet acquired a studio boat, a curious, ungainly little vessel, a makeshift pale green cabin with sloping roof and square windows built over a shallow black hull. Working from this floating studio, roaming the narrow Seine inlets, often accompanied by Camille, Monet became part of the boating community he depicted. He painted more than fifty pictures of boats on the Seine during 1872–4: pleasure craft, flotillas in races, vessels tied up in lonely moorings. 'I have never seen a boat poised more lightly on the water than in his pictures or a veil more mobile and light than his moving atmosphere. It is in truth a marvel,' wrote Stéphane Mallarmé.[7] Monet's boat allowed him to bring landscape and studio together, and to paint from water level – fragments of reeds and hazily outlined flowers in the dreamy summer in *The Studio Boat on the Seine*, dissolving reflections in *The Seine at Argenteuil in Autumn*.

Although they appear escapist and spontaneous, little is left to chance in the river paintings. Often the bridges structure the compositions, their geometric mass in counterpoint to the flowing river. These pictures carry optimistic narratives of restoration, communication, concord between the man-made and natural landscape. The rounded

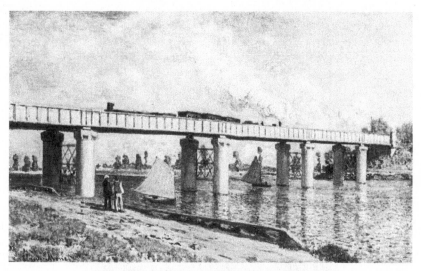

Monet, *The Railway Bridge at Argenteuil*, 1873

arches of the road crossing in *The Bridge at Argenteuil* turn golden in the afternoon light, part of a mosaic with the river's lapping strokes. The rail bridge, a poured-concrete and prefabricated iron construction on massive cylindrical supports, a triumph of industrial design rebuilt in 1873, is also harmonized with Argenteuil's country aspect. In *The Railway Bridge at Argenteuil* Monet takes a sharp angle from below, stretching the blunt horizontal across the canvas. Iron and concrete gleam within a symphony of whites of crisp sails, bluish white smoke billowing from an engine and merging with soft clouds: industry and leisure, mechanical and human, matter and air, unified by light and colour. Two tiny figures watching the trains slow down the picture, give it human scale. In another *Argenteuil Bridge*, it is Camille at the river's edge, her dress blending with the water delineated in long smooth strokes, Jean lagging behind on a flowery bank.

Integrating figures in landscape still compelled Monet. The most experimental and private attempts, paired full-length studies of Camille in winter and summer 1873, were never shown or sold in his lifetime. In *The Red Cape, Portrait of Madame Monet* [Plate 12], she passes outside the French windows of the house: a fleeting figure, a face, sketched in rough daubs, with an expression between poignancy and blankness. Reflected light from the snow floods a pale, bare room;

Monet, *Camille and Jean Monet in the Garden at Argenteuil*, 1873

Camille shivers outside, her red cape the sole warm note. In *Camille and Jean Monet in the Garden at Argenteuil* she is similarly caught as if unaware: arms raised, hands on her head, adjusting a ribbon in her hair. Both poses are difficult, and demonstrate Camille as flexible, patient, and as intuitive a model as in her teens. In the summer picture, she is immersed in flowerbeds and bushes which frame and partly screen her, as the window grid does in the winter painting. She gathers the garden into herself as she gazes at Monet, looking at once surprised, radiant, expectant. He bathes her in a brilliant luminosity, and a line of light flows from her to Jean, sprawled on his back: a secular Annunciation.

Camille and Jean wander through thick grass at Argenteuil in *The Poppy Field* [Plate 17], each figure repeated twice, establishing a diagonal, dividing zones of a hilly area of scarlet flowers from a bluish-green meadow. They anchor a painting whose swarming red blots and flecks, huge and diffuse in the foreground, then receding in diluted colour, were, in summer 1873, Monet's most abstracted

rendering so far. How the eye sees and registers shapes and colours is in part the subject. Monet did not read theoretical texts, but his interest in visual perception coincided with scientific studies of optics and the workings of the mind. Hermann von Helmholtz's *Optique physiologique* appeared in Paris in 1867; Hippolyte Taine's *De l'intelligence* in 1870.

'When you go out to paint, try to forget what object you have before you, a tree, a house, a field or whatever, merely think, there is little square of blue, here an oblong of pink, here a streak of yellow, and paint it just as it looks to you, the exact colour and shape, until it gives your own naive impression of the scene before you,' Monet would advise the painter Lilla Cabot Perry.[8] Théodore Duret invited his readers to

watch Claude Monet as he takes up his brush ... He sets a white canvas on his easel and suddenly begins to cover it with patches of colour that correspond to the areas of colour he discerns in the natural world before him. The first attempt often ends with nothing but a rough sketch. Upon returning to the same spot the next day he adds to the first sketch; details begin to stand out, objects begin to take shape.[9]

As he gained command of the motifs offered by his new home, Monet brought to an apogee the fragmenting brushstrokes and interplaying, dazzling vibrations developed at La Grenouillère in 1869. Adopting yet smaller, comma-like brushstrokes, he moved further from defining forms in favour of lively marks, dots, bursts of colour, which give an overall impression of the sensation and atmosphere of a scene. In *The Basin at Argenteuil* [Plate 11], a patchwork of dashes captures the movement of water and the reflections of the creamy boats and sails, there are flat touches for the mass of leaves and their purple shadows, mere flicks suggest promenaders on the far embankment, and brown, yellow, green jabs describe the knotty grasses in the foreground. A generation before, Ingres had insisted that, 'However skilful it is, the touch should not be visible, it hinders the illusion.'[10] At Argenteuil flecked, animated surfaces, evoking the play of light, trumped descriptive illusionist painting. To traditional eyes, the effect looked ungainly – 'a debauch of impasto ... the most dishevelled and disorderly type of painting one can imagine,' said the artist Frédéric

Chevalier.[11] But a paradigm had shifted, and Monet became a magnet for his forward-looking contemporaries. Renoir was the most frequent visitor, and Pissarro, Sisley, Manet all regularly came to paint in Argenteuil.

The years 1872–4 were a glory moment in French art, when people, place, time, thought, were propitiously aligned. The generation born between 1830 and 1840 were reaching maturity; a spirit of shared ideas, close friendships and rivalry spurred them on, and the experiments of the previous decade were a bedrock on which to build. In the 1860s Manet had dominated the avant-garde with heavyweight sociopolitical themes (*Olympia*, *The Execution of Maximilian*), and mythological or Christian subjects had still appeared in his work and in that of Cézanne and Renoir. In the early 1870s that vanished and it was Monet who pointed the way – as the painter of light, and also in his secular, apolitical worldview. Durand-Ruel noted that in 1872–3 Manet began to be 'visibly influenced by Monet in his exploration of light'[12] – *The Croquet Game* (1873), for example, followed by the monumental rendering of an outdoor domestic scene *Laundry* (1875).

Thus from Argenteuil Monet led what T. J. Clark calls 'the wonderful easy godlessness of French painting' in the late nineteenth century, a high point of 'the beauty and depth that secularization can attain'.[13] Monet's talent 'is very serious and very pure', Pissarro told Duret, and his work 'a highly conscious art, based upon observation and derived from a completely new feeling; it is poetry through the harmony of true colours'.[14] Armand Sylvestre, in an essay in 1873 about Durand-Ruel's collection, emphasized both Monet's signal position – 'M. Monet is the most adept and daring, M. Sisley the most harmonious and hesitant, M. Pissarro the most genuine and naive' – and that the paintings by all of them were 'singularly cheerful, a blond light floods them and everything in them is gaiety, clarity, spring festival ... what strikes you first of all is the immediate caress which the eye receives from it – it is above all harmonious.'[15]

This accorded with the mood of the young Third Republic, which was orchestrating France's recovery from the war more quickly than expected. Durand-Ruel wrote that 'the year 1873 began with great promise, thanks to lively business activity in general, and the business of selling pictures in particular. It looked like the start of a long period

of prosperity.'[16] In Paris, after the destruction during the war and the Commune, Haussmann's project continued, the capital scintillated again. In two works of 1873 entitled *Boulevard des Capucines* [Plate 18], Monet staked a claim for Impressionist painting to occupy the fashionable heartland, what Henry James called Paris's 'most sacred spot . . . the corner of the boulevard des Capucines, which basks in the smile of the Grand Hotel'.[17] Haussmann's massed blocks, lattices of trees, the avenue of carriages and people, blend into a sparkling web of midday sunlight. Evoked in countless staccato black slicks, the teeming crowd is fused within the powdery haze and effervescent light. The mob was an emblem of terror during the Commune two years before; here the crowd is absorbed into a vision of unity and opulence. Silhouettes of a pair of top-hatted observers lean in from a balcony, leading us into the glorious spectacle of Paris – paintings about how we look, how we experience a city as a confusion of movement and colour. Renoir's deliberately out-of-focus vista *The Grand Boulevards*, sunlight piercing through the trees, shadows cast on the broad avenue, followed in 1875.

In a secure position, retired from doing battle with the Salon, a well-funded Monet was immensely productive. He produced a hundred paintings in 1872–3, their subjects stretching along the Seine from Paris to the quays at Rouen and the thriving port at Le Havre, emblematic of resurgent France, to family life. Considerably the largest of all these pictures, at two-metres wide, was *Luncheon* [Plate 14], of summer 1873. A still-life bourgeois table – silver coffee pot, compotier laden with peaches, glistening wine glasses, a half-eaten brioche – and little Jean with his building blocks occupy the foreground, at the back Camille and a visitor are half hidden by a tree. Blazing geraniums enclose everything. High up on a branch hangs an oversized straw hat; its black ribbons flutter in a swirling emptiness in the centre of the canvas, giving a faint sense of threat, that all this may be precarious.

Monet's last canvas of this size had been completed five years before: the cramped *Luncheon* of 1868, to which this painting alludes. The cast of Camille, Jean and a woman visitor, the discarded straw hat with black ribbon, the white-clothed table still life, are all repeated elements, paraphrased, expanded, relocated. Monet's *Luncheon*

compositions are statement pictures, each a moment of personal con-solidation, and commemorating domestic pleasures, including his delight in food. He painted the repeated Camilles in *Déjeuner sur l'herbe* in 1865, at the start of a love affair; Camille and baby Jean in 1868 marked his pride in his young family; and the *Luncheon* of 1873 celebrates their improved circumstances, luxuriating in the gar-den of their first permanent home.

Monet's income more than doubled in 1873, to 24,800 francs.* The couple employed two servants, Marie and Sylvain, and a part-time gardener. The account book records payments to wine merchants in Bordeaux and Narbonne, preferred over the cheap local vintage. Camille's dresses, such as the velvet and damask outfit billowing in *Madame Monet on a Garden Bench*, resemble the year's fashions advertised in magazines such as *La Mode illustrée*. There was no sav-ing for a rainy day. When Camille's father died that year Monet had difficulty affording mourning clothes. Camille did not receive her full inheritance, leading to disputes with her mother which ended an already distant relationship. But the future held promise. Monet could expect regular sales of new pictures to Durand-Ruel, and he was mor-ally as well as financially buoyed by interest in his 1860s work. His prices were rising. Durand-Ruel paid 2,000 francs for the large *La Grenouillère*, demonstrating his grasp of its importance. The banker Hecht paid 500 francs for an 1867 Sainte-Adresse garden picture. So it was in a spirit of contented personal life that Monet set out to return to the public fray and picked up the idea he and Bazille had shared, for an independent show featuring their friends and sympa-thizers, to reach wider audiences and to 'be talked about'.

* For context, Gérôme's historical narrative of Cardinal Richelieu's adviser, *L'Émi-nence grise*, painted in 1873, fetched 60,000 francs.

9

'This School of the Future', 1873–6

The first reference to what would become the inaugural Impressionist exhibition came in a letter from Monet to Pissarro in April 1873, explaining, 'definitely, everyone finds this good, only Manet is against'.[1] Premises were found at the former studio of the photographer Nadar, on boulevard des Capucines – a prestigious address, and symbolic for the new painting, which challenged photography as a modern medium. Along with Monet, the chief instigator, and Pissarro, who hoped to promote a cooperative association, modelled on a bakers' union, 'everyone' included Renoir and Sisley, the more solitary Cézanne, and the upper-bourgeois Degas and Berthe Morisot. She was the only woman to sign up to the show, and her presence added to public perceptions of its radicalism. Very gifted, clever, beautiful, wealthy, at thirty-three still living with her parents, and with no need to sell, Morisot had exhibited at the Salon almost every year since 1864. She had everything to lose by throwing in her lot with Monet and Renoir – her social as well as her artistic reputation. 'All of these people are more or less touched in the head,' her former teacher Joseph Guichard wrote urgently to her mother. 'She must absolutely break with this new school – this so-called school of the future.'[2]

According to Morisot's grandson Denis Rouart, working towards the exhibition brought a deepened collegiality: 'it marked the awakening of these artists to the realization of what they had in common.'[3] Monet prized Morisot, respected her judgement, and enjoyed the company of 'a woman who could not be more charming, a great talent'.[4] Renoir thought Morisot 'acted like a special kind of magnet on people, attracting only the genuine. She had a gift for smoothing out the rough edges. Even Degas became more civil with her.'[5] Degas,

Manet, *Berthe Morisot with a
Bouquet of Violets*, 1872

known for his irascibility, was trying to be civilized now, proposing
that the artists band together under the banner 'La Capucine'. The
boulevard took its name from a convent, but *capucine* means nastur-
tium, a flower traditionally symbolizing victory, and Degas wanted
the flower on every poster advertising the show. This was vetoed, and
Renoir insisted on the neutral name 'Société anonyme des artistes pei-
ntres, sculpteurs et graveurs'. Degas, at a tangent from the others,
lacking interest in plein-air painting, sought participation from more
conservative figures whom, however, he had difficulty recruiting.
Monet too found that once the first dozen or so artists had commit-
ted, it was hard to round up more. For the enthusiasts, an attraction
was the unprecedented chance to see their works together. To others
the concept of a group show was simply peculiar – dealers did not
then sell pictures that way.

'I've got back from Paris, where I spent the whole day running
around to get the five signatures in question, and I've returned empty-
handed,' Monet told Pissarro wearily on 5 December 1873. 'It's harder
than you would believe, everyone has a different excuse ... it seems
to me more difficult to get these five signatures than the first fifteen.'
One refused from 'timidity', another 'was too busy', a third 'didn't
want to oppose the state because he isn't a French citizen. I'm going
to try the other side of the river ... will I be any luckier? Renoir's
going to see Guillemet tomorrow ... To sum up, if I don't get any-
thing, it won't be my fault.'[6] Guillemet declined, but disparate support
came – from Boudin to Bazille's aristocratic former comrade Viscount

Lepic. The artists thus were a broad range, with a contentious core. The stinging absence was Manet, who remained implacably hostile to the exhibition. Degas until the last minute went on attempting to persuade him ('I definitely believe him to be much more vain than intelligent').[7] Manet as futilely tried to dissuade Morisot.

Monet considered carefully which of his own works to show. The inclusion of the largest, the *Luncheon* of 1868, was vengeance for its Salon refusal, and gave prominence to Camille and Jean. The pair strolling in *The Poppy Field* [Plate 17] gave a rural accent, and brilliant red notes. *Fishing Boats Leaving the Harbour* [Plate 15], an agitated view of a flotilla of vessels whose large sails shroud the buildings on a rainy morning in Le Havre and *Boulevard des Capucines* [Plate 18] proclaimed Monet a painter of modern life. They share a depiction of the crowd as a pulse of sketchy rushing figures, on the quayside as on the fashionable avenue. Sketchiest of all was a painting of Le Havre [Plate 16] made in winter 1872–3 during a stay at the Hôtel de l'Amirauté: a moment of breaking light and its reflections, ghostly boats cloaked in mist, dockyards implied by a few loose strokes. Renoir's younger brother Edmond, charged with producing a list of works in the exhibition, asked Monet its title. It was 'something

Nadar's Studio, 35 Boulevard des Capucines, third floor: site of the first Impressionist exhibition, 1874

done out of my window at Le Havre, sunlight in the mist with a few masts in the foreground jutting up from the ships below,' Monet recalled. 'It couldn't really pass as a view of Le Havre, so I answered, "Put down *Impression*." Out of that they got impressionism.'[8]

With an entrance fee of one franc, the 'Société anonyme' exhibition opened its doors on 15 April 1874, a fortnight before the official Salon, and received 3,500 visitors in a four-week run. 'The public flooded in, but with the obvious intention of finding everything dreadful,' Durand-Ruel reported.

> Unable to assess the serious qualities of such new works, so different in appearance from the ones they were accustomed to seeing, they viewed the exhibitors as presumptuous ignoramuses seeking attention through eccentricity ... public opinion against these dangerous innovators was whipped up so intensely ... But exhibition-goers were not the only people to fail to understand the merits of these poor artists – most collectors and artists themselves were equally blind.[9]

It was the first time Monet, Renoir and Pissarro had been shown together, and their dissolution of outlines, absence of modelling, lack of finish, were barely comprehensible. To Paul Mantz, who had praised Monet's early seascapes, the paintings were 'anarchy'.[10] In *L'Indépendant*, Jules Claretie wrote, 'M. Monet ... Pissarro, Mlle Morisot etc. appear to have declared war on beauty.'[11] *Le Figaro*'s Albert Wolff could make no sense of the artists: 'they take canvas, paint and brushes, throw some colour on at random, and sign the result.'[12]

Bazille's prediction in 1867, 'you shall see that we'll be talked about', was not wrong, for although there were few sales, the exhibition opened a debate about what painting could be. Monet was always at the centre; being the most extreme, his painting elicited the most enlightened reviews, as well as the most derisory. Ernest Chesneau, in *Paris Journal*, singled out *Boulevard des Capucines*: 'in this streaming life, in this shimmering of great shadows and of great lights spangled with deeper shadows and more vivid lights, we salute a masterpiece ... what a clarion call for those with ears to hear, and how it echoes into the future!'[13]

Louis Leroy, in *Le Charivari* of 25 April, put the opposite view: he imagined a tour of the show with an old-fashioned connoisseur: who

sensed that a catastrophe seemed imminent, and it was reserved for M. Monet to contribute the last straw [with *Impression, Sunrise* – Plate 16] – I was certain of it. I was just telling myself, since I was impressed, there had to be some impression in it ... And what freedom, what ease of workmanship! Wallpaper in its embryonic state is more finished than that seascape!' Leroy imagined the response of the connoisseur accompanying him – 'In vain I sought to revive his expiring reason ... I looked for what was tolerable among the impressionist pictures ...'[14]

Countering Leroy, Monet's supporter Jules Castagnary, in *Le Siècle*, seized the term 'impressionist' as positive:

M. Monet has some passionate touches that are marvellously effective ... his 'Sunrise' in the mist echoes like the tones of the morning reveille. The consensus that unites [these painters,] and makes them a collective force in our disintegrated age is their determination not to seek an exact rendition ... If we must characterize them with one explanatory word, we would have to coin a new term: *impressionists*. They are impressionists in that they render not the landscape but the sensation evoked by the landscape. The very word has entered their language: not *landscape* but *impression* in the title given ... for M. Monet's 'Sunrise'.[15]

Castagnary shifted the record: it was not scornful Leroy who gave Impressionism its name but the artists themselves. 'A landscape is only an impression, instantaneous, hence the label they've given us,' Monet said.[16] Zola continued to use the term 'naturalist', and Degas, who had wanted the 1874 exhibition to be the equivalent of a Salon of realists, resisted the term. Nevertheless, the name 'impressionist' stuck because it was accurate. According to Duret, Monet 'has caught those myriad fleeting impressions communicated to the spectator's eye by changes in the sky, in the weather. It was to describe him that the term *impressionist* was first, quite aptly, created.'

So Monet emerged from the exhibition the implicit leader of a movement considered risible yet commanding debate, which increased through the decade. Duret wrote that 'a revolution was being carried out: dark painting grew lighter. Were we to be transported back to a Salon of thirty years ago, we would be greatly amazed at the change that has taken place in the overall colour tone.'[17] In 1876 Mallarmé informed

British readers of 'the plein air that everyone aims for in France today', in a democratizing context: 'the multitude desires to see with its own eyes,' he wrote, and will do so through the Impressionists, 'new ... men placed directly in communion with the art of their time'.[18] Seventy years later, Kenneth Clark's overview was that 'Impressionism achieved something more than a technical advance. It expresses a real and valuable ethical position ... Impressionism is the perfect expression of democratic humanism ... every day we pause with joy before some effect of light which we should otherwise have passed without notice.'[19]

The interest roused by the first Impressionist exhibition was also signified by the response of the artist who had kept his distance. Durand-Ruel observed of Manet in 1874 that Monet's works 'which he had not fully understood at first ... were to trigger a major change in his thinking'.[20] In summer 1874 Manet left Paris for Argenteuil, and painted a trio of open-air portraits of rakish canotiers (posed by his brother-in-law) and their girls, turning on social and psychological dramas. *Argenteuil*, Manet's couple in a boat on what critics complained was an indigo river, hung in the next Salon, declaring a conversion to plein-air painting.

Renoir was in Argenteuil with Monet in summer 1874 too, and there is an ecstatic virtuosity about the images the chain-smoking pair painted alongside one other. Often they worked a metre apart on the banks of the Seine: Monet's *Boaters at Argenteuil* and Renoir's *The Seine at Argenteuil*, for instance, a close-up of a sailing boat, and its long creamy reflection, docking on the south bank against, in Monet's case, a background of a couple of sculls and another sailing boat, and in Renoir's, a more bustling river.

There was a day in July 1874 when Monet depicted his guest in *Manet Painting in Monet's Garden in Argenteuil*, and Manet worked on *The Monet Family in their Garden at Argenteuil* where Monet, gardening, attends to a blur of red dots – geraniums – as if to a palette, and Camille and Jean are spread across the lawn. Monet, recounting the scenario, asserted Manet's conversion to plein air under his auspices, and that during the session Renoir turned up, demanded palette, brush and canvas, and painted the same scene; Manet, watching, whispered to Monet that he was talentless and Monet should tell him to give up. Renoir remembered the session

fondly: 'I arrived at Monet's at exactly the moment when Monet was starting . . . and do you think I'd have let such a marvellous occasion, with models all ready, escape me? When I left, Manet said to Monet, "You're Renoir's friend, you should advise him to give up painting! You can see yourself that it's not really his thing." '21

Manet esteemed Renoir; this was a joke, if an irritated one, by an artist distracted from his motif by one rival just as he set up to square with another. Posing Camille on the grass, beneath a tree, her white skirt extending in a wide circle on the ground, Manet assimilated Monet's plein-air achievements and concern with unity of figure and landscape, in a composition alert with his characteristic urbanity and wit. The row of rooster, hen and chicken are a comic fowl version of the Monet family; the red notes of Monet's flowers repeat in Camille's fan and Jean's shoes, and with Monet's blue smock, Jean's blue sailor suit and Camille's white outfit, make up the colours of the tricolour. Manet's picture is a rendering of bourgeois leisure – and the artist's place in it – in the young Third Republic. Then along came Renoir, and with sketchy panache he abbreviated the scene into a dashing close-up

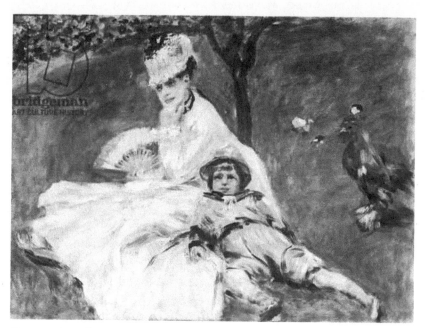

Renoir, *Camille Monet and her Son Jean in the Garden at Argenteuil*, 1874

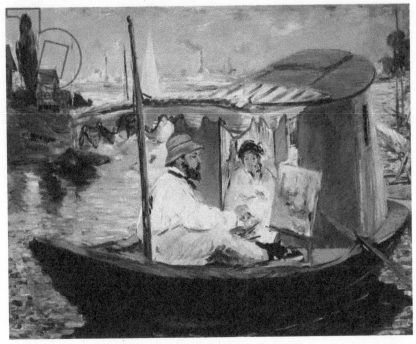

Manet, *Monet in his Studio Boat*, 1874

of Camille, graceful, sensual, seeming to absorb and enjoy the wriggling Jean leaning against her. Both Renoir and Manet allow a pictorial closeness between Camille and Jean as Monet never did: perhaps he treasured that intimacy too privately to set it down on canvas.

Manet followed up the family picture with a double portrait of Monet and Camille, the homage *Monet in his Studio Boat*, which works as a summing up of the early Argenteuil years. The river and its reflections are painted in broad strokes with Monet-like rapidity and freedom. The tall triangle of a white sail, such as Monet loved to paint, juts to the sky. Factories steam on the gritty, distant bank. In the foreground the sturdy, cross-legged figure of Monet paints beneath the shade of an awning, while Camille sits watching him from the cabin. Slightly huddled as the breeze comes off the water, she is elusive as usual, but a force of concentration and affection fills the picture from her gaze on her husband. Manet places the pair to suggest that she balances the little vessel. From within their boat, the couple both shelter from the world and, through Monet's art, fight for their place within it.

But outside that green and black boat in 1874, the world was becoming tougher. For sales, the timing of the first Impressionist exhibition turned out to be disastrous. Conceived in a period of security, it was launched seven months after the global financial crash in September 1873, which led to an economic depression whose effects were felt in France for years. 'It is a very bad time for selling; all the bourgeois are unwilling to spend their sous,' Cézanne complained in September 1874.[22] The exhibition made a loss, leaving each member liable for 184.50 francs. A follow-up attempt by the group to sell by auction at the Hôtel Drouot in March 1875 was a fiasco. Few collectors were willing to take risks on the new paintings, though the exhibition and auction together did introduce the artists to the two buyers whom Monet rated highest of all: 'the only men I knew who were real art lovers and not speculators were Chocquet and Georges de Bellio'.[23] Victor Chocquet was a civil servant of modest funds but discernment; de Bellio a Romanian aristocrat who practised as a homoeopath in Paris. There was also Gustave Caillebotte, a lean, neat, affluent 26-year-old with a passion for pictures, yachts and gardens, who inherited his father's fortune in 1874 and for whom that year's Impressionist exhibition was a revelation. Caillebotte became a painter, treading a line between Degas's realism and Impressionism, and Monet counted him a colleague, but he was also a collector, open-minded and open-hearted. His interest became vital because Durand-Ruel, in trouble following the crash, stopped buying from his band of artists after December 1873.

As a result, Monet's earnings for 1874 more than halved, to 10,654 francs, then fell to 9,764 francs in 1875. He had to borrow 100 francs from Manet to pay the rent in 1874, and pleas to Manet for loans through 1875 were for embarrassingly small amounts of 50, 60 or 20 francs. The relationship with Madame Aubry soured, predictably, over tardy payments, and on 1 October 1874 the Monets moved to a single-storey house, rented from a carpenter, at 2 boulevard Saint-Denis, opposite the station, a pink house with green shutters. At 1,400 francs a year, their new home was more expensive than Madame Aubry's. Monet balanced the books by giving up his Paris studio.

The move, after the departure of the summer's visitors, brought about a mood of withdrawal. Boulevard Saint-Denis was not a party house. The curtained interior *The Corner of the Apartment* introduces

it. Deep recessions lead the eye down the parquet floor of a long room, hung with chandelier and oil lamp, framed by plant pots and foliage, as if the garden has entered the house. Halfway down we meet Jean, hands in his pockets, no longer the little prince on horseback but a pensive, awkward seven-year-old. His figure is reflected in the shiny floor amid a bluish tint, cast by snow, filtered from the window at the back, where Camille is just visible. Caillebotte purchased *The Corner of the Apartment*, and bequeathed it to the French state; it hangs at the Musée d'Orsay, which characterizes it as 'reminiscent of the childhood world of Marcel Proust, as he would later describe it' – Proust was born in Paris four years after Jean Monet.

Complementing the atmosphere of retreat and stillness are sixteen snowscapes of Argenteuil silent, etherealized in muted whites tinged with lavender, violet, pale greys, beneath opalescent skies. Monet looked closely at Japanese prints for the flakes falling, like a screen of blots and loops across the canvas, in *Snow at Argenteuil*, and for the little figures with umbrellas hurrying home along a white path from the station in *Snow Effect at Argenteuil*. Rendered with extreme finesse, the snowscapes were sought by discriminating collectors. There was competition for the twilit *The Train in the Snow*, the engine with gleaming headlights shrouded in cloud as it arrives in Argenteuil station, a somehow nostalgic depiction of an emblem of modernity. It was acquired by de Bellio, who joked that it would be a derailment for it to fall into the wrong hands. Duret bought the largest, *Snow Scene at Argenteuil*, depicting the boulevard Saint-Denis looking towards the river. One winter he showed it to Manet, who had talked of painting a snow scene; on seeing it, Manet declared it impossible to do better, and gave up the idea.

The Monet-Manet-Renoir friendship flourished. In his affectionate portrait in 1875, Renoir concentrated the light on Monet's face, and placed an oleander behind him, playfully circling his head with its leaves – Monet the luminary of the new art, crowned with a laurel. Curly dark hair, bushy beard, brush in one hand, palette in the other, he looks out with a vigorous, resolute air, ardent if reserved – a vital spirit. That summer Manet, still under Monet's influence, travelled to Venice, seeking a more intense play of light on water, to out-glitter his friend. In turn Monet, remaining quiet in Argenteuil, focused on the figure – Manet territory – in *The Walk, Woman with a Parasol* [Plate 19].

Camille, in a voluminous white dress which wraps around her in the breeze, stands on a grassy hill against fast-moving wisps of cloud. The whole scene, animated by small, stabbing strokes for the swaying wild-flowers in the foreground, seems to be set in motion. She is backlit, cast in shadow; blinding light whitens the top of her green parasol, reflections from the sky turn parts of the dress blue, yellow mirrored from the flowers touches her sleeve, the wind whips her veil, in the moment that she interrupts her stroll to turn, in a gesture so characteristic of Monet's depictions of her, to catch him looking at her. Jean in his sun-hat, dizzy in the summer haze, is a bleached figure a few paces away.

Camille must have stood in the sun for hours, in a pose whose difficulty was apparent a decade later when, in a desperate throwback, Monet tried to re-enact the composition with one of his stepdaughters, who fainted. The incident suggests that *Woman with a Parasol* was iconic for Monet, as it became for the history of Impressionism – the decade's classic plein-air figure painting.

It was the last collusion with Camille which Monet acknowledged with pride. Its indoor, winter complement, *La Japonaise* [Plate 20], occupied the rest of 1875; bringing fame and embarrassment, it speaks of the beginning of an impasse at Argenteuil. In creating it, the couple looked back to their first success, *The Woman in a Green Dress*, and aimed to repeat it. Camille donned a blond wig and, swathed in a luscious scarlet and gold-edged kimono embroidered with the figure of a kabuki warrior, posed against a wall of fans, from one of which a coiffed geisha surveys her with astonishment. The interplay of figures at different levels of painted illusion – Camille, the paper geisha, the embroidered actor – produces a sumptuous piece of theatre, celebrating Monet's passion for things Japanese and Camille's love of the stage. The result is gaudy, funny and, with the embroidered warrior unsheathing his sword at Camille's thigh level, as close to sexual innuendo as Monet ever ventured. Yet the painting lacks the charged gaze which enlivens his best pictures of Camille. Something is deadened. Camille's eyes are glassy as a doll's, her grin is fixed like a clown's, and her wave of a tricolour fan at the viewer is full of pathos, like that of a performing animal. She looks strained and sad.

La Japonaise was the showstopper at the second Impressionist exhibition, held in April 1876 at Durand-Ruel's gallery, and was

popular because, by its traditional facture and composition, it made some concession to conservative taste. Monet later reacted against the painting with a vehemence shown to no other of his works. In 1918, informed that dealer Paul Rosenberg had bought it, he burst out, 'Well, he's got himself a piece of junk. Yes, junk; it was only a fantasy.'[24] Monet was incapable of turning out a conventional picture, but *La Japonaise* was opportunistic, created when sales were scant.

The second Impressionist exhibition was smaller, and less well attended than the first, though more widely covered, from diehard Albert Wolff's critical review, entitled 'Misfortune in the Rue Le Peletier', in *Le Figaro*, to Zola's prediction, in *Le Messager de l'Europe*, that a new school was emerging which would eventually transform the Salon itself.

Two important essays on the artists published in 1876 confirmed Zola's instinct. In the British journal *Art Monthly* Mallarmé offered the most sophisticated interpretation of Impressionism so far. Explaining its 'peculiar quality outside Realism', its 'transparent atmosphere' and depiction of life 'in passing', he understood the paintings as parallel to his experiments with language in poems employing fragments, blank spaces, odd arrangements of words on the page.[25] Mallarmé was Manet's close friend, and subject of his sympathetic portrait, wiry and faun-like, with pointed face, eager eyes, surrounded by scrolls of smoke. Writing to his friend Henri Cazalis as early as 1864, when he was twenty-two, Mallarmé had set out his aims 'to paint, not the thing, but the effect it produces' so that 'all the words should fade away before the sensation'.[26] It was a vision close to Impressionism. His dreamlike 'L'après-midi d'un faune', a landmark of symbolist poetry, also appeared in 1876, making his name but not his fortune; his poetry was so obscure that a standard joke was to ask for a translation into French.

The realist novelist Edmond Duranty, Degas's friend, was Mallarmé's opposite, but his *La Nouvelle Peinture* too celebrated that 'a new branch has developed on the old trunk of art'. He thought the Impressionists a mixed lot: 'original personalities along with eccentric and ingenuous characters ... real painting delight ... beside unfortunate attempts which irritate the nerves.'[27]

None of these commentators, however, helped sales during the

economic slump. 'One needs a large dose of courage to keep brush in hand in these times of neglect and indifference. If Paris were besieged it would be easier to sell a canvas than it is this year,' Boudin wrote in March 1876.[28] In this difficult climate, Monet made his move. A fortnight into the Impressionist exhibition, he removed *La Japonaise* from the rue Le Peletier and put it in an auction at the Hôtel Drouot, on 14 April 1876, of 'Modern Pictures from the Collection of M. XXX'. It fetched an unlikely 2,020 francs, a publicity stunt and a stitch-up with 'Monsieur XXX', by which artist and collector agreed a fictitious price but no sale took place. Monet begged Gustave Manet, 'I'd be very grateful if you wouldn't repeat to anyone what I told you about *La Japonaise*. I had promised to keep quiet ... I count on your discretion ... complete silence ... otherwise there will be ... endless trouble for me.'[29]

Monsieur XXX was Ernest Hoschedé, textile merchant and department-store owner. Monsieur Hoschedé par Durand' first appears in Monet's account book in 1874, listed as paying 800 francs for *Impression, Sunrise*, linking his name for ever to the history of Impressionism. Nothing about this thickset, bland-looking, good-natured *bon vivant* suggested that he would lose his heart to the new painting, but Hoschedé acquired four more pictures at an extravagant 1,000 francs each in 1874, contributing almost half of Monet's income that year. Convivial and easily establishing friendships with a range of artists, from the academic to the unconventional, he was a collector of status by the mid-1870s. At the 1876 Salon his portrait by Paul Baudry, the celebrity decorator of the new Opéra Garnier, hung prominently: a sedate depiction in Old Master browns and greys, though Baudry has caught a desperate look in Hoschedé's eyes.

'Hoschedé – well known to anyone who holds a brush', as *Le Gaulois* described him,[30] arrived as a gift to Monet at a time of financial and creative crisis. For by 1876 the happiness, clear direction and economic stability of the first years in Argenteuil had waned, and Monet was seeking fresh inspiration, as well as new support. Argenteuil itself was changing, becoming more industrial. The place and, the pictures suggest, Camille herself, so bound up in his vision of it, excited him less. The spring's quartet of portraits of the studio boat, on a branch of the Seine overhung with trees coming into leaf, are valedictions. In the

largest, *The Studio Boat* Jean in a sailor suit sits on the embankment, looking across at Camille – a tiny white dab – floating away in the boat in a pool of water enclosed by bushes and branches. Monet was depicting his wife disappearing from his painting. In pictures from the boulevard Saint-Denis garden, Camille is a pale, wraith-like figure, shrouded by tall flowers or half hidden under leafy trees. Sometimes her face is a blank, sometimes her expression so weary that she looks ill.

In summer 1876 Monet sent begging letters to de Bellio ('I'm in an extremely difficult situation, without a sou ... sorry not to come myself, I'm a bit ashamed'),[31] Zola and the publisher Georges Charpentier, Renoir's friend. At the same time, he made an effort with Victor Chocquet, depicting the Tuileries, lush chromatic blurs, the pavilions no more solid than the foliage, from the collector's apartment at rue de Rivoli. He was also in the wealthy eighth arrondissement, painting three views of the Parc Monceau ablaze with a spreading chestnut tree. The Hoschedé apartment, at 56 boulevard Haussmann, was nearby, and in one of the pictures, approaching on a curved walkway, is the slender silhouette of Ernest's wife Alice, holding their youngest child by the hand. There is no sign of Camille in any of the Parc Monceau paintings.

These Paris pictures herald the end of the Argenteuil period. Although Monet kept his home there for another eighteen months, he spent most of this time away, beginning in late summer when he accepted an invitation to create 'grandes décorations' for Hoschedé's country house at Montgeron, a small town eighteen kilometres southeast of Paris. It was a rare opportunity and a high-risk alliance. Monet would suffer for his trust in his impetuous new patron, and Hoschedé would pay steeply for introducing the artist to Alice.

Duranty, wondering where 'la nouvelle peinture' would go next, concluded with a warning. 'I wish the fleet fair wind ... I urge the pilots to be careful, resolute, and patient. The voyage is dangerous. Let us remember that ... it is a question of ocean-wide painting!'[32]

10

À Montgeron, chez Monsieur Hoschedé, 1876–8

Blanche Hoschedé, ten years old in August 1876, was keenly awaiting the new visitor to her family home, the Château de Rottemberg. 'I remember well his arrival at Montgeron, my parents' house,' she wrote. 'He had been announced to me as a *grand artiste* with long hair. That impressed me and I was immediately drawn to him, for one could feel that he liked children. He was a great tease.' Blanche was already responsive to her father's picture collection. 'I had always admired a small painting of a woman seated in the grass, which showed Madame Monet, I later learned. The dress was flecked with sunlight, which excited me enormously.'[1]

Short for her age, a moon-faced plump child with round cheeks, a rosy complexion and neat fringed hair, Blanche was Hoschedé's second daughter. In photographs with her siblings, each sister in fur-fringed velvet festooned with white bows, Blanche edges to the side or the back, standing when the others are seated in oversized armchairs, or perched on dainty stools. Marthe, serious, pious and with Ernest's heavy features, enjoyed the status of eldest, and a special relationship with her father. The carefree youngest sister Germaine ('Maine'), the only boy Jacques, and the middle child Suzanne ('Sukey'), prettier and more fragile than the rest, each had their roles. Blanche, cheerful, modest and hard-working, was the observer.

The children grew up in the company of artists, and their adoring parents were quick to commission their portraits. The society painter Jean-Jacques Henner was promised 10,000 francs for a full-length likeness of Suzanne, exquisite in feathered hat and boat-collared coat. 'The little Hoschedé . . . with muff, black coat and pink roses, 6 and a half years, very tall for her age' delighted the artist.[2] Hoschedé's slow

Renoir, *Monet*, 1875. Note the long hair, which Blanche so admired.

payment – Henner only received the 2,000-franc deposit – did not. In July 1876 it was Manet's turn. He attempted two plein-air portraits in the gardens of the Château de Rottembourg: Jacques peering out among flowers and grasses, and a double portrait of Ernest and twelve-year-old Marthe. Manet's Hoschedé is a buffoon in a straw hat, stocky, nonchalant, elbow jutting on a table. Button-eyed Marthe, with a concerned expression, leans protectively towards him. 'Awful and unappealing' was the verdict noted in the Durand-Ruel inventory of this painting.[3] Manet did not finish it. He was irritated at Rottembourg: 'too many distractions here to set down seriously to work'.[4] Among the distractions laid on by Hoschedé at his homes in Paris and Montgeron, Blanche recorded 'a "horrible heads" dinner at my parents' house' where Monet and Renoir both painted their faces with welts and 'Renoir had painted a cat face on Mme Charpentier, which was very successful. At this dinner there were many artists with whom my father liked to surround himself.'[5]

Hoschedé, or rather his wife, born Alice Raingo, had acquired the Château de Rottembourg on the death of her father in January 1870. With indecent haste, the couple made it a pleasure palace. Amid the tensions of the impending Franco-Prussian War, they sent out invitations decorated, in deliberately infantile style, with flying geese and ducks waddling around their ornamental pond, asking guests 'to avoid the rush of the opening of the Salon and come to spend the day 'Ô plein air!' The invitation, etched by Félix Bracquemond, a society figure and friend of Manet's, revealed the Hoschedés' cultural aspirations. They were Salon aficionados offering the frisson of bohemian chic, escapist, informal, lavish, new money out to play in the last weeks of the Second Empire. This party, in May 1870 was followed in June by the wedding of Alice's sister Cécile, twenty, to Auguste Remy, a middle-aged banker, a marriage which along with great wealth would bring extreme notoriety.

Hoschedé was the son of a shop assistant and a cashier who had made a fortune in textiles, taking over a fabric company with a store on the corner of boulevard Poissonnière and transforming it into the exclusive Maison Hoschedé-Blémont. Ernest joined the family firm, as expected. Photographs show an agreeable, slightly unsure youth, not ready for responsibility. His flair was for display. At the 1867

An invitation to a reception at Rottembourg on 1 May 1870, etched by the Hoschedés' friend Félix Bracquemond

Exposition Universelle he turned heads by showing Hoschedé-Blémont's lace, Indian cashmeres and expensive shawls in a specially built Renaissance-style pavilion, distinguishing the company from its rivals; *Le Monde illustré* commended it. His flamboyance had already attracted Alice, second of nine children of Alphonse Raingo, whose company Raingo Frères made decorative bronzes and clocks, with commissions from the Emperor. The Hoschedé parents opposed the match, Ernest defied them and married Alice, then nineteen, in 1863. She brought a dowry of 100,000 francs, and received 15,000 francs for her trousseau –thirty times more than the Doncieux gave for Camille's.

The families were acquainted, as both were originally Belgian, entrepreneurial, and thrived under the Second Empire's surging trade in luxury goods. Nevertheless, the solidly prosperous, industrious Hoschedés remained suspicious of the wealthier, more ostentatious Raingos, of a scheming element they detected in Alice, and of certain irregularities such as the illegitimacy of her mother Coralie, Madame Raingo, and, soon, the untrustworthiness of other Raingo sons-in-law. Michel Coste, husband of Alice's favourite sister Léonie, had to be rescued from debts of over a million francs by Alphonse, while

The catalogue of this last Hoschedé sale contained more than 100 items, of which

Ernest Hoschedé and Alice Hoschedé (above) and their four
eldest children: left to right Marthe, Suzanne, Jacques, Blanche,
photographed *c.*1873 by Paul Berthier

Achille Viallate, lieutenant in a Chasseurs regiment, married the third Raingo sister, eighteen-year-old Marie, in 1865 just after the birth in Paris of his illegitimate son Jules to his mistress, a Russian officer's wife. Hoschedé was a witness at this wedding. Before long he too was receiving funds from Alphonse, a loan of 400,000 francs, to support a lifestyle his parents feared would ruin him.

'Ah, Ernest! Ernest! What a fate awaits you!' his mother Honorine wrote in her diary shortly before her son married.[6] His daughters, romanticizing their father, liked to relate how Ernest climbed out of the window of his parents' apartment on the rue de Courcelles to court the teenage Alice against their wishes. Returning from their honeymoon in Florence, Alice hugged her mother-in-law, begging her to 'forgive her, to love her'.[7] Honorine Hoschedé thawed as grandchildren arrived and Alice proved a devoted, competent mother. Still, the Raingo effect became more marked when Alphonse purchased Rottembourg in 1866. While Ernest commuted to the boulevard Poissonnière, Alice spent the summers there. It was the birthplace of her younger children, and she proclaimed a sentimental attachment to the chateau, as if willing it to become the ancient family seat that it was not.

Château de Rottembourg

'It always hurts to leave you, much loved Montgeron, and today my heart is devastated,' she wrote on 27 August 1870, when she took her family to safety in Dieppe during the war.[8] Each time she left the chateau she went from object to object saying 'adieu', and asking 'what will happen?', and indeed the place seemed cursed almost as soon as her father had bought it. Her sister Léonie, twenty-three, died suddenly in summer 1868. A few months later their mother, forty-eight, died there, apparently of grief. Alphonse followed his wife to the grave in a little over a year. The death from smallpox of the eldest brother at the end of the Franco-Prussian War completed the rout of the senior Raingos, leaving Alice, herself recovering from the disease, head of the family and chatelaine of Rottembourg.

During the war, Hoschedé fought in the National Guard. After it, all pretence of commitment to the shop on the boulevard Poissonnière evaporated in favour of embellishing Rottembourg and collecting and speculating in pictures. He had an eye for an important canvas; many good collectors have a background in fabrics which hones under-standing of colour, texture, detail. And he was adventurous, for the Impressionists between them in the mid-1870s had fewer than a dozen committed collectors. But it was obvious that he was buying and selling too fast, holding auctions of recent acquisitions in 1874, 1875 and 1876, and ignoring the demands of his business. 'It's now the second week in which my son hasn't put a foot in here. No doubt he's at the museum every day, oh I have a heavy heart,' his mother wept in spring 1875.[9] Alice noticed her husband was taciturn, distressed. He admitted that he was in debt, and so alienated from the family business that his only solution was to leave it.

'The trouble is more serious than I thought. It's almost ruin. This thought eats up all my strength, all my energy. Am I really so weak before this test, so attached to material things?' Alice asked herself in her journal.[10] In the autumn Ernest staged a theatrical rendez-vous with his mother in the neutral territory of the Parc Monceau and quit the firm. Honorine continued to support him financially; Ernest refused to cut back his spending as she advised, blaming his wife's extravagance. 'Sad year, I see you finish without regret,' Alice wrote on 31 December 1875.[11] 'The wretched Alice dominated by her pride vis à vis her family above all won't leave Montgeron, what idiocy!'

wrote the old lady.[12] She was worried enough about the family's finances to send the children a garment each as New Year gifts. Monet too would complain of Alice's 'imperious family' sensibility[13] and her children remembered, among her well-married sisters, 'Aunt Cécile Remy, whose majesty appeared as though it would crush the whole garden'.[14]

Hoschedé spent the first half of 1876 buying then selling paintings he could not afford. Ernest 'is thrilled, he's made a sale of pictures and thinks he's won everything,' his mother reported in February.[15] 'I don't understand him, is he mad?' she concluded in June.[16] Hoschedé was then forming a new company, Hoschedé-Tissier, Bourely et Cie, launched on 1 August 1876 with capital of 2.9 million francs. It survived less than a year, but reassured Alice. 'At last we've achieved the long-sought result. My poor dear husband has been able to reorganize his company as he wished. He's so happy today: the deed has been signed and at last he can put his heart back into his work and into his home,' she wrote on 26 August.[17] A few days later Monet arrived in Montgeron.

He loved it. Although Hoschedé had been known to charter a train to bring visitors to Montgeron, Monet travelled alone from the Gare de Lyon on his first visit. The lyrical painting *The Arrival at Montgeron* reads like a spontaneous expression of joy. The villa's grounds were fringed by the railway and Monet depicted red and white flowers bursting over a small barrier before the track and climbing the embankment. The train shoots into sight on the line which marked the boundary of Hoschedé's estate and divided it from the river Yerre; the engine puffs blue spirals into a golden, heady atmosphere. The picture captures a rush of heightened sensations – hissing locomotive, fragrant wild flora, drowsy heat, gleaming track tapering to infinity in the sunlit distance. It is a memory of happy anticipation, the pleasure on disembarking for the paradise of nature, luxury and attention to his art awaiting him at Rottembourg. Years later Monet tracked this painting down and bought it back from a dealer.

His commission for the chateau was to decorate the rotunda salon. Hoschedé wanted something striking, a quartet of large panels depicting any part of the estate his guest chose. It was an unusual idea then, bringing images of the garden into the house, blending interior and

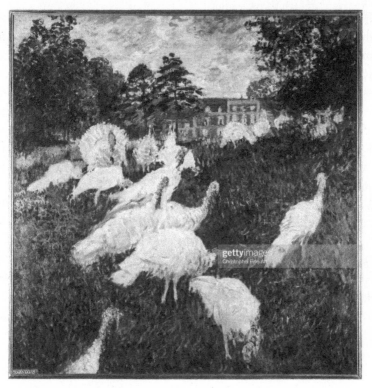

Monet, *The Turkeys*, 1876, showing the façade of the Château de Rottembourg

exterior, anticipating Bonnard's and Vuillard's decorative schemes in the 1890s. Hoschedé was not disappointed with the results. Monet's first panel, a flock of white turkeys roaming summer grasses, their snowy plumage huge, unruly, lighting up the parkland, has an elemental force. Outrageous, glamorous as Hoschedé sought to be, it provoked uproar, amusement and admiration even from the reluctant. The Irish novelist George Moore, who lived in Paris in the 1870s, remembered screaming with laughter before the painting, yet admiring in spite of himself the gobbling turkeys flooded with sunlight. The picture tells its own truth: the turkeys dwarf and partly obstruct Rottembourg's long red frontage, which shimmers like a mirage, a castle in the air. The chateau appears a place of enchantment, and a façade, a strutting show. Its generous, portly host perhaps resembled his own bewildered, guzzling birds.

The Turkeys shows how the setting immediately stimulated Monet. In the second large panel, *A Corner of the Garden at Montgeron*, late summer roses are piled high, and the view stretching across park, water, woods, expand on his delight. In the third, *The Pond at Montgeron*, Alice with her fishing rod is an almost stealthy presence in the corner, and in the final panel, *The Hunt*, within the multiple small touches building up the glimmering tunnel through russet trees swaggers Ernest, pointing his rifle at partridge and rabbits in the thicket. How apt that Monet depicted this voracious couple in predatory acts of stalking and acquisition.

Blanche liked to carry Monet's brushes and paints when he worked outdoors, so she may be the tiny figure in the undergrowth on the far shore of *The Pond at Montgeron*. In the shade close by, between two trees, Alice leans towards the pond. There is no horizon line, the trunks mirrored as deep verticals in the water stabilize the rippling surface; streams of yellows and greens inflect the dark undulations, lit with traceries of reflections from an invisible sky and surrounding foliage. Without contours on three sides, this film of water covers more than two thirds of the tremulous, enveloping canvas. On the left, a liquid zigzag of blond light spurts across the water – an implicitly sexual image – and is echoed by cursive golden marks, calligraphic accents swirling on the narrow strip of shore above. Everything moves, yet the painting evokes silence, secrets, the confined garden where Monet glimpses Alice across a flickering emptiness. *The Pond at Montgeron* is a pivotal work. A perfect example of Impressionism in its broken touches and transient light, it is also an abstracted world turned upside-down, where reflections matter more than 'real' objects, anticipating the immersive water-lily paintings created at Giverny.

Montgeron's pond, as well as its owners, were prominent in Monet's mind when he returned home at the end of summer 1876. In Argenteuil he painted late-afternoon and evening autumn scenes of the Seine, surrounded by foliage, as if the river too was an enclosed space. By October he was back in Montgeron, finishing *The Hunt* before the last leaves fell. A letter to de Bellio pleads that he visit Argenteuil to choose a picture, because Monet had left Camille without money. Camille led the doctor to the major portrait *Woman with a Parasol*, which he purchased on 17 November. On 4 December,

writing to Gustave Manet to delay repaying a loan, Monet continued to give his address as '*À Montgeron, chez M. Hoschedé*' – a Hoschedé who was mostly absent, fighting for the survival of his fledgling company in Paris. Through autumn 1876, therefore, Camille was in Argenteuil, impoverished and alone with Jean, while Monet enjoyed the comforts of Montgeron in the company of Alice.

As Camille's presence in Monet's paintings diminishes, Alice becomes sharply defined in his life, a clear, forceful personality. Many artists, including Sisley and Carolus-Duran, were summer guests at the chateau, and she was for them all an ideal, soothing hostess, practical and energetic too. Wandering the grounds one morning, Manet met her on her way to pick asparagus; the future painter of the famous *Bundle of Asparagus* stared up at the sky then down at the earth, confessed he had no idea whether the vegetable grew on trees or along the ground, and received a laughing lesson in kitchen gardens. Brought up to charm and be charmed, engrossed since childhood in the milieu of the decorative arts, with an understanding of high craftsmanship and seductive display, Alice had a refined taste and an elegant informality. At home in the interconnected worlds of fashion, money, art, she bought her clothes from the leading couturier Worth and her

Carolus Duran, *Portrait of Madame Alice Hoschedé*

perfume from Rimmel. Without being beautiful, she had style, presence, character.

Painted in the summer of Monet's visit and dedicated 'To his friend E. Hoschedé', Carolus-Duran's portrait of Alice relaxing in a garden chair shows a luxuriously attired woman in her early thirties, with chestnut hair, grey eyes and regular features, slightly heavy like Ernest's. More intimately sympathetic is a miniature from 1875 by Pauline, Madame Carolus-Duran, a a painter who exhibited miniatures and pastels at the Salon through the 1860s and early 1870s. She fixed in a few centimetres Alice's complexity: self-assurance and composure balance the impression of a high emotional tenor; both shrewdness and warmth are in the eyes, and something leaden, a burden of worry smouldering beneath the smooth exterior, weighs down the little likeness on ivory. Alice received it with elation: 'I am delighted to think that after my death my children will keep this image reproduced by a friendly hand. At the moment I had smallpox, I recall the pang of anguish I felt when thinking that my children had no portrait of me. It is thanks to you, my dear Pauline, that I will have this joy.'[18]

This was Alice as Monet first knew her. Even a hostile witness, Honorine Hoschedé, conceded that she was 'more delicate and prettier than in her photograph . . . This young woman has wit, intelligence in plenty and, I believe, strength of will.'[19] Her face in photographs expresses determination, ambition, an appetite for life. Her journal, begun in a tiny red leather *carnet* on the eve of her wedding, unfolds more complexity: into it flowed the not wholly articulated doubts of an educated, quick-thinking yet volatile young woman submerged within ceaseless domestic and social activities. Alice worried about Ernest failing to return from business trips, and burst into a hysterical fit of crying one day when, going to meet him after a shoot, she could not find him, and ran from room to room in the chateau as in a nightmare. She grew so jealous of the nurse for her first-born, Marthe, that she sacked her, a warning of a capacity for pathological envy. Above all, the anxiety twisted inward, making every birthday a narcissist's interrogation. On 19 February 1869, awaiting the birth of her fourth child: 'I'm 25 today, why am I so sad?' Three years later, at her twenty-eighth birthday: 'I don't know what to invent to torture myself.' In

1874: 'Thirty today. I can't believe that I am so old, that I am so stupid and, as my dear husband says, am still such a baby.'[20]

Perhaps it was Ernest who was childish. Alice was seventeen when she met her husband and at thirty-two was outgrowing him. A single ecstatic entry in her journal stands out, and coincided with Monet's stay at Montgeron in autumn 1876: '8 October! What a beautiful sky and what a lovely day I've spent today. It's been many years since I've been so happy.'[21] The discreet comment is not proof, but it seems there was an instant, powerful spark of attraction between Monet and Alice. From the moment of meeting, Monet made sure through the 1870s that he was not far from her. It was a factor determining where he lived, what he painted, and it began at once with a resolution to break from Argenteuil.

While still at Montgeron, he made plans to rent an apartment-studio in Paris, at 17 rue Moncey, in the new year. Rue Moncey was equidistant between the Gare Saint-Lazare and the Hoschedé apartment at boulevard Haussmann, and Blanche remembered that the families met at his studio. There is no suggestion of impropriety, how-ever, and Hoschedé, concealing his business troubles, remained a lively presence for Monet. The Hoschedé parade went on: artists' din-ners, shooting weekends, what *Le Figaro* referred to as Montgeron's 'legendary parties', all brightened by Alice's engaging welcome. 'Her conversation is easy,' her mother-in-law comforted herself, 'though I find her voice rather loud.'[22]

Did Alice's loud voice silence Camille? Monet's wife at this point appears passive, far from the vibrant model who was chatelaine of the forest in *Déjeuner sur l'herbe*, queen of the summer in *Woman with a Parasol*. Approaching thirty, Camille was battered by life, thrown back into financial insecurity, her husband absent at moments of crisis as he so often had been. Monet stayed at Rottembourg almost until the house was shut up for the winter on 24 December, working on the cheerful portrait *Germaine Hoschedé with her Doll*, where the three-year-old youngest Hoschedé daughter with bright blue eyes gazes at Monet with curiosity and confidence.

Alice left Montgeron in fear, dreading the next nine months: she had just discovered that she was pregnant with her sixth child. But in

Argenteuil, Camille's problems were of a different order. 'I am heart-broken,' Monet wrote at the end of 1876 to Manet.

> Yesterday evening I returned and found my wife very ill. The doctor has had to come several times. I've seen my landlord this morning and only by force of prayer did I manage to get him to wait until Monday. Friends are rare in distress ... I am begging you not to abandon me. I've run around all day looking for loans, but without success ... I'm scared, really scared, of not finding any help. Should this catastrophe happen, I don't know if my wife would survive the shock at the moment.[23]

Monet in cadging loans was not above using Camille to win sympathy, and this is a further reason, in the absence of her own voice, that she sounds helpless. But this time he was in earnest. 'New horrors overwhelm me,' he told de Bellio,

> my wife is ill, seriously ill, since the doctor here has asked to have another doctor's opinion. I'm very frightened, because they haven't hidden the gravity of the illness and my wife and I would be very glad if you would advise us, because they're talking about an operation which utterly terrifies my wife. I can't tell you exactly the name of the illness, but it concerns ulcerations of the womb.[24]

Camille did not have an operation – the homoeopath de Bellio would have advised against it– and Monet allowed himself to be reassured. Ulcerations could have indicated tubercular or cancerous lesions, but Camille seems to have rallied. And Monet was eager to be gone. Argenteuil offered only motifs which had lost their allure, a sickly wife, the reality of an impoverished existence. Jean's school fees were overdue; in January the headmaster agreed to accept three paintings instead. Hunched over his account book dense with IOUs, scribbled in black, Monet at the beginning of 1877 gave up calculating his debts and the sums are continued by Camille – poignantly the only writing in her hand which survives. Monet painted a portrait of her, *Camille with a Bouquet of Violets*, using the flowers which symbolize fidelity. It is full of pathos. Camille limply holds the little bunch of flowers, and her pale worn face and big sad eyes fix Monet with a look between understanding and reproach.

Monet, *Camille with a Bouquet of Violets*, 1877

Then he set off, alone, for Paris. By 17 January, two days after
Camille's thirtieth birthday, he was installed in the small ground-floor
apartment-studio at rue Moncey awaiting collectors. The rent, 175
francs a quarter, was paid by Caillebotte. Rue Moncey, facilitating his
withdrawal from Argenteuil, was now his business address, used for
meeting clients and for his correspondence. He threw himself into life
and painting in Paris, frantically completing a dozen Gare Saint-
Lazare paintings in as many weeks.

Renoir left an imaginative account of their genesis. Aiming 'to capture the play of sunlight on the steam rising from the locomotives ... with smoke from the engines so thick you can hardly see a thing ... a dream world', Monet, according to him, 'put on his best clothes, ruffled the lace at his wrists, and twirling his gold-headed cane presented himself to the director of the Western Railway.

> The head of the company knew nothing about painting, but did not quite dare to admit it. Monet allowed his host to flounder about for a moment, then deigned to announce the purpose of his visit. 'I have decided to paint your station. For some time I've been hesitating between your station and the Gare du Nord, but I think yours has more character.' He was given permission. The trains were halted; the platforms were cleared; the engines were crammed with coal so as to give out all the smoke Monet desired. Monet established himself in the station as a tyrant and painted amid respectful awe. He finally departed with a half-dozen or so pictures, while the entire personnel, the director of the company at their head, bowed him out.[25]

Actually, in a letter of 7 January 1877 Monet demurely requested help to obtain permission not yet granted to paint at the station. Renoir was celebrating the originality of Monet's venture, and the strange 'dream world' of illuminated steam – another play of light on water – that resulted from this forthright engagement with motifs of modernity. The railway, which had transformed France in Monet's lifetime, was the emblem of industrial materialism. Monet dematerialized that brute fact into phantasmagoria, weightlessness, indefinable smoky effects, while also depicting might and movement with an intensity of mark-making, a graphic brilliance of streaked, scribbled strokes, open brushwork, and blue-grey arabesques rising from the massive engines.

The Saint-Lazares are his first exploration of a single subject across several paintings, at different perspectives, times of day and season, levels of sharpness and blur. Together the paintings create a sense of the station as a place of incessant action and stimulation. Monet began in wan winter light, in January with *Interior View of the Gare Saint-Lazare*, and concluded in April with *Outside the Gare Saint-Lazare: View of the Batignolles Tunnels in Sunshine*. The works

range from the architectonic, with an emphasis on the iron and glass roof and the hefty interlocking diagonals of the Pont de l'Europe, to the much freer *Gare Saint-Lazare: The Signals* [Plate 22], dominated by two huge dark discs and rising smoke as almost abstract swirling marks, and a frenzied sketch pulled off in a single session, *Gare Saint-Lazare: Tracks and a Signal in Front of the Station Roofs*. Their vigour reflected Monet's energy and restlessness in 1877, unleashed in Paris after years of calm in Argenteuil. The biggest, *Gare Saint-Lazare: Arrival of a Train* [Plate 21], featuring an enormous gleaming black locomotive puffing along on a track leading towards the viewer, is a thrusting macho painting, and was acquired instantly by Hoschedé. He also bought the diaphanous *Arrival of the Normandy Train*, a blue-green harmony and evocation of emptiness – a vast bare foreground, and towards the centre an area of almost pure white. These choices underline his discernment, and his involvement was significant. Here and at Montgeron, Hoschedé's enthusiasm spurred Monet.

A *Gare Saint-Lazare* hung at the entrance to the third Impressionist exhibition, and many others were included, leading *Le Figaro*'s critic to complain that the show imitated the cacophony of several locomotives whistling at the same time. The exhibition opened on 4 April 1877, and Monet took an active part in channelling its focus and quality. Cézanne boasted that Monet had passionately defended his presence in the show. It was the first exhibition for which the artists embraced the term Impressionist. There was a tight identity among the core group of Monet, Renoir, Pissarro, Sisley, Cézanne, Degas and Morisot. Caillebotte was one of only a couple of newcomers and the old guard, even sympathizers like Boudin, had either withdrawn or not been invited, making the show more distinctive.

How emblematic of modern Paris this exhibition must have been. Alongside Monet's locomotives hung Renoir's breakthrough piece of Parisian society *Dance at the Moulin Galette*, and Caillebotte's masterpieces of urban alienation *Paris Street: Rainy Day* and *Le Pont de l'Europe*. Monet showed thirty paintings, his biggest display so far, including marines from Sainte-Adresse, flowering fields from Argenteuil, the Paris Tuileries and stations, portraits. Listed in the catalogue as an 'unfinished decoration', the *Turkeys* had a room to themselves

and drew particular attention. 'What will it be, good God, after the final brushstroke?' asked *Le Moniteur universel*.[26]

As a collector, Hoschedé enjoyed glory from this. He owned eleven Monets on display, as well as works by Pissarro and Sisley, and was the biggest lender to a show which, for all the glitz of the opening party, the crowds, the reviews, laid bare how dependent the Impressionists still were in the late 1870s on a tiny band of buyers; the attention they garnered did not yet translate into a serious market. Durand-Ruel's position was so difficult that he had been forced to rent out his gallery for the whole of 1877, so Caillebotte found and paid for premises down the road, at 6 rue Le Peletier. Cézanne, Renoir and Monet were thus each dependent on their own patrons. Cézanne showed a portrait of Victor Chocquet, who retired that year to devote himself to his collection. He gave the Impressionists a terrific moral boost. Daily at the 1877 show he took mockers to task,

> persuasive, vehement, domineering in turn, he devoted himself tirelessly, without losing the urbanity which made him the most charming and formidable of opponents ... He was always ready for them. He always found the right word where his painter-friends were concerned. He was above all untiring on the matter of Cézanne ... Many visitors were entertained by Chocquet's enthusiasm, which seemed to them a form of mild insanity.[27]

Renoir's patron Georges Charpentier, publisher of Zola and Flaubert, was a milder, sociable, worldly figure, for whom Maupassant claimed the word 'sympathique' had been invented. Renoir showed portraits of Charpentier's daughter and his wife Marguerite, hostess of a weekly salon. The Charpentier collection was small, and although the couple occasionally considered buying from Monet, they haggled. Hoschedé by contrast did not. In 1877 he was a collector on a scale well exceeding Charpentier or Chocquet, and more flamboyant. If the cerebral Chocquet was a natural fit for Cézanne, and the easy-going Charpentier for Renoir, it was Monet's fate to have found in Hoschedé a temperament as impetuous and extravagant as his own.

Alice was back at Montgeron in spring 1877, preoccupied with Marthe's and Blanche's first communions. In June the Hoschedé children received a legacy of 250,000 francs, to be administered by their

grandmother, from François Herbet, business partner of Hoschedé's father. To Hoschedé, of whom he had been fond but despairing, Herbet bequeathed his picture collection, mostly Barbizon artists. The implication was that he wanted to safeguard the inheritance from Hoschedé's profligacy or eventual creditors. But Hoschedé needed cash, and the bequest emboldened him. On 23 June he took out a short-term loan of 100,000 francs, from picture dealer Émile Barre. He was unable to repay in time. He already owed 200,000 francs to his associates at Hoschedé-Tissier, and when they summoned him, he refused to appear. The apartment at boulevard Haussmann was authorized to be seized, and the furniture sold in three sales, ending on 1 August. It fetched 20,922 francs.

Alice, in Montgeron, had no idea that her Paris apartment was being emptied, although she noticed her husband was preoccupied. Monet spent part of the summer in Montgeron, finishing Hoschedé's panels, and there was a semblance of normality. Carolus-Duran, also there, painted Marthe in pale pink, an open book on her lap, in shade in the garden. The daughter most sensitive to her parents' moods has a gauche charm, but appears apprehensive, tense, too earnest for a thirteen-year-old.

On 15 August the family celebrated the fourth birthday of Germaine, the summer child born in the optimistic aftermath of Ernest's return from the war and Alice's recovery from smallpox. The new baby was due in altered circumstances, and on 18 August Alice spent a feverish night waiting for Hoschedé to return from Paris. He did not. He was declared bankrupt the same day and fled to Brussels, trying to escape his creditors. On the way he happened to meet a friend – he had so many that this was not surprising: painter Victor Leclaire accompanied him and apparently prevented him from suicide. A letter arrived at Rottembourg the next morning: 'My beloved wife! What can I call you, what may I call you now? I struggled like a giant for a whole month. I lost my head. I wanted to kill myself, I can't stay in Paris. Am I to go on living for your sake and that of our beloved children? Don't curse me. Tell me to take heart or tell me to disappear. Let no one try to find me, or I shall kill myself.'[28] That was how Alice discovered the fall of her husband's house of cards.

Creditors had an appointment at the chateau on 7 September, to

seize what they could and make an inventory of the rest. Entrusting her jewellery and silver to her brother-in-law, the banker Remy, Alice left Montgeron. She took her five children, a single remaining servant, and her little diary, to the Gare d'Orléans (now Austerlitz) and set out for her sister Madame Viallate's home in Biarritz. 'Alas, how can I manage the journey in the state I'm in?' she wrote. 'What to do alone without support. Griefs overwhelm me. It wasn't enough to have ruin, dishonour, abandonment. I discover that I have been betrayed, me who believed so much in love.'[29] As the family fled south, the theatrical Hoschedé-Raingo style had a final flourish. The train was halted en route when in the 'wagon de souffrances', on 22 August, Alice gave birth in her compartment to her sixth child, Jean-Pierre Hoschedé, while in a neighbouring compartment the stunned station manager minded the newborn's siblings.

Monet followed disastrously in the slipstream of Hoschedé's misfortunes. In Montgeron or in Paris he may have gleaned something of his patron's problems before the collapse. A letter to an unknown recipient on 5 July shows his ties to Hoschedé and that he feared the worst: money was supposed to have been paid on his account by the collector but, he wrote, 'the danger is great and above all very near'. In debt, threatened with the bailiffs, Monet feared bankruptcy himself: 'I would prefer to be done with it once and for all rather than drag it out moaning to everyone, and I don't have the strength to beg my bread.'[30]

At this nadir in the Monets' fortunes, Camille became pregnant, a debilitating experience for a woman who had been seriously ill. If the pregnancy had been planned, the Monets must have overcome concerns about her health, or the winter's brush with mortality spurred them to want a baby. After a decade without another child, the coincidence of Camille's pregnancy with Alice's is notable, and raises possibilities of subtle veins of jealousy, guilt, competition, emulation: that the Monets were trying to save an ailing marriage, that Camille was stung by Monet's attention to Alice and her children into wanting another child, or simply that Monet had enjoyed himself so much with the big clan at Montgeron that he wanted to enlarge his own family. Lilla Cabot Perry remembered that 'this serious intense man had a most beautiful tenderness and love for children, birds and flowers, and this warm nature showed in his wonderful, warm smile'.[31]

The Hoschedé children recalled the spirit with which he played hide and seek, tennis and croquet: when he stopped playing, the game lost all interest.

Jean-Pierre's birth was registered in Biarritz, and his mother nursed him in the luxury of the Viallates' Villa Maria, where the Raingo family held council and offered Alice a small allowance. While both she and the baby thrived, Camille in Argenteuil did not. Monet was her nurse, and was constantly at her side: 'impossible to think about painting during this time'.[32] His letters before and after the birth are a litany of apologies for failing to keep meetings, for delays in finishing promised pictures, and for the embarrassment of pleas for loans. Between his final visit to Montgeron in summer 1877 and April 1878 he completed only four paintings, a quartet of small views of banks of flowers at Argenteuil.

'I went to see Monet yesterday, I found him quite broken down and in despair,' Manet told Duret in late 1877.[33] Monet cast himself as 'un pauvre sans-le-sou' in begging letters circulated to a core of collectors, chiefly doctors de Bellio and Gachet, Chocquet, banker Ernest May and pâtissier-restaurateur Eugène Murer. Hoschedé's patronage was finished. He contested bankruptcy, but his claim was rejected on 5 October 1877. He had debts of over 2 million francs, to picture dealers including Georges Petit and Durand-Ruel, to fabric suppliers, restaurants, his hat-maker, Alice's couturier Charles Worth. Monet meanwhile was dealing in rock-bottom propositions: 50 francs each for four pictures to Murer; twenty-five canvases as a job lot for 500 francs to de Bellio. 'I could not be more unhappy.' Monet told the doctor. 'Once on the street and with nothing, there will be only one thing for me to do: accept some kind of employment ... I can't believe it and I'm fighting with my last strength.'[34]

Was Monet really so poor? His earnings for 1877 were his best since 1873 – 15,197.50 francs. Over half of this came from Hoschedé in the early part of the year, and medicines and doctor's bills for Camille through 1877–9 drained his resources, but it remains a considerable sum. A doctor lived comfortably on 9,000 francs a year in 1870s Paris. The poet Mallarmé earned an annual 3,300 francs as a schoolteacher at the prestigious Lycée Condorcet. A labourer took home on average 1,800 francs, and Zola in the 1860s had told

Cézanne he would need 125 francs a month to live in Paris – as a single man, but including hiring a studio.

Monet's haranguing missives declaring poverty recall those to Bazille before Jean's birth, but Monet was now thirty-seven, selling regularly, acknowledged the leading artist of his generation. There is an inverted arrogance in these letters. The tone varies, more respectful to the banker, more hectoring to the baker, but the urgency does not. 'My wife could give birth any day and I am without a sou,' he wrote two months before the baby was born.[35] An eviction, a baby, days or hours away, a note sent with a porter waiting to return with a few francs to save the Monets from their latest mishap, all conferred pressing responsibility for his troubles on the unlucky recipients of his letters. It is an attitude that reflects Monet's confident assumption that his welfare must be, deserves to be, the immediate concern of others.

It was a vanity born of supreme egoism. Neither acquisitive not envious, Monet lived in modest houses and was far less in need of admiration than, for example, Manet, but he believed his art conferred a right to good living, and he enjoyed fine things. Renoir's story was that, even when impoverished, 'Monet continued to wear shirts trimmed with lace and to patronize the best tailor in Paris. He never paid the poor man';[36] Camille's expensive fashions, asides to Bazille asking for good wine amid wails of poverty – all declare a profligate spender, whose experience was that help came in desperate moments. His dread of the quarterly rent day, or the termination of a paint merchant's credit, was nonetheless real; the letters were not mere manipulations. 'Would you and could you do me a big favour?' he asked Zola in 1877. If I haven't paid 600 francs by tomorrow night, Tuesday, our furniture and everything I possess will be sold and we'll be on the street. I don't have one sou ... I'm desperate my poor wife doesn't learn the reality of this, and I'm turning to you in the hope that you could perhaps lend me 200 francs ... I don't dare come myself.'[37]

Near-eviction happened too often, and by the end of 1877 Flament, the landlord, had lost patience with his unreliable tenants just as Monet had lost patience with Argenteuil. A sentimental reason for moving to Paris was for the new baby to be born there, as Monet, his parents and Jean had been. The Hoschedés were another attraction. They were back in the capital and still able to afford, on New Year's

Day 1878, a visit to photographer Paul Berthier's studio on quai Malaquais. Alice, immaculate in a brocaded jacket, holds Jean-Pierre on her knee and looks composed, resolute. Her expression gives away nothing of what she felt about the husband who had squandered her inheritance and lost her Rottembourg. The chateau was mortgaged and was about to be sold for 134,000 francs, considerably less than its 175,000 franc valuation when Alice inherited it. Looming as a memory across the gulf that separated the two halves of Alice's existence, the chateau stood between her and Ernest. From now on it would be no more than a glimpse from a train window. 'Voilà Montgeron,' Alice headed a letter scrawled one December morning thirty years later, when she happened to be awake in the sleeper compartment of the overnight express, as it hurtled past on its way to Paris.

Monet and all the Impressionists dreaded the auction of the paintings which had been Hoschedé's ruin. 'The Hoschedé sale killed me,' Pissarro wrote.[38] One of his canvases was knocked down at 7 francs, another at 10, catastrophically devaluing his work. Hoschedé's Renoirs made between 31 and 84 francs. His Monets did better, although they sold lower than the collector had paid. For 210 francs de Bellio got *Impression, Sunrise*, which had cost Hoschedé 800. Some failed to sell. The market was thus flooded with Impressionist works at a time when economic conditions had been getting tougher. Unlucky, overgenerous Hoschedé: his understanding of art was in advance of his time, but his head for business was so weak that he could not afford to wait for taste to catch up. Most of the Monets and Manets he owned are now prize works in museums.

'The entire clan of painters is in distress. Édouard speaks of watching his expenses and giving up his studio,' wrote Manet's brother Eugène in late 1876.[39] But the Manets' lives were rarified. Eugène, coming across Mallarmé one morning carrying wine up from his cellar, was appalled that a poet should have to perform such domestic chores. Édouard Manet, although he craved sales as a sign of recognition, did not need to sell. Sensitive to Monet's greater difficulties, he sent him a 1,000-franc loan on 5 January 1878, making possible the move from Argenteuil. It did not fully cover Monet's debts. On 8 January, a week before the final rent was due, Monet, in arrears, was unsure whether he could leave without having his furniture and

paintings seized. Everywhere he was trailing debts. The sum of 1,550 francs to a framer called Nivard on rue de Vintimille, owed since 1875, was finally paid, plus interest of 785.20 francs, in 1885 under threat of litigation. A laundrywoman, Madame Prétot, who could not afford a lawyer, was still chasing Monet for unpaid bills in 1896. When the removal was already booked on 15 January Monet begged de Bellio for 'a *final* service' of a 200-franc loan, for 'I hope you won't want to abandon me just at the moment when I'm coming into port.'[40] On 20 January a porter delivered a note to Murer: '*Me voilà dans une cruelle situation*; our furniture is loaded on to the van, but how to pay the removers – not a sou. Would you do me the biggest favour, and advance me 100 francs, without which I don't know what to do. If you can't part with that much, send the porter what you can.'[41]* It was eventually Caillebotte who dispatched 160 francs, and the little family set off for their new apartment, five rooms on the third floor at 6 rue d'Édimbourg, a few minutes' walk from the flat Honorine Hoschedé had rented for her son at rue de Lisbonne.

Remaining in Flament's basement as security against remaining unpaid rent was the giant *Déjeuner sur l'herbe*, portraying the five happy Camilles in the forest of Fontainebleau. Symbolically, Camille as Monet had known and loved her was left behind in Argenteuil.

* This letter begging 100 francs sold for £27,500 at Sotheby's on 7 December 2000.

11

Pastoral, 1878–9

Michel Monet, nicknamed Mimi, was born on 17 March 1878 in Paris, and registered at the town hall of the eighth arrondissement by Manet. Monet celebrated with two exuberant flag paintings, *Rue Montorgueil* [Plate 23] and *Rue Saint-Denis*, holiday pictures of tricolours, fat staccato red, white and blue strokes fluttering, flapping, twirling above narrow thronging streets. The flag motif connects these joyful works with *Terrace at Sainte-Adresse*, made during summer 1867 when Jean was born. The births of Monet's two sons happened to take place in the years of Paris's second (1867) and third (1878) Expositions Universelles, and each time the city was in festive mood. At a republican *fête nationale* – a precursor to Bastille Day – in 1878, Paris partied to tricolour displays across streets, buildings, restaurants, carriages, even hearses. Monet rode the tide of national jubilation, combined with his own elation at the birth of Michel, who 'happily is doing marvellously'.[1] 'I'm very fond of flags,' he recollected of these paintings to the dealer René Gimpel. 'I went out with my working equipment to the rue Montorgueil; the street was decked out with flags and the crowd was going wild. I noticed a balcony, I went up and asked permission to paint, which was granted me. Then I came down again incognito. Ah, it was a good time, a good time, although living wasn't always easy.'[2]

The man met the moment in these impetuous, vertiginous paintings, finished on the spot like a virtuoso performance, and sold instantly. They concluded Monet's Paris pictures of the 1870s when, art historian Meyer Shapiro writes, 'a degree of impulsiveness and freedom hitherto unknown in painting was realized through a brushwork that had a correspondingly chaotic air and yet was held together

Monet, *Flowers in a Pot*,
1878, painted at the time
of Michel's birth

by his firm touch and spontaneous rhythms of execution, which
seemed to issue from his conviction and enthusiasm before the human
world in movement, the outward life of the city.'[3]

In his exhilaration in spring 1878, Monet even sent his still lifes
spinning. In *Flowers in a Pot*, abundant pink roses and feathery white
gypsophila burst out of a silver dish, its tarnished ribbed surface also
undulating. The pot stands on a table that seems to surge towards the
viewer as soft petals fall on a striped cloth. There is comparable
expressive rhythm in the blossoms and flowers in three dappled *Parc
Monceau* pictures, dramatic dispersions of light and shadow where
sun-pierced foliage envelops sketchy figures in white, women holding
babies, small children sitting on the gravel paths and, in one render-
ing, an older girl in a drop-waist dress with a pink bow, probably
Blanche.

'In 1878 . . . we were very close to the Monets, who then had two
children, and we often met them in the Parc Monceau where Monet
painted his canvas,' Blanche writes in her child's voice in a brief

memoir, continuing, 'In July our two families rented a house in Vétheuil for the summer, which we did not leave until three years later. Monet was not terribly well off, and neither were we, for my father's business affairs were going from bad to worse.'[4]

The Parc Monceau and flag pictures were Monet's farewell to Paris. He never painted the city again, and quit it for good shortly after completing them. The Monceau group, however, was a beginning, too, an introduction on canvas to the blended family coming into being.

The unconventional plan to live communally, away from Paris, was justified as a pooling of resources. Monet's crop of attractive still lifes and Paris pictures all sold fast, but, partly due to Hoschedé's auction, prices were low. Hoschedé was surviving on a 500-franc monthly stipend from his mother. Alice had a modest allowance of 680 francs a year from her sisters, supplemented by gifts from the richest of them, Cécile Remy. Given the wealth in the extended Hoschedé-Raingo families however, it is hard to believe that economy was the main factor in the joint move to Vétheuil. Rather, each party was influenced by subtle plays of advantage. For Alice and Monet, a strong mutual attraction, even if as yet undeclared, was surely the driving impetus; they wanted to stay near each other. Ernest also sought to keep close to Monet as his lifeline to the world of art; he would not leave the milieu of his misfortunes. Although disgraced, he was still trying to trade pictures, including in 1878 *The Turkeys*, and before they left Paris, Monet allowed him to buy *The Rue Saint-Denis* for 100 francs. Hoschedé resold it days later at double the price, to the composer Emmanuel Chabrier, Manet's friend. Monet had sold directly to Chabrier before and could have done again. He was in generous, or guilty, mood, and full of hope about his next paintings.

'I have planted my tent on the banks of the Seine at Vétheuil, in a ravishing place from where I should be able to bring back things that aren't bad,' he wrote on 1 September.[5] Sixty kilometres downstream from Argenteuil, Vétheuil, then a village of 600 people, stands on a loop of the Seine, squeezed between the river and chalk hills and cliffs. The Romanesque church of Notre-Dame-de-Vétheuil rises above a cluster of red- and grey-roofed houses, throwing long reflections in the water. Across the wide river, dotted with grassy islands, is Lavacourt, a

hamlet with a towpath running along its embankment. A flat-bottomed ferry connected the two, and by boat it was also possible to reach shallow, willow-fringed inlets. All around were meadows and fertile plains, and orchards studded the slopes.

Monet painted an initial enchanted summer landscape, *The Seine at Lavacourt*, a foreground of water, blots of reeds, bushes, vibrant reflections, and in the distance the cluster of houses and poplar-lined bank. He loved this view, painting it eight times between summer 1878 and spring 1880, culminating in a refined, silkily brushed large version, of which the conservative *Gazette des Beaux-Arts* said the 'luminous and clear atmosphere makes all the landscapes around it in the same gallery seem black.'[6]

Lavacourt under bright skies and the river swollen in a summer storm gave way in his autumn paintings to vistas of misty mornings and cool evenings on the tidal islands, in almost symmetrical compositions of the trees in the water such as *The Petit Bras de la Seine at Vétheuil*, a lyrical vision of shelter and secrecy. Crops glow and geese graze at the waterside in *The Banks of the Seine at Lavacourt*, trees are laden with fruit in orchard paintings from the Chantemesle hills. Vétheuil, remote, picturesque, offering rural life in accordance with the seasons, was untouched by incursions from city or suburbs. The nearest station was twelve kilometres away at Mantes, where travellers boarded the twice-daily 'voiture publique de Monsieur Papavoine'

Vétheuil, late nineteenth century

for the final lap on uneven roads. The journey from Paris took seven hours. 'Few Parisians know about Vétheuil, which is perhaps why it is one of the most charming spots I've ever seen,' wrote the journalist Émile Taboureux, who made the trip in 1880 to interview Monet.

Inaccessibility meant lower rents and living costs. At first the families squashed into a little house on the Mantes road. Then they took, on a lease beginning 1 October 1878, the last house in a row of three giving straight on to the route de La Roche-Guyon, the northern road into the village. The annual rent of 600 francs was less than half what Monet had paid in Paris or Argenteuil, and was split between Monet and Hoschedé: just 25 francs a month each. Further expenses were to be divided, according to mouths to be fed, excluding the babies, in the ratio Monet–Hoschedé three to seven.

The house, twelve metres wide by ten metres deep, had living and dining rooms downstairs, three bedrooms on the first floor, a big attic, and a rare state-of-the-art bathroom with English plumbing installed by the owner, Madame Elliot, the widow of a Nottingham merchant. Taboureux described 'a charming house, completely modern' though simple, 'an interior furnished with only the most elementary, primitive objects: a bed, a chest of drawers, a wall cupboard, a table that was not exactly loaded down with books ... and, hanging on the walls there (the totally vulgar wallpaper left me cold), were paintings by Monet!' There was no studio. Monet worked downstairs or in the attic.

To the side was a garden; another, across the road, was reached by a wooden staircase leading to a path where Monet placed his blue and white pots. There were wild flowers, an apple tree, cliffs hollowed out into cave-like cabins, vegetable patches, chicken runs and rabbit hutches – food for the many mouths – and a gate in the trellis fence opening to the Seine. Here, Monet kept his floating studio and Hoschedé a mahogany rowing boat, known as 'La Norvégienne'. 'You know where I met Monet?' Taboureux asked his readers. 'On what he rather loftily calls his "port". Note that this "port" of his consists entirely of a few heavy planks hammered roughly together, encircled by a primitive railing, next to which three or four boats are rocked by the waves of the Seine.'[7]

There are inconsistencies, as usual, in accounts of need. Camille pawned her jewellery, yet Monet in February 1879 ordered 20–30 litres

of 'bon cognac' from Duret.[8] Alice, resourceful and stoical in the face of social humiliation and a husband incapable of accepting responsibility, took in dress-making, gave piano lessons and adapted to kitchen drudgery, though the well-born woman's horror of rodents – 'I can hear your screams from here, I know your fear of mice,' Monet wrote – never left her.[9] She was often in low spirits, which she attempted to conceal from the children. 'Why do you hide your troubles from me?' fourteen-year-old Marthe wrote in a letter in October handed to her mother, because she dared not talk to Alice face-to-face. 'I've searched hard, and I can't find the cause for this sadness . . . Madame Monet, like me, noticed and this morning asked me the reason.'[10]

Marthe's is one of only two stories about Camille at Vétheuil. The other, similarly benevolent, comes from Germaine Hoschedé, then five, who remembered Camille gently stroking her hair while lying on a chaise longue, too weak to get up, as she watched the children play. Her tenderness shines through in both accounts. There is an implication too that a sickly Camille, estranged from her mother, took comfort from the company of women. That freed Monet from constant attendance. With fewer domestic demands, a new baby he adored, Alice always close, and a fresh, enticing landscape, he expected Vétheuil to be 'an idyll of work and happiness'.[11]

It never was. Camille, initially able to accompany the family on short walks, soon tired after the slightest exertion. Her illness remained undiagnosed; Monet described abdominal pain, haemorrhaging and losing water, and mentioned ulceration, metritis and dyspepsia. These suggest uterine cancer spread to the digestive system, the early signs in 1876–7 having been perhaps masked, and also exacerbated, by pregnancy. In 1878 she gradually became more debilitated. She was very frightened, especially after a delirious fit in September. Monet turned to de Bellio: 'My wife is less and less well, extremely weak, feeling ill every moment.' Medicine taken on the doctor's advice did not help 'an illness with no remedies'. Should Camille wean Michel, who was perhaps getting 'bad milk' and exhausting his mother, Monet asked, begging de Bellio to visit Vétheuil where 'you will see superb countryside and we will do our best, Hoschedé and I, to make sure you have a good day here'.[12]

Unconnected to the village, a world apart within themselves, the families grew increasingly interdependent. A governess, hired by

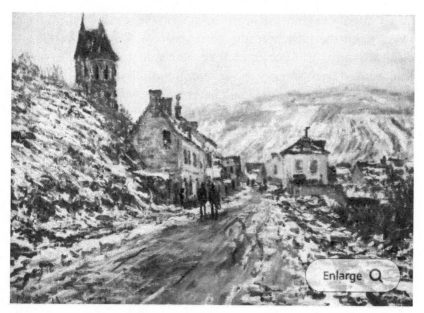

Monet, *The Road to Vétheuil in Winter*, 1879. The shared Monet-Hoschedé house is visible on the left

Hoschedé in July, left in November and successfully sued him for unpaid wages. Hoschedé himself briefly replaced her, followed by a tutor, Monsieur Cauchois, who Monet noted was rather uninterested in his pupils, perhaps because he was paid little and late. The cook, Madeleine Blardat, found this too. She lasted over a year, much of it unpaid, before also suing Hoschedé, but she must have been fond of Camille, for she tended her grave for many years, long after the rest of the household had left Vétheuil.

For the Hoschedés, it was a steep fall from privilege. Alice and her daughters ran the house, and Marthe bore the brunt of the work. Thoughtful and perturbed, she watched the quartet of adults with an anxious eye, and composed prayers. Blanche, equable and mesmerized by Monet, endlessly observed him paint, and decided to become an artist herself. Monet gave her his painting *The Road to Vétheuil in Winter*, featuring the modest Monet-Hoschedé home. Blanche's first surviving canvas, from 1878, is a depiction of four sunflowers, over-large for their vase, decorated in Japanese style. The composition, signed 'Blanche' in red, is already competent in its handling of oils, and bold

for a thirteen-year-old; the bright solid forms suggest her cheerful personality. All the girls bore the adjustment to relative poverty with dignity, inspired by Alice. Saddest of the children was eleven-year-old Jean, yanked from security and indulgence as the only child at Argenteuil, plunged into an unfamiliar environment with people he hardly knew, watching his mother deteriorate.

Already in the autumn, Monet described 'what anxieties I have had about my wife's health . . . I am in the greatest trouble, up to my neck in worry. I absolutely have to bring my wife back to Paris, because her health is extremely bad.'[13] But he did not. After a dismal November – total income 10 francs, a loan from Léon Monet – he went to Paris alone, staying at a new small apartment, 20 rue de Vintimille, which replaced rue Moncey as a place to store work and receive buyers, and was again paid for by Caillebotte. For a fortnight Monet tried to sell pictures from there, waiting all day for clients who did not come. He bargained with Murer and Gachet, who bought so cheap that it was hardly worth selling to them, while sending out works speculatively to others at still low prices. On Friday 13 December he offered Charpentier a painting for '150 francs, and if that seems too dear to you, 100 francs. I've thought it possible to ask you because for a long time you've given me the hope of acquiring something from me.'[14] Hours later he received bad news about Camille's condition and rushed to Vétheuil, borrowing the fare for the train journey.

It was a terrible end to a year that had held such promise. 'I'm no longer a beginner and it's sad at my age to be in such a situation,' Monet wrote. '79 will start, as this year has finished, very sadly, especially for my loved ones, to whom I can't give the most modest present.'[15] This at least was untrue, as two stunning portraits of their babies were New Year gifts for Camille and Alice. Curly-haired, ruddy-cheeked sixteen-month-old Jean-Pierre Hoschedé pouts at Monet with the shining gaze of the cosseted youngest of a loving family, in an easy likeness, signed and dated 31 December 1878. *Michel Monet, Baby*, unsigned, more intimate, is different. All Monet's fears for his family is distilled into this depiction of a fat-faced, worried-looking baby with his mother's big dark eyes, swathed in thick slashes and scrawls of white pigment – a large bonnet and collar – as if to shield him, fight for him, in paint.

Monet's portraits of the two babies in the Vétheuil household,
his New Year gifts to their mothers on 1 January 1879: left
Jean-Pierre Hoschedé, called Baby Jean, right *Michel Monet, Baby*

The portraits mark Monet's curious position emerging as head of the
fused family, and his double affection for two 'loved ones'. Ernest drifted
back to Paris, making excuses to stay alone in comfort at a pied-à-terre
provided by his mother. Camille was confined to the sickbed. The bond
between Alice and Monet tightened. He was in the prime of life, 'a big
strapping fellow, hale and hearty, with a matching trim of beard . . . and
eyes as limpid as spring water'.[16] For Alice, his hard work and strength
of character could not but contrast with the lightweight Hoschedé. For
Monet, she had become indispensable: sympathetic, lively, competent,
reassuring, and the essential carer for Camille and his sons.

Thanks to Alice, he was able to paint, and against the pitiful struggle
for survival in the cramped house, his consolation, source of courage,
refuge, was the beauty of nature. His rapture at Vétheuil in the summer
and autumn paintings continued in the winter. From his boat he
depicted Notre-Dame under snow and the village seen across an ice-
specked river negotiated by a little rowing vessel in bluish light, in the
splendid panorama *Vétheuil in Winter* (now in the Frick collection).
In spring 1879 came close-ups of plum, pear and apple trees, and three
small children, loosely sketched, and a taller girl gathering flowers,

wading through *Poppy Field near Vétheuil*. Michel is learning to walk, Camille is not there. This picture recalls the first *Poppy Field* painting, shown at the 1874 Impressionist exhibition. But the Vétheuil picture has none of the drowsy contentment or perfected geometry of the Argenteuil *Poppy Field*, and is almost defiant. The scarlet is a higher key, the facture for the flowers more aggressive, the background laconic, mere dabs of houses beneath rushing skies. Then it was summer again and Monet in his boat looked upstream, depicting round cloud forms, elongated into more slender strokes in their silvery-green reflections, in the muted balance of sky and water in *The Seine at Vétheuil*. He brought the cycle of the year at Vétheuil full circle with four further renderings of his initial crystalline landscape *The Seine at Lavacourt*.

The entire cycle of 1878–9, elegiac, recording the passing of time, infused with sadness, has to be read in the context of Monet watching Camille slipping away. His loneliness was intense; he mentioned 'the void that has formed around me' even as he sought to be alone.[17] Every painting was made minutes from the house, for apart from scant, brief trips to Paris to hawk pictures, Monet could not be long from Camille's bedside. The year from September 1878 to September 1879 was desperate. Halfway through it, on 10 March, Monet wrote to de Bellio, 'I am absolutely disheartened and demoralized by this existence . . . When you are my age, there's no longer anything to hope for. Unhappy we are, unhappy we will remain . . . I no longer feel the strength to work in such conditions.'[18]

But Monet did not give up. The greatest of the 1878–9 four seasons pictures at Vétheuil was created at that dark moment, just before the hard winter turned to spring. Monet waited on the shore at Lavacourt for the sun to emerge from an opalescent blue-brown, yellow-violet mist shrouding the church, its mirror-image reverberating in white impasto beneath the river's glassy surface: the ethereal *Vétheuil in the Fog* [Plate 24]. He captures a momentary effect, and transforms the transparent skeletal forms of the ordinary village into something monumental, a disconsolate landscape of the mind. In 1879 Monet offered the picture to the baritone Jean-Baptiste Faure, who rejected it as too white and said it was not worth 50 francs. Later Faure realized he had missed a masterpiece, proposed 600 francs, and was refused. The picture became a talisman for Monet, he would never sell it. If the bright

sails and dazzling reflections in *The Basin at Argenteuil* embody the joy and certainty of the first Impressionist moment, the village in the fog is the emblematic Vétheuil picture – of Monet's melancholy, of the indefinite manner with which he now pushed figuration to the brink of dissolution, challenging not just conventional rendering of light and colour, but the concept of what a picture could be. 'I am a man of the fog (*un homme du brouillard*),' he would repeat from now on.[19]

In the solitude of Vétheuil Monet ceased to paint modern urban subjects. In pictures at Le Havre and Honfleur, Bougival and Argenteuil, he had entwined nature, leisure, pleasure, industry. All that disappeared from his work now. Monet in his first year at Vétheuil was a painter of pastoral. The timing shows how crucial Camille had been to his vivid engagement with the outside world. The flag pictures, dated 30 June 1878, were a valediction not just to Paris but to a way of painting, for the facture and manner of composition changed too. It was the beginning of the evolution of Monet's painting from the outward-bound to the inward-looking. He was no less ambitious for his work, but Vétheuil was a period of intense introspection, the opposite of the flow and sociable life at Argenteuil. His production was uneven, and he worked compulsively to escape in paint and canvas from medicines, sickbeds, the prospect of death, as he depicted the physical world disintegrating in Vétheuil and created images for loss and grief.

With its sense of atmosphere taking priority over subject, *Vétheuil in the Fog* looked far ahead. Clemenceau, who saw the picture hanging in Giverny, called it the 'most precious document on the formation of the artist in his laborious research into the subtle dispersion of light'. '*Vétheuil*,' he wrote, 'with its misty reflections and whitened Seine, would be the clarion call which announced the curtain-rise at the lily pond.'[20] But Monet did not dare show *Vétheuil in the Fog* for a decade – until he was on the verge of his series paintings with their 'envelopes' of light, and even then the critic Hugues Le Roux, although admiring it, concluded it must be unfinished.

In 1879 Monet's friends rounded on him as lazy, slapdash, irresolute. The issue of finish was a battle fought since the outset of his career, but in Vétheuil he shifted the terrain, to general bewilderment. He lost the support of Zola, who criticized him for hasty overproduction of sketchy pictures, dashed off in the need to sell, in *Le*

Messager de l'Europe in 1879 and again the next year, in *Le Voltaire*. Although Zola failed to understand the development of the work, Monet later seemed to acknowledge some truth in it: 'when I didn't have enough to live on, I sold the study I was working on as soon as it was finished. Sometimes it was a good one, sometimes not. When I no longer had to sell, I was able to work.'[21]

Especially disappointing for Monet was the usually faithful de Bellio, whom he invited to visit his Paris studio to help himself to anything, at any price. 'I must tell you frankly,' de Bellio answered, 'that it is truly impossible to think of making money with these very incomplete paintings. My dear friend, you are stuck in a vicious circle.'[22] De Bellio's harsh words sharpened Monet's feeling of isolation in tragedy. He replied simply: 'how sad a situation is mine, alone in the world with two children, without resources, without a sou: and what is going to become of me if a few friends like you don't help me a bit.'[23]

Monet was too demoralized to want anything to do with the 1879 Impressionist exhibition, the group's fourth. He stuck his foot through some canvases and agreed to show only reluctantly. Caillebotte repaired the canvases, and assembled, framed and hung Monet's paintings. The Impressionist exhibition was 'astonishing!!!' and also popular: 'the public is cheerful, people have a good time with us,' he reported, whereas the Salon 'is more and more sleepy'.[24] When its doors closed, the Impressionist show turned out to have actually made money, 439 francs per participant, as well as sales of pictures. Real acceptance and a stronger market seemed close, and Monet was again singled out for praise by reviewers. But the gap remained between his status as avant-garde leader, and his poverty. Of sixty-eight canvases painted between summer 1878 and summer 1879, only eight sold during that time.

The most perceptive observer of the fourth Impressionist exhibition was *Le Gaulois*'s critic, describing the extreme emotion in Monet's pictures: 'an artist's temperament stretched to its utmost, quick to hope and quick to despair'.[25] That sums up the volatility of Monet's work and spirits in the first year of Michel's life. The ebullient Paris canvases of 1878 were in the show, alongside half a dozen mournfully lovely Vétheuil scenes. As a parallel to the festive compositions, Caillebotte arranged the loan from Montpellier of the earlier flag painting *Terrace at Sainte-Adresse*. Monet never saw the exhibition and took

no interest in its victories. He was, he told Manet on 14 May, 'in trouble up to my neck . . . the little money I have had is entirely spent on medicines and doctors' visits, my wife and the little one are almost constantly ill . . . I have had it up to the eyes with painting, because I can see that I will have to drag out this miserable existence to the end without hope of ever succeeding. I learn with pleasure that your pictures have been successful.'[26]

Monet did not know where to turn. He wrote to Hoschedé the same wet May day, proposing the couples go their separate ways. 'I don't know if the weather in Paris is the same as here, it's likely, so you can understand my discouragement,' he opened.

> I am heartbroken and I absolutely have to share my disappointments with you. For almost two months I've been giving myself a lot of trouble, with no result. Perhaps you doubt this, but it's the case . . . Only I know my anxieties and the difficulties I make for myself to finish paintings which don't satisfy me and please so few people in the world . . . I have to face the fact that I can't hope to earn enough with my paintings to live the life we are leading in Vétheuil . . . On top of that, I don't think we can be very pleasant company for you and Madame Hoschedé, me always and more and more bitter and my wife almost always ill. We must be, we are, I'm sure, an impediment to all your plans . . . I sense too well . . . the impossibility of making our contribution to the expenses if we continue living together. It is best to see things as they are . . . I am devastated to talk to you like this, I am completely discouraged, I see everything at its blackest and worst, and I don't believe I'm mistaken in saying our departure would be a relief to everyone in the house.[27]

For all its tone of measured realism, Monet's letter was a scream of despair and, by dwelling on financial trouble, also an attempt to deny to himself the greater catastrophe of Camille's illness. Hoschedé, and perhaps Monet himself, knew there was no question of the Monets moving: Camille was dying. 'Madame Monet's condition is what most concerns us at the moment,' Hoschedé told his mother on 16 May, shortly after receiving Monet's letter, 'I don't think she has more than a few days to live and her slow agony is very sad.'[28]

Camille's suffering lasted another four months. Alice nursed her with unstinting devotion, and in Paris Hoschedé worked on Monet's

behalf. He sold a Vétheuil picture to Duret, and tried to sell to de Bellio 'in the name of Monet and myself' the Montgeron decorations. On 9 July he told the doctor, 'I've just received a letter from my wife at the moment troubled also by the illness of one of our little girls. You know Madame Monet, very ill without hope for many months, has cost Monet the greatest sacrifices; in short, they are all in a desperate situation [but] Monet has made very beautiful things.'[29]

No one else thought so: when Monet went to Paris, he failed to sell a thing. He returned on 16 July and Alice, grieved to see him so defeated, took it out in a letter that evening to Ernest, no longer addressed as 'mon chéri' but only 'mon cher ami', accusing him of lingering in Paris: 'On my side I feel totally abandoned by you.'[30] Their marriage was crumbling, tensions mounted through that interminable summer, yet neither Hoschedé or Alice, nor Monet, could think of changing the status quo while the prospect of death held sway. The grocer Madame Lefèvre claimed a 3,000-franc debt, the draper Madame Ozanne was as demanding, Alice complained to Hoschedé, whose only recourse was his mother. Repeatedly, Honorine sent emergency funds, supporting the Monets too. 'Once this sad period is over Monet will return to his usual financial arrangement with me and will discharge his debt as agreed between us,' Hoschedé explained. Afterwards, he added optimistically, would come the chance of 'straightening everything out'.[31]

Camille struggled on to see Jean turn twelve on 8 August. From 10 August, she was unable to eat. 'For a long time I have hoped for better days, but alas today I fear I must abandon all hope,' Monet told de Bellio on 17 August.

> My poor wife suffers more and more, she is in increasing pain and I cannot imagine that she could be any weaker than she is now. Not only does she no longer have the strength to stand up or walk a single step, she cannot hold down the slightest food . . . We have to be continuously at her bedside to sense her smallest needs in the hope of calming her suffering, and the saddest thing is that we cannot always satisfy these needs for lack of money. For a month I've been unable to work for lack of paint; but that is nothing: for the moment what terrifies me is to see my wife's life in danger, and what is really awful is to watch her suffer so much without being able to help her . . . Her stomach and legs are

swollen, and also often her face; with this there is constant vomiting and choking, it is a terrible suffering, especially when one has no longer a shadow of strength. If, after what I've said here, you have any advice to give us, it would be welcome and followed to the letter. But what I want to ask you, dear Monsieur de Bellio, is to help us from your own purse; we are without the least resources . . . I beg you, don't remain deaf to my call and help us, and send us what you can.[32]

On this crucial occasion, de Bellio did not deliver; he was temporarily in financial straits himself, and answered only, 'I am very sorry to learn that Madame Monet is in the sad condition which you describe so blackly. Let's hope that with care, with a lot of care, she will recover.'[33]

Camille was receiving 'a lot of care'; Alice or Monet were always at her bedside. Better financial circumstances might have made her more comfortable; they could not have saved her. Camille's fate was tragic but not exceptional in late-nineteenth-century France. Even in Monet's small circle many young women, all cherished mothers of small children in affluent families, had been beyond saving. Céline Lecadre, mother of his cousins, died at thirty-two when the younger boy Eugène was three. Marguerite Gaudibert, subject of Monet's first portrait commission in Le Havre, died at thirty-one in 1877. Eva Durand-Ruel was twenty-nine when she died just before the birth of her sixth child in 1871. Alice's family was haunted through generations by the deaths of young mothers: her sister Léonie in 1868, and later, one of her own daughters. And concurrent with Camille's decline was that of Renoir's lover, 23-year-old model Margot Legrand, who died on 1 February 1879, leaving a son. De Bellio was her doctor. 'The young woman you were kind enough to treat, unfortunately too late, died,' Renoir informed him. 'I am extremely grateful to you for the relief you provided her with, even though both of us were convinced it was quite worthless.'[34]

What relief for Camille? 'Madame Monet's terrible illness occupies all my time, apart from the children and the piano lessons,' Alice told her mother-in-law on 26 August. 'I fear a fatal end to the poor woman's sufferings. It's horrible to see her endure such torture, and that death is therefore desirable.'[35] She asked the Vétheuil priest, Abbé Amauray, to visit Camille, and on 31 August Monet the atheist went

through the ritual, for either Camille's sake or Alice's or both, of having his civil marriage legitimized 'in extremis' by the church. On 1 September Hoschedé wrote of 'the sad state of Madame Monet, whose end we expect every day', and that 'thanks to Alice, she was given the last rites yesterday, and is a little calmer today, but what heart-rending suffering!'[36]

In differing accounts which reflect their characters, Hoschedé, Alice and Monet each described what happened in the long days and nights between the Abbé's visit and 32-year-old Camille's death on Friday, 5 September 1879. 'The poor woman died in absolute calm and without suffering during the last two days,' Hoschedé told his mother.[37] Alice reported that Camille 'suffered horribly' and described her sorrow saying goodbye to her children, but 'amongst all this sadness I had great joy seeing my poor friend receive her God with faith and conviction and receive the last sacraments.'[38] Monet informed only de Bellio:

> My poor wife succumbed at half past ten this morning, having suffered horribly. I am distraught to see myself alone with two poor children.
>
> I am writing to ask you a new favour, which is to retrieve from the Mont de Piété [the pawnshop] the medallion for which I'm enclosing the ticket. It is the only keepsake my wife had been able to hold on to and I would like to be able to place it around her neck before she leaves ...
>
> Your very unhappy and pitiable friend Claude Monet
>
> PS Not being able to send out a letter of announcement, I would be grateful if you would pass on the fatal news to those whom it interests.[39]

At four o'clock in the afternoon neighbours Aimé Paillet, a mason, and Louis-Gustave Havard, a clock-maker, registered the death at Vétheuil's town hall. The next day de Bellio sent the medallion, worth 15 francs. But Paris was still empty in early September, and no one received the news in time to attend the funeral. Caillebotte wrote on 9 September that he had just heard 'this instant', for 'no one has been in Paris for a week, I am sorry not to have been told in time. If you have need of anything or would like me to come to Vétheuil, just tell

me.'[40] He sent 500 francs, Duret 100 francs, Monet's brother Léon two loans of 20 francs, de Bellio 50 francs. Marthe and Blanche, Alice related, 'were very courageous and very kind; they helped me in the sad last attentions and stayed in vigil for two days over the poor dead woman.'[41]

The funeral took place at 2 p.m. on Sunday 7 September. Before the little party climbed the steps to the church for the service and then walked on to the cemetery on the hill, came Monet's last rite and final act of intimacy. Seen as if through a blur of tears, the tilted oval head, pallid wasted features and mouth almost on the verge of a smile in *Camille Monet on her Deathbed* [Plate 25] are just recognizably those of *Woman in a Green Dress* and *Women in the Garden*, but the face is veiled, shrouded, in fast, rough, bluish-violet-white marks, and a rush of horizontal strokes course below, as if immersing and sweeping away the body. The French noun and verb *disparution* and *disparaître* – disappearance, to disappear – are also used for death and dying. Monet painted his wife in the process of disappearing, vanishing into paint, returning to nature. The icy tonality, broken by the merest glimmers of rose and vermilion, is of flesh gone cold, but the image of dissolution in a mist of white brushstrokes is close to the evanescent outlines in *Vétheuil in the Fog* and *Vétheuil in Winter*. Monet turned Camille, as she passed from him, into a landscape, incorporating and freezing her into the pastoral cycle of his Vétheuil paintings. His watery memorial is alive with the movement of paint, and confrontational in its absolute assertion that Camille is dead.

Monet never exhibited the picture, and kept it all his life. Later it hung in his bedroom, Camille as a continuous presence. In his last years he talked of it to his then dearest friend, Clemenceau:

One day, when I was at the deathbed of a woman who had been, and still was, very dear to me, I found my eyes fixed on the tragic countenance, mechanically trying to seek the sequence, the degradation of the colours, that death had just imposed on the motionless face. Shades of blue, yellow, grey and I don't know what. That's what I had become. It's natural enough to want to portray a last image of one who was leaving us for ever. But even before I had the thought of fixing the features to which I was so deeply attached, my automatic instinct was first

to tremble at the shock of the colour, and, despite myself, my reflexes pulled me into the unconscious operation that is the everyday course of my life.[42]

Half a century of memory and regret are condensed into this explanation, Camille reduced to the anonymous 'a woman', Monet reducing himself to 'reflexes' of looking – a version of Cézanne's description of him as 'only an eye', which by then Monet knew and sometimes quoted. Making that painting demonstrated, he told Clemenceau, the primacy of sight as 'the obsession, the joy, the torment of my days'. Perhaps the picture was also a last acknowledgement of Camille's role in all that. For a decade, his delight at her eyes looking at him – peering out playfully over a bouquet in *Women in the Garden*, turning a quick gaze on him through a windswept veil in *Woman with a Parasol* – had animated some of his greatest paintings. Monet painted no nudes; instead he eroticized vision. He had become a painter in part through painting Camille. Now he burnt the image of his dead wife into his mind.

An underlying current of his account is that it was as a painter that he survived or sublimated the unbearable fact of her death. But another, the play with the tenses 'had been, and still was, very dear' implies a more bitter truth – probably responsible for the self-accusatory tone of the entire recollection – that by the time of her death Monet loved Camille less than he had done. The pictures after 1875 show that already Camille mattered less to his painting, that a spark had gone.

It returned, in the shock of loss, in *Camille Monet on her Deathbed*, which joined other paintings in which he enfolded her into his past. *Camille with a Dog*, the teenager in Paris; Camille looking joyfully at Monet from among the flowers in *Camille and Jean Monet in the Garden at Argenteuil*; the last reproachful portrait, *Camille with a Bouquet of Violets*. None of these left his possession, and *Women in the Garden* only did so to enter the Musée du Luxembourg at the end of his life. *Le Déjeuner sur l'herbe*, his first collusion with Camille, had a more wretched fate. When Monet retrieved it from Flament's damp cellar, it was irreparably damaged by mould, and he cut it down, saving two sections: Bazille entering the glade with two Camilles, and

the two seated Camilles. 'I am much attached to this piece of work that is so incomplete and mutilated,' he said.[43]

By 1879 all these paintings were a closed chapter. As Camille faded, Monet's art changed definitively, acquiring a new overflow of feeling, expression of interiority, and concern with time, as he withdrew from contemporary life and its depiction, in favour of recording fugitive aspects of nature, mutable, impermanent. The Vétheuil landscapes were in a tragic sense the couple's last collaboration, as well as Monet's letting go of Camille. She belonged to the heyday of Impressionism. Now her death set him free for the battles of the next decade: to follow through the implications of the shift in his painting, and to fight for new love.

12

Alice, 1879–81

'I am devastated, not knowing where to turn or how I'll be able to organize my life with my two children. I am much to be pitied,' Monet wrote to Pissarro on 26 September.[1] In October he repeated to de Bellio, 'I am more to be pitied than you could think and very unhappy.'[2] He would sympathize, when Boudin was widowed, that 'I have passed through there, I know the emptiness such a loss leaves. Be strong and courageous, it's the only thing I can tell you.'[3]

This was said from experience. For although immediately shattered by Camille's death, Monet at thirty-eight was not a man to choose a life of mourning. He ended his letter to Pissarro already expressing interest in the future, the outside world: 'tell me how things are going for you and Sisley, and the hopes that I can have'. Renoir, who was staying in Chatou in September, beginning *Luncheon of the Boating Party*, heard the news of Camille's death on returning to Paris sometime later. He implied an appreciation of the complexity of his friend's grief when he said, 'I want you to understand how I share your sorrow,' yet admitted he had been unsure whether to write because 'for a long time I hesitated before making you remember what I should let you forget'.[4]

For a month or two, Monet the widower painted only in the house, keeping his sons close, working and sleeping in the dining room. Still lifes of pheasants and partridges, two larger birds and two smaller ones laid out on a slab, read like metaphors for the end of the foursome that had been his family. There were also harvest fruit baskets, intensely coloured, worked with impassioned drawing and a trembling sensuality, and vases of nasturtiums. These were created in the company of Alice and her daughters while Hoschedé stayed in Paris,

avoiding creditors in Vétheuil. One of them barged into the dining room and, finding him absent, picked up a vase of flowers and smashed it down on the piano. Marthe, in a letter which conveys the sensitive atmosphere with which the Hoschedé girls surrounded Monet, explained that luckily he was painting a different bouquet. 'M. Monet is working very hard on his still lifes, which are very pretty; yesterday, as the sun came out and disturbed him doing a picture of fruit, he painted a small blue porcelain vase with nasturtiums; he succeeded perfectly and this little picture is charming. The nasturtiums he painted are truly extraordinary, because it's a long while since they were picked and after a certain time, instead of withering as we expected, on the contrary they thrived in the water and are growing every day.'[5]

Monet was engrossed in these in November when a 'pitiless winter', according to the *Journal de Mantes*, among the worst on record, came early. Marthe's letter to her father reported snow, and that 'the flowers in the orchard are completely frozen, the water in the streams the same, and you can't put your nose to the window without it also getting frozen.'[6] Blocks of ice floated down the Seine, Papavoine's carriage got stuck in snow drifts and Vétheuil was cut off until the river froze completely, making it possible to walk across to Lavacourt.

A hot-water bottle in each pocket to keep his fingers from freezing, Monet ventured outside and completed Vétheuil's pastoral cycle of 1879 in a sensational way. In any circumstances he would have been excited by the spectacle of frost, ice floes and then the great thaw, *la débâcle*, when the river flooded its banks and destroyed bridges and property. But now it was as if nature itself was cloaked in mourning, enveloping the landscape in the same white-grey-blues of *Camille Monet on her Deathbed*. Using this reduced palette, Monet depicted hazy effects or clear winter days, diffuse light reflected off white fields and the frozen river, frost lit by pale sun or under steely skies, trees bare and rigid.

While he painted on the ice, the children went skating and Alice did all the jobs in the house, including chopping firewood, and kept constant watch over the two babies playing near the fire. Hoschedé, sensing danger, suddenly made an effort to reclaim his wife. Since Camille's death he had scarcely put in an appearance at Vétheuil. All autumn he was expected, but he missed date after date, notably to his

children's disappointment Blanche's birthday on 10 November. Alice was hectoring him for money, but a promised 800 francs never arrived. Gossip ran rife in the village.

Monet's defensive letter of 16 November to Hoschedé was very carefully composed. 'Day after day I want to write to you and am unable to; when I've finished working the post has gone and I always put if off ... We were always hoping to see you ... even if only for two or three days,' he began. 'Such absurd rumours are running around here, which only your presence can allay ... We've been through a lot of trouble and there have been moments of real difficulty.' Amid the clamour for Hoschedé to return, the pronouns speak louder. Alice and Monet are 'we', Hoschedé is 'you'. No mention here of dissolving the household, as he had suggested to Hoschedé six months before.

Now Monet boasts that he kept at bay 'Messieurs the bailiffs' on their behalf, promises that he will 'provide a more serious contribution to the communal fund', gives Hoschedé news of his own children ('always devilish and noisy but very sweet'), and offers pictures for Hoschedé to sell. 'Nothing particular to tell you,' he concludes casually, while implying a great deal: that Monet expected Hoschedé to act his assigned part by returning, 'even if for a short time and without much money, I am sure it would have a good effect', to sanction, by his presence, living arrangements he had come to detest.[7]

Hoschedé did not play the game. He replied to Alice, demanding her return to Paris with their children. She procrastinated. 'I too am very sad about the accounts that you present to me. If we spend a relatively large sum here, what would it be in Paris? Anyway, we'll talk about all this.'[8] Hoschedé set out to visit on 8 December, but got stuck at Mantes. The snow was so deep that Papavoine anticipated a three-hour drive and would not depart until the morning. Hoschedé spent the night at Mantes's Hôtel du Rocher de Cancale, literally frozen out of life at Vétheuil. On 10 December the temperature fell to a record low of minus 26 degrees and his conversation with Alice resolved nothing. He departed the next day.

A martyred letter on 12 December followed him to Paris. Alice had been up all night with three of their six children ill: Jacques and Jean-Pierre coughed incessantly, Germaine screamed for hours with eczema,

the freeze was pushing up local prices, the market gardener had to dig through the snow to reach Vétheuil and sell rotten vegetables at inflated prices. By return, Ernest lashed out at Monet. Alice's response hinted at shifted allegiances. 'I have nothing to reply to the reproaches you make to M. Monet, who more than anyone is very unhappy when there is a lack of money here, and who, fortunately, was able to help us last month. He is working a great deal.'[9]

Hoschedé's revenge was silence. He neither came nor wrote for Christmas. Alice sent him daily letters describing a holiday without presents, a wardrobe so scant that Jacques had nothing to wear for midnight mass, and eleven-year-old Suzanne had to borrow twelve-year-old Jean's boots to walk there. (The atheist Monets did not go to church.) A parcel of clothes arrived from the children's grandmother, but on 28 December Alice warned Hoschedé that 5 francs remained in the kitty and his absence was inciting more local gossip. Monet left that night for a sales trip to Paris and Hoschedé reached Vétheuil the next day, making it clear who was keeping him away.

He had gone again by 4 January, and Monet was back. Alice was sleeping upstairs with the children when, she told her husband,

> at five in the morning I was woken by an appalling noise, like the rumble of thunder; a few minutes later I heard Madeleine [the cook, who lived next door] knock on M. Monet's windows and tell him to get up. At once I did so too, while the scary rumble mingled with cries coming from Lavacourt; very quickly, I was at the window, and in spite of the darkness, you could see the white masses falling; this time, it was the real break-up of the ice floes.[10]

Monet, Alice and the children hired a carriage and drove to La Roche-Guyon and Gloton, site of his first river stay with Camille in 1868. In paint, Monet seized the extreme contrasts offered by the natural drama. Rough specks of dark vegetation push up through the snow, fringing glassy water, in *The Thaw at Vétheuil*. Dissolving patches of ice on the river tinged pink in late afternoon light are interspersed with broken reflections of tall poplars in the luminous *The Ice Floes*, the most daring in its play of the real and the mirrored, a picture of great beauty wrought from violence and fear.

The two dozen canvases beginning in November 1879 with *View of*

Monet, *The Ice Floes*, 1880, shown at his first solo exhibition at the gallery of publisher Georges Charpentier's *La Vie moderne*, and purchased by Madame Charpentier. The large expanse of water dotted with patches of broken ice prefigures Monet's twentieth-century compositions foregrounding the water lilies on the pond.

Vétheuil, Winter, and concluding with the sun hanging low over flooded banks in the calm after the storm of *Sunset on the Seine at Lavacourt, Winter Effect*, completed in March 1880, are an incipient series. Fixing transient moments across the same unstable watery motifs, they are images more consciously than before concerned with time as well as place. Camille's death shaped these lyrical paintings of loss and change, but their scale and refinement were connected to Alice. *Ice Floes* and *Sunset on the Seine* are larger than anything Monet had done since Montgeron. When he began the winter paintings, he was lost in grief. By the time he concluded them, he aspired to share his life with a woman whose expectations far exceeded Camille's. The hand-to-mouth selling of canvases for 50 or 100 francs would not do.

For the first time in a decade Monet considered submitting to the Salon, and worked to complete *Ice Floes* and *Sunset on the Seine* to Salon demands of high finish. In December he made contact with

rising dealer Georges Petit, who bought two snowy Vétheuils and a still life, and recommended Monet raise his prices. Petit, a stocky, competitive 23-year-old, had just inherited his father's gallery and 3 million francs. A fellow dealer later described him as 'a huge sybaritic tom, seated in front of his little glass of chartreuse, like a cat watching a mouse'.[11] He had come of age with Impressionism and foresaw its imminent accommodation by mainstream taste. 'M. Petit wants to give me a real shoulder up,' Monet told de Bellio in his new year letter. At the start of 1879 he had written dolefully to de Bellio of his hopeless prospects. In January 1880, by contrast, he sent the doctor a cheerful note, with instructions 'to buy a bit less but pay me a bit more'.[12] Monet greeted the new decade with optimism and vigour. He was set on a clear path: the refinement of his work, the unabashed pursuit of his own happiness and the welfare of his sons.

On 24 January 1880, Monet in Vétheuil and Hoschedé at the rue de Lisbonne each opened the daily newspaper *Le Gaulois* to find their domestic drama spread across the page of the gossip columnist who signed himself 'Tout Paris'. The writer was well informed. A mock death announcement, edged in black, announcing that 'the impressionist school has the honour of informing you of the grievous loss it has suffered in the person of M. Claude MONET', alluded to Monet's intention to submit to the Salon, which by Degas's rule disqualified him from the forthcoming Impressionist exhibition. It was followed by a personal sting, an account of life at home with

> Claude Monet who divides his time between his art and his family: a charming wife and two pretty babies ... Monet lives far from the bustle of Paris, in Vétheuil, in a little white cottage, where he receives his friends and admirers. One of these is Hoschedé! Hoschedé ... was once wealthy. He ruined himself – the dear man – buying, for very high prices, Impressionist paintings by every discount-studio dauber who came to show him his work. Today Hoschedé, now a Platonic art lover, is making up for his bad luck by spending his life at Monet's studio. The artist clothes him, houses him, feeds him, puts him up and – puts up with him.[13]

'I can only consider the passage about Hoschedé as malice towards him, but I find it very disagreeable and I want to get to the bottom of

all this,' Monet told Pissarro.[14] The article, however, accurately reflected the men's relative fortunes, Monet's rising, Hoschedé's falling. And Hoschedé was mocked for not only living off Monet, but being cuckolded by him, for the 'Platonic' had a double edge, and for those who knew Monet, and knew of Camille's death, who else could the woman described as Monet's 'charming wife' be than Alice?

Through 1880 a modus operandi, a hangover from their earlier collaboration, developed, by which the former patron was co-opted as the artist's factotum, instructed via Alice to sell, deliver, frame his pictures, even to send pheasants for his still lifes. 'M. Monet asks you to let him know where *The Pink Frost* is,' she wrote to her husband, then, 'M. Monet tells me to warn you that he has told his gilder to bring his Salon picture to you. If that's difficult, please alert him', and 'Can you inquire if M. Monet's exhibition could last until the first days of July . . . that would be very helpful to M. Monet, allowing him to finish several canvases.'[15] The process emasculated Ernest, standing by as Alice's life revolved visibly around Monet, his paintings, his exhibitions, his sales, his moods.

What began to sound like a brazen display of intimacy more likely reflected a gradual uniting of forces between Alice and Monet at Vétheuil. It evolved in the context of mourning of which Hoschedé was kept abreast, for example in a family letter reporting the Hoschedé girls collecting violet roots to plant on Camille's grave. And the men still shared a financial arrangement. The expenses in 1880 were divided in the ratio three to seven, in an altered metric: Monet and his two sons, Alice and her six children, excluding Hoschedé in acknowledgement of his departure from the Vétheuil household. This effectively marked the end of the Hoschedés' marriage, though from Ernest's viewpoint, his absence was a temporary measure until he could afford to bring his family back to Paris. But the longer he stayed away, the closer Alice and Monet grew, which in turn kept him at a distance. Even when he had agreed a date, he failed to visit, often cancelling at the last minute; he could not face seeing his wife at home with another man. 'I am wondering which one of us is mad,' Alice told him on 29 March. 'I shall never again wait for or announce your coming.'[16]

The indignation was calculated. The paintings told another story.

Monet was at the end of March completing the winter Vétheuil series with *Sunset*. Almost square, it depicts a stretch of water funnelled between two grassy verges, their trailing vegetation more vivid in reflection than in their actual shapes massed in shadow. The river gleams, the sky is streaked with rose, the sun burns orange, and is seen through an arabesque of bare branches. The ice has melted, the bleak white tonality has gone. It is nearly spring. Monet gave this picture to Alice.

Despite his humiliation, Hoschedé maintained cordial relations with Monet. He could hardly avoid him in Paris, for his latest plan was to launch a magazine, *L'Art de la mode*, drawing on his ill-fated experience of both art and fashion. Surprisingly he found backers, and the project returned him to the heart of the art world just when Monet, after two years secluded in Vétheuil, was renewing his assault on the capital. Their associates were the same. Georges Petit dealt in Monet's pictures and financed Hoschedé's magazine. Hoschedé consolidated friendships with collectors Gachet and Murer. In the spring Monet invited Duret to see his new paintings at Hoschedé's premises. In the summer he robustly supported the launch of Hoschedé's magazine in public, though secretly he doubted the success of the venture. Manet gave Hoschedé his seal of approval by visiting *L'Art de la mode*'s offices. Hoschedé, he told Astruc in July 1880, 'is hope incarnate – he deserves to succeed and actually tries his best, but he started by getting a Belgian to do his first *Paris fashion* plate. Will he never learn?'[17]

Outwardly Monet and Hoschedé presented a united front, and Monet chattered on companionably to his rival, relaying domestic incidents – disorganization in the house, problems when the cook departed. In July he ventured, 'Won't you come and spend at least a day or two here? You must be suffering terribly in this heat.'[18] Hoschedé, rather than Alice, must have wondered who was mad.

It had been possible for another man to share a house with a Monet subdued and needy during Camille's illness. But a newly single Monet, fighting ruthlessly for his future, forced Hoschedé out. Communal life at Vétheuil had begun with an arrangement presuming each man's interest in the other's success, now there emerged instead unspoken competition for one of them to earn enough, alone, to look after Alice.

Their relationship became a confusion of professional support, personal disloyalty and a certain complicity over Alice. Blatant ambition now conditioned Monet's approach to exhibitions, marketing, his relationships with his peers, and throughout the 1880s shaped critical decisions for his painting as he pushed towards a showy modernity.

Compromising with the Salon was the beginning. 'I'm working hard on my three big pictures, of which only two are for the Salon, because one of the three is too much to my own taste to send, and it would be refused, and instead I have had to do something more sensible, more bourgeois,' he confessed to Duret, adding, 'It is a crude part that I am going to play, and *me voilà* treated as a traitor by all the band, but I think it is in my interest to play this part', for business would go better 'once I have forced the Salon door'.[19] The 'bourgeois' picture, a serene *Lavacourt*, was accepted; the more daring *Ice Floes* was not, but Monet quickly positioned it to win fashionable exposure. Impressed by his Salon presence, publisher Georges Charpentier offered him his first solo show. The venue was the splendid gallery at 7 boulevard des Italiens belonging to *La Vie moderne*, the journal Charpentier had launched in 1879 with Renoir as illustrator. *Ice Floes*, number one in the catalogue, was the trophy exhibit and Madame Charpentier bought it for 1,500 francs. Although paid in instalments, it was the highest price Monet had received for a single canvas for many years and set a benchmark. The Salon's *Lavacourt* and the third large picture, *Sunset on the Seine, Winter Effect*, also both subsequently fetched 1,500 francs.

Monet's return to the Salon strengthened his links with Renoir, who, to much acclaim, had shown *Madame Charpentier and her Children*' there in 1879. He concluded, 'There are in Paris scarcely fifteen art lovers capable of liking a painting without Salon approval.'[20] The Charpentiers pulled Monet, as they had pulled Renoir, into the boisterous milieu of 1880s journalistic promotion with which *La Vie moderne* lived up to its name. Charpentier was far-sighted; like Petit, he perceived how Impressionism had become a cause célèbre. The political current was in favour, not only liberal – in July parliament voted for an amnesty for all Communards – but, following the appointment in Gambetta's government in 1880 of Manet's friend Antonin Proust as arts minister, actively promoting the radicals.

Manet was recommended for the Légion d'Honneur. In 1880 Clemenceau founded his progressive journal *La Justice*. Economic conditions were favourable too, for after the fall-out from the 1873 crash, business was recovering, speculators returning to the stock market.

In this encouraging climate Charpentier backed Monet's exhibition to the hilt. To write the catalogue, he commissioned the distinguished Duret; Monet gave him a painting in thanks. For the magazine, Charpentier sent Émile Taboureux to Vétheuil, the first journalist to interview Monet, who played up superbly. Deflecting attention from his modest living quarters, Monet started the myth, which lasted decades, that he only worked outdoors. When the journalist asked to see his studio, he answered, 'My studio! But I never have *had* one. I don't understand why anybody would want to shut themselves up in some room.' Then he waved at the Seine and said, 'That's *my* studio!' To Taboureux's inquiries about how he became an Impressionist, he countered, 'I didn't *become* one . . . I've always been one . . . I am the one, after all, who invented the word . . . I hardly see my colleagues any more . . . our little temple has become a dull school room whose doors are open to any dauber.'[21]

This was a dig at Degas's friend the realist painter Jean-François Raffaëlli and Pissarro's protégé Paul Gauguin, among those making up numbers for the fifth Impressionist show, which was lacklustre with Monet, Renoir, Sisley and Cézanne all absent. Gauguin, still a part-time stockbroker, threw his weight around and escorted from the premises a seventeen-year-old trying to sketch a Degas painting. This was Paul Signac, who moved on to Monet's glamorous, welcoming exhibition and stood enthralled before *Apples Trees in Blossom at the Water's Edge* painted in swarming rapidly brushed small dots, pointillist before the term. Signac taught himself to paint using as 'my only models . . . your own works; I have been following the wonderful path you broke for us,' he told Monet.[22] In the 1920s he bought *Apple Trees*.

The contrast between Monet striking out for individual triumph and the mediocre fifth Impressionist exhibition publicly signalled division among a group which was anyway fracturing. Each artist, in the early 1880s, in his own way had to face, as Monet had done in

Vétheuil, problems developing the implications of the movement after its original breakthrough. Pissarro worked with younger artists – Gauguin, then Georges Seurat. Renoir, concentrating on figure painting, travelled to Italy to study the Renaissance. 'I'm still suffering from experimenting. I'm not content and I'm still scraping off, scraping off . . . and I'm forty,' he wrote in 1881.[23]

Degas continued to push for the group exhibitions to include more realists and conservatives, and thought Monet's behaviour in bad taste. But Monet, treading a canny path with journalists, playing and befriending them, now strove 'at any cost to secure the involvement of the press because even intelligent collectors are aware more or less of the noise made by the papers'.[24] That collusion between artist, gallery, newspaper, collector-critic, still recognizable in the performances around commercial exhibitions today, was a new phenomenon in the 1880s, and the hype around Charpentier's show worked. Monet's reputation and prices were strengthened, and by the end of the year nearly three dozen Vétheuil paintings had sold. The uptick in fortune within less than a year of Camille's death is striking. An improved economy, and growing accommodation by the public to the new art, were factors. Another was that Monet, after the long nursing of his wife, could throw all his energy at painting and marketing. Above all was Alice: her strength, his strength of feeling for her, her refinement, her faith in him, and ambition for him.

'I want to have many good canvases in advance of the collectors' return to Paris; I think things will go well for me,' Monet told Duret in August.[25] A succession of pictures of fine days in speckled sunlight commemorates this summer as a time of recovery. Fourteen-year-old Blanche was singled out among the Hoschedé children for a joyful portrait where she surveys Monet with patience and sympathy. Her flushed round cheeks, the inner glow of a thoughtful child, the dress a flurry of white with a dash of pink for a bow, a bright red hat: everything about this picture expresses Blanche's warm, optimistic, nurturing personality. Monet also included Alice and her daughters as small blurred figures in rowing boats, or laying out a picnic on the embankment. Among views of Lavacourt through a screen of trees is *Woman Seated under the Willows*, Alice looking down, wearing a floral hat. It is a first portrait of sorts, gentle, decorative, the mood of calm

afternoon heat according with her comforting presence, though the figure is discreetly generic.

Monet now expanded ideas about the indirect image, the play between reality and reflection, and the abstract character of the painted surface, such as the foreground pattern of dotted wildflowers pushing back the illusion of space in *Île aux Fleurs near Vétheuil*. Nevertheless, by the autumn he knew that he had exhausted the village. It was smaller and less varied than Argenteuil; he had mined it intensively and the pastoral cycle of 1878–80, completed with the thaw pictures, had a self-contained perfection to which he could add nothing more.

Monet needed the stimulus of a new location, but to seek it accompanied by Alice risked forcing the situation with Hoschedé. For Alice to remain with her children at Vétheuil, where she had nursed Camille and was bringing up Monet's sons, in an arrangement which her husband had established, could be interpreted, by him and others, as a temporary measure conditioned by death and economy. But for her to follow Monet elsewhere would be an enormous step. It would mean openly abandoning her marriage for a relationship which had no legal status, with another impulsive man of unreliable income.

So the couple remained in Vétheuil, but in September, around the first anniversary of Camille's death, Monet travelled alone to Normandy, visiting his brother Léon in Rouen, then staying at Léon's holiday villa at Les Petites-Dalles on the coast. He painted four seascapes – two sheer cliff faces, the rocks hewn in paint straight from the tube, and a pair of vistas of waves rolling in towards the shore, one placid, the other in a gale. Roughly painted, they contrasted with Vétheuil's soft rural aspect. He did not know it, but these canvases contained the seeds for the next decade of his painting. To return to the coast of his childhood was more than comfort and familiarity. From this trip followed sustenance and inspiration, as for seven consecutive years, 1880–86, he would paint the Channel coast.

Alice made a point of noting his absence to her suspicious mother-in-law: 'I have nothing to say about M. Monet, who is spending the festival days at Rouen near his brother.'[26] The old lady was ill and her death in December 1880 was, Monet told Duret, 'a major misfortune for the Hoschedé family, for the worry is that the creditors won't

spare what the mother has been able to bequeath, and I fear for Hoschedé's position at *L'Art de la mode*.'[27]

Monet's last works of 1880 were sumptuous still lifes of chrysanthemums, flowers of mourning, and heartbreaking portraits of his sons. His letters, from the moment of bereavement, dwell on the catastrophe of being alone with his young children, never on the loss of Camille as lover and companion. But his sadness, as well as his knowledge of what it felt like to lose a mother too young, is surely channelled into these portraits. Jean, thirteen, wide-eyed, earnest, full of apprehension, regards his father without hope. Black-haired Michel in a bobble hat, a staring, nervous toddler, tries to appear composed, but has a lost look, still there in Monet's portrait of him aged five and in later photographs. Both children resembled Camille. Jean clung to Monet, and found it hard to fit in with the Hoschedé gang. 'Are you happy with him and is he getting on with the other children?' Monet worried to Alice. 'I hope he isn't causing you difficulties . . . this always torments me.'[28] In contrast to the hard-working girls, Jean was unmotivated and fell behind academically. In considering new locations, Monet made Jean's education a priority, asking Zola and Pissarro for recommendations of 'a serious school' to help the boy, who would find boarding at a distance hard, 'as I don't feel he has the courage to go far from me'.[29]

If Michel as a child seemed to do better, it was largely thanks to the love of Alice, whom he called 'Maman' and who treated him as her own. There was also the protectiveness of little Jean-Pierre, seven months older and constant guardian of his stepbrother. Michel, a fearless, foolhardy boy, was a constant concern to his father for the opposite reasons from Jean. 'Michel with his bravery . . . he'll quickly break his head; watch him,' he told Alice.[30] In good times and bad, his letters to her are full of appreciation for her attention to the boy. Michel was devoted to Alice, though as an adult he retained a sentimental attachment to the mother he could not remember. Presiding over his own home were Renoir's 1873 portraits of Camille and Monet, which he placed in a double frame, so that his mother gazed happily at his father.

Alice's dedication to his boys, and their need of her, strengthened her hold over Monet. He expressed his own need for her throughout their relationship in frank physical terms: 'the height of happiness . . . would be to kiss you, to possess you;'[31] 'I would give I don't know

Monet, *Portrait of Blanche Hoschedé*, 1880

Monet, *Jean Monet*, aged thirteen, in
1880, a year after his mother's death

Monet, *Michel in Pompon
Hat*, 1880

what to be in your arms.'[32] Yet he had no claim on her, and the Hoschedé/Monet identity among the children remained separate. Jean-Pierre, who scarcely knew his own father, liked to hint that he was Monet's child, but the evidence is against him. Hoschedé never questioned his paternity, Monet never treated him as a son, and in writing to Alice, privately, he always called Jean-Pierre 'votre Bébé', distinguished by pronoun from 'mon Mimi', even though the little ones were inseparable. Jean-Pierre was too small to be included in a pastel from this time of four of the Hoschedé siblings, which emphasizes family resemblance and unity. Monet does not conceal a sadness in the expressions of Suzanne and Germaine, while Blanche looks at him warmly. Jacques glances uneasily down, as if uncertain of meeting Monet's eye or whether he should be participating in the portrait. Marthe, increasingly suspicious of Monet, refused to pose.

The mood in the house was strained, and money short. In November Alice complained to Hoschedé that she had had to appeal to her sister: 'this morning I received 200 francs sent by Remy; I had addressed myself to Cécile personally, and the letter which she answered in sending the money made me almost regret the request.'[33] Monet, seeking new inspiration, prospected unsuccessfully for a trip to paint the Thames in London. Then his position suddenly strengthened in February 1881 when after an eight-year gap Durand-Ruel was again able to buy, and purchased 4,500 francs worth of paintings in one swoop. Debts began to be repaid: 'Monet must be doing reasonably well now because he brought me some money the other day.' Manet told Duret in March.[34]

The days of the 50-franc picture were over; nor did Monet ever submit to the Salon again. There were no more begging letters to collectors either, and soon no direct dealings with them at all. Everyone was referred to Durand-Ruel. The dealer never contested the need for advances, which rose fast. Seven hundred francs in March was followed by a request for 2,000 francs in June. Durand-Ruel's taste, and the market he was able to build, corresponded with Monet's desire for travel and the sea. In spring 1881 the dealer began a trend of favouring seascapes, buying eighteen paintings begun during a recent trip to Fécamp. Monet's seascapes, featuring sites already famed as tourist views at a period when seaside vacations were becoming more

popular and affordable, were his bestsellers of the decade. His earnings were 20,400 francs in 1881.

So a pattern was repeated. As had happened with the river paintings in 1872–3, in Argenteuil, Durand-Ruel's enthusiasm for the seascapes in 1881–3 enabled Monet to envisage establishing a permanent family home. But what family? The question pressed throughout 1881. The year's high point was a group of large garden paintings alluding to home, belonging, the family Monet hoped to share with Alice. Led by *The Artist's Garden at Vétheuil* and *Monet's Garden at Vétheuil*, they take an unusual view from the river gate up the steps, with the blue patterned pots flanking the paths in geometric design. Sunflowers climb the canvases, two toddlers in matching white tunics are on the steps; in one painting, Alice in a blue gown hovers protectively in the distance.

She appears close up in the same summer's *Alice Hoschedé in the Garden* [Plate 26], and *The Terrace at Vétheuil*, sold to Durand-Ruel and publicly declaring the couple's relationship, especially when the dealer exhibited one of them in the seventh Impressionist exhibition in 1882. They are bucolic, ingratiating pictures. Alice, demurely absorbed in her sewing, reclines in a pink metal armchair in the shade of an arching tree. The Seine glides past, and the chromatic contrasts of river, lawn, crimson flowers, serve as a foil for Alice resplendent in white, her flesh tones warm, her figure dissolving into the garden yet the focus and force of the composition. She lights up the landscape. More fully rendered than any other depictions Monet made of Alice, these are homages, even courtship paintings, from the artist to a woman who was not wholly his, whose identity was independent, and would never be that of model or muse.

Alice could not compete with Camille's dramatic looks or teasing gestures as a model; instead her pose is conventionally graceful, with no sense of collusion. Camille acted her parts for Monet's pleasure; Alice, unyielding, keeps him at a distance. This explains why the pictures are so atypical of Monet's portraits, and why there were no more. Monet the figure painter worked by dominance over a few pliant subjects: Camille, his sons, the Hoschedé siblings, and sometimes other children, including sensitive local portraits in 1880–81 of a Vétheuil lawyer's son and a merchant's daughter. Over the next few

years, he also occasionally used rainy days for studies of people, usually social inferiors, encountered on his travels – an innkeeper and his wife, a fisherman-porter. But his extreme control in his interaction with his subjects, the caricaturist's aggression carried over from his youth, the need to deflect the objective reality of another person, made it difficult for him to depict those with whom he felt in an equal relationship. A mature woman with whom he was in a complex liaison was too challenging to the psychic space he needed to create his pictures.

Camille figures in more than fifty paintings, Alice in a mere dozen, and usually as a tiny figure among several. A further reason was the question of privacy. Thanking her for her photograph, Monet wrote, 'I only want it for myself. This idea of a portrait, the idea that others can see you, makes me ill, but the sight of your dear image makes me want even more to return ... all my kisses, the most ardent, the most tender.'[35] But anyway there could be no repeat of Monet's creative partnership with Camille, forged when she was a teenager. Alice, aged thirty-seven in 1881, was not to be subjugated; her resolve, her desires were as strong as Monet's, and were often a challenge as she was his temperamental opposite. The memories of her daughters, passed to the next generation, fixed the family image of Alice as 'a deeply sensitive woman with mystical tendencies',[36] 'a socialite, quite excitable, very pious ... an attentive hostess and very lively, but sensitive and easily tired. Today she might be described as a cyclical manic depressive.'[37]

Monet was beginning to understand that the flip side of her tenacity and verve was despondency, introspection, what she called through her diary her 'tristes humeurs' and 'pressentiments'. With them came a yearning for exaltation, sought in art and also in tradition and ritual – she was a monarchist ('ô mon roi bien aimé!' recurs in her journal) and a devout, church-going Catholic who sent her daughters to convent schools. But there was too an extreme emotional edge, an urge to lash out. 'What villainous imagination made you write those wicked lines about your jealousy,' Monet would ask.[38] Fearing 'all the folies of your imagination', he would try to calm Alice's 'vilaines pensées', 'idées noires' and 'terribles rages'.[39] Tough and competitive, she had a brutal streak, which found an outlet in a passion for attending

wrestling matches, *les luttes*, as reported in her letters: '*les luttes!* ... really exciting, they almost killed each other there yesterday.'[40] Yet her robustness translated also into fierce protectiveness of those she loved, from which Monet as well as her children benefited.

So Alice's eyes and spirit became vital to Monet in a different way from Camille's provocative gazes. He said he felt, when painting, that he wanted to bring her joy; if he could not be with her, he wrote, 'every motif that I do, that I choose, I say to myself I have to render it well so that you will see where I have been and what it's like.'[41] He longed for her responses: 'my pictures ... are all spread out, and I wanted you right there, next to me, to have your impressions.'[42] Her own delight in nature and the seasons is palpable in her letters, from spring's 'pink reflection of poplars with their new leaves, a field as a vast lake'[43] to winter, 'a marvellous sight with the frost and the sun, everything reflected in the mirror of water'.[44]

Throughout 1881 Alice walked a tightrope between her husband and her lover. Hoschedé did not come for Easter, and to Marthe's distress missed her seventeenth birthday on 18 April. Neither Hoschedé nor Monet had paid rent for over a year, willing a crisis, and in June the landlady, giving them twenty-four hours to pay six outstanding quarterly payments, refused to renew the lease in October. Monet wanted to leave anyway. Hoschedé saw the break as the chance to reclaim his family. On paper Alice consented: 'You reproach me for not agreeing to come and live with you, when on the contrary, I have decided to return to Paris in October. I urge you to rent this house that you've found and settle into it to get ready for our return.' Perhaps, knowing he could not afford to do so, she was calling his bluff. She added, 'You reproach me for not being alone at Vétheuil; the situation is still the same, and you accepted it before; your absences have become longer. Whose fault is that? Anyway, the way you behave to M. Monet creates a very strange and singular situation.'[45] Without denying a liaison with Monet, she ended with 'a thousand sad thoughts' and notice to her husband to prepare for his next visit, for Jacques's first communion.

Hoschedé duly attended Notre-Dame-de-Vétheuil on 28 August. Monet made himself scarce, travelling to the Normandy coast, his fourth such solitary journey in two years. He was thus alone by the sea

again, revisiting the past, on the second anniversary of Camille's death. In Trouville, he painted not the social scenes as on his honeymoon, but empty vistas of the tide going out, water lapping blond sand in *The Hut at Trouville, Low Tide* and a lone misshapen tree, buffeted by a wind so strong that the low hills above the sea seem to sway with it in *On the Coast at Trouville*. Going further back, to memories of walking as a child above the sea from Le Coteau, was the muted *Cliffs at Sainte-Adresse, Grey Weather*.

Returning three weeks before the Vétheuil lease ended, he rented temporary lodgings in the town while the equivocations continued. Alice neither prepared to join her husband, nor committed to Monet. Marthe, fiercely loyal to her father, was furious, guessing at her mother's relationship with Monet, whom the younger children were now urged to call 'papa Monet'. Marthe refused, though she did allow him to paint her, sitting with one of her sisters. Unfinished, *In the Meadow, Vétheuil*, a close-up of a scowling teenager, was Monet's final painting before leaving Vétheuil. Then he informed Hoschedé that if his wife returned to him, he must settle a 3,086 franc debt, Monet's surplus contribution to the communal expenses. Hoschedé paid nothing. Perhaps he saw the amount as a fiction invented by Alice and Monet, or did not really want her and six children back in Paris, or could not afford them. A year later, when Alice reminded him that she had large debts in Vétheuil, and he should help in supporting their children, he offered 100 francs.

Alice's mass of debt elicited concern even from the uncreditworthy Monet. The once shameless borrower now had to counsel prudence to a woman who, as soon as funds were within sight, behaved as if extravagance were a right. Monet's account book in the early 1880s is full of sums of hundreds of francs 'remis à Madame Hoschedé'. 'I must again make all sorts of recommendations to you on the subject of money and economies,' he would have to tell her, though 'it costs me to insist like this.'[46] Having met his match in indulgence, he was forced to become the voice of responsibility, while struggling to rise to Alice's material expectations: 'I have never wanted to tell you to spend less ... what you tell me about your privations is always painful for me.'[47] Yet even when Monet's canvases began regularly to fetch four-figure sums, he admitted that 'I am always afraid of finding myself

without a sou.'[48] The difference between them was that Monet never forgot being poor while Alice never forgot being rich.

Accepting that he could not yet support his wife and children, Hoschedé was persuaded to sanction, as a further temporary measure, Alice's move with Monet in December 1881 to a new address, Villa Louis, rue de la Seine (now cours du 14-juillet), Poissy. It was a solid square house overlooking the river in an undistinguished small town, upstream from Vétheuil. 'This horrible Poissy', as Monet called it, was a compromise.[49] It was of no interest pictorially, but it offered acceptable schools, cheap rents and good rail links – to the Norman coast for Monet, and to Paris, supposedly facilitating Hoschedé's visits. Artistically, its connections were ominous. The successful academic painter Ernest Meissonier occupied one of the largest houses, known as La Grande Maison, and was a former mayor.

There remained two last rites in Vétheuil. In the crises following his birth, neither of his parents had thought to have Michel baptized, and Monet the atheist would not have bothered. But on 18 November 1881 the three-year-old was christened at the Notre-Dame church at Alice's insistence, as a sign of her commitment to the little boy, including his spiritual well-being. Two months later, on 25 January 1882, Monet returned briefly to Vétheuil to acquire a lease on the plot in the churchyard where Camille remained, overlooking the river immortalized in the paintings of Monet's middle age.

He did not revisit Vétheuil until 1901, when he was beginning to think about the reflective possibilities of his pond at Giverny. By then the lease on Camille's grave had expired, and he did not renew it.

PART TWO

Eyes Turned Inward

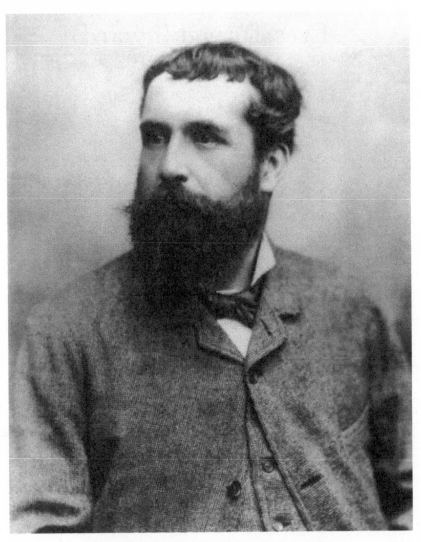

Monet photographed by Wilhelm Benque, 1883

13

The Path to Giverny, 1882–3

On 15 February 1882, the eve of the highest tide of the year, Monet arrived in the deserted fishing village of Pourville, close to Dieppe. For 6 francs a day full-board he took a room above Monsieur Paul's restaurant 'À la Renommée des Galettes', on the shore. 'The waves bash the stones of the house,' he wrote happily.[1] He worked, soaked to the bone, through storms, remaining inside only to paint Paul in his chef's whites and his golden, freshly baked galettes, a still life compared, when exhibited in Paris, to 'the immortal brioche by Chardin'.[2] Monet stayed until April, risking Alice's fury when she wrote 'to ask me to remember that I will find at Poissy my children from whom I've been apart for so long'.[3] Another visit followed in the summer, and in half a year he painted 100 canvases there. It was a heroic achievement, spurred by his delight at a fresh subject, and an urgency to earn enough to win Alice permanently and support eight children.

Between Poissy and Pourville, the terms of a partnership were being defined. Monet, funding the household, would be away for months painting the sea, while Alice was alone caring for his and her children, on a tight budget, in a dull backwater. 'I understand your tedium, always shut in like this', and 'go for a short walk, get fresh air every day,' Monet would cajole but Alice, depressed when under-stimulated, retreated with her resentments into herself, into the house.[4] She was beseeching money not from one man but two; her husband, expected to turn up and pay up while her lover was away, did neither. 'There is no hope of anything from Hoschedé,' she had to admit.[5] When eventually he did talk of visiting, it was close to the time of Monet's homecoming: 'I should warn you of M. Monet's return ... if you

don't want to meet him, send me a note or a telegram specifying the exact time of your arrival.'[6]

Monet wrote to Alice daily, respectfully addressing her as 'Chère Madame' and 'vous'. He loved to imagine her with his sons: 'Mimi must be in rapture, I can see him going to bed with all his toys. Jean tells me he is always good, is that true?'[7] In reply came tales of domestic misfortune, illness, low spirits, which were 'a reproach to me ... you're always a bit resentful of me who enjoys good things. I should return to take my part in the troubles.'[8] But he did not; his answer was 'Don't torment yourself about money, I'm earning it this moment.'[9]

The Pourville paintings earned Monet 31,000 francs in 1882, a bumper year. In this varied body of work, he depicted the coast in turbulence and tranquillity, under dark clouds and in crystalline winter light in *Stormy Sea at Pourville* and *Cliffs at Pourville, Fog Effect*, the cliffs reflected in a flat gleaming sea in *Low Tide at Pourville*, or vibrating in turquoise silhouette on whipped waves, like flashing shards of a broken mirror, in *Shadows on the Sea at Pourville*. The cliffs' stark masses and sheer hewn surfaces, the plane of the sea, the void between them, determine formal construction and drama. Monet was after exhilaration, a sense of danger, tempered sometimes by images of shelter; one feels his own disquiet and longing. Small stone cabins, built as observation posts during the Napoleonic wars, subsequently used by fishermen for storage, were the subject of a group called *Custom Officer's House* or *Fisherman's House*: tiny holdouts tucked into grassy hill crops where there seems nowhere to stand. Substitutes for a solitary human figure, the cabins peer out from the cliff edge in vertiginous drops to the abyss of furrowed seas, changing colour with light, weather, tides, and as the waves tow in sand or seaweed, sometimes cast in shadows, or lurching as if about to fall out of the picture, the windswept outcrop rearing up insistently.

At nearby Varengeville Monet chose a comparable motif of a man-made structure vulnerable yet steadfast against the elements. This was the Romanesque Saint-Valery church, with its sailors' graveyard – Georges Braque is also buried here among the mariners – clinging to the Ailly cliffs eighty metres above the water. In the first paintings, the light behind the church dissolves its form, its vertical structure rhyming with trees and a triangle of pale sea. Later Monet took a harsher

approach. Teetering at the brink of the precipice, the building in *Church at Varengeville, Morning Effect* [Plate 27] is seen in sheer upward view, the bulky granite cliff face streaked with soil stains, pounded with waves. Geffroy called the Monet of Varengeville a 'geologist': 'with the tip of his brush, he illuminates all the stones, all the minerals, and all the veins within the rocks.'[10]

These pictures converge many temporal realities: Monet's response to the sea and the memories it carried; the centuries-old church; rocks which had been there for millennia yet were eroding to push the church to the cliff edge; and the waves currently lashing them. Monet distilled geological, natural, human time in a single moment, paradoxically achieved through weeks and months of labour. He worked on each painting for ten or twelve sessions, and on some up to twenty. 'I've spent so much time on some canvases that I don't know any longer what to think of them,' he told Alice; 'nothing satisfies me.'[11] He was building on a decade of rendering light and weather effects to make the Impressionist vision a more constructed image. The paintings' 'extraordinary power of illusion' was immediately praised: 'for the first time I see rendered . . . the swells and long sighs of the sea, the rivulets . . . the glaucous colours of the deep and the violets of the low waters on their bed of sand,' Ernest Chesneau wrote in 1882.[12]

For the critic Philippe Burty, the paintings suggested yearning and restlessness: the waves shattering on black reefs in *Rocks of Pourville* 'evoke the many varied sensations and stubborn laments of the rising tide, the salty mists which sting the lips, the vague desire for a long voyage to unknown lands, and all in all, a wordless conversation with an intelligent and beloved being'.[13] A metaphysical element is there especially in the Varengeville paintings. It is telling that churches – Vétheuil, Varengeville, soon Vernon, then climactically Rouen cathedral – appeared in Monet's paintings when Alice entered his life. From what we know of Camille, she was a material girl, bringing to Monet's art the pleasures of costume, pose, a garden or a beach. Alice, though no less worldly, was a devout believer and her mystical aspect complemented Monet, resistant to metaphysical speculation, master of an art celebrating the external world, as Impressionism had done in the 1870s. Her letters ring with spiritual cadences – 'my enraptured soul', 'the true path to my heart'.[14] This sensibility enveloped Monet as

his paintings became more concerned with transience. The passage of time is a natural theme for an artist in later life, especially after a bereavement; for Monet it accorded with the tenor of Alice's habitual musing on loss and change, days and dates. The Raingo fortune was, after all, based on devising the most luxurious, decorative way to record the invisible, inevitable march of the time: Alice had been brought up surrounded by clocks.

Monet wanted to show her Pourville, and with Durand-Ruel's advances, the couple and their eight children were installed at Villa Juliette there in June. In the summer paintings the hillsides are covered with flowers and in *Walk on the Cliff at Pourville* the small, finely dressed figures of Alice and a lithe daughter, probably fourteen-year-old Suzanne, look out from the heights across a bay. Blanche, thrilled to paint outdoors, filled sketchbooks with drawings of boats, and wrote her father a cheerful letter in July about the family holiday without him: 'Jacques has been in the boat with M. Monet and was pleased that he didn't get seasick.'[15] But the pressures of a stepfamily cooped up in a home that was not their own were also felt. Alice was bored and worried, the children hampered Monet from painting, poor weather forced him to work indoors on still lifes, and he scratched out and then slit several works. In September he told Durand-Ruel he no longer wanted to 'look at my horrible canvases ... I am seized by doubt, it seems to me that I am lost, that I will never be able to do anything.'[16] The dealer sent an advance of 1,500 francs and a torrent of encouragement. 'We'll mint money' from the seascapes, he promised, 'never have you been on a surer path or of better inspiration'.[17]

Monet took himself off with Jean and Michel to his brother at Rouen, 'to have a few days' rest without thinking about painting, if that's possible for me'.[18] Alice wrote to Hoschedé, complaining that he was 'no longer paying any attention to my accounts with M. Monet and leaving me with full responsibility for them. I am certain that despite all my efforts in this respect you have written IOUs and are going to find yourself in trouble again.'[19] The subtext was to break Hoschedé's hope of reclaiming his family – the hope that kept her and Monet living provisionally. Hoschedé had sanctioned Poissy, and Monet was certain that 'if the question of moving could lead to some catastrophe, it would be better to stay in this horrible Poissy rather than be

separated'.[20] Alice tried to gauge Hoschedé's position without alarming him: 'You would have done better to write me the long letter you've been mulling over for such a long time. Our recent conversations have been wretched affairs, and I fear the same kind of scenes in the future ... write to me about your plans, so that after thinking things over I can write back to you. Without this our conversation will doubtless end in foolish things being said on both sides.'[21]

In Poissy tension hung heavy, and it was almost a relief at the end of the school term when the house flooded, demanding communal, practical effort. Germaine, nine, remembered December 1882 as magical for the younger children gliding up to the kitchen table in a dinghy. And then it was 1 January 1883 and her father for the first time failed to visit for the holiday.

'Hoschedé,' Monet addressed his former friend,

> Let me tell you all the pain I feel thinking that my presence alone prevents you from being with your children today. I had hoped that by absenting myself for several days you would at least have consented to come and spend New Year's Day with them; you refused to give them that pleasure. I am very upset by this, because you've never missed the day in previous years. However, if I am here among your family, isn't it by common agreement, and wasn't it with your assent that I was able to rent our house in Poissy? Yes, you know that well, but you have suddenly decided to no longer come here and you have created a most difficult situation between us. Although I know that it will be no more pleasant for you to read me than to see me, I can't resist telling you all my grief.[22]

Although aware he was the cause, Monet was upset to watch the children miss their father, but this letter was a declaration of war. With his healthy account book for 1882, and the Poissy lease about to end, Monet began 1883 determined to force the issue with Hoschedé, move to a permanent home with Alice, and establish their life on a secure footing.

In January he went to the familiar resort of Étretat for a month's frenetic painting of rough seas, boats lined up on the shore, pierced cliffs such as *The Manneporte (Étretat)* [Plate 28]: a feast of motifs which drew him back every year until 1886. Here he waited for news

of Alice's reckoning with her husband, an encounter both Hoschedés repeatedly postponed. 'The more this goes on, the more you make a monster of it – April will arrive and he won't have come to see you, you must fish him out and have a wise and serious conversation with him,' Monet instructed. 'You can be sure of my love, have a bit of courage.'[23]

Hoschedé, as if to reawaken bitter memories, installed himself in a hotel at Vétheuil, and did not budge. Monet even suggested sending him the fare to Poissy. Over-jaunty, he refused at first to face Alice's fears of how Hoschedé, confronted definitively with losing his wife, might behave, but by the time Hoschedé arrived at Poissy on 18 February, he too had become uneasy. The next day, Alice's thirty-ninth birthday, which he had forgotten ('you know I am not a man for dates and Jean ought to have at least warned me'),[24] a short note arrived which devastated him.

'I feel that I love you more than you could suppose, more than I believe myself.' he replied.

> You can't know what I've suffered . . . in what anxious state I've been to have news: so you can judge my state when, this morning, I received your four lines which tell me more certainly than four detailed pages. I've read them and reread them 24 times; I am dissolving in tears: is it possible that I must get used to the idea of living without you? I know, however, that I can do nothing and I mustn't say anything against what you decided yesterday, I have to submit to it, having no right, but I am unhappy, very unhappy . . . My canvas can be good or bad, it's all the same . . . You tell me to come at once: so do you want to leave me at once? . . . I want to go far away, knock myself out, exhaust myself, who am I? . . . I remained looking stupidly at the waves, wishing that the cliffs would crush me. I love you, I can still say it to you, no?

He was afraid to go home because, he wrote, 'I don't want to meet M. Hoschedé' – now dignified as 'Monsieur'.[25]

By forcing the case, perhaps Monet drove his rival to the brink, and Alice to desperation, for it seems Hoschedé's arguments concerned the children. He may have threatened to claim custody unless Alice returned to him. This would have worked, as Alice and Monet both knew she could not live without them. In answer to her explanation

Monet said, 'I understand everything you tell me on the subject of the children, it is a sacrifice which would be wicked to ask of you. When I think only of you and me, I find it impossible to live one without the other ... the idea of a separation drives me insane.'[26]

But the immediate danger passed. Hoschedé withdrew, Monet returned to Poissy and for now his charismatic presence carried the day. Hoschedé, however, remained in the background, even rebooking his Vétheuil hotel for next winter. 'I know how much you love me, but I am always afraid that he is scheming something, especially profiting from my absence,' Monet told Alice.[27]

The faultlines of a stepfamily were clear from this rocky start. Alice's closeness to her daughters was as non-negotiable as Monet's painting. She struggled being absent from her children for even a day, surrounding her daughters especially with a cocooning affection, and in turn she needed their gentleness. While Monet painted and travelled, the girls were Alice's engrossing consolation. As young women they absorbed her outpourings about the difficulties of life with Monet. 'What turbulent and sad days I'm spending at the moment (entre nous),' she would write to Germaine from a trip with Monet. 'You know him, you know his extreme leaps, from beautiful to ugly, from good to bad ... Alone here, it's hard, he has his work, I have my thoughts. All this only for you alone.'[28]

Alice guarded this zone of her life jealously. 'I think of the children whom you love and who love you, but I can also see everything that is coming between us and this will increasingly divide our life together,' Monet told her.[29] He felt real affection for the Hoschedé children, but his deep, vulnerable love as a parent was for his own sons, 'my little Mimi ... with his poor pale figure'[30] and 'this devil ... my poor Jean'.[31] That increased his dependence on Alice, irreproachably loving as their stepmother.

But if the emotional power was with Alice, social power was against her, and that shaped how she felt and behaved. Anyway anxious by temperament, she had reason to be frightened of her love for Monet because in social and legal terms it left her vulnerable. 'I am sorry to see you always lamenting your worries ... about *loving me too much*,' Monet underlined.[32] He had vanquished Hoschedé as a lover and trumped him economically, Alice could sense that his star was rising,

he could offer her and her children a more comfortable life, and these pragmatic considerations counted. But Monet could not marry her, and the weapon of the law was with Hoschedé.

Responding to one of her tantrums in 1884, Monet accused Alice of behaving 'like a heroine from Zola'. Trying to cheer her out of boredom, he sent her *Anna Karenina*, and received no word of her thoughts about it. The references were too close to the bone. Female adultery was at the heart of the nineteenth-century novel because it was seen as a major threat to the social order. Flaubert faced the courts for obscenity for his novel of adultery *Madame Bovary* in 1857. Under the July Monarchy, the Second Empire and the Third Republic alike, female adultery remained a crime, punishable by jail. Although most couples arranged things themselves and cases rarely came to court, there were shocking exceptions, even within liberal artistic and literary circles. In 1845 police, tipped off to find 43-year-old Victor Hugo and his 25-year-old mistress Léonie d'Aunet, wife of the painter François-Auguste Biard, *in flagrante* in a Paris hotel, allowed the writer to go home and arrested Léonie. She was sentenced to two months at the Saint-Lazare prison, followed by further incarceration in a convent. Monet's friend Clemenceau separated from his Massachusetts-born wife Mary Plummer in 1876, and had countless affairs; discovering a liaison between Mary and their children's tutor, he had her thrown into jail for a fortnight, stripped of her French citizenship and escorted, on leaving prison, to the docks with a third-class single ticket home to America. None of this prevented Clemenceau from naming his newspaper *La Justice*.

In 1883 there was no divorce in France. Debate raged about whether to bring back the Revolution's no-blame divorce laws instituted in 1792, and abolished with the return of the monarchy in 1816; the issue was part of the Third Republic's fraught liberal/conservative identity. When divorce did return to the statute book in 1884, punishing caveats included that an adulterous couple were forbidden to marry following the divorce of either. Nevertheless, the possibility of divorce was perceived as republican radicalism and never occurred to Alice. But had Hoschedé divorced her, she would have been unable to marry Monet. And for those few couples who did divorce, custody of children usually went to the father.

So Monet was asking a lot of Alice, when the only security he could give her as she contemplated decisively, overtly, abandoning her marriage and making her life with him in 1883 was protestations of love: 'toute ma vie c'est toi, so love me without fear'.[33] Her fears account in some measure for her extreme outbursts of jealousy, especially at a time when male fidelity was unusual. Manet, Zola, Mallarmé, all had extramarital affairs, Renoir was known to be a womanizer, Cézanne avoided his wife for the brothel. Monet, unusual in his faithfulness, was understandably upset by Alice's suspicions, just because they were groundless, and tried hard to allay her general nervousness. In 1883 he begged, 'How can you think that I am lost for you and that you'll never see me again. Don't fear these things, I think of you endlessly and will come back to you full of happiness.'[34] Alice craved daily reassurances throughout the uncertain 1880s and Monet needed all his buoyancy to provide them.

The question, dogging the decade, was whether these reassurances could be enough. In a revelatory note, Suzanne Hoschedé would confide to her fiancé that not being married to Monet was 'something that troubles Maman very much' and also that Monet wanted to be married 'to be more at ease in his relationship with our family'.[35] Her granddaughter-in-law believed that Monet and Alice's 'irregular relationship disturbed the couple in different ways. Lacking social sanction, it embarrassed Monet, who was traditionalist and conservative in such matters. Lacking God's formal blessing, it made Alice unhappy.'[36] Alice had begged Monet to sanctify his civil marriage to Camille on her deathbed. Sexual morality was an insistent part of the education of nineteenth-century bourgeois girls; it would have been surprising if her situation had not made Alice unhappy.

Social acceptance was no issue in a bohemian circle. Caillebotte never married his long-term companion Charlotte, Maître lived for thirty years with his mistress Rapha, de Bellio was raising his illegitimate daughter alone, Alice's friend Pauline Carolus-Duran was the illegitimate daughter of a French dancer at the Mariinsky Ballet. Only Monet's provincial narrow-minded brother Léon refused to meet Alice. Nonetheless, negotiating long-term commitment outside legal boundaries complicated the emotional stakes. In an oppressive patriarchal society, civilized relationships worked by private redressing of

legally ordained injustice. Hoschedé was not Clemenceau. Monet, a decade after he became Alice's lover, still addressed her by letter formally as 'Chère Madame' and 'vous' to signal respect; only in moments of longing did he lapse into 'tu': 'I have only thoughts, desires, pour *toi, je t'aime*.'[37] Social imbalance created a sort of reversed emotional imbalance. Alice could doubt and hurt Monet, threaten to leave him, even expel him from home, but the insecurity of her public and legal position meant he could not do the same back. He had to be restrained, passive, a role demanding real strength of character.

Manet, Pissarro, Renoir, Cézanne, Caillebotte all had partners from a lower social class and kept their professional and personal lives separate. 'I shall never succeed in describing to you my astonishment at the sight of this incredibly heavy woman,' Berthe Morisot told Mallarmé in 1891 on meeting Aline Charigot, a dressmaker from the provinces whom Renoir had concealed from most of his friends for years before they married in 1890, by then parents to a five-year-old son.[38] Aline never accompanied Renoir to gatherings at homes such as Morisot's, and had an uneasy relationship with the social circle around her husband. Uniquely among his artist friends, Monet chose a refined, educated woman of a higher class than himself. 'She welcomed the artists so affably, and with such grace,' recalled Boudin.[39] Indeed, Alice was so well bred, well dressed, and able to charm dealers and collectors that some less successful artists, notably Pissarro and Sisley, believed that she was supporting Monet, enabling him to raise his prices. This was false: after Hoschedé's bankruptcy Alice had very little money of her own and brought Monet six extra mouths to feed.

He got in return absolute commitment to his art, and acceptance of his great neediness and the demands of his pattern of work. This meant long absences when he left her with his children, the insistence on expansive correspondence, and an understanding that, as she put it, 'You know the pain he causes you when you see him doubt himself.'[40] He prickled at a moment's neglect such as 'a very short letter; four pages, you tell me; but, *sapristi*, you must have been busy, because there is a space between the lines, as if you were in a hurry to finish. So I am cross with you.'[41] Alice tolerated all this. She loved the painter as well as the man. Monet took for granted that his painting was their joint endeavour: 'The best is to work and bring back, if possible, beautiful

things; for that let's each of us have courage and hope and, if we have anxieties and troubles, let's not reproach each other for them.'[42]

Their extended correspondence is remarkable for its inward focus. There would occasionally be mention of a local event, such as a train accident; politics never; a few friends from time to time. Otherwise problems of money, the quotidian progress of Monet's painting and the wellbeing of their children fill a self-enclosed world. Health has a special place. After Camille's death, Monet was desperately cautious and 'la santé avant tout', health before everything, resounds through his letters to Alice: 'Keep everyone well, that's the important thing.'[43] The children were kept home if there was any rumour of disease, Monet never travelled without Alice's little book of pharmaceutical remedies; few names recur as frequently in the correspondence as that of 'Monsieur Love', the homoeopath in whom all Monet-Hoschedés had boundless faith, and Alice knew that daily telegrams of reassurance when Jean or Michel were ill were the only way to calm Monet.

Monet had found a soulmate: 'I don't stop thinking of you in pain as in joy,' he said, and 'I can't dissemble, and to whom can I confide my thoughts, if not to you?'[44] Yet at any minute Alice could fracture his equilibrium, and he wondered, 'How odd it is that while I think of you with such affection and try and show it to you as well as I am able, your thoughts are always at their blackest.'[45]

It was often comforting to work alone on the coast: 'You know my passion for the sea, and here it is so beautiful . . . I think that each day I understand her [the sea] better, the slut, and certainly that name suits her, for she is dreadful; she offers up . . . some absolutely terrible aspects.'[46] It is an erotic comparison written to the woman whom Monet found, like the sea, mesmerizing, changeable, hard to control. He was pushing Impressionism to new extremes, in violent, fluctuating motifs far from the riverside calm of Argenteuil and Vétheuil. The restlessness and machismo of his seascapes of the 1880s, their brittle, excited surfaces, were created amid the dramas of life with Alice. These pictures 'shatter nerves', Monet is 'a feeling artist who makes us feel', wrote the critic of the *Gazette des Beaux-Arts*, reviewing Durand-Ruel's show of the seascapes in March 1883, Monet's second solo exhibition.[47] Burty saluted Monet's 'agitated aesthetic sense . . . completely modern', concluding, 'He is entering a new phase.'[48]

This show was, however, a disappointment. Sales were scant and Burty, bribed with a painting, was one of the few journalists to cover it. 'Monet's show, which is marvellous, has not made a penny,' Pissarro told his son.[49] Monet was hurt, thought the show a catastrophe, and refused to come to Paris, which would 'only confirm my unsuccess and see people talking to me about it, some with pleasure, others deploring it. I prefer to stay in my corner with my worries.'[50] But he did venture to the city in April to visit Manet, suffering from complications of syphilis, his gangrenous left leg just amputated. As Monet sat down on his old friend's bed, Manet shrieked out that Monet was hurting his (phantom) limb. So Manet was riled by him to the end.

It was a weary Monet who, after this turbulent winter, set out on 5 April to seek a new home where he could install Alice as his companion, no longer in a place sanctioned by Hoschedé. He wanted to be back in Normandy, and downstream from Poissy, where the river loops on after Vétheuil, he took the slow, twisting narrow gauge train from Vernon to Gisors on the Pacy-sur-Eure line, which stopped at every village along the Epte river. *The Train at Jeufosse*, pink-tinged smoke from the locomotive rising up a wooded slope overlooking a gently curving bend of the river, whose arc swells to transform the foreground into a mosaic of coloured reflections, records such a journey. It was a landscape of broad, flat meadows and low chalk ridges where grain fields and dense orchards unfolded across the valley, rows of poplars and willows marked the contours of little tributaries, the light was soft and changeable, a lilac haze often hovering over the Seine at dawn. 'The greatest charm lies in the atmospheric conditions over the lowlands, where the moisture from the rivers, imprisoned through the night by the valley's bordering hills, dissolves before the sun and bathes the landscape in an iridescent flood of vaporous hues,' wrote a nineteenth-century American visitor, painter Will Low.[51] Another, Malcolm Cowley, in the early twentieth century, was less romantic: 'the north winds are cold and wet, the south and west winds warm and wet . . . Fogs and mud . . . little copses and wheatfields . . . damp green fields.'[52]

Between the river and hills, a little downstream from Jeufosse and four kilometres from the market town Vernon, was a village of 279 people where a substantial, slate-roofed farmhouse, painted pink with grey shutters, with lime trees at the door, was vacant. It had ten large

rooms plus attic and cellar, and stood on a plot in a part of the ancient domain known as Le Pressoir, the cider press, between the two parallel main streets lined with modest houses and hedged gardens: the Grand'Rue, also known as the rue du Village and now rue Claude Monet, descending from the Romanesque church of Sainte-Radegonde, and the lower Chemin du Roy, chief thoroughfare from Vernon to Gisors. What would become Monet and Alice's suite – a bedroom each connected through two dressing rooms – looked out on to high ground. There were orchards in front of the house, barns with floors of beaten earth at each end, further outhouses, and yews at the top of a sloping path in a garden descending to a meadow; adjacent was a field of wild irises fringed by pollarded willows.

The village, smaller and more rural than Vétheuil, was a community of little family farms and lived to the rhythms of sowing, haymaking, reaping; the peasants 'made their own bread and only ate meat on Sundays'.[53] The residents included a blacksmith, a village idiot called Bertinet, a beggar known as 'a mère Brandin' who was not in fact poor, and a half-mad old lady considered a witch, 'la mère Deric'. There were three mills, a school and even a train station. Vernon, on the Paris–Rouen line, was an hour from the capital; a branch line passed through Giverny, though most travellers descended at Vernon and reached the village by coach or on foot via a road following the river's north bank. Immediate attractions for Monet were the high, enclosing wall, the fruit trees in blossom, and the view of wooded slopes towards the river. Unaware of his new tenant's record of defaulted rents, the farmer-owner, Louis-Joseph Singeot, was pleased to find a taker for so large a property. A happy sign was that during Monet's journey, the little train came close to the road near the village of Gasny, and stopped between stations to allow the ascent of an entire peasant wedding party, headed by a violinist.

Moving day was the usual fiasco for a pair of debt-ridden spendthrifts. Durand-Ruel learnt the new address when Monet wrote from Poissy on 29 April, 'I am leaving this morning with some of the children. But we are so short of money that Madame Hoschedé can't depart, and she has to be out of the house by ten tomorrow. I therefore beg you to send ... one or two notes of a hundred francs ... Address them to me directly at *Giverny, by Vernon, Eure*.'[54]

GIVERNY. - Les Prairies

Phot. A. L., Vernon

Giverny, late nineteenth century

Alice arrived on 30 April, followed the next day by a telegram from Eugène Manet: 'My dear Monet my brother dead please be one of the pall bearers.'[55] The first lines Monet penned from Giverny, on 1 May 1883, were to Durand-Ruel: 'I've learnt this instant the terrible news of the death of our poor Manet. His brother is relying on me as a pall bearer. I need to be in Paris tomorrow night.'[56] Monet was forty-three, exactly halfway through his life, and possessed money for neither the train fare nor mourning dress. Durand-Ruel paid for both and checked the progress of the suit at Monet's tailor, the prestigious Auld Reekie at rue des Capucines. Even if he did so on credit, Monet would look the part. He posed that year for Wilhelm Benque, photographer to Paris opera stars, who cast him as a resolutely modern figure, grave, clear-eyed, hair and beard neatly trimmed, Scottish tailor's coat light and lean, in contrast to the fusty 1860s–70s fashions in previous photographs.

'On the day of the funeral, all these people, usually so cold, appeared to me like one big family weeping for one of its own,' wrote Berthe Morisot.[57] Following Manet's death, Impressionist divisions were suspended, some closer ties developed, including between Monet and Morisot, and positions were jostled. For the Paris intellectuals – Zola,

Duret, Burty, Antonin Proust – who carried the coffin with him at the Passy cemetery, and the wider artistic community, Monet was Manet's heir as leader of the new painting. 'Don't forget that you are walking in Manet's footsteps and that in the eyes of the public you are at the head of that remarkable artistic movement in which France has set an example. Manet is dead! Long live Monet!' de Bellio wrote.[58]

But in private behind the walls of his new home, Monet was withdrawn, believing only that 'if I am settled in a fixed place, I could at least paint and face (mis)fortune with a good heart.'[59] In May he took Jean, nearly sixteen, for his first day at school in Vernon, and thought the surroundings enchanting. Alice wrote to Germaine, at her convent boarding school, of woodland full of lilacs and bright yellow broom, smelling of vanilla: 'The countryside is even more beautiful than at Vétheuil, we are amazed, and we never stop going for walks.'[60] Yet Monet vacillated, regretful in June: 'I think I've made a terrible mistake in settling down so far away.'[61] And he was not welcomed. While Alice, respectably dressed and friendly, became accepted in the village, Monet was considered taciturn and aloof. The locals 'gave us the eye' Jean-Pierre remembered of the early days in Giverny.[62]

'The countryside is superb, but so far I haven't been able to take advantage of it,' Monet admitted in July, for 'it always takes a while to get to know a new landscape.'[63] He scouted subjects, and by September boasted that he had not set foot in Paris all summer. He explored marshes and meadows, walked in the hills, moored his boat to willow trunks at the Île aux Orties (Nettle Island), where the Epte meets the Seine. His dozen paintings from that first year are tentative, though some – the misty Seine at nearby Port-Villez, trees along the Epte – are initial renderings of motifs which would later immortalize Giverny. But in 1883 it was an obscure village offering uncertain rewards, a place where Monet could recuperate after the nomadic half-decade since leaving Argenteuil, build and grow.

He started renovating the kitchen and giving the west barn a pitch pine floor and a big window for it to become the studio. The dining room was painted two shades of yellow, contrasting with Monet's Dutch and Chinese blue ceramics; his Japanese prints were hung. Monet planted the garden with chrysanthemums, poppies and sunflowers, vines and rambling roses were trailed on the outside of the

house, whose shutters were repainted green. Against Alice's wishes, he had most of the spruce trees chopped down. The children were co-opted to plant and water. All this preoccupied him and, compared with a haul of 106 paintings in 1882, 1883 was slow. He completed only twenty-nine works, and eighteen of those were painted in Étretat in January and February. These, together with continuing strong sales from the previous year's Pourville paintings, kept Giverny afloat. Thanks to Durand-Ruel's ability to sell the seascapes, Monet's earnings for 1883 were a record 34,541 francs.

Monet's ambition therefore had to be with the sea, but his personal hopes of Giverny were expressed in the year's largest canvas, *Luncheon beneath the Canopy* [Plate 31]. To attempt the subject was almost a ritual consolidating a new domestic situation, and *Canopy*, the monumental painting made ten years after depicting Camille and Jean in *Luncheon* at Argenteuil, is the last of four compositions, all titled *Déjeuner*, all substantial. The Giverny painting is as theatrical and unusual as its predecessors. Under a vast orange canopy, trestle benches flank a table laid with a cloth, a golden loaf, plates, wine glasses. Against banks of flowers, lunch is set out in the garden to accommodate the entire Hoschedé-Monet clan. But most of the benches are empty. Monet invites only two figures into his painting – Alice, statuesque in a white dress, and Michel in his sunhat, its red band matching the ribbons on her bonnet. 'It makes me so happy when you tell me that Mimi is your joy, you who are so good for him,' Monet thanked Alice that winter.[64] *Luncheon beneath the Canopy* wistfully reprises the mother and son pairing of the earlier *Déjeuner* compositions, and attempts to build in paint the love and security which Monet longed for Giverny to represent. But Alice's and Michel's faces are blank, the garden is hardly decipherable even as a sketch. Monet could not bring the picture to any sort of conclusion. It remained unfinished, an image as provisional as his new family – bright, all-encompassing, yet still as flimsy as the gorgeous billowing canopy.

14

Home and Abroad, 1884–6

The medieval town of Bordighera stands on the slopes where the maritime Alps plunge towards the Ligurian sea, twenty kilometres from the French border. In the nineteenth century, Napoleon's Corniche road, and then the railway, altered its fortunes. The Hôtel d'Angleterre, the town's first, opened in 1860 and hosted the British prime minister Lord John Russell. The microclimate of warm winters and the palms, olive groves and citrus trees framing spectacular sea views began to attract tourists, but it remained a remote location until the Compagnie Internationale des Wagon-Lits launched the Calais–Nice–Rome Express, speeding access from Paris, on 8 December 1883. A week later, on the evening of 16 December, Monet and Renoir were aboard.

Renoir, a veteran Italian traveller, was the instigator. Monet, having been enclosed in the Giverny studio, frustrated making still-life panels for Durand-Ruel's salon, accepted his invitation with alacrity. Giverny in winter could be dreary: 'Here we are fallen again into rain and mud, it's deadly!' was Alice's description.[1] Sensitive to the Hoschedé children's hope to spend the holiday with their father, Monet was anyway seeking to absent himself over Christmas. The fortnight with Renoir gave Hoschedé a clear run.

It was a decade since Monet and Renoir had painted together, and they had staked out opposing realms: the social gaiety of Renoir's figure paintings versus Monet's landscapes of solitude. But each had recently stalled. Renoir, having encountered Raphael in Rome and the frescoes in Pompeii, was actually beginning to dislike Impressionism. 'Around 1883 a sort of break occurred in my work. I had gone to the end of Impressionism and I was reaching the conclusion that I didn't

know how either to paint or to draw,' he said. 'I was at a dead end.'[2] Monet was also taking stock. He told Durand-Ruel on 1 December, 'I have more and more trouble in being satisfied with what I do, and I've come to wonder whether I am going mad, or whether it is simply that what I do is neither better nor worse than before, but that I have more difficulty today in doing what I formerly did easily.'[3]

Despite their differing paths, Renoir was scanning Monet, and other friends. A stay in L'Estaque, near Marseille, in 1882 had brought him closer to Cézanne, whom the pair visited on their way home. Renoir hoped to learn from the south: 'While warming myself and observing a great deal, I shall have acquired the simplicity and grandeur of the ancient painters.'[4] He enjoyed being there again with Monet, telling Durand-Ruel, 'We are enchanted by our trip. We judged that it was preferable to study the countryside carefully so that when we come back we will know where to stop.'[5]

Monet too scrutinized Cézanne's landscapes, then developing their full ripeness of colour, airiness, consistent luminosity. As he considered his next move, he may also have noted Morisot engaged on a large, freely worked copy of the Rococo artist François Boucher's *Venus at the Forge of Vulcan* at the Louvre, dominated in her impressionist rendering by vigorous pink-blue-cream slashes. Morisot intended this to hang in the living room at her new home at the rue de Villejust, and when they met at the opening of Manet's memorial show on 6 January, Monet to her surprise suggested that he paint as a gift a large Mediterranean panel for the same space. 'Monet insists on offering me a panel for my drawing room. You can imagine whether or not I will accept it with pleasure,' she told her sister.[6] Monet was thus already thinking in ambitious terms about the possibilities of the Italian motifs.

Yet, to Renoir, he was circumspect about his Mediterranean plans. The pair were not, as Renoir had assumed, to return together. Cézanne's single-minded isolation, rather than Renoir's sociability, was the example Monet held from the journey. On 12 January he informed Durand-Ruel that he was about to leave. 'I want to spend a month in Bordighera, one of the most beautiful places we saw on our journey . . . I beg you to talk of this trip to *no one* . . . I want to *do it on my own*. However pleasant I found it to be the tourist with Renoir,

it would annoy me to make the trip *à deux* to work there. I have always worked best alone, and following my own impressions only.'[7] There was a commercial element too. For his popular seascapes Monet had to surprise each time, and he had an instinct to be just ahead of the tourist curve, and to make the subject his own. Stéphen Liégeard's *La Côte d'Azur*, giving this stretch of coast its name, did not appear until 1888, but it was a destination on the rise. The resorts of Monaco, Menton, Villefranche were also within Monet's sights.

On 17 January Monet set out alone, promising from the Gare de Lyon, 'I am going to do astonishing things.'[8] On arrival in Bordighera, after a false start at a *pensione* filled with Germans, which he loathed, he settled into the modest Pension Anglaise, whose lingua franca at the *tables d'hôte* was English, changing to French when the men retired to smoke. From here he began a regime painting outside from dawn to dusk. 'You have never seen me at work when I am alone and far away,' he told Alice. 'I don't give myself a minute's respite, I have such fear of coming back empty-handed.'[9]

Bewitched by a landscape whose blanching light suggested he needed a palette of jewels, he started with vistas from the slope of the Collina dei Mostaccini looking down to the old perched city, topped by the tower of Santa Maria Maddalena with the sea beneath, as in *Bordighera* [Plate 29]. The colours are Cézanne's: red roofs, azure water, a frame of twisting pines, but Monet sometimes veils it in a violet haze. For the Strada Romana, lined with its villas in Moorish design, he overwhelmed the buildings by luxuriant foliage and palms. Their thrusting forms declare rampant nature overpowering civilization. Among interwoven pale colours – yellow-orange, lavender – the palms star, yet 'these palms will be my damnation. The motifs are extremely difficult to seize ... it is all so dense. As for the blue of the sea and the sky it's impossible.'[10]

Yet more thrilling was a garden of palms, agaves, yucca, and rare species belonging to Francesco Moreno, 'a true Marquess of Cara-bas', who welcomed Monet and gave him his own key. 'A garden like this is like nothing else, it's a pure fairy tale, all the plants of the world ... all varieties of palms, oranges, mandarins.'[11] The *Garden in Bordighera* paintings are highlights of the trip: fragments of the old town glimpsed in a morning view of greens and lemons with blue-rose shimmers cast by the rising sun, and spiky palms in contrasting light

and dark offset by a flowering agave. Moreno's was a memory for the abundance and controlled wildness which would later characterize Giverny's mature garden.

Then Monet went inland to depict *The Valley of Sasso*, with its tumbling vines and lianas, slopes of palms and citrus trees. A stone cube shed, recalling Pourville's white cabins, is an anti-focus, overrun with bushy vegetation, the diagonals packed tightly to engulf and block access. In the melded pinks and apricots, the heat is palpable, oppressive, the eye knows no peace and there are no pathways, only a richly textured surface. The nervy grace, the web of agitated strokes like a tangle of plants, is new in Monet's painting; it disorientates and suggests his own excited disorientation.

He had gone to Italy to provoke that liberated, unkempt effect. In a fast, opportunistic move to grasp Bordighera's possibilities and so renew his art, he had recklessly thrown over his oldest friend, and then risked his relationship with Alice when a stay billed as three weeks became three months. His efforts had long repercussions. Since Vétheuil, Monet had battled the limits of Impressionism; here he discovered a landscape which outdid him in glare and colour. Bordighera demanded different sorts of composition, denser and more jumbled as well as brighter. The twenty-five works depicting the Italian town look unlike any paintings he had made up to that point.

Both Renoir and Monet travelled to Italy to break a creative impasse, with opposite results. Renoir discovered classicism, seeking as Cézanne did a solidity of form to counter impressionist fleetingness, whereas Monet sought to depict a contemporary Mediterranean. Its exoticism and brightness affirmed his conviction as a painter of light and colour: 'people will scream at the lack of resemblance to nature, at the madness, but too bad. I had to come here to catch the striking aspect. Everything I do is flaming punch or pigeon-throat.'[12] Bordighera urged a high-key chromatic daring which would subsequently transfigure his paintings at home. And in rendering its impenetrable terrain, Monet adopted a curvilinear decorativeness, an emphasis on surface patterning, as in the silvery-blue mesh in *Study of Olive Trees*, which developed in Étretat and Brittany in 1885–6, and reached full expression in the water-lily paintings.

Following Monet, subsequent northern-born painters, from Van

Gogh in Arles in 1888 to Signac, Bonnard, Matisse along the Côte d'Azur, would find in the south a similar combination of emotional release, challenge and reinvigoration. In these sites of pleasure were built twentieth-century transformations to non-representational colour, increasingly abstract. Monet was a pioneer. Van Gogh wrote of seeing the landscape of Provence as a Monet painting: 'One evening recently,' he wrote to his brother Theo three months after arriving there, 'I saw a red sunset that sent its rays into the trunks and foliage of pines rooted in a mass of rocks, colouring the trunks and foliage a fiery orange while the other pines in the further distance stood out in Prussian blue against a soft blue-green sky – cerulean. So it's the effect of that Claude Monet.'[13]

If Bordighera loosened Monet, set free his romantic sensibility, it was also a journey of self-discovery, testing the extent to which he could both position himself as part of the new family in Giverny and work independently away from it. Alone after long days' working, he wrote to Alice of 'death in the soul this evening', that 'I am in terrible sadness when I'm not working, like a soul in pain and desperate.'[14] Eventually he felt out of his depth. He feared the paintings were dreadful; he had a nightmare that all the colours were wrong in his pictures, that no one understood them and Durand-Ruel rejected them, and the next morning the guests at his pensione told him he looked ill.

Through a daily correspondence chronicling his highs and lows, Alice was the affirming echo for everything he was experiencing as he unfolded to her the internal drama of making the paintings, against a comedy of manners of late-nineteenth-century middle-class riviera tourism – no Hôtel d'Angleterre for Monet. His tale of an eccentric traveller who never removed her 'Rembrandt' hat provoked jealousy, but he cheerfully described a quartet of robust, good-humoured Scottish women walkers, travelling by foot from Biarritz to Rome: their joint age was 250, he reassured Alice. He lost 10 francs gambling at Monte Carlo, and Moreno scooped him up into luxury for an Italian 'déjeuner pantagruélique'.

While Monet feasted in the sun, typhoid came to Vernon. Alice kept the children from school, had to appeal to Cécile for money, and was bored to tears. 'I understand your unhappiness, I understand what

your life is like, so buried, [but] you have the children around you, this isn't nothing,' Monet pleaded.[15] Her first jealous outburst came after a week. 'You have a peculiar idea to think that I would interest myself in the young Misses Anglaises, and especially that they would interest themselves in me,' Monet replied.[16] Within a month Alice was talking of separation, depression, that it was nothing to her if Monet were unfaithful. 'Don't you think this is bad for me? I'm very unhappy, very anxious, me who only dreams of being with you again; talking to me of infidelity, won't you ever know me?' he answered, then, 'Damn this trip. Knowing you are in this state is hateful to me, I really don't know what to say to you, if you believe in nothing, and if you are indifferent to everything . . . We need, you and I, to encourage each other to bear this separation. I beg you: reflect, you aren't being reasonable.'[17]

Alice had expected him for her fortieth birthday on 19 February. Hoschedé came instead; Monet moved only as far as the flower shop, to send her blooms placed in the box with his own hands. He imagined the birthday scene, '*la petite fête*, the arrival at the table, the surprises, the hugs, the tales which the little ones recited so admirably.'[18] When Alice exploded at her domestic cage, Monet soothed, 'I want to be there to calm these terrible rages', but he also skipped the next family occasion, Michel's birthday on 17 March.[19] His son's phrases, *faire dodo* (go to sleep), *manradarines* (mandarins, sent, thanks to Moreno, as a treat), recur through the letters, comforting sounds of home which evoked physical presence for Monet. 'You are no doubt in bed, hugging your big baby [Jean-Pierre was then six] and opposite Mimi who is no doubt snoring. Every evening I spend with you and see you all', for 'the most beautiful country in the world doesn't replace the joys, even the small miseries of our intimacy'.[20]

If this was true, it was a gamble, after five years working to win her from her husband, to leave a volatile Alice through the first winter and spring in their new home. He ran out of paints and replacements were ordered from Turin. His shoes and clothes wore thin; he was so tired that, strolling down the street smoking, he did not notice that he had set his jacket on fire with his pipe. Still he could not leave the Mediterranean, lingering en route home in April to paint at Menton, and admitting to an icy Alice that he would miss Easter in Giverny. 'I

have been away too long and, who knows, perhaps you don't want this return ... I torture my imagination.'[21]

It had been essential for him to go away, on his own terms. The Bordighera pictures were a marker: he could live in unremarkable Giverny and still paint glamorous sites. The trip asserted to Alice that 'painting, this damned painting, is my life, and consequently it is your life too', and confirmed their domains.[22] 'You have the lovely faces, the cheerfulness, the laughter with you, I don't. I work, it's my great joy, for me ... it's all that I think about.'[23] Durand-Ruel's enthusiasm proved the success of groups of seaside pictures. The Mediterranean works, three quarters of his output that year, yielded further record sales. Monet earned 45,000 francs in 1884, and resolved, he told Durand-Ruel, 'only to give you things with which I am absolutely satisfied ... otherwise I will become a machine for painting'.[24]

The year's success was crowned in November in an article by journalist Octave Mirbeau in the conservative newspaper *La France* lauding Monet as the poet of passing sensation, evoking nature 'in her ever changing aspect ... a surprise every hour, every minute'.[25] Mirbeau, a fellow Norman, fiery and lucid, red-haired, blue-eyed, a political anarchist who managed to operate in establishment circles, wealthy by stock market speculation, was a passionate, witty man who took his commission to write on the artist very seriously, and soon came to idolize him. His article, widely read, was Monet's breakthrough in the right-wing press. 'The hour of general consecration is near,' wrote de Bellio.[26]

Within a year of moving to Giverny, Monet had established a workable pattern of home and abroad, of distinctive groups of canvases begun with tremendous effort and emotional engagement *in situ*, and laboriously finished in the studio. The Mediterranean pictures set the bar for exhilaration provoked by extremes of nature as, travelling widely through the 1880s, Monet sought new rapture which, as at Bordighera, would unleash imaginative freedom. Engaged for months on a Bordighera composition as the promised panel for Morisot, in a pink-blue tonality concordant with her own *Venus* for the same room, he told her in the autumn, 'It isn't a picture but a decoration, very crude, or perhaps not crude enough,' implying that he was continuing

to contemplate possibilities of expressive style suggested by his Mediterranean visit.[27]

From now on each painting campaign, although self-contained, was part of a quest to test representational possibilities in ever more dramatic seascapes. High excitement became the addiction and obsessive observation the means, because 'to paint the sea, one must view it every day, at the same time, and in the same place'.[28] He needed these stretches of solitude, alternated with familial existence at Giverny, whose bourgeois domesticity functioned as a consoling idea in his absences. 'I will order in advance two good bottles of champagne and some morels, and what a good pipe I will smoke on the divan in the studio,' he wrote from Bordighera.[29]

After his Italian adventure, to prove his loyalty to Giverny, he promised not to miss a single season for a year, and some fifty works from autumn 1884 to summer 1885 record his home and family. In *Frost at Giverny* Michel and Jean-Pierre are stick figures perched on half-melted snow. *Route de Giverny in Winter*, lit by blue shadows of trees on the snowy curving road into the village, and *The Entrance to Giverny in Winter*, under a pink sky, are comforting homecoming pictures. In spring came paintings of willows and poplars, and a summer's day at the pasture across the Ru, a little tributary of the Epte, yielded the late-afternoon *Haystacks at Giverny*, Alice in a wide skirt echoing the shape of the conical haystacks, the little boys close, Germaine striding ahead. In *The Haystack*, the shadows have lengthened and, set apart from the others, Alice and Michel rest at the foot of the stack, dappled with a few last strokes of sun. Although the stacks are smaller, *meules de foin*, rather than the massive stacks of wheat, *meules de blé*, with their own thatched roofs, in the *Haystacks* series of 1890–91, the connotations of shelter, solace, succour, and an association with the female figure, are the same.

During these quiet months in Giverny, Monet also reconnected with Paris. At the end of 1884 he nominated the chic Café Riche for regular dinners with a group including Renoir (who could not stomach the rich food), Pissarro (who could rarely afford it), Caillebotte, and his key supporters – new devotee Mirbeau, faithful critic Duret, long-term collector de Bellio. It was a push for solidarity, a public signal of his growing affluence. On the corner of the boulevard des

Italiens and rue Le Peletier, the café, a byword for risqué chic, had been a haunt of Zola's, and its chandelier-lit interior a backdrop in his novel *La Curée* (The Kill). Maupassant rolled out a Café Riche menu in his 1885 novel *Bel-Ami*: champagne, plump Ostend oysters, foie gras, pink trout, likened to a young girl's flesh, lamb cutlets with asparagus tips, partridges flanked by quail. House specialties were 'sole à la Riche' and 'bécasse à la Riche' – Monet's favourite game bird, the highly flavoured woodcock.

The same guests enjoyed lavish hospitality, with notes of their culinary preferences kept by Alice, when social life opened at Giverny in 1884. The uncertain ménages and empty coffers at Vétheuil and Poissy had limited visitors; now Alice as hostess shone again. 'You get the best cuisine in France at his house,' Durand-Ruel said. 'Monet was always a sybarite.'[30] Caillebotte came by boat from nearby Gennevilliers, where he was developing a magnificent garden; Pissarro was

John Singer Sargent, *Claude Monet Painting by the Edge of a Wood*, 1885; Alice is seated behind him

close at Éragny with his growing family and Monet stood godfather to the youngest Pissarro, Paul Émile, born 1884. Berthe Morisot, excluded by gender from the Café Riche dinners, visited with her husband Eugène Manet and their little girl. John Singer Sargent, a fervent admirer, came to paint. From summer 1885, Sargent's *Claude Monet Painting by the Edge of a Wood*, where Alice in white waits patiently under a tree close to the easel, conveys her reassuring presence and Giverny's calm. Jean-Pierre remembered, of his and Michel's childhood, that 'we were always all together, Monet painting, my mother sewing while we were fishing or playing not far from them'.[31] Alice's refrain was, 'Monet has got used to me staying close to him while he works and I daren't move.'[32]

The rhythms of Giverny followed the needs of one person. Never drawing his bedroom curtains, Monet rose at dawn, took a cold bath, breakfasted heartily – Kardomah tea, eggs, sausage, cold meats and cheese, toast and marmalade – and went out to paint, often with Blanche, who shared the breakfast and pushed the wheelbarrow of canvases. He 'would be back at eleven, impatient to sit down to lunch and a demon for punctuality. A first then a second stroke of the gong would assemble the scattered family in the dining room, and lunch was served at 11.30 precisely. Monet would cough irritably on the very half second, causing panic in the kitchen.'[33] The little boys knew – 'we had to run, and fast' – to get there in time from their games.[34]

Everyone was hostage to the progress of the canvases. 'Alice and her daughters could tell at once from the way he walked, or from the first words he uttered, whether his work had gone well.'[35] Either way, lunch was quick. 'Monet never lingered over his food', though 'he could burst into a rage over a sauce' and his appetite was gargantuan.[36] 'He eats like four. I promise you that's not just a manner of speaking. He'll take four pieces of meat, four servings of vegetables, four glasses of liqueur,' was the Durand-Ruel family recollection.[37]

After lunch Monet returned to work until the gong sounded at seven for dinner. By 9.30 p.m. at the latest he was in bed. If he was very disappointed with his work, he stayed there several days, sulking, and 'silence hovered over the house ... at the table no one moved or spoke and you only heard the sound of the forks on the plates.'[38] At other times, when dissatisfied, his sharpness unsettled everyone. 'The

Monet's house in Giverny

way in which he talks . . . he is so hard that it's upsetting for me,' Alice would admit, 'in spite of all the kindness of his heart, he hurts you a lot.'[39]

Rather than granting relief, when he left on his travels, energy vanished from the family, Alice wilted. His comings and goings dominated. During the preparation and anticipation, the children 'never stopped talking about the places where he was going – in those days one travelled little', and 'once the return was announced' the chatter was about the presents which 'he never forgot to bring each of us', whether or when he would unpack and show the canvases, the eagerness in quiet Giverny for his traveller's tales.[40] All the children understood the ebb and flow of his painting, including the frustrations of inactivity. 'Your letter telling me that Monet was going to set to work delighted me,' Germaine wrote to her mother from her first long journey away from home. 'Kiss him for me and tell him all my pleasure at knowing that he is working. But perhaps I'm getting ahead of myself, because I know it's very difficult for him to settle down during the first days.'[41] Germaine conveys the atmosphere with which the girls continued to envelop him, one of Alice's gifts to him.

Alice nicknamed Monet 'the marquis', and so he appeared to the children, for his charisma, his 'grand air' and expansive gestures. Jean-Pierre, who adored him, left a warm portrait of Monet 'silent and serious but not grave', always dangling a half-smoked cigarette, never smoking it to the end, as a benign presence at home and a model of 'la vie droite' – the honest life. 'Physically and morally' robust, 'simple and generous', he gave to beggars, he was 'tolerant and respected other people's ideas'. He lived 'without equivocation or dissimulation ... he knew where he wanted to get to, what he wanted to achieve and he always achieved his goal.'[42]

It did not happen all at once, but by summer 1885 Monet could believe that his dream of family life under Giverny's capacious canopy was coming into being. He planned for the long term. Helped by his sons, he dug flowerbeds and built trellised arches for climbing roses, envisaging a garden always in bloom – peonies, hyacinths, nasturtiums overgrowing the paths, mauve and lilac irises, lilies, poppies, clematis, ballooning hollyhocks, dahlias in every colour, Chinese asters, Japanese anemones. Michel and Jean-Pierre canoed and caught eels in the Ru, collected insects and plant specimens, attempting cross-fertilizations with guidance from Giverny's parish priest and botanist Abbé Toussaint, the only local visitor to the house. Over years they compiled a 'Flora of Vernon', which Michel refused to sign on completion, according authorship – responsibility – to his stepbrother. For Jean-Pierre, botany was his connection to Monet; he eventually studied agriculture. Michel's passion was tinkering with bicycles and inventing clunking motorized machines in the garage. He was always fast and unruly; a perilous driver, he would die, aged eighty-eight, in a speeding accident.

Monet longed to be close to this child, who remained distant: 'Does he think a little about his father, my dear Mimi?'[43] Expressing affection in the Giverny household was complex. Michel and Jean-Pierre found it impossible to address Monet as 'tu', and, to cover the embarrassment, 'always spoke to him in the third person, addressing him as 'il' or 'on'. They would say, 'On va au marais?' meaning 'Are you going to the marsh?'[44] With Jean it was different. Monet was his tightest bond in the house. But both his sons were overwhelmed into inaction by the force of Monet's personality. Family memories were

that 'Monet never passed judgement on people; he only implied his opinion of them by his tone of voice.'[45] Lilla Cabot Perry described a strong-minded liberal: 'Monet was a man of his own opinions, though he always let you have yours, and liked you all the better for being outspoken about them.'[46]

He did not judge his sons, but Jean's character was his opposite, and hard for him to understand: 'as for Jean I fear a certain softness that has become a habit'.[47] He employed Michel's teacher to give poor Jean dictation lessons to improve spelling and handwriting, to little effect. 'Can you believe that in his last letter he wrote *onze* with an h ... it's unpardonable,' Monet complained when Jean was nineteen.[48] Jean in turn moaned that Monet's letters were short and late. The boy's escapes were to his stolid Uncle Léon in Rouen, a prosperous chemist without sons, whose interest in him amplified the Monet identity for the teenager swamped by Hoschedés. Jean's interests met his father's only in his love of water; he flourished in races and regattas, and letters to Giverny were addressed 'Monsieur Jean Monet, King of the River'. On land he was quiet and inexpressive, 'absolutely locked up, as you say', Monet agreed sadly with Alice.[49] His sense of Jean's loss of Camille hurt: 'Talk to him like a mother, I ask you to and you must do it,' he begged.[50]

These and other strains are evident in the sole surviving photograph of all ten Monet-Hoschedés in the Giverny garden, around 1885–7. Sitting close to Monet are Blanche and Jean-Pierre, the Hoschedé children most devoted to him. Monet has positioned himself in the corner at the back, as if to diminish his powerful presence, to emphasize he is not playing the paterfamilias to his stepchildren – or perhaps he felt an outsider with them. In front of him Alice, ample, maternal, has an ambivalent smile. Leaning at her feet is Michel with his customary blank look. Jean-Pierre squeezes comfortably between his mother and Monet and stares brightly at the camera. Jean appears benign but stressed; behind him Jacques stands apart, as if trying to separate himself from the gathering. Suzanne, fulfilling childhood promise, is tall, lithe, with a docile grace and wide, slightly sad eyes; she wears a dark dress distinguishing her from the others in white. Germaine, a young teenager, surveys the group with curiosity. Marthe has turned away and looked down at the wrong moment; her expression is

The Monet-Hoschedé family c.1885–86: left to right, standing at the back
Monet, Jacques; seated middle row Alice, Jean-Pierre, Blanche, Jean,
Germaine; front row Michel (leaning against Alice), Marthe, Suzanne

troubled – another Hoschedé uncomfortable to be part of the group.
By contrast round-cheeked Blanche beams and her warmth fills the
picture. In a photograph from around the same time, Monet is on the
terrace with the girls, identically dressed in dark skirts and patterned
shirts, underscoring their unity. Monet and Blanche stand together,
Suzanne and Germaine are opposite, Marthe leans out of a first-floor
window – wanting to be there, unwilling to be fully involved.

If Marthe inherited her mother's depressive tendency, Blanche had
Hoschedé's easy cheer. Her fixation on Monet was a family joke. At
the table she copied his taste for strongly flavoured food disliked by
everyone else: 'for the salad, he seasoned it himself, and how!' and it
was thus always served in two bowls, one black with pepper and
edible only for Monet or Blanche – 'she loved everything that he
loved.'[51] She almost shared his birthday (they were four days apart;
the other seven children had spring or summer birthdays). She
tended daily to the chickens and ducks in his poultry houses and,

most of all, she claimed affinity as a painter and often worked along-side him outdoors. Monet took a respectful interest in her efforts while recognizing that she needed freedom from him: 'I've already noticed that, left to yourself, you gave yourself more trouble and pushed more.'[52] Jean-Pierre believed she was Monet's favourite of the Hoschedé children.

Monet trod a delicate path with his stepdaughters, not presuming to replace their absent father, keeping his distance from wary Marthe, and with the others engaging in a playful, detached courtesy which dignified them as young women and affirmed that 'in spite of my sullen character, I love you all'.[53] A letter to Blanche and Suzanne in 1885 shows his style.

> I would have liked to write to each of you [separately] to thank you for your kind letters [but] writing isn't my thing, so don't hold it against me, will you? The important thing is that you know I'm very grateful for your thoughts. You're very kind, I've known it for a long time ... I'm looking forward to being among you, to tease you a bit, Mlle Suzanne, and to admire the progress of Mlle Blanche. I hear of a certain 'Church at Giverny' which, it seems, has difficulty standing up straight. When I return, we'll take up our studies together. Till soon, *mes chéries*, two big kisses each ... Your Monet who loves you.[54]

This was written from Étretat, where the entire family holidayed in 1885, in a villa loaned by the composer Gabriel Fauré, before Monet established himself there alone for the winter, at the beachside Auberge Blanquet, looking out to sea. Maupassant observed him:

> Monet was no longer a painter but a hunter. He went along followed by children who carried his canvases, five or six canvases all depicting the same subject at different hours of the day and with different effects. He would take them up in turn, then put them down again, depending upon the changes in the sky ... He waited, watched the sun and the shadows, capturing in a few brushstrokes a falling ray of light or a passing cloud and ... transferred them rapidly onto his canvas. In this way I saw him catch a sparkling stream of light on a white cliff and fix it in a flow of yellow tones that strangely rendered the surprising and fugitive effect of that elusive and blinding brilliance.[55]

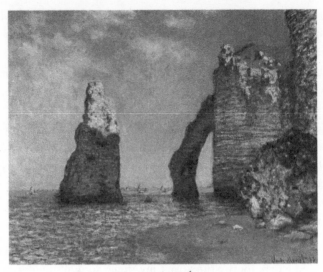

Monet, *The Cliffs at Étretat*, 1885

Étretat 's attraction was the spectacular pierced rock formations which flank the crescent shoreline: the arched Porte d'Amont, which Maupassant compared to an elephant sinking its trunk into the waves, the Porte d'Aval with its Needle, the Aiguille, rising out of the sea, and the taller, bulging portal Le Manneporte. These were ready-made geometric structures to anchor Impressionist freedom of handling. The rocks were a surface for changing light, colour, textural effects, natural contrasts between the hefty limestone walls and the open flowing sea, as in *The Cliffs as Étretat*. Monet depicted the broad bulk of the biggest cliff in aggressive, truncated close-ups such as *Waves at the Manneporte*, and in brutal-tender renderings where the surface sometimes gleams lustrous in fluttering soft touches. Beneath a roseate sky in *The Manneporte, Viewed from the West* the entire rock glows pink, and the opalescent sea too. The influence of Bordighera is evident, and the sparkling *The Beach and the Porte d'Amont*, lit up by myriad sails as improvised dabs of warm colour, is almost a Fauve picture. Monet was in his element. Alice visited for his forty-fifth birthday, and sent him afterwards his brace of his favourite woodcocks, plus a letter so happily explicit that, on her instructions, Monet burned it at once.

Then, at the end of November, Monet was perched on some rocks, water lapping his feet, when, he wrote to Alice, he failed to

see an enormous wave which threw me against the cliff and I tumbled into the foam with all my things! I thought myself lost, stuck in the water, but at last I got out crawling on all fours, but in what a state, all soaked; my palette, still in my hand, hit me in the face, and my beard was covered in blue, yellow ... I lost my picture, which was quickly smashed up, and my easel and bag. Impossible to fish anything back.[56]

To think, he concluded, 'that I could have never seen you again'. Afterwards he had a fever and nightmares, 'me who never has them'. He relished the survivor's tale, a boast of martyrdom to art and of physical prowess.

Still, the accident marked the moment when his luck began to turn. The weather worsened and he could not recapture his effects. News that Durand-Ruel, financially stretched, was planning to take works to America because 'we must succeed in revolutionizing this country of millionaires and try to become so ourselves' was upsetting; to all the artists it seemed mad.[57] So Monet was cautious when Alice demanded more funds. 'You say you think only about making economies, but that you don't manage to do so. You must, however,' he instructed, 'only count on what we have, no more for the moment. Come on, believe me that if your children are brought up modestly, without too much coquetry, they will only be happier, better appreciated, and you

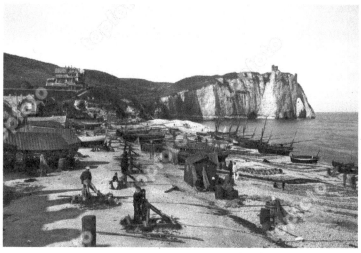

The beach and cliffs at the resort of Étretat, c.1890

too, and one can be happy like that.'[58] Alice brooded, urged on to resentment by Marthe. Monet's position was threatened once more.

Grave, refined Marthe, perpetually on edge, back and forth to Dr Love for nervous ailments, at twenty-one yearned to be married. In the circles in which she had been brought up, she had always charmed, for example winning Manet's affection in her later teenage years ('Dear little Mademoiselle Marthe, I for my part collect autographs of the people I like best, so you can imagine how welcome your letter is').[59] What suitors could Giverny offer? Alice sent her eldest daughter to spend time with a Raingo uncle, a humiliating visit. 'Your brother is a peasant, and poor Marthe must have been very pained by this coldness,' Monet wrote after it.[60] Dances in Fontainebleau, a garrison town, were no more successful: 'Marthe was too upset by these blessed officers.'[61] In her disappointment, she blamed Monet, for the improper ménage, the rural backwater, her banished father.

Monet reappeared in Giverny in a foul mood in December from 'a disastrous campaign at Étretat . . . had to return with nothing finished'[62] Arguments seethed. Through the 1880s Monet complained to Alice, 'You seem to make me responsible for all your troubles'[63] – which included the dearth of suitors. In the customarily tense build-up to her birthday, Alice began to believe that Monet must be sacrificed to her daughters' marriage prospects. Hoschedé was invited to Giverny for the festive day. Monet was asked to leave. The men narrowly missed one another, Hoschedé arriving from Paris at Vernon station just after Monet, with a crate of canvases, departed, taking the train back to exile in Étretat.

The works to be completed included some of his most intensely expressive responses to this stretch of coast. In the forceful 'Manneporte' paintings, the solid yet precarious rock is struck through by a great emptiness, crumbled by waves, jutting out alone in the sea. *Boats in Winter Quarters* depicts the *caloges*, old boat hulks serving as storage, covered in tarred planks, with a few vessels beached on the shore – forlorn images of refuge as the water rushes in. They suggest Monet's desolation and longing as he wondered where he could call home now.

15
Betrayal and Loyalty, 1886

At the deserted Auberge Blanquet in vile weather, Monet stared out at the sea and refused to unpack his paintings. The distress was worse than in 1883, when he had similarly been in this same hotel in Étretat, fearing that Alice would leave him. This time he had become confident in their future together, and in Giverny. It was scarcely comprehensible then to be banished from the pink house he had rented and paid for them all to call home, and where he had been building up a life 'which I thought was to be so sweet'.[1]

He hardly dared write, but anxious that she would blame him or worry, sent a note 'for you to know that I've arrived, but, alas, so sad and absolutely annihilated to find myself here after all these shocks. I don't stop thinking of you and our two dear little ones.'[2] He hoped, he said, that her birthday celebrations had 'brought a bit of balm to your heart. Forgive all the unhappiness that I cause you in spite of myself. Pity me, I am very ill. Think that I love you.' He paced the room 'pursued by my sad thoughts and horrible nightmares' and signed off, 'And you, are you going to write to me? Your poor, very unhappy Monet.'[3]

She replied next day, and with Marthe and a vengeful Hoschedé at her side, was in vindictive spirit, punishing and self-punishing. 'Your letter,' Monet understood, 'well expressed our situation, your joy in the happiness and success of your daughters, but, as you said, I have no right to share your joys, all the misery is there, and it doesn't allow me to see you, to be proud of you, no, that isn't for me. I knew very well, at the beginning of our love, that I had nothing, nothing to say to that ... The painter in me is dead, there is only a sick brain.'[4]

After five days alone on the coast, only emotional blackmail was

left. Monet's intimate correspondence often employs complaint and elicits sympathy to win love, a passive aggression so ingrained that it is difficult to know the extent to which his desperate letters were also calculated:

> You decide, I'll submit, even if I should die of it. I feel very much that in every way I am completely lost ... more and more battered. Only you (your love for me and my children apart) can bear a separation, you have compensations in the tenderness and happiness of your daughters. I can only repeat that I love you and am yours ... Tomorrow I will bundle up my packages, and make myself ready for whatever eventuality.[5]

The letter worked. Pushed to the brink, Alice drew back. Monet was a lot to lose, and Hoschedé, gouty, impoverished, moving between a succession of rented rooms, unable to earn a living, was pathetic. He was trying to pursue a career as an art critic, frequenting bohemian café society – not the Café Riche but Le Tambourin at boulevard de Clichy, where the unknown Van Gogh would soon be a habitué, and the free-for-all Salon des Indépendants founded by Seurat and Signac in 1884. He was a minor player. 'Hoschedé made a little speech and drank to the honour of the old Impressionism. He seemed to be criticizing Monet ... there is something besides art in his criticism, I fear,' Pissarro reported of a dinner for younger painters in 1887.[6]

So it was not a surprise that Alice's torments about her lover quickly burnt themselves out, and perhaps Monet knew he had to take this part in a drama which she felt compelled to enact. Alice now offered to come to Étretat. No, he said,

> I still want to try, not feeling the courage to live without you, but I can't tell you that I will return cheerful, I have suffered too much ... the former Monet is dead, I feel it strongly, if it recovers, it will only be little by little ... Spending a day or two with you, I would still delude myself that you believe in me alone, when on the contrary I have to persuade myself that you must be less and less mine.[7]

Was the tremendous ego that was Monet impossible to love unless he was reduced periodically to a crumbling wreck, crying beneath the cliffs of Étretat? Alice had proved to herself that Monet's equilibrium

depended on her, at a cost: 'our life in common is disorganized for ever'.[8] He left Étretat for Giverny in March, then went quickly to Holland to paint the spring tulips. The couple were apart for much of 1886.

When he returned from Amsterdam, Monet walked straight off the train at the Gare du Nord to the Café Riche for the monthly artists' dinner, where betrayal, in different forms, was the only topic of conversation. One concerned divisions over the eighth Impressionist exhibition, about to open. At Pissarro's insistence, and defying Degas and Morisot, it was to include 26-year-old Georges Seurat's stiffly geometric pointillist sensation *An Afternoon at the Grande Jatte*, which brought Impressionist emphasis on pure colour, light and form towards something mechanized and impersonal. Renoir and Monet abstained, ensuring the show would be, apart from Seurat, lacklustre. It was a badly hung mess, a defeat ensuring that this was the last group exhibition to take place under the Impressionist banner.

Seurat was the first artist of the emerging generation to challenge Impressionism as the avant-garde movement of the future. The book under discussion at the Café Riche, meanwhile, dredged up Impressionism's past, and seemed to the artists truly treacherous. 'Have you read Zola's book?' Monet asked Pissarro. 'I am very afraid that it will do us great harm'.[9] *L'Œuvre*, published in April 1886, starred an artist of whom, as Monet still fumed a decade later, Zola tried to 'make a failure'.[10]

It tells the story of Claude Lantier, a promising plein-air painter, who lives impoverished in Bennecourt in the 1860s with his devoted girlfriend Christine – 'Claude and Christine. We both start with the same letter!' – of this hero's multiple frustrated attempts to depict her in natural light, and of his response to the death of his son: to paint his dead portrait. The narrative centres on a monumental canvas, unfinished and unfinishable, which drives Claude mad. This canvas, called 'Plein Air', a nude woman plus a fully dressed man, converges Manet's *Déjeuner sur l'herbe*, painted in the studio, with a title, size and method alluding to Monet's open-air *Déjeuner*. Monet's life with and paintings of Camille thus formed a backbone to *L'Œuvre*: intimate, antagonistic, finally devastating when Lantier dies, hanging himself before his failed picture.

In Aix-en-Provence, Zola's schoolfriend Cézanne recognized Lantier's

depressed, shy, explosive temperament, Provençal roots and lack of success as his own. On 4 April he briefly wrote to thank Zola for 'this kind token of remembrance' and never spoke to him again.[11]

Monet too replied immediately to Zola, in tones of combative restraint:

> You had the courtesy to send me *L'Œuvre*. I am very grateful to you. I have always had great pleasure in reading your books, and this one doubly interested me since it raised questions of art for which we have been fighting a long time. I have just read it and I must admit I remain troubled, anxious. You took care, intentionally, that not one of your characters resembles any one of us, but in spite of that I'm afraid that in the press and among the public, our enemies will declare the names of Manet or at least our names to call us failures, which was not in your mind, I don't want to believe it. Forgive me for telling you this. It's not a criticism; I read *L'Œuvre* with very much pleasure, retrieving memories on every page. Anyway you know my fanatical admiration for your talent. No, it's not that, but I have been battling for quite a long time and I fear that at the moment of achieving success, our enemies will use your book to knock us out.[12]

The detached voice, refusing to admit any pain caused yet determined to answer in the face of attack, is perfect pitch. Monet spoke for all the group and his note to Pissarro suggests that his concerns really were less personal than about the risk to Impressionism's reputation. Pissarro thought the book a failure, and reported that 'all the young poets ... tore Zola's *L'Œuvre* to pieces, it seems to be completely worthless – they are very severe.'[13] According to Pissarro, Zola had alienated almost everybody, even the painter Antoine Guillemet, who had supplied insider information. The tattler Guillemet had been Camille's mocking escort when Monet ran away in Bennecourt in 1868. As reward for his gossipy recollections in 1886, Guillemet had asked to be the book's dedicatee. Zola refused and, on reading it, Guillemet understood why. 'My compliments, Émile,' Guillemet wrote sarcastically. 'All in all it grips the reader but casts him down. I see only sadness and impotence. God forbid that members of the little gang, as your mother used to call us, should recognize themselves in your characters. Mean-spirited, they are of little interest.'[14]

In the 1860s Zola had emphasized parallels between his own aggressive naturalism and Manet and Monet. His taste was for firm, finished compositions, and in the 1870s, when it became obvious that Impressionism was not naturalism, he lost interest, then grew hostile. Prosperity entrenched his views. While the Impressionists were still battling for acceptance, *L'Assommoir*, in 1877, was his breakthrough book, selling 16,000 copies in a month. The bestselling novelist began to conceive less successful artists as creative failures. A review published in Russian in 1879 in *Le Messager de l'Europe*, and subsequently translated in *La Revue bleue*, criticized Manet. Either Zola thought better of it, or the mistake was genuine, for he claimed that a single vowel had been altered. Manet, who had been hurt, was relieved, and 'with his malice and gaiety' could not resist informing Monet 'it was a misprint, it was of you that Zola meant to talk'.[15] Zola talked much more in *L'Œuvre*, and was similarly slippery about his target – his hero Claude Lantier is an amalgam of Monet, Manet and Cézanne.

The novel is usually read as expressing Zola's disappointment with Impressionism, but more likely what spurred him was that the movement was beginning to get serious recognition. The relative positions of Zola and Monet had shifted since the 1870s, and Monet's 'very moment of reaching success' was pertinent to the book's vindictive energy. Of its three victims, Manet was dead and Cézanne obscure in Aix, but Monet was noisily alive, prominent in Paris and, as Zola in his notes for the novel mused, visibly on the rise: 'Durand-Ruel ... crazy for Monet, he buys and buys still more ... All the sketches that Monet gives him: a pit, a chasm. A thousand Monets.'[16]

Zola himself in the mid-1880s was uncertain, troubled by childlessness, and not sure that his literary offspring, the *Rougon-Macquart* cycle, of which *L'Œuvre* was number fourteen, would confer immortality. The year 1886 was a moment of literary battle. Published in *Le Figaro*, Jean Moréas's 'Symbolist Manifesto' gave a name to the movement challenging naturalism. Zola had previously enjoyed a circle of acolytes, including Joris-Karl Huysmans and Mirbeau, but they were turning away from him. Each won acclaim with unruly novels, Huysmans's *À Rebours* in 1884 and Mirbeau's *Cavalry* in 1886, which disobeyed Zola's verisimilitude, playing with unstable psychologies

and non-linearities. Both Mirbeau, and subsequently Huysmans, wrote warmly about Monet.

Responses to *L'Œuvre* were mixed, from *Le Matin's* 'Zola has risen to genius' to *Le Français* warning that Zola and his followers 'will strangle themselves, like Claude Lantier, with the rope they have passed around their necks'.[17] Mirbeau predicted for Zola, in an article in *Le Figaro* entitled 'The End of a Man', 'loneliness for his old age ... wandering through the frozen plains of literature ... so he searches. He hopes that the friendship of academics will fill the void left by the artists, comrades of the first struggles, of the first hopes.'[18] It did not eventually happen like that, but Monet, and Pissarro, Renoir and Sisley, now avoided Zola.

For Monet, the revenge of living well was already happening. In a betrayal of his own, he arranged, while Durand-Ruel was exhibiting in America, to show at rival gallerist Georges Petit's annual group International Exhibition in June 1886. Although he did not have an exclusive contract with any dealer, it was a cruel defection, especially as the works chosen specifically excluded the scores of Monets which Durand-Ruel owned. But it was a smart move. Petit had more conventional taste and, appealing to more conservative buyers, could widen Monet's collector base. As Morisot's daughter Julie quipped, 'when one is called Petit one does things on a large scale', and at Petit's splendid galleries on rue de Sèze, Monet starred and sold.[19] 'That bugger has become so daring with his colours that after him you can't look at anything else,' sighed Boudin.[20]

Petit's prestige pulled in aristocrats and heiresses. The Comtesse de Noé bought *Étretat in the Rain*, Winnaretta Singer, heir to the Singer sewing machine fortune, acquired *Tulip Fields, Holland*. A shy young dealer from Boussod & Valadon's gallery at 19 boulevard Montmartre also came and, after the show closed, bought *Fields of Flowers and Windmills near Leyden*. The subject must have reminded him of home, for this was Theo Van Gogh, the painter's brother, who began to court Monet too. Prices of 1,000 to 1,500 francs per canvas were steps up from Durand-Ruel's standard payments. Monet always pinpointed this show as the turning point. 'My first success dates from an exhibition at Georges Petit's. Because M. Durand-Ruel didn't get us a cent from America, I finally gave in to Petit's urging ... the public

stopped laughing the day Petit legitimized Impressionism. One show followed another. The reversal was complete.'[21]

Durand-Ruel was coolly informed that he must compete with the other dealers for Monet's paintings. Monet's behaviour compares badly with that of Renoir, who during bad times told Durand-Ruel, 'Consider me entirely at your disposal . . . I will always be loyal to you . . . If you are obliged to make sacrifices [i.e. sell cheap] . . . when it comes to the paintings, regret nothing. I will paint other better ones for you.'[22] It is painful to read Durand-Ruel's plea as Monet drew away from his primary supporter. 'Dear M. Monet, don't forget me. Give me, as in the past, preference for your work. I well deserve it, because . . . I have worked hard enough for you in all the countries of the world . . . You will never know how much it cost me in pain, anxiety and money.'[23] Yet Durand-Ruel also came to see 1886 as a triumph, the vindication, against his artists' expectations, of his American venture. 'Do not think the Americans are savages . . . they are less ignorant, less close-minded than our French collectors . . . Without America, I would have been lost, ruined, after having bought so many Monets and Renoirs. The two exhibitions there in 1886 saved me.'[24] Ultimately, his American success was Monet's too, while with his huge stock Durand-Ruel benefited from Monet's rising prices following Petit's show.

'Yes I'm very happy, everything sold expensively,' Monet told Morisot, though he deplored 'this terrible disunity among us at the moment'.[25] His success was divisive. Morisot reckoned that 'there are clashes of vanity in this little group that make any understanding difficult . . . I am about the only one without any pettiness of character; this makes up for my inferiority as a painter.'[26] There was even a brief cooling between Monet and Renoir, while a resentful Pissarro, complaining that he had 'not a single friend with enough confidence in me to lend me enough to keep alive', saw Monet on the make: 'for some reason or other he always seems to have a sly look'.[27]

Monet's only completed self-portrait dates from this troubled year. Monet seen by Monet has the stubborn features and steady demeanour recognizable from photographs, and the impression of quick thought in the creased, animated forehead, but the piercing grey eyes are sad and apprehensive, and there is a pensive

vulnerability: partly in shadow, Monet looks out uneasily from under a beret. He is wrapped, as if defensively, in a big coat, and the thick moustache and beard, flecked with white, seem like protection for a thin skin. Monet appears to play down his assertive aura, yet the head pushes forward from the darker to the lighter side of the picture – a surging force.

Morisot wrote after Petit's show that Monet 'has exhausted the subject of landscape, so to speak; no one has the courage to try that which he has already done perfectly'.[28] How to proceed was a problem recognized by Monet himself, and complicated by his personal situation. There were opposing possibilities: to find a way of working differently at Giverny, or to go far away to develop innovations in seascape and further amaze his new audience.

Opportunity for the first presented itself one July evening when, returning from the Epte, Monet encountered Suzanne holding a green parasol, standing at the brow of a low hill, framed by a vast sky. She reminded him of Camille at Argenteuil, and eighteen-year-old Suzanne's fate as his favourite model was sealed. The next day, painting from a low viewpoint, Monet demanded two different poses from her, one looking left, one right, each bolt upright. His titles, *Study of a Figure Outdoors*, suggest the compositions felt tentative. Suzanne, in a flowing white frock with a fluttering scarf, silhouetted against fast-moving clouds and seeming to dissolve in light, visibly struggles to hold her poses. Mirbeau described 'this dress made of an unnamable fabric of fused reflections, gentle shadows and vivid light' as ethereal, weightless – and so Suzanne appears, not a solid figure but an evanescent memory of Camille in *Woman with a Parasol* of 1875.[29]

The contrast is poignant. Camille animated Monet's pictures; Suzanne, lacking Camille's naturalness and composure as a model, looks vapid. Monet later claimed that was the point: 'It's the same young woman, but painted in a different atmosphere. I could have done fifteen portraits of her, just like with the haystack. To me, only the surroundings give true value to the subject.'[30] A few months earlier, Monet had included Suzanne in a couple of spring landscapes of orchards, but this pair of summer pictures marked his return to monumental figure painting after a ten-year gap – and it was unpromising. Germaine recalled that the gruelling session ended only when Suzanne

Monet, *Woman with a Parasol*, 1890, a black crayon drawing made after one of the paired paintings titled *Study of a Figure Outdoors*, 1886

fainted. Enraged when working on the canvases in the studio, Monet stuck his foot through one of them. He needed to get away. Alice spent August at a spa with Marthe. Days after their return, Monet left alone on 11 September for Belle-Île, a barren island off the Quiberon peninsula. He stayed in Brittany until December.

Choosing a stretch of coast known as 'La Mer Terrible', where there were only rocks and not a tree for ten kilometres, he lodged at the outhouse of an inn in Kervilahouen, a hamlet of twelve houses. For most of the time he was the only guest. His neighbour was a pig whose groans and stench kept him awake, the diet of eggs and lobster was a trial and varied only by porpoise, but the sea was at the end of a footpath, he swam naked, went eel fishing at moonlight, enjoyed the

tales of fishermen and pilots, and the services, for 2 francs a day, of a 59-year-old former lobster catcher, Hippolyte Guillaume. 'Poly' kitted Monet out in oilskins, led him to inaccessible sites, pinned down his easel with ropes and stones, held an umbrella to protect his canvases from wind and rain, and lugged everything up and down cliff paths.

It was Monet's walk on the wild side, though his initial inspiration was literary; he chose Belle-Île after reading Flaubert's travel essay 'Par les champs et par les grèves: Un voyage en Bretagne)', published posthumously in 1885. Flaubert wrote of foaming waves swirling in crevices and leaping like fluttering fabric, of rocks like black ghosts. Monet's paintings resemble Flaubert's descriptions: rocks rising from scintillating emerald or turquoise seas tipped with dense white foam, high pointed crags, like ruined, weathered towers, at Port Coton, boulders at Port Goulphar and Port Domois, whose shapes sometimes suggest animals sculpted by waves. Monet painted them dark against raging seas or mineral-encrusted; at sea level his waves rush at the viewer, from high vantage points vistas plunge to translucent water.

Belle-Île, so different from Étretat – granite instead of soft crumbing chalk, jagged inlets instead of an open bay, deep ocean instead of Channel shallows, ferocious Atlantic gales – encouraged harsher paintings of coarse textures, rough materiality, loaded brushstrokes, and answered something restless in himself in 1886. He described 'a terrible sinister landscape but very beautiful', calling it diabolical, fantastical.[31] The terms correspond to a development in his painting: depiction of place was becoming inseparable from evocation of Monet's physical experience of it. At Belle-Île he held in balance an enduring Impressionist commitment to nature with a more openly declared subjectivity. In paintings such as Storm off the Belle-Île Coast [Plate 30], The sense of his own grappling with the landscape, the process of painting built into its rendering, is almost expressionistic, yet expressive rendering is taken so far that it is stylized, as the exaggerated colours and churning waves suggest the churning soul. Van Gogh arrived in Paris in 1886 and his curling sinuosities and staccato dashes follow Monet's looping comma strokes. The Belle-Île paintings were considered the most exciting modern landscapes for a decade. Matisse went to paint there in tribute in 1896 and 1897. Later William Seitz claimed the Belle-Île canvases as initiating 'the method which

expressionist landscape was to follow ... At what point would the churning impastos and writhing contours by which the sea, rocks and storm are pulled forward towards the picture plane express man's, rather than nature's anguish?'[32]

Monet met a young man by chance one day occupying his usual place at the table at the inn. He turned out to be the art critic of *La Justice*, and had already eulogized Monet. Gustave Geffroy's boss was Georges Clemenceau, and Geffroy's political credentials were as impeccable: he was on Belle-Île researching a biography of the socialist revolutionary Auguste Blanqui, who had been exiled there. For Geffroy, Monet 'covered in sweater, boots and wrapped in a hooded slicker', solitary, clutching his palette as gusts tried to snatch it, shared characteristics with Blanqui, 'condemned to his extraordinary inner life ... a new Hero'.[33]

Geffroy promptly moved into the inn for his week-long stay in Belle-Île, and, enthralled, watched Monet at work: 'he hastily covers his canvas with the dominant tones, then studies their gradations, contrasts and harmonizes them ... all these different states of the same nature ... mornings rise before you, afternoons light up, evenings fall.'[34] It is a revealing observation, for, unlike Étretat, Belle-Île was dramatically bleak and offered no real diversity, which forced Monet to intensify a practice of recording the sea at particular instants. The changing conditions governed by weather and tides dictated working in rapid sequence on numerous incomplete paintings. It set the method for the series painting in the 1890s, the works with which Monet eventually painted his way out of the problem identified by Morisot of exhausting the subject of landscape.

Belle-Île was an eloquent pinnacle in Monet's seascapes. The ruggedness appealed to the symbolists, and when Geffroy left the inn, he sent Monet Jules Barbey d'Aurevilly's sensationalist novel *Les Diaboliques*, about women's acts of revenge and violence, diabolical as the seascapes. Mirbeau argued that Monet 'goes beyond the mere representation of nature ... one sees and feels all the emotions, the hidden passions, the moral tremors ... all the energies of the soul that nature stirs in us, all that is infinite and eternal ... all that is immortalized in nature.'[35] This was a new siting of Monet, within symbolist parameters. Although it was not how he saw himself, it was valid and

persuasive to new audiences, and it set his painting in a milieu far from that remembered in Zola's *L'Œuvre*.

More analytical observers were suspicious of the shock effect of Belle-Île, seeing decadence in the twisting strokes and shrill colour to which Monet subjected landscape painting while still asserting its naturalism. Félix Fénéon complained that the Belle-Île pictures demonstrated Monet's 'propensity to make nature grimace in order to prove that the moment is unique and that we will never look on its like again'.[36] Despite his admiration for Monet, Pissarro thought the paintings were disorderly romanesque fantasies. Yet he could only look on enviously as Mirbeau and Geffroy hitched their names to Monet as they became 'the master critics of Paris who lead the way and whose good opinion is so sought after by the most fashionable'.[37]

Belle-Île sealed these two literary friendships for Monet. Earnest, intelligent, responsible, and with a stubborn passivity almost like inertia, Geffroy had some of Bazille's temperament. He lived chastely with his mother and disabled sister Delphine, and poured his emotion into his lyrical prose. Monet responded to his sympathetic receptiveness to painting, and soon became surprisingly dependent on this mild-mannered intellectual: 'something is missing when I go a long time without seeing you,' he said.[38] Later he introduced Geffroy to Cézanne, who spent three months painting his portrait as a hunched pyramid, hemmed in by books and papers lurching at him from all directions – the man almost a still life himself, steady, reserved, determined not to impose. He was an ideal echo chamber and confidante – Monet's Boswell and biographer. 'My loyal friendship for you is unalterable,' Monet told him.[39] The relationship was lifelong: in 1925 seventy-year-old Geffroy, revisiting Kervilahouen, wrote to 84-year-old Monet that his affection was as unchanging as this savage coast fixed on his canvases.

Not to be outdone by Geffroy, Mirbeau sailed to Belle-Île in awful weather, certain that Brittany would inspire, as he told Auguste Rodin, 'a terrible, formidable Monet, whom we have not yet known'.[40] Pessimistic, loquacious, with a fervent interest in politics and religion, emotionally troubled since a childhood of abuse by Jesuit teachers, Mirbeau was an unlikely friend for Monet, who was surprised and

The four writers who befriended and published articles on Monet.
All were initially supportive, but Zola later became an outspoken critic.
Mirbeau and Geffroy, the leading French critics of the late 19th century,
vigorously championed Monet and were personally devoted to him. As an
artist, Monet felt the closest affinity to Mallarmé, who sought in his poetry
'to paint, not the thing, but the effect it produces'. Mallarmé said 'one thing
that makes me happy is to be living in the same era as Monet'. Émile Zola,
1885 (*top left*); Gustave Geffroy (*top right*); Octave Mirbeau in his study
(*bottom left*); and Stéphane Mallarmé, *c*.1890 (*bottom right*), all
photographed by Nadar.

soon touched by his attention and won over by his extreme enthusiasm. Mirbeau, according to Sacha Guitry,

> woke up furious every morning. He would open his eyes convinced that in the course of the day a hundred injustices would be committed, and he was exasperated in advance of their commission. He took it for granted that his interlocutors were his adversaries; and he had a fashion of urging you to see an exhibition of paintings by Monet which was like a challenge to mortal combat ... Many people thought they disliked Mirbeau. They were wrong: it was he who disliked them.[41]

But when this excessive character gave his affection, it was unconditional. 'Monet, you are present every day in my spirit and heart,' he wrote.[42]

Sailing with Mirbeau to Belle-Île in November 1886 was his partner Alice Regnault, a beautiful former courtesan. They were marooned there by storms, and 'la belle Alice' delighted Monet by taking over the kitchen. Her impact on him, after months in the company of only fishermen and herders, was unwisely conveyed in letters to his own Alice. They sparked hysterical outbursts which 'sort of broke something in me', he told her.[43] So he finished the year rather as he had begun it. 'Well,' he wrote, setting off for Giverny at the end of November, 'I am coming home, and I hope not to find, as sometimes before, that sense of being isolated and a stranger.'[44]

16

Les Demoiselles de Giverny,
1887–91

In 1887 Monet fought his way back into family life – in paint. Blanche, twenty-one, was his loyal weapon. In the spring he painted Blanche painting a wooded landscape, in sunlight and in shade, in the paired works *Blanche Hoschedé at Her Easel with Suzanne Hoschedé Reading*. Blanche attacks her canvas with strength and concentration; her

Monet, *In the Woods at Giverny, Blanche Hoschedé at her Easel with Suzanne Hoschedé Reading*, 1887

movements animate the pictures. This was his tribute to her as an artist, narrating their work together, a deepening bond. With Monet the girls formed a trio. Blanche, short and lively, the ally, and Suzanne, willowy and placid, the favourite model.

In the summer Monet pushed for something stranger: depictions of Alice's daughters dreamily rowing on the river Epte. They were intended as statement pictures; they occupied him intermittently for three years, and his view of their importance is suggested by their size. At around two metres square, sometimes more, they are considerably larger than anything he had attempted since the unfinished *Luncheon beneath the Canopy* in 1883, or would attempt again before the monumental *Water Lilies* series begun in 1914.

In contrast to Belle-Île's leaping waves, and in retreat from the rushing energy of five years of seascapes, stillness is the defining quality of the boat pictures. The girls drift, luminous and graceful, and external reality seems shut out and time arrested as horizon line, sky, earth, riverbank are eliminated in the focus on almost transparent figures. In *Young Girls in a Boat* they are mirrored in water glowing pink, gold, turquoise; in *The Blue Boat* they are set against a glassy, film-like surface. *In the Norvégienne* [Plate 32] features Germaine in knee-length dress standing with her fishing line, Suzanne and Blanche seated, their figures continuous with the riverscape. Their weightless silhouettes cast deep reflections, more sculptural than their actual forms, yet illusory – evoking the transience, elusiveness, of the moment, of the girls' youth, the illusions of the painted image itself. Light plays off the white dresses and is held within the boat's interior. The quietude and intense tonalities summon an unreal atmosphere – Impressionist *instantanéité*, held within compositions of striking artifice.

'I am working as never before on a new endeavour: figures in the open air as I understand them, done as landscapes. It's an old dream which still torments me and I would like to master it for once, but it's so difficult!' Monet told Duret. 'It's absorbing me to the point of making me almost ill.'[1] Stubborn and demanding as his models struggled to keep their poses, Monet was bewitched by them. He 'loved to see, to the point of demanding it', the girls in white, bright, docile, framed against water, foliage, flowers.[2] It was a personal quest, an attempt to

integrate himself into Giverny, fused with a creative one: a route out of the dilemma that his landscape painting had reached an apogee.

In *The Boat* an empty skiff tilts precariously in the corner of a canvas overrun with tangling reeds on the water, a swirling void. It anticipates the eeriness of the two further boat pictures completed in 1890, when Monet wrote that he had 'again taken up things impossible to do: water with grass waving in its depths'.[3] In the off-balance *Canoe on the Epte* and *The Pink Skiff*, the vessels thrust at sharp angles, slightly out of focus, as in photographic blurring. Blanche, the active steadying figure, is rowing, and the water folds in on itself, its undulating swampy surface painted in thick ridges; crimson-purple algae twist like hair, stretch like tentacles, the shadowy depths contrast with brilliant light pooled within the boat, tinting the girls mauve and rose. The dealer René Gimpel thought the figures in *The Pink Skiff* were 'illuminated like torches by reflections glancing off other reflections. It is one of the most skilful effects ever achieved in the art of lighting. They pass so swiftly . . . like a dream, or like a desire that cannot be satisfied . . . the two pink pelicans in their pink boat speed on, graced with inordinately long pink oars; through the wake in the water trail our hearts.'[4]

Camille is a precursor to all the boat paintings, which must be considered as a group. With the sun flickering on their white dresses, their figures simplified into cut-outs, the Hoschedé sisters in their boat are re-embodiments of the multiple Camilles in *Women in the Garden* in 1866. Debts to Japanese prints – flattened forms, cropped, off-centre compositions, the boats jutting off the picture's edges – are pronounced. The Hoschedé pond is also a memory: the long poles of *In the Norvégienne* mirrored in the water, flanking the reflections of Germaine and Blanche casting their fishing lines, recall the reflections of trees and of Alice fishing at Montgeron. The girls are sealed off, inaccessible, within Monet's canvases, as Alice shielded them at Giverny. Their straw hats and flesh tones add warm notes, but sensuality is muted. These are discreet pictures, implying modesty, Monet's respectful distance from his stepdaughters.

The boat pictures are uncanny and nothing in the 1880s anticipates them. Monet hoped that returning to the figure would save him 'from this terrible specialization as a landscapist' for, he wrote to Geffroy, 'I so much want to prove that I can do other things.'[5] There was a sense

too that figure painting was the arena of battle. 'What Claude Monet is in landscape, the same thing in figure painting, who's going to do that?' Van Gogh asked Theo in 1888, 'like me you must feel it's in the air'.[6] Monet was looking closely at his friends' approaches. Renoir's Ingresque *Large Bathers* appeared at Petit's in spring 1887 – superb, Monet insisted to Durand-Ruel, who hated it. In April 1887 Monet acquired from Theo Van Gogh Degas's pastel of a woman drying herself, *The Tub*. Both these classical works were very different from his own. Of his colleagues in Paris, Morisot was the most aligned to his interests: between 1883 and 1886 she had painted her daughter and husband as blurry silhouettes in their garden and at the Bois de Boulogne, amid a play of delicately coloured shadows and reflections – sailing toy boats in the pond in *Monsieur Manet and his Daughter*; with swans in *On the Lake*; disappearing into foliage in *The Lesson in the Garden*. There was also the example of Sargent: in May Monet travelled to London to visit him and saw *Carnation, Lily, Lily, Rose*, the American's most Impressionist piece, created in the open air at twilight, combining plein-air freshness with girlish innocence.

But although Monet was looking closely at his colleagues, the deeper affinity of the boat pictures was with symbolism's literary currents. In 1885 Mallarmé's prose poem 'Le Nénuphar blanc' (The White Water Lily) appeared in, of all places, Hoschedé's magazine *L'Art de la mode*. It opened with 'J'avais beaucoup ramé' – 'I had been rowing for a long time, with a strong, clean, soporific motion, my eyes turned inward, and utterly oblivious of my journey, as the laughter of the hour was flowing all around.' The poem lilts in rhythm to webs of underwater plants and reeds as the speaker, drifting, dreaming, rows through different landscapes, each in turn 'borne away with their reflections in the water by the same impartial oar-strokes'.

To publish the poem was the coup of Hoschedé's career at the journal, for 'Le Nénuphar blanc' acquired cult status in Mallarmé's small circle, the writers and artists who squeezed into his 'Mardis', the Tuesday salons at his small fourth-floor apartment on rue de Rome. An illustrated edition of the prose poems, *Le Tiroir de laque* (The Laquer Drawer), was proposed in 1887. Although unrealized, the project showed the reverence in which Monet's generation of painters held Mallarmé. Renoir offered a nude, Degas was allocated the poem 'Ballet',

Morisot learnt printmaking in order to depict the water lilies. Monet admired one of her etchings featuring aquatic vegetation with her initials BM reflected in the water. He failed to make a contribution himself, regretting to Mallarmé that he could do nothing worthy of his exquisite poems. Yet his Epte paintings echo the evocations in 'Le Nénuphar blanc', of the trance-like journey 'through the lively gap between the drowsing vegetation of a persistently narrow and wayward stream in search of water flowers'. Even the poem's luminous hollow whites of the lily flowers are recalled in the light on the Hoschedé girls' white dresses.

It was as an interior, imaginary world that Monet's admirers read these pictures. Geffroy called the girls 'fleeting apparitions', 'jeunes filles dans la fleur de la jeunesse, apparitions délicieuses et passagères'.[7] The language, equating the girls in their youth with ephemeral flowers, is analogous to Proust's *À l'ombre des jeunes filles en fleurs*, the second volume of *À la recherche du temps perdu*, and the effects of these paintings are comparable to Proust's slow-motion prose. Mallarmé's poem ends at a 'watery and impenetrable retreat' whose owner 'had formed this crystal into an internal mirror to shelter her from the brilliant tactlessness of the afternoons; she would come there, and the silvery mist icing the willows would soon be only the limpidity of her gaze familiar with every leaf.'[8] The description, and the seamless shift from place to perception, seems to predict Monet's water-lily garden and its animation on canvas by his own gaze familiar with every leaf; in their liquid foregrounds, horizonless, enclosed, and in the water's decorative patterning, the boat pictures contain the germ of the *Water Lilies* paintings – the Monet contemporaneous with Proust.

'Young women in boats – fleeting pink nosegays between the greens of the shore and the dark water,' the duc de Trévise said when he later saw the 1887–90 works hung alongside the *Water Lilies*, as if referring to the drifting girls and the floating flowers in one breath.[9] Alluding to his water-lily series, Monet would compare himself to Mallarmé and Debussy. In turn Mallarmé told Berthe Morisot in 1890, 'one thing that makes me happy is to be living in the same era as Monet.'[10]

The boat paintings were transitional works. Monet was uncertain about them, and relinquished them reluctantly; some of their importance to him was as family pictures. 'Pay no attention to that; I am not satisfied with it!' he told Trévise in 1920 of *Young Girls in a Boat*,

which however hung prominently in his studio.[11] Gimpel managed to buy *The Blue Boat* and *The Pink Skiff* in 1926, and wrote, 'I don't believe two canvases can be found as beautiful as the two which belong to me of women in boats ... Monet asked me for twenty-four hours to sign the canvases, but I was so afraid that he might change his mind and keep them that I made my escape with them hastily by automobile.'[12]

Only one of the group was exhibited or sold in the nineteenth century: in a sale brokered by Sargent in 1889, Winnaretta Singer paid 5,000 francs for *In the Norvégienne*. In 1893 this young enthusiast for Monet became, by her second marriage, the Princesse de Polignac and hosted a celebrated Salon, where those viewing the Hoschedé girls as '*jeunes filles dans la fleur de la jeunesse*' included Proust. When the princess subsequently acquired *The Turkeys*, the big white birds roaming before the façade of the Château de Rottembourg, Hoschedé's daughters were reunited, in her collection as they could never be in life, with their childhood home.

At Giverny the pictures helped Monet consolidate a sense of belonging. In summer 1887, for the first time, he painted his garden, peonies on trellises. For the first time too he dared express his own glint of pride in the girls. De Bellio and his daughter were invited to Giverny with the promise of the Hoschedé sisters as hostesses; they were also attentive to Julie Manet, Morisot's daughter. Mirbeau wrote in the late 1880s of the 'harmonieuses filles' who made Giverny so charming.[13] Geffroy recalled the place 'full of life and youth', with Alice at the centre, reigning in the mauve sitting room where 'surrounded by her children and Monet's, she appeared in all the peaceful radiance of a happy life, her bright eyes shining beneath a halo of powdered hair'.[14]

In the daytime this drawing room was the girls' domain; they sat on plush sofas, 'embroidering while sucking candies from Fouquet, bergamot oranges candied in honey, or violet bonbons'.[15] In the evenings it became the 'library' – containing some 600 books – where Monet settled down to read, often aloud. Alice listened, while sewing, and Monet often interrupted himself 'with reflections, commentaries or to laugh'.[16] Delacroix's journal and letters were favourites. Jean-Pierre remembered him reading from Saint-Simon's *Memoirs* and Michelet's *History of France*. Among the poets, Monet especially loved Théophile Gautier's *Émaux et Camées* (Enamels and Cameos), describing

dreams of enamels and cameos, safe from the hurricane of outside events battering the window. Monet read it in Charpentier's 1887 Japanese-paper edition, in a citron-green leather binding with a trelliswork design, dotted with pomegranates.

Monet also read in his studio, reclining on a couch covered in ivory silk standing on thick rugs. In this bourgeois milieu the boat pictures were finished. The photographs of his literary friends were here: 'Stéphane Mallarmé, with his drowsy dreamer's expression; the sweet and weathered face of Gustave Geffroy; Mirbeau, with his forehead showing creases deep as sabre cuts.'[17] So, displayed in a glass-fronted cabinet on a little easel, was a yellowed envelope from Mallarmé addressed to:

> *Monsieur Monet, que l'hiver ni*
> *L'été, sa vision ne leurre,*
> *Habite, en peignant, Giverny*
> *Sis auprès de Vernon, dans l'Eure.*

> (Monsieur Monet, whose vision neither winter nor
> Summer can deceive,
> Lives while painting, at Giverny
> Close to Vernon, in the Eure.)[18]

The encouragement Monet took from these writers at a time of creative uncertainty in the late 1880s is not be underestimated. At the same time, the cocoon with which Alice and her daughters now surrounded him gave a new stability.

With his concentration on them, a gentleness entered his painting. Seascapes remained necessary as his livelihood, and in January 1888 he chose Antibes, the antithesis of Brittany: 'after Belle-Île the terrible, this will be all tenderness'.[19] News of a visit from Hoschedé, now referred to impersonally ('I thought that during my absence he would come – *l'on viendrait*') was equably received: her husband's appearance was unwelcome to Alice and it was Monet who consoled her that 'the visit was short, and you don't need to be unduly alarmed by it … your situation is difficult because of your dear children', who needed to see their father, 'so don't torment yourself too much'. Hoschedé, no longer a threat, had become merely a nuisance. Monet reassured Alice, 'you have in me a heart who loves you, a support on

which you can always count. You will never know how much I am yours, in spite of the outbursts and the bad side of my character.'[20]

While Monet painted in sunny Antibes, Giverny froze, the meadow became a huge ice rink, framed by paper lanterns hanging from trees and 'with me gone, all these little parties can happen with no hindrance,' Monet wrote. 'I see there's no boredom in Giverny.'[21] He sent his love to the skaters, '*les patineurs et patineuses* (ours, of course)' – an aside resonant of his integration into the extended family – and he joked to Alice that she could watch the Americans skate past her on the rink.

The Americans, and a Canadian, William Blair Bruce, were the impresarios of the winter parties. Bruce wrote home from Giverny in January 1888 that they 'had a jolly evening skate and such good ice. I have been quite turning the French peoples' heads with our Canadian fantastic skating.'[22] The 'French people' included Marthe and Blanche. Of her eldest daughter, Monet asked Alice, 'to have her married, do you really have hope of these Americans? In that case, I would be ready to make all the sacrifices.'[23] Blanche meanwhile was completing her first submission to the Salon, and painting alongside her was 29-year-old John Leslie Breck, known as Jack. In February Breck painted *Giverny Winter*, the field and village under snow, and a portrait of Blanche in a blue beret and red scarf with a prominent tie pin. Strong features, bright full cheeks, confident gaze, she eyes Breck intently.

Monet seemed only encouraging. He wrote to Blanche ahead of the Salon deadline:

> I'm scribbling you these few lines which prove to you that I am think-
> ing of you and bring my best wishes. I don't know those which are
> growing under your pretty little forehead and at the bottom of your
> heart, but I hope they will be realized. It seems that you are creating
> wonders. How I wish I were there, to guide you and help you come to
> a decision for the exhibition . . . I kiss you on your lovely cheeks.[24]

But to Alice ten days later came an outburst that she was

> talking to me about *ce monsieur* whom you want to become my friend,
> as he is of the children. Reading this, I report immediately back to
> Giverny, I see you all there with your new friends; if he is jealous of me,
> I am more so of him, and that's natural, since he's made himself loved

even by my children, without my knowing him. Don't hold it against me. I am irascible and nervous.[25]

How to describe the effect on four demure convent-educated sisters, lacking civilized male company, of the appearance of 'the Americans' in Giverny? The young artists arriving there in 1887–8 from New York, Vermont, Ohio, stirred the sort of havoc that a regiment newly stationed in an obscure town might have done a century before. Alice had worried her ménage with Monet would deter suitors. It turned out that he lured them from across the world, and now, most reluctantly, he had to deal with them.

Monet's first American connection was Sargent. His next was the thoughtful, unassuming Theodore Robinson, who had trained with Carolus-Duran and visited Giverny from 1885 onwards; he became an admiring, valued friend, to whom Monet talked frankly about his own work. A younger band followed in 1887, including Willard Metcalfe, originally a wood carver, from Boston; Theodore Wendel, an Ohioan circus-trained acrobat; Bruce, Breck, his violinist brother Edward, and their mother. The Brecks were wealthy global flâneurs. Jack was born in 1860 aboard a clipper in the South Pacific Ocean, the son of a US naval officer, and had lived in San Francisco, Massachusetts, Germany and Paris. Edward claimed this group formed the first American colony in Giverny, though during that initial season none met Monet.

Academically trained, the Americans painted far more literally than Monet, and chose anecdotal subjects – peasants in the fields, rural lanes – but they embraced plein-air methods and bright light. 'These young men ... have all got the blue-green color of Monet's impressionism and "got it bad",' the journal *Art Amateur* reported in October 1887.[26]

In Giverny, Breck persuaded the entrepreneurial Angélique Baudy to convert her grocer's shop and café into a hotel. Full board was 5 francs a day, red wine included. Madame Baudry provided piano and billiard table, was the agent for Lefebvre-Foinet art supplies from Paris, cooked Boston baked beans, celebrated Thanksgiving, and accepted payment in pictures. By 1888 her establishment was buzzing, with artists including Ohians Henry Fitch Taylor, a former actor, and Theodore Butler, a

dapper dresser who played the harmonica. Arriving at the Hôtel Baudy, a Frenchman said, was like landing 'en plein Middle-Ouest'.

Dawson Dawson-Watson, a 23-year-old British painter lured to Giverny after meeting Breck in a Montmartre café, embodied the Baudy spirit of romantic escapade when, three weeks after checking into the hotel in spring 1888, he met and married a fellow guest, Mary Hoyt Sellars of Illinois, at the British Embassy in Paris. They stayed in Giverny five years and Dawson-Watson left the fullest record of the colony, noting the trio of Bruce, Breck and Taylor as particular friends of the Hoschedé sisters.

The Baudy amateur journal, titled *Le Courrier innocent*, included a poem by the Hoschedé girls on the pleasures of skating, and proclaimed innocent fun. But Robinson's model Marie gave birth to his child, and when Metcalfe's model became pregnant in 1888, he was accused of and denied paternity. Monet, seeing that the visitors were self-selected, impetuous adventurers, was wary. He asked, 'Why do the Americans come to France to paint? Have they no landscape at home?'[27] His instinct was to avoid them. 'I had a nodding "time o' day" acquaintance with him and occasionally saw him out painting in the fields or on the river Epte, but I never made an attempt to get close enough to see what he was doing. Others that had no respect for privacy, did so ... and got cussed out for their pains and it served 'em right,' Dawson-Watson remembered.[28]

But for Alice's daughters, the Americans were irresistible. Their energy, experience and travellers' tales opened up vistas to intelligent girls crazy with boredom in a Norman village. The Baudy, a few steps from their home, was a bohemian haven of exotic young men, yet comfortingly familiar to the girls as a place devoted to artists. Perhaps it was inevitable that each of Alice's daughters fell in love for the first time with a painter.

While Monet lingered in Antibes, the Hoschedés celebrated Easter with the Americans. By the time he returned, Breck's Salon painting, a polished scene of grazing sheep, its influence less Monet than Millet, had been accepted, and Blanche's picture, in family tradition, had been rejected. She was not disheartened; in an informal snapshot taken in the Giverny garden in summer 1888 with Breck and Taylor, her broad smile radiates across the group. Breck, seated on the grass

at her feet leans forward, relaxed – too much at home. Taylor the extrovert thrusts at the front. Jean Monet shyly hides himself at the edge. Suzanne, the only one supplied with a chair, has her special status, enthroned; watchful, quiet, she was biding her time. Monet stands apart, hands in pockets, gruff, suspicious.

In *Chez Monet*, Breck dared depict his host alongside Blanche at her easel, painting the façade of the house. Outlining Blanche's sinuous figure, her face in profile, he emphasizes the colour rushing to her cheeks, matching her red jacket; in her contented expression he catches her double pleasure in her work, in his gaze.

According to the *Boston Sunday Globe,* Monet had told Breck, 'I won't give you lessons, but we'll wander about the fields and woods and paint together.'[29] That is what he meant when he promised Alice to 'make all the sacrifices', of his peace, privacy, pride, to smooth the romantic lives of his stepdaughters. Did the Americans play the girls to reach Monet, or play Monet to chase the girls? Later Monet regretted it: 'you know what I did with Breck and the other one, and you know the result'.[30] 'The other one', unmentionable or forgettable, was the American of whom Alice had hopes for Marthe, possibly Taylor. Monet was not patient with any of them for long. In June, complaining he had to suspend figure painting 'because of these damned Americans', he fled his family's new friends and crossed the Channel to London and then Calcot, on the Thames.[31] Here Sargent was depicting his teenage sister Violet in white against a pool of water.

Monet came back to paint the lustrous *Landscape with Figures, Giverny* [Plate 33], set on an open meadow edged with trees, which Sargent bought for 3,000 francs. Close up in the foreground, fifteen-year-old Germaine, massive, insouciant, looks not quite real, an overgrown child in drop-waisted dress with an adolescent face, a blank stare. Michel and Jean-Pierre flank her and are contrasted with Jean and Suzanne, posed as an adult couple, further back, smaller, but casting long shadows which hit the picture's edge, and are repeated by nearly parallel shadows thrown by the trees. Still and straight, all five figures echo the trees behind them, like natural extensions of the landscape, absorbed into it by the dazzling light. There is something of the hieratic fixedness of figures that recalls Seurat's provocative *La Grande Jatte,* harnessed to Impressionist luminosity.

Landscape with Figures has a twin, an overcast picture in the same setting, *The Walk, Cloudy Weather*. This picture stars Blanche, upfront, her hourglass contours stunning in a high-necked, tight-fitting dress – an adult woman, joyous, a force that cannot be held back. Together the paintings suggest thoughts about vulnerability, protectiveness, estrangement and fear of loss in a family of marriageable girls.

The significance of these paintings stretched forward. A few years later Monet painted, as a variation on his haystacks, the *meulettes*, wheat sheaves bundled into small stacks, tied at the tufted top. They resemble the female figure – head, neck, long dress – and Monet drew attention to the similarity: he titled the paintings *Les Demoiselles de Giverny*. The forms reiterate Blanche's and Germaine's in the 1888 pictures, and there was an immediate link, for when Monet finished his two big figure paintings, it was the end of August and the farmers were making haystacks on the Clos Morin, the land next to his garden. Monet painted them in several canvases where two haystacks of different sizes, like the groups of children, stand separate but bound together by atmospheric effect – ice, dawn, twilight. When Mirbeau once regretted that Monet had given up figure painting, he corrected

Monet, *The Walk, Cloudy Weather*, 1888. Blanche is the figure in the foreground

himself: 'as if your *meules* weren't figures! And what figures!'[32] The relationship between the *meules* and the figure paintings is pronounced. The 1888 haystacks are charged with the emotional connection Monet felt to the members of the family depicted within the landscape – his own and the Hoschedé children who accepted him. Marthe's and Jacques's absence is telling.

So Giverny, which as inspiration had long come second to more dramatic or beautiful places, began to find its role. Its ordinariness was the point. 'When I walked out into the meadows, down past the pollarded willows, I discovered (what I might have inferred) that Monet had glorified a sadly commonplace little valley. He ... had haloed every object, lifting it to a higher quality than it actually possessed,' wrote a visiting American novelist, Hamlin Garland. Monet's house was 'an uninspiring spot. His dwelling was ordinary and his garden formal without being tasteful. The more I studied this village, the more I marvelled at the transforming power of art.'[33] Setting his and Alice's children in the landscape in 1887–8, Monet began to see how he could use Giverny's banal motifs of broad plains and lines of trees as armatures for structure, imaginative colour and light effects. It would take until 1890 for Giverny to reveal its full potential as impetus for his next move, when he came to paint the *Haystacks* as a series. But for now these experiments prepared the way for possibilities beyond the landscapes. 'The more I go on, the more I am seeking the impossible, the unseizable,' he told Geffroy in 1888.[34]

Theo Van Gogh, stealing a march on more established dealers, staged the exhibition of the Antibes paintings in the summer. His courting of Monet underlines the fast-changing markets and allegiances of the late 1880s, amid a fracturing avant-garde, when Monet appealed intently to some younger artists and critics but was reviled by others. Among the dissenting voices was again Fénéon, who thought Monet 'served by an excessive bravura of execution, a fecundity of improvisation and a brilliant vulgarity ... He works up an immediate emotion in front of a spectacle, but there is nothing in him of the contemplative or the analyst.'[35] Monet coolly told Theo Van Gogh that Fénéon's criticism 'could have been anticipated'.[36]

The reserve among his friends was palpable. 'You have conquered this recalcitrant public. At Goupil's one meets only people who have

the highest admiration for you,' Berthe Morisot congratulated him. This was a diplomatic answer to his demand for endorsement: 'I find that there is much coquetry in your request to me to give you my opinion – I am simply dazzled! and you know it quite well.'[37] Pissarro mused that the paintings 'are beautiful, but Fénéon is right, while good, they do not represent a highly developed art ... Almost all the painters take this view. Degas is even more severe, he considers these paintings to have been made to sell ... he maintains that Monet made nothing but beautiful decorations. Renoir also finds them retrograde.'[38] All were jealous, though history has supported them in prizing the Antibes works less, and also their successors of 1889, from a trip inland in the Creuse river valley, a site suggested by Geffroy.

Monet's frustrations in both places were connected with the difficulty of expressive stylization driven to its limits – Fénéon's 'making nature grimace' – and are best perceived as the tail end of this process, a method necessarily yielding diminishing returns. A certain fatigue and lack of invention at the end of the Argenteuil and Vétheuil periods is comparable. By 1889, among the torrents and boulders of Fresselines close to the Massif Central, depicted in slashing russets and purples, Monet felt immense weariness in engaging with a new place. The conditions at the Creuse from February to May were awful, and amid gales, heavy rain, mud, rough terrain, he suffered from unfamiliarity with the wild interior region. He was exhausted, homesick, and starting to suffer from rheumatism. Years of battling the elements had taken their toll. Towards the end of the trip he signed himself to Alice 'your old, very old Claude'.[39]

The madness of continuing struck him when an oak he had been depicting burst into leaf, and the only way to save five paintings was to persuade its owner to strip the foliage. Fifty francs produced 'permission to remove the leaves from my beautiful oak tree ... It was quite an effort to bring big enough ladders into this ravine. At last it's done, two men have been working on it since yesterday. Isn't it something to finish a winter landscape at this time?' he asked Alice on 9 May.[40] It was an absurdist ending to the 1880s painting campaigns, inaugurated with Monet's exhilarated response to the sea at Pourville in 1882 and concluded with this alteration of nature for art. It pointed to a future when, eventually, he would train nature itself into the

artifice of his garden, controlling not only his painting but the natural world which was its subject.

A phase had ended. Monet painted only two canvases between spring 1889 and spring 1890. Instead, as he approached his fiftieth birthday he threw himself into a pair of projects concerned, one way or another, with securing his reputation.

The first was sparked by Petit. Envious when Monet defected to Theo Van Gogh, he proposed his more glamorous gallery for a double show of Rodin and Monet, to coincide with the summer's 1889 Exposition Universelle. Rodin, two days older than Monet, was then more widely known, and tremendously ambitious in seeking a wide public. A policeman's son, he was mostly self-educated and had made his name in Paris in 1877 with *The Age of Bronze*, a sculpture of a soldier in a pose partly based on Michelangelo's *Dying Slave* but stunning for its naturalism. His rejection of academicism, gift for modelling expressive textured surfaces which emphasized plays of light and shadow, and his declaration of fragments as autonomous works, all brought him close to the Impressionist aesthetic, although his sensibility was more rooted in Romanticism. Monet admired him enormously, and was excited by the chance to show with a more eminent name. The result, however, disappointed him. Rodin misbehaved, installing his sculptures at the last minute, and placing the *Burghers of Calais* to obscure the strongest wall of Monet's paintings. Rodin's press coverage similarly overshadowed that given to Monet, who was mortified, though he never lost his respect for Rodin's art, and their friendship was maintained. Rodin's Gothic inflection to Impressionist sculpture in the *Burghers* was a memory when Monet painted Rouen cathedral.

Looking back, Boudin's friend Jean-Aubry saw the show as definitive. 'The exhibition of Monet and Rodin at the Galerie Georges Petit in 1889 marks, historically, the end of the struggles of the Impressionists . . . the iron age of French painting was over and the golden age was beginning. The private collectors, dealers and salons were multiplying.'[41] Monet also had works at the Exposition Universelle, and the dual exposure worked wonderfully. Among many American art lovers introduced to Monet by these shows was the Boston painter Lilla Cabot Perry. Five days after seeing 'Monet–Rodin', she impulsively installed herself and her family at the Hôtel Baudy. They returned to Giverny for subsequent

summers, sometimes taking the house next to Monet, who enjoyed her company. From his studio she bought an Étretat picture, the first Monet ever seen in Boston. Meanwhile, in Paris, Pissarro groaned that Theo Van Gogh sold a Monet to an American for 9,000 francs.

But Monet was discontented. In a glowering photograph at the Exposition with Sargent he stands tensely, arms akimbo, looking impatiently sideways from under his top hat as if sniffing out escape. 'You are you, completely. Male, powerful, with your eye that tames the sun,' Mirbeau wrote of this snapshot where Monet is at once the fashionable establishment insider and an aggressive independent spirit.[42] A garden photograph taken by Theodore Robinson during the same summer is the opposite of the top-hatted man about Paris: he casts Monet as a farmer, with a felt hat and wooden clogs, studiedly normal, without pretension. It was on Monet the gardener that the Exposition Universelle in fact had a determining impact, for he saw and began to think about Joseph Bory Latour-Marliac's prize-winning display of highly coloured water lilies, new hybrids crossing exotic and hardy species.

Jean-Pierre recalled that once home, instead of painting, Monet spent all day writing letters with his goose-quill pen. This was the beginning of a year-long battle to secure Manet's *Olympia* for the French state. Sargent had alerted him to an American offer for the work made to Manet's widow. Monet, with no immediate project and in need of a cause, transferred his energy, and expertise in begging, to save the painting for France. His campaign to raise 20,000 francs to buy and donate it to the Louvre was a loyal gesture to his friend's memory. It also cemented Monet as Manet's heir, and gave proof of his own success. The list of subscribers, with the sum promised by each, was circulated to all those solicited.

Monet gave 1,000 francs, as did his supporters de Bellio, Caillebotte, Duret and Sargent. Contributions from painters across the spectrum, including society portraitist Giovanni Boldini, muralist Pierre Puvis de Chavannes, realist Alfred Roll, suggest the breadth of the Manet/Monet standing by 1889. Winnaretta Singer, new owner of *La Norvégienne*, was the most generous subscriber at 2,000 francs. Renoir regretted that 'Manet will have to go to the Louvre without me', but sent 50 francs at the last minute.[43] Degas gave 100 francs, Pissarro 50, Mirbeau 300, Durand-Ruel and Petit 200 each, the

Monet in his garden, photographed by the American painter Theodore Robinson, *c.*1889

schoolteacher Mallarmé, the writers Geffroy, Burty and Huysmans, and the petulant Rodin all gave 25, though Geffroy at the last minute doubled his sum. Zola refused.

Monet had raised 18,550 francs by November, and some debate when it looked as if the state might reject the gift. Misunderstandings in the press, stoked by that lover of controversy Mirbeau, led to Antonin Proust, Manet's childhood friend and a former arts minister, challenging Monet to a duel. Proust had himself contributed 500 francs, and he and Monet had the same goal for *Olympia*, so this was an anachronistic farce – and a glimpse of how aspects of *ancien régime* manners and customs remained part of the social life of those forging modernity at the end of the nineteenth century. Fortunately, Monet's 'seconds', Duret and Geffroy, went to soothe Proust, who met Monet amiably in a café, and agreed to use his contacts to smooth the

passage of *Olympia* as the first state-owned Manet. 'What a singular thing!' Duret wrote to Monet. 'It will be you who will make the breach through which Manet will pass, although it was he who was the precursor. Your work coming later finds the terrain better prepared; then too Manet was a figure painter and there the terrible academic convention . . . reigns and will always reign supreme.'[44]

But Monet himself was not finished challenging that convention. He was at work on the two final, and largest, of the group of paintings depicting the girls rowing, *The Pink Skiff* and *Canoe on the Epte*. The girls were his again, as the Americans had gone. Taylor had returned permanently to New York. Breck had left France at the end of 1889 and was in Boston teaching plein-air painting. The Boston *Transcript* reported in June 1890 that 'Mr Breck is somewhat famous in a limited way as the only pupil of the impressionist Claude Monet, and we may as well be prepared for anything and everything when he lets loose a flock of sweet girl graduates, duly inoculated with the impressionistic visual virus.'[45] This hints at a romantic reputation, and indeed Breck had a fiancée to revisit, Nellie Plummer of Auburndale. Helped by Cabot Perry, whom he had met in Giverny, he also launched his first solo exhibition, at Boston's St Botolph Club in autumn 1890. Including paintings of Monet's garden, it was a local *succès de scandale*, much helped by the august French connection.

In Giverny the boat pictures ran aground. 'Desolation: my pretty models have been ill,' Monet told Morisot.[46] He destroyed many canvases, and sought company to alleviate his discouragement. Geffroy brought Clemenceau, sparking the revival of old acquaintances into friendship; the politician admired the mature Monet as 'a healthy mind in a healthy body . . . of medium height, well-built, steady and robust, with smiling determined eyes and a firm, sonorous voice.'[47] Morisot brought Mallarmé, who was compensated for Monet's inability to illustrate his poem with the offer to choose a painting. Too modest at first to admit the one he really wanted, he finally, on Morisot's encouragement, took *The Train at Jeufosse*, steaming as it passes a bend in the river. On the train home from Giverny, Mallarmé cradled, as it were, the passing scene in his arms. 'One does not disturb a man amid a joy such as that which the contemplation of your

picture brings me, dear Monet. I am drowning in the dazzle, and my spiritual health improves as I look at it.'[48]

Then Monet more or less stopped painting when Jean was invalided out of the army to the military hospital in Le Havre with a chest influxion. He commuted to and from the hospital, and subsequently nursed Jean at Giverny while pulling every string, from Clemenceau down, to exempt him from finishing his military service. Monet's fears were not unrealistic. In the 1890s Charpentier's son Paul also sickened during military service, came up before a severe doctor who refused to acknowledge his illness, and died aged twenty. Monet managed to get his son extended leave, but this only made it harder for Jean to go back after extended cosseting at home.

In weather too poor to be outside Monet resorted to a full-length indoor portrait of his favourite model, sombre in a mauve dress, with three immense blooms spinning around her head. Once more Suzanne recalls Camille. Monet's last indoor full-figure portrait had been the sad *Camille with a Bouquet of Violets* of 1877. Suzanne in 1890, slightly smaller than the flowers disconcertingly painted at life size, is similarly a figure of pathos. *Suzanne with Sunflowers* is atypical, hardly recognizable as a Monet, never exhibited. Mirbeau adored it:

> her beauty is delicate and sad, infinitely sad. She is enigmatic, her eyes
> are vacant ... her posture is apathetic. What is her souls's secret? ...
> She is as strange as the shadows that envelop her completely, that, like
> her, are disturbing and a little terrifying ... One is reminded ... of certain images of women, spectres of the soul, like those evoked in certain
> of Stéphane Mallarmé's poems.[49]

Alice later saw presentiment of tragedy in the painting, but the cause was obvious and immediate. Monet fixed in Suzanne's portrait a sadness hanging over all Hoschedé's children. Their father had been ill since the beginning of the year, and declined towards its end.

'Creating is good, but prolonging life is better,' Hoschedé joked in January 1890 to his doctor, Paul Gachet, homoeopath and psychiatrist to the artists.[50] Gachet treated his disabling leg pains as the gout of a heavy, unfit *bon viveur*. Hoschedé convalesced and appeared to recover under the care of Norbert Goeneutte, a younger painter on

the fringes of Impressionism, also ill, with a lung disease which would soon kill him. The year began with the invalids rallying together: 'It's from the revived Goeneutte that the restored Hoschedé writes you these short lines, my dear Gachet.'[51] This was in Auvers-sur-Oise, where Gachet lived, a magnet for his patients. The most famous of them, Van Gogh, died there in July.

Hoschedé, who had remained single since his separation from Alice, returned to Paris to publish, at his own expense, his *Brelan des Salons*, an account of the proliferating salons such as the Indépendants. In this milieu he had many friends among the minor artists, and one of them sketched a pastel, unsigned, of a haggard, sunken Hoschedé, a painful memento which found its way to Suzanne. The *Brelan* itself remained a family treasure: it was the volume Germaine was reading when she died, aged ninety-five, in Giverny. *Brelan* failed, however, to make Hoschedé's name in 1890, and left him out of funds. In September Monet discovered that Marthe was secretly slipping banknotes into letters to her father. In November, lodging in cheap hotels, increasingly paralysed, Hoschedé no longer joked. He told Gachet that 'dislocated by particular pains ... I've been suffering greatly since I saw you ... I'm in despair ... I don't know if I will be able to get up tomorrow. What shall I do?'[52] He withdrew to his final boarding house, 45 rue

Ernest Hoschedé, *c.*1890, an anonymous pastel
sketched by one of his friends

Laffitte – coincidentally the address at which Monet was born, though not the same building, the street having been renumbered.

It happened that at the moment of Hoschedé's decline, the Maison du Pressoir came up for sale and Monet bought it, for 22,000 francs. His banker was the forgiving Durand-Ruel. Of Monet's other dealers, relations with Petit had cooled and Theo Van Gogh, distraught at his brother's death, had entered Dr Blanche's sanatorium in Passy and had only three months to live. 'The only obstacle to the business between us was that poor Van Gogh, who has ended up so pitifully. He put a spoke in our wheel, and I have never really understood your fondness for him. Now he is gone, you may count on me absolutely,' Durand-Ruel exulted to Pissarro.[53] The dealer was as delighted to make himself indispensable to Monet. On 17 November, three days after his fiftieth birthday, Monet became a home owner. He told Durand-Ruel that he would never find another place as suitable, or set in as beautiful a landscape.

By then he was entirely occupied, in a way unprecedented since he had moved to the village, on a landmark group of works. Their first mention is in parenthesis, to Geffroy on 7 October: 'I'm working very hard, I'm stuck in a series of different effects (of haystacks).' Complaints and discouragement vanished as he told Geffroy his intentions:

> The further I go, the more I see the need to work very hard to be able to render what I'm seeking: 'instantaneity', especially the envelope, the same light spread everywhere ... I am more than ever wild with the need to put down what I experience, and I hope to go on living, not too powerless, for it seems to me that I will make progress. You can see that I am in a good mood.[54]

The opposite of the simplistic or misleading statements fed to journalists over the years, this is reminiscent of one other letter in Monet's correspondence: a similarly highly wrought expression written at a moment when changes in his art urged a need to lay out his position to himself via a trusted confidante. In December 1868, on the verge of the experiments leading to the Impressionist paintings at La Grenouillère, Monet had written to Bazille that he would paint 'what I myself will have experienced, I alone ... The further I go, the more I notice that one never dares to express frankly what one experiences.'[55] The letters,

written on the brink of the two most significant advances of Monet's career so far, share an insistence on inner life and his own confidence. The material circumstances in which Monet wrote them were very different, the emotional ones less so: both were times of calm after the storm with the woman he loved. In December 1868 he was enjoying family life with Camille and a measure of financial security after many upheavals. In October 1890 his relationship with Alice had stabilized, and he was about to own his home in Giverny. He had achieved peace.

As the days shortened, Monet stood on farmer Queruel's land, the Clos Morin, and in his series *Haystacks* [Plates 34–5] repeatedly depicted six-metre conical haystacks against horizontal bands of fields, distant hills and sky. Responding to them as a majestic group, he painted the stacks alone or in pairs of large and small, like the children in the fields in his 1888 figure pictures. Blanche worked on her own *Haystacks* canvases at his side, and fetched and carried. In Monet's later account she is the pack horse in a spontaneous, almost naive venture: 'One day I noticed that the light had changed. I said to my stepdaughter, "Would you go back to the house, please, and bring me another canvas?" She brought it to me, but very soon the light had changed again. "One more!" and "One more still!" And I worked on each one only until I had achieved the effect I wanted; that's all.'[56] But analysis of technique and surfaces in the *Haystacks* show how much work, with complex paint applications, continued in the studio, where Monet developed relationships between the various compositions. Showing the paintings to Dutch writer Willem Byvanck, he explained that 'you have to know how to seize just the right moment in a landscape instantaneously, because the particular moment will never come again' yet the paintings 'only acquire their full value by comparison and in the succession of the full series'.[57]

This was the breakthrough. Monet had built landscapes on nuances of effect through the 1880s, especially at Belle Île, but it was something else to construct them deliberately as a moment-by-moment series – paintings declaring themselves to be primarily about time rather than place. An Argenteuil picture gives the viewer the uncomplicated delight of looking at nature in one fresh moment. By contrast the *Haystacks* insist on contemplation of that moment passing, of the transience of all moments. It was a conceptual project, predicated on

the paradox of working up the impressions of an instant over months, and on the artifice of co-opting instantaneity into a drama of repetition and difference. The short staccato strokes produce waves of colour in multiple layers, suggesting light as a pulsing force, yet blending into an opalescent haze seen from a distance. 'Their sides split and light up, revealing garnets and sapphires, amethysts and topazes; the flames scattered in the air condense into violent fires,' Geffroy wrote.[58]

With a sort of renewed beginner's luck as Monet embarked on the oeuvre of his late middle age, the *Haystacks* came easily. By the end of January 1891 he had finished twenty-five of them. He promised first choice to Durand-Ruel, who came to view them in February. Petit had leap-frogged his rival with the prestigious 'Monet–Rodin' exhibition, but Durand-Ruel's loyalty was rewarded now. No artist had ever displayed multiple views of the same subject arranged together. With Durand-Ruel, Monet planned the haystacks presentation of 1891, which would constitute his most successful, radical exhibition so far, and stamp the dealer's name on one of the historic shows of the nineteenth century. Fifteen *Haystacks* were selected, to which Monet added the two depictions from 1886 of Suzanne with a parasol, *Study of a Figure Outdoors*. His feeling about a connection between the *Haystacks* and Hoschedé's daughters could not have been clearer. Their inclusion marked a farewell. Suzanne, 'standing on this hill with her white parasol, knows she's the last one; she appears to be waving goodbye to us,' said the duc de Trévise.[59]

When asked why he had stopped painting people, Monet would say no one wanted to pose. The truth was that, without the animating psychological connection shared with Camille, the renewed attempt at the 'old dream' had both stalled and served its purpose, for the future of his art, and in his emotional life. Monet produced only two more figure paintings, and these were private pictures, one featuring Blanche in 1892, and the other Suzanne in 1895, made at a time of crisis in each girl's life, and not for exhibition.

Burnished by golden rays or sprinkled with snow, symbols of endurance as they – and their creator – withstood rain, ice, fog, the *Haystacks* as bundles of wheat and wealth embody shelter, bounty, nurture. This was everything Monet had longed for when he painted Alice and Michel at the foot of a small haystack in 1885, and now had within

his reach; everything that Hoschedé, dying in his boarding house, had lost. Geffroy likened the stacks with their thatched roofs to cottages. Monumentalized geometric forms, they are the apotheosis of the disparate refuges – Pourville's *cabanes*, Étretat 's *caloges* – dotting the seascapes of the 1880s.

They are also vehicles for abstraction, flattened by the sun, dissolving in the mist. Geffroy called them '*objets passagers*', 'transitory objects on which are reflected, as on a mirror, the influences of the surroundings'.[60] Monet did not read theoretical texts, but the *Haystacks* coincided with the call issued in summer 1890 by Maurice Denis to remember that a painting is a flat surface covered with colours in a certain order. The *Haystacks* would shape the rest of Monet's work, ground him in Giverny, bring prosperity and fame, and transform art history.

On 7 March, with some of the paintings already sold, Mirbeau announced in the journal *L'Art dans les deux mondes* the forthcoming appearance of a 'stunning series of haystacks in winter' by a Monet possessing, like the life-preserving stacks, 'this magnificent moral health that nothing enervates, nothing defeats'.[61] The following week, Alice left for Paris, and for six days and nights she nursed her husband in his last illness. At a quarter past midnight on 19 March, with his wife at his side, Hoschedé died. He was fifty-three. As he had died in debt, Monet paid for his funeral at Notre-Dame-de-Lorette, the church where Monet himself had been baptized. Monet reported to Durand-Ruel on the grief of the Hoschedé siblings, and that their mother came home, collapsed, and spent three days in bed. 'The children wanting to have their father close to them', Monet also paid for Hoschedé's burial in Giverny.[62] The reversal of fortunes between the Maecenas of Montgeron and the penniless artist of fifteen years ago was complete.

17

'Now You Have Happiness', 1891–2

In April 1891 Pissarro had a show at Durand-Ruel's and hardly sold a work. 'This is a bad moment for me,' he lamented to his son Lucien; 'people want nothing but Monets, apparently he can't paint enough pictures to meet the demand. Worst of all they all want *Haystacks in the Setting Sun!*'[1] He wondered 'how Monet can submit to this demand that he repeat himself – such is the terrible consequence of success!' and he quoted rumours of sales of up to 6,000 francs for each picture.[2] Sixty-year-old Pissarro, with an abscess on his eye, expensive medicine to buy and several dependent children, had to swallow his pride and ask Monet for help. Monet sent 1,000 francs, addresses of potential buyers, and magnanimity: 'if there has been some small coldness or dissent between us ... we are too old friends not to help each other out.'[3] Within the year, Monet lent Pissarro 15,000 francs to buy his home at Éragny.

Monet was confident and slightly devious: though he encouraged the reports, his *Haystacks* were not as expensive as Pissarro thought; he received 2,500 francs per painting from Durand-Ruel. 'Keep the price secret,' he insisted to the publisher Gallimard, among the first to buy a *Haystack*; 'if anyone asks, I'd be grateful if you would say 5,000 francs.'[4] So the hype mounted in the weeks before the *Haystacks*' public unveiling.

Pissarro with his sore eye and heart is the reporter on their launch at the rue Le Peletier on 4 May:

Yesterday Monet's show opened at Durand-Ruel's. I saw everybody there. I went with one eye bandaged and had only the other with which to take in Monet's marvellous *Sunsets*. They seemed to me to be very

luminous and very masterful . . . in rightness and harmony they leave nothing to be desired . . . this is the work of a very great artist. Need I add that the show is a great success?'[5]

With no precedent as an exhibition, the fifteen *Haystacks* excited and disturbed. Byvanck confessed that 'those loud colours, those zigzagging lines, blues, yellows, greens, red and browns, dancing a mad saraband on the canvases, hurt my eyes'. Then he perceived 'a stack in its full glory. The purple and gold rays of an afternoon sun ignited the straw, and the burning stalks blazed with a dazzling brilliance. The hot air visibly vibrated and bathed objects in a transparent blue haze.'[6] The effects lasted: Mallarmé wrote, 'You dazzled me recently with your haystacks, Monet, so much that I find myself looking at fields through the memory of your painting, or rather, they demand to be seen like that.'[7]

Four days into the show, Durand-Ruel confirmed '*beaucoup de monde*, and especially *un très beau monde*'.[8] Monet's earning for 1891 would hit 100,000 francs. Bertha Potter Palmer from Chicago bought seven *Haystack* paintings on the spot, then two more in New York in the autumn, confirming the series as not only an aesthetic conquest but a financial masterstroke. *Haystacks* went to collectors in Boston, Cleveland, Connecticut. For this and the series which followed, certain wealthy collectors wanted one of every group, sometimes contrasting examples within each. The format assured them an understanding and gauging of prices between works which were often identically sized, within the same series. On a collector's wall, a *Haystack* or, later, a *Rouen Cathedral* conferred prestige, a particular stimulus on the American market.

Durand-Ruel's transatlantic gamble paid off in the 1890s, and boosted French sales. He congratulated himself that 'the same people who had not dared to buy a Manet, Renoir or Monet, or would only pay a few hundred francs for them, now resolved to pay as much as the Americans.'[9] At once creating and benefiting from the rising market for Impressionism, Durand-Ruel led a victory for the commercial gallery itself, whose influence in charting avant-garde taste dominated the twentieth century. In 1881 Renoir had regretted that hardly a collector bought outside the Salon; by 1891 the Salon, though it lumbered

on, was irrelevant to modern painting. Conservative taste for *pompier* art, however, was not extinguished. At the 1897 sale of Henri Vever's famous collection, Monet's *Road Bridge at Argenteuil* of 1874 fetched a triumphant 21,500 francs – and a Meissonier 94,100 francs. But the 1890s saw the beginning of the global reach of Impressionism. By 1900 Monet could say, 'Today nearly everyone appreciates us in some degree.'[10]

'To paint landscape in 1889 without knowing Monet by heart would be ... to betray a want of education,' Walter Sickert wrote in the *New York Herald*.[11] In Moscow in the 1890s Kandinsky saw a *Haystack* exhibited and began to conceive abstraction: 'for the first time, I saw a *picture*. That it was a haystack, the catalogue informed me. I didn't recognize it ... Painting took on a fairy-tale power and splendour. And albeit unconsciously, objects were discredited as an essential element.'[12] For Theodore Robinson, writing in *The Century Magazine* in 1892, 'M. Claude Monet is the most aggressive, forceful painter, the one whose work is influencing its epoch the most.'[13] The pulse towards Monet was moving so quickly that in Paris dealers hardly kept up. After Theo Van Gogh's death in 1891, Monsieur Boussod explained to his successor, an eager youth called Maurice Joyant, that the gallery's former employee, 'a sort of madman', had overstocked the place with rubbish, adding, 'You will also find a certain number of canvases by a landscapist, Claude Monet, who is starting to sell a bit in America, but he does too much ... always the same subjects.'[14] Yet at that very moment Boussod's more alert partner Monsieur Valadon was at Monet's door in Giverny, asking for some *Haystacks*.

Monet's serial painting chimed with particular currents in 1890s Paris. In 1889 Henri Bergson published *Time and Free Will*, introducing the idea of *la durée,* a theory of time, timelessness and consciousness: an awareness that as soon as a moment was measured, it was gone, thus pointing to the importance of memory, the continuum in the mind of past and present – the individual's subjective experience of time. Art and literature led there – Impressionist concern with perception of the moment, Mallarmé's fragments and disjunctions and, soon, Proust's atomization of memory. (Proust was best man at Bergson's wedding in 1891.)

There is no suggestion that Monet read Bergson, but the ideas were in the air. *La durée* was a cultural fixation at the *fin de siècle*, with Monet's serial painting the visual expression of it. Clemenceau considered the series painting 'marked an era in perception . . . a new way of seeing, of feeling, of expressing'.[15] In devising his method to record the same scene changing according to different 'envelopes' of light, Monet found a way to combine the quick observation of a glance with extended meditation on a theme. In his essay *L'impressionnisme et la pensée de son temps*, the Louvre curator René Huyghe argued that 'Bergson in his philosophy, Proust in his novel and Monet in his series are haunted by the idea that neither we ourselves nor things remain the same, they do not keep their identities intact: every new second brings them a modification which transforms their very nature.'[16] From this position flowed themes of interiority, remembrance and, with them, an increasingly self-referential, abstracting art.

Abstraction as an evolution from Impressionism, with its emphasis on the subjective appearance of things, was inevitable. It was predicted by commentators early on: 'impressionism . . . is a school of abstraction,' Seurat's friend Paul Adam declared in 1886.[17] But serial painting was not inevitable, it was Monet's individual, original invention. Unlike his colleagues – Renoir with his classicized figures, Pissarro in pointillism – who explored different routes towards a greater solidity, Monet kept faith with images of the fleeting moment, and constructed from them something symphonic, architectonic, giving Impressionism weight and permanence. It answered his own internal questions about the development of his painting, and it answered his critics. A whole series could not be accused of being dashed off like a sketch; it declared discipline, persistence, order, the harmonizing of colours and forms across multiple works, over months, in the studio. Monet was understood as both innovative and authoritative. Even Fénéon admired the *Haystacks*, especially at twilight, 'in summer haloed in flaming powder, in winter phosphorescent shadows streaming in the sun'.[18] The sunset pictures mirrored the sun setting on a century. A sense of the passage of time was swathed within a spectacle of ripeness and joy, and transient, individual sensation held within depictions of elemental, eternal nature.

Pissarro, who after his initial suspicions was converted to Monet's

serial method, summed up the *Haystacks* as 'these canvases breathe contentment'.[19] That reflected Monet's life at the time. The concept of the unified series allowed him to stay at home and work in Giverny, or at least nearby, and in 1891 he had already mapped out half a decade's work. He chose the motifs carefully: formally, as armatures for light and colour effects, for their interest, and for their locality. Robinson reported Monet saying that whereas in the past 'anything that pleased him, no matter how transitory, he painted, regardless of the inability to go further than one painting. Now it is only a long entwined effort that satisfies him, and it must be an important motif, one that is sufficiently compelling.'[20]

When Durand-Ruel's exhibition closed, Monet basked at home, rowing daily to Limetz, two kilometres away, to paint the row of poplars lining the Epte where the river bends back into an S curve. Halfway through the *Poplars* series [Plate 36], he learnt that they were to be cut down, so he bought them in order to finish painting them. Monet liked this story: it conferred him power over nature, and gave him a passing role as a Norman farmer. Assured of his trees, he settled into his studio boat, equipped with grooves to hold multiple canvases, and from the middle of the river completed twenty-three paintings of the poplars, from dawn to dusk, beneath warm sun or grey skies, brilliant blue and verdant green as the wind blows through them, rose and gold when the sun falls hard on their trunks.

The tall trees in their regular layout, planted eight metres apart, light piercing the spaces between, and their trembling reflections, encouraged an airy vivacity. These are refined paintings, in the balance between grid-like composition and fluttering leaves and plays of light, and in the darting brushwork, delicate and free but also layered. The surfaces shimmer, with a foreground frieze often offset by a second row of trees winding away in the distance, giving depth and recession. Observation of nature, time, weather, is not sacrificed. Monet explained to his sometime neighbour Lilla Cabot Perry that for one painting, 'the effect lasted only seven minutes, or until the sunlight left a certain leaf, when he took out the next canvas and worked on that'. She added that 'he always insisted on the great importance of a painter noticing when the effect changed, so as to get a true impression of a certain aspect of nature and not a composite

Monet photographed by Lilla Cabot Perry, 1890–95

picture . . . He admitted it was difficult to stop in time because one got carried away, and then added, "*J'ai cette force-là, c'est la seule force que j'ai!*"* (I have the power to do that, it's the only power I have.)[21]

Yet what makes the prime impact is the composite – pictorial organization and symmetrical reflections directed towards a decorative grace, close to the exaggerated elegance of Art Nouveau, its blend of organic and ornamental motifs, though tougher. Art Nouveau is a decorative style, dominant in the look of 1890s and 1900s Paris, in Hector Guimet's curling Métro entrances, in Siegfried Bing's 'Maison de l'Art Nouveau' store with Tiffany windows. Monet's decorative

* Cabot Perry, writing in English, kept this quotation in the original French, commenting, 'I give his exact words, they show his beautiful modesty, as great as his genius.'

patterns, brought to a finish in the studio so that each work echoed elements of the others, create an ensemble of tone poems, close to musical harmony. As the 1880s groups of works had proceeded by contrasts, so did the four major series of the 1890s. After the arabesque motifs from nature of *Haystacks* and *Poplars* came the manmade Rouen cathedral, whose stone was then contrasted with fluidity in *Mornings on the Seine*.

The *Poplars* share with the *Haystacks* optimistic connotations of nature and nurture blended, and are a first run at the extreme verticality of the *Rouen Cathedrals* series [Plates 37–40], with which they also have in common references concerned with French history and national character, for poplars (*populus*, of the people) had been considered the 'tree of liberty' since the Revolution. Poplars were ubiquitous, and typical of Normandy, lining riverbanks to minimize flooding, separating properties, and used as timber. In 1891-2 the sturdy stacks and rows of upright trees represented well-being and order. Robinson wrote that 'Monet's art is vital, robust, healthy . . . it shows the joy of living.'[22] Monet transformed the trees from banal to majestic. These 'evocations of nature pass well beyond reality. They render nature's great mystery. This painting satisfies the soul as much as it enchants the eye,' wrote the novelist Georges Lecomte.[23] There is a yearning richness, as if Monet, knowing the trees were to be soon cut down, was already memorializing their lilting rhythms.

The paintings expressed Monet's personal sense of well-being. The summer of 1891 brought the first communion of 'our two young boys'[24] – note the pronoun – when Monet assumed the role of father for Jean-Pierre in this ritual inaugurating the reconfigured family, and the return from the army of Jean 'mon sergeant', who arrived by boat at the lock at Port-Villez, close to Limetz. The 24-year-old went on to study chemistry in Switzerland, and Monet became confident that 'provided he does nothing careless or stupid', he was on the right track.[25]

Monet himself was reluctant to be absent from home even for a day, 'now that I am arranging the house and garden to my taste'.[26] A Japanese gardener came to give advice, and the following year the first of six full-time gardeners joined the Giverny payroll. One of the happiest photographs of Monet is an informal one taken by Lilla Cabot

Perry, who remembered that 'he would sometimes stroll in and smoke his after-luncheon cigarette in our garden before beginning on his afternoon work. The man himself, with his rugged honesty, his disarming frankness, his warm and sensitive nature, was fully as impressive as his pictures.'[27] Mirbeau sought the man in Monet the gardener: 'we'll talk gardening, as you say, because as for art and literature, it's all humbug. There's nothing but the earth.'[28] He documented Monet in shirt-sleeves, his hands black with soil, his face tanned by the sun, happy to be planting seeds, in his garden always radiant with flowers', yet he also described the garden at Giverny as a hothouse paradise, something like a landscape of the mind. 'Irises raise their strange, curling petals . . . their elaborate depths evoke mysterious analogies, dreams of temptation and perversity, like those that emanate from the disturbing orchids . . . the suns of the Texas roses reach out their long bracts heavy with buds, and the great California sunflowers leap, their tousled flower heads crested with gold, like fabulous angry birds.'[29]

In 1892 Monet's income rose again, to 113,000 francs, and in his house as well as his garden he could be self-indulgent. The painter Jacques-Émile Blanche, Proust's friend, visited in 1893, and left an account of Giverny when Monet's 'arranging' had been perfected, but before later extravagant rebuilding. He thought the house 'deliciously cool, cheerful, full of esparto, cretonne, fans and Japanese prints; bamboo and red Andrinople cotton were all the rage. Monet had lined his dining-room walls with white damask, a silver ground on which the images from the Japanese album leapt out.' The table arrangements were as preciously delicate as at Whistler's, and 'the master of the house, a gourmet, was known for the succulent surprises he kept for his guests. One felt he was a simple man, peaceable, sensual, happy to have a very comfortable roof over his head.'[30]

Adorning this home was the beginning of Monet's substantial art collection, as he now started seriously to acquire works by his friends, buying through dealers, without negotiating reductions. Cézanne, whose prices were still low, held a special place. By the mid-1890s Monet took his morning cold bath in the company of the vigorous male nude *The Negro Scipio* (400 francs) and had also purchased a view of L'Estaque (600 francs) and *Boy in a Red Vest*; eventually he

owned fourteen Cézannes. There was a Renoir nude, soon joined by the orientalist portrait of Clémentine Stora, a North African antiquities store owner, 'a ravishing woman dressed in gold and blue with an apricot orange belt, the most beautiful Renoir',[31] which Monet snagged from young painter Paul Helleu, and *Mosque, Arab Festival*, bought for 10,000 francs from Durand-Ruel. Such paintings suggest the exotic flavour – Japan, Africa, the Mediterranean – which Monet gave the ordinary French farmhouse. By contrast, Monet joked, Renoir had no foreigners at home – no works by other artists.

Through their pictures, Monet kept in dialogue with distant colleagues. He also collected Morisot, now occupied with her sick husband and rarely leaving Paris. The illness then death, in 1892, of Eugène, last of the three Manet brothers, and Morisot's departure from their sumptuous apartment on rue de Villejust, brought to an end what Renoir called 'the Manet circle . . . one of the most authentic centres of civilized Paris life'.[32] Weeks after Eugène's death Monet bought Morisot's *The Bowl of Milk* for 1,500 francs, the most he had so far spent on a picture.

Gradually, Monet drew younger company to Giverny. He was especially fond of wispy, long-fingered, long-legged Helleu, Sargent's protégé, a figure painter who gravitated to high society. Proust's friend, Helleu gave his name, in conjunction with Whistler, to Elstir, the artist character in *À la recherche du temps perdu*. He proved respectful, unthreatening, and very loyal. The favourite remained Geffroy, constantly urged to Giverny. 'You can't imagine how happy I'd

John Singer Sargent's sketch of his protégé
Paul Helleu

be to have a visit from a good friend, a Frenchman, because *me voilà* too famous among the Americans,' Monet told him in the summer, and when he failed to appear. 'You've forgotten all your promises, so that I no longer dare ask you to come to Giverny . . . I'm asking myself what you've got against me.'[33]

Giverny was indeed still full of Americans. The Baudy became the Breck family headquarters when Jack signed in on 9 July 1891, followed by his brother Edward and their mother, who played the piano at the hotel. Breck's friend James Carroll Beckwith arrived in August and described the Baudy as 'all art or music rather more Boston than usual in art colonies', with waltzes and quadrilles in the evening and tennis until dusk. Carroll Beckwith thought 'the Normandy sky with its clouds and rain every half hour is hard on the painter,' but was delighted by an invitation to dinner with Monet.[34]

This was in the calm of September, when Monet was busy with the *Poplars*, and not immediately aware of two fresh developments between Alice's daughters and the Americans. One was the return to the Baudy on 7 October of Theodore Butler from Ohio, where he had attended the last illness, and in August the death, of his father, a bereavement drawing him close to the experience of the still grieving Hoschedé girls. The other was a tightened working relationship between Breck and Blanche, when Breck began his own series of fifteen *Haystacks* – the exact number at Monet's exhibition, though Breck's were smaller, and rather precisely systematic. Blanche was having some success with her own *Haystacks*, accomplished if imitative: in October the Potter Palmers bought two of them. Breck's paintings made clear his debt to Blanche, how she was for him a conduit to Monet's processes and ideas. But romantically their relationship was uncertain. In mid-November Monet asked him to leave Giverny. Breck signed out of the Baudy on 21 November, and returned to Boston via London.

It is not clear whether Breck or Monet crushed Blanche's hopes. The story crystallized that Monet banished the American as punishment for pursuing Blanche, which perhaps was how Breck told it – to clash with the master for love sounded gallant. But Monet, writing privately to Alice, did not talk of it like that. He bemoaned the 'disappointments and disillusions' caused by Breck, which were upsetting

enough to Blanche for Monet to doubt that 'after what's happened' any Hoschedé daughter would be attracted to an American again.[35] Breck's fault may have been not too much interest in Blanche but too little, that he exploited her as a fellow painter connected to Monet, but did not commit to her. Alice wanted her daughters married, Blanche and Marthe were twenty-six and twenty-seven, well-born girls without dowries. Monet had agreed to welcome the Americans as suitors. Perhaps he lost his temper over Breck's *Haystacks*, but in exiling the young man, it seems likely, as his letter to Alice suggests, that Monet was responding to a relationship already failing or failed. He was trying to protect Blanche, and was angry with himself for having welcomed Breck.

After Breck's departure, Monet tried hard to console Blanche. She came with him to London in the winter to meet Whistler, he took her to Paris to visit the Salon, then she alone accompanied him on a week-long trip on the steamship *Normandie* making for Cherbourg in violent storms, where they were the only passengers not seasick and day after day the pair of them, clad in oil skins, sat together on the deck, held by the swelling ocean.

Blanche's comfort was her art, inevitably in Monet's shadow. Julie Manet in 1893 recorded, 'Mlle Blanche showed us some of her own paintings, which are a lovely colour; two of them of trees reflected in the Epte are very like M. Monet's painting.'[36] In America, Breck too forged on, with an exhibition of his Haystacks as *Studies of an Autumn Day'*. He sustained a modest career in Massachusetts, applying Impressionist methods to depicting the Charles River, but he proved unreliable and unstable. He dithered for years over his Boston fiancée, never married, and in 1899 he gassed himself.

Without him, through the winter in Giverny in 1891-2, the Baudy parties continued. Monet noticed but told Alice, 'I didn't say anything about the skating, because you would have reproached me for seeing trouble everywhere, and especially because I was sure that the girls would be sensible.'[37] He left Giverny in February for Rouen to begin his 'Cathedral' paintings, which proved difficult. To see the façade close up, for the only time in his life he worked on a major subject indoors, looking out through the window from a cramped, makeshift studio in Monsieur Levy's millinery shop, at 23 place de la Cathédrale,

then later in the day in an empty apartment a few doors down. He stayed at the Hôtel d'Angleterre, returning home some weekends. He was absent when, on 9 March, Butler appeared at the Maison du Pressoir and asked her mother for Suzanne's hand in marriage.

Alice was astonished. A steadier character than Breck, Butler had watched his fellow American's expulsion, and trodden carefully and discreetly. Monet had never set eyes on him, but shocked by the news, he vowed on the instant to leave Giverny. 'It's impossible for me to stay in Giverny any longer. I want to sell the house immediately; you know what I did with Breck and the other one, and you know the result: I don't want to start again.' His madly emotional response reads like that of a suspicious bourgeois father, which was perhaps how he felt, though much of his upset was distrust: that Suzanne would be let down, that he knew nothing of Butler's 'existence d'aventures'; it was not enough that his 'friends at the hostel will tell you great things'. He told Alice 'the more I think of it, the more I find it disturbing and saddening, but I don't share your surprise. I saw very well that outside skating there had been other meetings. But what surprises me much more is that after all these past disappointments and disillusions, the girls could have responded to advances from Americans passing through Giverny.'

Butler, who was thirty, may be a 'good boy', Monet continued, and

> you don't have the right to reject requests for your children, but your duty is to watch over the choices ... You should, after what's happened, refuse your daughter to an American, unless he is known to us by connections or introduction, not just met on the road ... You should get a clear answer from Suzanne: if she is madly in love, if it is a passion, make her see how inappropriate it is after inquiring; if, which must be the case, it isn't an unconquerable passion, cut off all hope ... Everything I say here, I say because I am not wrong, because I love the children, but my position is delicate.[38]

Alice, ever benevolent to her children, and having finally netted an American for one of them, brushed off Monet's histrionics and his advice. Suzanne told Butler that 'Maman will join me in doing everything possible for my happiness'.[39] The docile girl the family knew at home had a more adventurous persona outside it, as Butler's subtly eroticized portrait of 1891 implies: Suzanne as a modern, provocative

young woman in a jaunty orange beret and loose-fitting jacket, long neck, colour rising to her pale face, wide eyes, bright red rosebud lips, and caressing a pet rabbit. The artist community urged the couple on. Dawson-Watson drew a Cupid dangling a pair of skates, Robinson and Carroll Beckwith sent letters praising Butler's impeccable character and credentials. Bunches of violets from the Baudy arrived daily at the Maison du Pressoir.

As handsome, warm-hearted, unassuming and dutiful as his bride, and like her known for his elegance – even Durand-Ruel commented on his fashionable dress – Butler, as Alice and Monet now learnt, was the last of eight children of a wealthy wholesale grocer, Courtland Philip Livingston Butler, descended from a republican family including Philip Livingston, who had signed the Declaration of Independence.* This impressed even Monet who, more anxious about his cathedrals than about Suzanne, quickly returned to Rouen.

'I've started here things terribly difficult to do and in which I'm afraid I won't succeed,' he told Pissarro.[40] In early April Monsieur Levy threatened to evict him from his shop because his presence discouraged customers trying on hats, and Rouen coal merchant and collector François Depeaux had to make peace by providing a screen between them. So Monet stayed, remained unsure about his painting, and brooded to Alice: 'all my worries come back, and such a sweet girl as Suzanne deserves more than just a good boy. Heavens, may she reflect while waiting ... to marry a painter, if he can't do anything else, it's upsetting, especially for a nature like Suzanne's.'[41]

No one seems to have listened to him. Alice and her daughters were entirely caught up in wedding preparations. 'Useless to tell you that this has not been without obstacle on my part,' Monet groaned when he informed Geffroy of the marriage, but he cannot have been very assertive, because Suzanne perceived him as an ally.[42] 'You don't know everything I owe him, he has always surrounded us with a huge and sincere affection and, last year when Papa died, he showed us great devotion and promised to replace him whom we had lost. So for me

* The political connections endured: Butler's sister Mary was the great-grandmother of President George Bush.

he is more than a friend and concerns himself with my future like a father,' she told Butler.[43]

Even if not all the Hoschedé children responded to Monet's gesture with the same uncomplicated gratitude, he now took the boys in hand, guiding them towards careers as their father had not. Jacques, through Caillebotte, found a place in a ship brokerage firm in Le Havre, and Jean-Pierre, the plant enthusiast, studied agriculture. Both thus made interests shared with Monet – boats and botany – the basis of their professional lives. Although he always referred to the boys as his wife's sons, Monet wanted to become the children's official step-father. Butler, with his brother Courtland arriving to represent the family at the wedding, was politely asking why no date had been set when he received from Suzanne a letter explaining,

> You cannot suspect that another, quite serious matter is to be settled quite soon. M Monet intends to marry Maman, and in order to make things more regular, they both want it all done in time for our wedding, so that M. Monet may assume the responsibility he is eager to have and replace my father in escorting me to the altar, and also to be more at ease in his relationship with our family. It's a big secret that I'm entrusting to you, and you must promise to speak of it to no one.[44]

On 10 July 1892 Abbé Toussaint, having dispensed with two of the three banns conventionally required, officiated at the marriage of Monet and 'Alice Raingo Veuve [widow] Hoschedé', as she titled herself in the wedding invitation, at Sainte-Radegonde's church, Giverny. On 16 July a quiet civil ceremony followed. The witnesses were Léon Monet and Georges Pagny, Alice's brother-in-law, and Caillebotte and Helleu – devoted painter friends who were also affluent and at ease in the upper-class milieu of Alice's family. There was a particular connection with Helleu at the time as he was painting the inside of Rouen cathedral as a series, fascinated by the diffusion of light from the stained glass.

Monet told Geffroy that the wedding was 'a union envisaged a long time ago, but we had to hurry because of Suzanne's marriage to alas! an American painter'.[45] The chief difference the marriage made was, at last, the *tutoyer* of their letters. Alice now became 'ma chérie' and Monet 'ton mari qui t'aime'. But their secure, less embattled relationship was already

established by 1890. As with Camille, Monet married Alice by the system of *séparation de biens* – separation of property – this time to protect Monet from his wife debts, or rather from Hoschedé's. Her own possessions listed at her marriage were few, confirming how wholly her first husband had impoverished her and their children. She became Madame Monet exactly when Monet's earnings allowed luxury at Giverny.

Butler and Suzanne were married on 20 July, with Léon Monet and Pagny again witnesses on the Hoschedé side and Courtland and Philip Hale, the artist with whom Butler had first sailed to Europe, the American representatives. Theodore Robinson, a guest at both weddings, recorded

> a great day – the marriage of Butler and Mlle Suzanne. Everybody nearly at the church – the peasants – many almost unrecognizable . . . The wedding party in full dress – ceremony first at the Mairie – then at the church. Monet entering first with Suzanne. Then Butler and Mme H – a considerable feeling on the part of the parents – a breakfast at the atelier – lasting most of the afternoon . . . Dinner and evening at the Monets: bride and groom left at 7.30 for the Paris train. Monet rather upset and apprehensive, which is natural enough. I had to reassure him.[46]

Hale's account in a letter home is more ambivalent, and implies Monet's inevitably overbearing presence:

> I sdown [sic] here at Giverny in the same place with Robinson. I don't know if he described to you Theodore Butler's marriage here – which was quite an event in such a quiet little hole as this, the whole thing had a strange, bizarre side to it: this Westerner's being married in an old Norman town was queer tenough [sic] of itself, and then the Breakfast in a Salle a Manger hung from top to bottom with Monet's pictures only increased the feeling of a bad dream.[47]

That Suzanne and Butler would remain in Giverny was unquestioned. Butler's furniture was shipped from Ohio in wooden crates, from which Dawson-Watson built a boat, his wedding present to the couple. The Butlers moved into a cottage, the Maison Baptiste, close to the Maison du Pressoir, before having their own home, which became known as the Maison Butler, built in 1895 on rue Colombier. Suzanne returned from the honeymoon pregnant. Butler depicted her, tranquil,

glowing, waiting for the baby, in a corner of their white living room. Everything augured a contented, unambitious life. Butler was absorbed into the family. Monet's cook received recipes for his favourite American dishes, though the servants had instructions not to offer dishes twice when Butler was there 'because his slow eating habits drove Monet crazy'.[48] There was a certain initial reserve, and Suzanne was perhaps over-hopeful in telling Butler that she thought Monet 'regrets a little that we don't sometimes talk about painting with him, because he loves art, and as you are also an artist, I would be very happy to see you get on with him.'[49] But by 1893, sending greetings via Alice to Suzanne, Monet added 'mes compliments à son mari', and by 1895 'grandes amitiés à Butler'.

Two painted records of Suzanne and Butler date from summer 1892. Robinson's affectionate *The Wedding March*, depicting the procession to the church headed by Monet leading a veiled Suzanne, with Butler and Alice behind, has the look of a sketch of the moment, but was painted from memory a fortnight later. Monet painted a valediction set in his garden just before the wedding. Butler is seated at an easel, and Suzanne, a graceful silhouette, stands behind him in an adoring, proprietorial pose. But they are in the background, already distant. In the foreground Blanche, also at her easel, is the substantial figure. Her body is taut, the opposite of Suzanne's relaxed fluidity, and the usual joy has drained from her face, twisted into a resigned expression. The sisters are dressed identically, sharpening the difference between their fates – love or work, fulfilment or loneliness.

Blanche had been working hard and to good effect. 'I saw some things by Mlle Blanche, she has improved greatly since I saw her work last – a spring landscape, sold to Potter Palmer, quite charming,' Robinson noted shortly before the two weddings. He understood her problem. 'Monet said she ought to work away from him – they both like to work together.'[50] What Blanche was up against in the wider art world is suggested by a later conversation recorded between one of Durand-Ruel's sons and the dealer René Gimpel. 'The little Hoschedé girl did some painting, and not badly, imitations of Monet. Wherever Monet painted, she would station herself behind him, copying both Monet and nature; but her canvases are smaller than those of [Monet], who has never allowed her to paint the same size.' Although she

signed her work, Durand-Ruel concluded, 'We had better be on our guard; although her canvases aren't yet passing for Monets, they certainly will'.[51]

Monet's picture of stoical Blanche ends the cycle of figure paintings inaugurated in 1887 with the hopeful *Suzanne Reading and Blanche Painting*, to which it directly refers. That painting had marked the beginning of Monet's move to integrate himself truly into family life Giverny, fully achieved when he walked Suzanne down the aisle. Among the letters of congratulation on his own marriage came one from the French embassy in London. The diplomat Paul d'Estournelles de Constant, who had long followed Monet's career, wrote: 'after so many years of battle and hard struggle, you finally conquered success. Now you have happiness.'[52]

Monet, *Blanche Hoschedé Painting*, 1892. This is Monet's last painting of Blanche. In the background Suzanne stands behind her fiancé, Theodore Butler, at his easel.

18

Revolution in the Cathedral,
1892–7

'To think that I abandon everything, you, my garden, to work eleven hours a day, it's killing,' Monet wrote to Alice from Rouen.[1] But not to paint was worse. Before and after the wedding, Monet's refrain was, 'I think only about my cathedrals.'[2] In early 1893 he was back in the city, in new premises at Monsieur Macquit's novelty store. When the British painter Wynford Dewhurst asked for an account of the Rouen pictures, Monet replied, 'I painted them, in great discomfort, looking out of a shop window opposite the cathedral. So there is nothing interesting to tell you except the immense difficulty of the task, which took me three years to accomplish.'[3]

As the *Haystacks* and *Poplars* had come easily, so the *Rouen Cathedrals* series was long, hard work. It engrossed and disturbed Monet awake and asleep: 'I had a night full of nightmares: the cathedral fell on top of me, it seemed blue or pink or yellow.'[4] The haystacks which lasted a season, the poplars about to be chopped down, invited transient effects, for the motifs themselves implied nature's progression. But to dramatize how a static, solid, permanent edifice, 800 years old, similarly changed hour by hour, endlessly differing from itself according to the atmosphere and light around it, according to the artist's shifting experience of it, was to deny fixed reality.

To Robinson, he explained that 'I have wanted to do architecture without doing its features, without the lines.'[5] Line and colour are balanced in the *Cathedrals*. Drawing anchors the Gothic façade, paint drenches and penetrates it, air, sun, rain, fog, piercing and vaporizing the stone. The cathedral, white and sun-bleached, or red and gold, seems always in movement, animated by the fluidity of trails of paint forming webs across its surface. 'It's a stubborn crust of colours,

that's all,' Monet feared, 'but it isn't painting'.[6] The triumph, though, was the mix of crustiness, the rough handling which imitates the stonework, achieved by adding scumbles, glazes, whites to the pigments – complex paintings which at once materialize the ephemeral and dematerialize the cathedral.

He painted *The Portal and the Tour Saint-Romain* in morning mist, the façade in shadow, the tower emerging in the sun, with crows scattering through the sky. At midday the warmed stone is luminous; at sunset a golden light clings to the cornices and gargoyles, then the building sinks into darkness, heavy and silent. The cathedral clock, varyingly white or lemon or mauve, is often at the centre, but always a blur – time cannot be caught. Monet was playing with ideas of human and divine time that the cathedral represents, transforming a historical monument into the fleeting, present tense. The effect of the paintings together is that the façade flickers in and out of visibility like patterns on a screen, shifting as in a film. The *Cathedrals* happened to coincide with this new medium: the Lumière brothers showed their first film in March 1895 in Paris.

'Everything changes, even stone,' Monet complained to Alice.[7] Yet stone does not change colour as, for example, the sea does, and a phantasmagorical element entered these paintings. Sixteen-year-old Julie Manet was the first of many viewers both to admire them – 'they're magnificent, some all violet, others white, yellow with a blue sky, pink with a greenish sky; then one in the fog, two or three in shadow at the bottom and lit with rays of sunshine' – and to admit that they 'made me think a bit of strawberry ice cream'.[8] The critic Camille Maclair wrote that 'colour wanders with some insolence around these Middle Ages disturbed by a disorderly genius.'[9] Monet acknowledged an internal problem in the extreme subjectivity: 'the weather has stayed the same, but alas it's me and my nerves that are changing,' he wrote to Alice.[10] 'Happy are the young, those who believe it is easy. I was like that; it's finished now, yet tomorrow morning at 7.00 I'll be there.'[11]

Eventually he concluded that 'the motif is something secondary for me: what I want to render is what there is between the motif and myself.'[12] The subject of the *Cathedrals* became his own mental and perceptual process. The series pushed to a conceptual limit what was inferred in the *Haystacks* and *Poplars*, but it was much bolder to

Monet holding his godson and step-grandson James Butler,
'*mon petit Jimmy*', 1893

dismiss a Gothic cathedral, with all its historical associations, as 'secondary'. That was the challenge: this motif offered Monet the resistance he needed after having conquered seriality in representations of nature, yet he found blending the cathedral and the 'envelope' intensely troubling.

The pictures went home from Rouen incomplete, reaching Giverny just before the appearance of James Butler at the Maison Baptiste on 24 April 1893; Monet, appointed godfather, was fond of 'mon petit Jimmy'. Holding up a plump, healthy baby, Suzanne in a snapshot from the terrace of Monet's house looks ecstatic. With his young family, Butler found his *intimiste* subject of cosy interiors in a pastel palette. The happiness Suzanne and Jimmy brought is shown in a summer photograph in Monet's garden: charming his lunch visitors, Suzanne and her big pram form a group with Monet, dressed as a farmer, in concentrated conversation with Durand-Ruel, the urbanite in suit and bowler hat. Monet is attentive to the dealer, but there is a sense of his pride in the support cast lined up under the lime trees. Alice and her unmarried daughters are seated in a row; fifteen-year-old Michel, in knee-length boots, leaps on his peaceable older brother.

Monet spent the rest of the year at home, confronting his cathedrals, and battling the Eure local authority. Having purchased land on the other side of the railway track bordering Le Pressoir, he began planning a water garden. Initially denied permission to have his newly dug pond irrigated by the tiny Ru, and stirring hostility from neighbours who claimed his flowers would poison it, he was eventually allowed to divert the stream for his pond to cultivate 'aquatic plants . . . for the pleasure of the eyes, and in order to have subjects to paint'.[13] When Morisot and her daughter visited in October, the water garden was under way. Julie reported, 'We walked beneath the poplars to see the greenhouse where there are magnificent chrysanthemums. Then on to the ornamental lake across which is a green bridge which looks rather Japanese. Monsieur and Madame Butler came – their little boy is sweet; he kept on trying to pull my hair (he's six months old)'.[14]

Widowed, white-haired Morisot was not strong, and this was her last visit to Giverny. 'I am surrounded by sick people . . . Maître, Caillebotte, Bellio. Only Monet is in superb health as always,' the arthritic Renoir wrote during the tough winter of 1893–4.[15] Maître, Bazille's old friend, lasted until 1898; de Bellio, aged sixty-five, died in January 1894 and Caillebotte, only forty-five, in February – Monet's two indispensable supporters from the 1870s, and his most loyal, perceptive collectors. Caillebotte, whose death especially saddened Monet, went on being supportive of Impressionism beyond the grave. The bequest of his collection to the nation, and the hanging of a good proportion of it – some was rejected – in the Musée du Luxembourg, was the biggest victory of modern art over the French state in the nineteenth century.

The *Cathedrals*, begun at a period of contentment, were completed in a more sombre mood, and in spring 1894 Monet destroyed several and hesitated about exhibiting them at all. This only enticed interest. Hidden, talked about, glimpsed by the privileged few, the paintings began to acquire a legendary quality, as elusive as the façade coming in and out of focus behind Monet's skeins of paint. Collectors and dealers begged invitations to Giverny to see them. Japanese dealer Tamara Hayashi wrote, 'Your cathedrals which seem to push majestically into the sky impressed me deeply . . . I didn't dare ask if one of them was available.'[16] It was – for 15,000 francs. Monet was unrepentant when

Durand-Ruel refused to buy. 'Everyone except Depeaux is frightened of my prices,' he said.[17] The paintings had cost him too dear to make big compromises. The banker Isaac de Camondo came with the dealer Maurice Joyant in September and bought four for 55,000 francs, a minimal discount.

The season's strangest visitor was the reclusive Cézanne, then the least successful, most ridiculed of Monet's contemporaries. He had not exhibited for a decade; it was hard to see his paintings, hard to meet the man. Monet hoped Geffroy's prose would achieve 'justice for the pure artist who is Cézanne',[18] and the critic's attentions did transform Cézanne's fortunes, putting him on the first step to finding a dealer and then an exhibition, with sharp-eyed novice Ambroise Vollard. To thank Geffroy, Cézanne visited Giverny. On 7 November 1894, 'a cutthroat with large red eyeballs standing out from his head in a most ferocious manner', according to Mathilda Lewis, an American fellow guest, checked in at the Hôtel Baudy. Cézanne astonished the women there, initially by his rough table manners, then by his sensitive courtesy: 'in spite of the total disregard of the dictionary of manners, he shows a politeness towards us that no other man here would have shown.'[19]

Monet's lunch in his honour, with Geffroy, Mirbeau, Rodin and Clemenceau, was touch and go: 'I hope Cézanne . . . will join us, but he is so singular, so fearful of new faces, that I'm afraid he may let

Cézanne in his studio in front of his painting *Large Bathers*,
1904, photographed by Émile Bernard

us down, despite his wish to meet you. What a pity this man has not had more support in his life! He is a real artist, who has come to doubt himself too much.'[20] Cézanne came and felt threatened. His biographer Alex Danchev suggests that, as a Catholic traditionalist, he felt uncomfortable because 'Giverny was a nest of free-thinkers and atheists' – hardly a description Alice would have relished or recognized.[21]

In response, Cézanne mercilessly played Mirbeau and Geffroy, who was taken in by a performance that used the worldly Rodin as fall guy. 'Timid and violent', Cézanne 'showed us the extent of his innocence or confusion,' Geffroy recorded, 'by taking Mirbeau and me aside to tell us, with tears in his eyes, "He's not proud, Monsieur Rodin, he shook my hand! A man who has been decorated!" Still better, after lunch, he fell to his knees before Rodin, in the middle of a path, to thank him again for shaking his hand.'[22] Clemenceau, with 'a particular gift for putting him at his ease', then calmed Cézanne down, but on another visit shortly afterwards Monet made a mistake by over-praising Cézanne, who believed he was being mocked, left in distress and fled to Aix. Of his visit he wrote, 'Monet is a great lord who treats himself to the haystacks that he likes. If he likes a little field, he buys it. With a big flunkey ... so that no one comes to disturb him. That's what I need.'[23] But the following year he renewed contact with Geffroy, and began painting his portrait in Paris; during the many sittings, he 'laughed and cried as at Monet's' and 'was very critical of his contemporaries, except Monet, "the strongest of us all", he said. "Monet, I'd put him in the Louvre!"'[24]

Monet's admiration for Cézanne was such that, visiting Caillebotte's bequest at the Musée du Luxembourg, he tried to swap Cézanne's badly hung L'Estaque with one of his own prominently displayed works. At Cézanne's first solo show, Vollard remembered,

> on the first day ... a very stout man with a beard came into the shop. He looked a typical gentleman-farmer. Without haggling he purchased three of the most important paintings. I imagined I had to do with some provincial collector. It was Claude Monet ... what was most striking, in a painter of his celebrity, was his extreme simplicity, and the fervent admiration he expressed for his old comrade ... Cézanne, still so little known.[25]

Monet finally decided to exhibit his *Cathedrals* in 1895, but he needed to clear his head, and to do so he left the country. Jacques Hoschedé had moved to Norway, and Monet liked the prospect of painting the Norwegian winter. Grief struck again while he was there – Berthe Morisot died aged fifty-four, leaving Julie an orphan. 'I don't stop thinking about her, she was so intelligent, had so much talent,' he told Alice. 'I wrote to Renoir, thinking of the sadness he must be experiencing, and then for us to encourage one another, because it's . . . very very sad, very hard to see all our friends leave so soon. Of our little group, how many of us remain, alas?'[26]

Monet painted fjords and mountains, but could not resist taking some *Cathedrals* in his luggage. The painter Frits Thaulow, politely concealing his opinion that Monet's Norwegian pictures were failures, accompanied Prince Eugen of Sweden to pay homage at the Grand Hotel in Kristiana (Oslo), and through a half-open door they glimpsed what the Prince remembered as

> a large canvas showing a sculptured stone façade, seen almost without perspective and distance, a visionary picture of a church façade – incredible, fascinating, fantastic as an idea . . . I was seeing a sample of Monet's by-then-nearly-legendary series of the Rouen cathedral . . . Monet opened the door hesitantly. 'I shouldn't be showing that picture in this state,' he explained. 'I'm trying to get it into shape. It is costing me a great deal of difficulties.'[27]

Twenty *Cathedral* paintings were finally unveiled in Paris at an exhibition at Durand-Ruel's on 10 May 1895, and responses were culturally freighted. Religion was the topic of the day, anti-clericalism the force in republican politics, while right-wing nationalists blamed a weakened France on the decline of Christianity. Despite the *ralliement* movement, advocating that Catholics accept the Republic, proposed by the Pope in 1892, the fight between secular and Catholic forces for French national identity continued. So it happened that, to Monet's astonishment, Clemenceau wrote and devoted the entire front page of his newspaper *La Justice* on 20 May to a review of the exhibition entitled 'La Révolution des Cathédrales'.

Having lost his seat in the Chamber of Deputies in 1893, Clemenceau was waging his political career in journalism. He saw in Monet

a republican atheist like himself, and the *Cathedrals* as a victory for anti-clericalism and secular materialism. Monet's stone, 'solid in blurring fog, made tender under the changing skies', was a celebration of nature, the power of the eye, and of art, for which the cathedral is a cipher, devoid of religious symbolism. Thus, 'while my sad priest tortures himself to wonder at miracles that don't exist', Clemenceau rejoiced at painting which 'intoxicates me with miraculous realities'.[28]

By insisting that 'the subject is of secondary importance' and taking the weighted example of a cathedral to prove it, Monet had produced a series in which the motif was in fact what everyone talked about. The Gothic cathedral was more than a symbol of national pride, a glory of France; at the *fin de siècle* it was an emblem of nostalgia in the face of industrial modernity. Monet's friend Helleu became fascinated by the interior of the Gothic Basilica of Saint-Denis in Paris, painting it in 1891; 'Do you remember our conversations about the Cathedral?' he asked Monet twenty years later.[29] Two 1890s bestsellers, Émile Male's *L'Art religieux du XIIIe siècle en France*, and Huysmans's novel *The Cathedral*, starring Notre-Dame-de-Chartres, signalled the decade's fascination with Gothic. Pissarro, recording his own admiration and that of Renoir and Degas for Monet's exhibition, noted that it stirred fierce debate. This was not aesthetic; the paintings polarized on political grounds. In *L'Ermitage* Raymond Bouyer complained of 'the pious cathedral crumbling under an atheist sun'.[30] For Maclair, 'the very idea that Gothic art ... has provided a theme for this so superbly sensual pagan is somewhat hurtful'.[31]

Despite Clemenceau's trumpeting of Monet's secularism, it was not quite that simple. The *Cathedrals* assert paint's metaphysical qualities, and there was even some coherence between Monet making the invisible visible and the Gothic builder who flooded stone, mass, volume, with light through stained glass, a metaphor for divinity overwhelming earthly existence. It is the aspect of Gothic which Huysmans dwelt on in his novel, and perceptive commentators saw that Monet, for all that he set himself loose from religious symbolism, shared something of that overwrought sensibility. The critic André Michel thought the paintings 'exasperated and morbid ... brilliant and arbitrary evocations which satisfy an exalted lyricism', which had nothing to do with 'study of nature or direct observation or sincerity', and represented an

endgame: 'after such abuse and such a dislocation of the *métier*, oil painting has no longer anything to say'.[32]

Monet would go on to prove that he, and painting, had something to say. The Rouen pictures, a finale to his nineteenth-century oeuvre, were also a gateway. In their 'abandonment' of paint, arbitrary in referencing only itself, they opened implications to be fulfilled, in the freedom of the London paintings, then the *Water Lilies* series. A connection to the latter is already suggested in 1895: in January, during snowfall, the Japanese bridge over the pond made its inaugural appearance in Monet's work.

The tremendous effort of the *Cathedrals* took a toll. Monet was exhausted at the end of the exhibition, and complained of suffering 'always these dizzy spells and fear of falling'.[33] From now on, these afflictions, associated with stress, periodically troubled his otherwise excellent health. He painted only three canvases during the rest of 1895: two depictions of the Japanese bridge in summer, and another garden piece, the last in all his work to include a prominent figure. The flowers are in full bloom in *Monet's Garden in Giverny* as Suzanne wanders the colour-fringed path. She wears a red jacket and white skirt as in the picture with Butler on the eve of her wedding, but the verve has gone. This young woman is limp, lustreless, on the verge of disappearing into the flowers. Monet had painted Camille like this, vanishing into the garden at Argenteuil, in the later 1870s. So often Suzanne was the stand-in for Monet's memory of Camille; now there was a correspondence between their lives. Like Camille, Suzanne could not recover her strength after the birth in October 1894 of her second child, Alice, known as Lily.

Monet attempted to reassure his Alice that warmer weather, rest, time, a spa in the Pyrenees, would heal her daughter. None did, and Alice's own health suffered as Suzanne failed to improve. In November Monet took 'our poor patient to Paris', but, he told Geffroy, 'I have real fear of the powerlessness of the doctors and I daren't think about the future ... impossible to think of other things, and painting, which was all my life, takes third place, who knows if I will ever do it again. I no longer see anyone ... when will you come?'[34]

Geffroy became the Bazille of the 1890s, forced by the insistence of Monet's demands to alternate kindness with silence. He was relieved

when Monet departed for Pourville in February 1896, to 'work facing your grand inspiration the sea. I'm sure you will have a good dialogue with her.'[35] During two winters, 1896 and 1897, Monet sought restoration at this scene of his prolific 1882 campaign, but the results were weaker, like wavering, ghostly versions of those bold seascapes. Monet felt it: 'what immense waves! What force and how beautiful! But I was too impotent to benefit from them. I am getting old and can no longer do what I used to do.'[36] It was a melancholy break to go to Paris in March 1896 for Morisot's memorial exhibition, 'a lovely reunion of works, so pure and so beautiful', marking the first anniversary of her death.[37] At this gathering there was no sign that Monet was a diminished force. When Morisot's daughter Julie arrived early in the day, she wrote, 'Monsieur Monet was already there. He kissed me tenderly and I was very pleased indeed to see him again; it was very kind of him to come running over here like that, abandoning his work. Monsieur Degas was busy with the hanging; then Renoir arrived not looking well.'[38] With a female audience – Alice, Blanche, Julie and her cousin Jeannie Gobillard – the powerful egos of Monet, Renoir, Degas and Mallarmé were responsible for choosing and installing the paintings, and as the day wore on they squabbled. Julie reported:

> It was dark by then, and, as he spoke, M. Degas paced back and forth in his great hooded cape and top hat, his silhouette looking very comical; M. Monet, also on his feet, was beginning to shout; Mallarmé was trying to smooth things over; M. Renoir, exhausted, was stranded on a chair. The Durand-Ruel men were laughing. Mlle Blanche, Jeannie and I were just listening.
>
> 'You want me to remove this screen, which I adore?' M. Degas said, emphasizing the last word.
>
> 'We *adore* Mme Manet,' retorted M. Monet. 'This isn't about the screen, but about Mme Manet's exhibition.'[39]

At the last minute, Monet also insisted that the show include Morisot's version of Boucher's *Venus at the Forge of Vulcan*, and *Two Nymphs*, another free copy she had made in 1892, from the lower section of Boucher's *Apollo Revealing his Divinity to the Shepherdess Issé*. Morisot's curling sinewy brushstrokes, delineating reeds and

aquatic foliage in that work, not only have something in common with Monet's boat pictures of 1887–90, but with the *Water Lilies.*

Back home in spring 1896 Monet had to admit, in one of those letters to Geffroy that functioned like a diary, that he was 'haunted by the blackest ideas, in a feverish state which will end up making me ill or mad. The truth is that I feel empty, finished, finished since the Cathedrals ... I am doing nothing. I am in a state of sadness and abandoned by all my friends and, if your letter hadn't come, I would have wondered whether you too had deserted your friend.'[40]

One problem was that Giverny was less lively. The three older boys were forging careers. Jean the chemist was in Rouen working with his uncle. Jacques the ship broker married a Norwegian divorcee, Inga Bergman, in 1896, and lived at Saint-Servan in Brittany with her and her little daughter. Jean-Pierre moved south to study agriculture. Robinson, the Monets' most cherished neighbour, was in America; he wrote that he intended to return but he died suddenly, aged forty-three, of an asthma attack in New York, in April 1896. That same month Suzanne was discharged from the Paris clinic, with no improvement. Marthe worked tirelessly caring for Jimmy and Lily. Butler continued to depict Suzanne, in an armchair, or resting in the garden while the children toddle around her, as if wistfully painting her back to the health she could not regain. At the end of 1896, Monet told Geffroy, 'The condition of our patient isn't worse, but she is still very very ill and that greatly saddens our life.'[41]

In the midst of the *Cathedrals*, Monet had confidently dwelt to Robinson on the advantages of age: 'Obviously one loses on the one hand if one gains on the other. One cannot have everything. If what I am doing no longer has the charm of youth, I hope that there are more successful qualities so that one could live longer with one of these paintings.'[42] The three series paintings of the *Haystacks*, *Poplars* and *Cathedrals*, begun in as many years, were a heroic achievement even by his energetic standards; a fresh departure, they also marked the climax of a long experiment with painting place as repetition, variation and a meditation on time which he had inaugurated in Vétheuil. The Gothic church and the rural motifs of field and river were forerunners of the more consciously constructed and fourth series. In that time Monet, the near destitute widower of 1879, had

fought indefatigably, cannily, and won all the prizes: Alice, the security of his family, his house at Giverny, his expanding garden, a position as the leading painter of his day. Now, nearing sixty, he slowed down, took stock, considered how to develop the serial method, while events in his private life, and in the life of France, turned darker. He told the collector William Fuller towards the end of the 1890s, 'Life with me has been a hard struggle, not for myself alone, but of my friends as well. And the longer I live . . . the more I realize how difficult a thing painting is, and that in one's defeat [one] must patiently strive on.'[43]

19

Retreat to the Garden, 1897–9

Monet was back in Pourville in winter 1897, when in the quiet of the Maison du Pressoir Blanche summoned the courage to talk to her mother. Again romance had blossomed under Alice's nose and she had guessed nothing. Blanche intended to get married – to Jean Monet. Monet was apprehensive. 'I don't feel he is absolutely smitten, not as decided as Blanche seems to be . . . let them each go home and maturely reflect.'[1] Jean seems to have been influenced by his uncle, for Léon, sixty-one and widowed in 1895, was about to get married again, to a woman close in age to his nephew.

The prospect of marriage between the step-siblings brought out tribal loyalties. Alice rooted for Blanche's happiness, Monet dredged up his hopes, anxieties, disappointments about the son whom he overshadowed, and who now as in adolescence 'does not have the courage to go far from me'. Monet talked to Jean through Alice. 'Tell him that I am not against her, but I would be sorry if I saw Jean only marry her out of devotion, so as not to make her unhappy.'[2] Jean would turn thirty in August 1897, Blanche was thirty-one. They were two affectionate, faithful people who shared enthralment to Monet. They had grown up together and known one another for twenty years, with no indication of romantic attachment. Perhaps Blanche's strongest feeling was for Monet and, entwined with him, her painting. Jean understood both. To marry him kept her within the fold, while offering respite from dark days at Giverny, where life – and her prospects – stood still. She seized her chance. She was cheerful, decisive, nurturing, a rock on which the less confident, wavering, good-natured Jean could rely.

The wedding, a church and civil ceremony on 9 and 10 June, was a small family affair. Jean and 'ma bonne petite Blanche' became 'nos

enfants de Rouen', settling in the city with their dog and, soon, a car, in which they drove every weekend to Giverny. Monet was constructing an annex, chiefly a studio with a huge northern window and a glazed balcony to the south; the building included an apartment for the new-lyweds, and another, scarcely used, for Jacques and Inge. It was an odd repositioning for Blanche. She gave up the mauve-painted bedroom next to her sisters, and without fully relinquishing the cocoon of Giverny was able to discover landscapes where Monet had not been before her. She found her own stretch of the Seine, at Flaubert's Crois-set, depicting the wide bend in the river and the reflection of the trees, and painted cityscapes and quayside views of Rouen. She flourished, sending works to the Salon des Indépendants and, after its launch in 1903, the Salon d'Automne. Jean continued to work – not too industriously – for Léon.

Unsettled by the wedding, Monet sought solitude after it. Every morning through summer 1897 he slipped out of the house while the family slept, and at 3.30 a.m. painted light breaking through dawn fog on a secluded inlet, overhung by tall trees, where the Epte enters the main river. In this protected space, the mist hung in thin veils, muf-fling colour and sound. For *Mornings on the Seine*, his final series paintings to be shown in the 1890s, Monet did not want heroics. He said he chose 'an easier subject and simpler lighting than usual'[3] and returned to his old, consoling love, the river.

He had attempted this series in 1896, but poor weather dashed pro-gress. The sustained effort in 1897 was, Monet felt, significant enough to be documented. Dragged awake at what is a journalist's bedtime, Maurice Guillemot of *La Revue illustrée*, at 'the crack of dawn', fol-lowed Monet,

> his torso snug in a white wooden hand-kit, his feet in a pair of sturdy hunting boots with thick dew-proof soles, his head covered by a pictur-esque, battered brown felt hat with the brim turned down to keep off the sun, a cigarette in his mouth ... He pushes open the door, walks down the steps, follows the central path through his garden ... crosses the road (at this hour deserted) ... skirts the pond mottled with water lilies, steps over the brook lapping against the willows, plunges into the mist-dimmed meadows, and comes to the river. There he unties his

rowboat moored in the reeds along the bank, and with a few strokes, reaches the large punt at anchor which serves as his studio.[4]

Painting from the water, Monet wrought symmetrical patterns from arabesques of foliage mirrored in the still pools, nebulous in the weak light, more defined, with deeper shadows, as the day brightens. The *Mornings on the Seine* are as soothing and smoothly blended as the *Cathedrals* are confrontational and intricate. Tonal paintings in a restricted pale pink to blue-violet range, they are Monet's meditative homage to the river. Julie Manet was surely right when she observed, 'his *Seine* series seemed very sad to me.'[5]

Within the context of his overarching confidence, Monet was not Monet without the self-doubt that came picture by picture. 'I am by nature always inclined to find what I've done bad,' he said.[6] This was acute throughout 1897: 'more than ever I doubt myself ... it's the powerlessness that comes with age.'[7] There was one exception. In August Monet worked for a month on 'a big study with a view to a decoration. This thrills me and gives me back my former ardour.'[8] This is the first mention of the large 'decoration' that would eventually become the *Water Lilies* series. Although they have precursors – the reflections in the pond at Montgeron in 1876, and compositionally the ice floes spangled across the river in the Vétheuil paintings of 1879–80 – it is notable that at his impasse a year before, in 1896, Monet had re-encountered and championed Morisot's swirling decorative panel *Venus* and her watery *Two Nymphs*.

Monet talked about 'models for a decoration' to Guillemot, who asked his readers to 'imagine a circular room in which the dado beneath the moulding is covered with [painting of] water, dotted with these plants to the very horizon, walls of a transparent alternately green and mauve, the calm and silence of the still waters reflecting the opened blossoms.'[9] Eight experimental water-lily canvases from 1897 survive; they are rather heavy and airless, and the pond then was anyway not fully developed. A parallel innovative endeavour, very successful, was a quartet of large close-ups of chrysanthemums, the pink, gold and red heads painted flat, with no horizon, pictorial space collapsed in favour of all-over compositions, which anticipate the patterned surfaces of the water-lily paintings. These fascinated Monet.

After the *Seine* series, the *Chrysanthemums* were the only pictures he completed during 1897. Giverny, Guillemot explained, 'represents an ambience which the painter had arranged for himself ... during periods of inactivity – he can go for months without doing a thing – he continues his work, without appearing to, if only by going out for a walk; his eye contemplates, studies and stores.'[10] For two years Monet did this, waiting to set down the water garden on canvas. Then he depicted his garden as a haven from disturbances outside which, between 1897 and 1899, were too loud to ignore.

On 25 November 1897 Zola published the first of two articles in *Le Figaro* proclaiming the innocence of Captain Alfred Dreyfus, a Jewish officer convicted of spying for Germany and imprisoned on Devil's Island. In the subsequent division of French society around anti-Semitism, anti-Dreyfusards Degas and Renoir crossed the street to avoid Pissarro, for whom 1896–7 was a calamitous moment. The day the first of Zola's articles appeared his 23-year-old son Félix died and through the tempestuous year Pissarro wandered the streets of Paris in mourning, attempting to reassure his son Lucien in London.

> You need not worry about my safety here. For the moment we have to deal with nothing more than a few Catholic ruffians from the Latin Quarter, favoured by the government. They shout 'Down with the Jews', but all they do is shout ... Yesterday at about five o'clock, while on my way to Durand-Ruel, I found myself in the middle of a gang of young scamps seconded by ruffians. They shouted: 'Death to the Jews!' Down with Zola! I calmly passed through them and reached the rue Laffitte ... they had not even taken me for a Jew![11]

This was odd, since everyone agreed that Pissarro looked archetypally Jewish, 'that old Israelite head of his', in Degas's words,[12] or like an Old Testament prophet, 'worthy of being painted by Rembrandt ... infinitely venerable with his handsome regular face, large oriental eyes full of light, his beard which age was beginning to dot with white flakes', according to Dreyfusard Geffroy.[13]

Monet was the first of Zola's former friends among the artists to send him support. On 3 December he broke the silent animosity of a decade to congratulate the author of *L'Œuvre*: 'My dear Zola, Bravo and bravo again for your two beautiful articles in the *Figaro*. You

Pissarro, *Self-portrait*, etching, *c*.1890–91

alone have said, and said well, what was needed. I am happy to send you all my compliments, your old friend, Claude Monet.'[14] He wrote again praising his bravery after 'J'Accuse', Zola's 'letter to the President of the Republic', was published on 13 January 1898. Pissarro was similarly spurred to write to Zola the day after 'J'Accuse' appeared: 'Accept the expression of my admiration for your great courage and the nobility of your character. Your Old Comrade.'[15]

Reiterating Dreyfus's innocence, claiming army cover-up, judicial error, fraud and conspiracy, and that the real traitor, Officer Walsin-Esterhazy, had been acquitted on official orders, Zola's article took up the full front page of Clemenceau's newspaper *L'Aurore*. The title 'J'Accuse' was Clemenceau's. He recruited scores of news criers and 300,000 copies of the paper sold, galvanizing public opinion on both sides. Zola expected prosecution for criminal libel, in order to expose in court the corruption of the case. He was tried in February, convicted and, after appeal, awaited a second trial in July. Encouraging him, the out-of-office Clemenceau embraced a political cause which threatened the government. There was no middle ground between the liberal republican demand for justice, transparency and equality before the law, and the conservative patriotic view, connected to Catholic piety, clerical power and anti-Semitism, that the army represented the country's strength. More than the innocence of one man was at stake. The battle was for the values of France, progressive republican ideals versus nationalism and history. Pissarro told Zola, 'You are rendering a proud service to France, your great cry of an honest man has rectified her moral sense'.[16]

Many French people however simply could not allow the thought that the army was wrong, therefore for them Dreyfus had to be guilty. On the day 'J'Accuse' appeared, Pissarro lamented that at Durand-Ruel's gallery, everyone 'except the doorman' was against Dreyfus.[17] Julie Manet said that it would be terrible if Dreyfus were innocent – but that this was impossible. The orphaned Julie's guardians, officially Mallarmé and unofficially Renoir, were emblematic of the national divide. The poet, a Dreyfusard, applauded Zola: 'The spectacle has just been enacted, once and for all time, of a genius's limpid intuition against the powers that be. I venerate this courage and admire a man who ... appears fresh, whole and so heroic!'[18] But Renoir fumed, 'There are a lot of them in the army, because the Jew likes to walk around wearing a uniform ... but if there is any fighting to be done they hide behind a tree', and 'Duret (still the Dreyfus affair) is protecting the Bernheims, horrible Jews, against Durand-Ruel. He is a man we can no longer invite.'[19] This was Théodore Duret, esteemed historian of Impressionism, who had helped the group since the 1870s, and the rising young Bernheim-Jeune dealers, Gaston and Josse.

Monet sent support to Zola again during his trial. It was the most political gesture of Monet's life so far. Uncharacteristically, for a man who avoided such things, he signed L'Aurore's Dreyfusard petition, 'Manifesto of the Intellectual', and he followed the reports of the case intently. The major Dreyfusard players were his friends: Clemenceau; the Bernheim-Jeune dealers, who drove Zola to his trial in July in their flashy car; Charpentier who, after the sentence of a year's jail term was handed down, accompanied Zola to the Gare du Nord and purchased his ticket to exile in London; Mirbeau, who paid Zola's fine and costs, to avoid his property being seized.

For Monet and Mirbeau, the gulf of a decade since they had stopped speaking to Zola ceased to matter. Zola now wrote rarely on painting. Since L'Œuvre, he had accepted the Légion d'Honneur, unsuccessfully sought admission to the Académie Française, finished his Rougon-Macquart series, and fathered with his working-class mistress two longed-for children, to whom he was utterly devoted, while guiltily maintaining his marriage. He was nearly sixty and in his stolen happiness looked older: a tight, tense balding figure, grooved face and eyes doleful behind thick spectacles. Conflict in his personal life and

in his relationship with the state, as well as a lifelong eagerness to champion the victim, may have driven him to the stand for Dreyfus, for which he risked everything – liberty, his career. In doing so, he pulled ideological commitment into intellectual life in a manner which had not existed in France since Courbet and the Commune.

On the other side, feelings ran as high. 'The difficulty, there is only that, one cannot speak of the "Affair" without crying out in anger,' Degas, most passionate anti-Semite among the artists, wrote to Alexis Rouart in September 1898.[20] The divisions cast shadows even after Dreyfus's pardon in 1899, a face-saving move by the army when evidence of his innocence was incontrovertible, and Zola's return that year from exile, and even after the writer's death in Paris in 1902 by carbon monoxide poisoning. This was murder, by an anti-Dreyfusard stove fitter, never prosecuted, who blocked his chimney. Zola thus died a martyr. Cézanne, unreconciled with his childhood friend, howled on hearing of his death. He never knew that Zola, once he was assured of immortality and the moral high ground as author of 'J'Accuse', allowed himself, speaking privately, to consider Cézanne's greatness: 'I am beginning to have a better understanding of his work, which I always liked, but which eluded me for a long time, for I believed it mistakenly to be strained.'[21] Among the ironies of the Dreyfus case as it connected with the visual arts was that posthumously Zola, who had lost so many painter friends over L'Œuvre, was blamed by anti-Dreyfusards for encouraging Impressionism. Henri Rochefort, the Communard turned right-wing nationalist, complained in L'Intransigeant in 1903 that Zola had supported

> Pissarro, Claude Monet and the other more eccentric painters of the plein air and of pointillism . . . we have often averred that there were pro-Dreyfus people long before the Dreyfus case. All the diseased minds, the topsy-turvy souls, the shady and the disabled, were ripe for the coming of the Messiah of Treason. When one sees nature as Zola and his vulgar painters envisage it, naturally patriotism and honour take the form of an officer delivering to the enemy plans for the defence of his country. The love of physical and moral ugliness is a passion like any other.[22]

Cézanne, an anti-Dreyfusard, refused to give Zola any quarter, but made some concessions. In a gesture against anti-Semitism, he chose

in 1902, aged sixty-one, to sign himself at an exhibition in Aix, 'Cézanne, pupil of Pissarro', and did so again after Pissarro's death in 1903. Degas, who would cross the country for a funeral, refused to attend Pissarro's in Paris. 'What did he think since the revolting affair? What did he think of the embarrassment one felt, in spite of oneself, in his company?' Degas wondered. 'Did he think only going back to the times when we were more or less unaware of his terrible race?'[23] But the death unsettled him. He dreamt that he met Pissarro and just managed to stop himself in time from saying to him, 'I thought you were dead.'[24] Pissarro had been dead to his former friend for years.

In a noxious climate, Monet was unusual in refusing to let the Affair come between him and anyone. He kept on warm terms with the anti-Dreyfusards Renoir, Durand-Ruel and Rodin, though his grand gesture was the gift of his Creuse painting *Le Bloc* to Clemenceau to tell him 'everything that I think about his beautiful campaign for right and truth'.[25] As an image of how the two thought about themselves and each other, *Le Bloc*, a massive craggy rock, solid, irrefutable, cemented an understanding which would ripen into the most sustaining friendship of the old men's lives. Clemenceau called the newspaper he founded in 1900 *Le Bloc*.

From 1897 to 1900 it was impossible not to be constantly aware of the Affair. 'France is really sick, will she recover?' Pissarro asked Lucien. 'Despite the grave turn of affairs in Paris, despite all these anxieties, I must work at my window as if nothing has happened.' His window was at the epicentre of French history, the Hôtel du Louvre, from where he was painting vistas of the Tuileries – part of his group of Paris cityscapes adopting Monet's serial method. In 1899 he was uneasily still there, 'completely occupied with painting from my window ... if only nothing comes along to upset things here! For there is much talk of expelling the Jews, which would be the last straw!'[26]

Monet, on the other hand, hardly touched a brush during this period. In summer 1899 he told Geffroy he had not worked for eighteen months. The Affair altered his relationship with France. The 1890s series can be read as an engagement with aspects of the country: the fertile land of the *Haystacks*, the patriotic symbol the *Poplars*, the mighty cathedral and river. After 1899, Monet turned inward, to

his garden, and then abroad, to London and Venice. He never painted a public French site again.

But there were also private reasons, a series of crises, which account for his lethargy and discouragement. In March 1898 Jean-Pierre was brought home temporarily blinded by a chemistry experiment in his agricultural college, and feared insane; Alice was desperate until he rallied. In June Monet's show of his Seine pictures at Petit's was the occasion of tragedy: the Helleus, attending the exhibition, arranged for their younger daughter to be taken for a ride in a little carriage, and while they were looking at Monet's pictures, the child was run over and killed by a larger carriage whose horses had bolted. In the summer two of Monet's old friends died: 73-year-old Boudin, ailing for some years, had returned to Deauville to die within sight of the Channel, in August, and Mallarmé, suffocating from a laryngeal spasm, died suddenly aged fifty-six, in September. Then Michel, in London learning English, fell ill. Monet rushed to his side, and fell in love with the city. And all year Suzanne's health was Alice's consuming fear.

Monet was further stricken when Sisley, recently widowed and suffering from cancer, called him to his home in Moret-sur-Loing to say goodbye, asking him to look after his children, whom he was leaving destitute. Following Sisley's death in January 1899, Monet fiercely embraced his cause, and raised 160,000 francs in a benefit auction. There was no glory, as there had been with Manet. Sisley died unrecognized, after a quiet life devoted to the landscape painting that the Impressionists had inaugurated in the 1870s. He belonged to the simplicity of their youth, and Monet in his efforts on his behalf was perhaps remembering past innocence and collaboration, after the deaths of so many colleagues. 'Everyone is leaving now,' he wrote.[27]

Thirty mourners attended Sisley's funeral, including Renoir and Pissarro, walking side by side again by the river Loing to the cemetery on an icy February afternoon. Alice caught bronchitis there. On the way home, she and Monet stopped in Paris and bought flowers for Suzanne, and in Giverny Alice went straight to deliver them to the Maison Butler. She found Suzanne weak and tired, suffering from a cold but delighted by the bouquet. She would stay in bed 'just to be on the safe side', she told her mother. 'Sleep, and call me when you

wake up,' Alice said.[28] When she returned the next day, 6 February, Suzanne was dead. To Geffroy, Monet grieved, 'misfortune, which has not stopped falling on us, has hit us very hard. What a terrible thing, the end of life.'[29]

He had been very fond of Suzanne, but it was Alice's desolation that terrified him. 'You've always had courage and I hope you'll keep it for these cruel moments,' Renoir wrote, hoping that Alice, 'overwhelmed by an excess of devotion, will recover better than you think'.[30] She did not, and to Monet fell the task of alternately indulging and trying to restrain what he called, sympathetically, Alice's 'cult of her darling late daughter'.[31] For the next decade, every dawn when Monet rose to work, Alice walked the short road to the cemetery where Suzanne was buried in the same grave as her father, and she marked every morbid anniversary associated with her daughter. When away from home, she was impatient 'to return to my niche and above all (forgive me) to the dear tomb where, on my daily visits, I talk to my adored daughter'.[32] Nine years later, absent from Giverny on All Souls Day, *la Fête des Morts*, she wrote that 'it costs me terribly to be far away on the cruel date, all day I was in spirit at the dear cemetery'.[33]

Alice filled her journal with despairing outbursts, or addressed Suzanne as if she were alive. 'My husband had the sensitive thought of finding me your portrait by Henner, what emotion when seeing this image of your childhood again. Do you remember the stories I invented so that you would pose?' she wrote when Monet tracked down and gave her the portrait of the 'little Hoschedé' with her muff, for which Ernest had failed to pay in 1875.[34] Giverny became a shrine of images: Suzanne's reflection in *Young Girls in a Boat*, Suzanne with her parasol on the hill. Coming across Mirbeau's description of *Suzanne with Sunflowers*, 'sad, infinitely sad', Alice asked her daughter, 'Did you see the future, this death which would take you from us all? One thinks of some light, phantom, real spectre of the soul.'[35]

At Sisley's memorial exhibition, Julie Manet encountered Alice 'in a nervous, morbid state. The only thing she spoke to me about was the death of her daughter.'[36] Alice was always grateful to be asked 'the details about my adored daughter Suzanne, her illness, her death'; the inquiry was 'the true path to my heart'.[37] Jean-Pierre wrote that

Alice by Nadar, 1899

'although she employed an incredible strength of will to mask her grief', Alice remained 'inconsolable for the death of her daughter ... *Pauvre maman.*'[38] Nadar's photographs in late 1899 of Alice, swathed in stiff black, hair turned white, lined face visibly aged, struggling for composure, suggest reserves of determination turned to an acceptance of living with sorrow.

Without succumbing to it, Monet felt and responded to the sadness around him: Butler, left alone with two children as he himself had been; six-year-old Jimmy, face blanked, perched on a sofa, in a photograph from the mauve drawing room, another motherless boy growing up under his gaze; Alice's insistence on keeping Suzanne's memory vivid by maintaining the rawness of her grief. 'So it's not enough to have fought all one's life for the moment when material existence is finally more merciful to us, new anxieties come to afflict us at the end of our life,' Monet wrote to Pissarro.[39] He feared Alice would collapse: 'I beg you, shake yourself, don't let yourself give in to such dark ideas, otherwise you will become really ill ... What you are truly isn't reasonable.' Her grief brought about a recalibration of all the relationships at Giverny. Monet offered love, homage, distractions as he could. The girls became his allies to pierce Alice's isolation. 'Was it only she who is no longer here who knew how to love you, and are the rest of us worth so little, and our affection therefore nothing to you?' he implored two years after Suzanne's death. 'Certainly, life has

sad moments, but if you let yourself continue like this, you are lost . . . I know you have your reasons, but don't you also have some joys?'[40]

Nadar's 1899 photographs of a contemplative, serene, sturdy Monet, broad brow, warm eyes, abundant white beard, suggest a man conscious of his responsibilities and position but not crushed by them. Monet loved these photographs, which correspond to Louis Vauxcelles's account of him: 'Notwithstanding his sixty years, Claude Monet is robust and hearty as an oak. His face has been weathered by wind and sun; his dark hair is flecked with white . . . his clear, steel grey eyes are sharp and penetrating – they are the sort of eyes that seem to look into the very depths of things.'[41] Monet's old friend the doctor Cabadé told him in the late 1890s that he had 'a head as beautiful as Tintoretto's'.[42]

Not until July did Monet return to painting. It was a relief: 'I am beginning to come back to myself a bit.'[43] A dozen canvases featuring the Japanese bridge over the pond in the summer, then a further six the following year, introduced the water garden as a major motif in his art and formed the series *Water Lilies and Japanese Bridge* [Plate 41]. Some were sold before the end of 1899, and a group was exhibited in 1900. The title *Le Bassin aux Nymphéas* adopted the botanical name for the flowers, derived from Latin *nymphaea* and Greek *nymphaia*, alluding to the nymphs of classical mythology.

The curving green-painted wooden bridge arches over scintillating lilies and reflections of foliage in the little pond, bisecting almost square canvases, in ordered, cohesive compositions. In their crisp forms, firm structure and easy readability, these paintings stand apart from the other series of the 1890s. Nothing is blurred or dissolving. Light on water is rendered in quick, precise dabs, fluid strokes delineate overhanging plants, their mirror images dart between the lilies in densely woven, meticulous mosaics of greens, emerald, turquoise, offsetting flicks of red, pink and white flowers.

The journalist Arsène Alexandre thought the 'little green Japanese bridge spanning the ornamental lake surrounded by willows . . . resembles – damascened as it is with the water lilies' great round leaves, and encrusted with the precious leaves of their flowers – the masterwork of a goldsmith who has melded alloys of the most magical metals'[44] The temporal drama of serial painting is stilled, and each

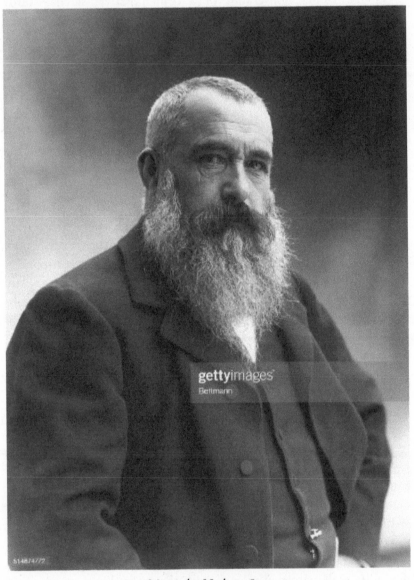

Monet by Nadar, 1899

Japanese Bridge picture is its own entity, clear, defined, not part of an ensemble. The effect is precious, and reassuring – the retreat to a private domain after the tumult of Dreyfus, and in the context of Monet's attempts to comfort Alice. The world is kept at bay.

But for how long? Monet needed a broader scope. Of all his oppositional strategies, none is as idiosyncratic as the one that took shape in 1899–1900: long stretches of Waterloo and Charing Cross bridges across the wide Thames versus the dainty arches over Giverny pond. The catalyst, surprisingly, was dutiful, stay-at-home 35-year-old Marthe, suddenly about to embark on a romantic adventure to take her further from Giverny than any of her sisters had ever been. In summer 1899 she sprang the news that Butler was taking his children to America, and she was going too. Monet knew he had to distract Alice from another loss, and he sought a tonic for her in the largest, loudest, liveliest capital in Europe. So the quest to bring his wife back to the world of the living also granted reprieve from the claustrophobia of Giverny in mourning. In London Monet planned a new painting series for a new century.

20

Unreal City, 1899–1903

On the docks at Le Havre, in September 1899, an emotional Alice waved goodbye to Marthe, Butler and her grandchildren as they sailed for New York. Then she, Monet and Germaine took the boat to England. Their base in London was a river-facing suite on the sixth floor of the Savoy Hotel, opened in 1889 and luxurious. At the bend of the Thames, it offered Monet the high vantage point which he favoured for city views. To the right loomed the Houses of Parliament behind the wrought-iron Charing Cross Bridge, carrying trains across the river. To the left rose the stone arches decorated with Doric columns of the older Waterloo Bridge, which Canova had thought the noblest in the world. In the pale sun the bridges changed appearance from hour to hour as winter mist mingled with smoke from the factories and furnaces on the south bank. Monet had found his new subject: the London series depicting the two bridges and also the Houses of Parliament [Plates 42–5]. After the slow disconsolate years, he was reinvigorated. 'I so love London! But I love it only in winter,' he said, 'for without the fog London wouldn't be a beautiful city. It's the fog that gives it its magnificent breadth. Those massive, regular blocks become grandiose within that mysterious cloak.'[1]

For an artist whose oeuvre turned on the pursuit of transitory effects, the changeable Thames obscured by fog was a motif in waiting. Wynford Dewhurst, who stalked Monet on this trip, described his view of 'the tidal ebb and flow of the great grey river, with its squalid southern banks shrouded day by day in white mist and brown smoke, the warehouses and chimneys coated in a veil of soot, the legacy of ages'.[2] Henry James thought London's fogs created 'the most romantic town-vistas in the world'.[3] The novelist Gabriel Mourey conveyed

a Frenchman's excitement about the Thames in the 1890s: 'the activity on the river unfolds in the incessant passage of steamers along wharves whose dark walls, plunging down into the current, conceal the wide world's riches. The thick smoke of the atmosphere prevents one from seeing the opposite bank . . . the spectacle of the perpetually changing sky is marvellous.'[4]

In this first exploratory visit, Monet made a few sketches, described to Pissarro as 'not bad things'.[5] His old friend's return to cityscapes after years painting rural Éragny may have further stimulated his own choice of an urban subject. Rouen cathedral excepted, Monet had not painted a city since 1878. He resolved to return to London, alone, in the new year. He earned 227,400 francs in 1899 and was prepared to spend lavishly. In place were the river view; the upper-floor suite divided into studio, with the furniture removed, and bedroom; the two bridges in the morning and early afternoon; a plan to paint the Houses of Parliament from the terrace of St Thomas's Hospital in the later afternoon and evening; and a cast of hotel staff and supporters including Sargent, his mother, sister, and one of his recent subjects, Mary Hunter. 'Ma chère Mary', wife of a northern colliery owner, who knew most of London and indeed Europe, was won over by Alice's charm – the start of a lasting friendship.

Art history owes Mary Hunter a double debt. She facilitated Monet's access to paint London from St Thomas's through a physician there, Dr Payne, and a decade later her hospitality was 'the reason that my dear Monet decided to paint' Venice.[6] Sargent's portrait of 1898 depicts Mary, then forty-two, in a pink chiffon cape and fantastic beribboned hat: good-natured, gregarious, over-eager, slightly ridiculous. Her indulgent personality and extravagances appealed to Alice, and the Sargents and the Hunters, including Mary's eccentric sister Ethel Smyth, a composer and suffragette, chiefly constituted the Monets' London social life.

Mary Hunter's heaped bouquets filled the suite at the Savoy – on the fifth floor, as Princess Louise had commandeered the sixth for wounded officers of the Boer War – to greet Monet on his second visit in February 1900. His travelling companion was his son, returning to lodgings and English lessons. On arrival Michel vanished, spent the day skating, stood Monet up for lunch, failed to appear as the promised interpreter to fix the arrangement at St Thomas's, joined a skating

club, and was not seen again until the ice melted. Then he came daily
to the Savoy, happy to procure a free lunch. Monet's life was 'very
calm and regular, working all day, having lunch and supper almost
every day downstairs in the Grill Room ... spreading out my can-
vases which I look at until the moment I go to bed'.[7] He slept well,
rose with the sun, and was feted by Dr Payne at a party which was
'quite enjoyable but I fear it will lead to other invitations'.[8]

Despite his wariness, Monet rather enjoyed his dip into London
society: Mary Hunter in Dover Street, the Wertheimer art dealers in
Connaught Place, a night at the Café Royal. Monet did his best to
entertain the women of Giverny with his accounts of the high life,
apologizing that to describe dresses which 'could not be more elegant'
was 'beyond my aptitude', and admitting that 'if it weren't for my
evenings out and dinners in town, which are rather frequent, I would
become stupefied ... not being able to stop myself from looking at my
canvases and thinking about them ceaselessly.'[9]

Monet was trying to fix every nuance of light and weather so
acutely, setting down each instant on so many canvases, rapidly seized
one after another, that 'sometimes I get lost in them.'[10] He had forty-
four under way by 1 March, sixty-five a couple of weeks later, 'for this
is no ordinary country,', he complained, not a day was the same, and
under the fogs London colours – black, brown, yellow, green, purple –
changed so fast that he found them difficult to fix.[11] It was also
frustrating working in two places, dragging himself away from his
bridges in order to catch the afternoon light for his Parliaments. He
saw the absurdity himself: soon he had

> up to one hundred canvases under way, all on the same subject. Search-
> ing feverishly among these sketches, I would choose one that was not
> too different from what I saw; in spite of that I would alter it com-
> pletely. When I had finished working I would notice as I shuffled my
> canvases that the one I had overlooked would have suited best and I
> had it right under my hand. How stupid![12]

Yet 'each day I find London more beautiful to paint,' he told Blanche.[13]
He tried to describe moments to Alice: 'there was an astonishing clar-
ity; then the sun rose so blindingly one couldn't see it. The Thames
was only gold. God it was beautiful, so good that I set to work in a

frenzy following the sun and its shimmers on the water. During that time the kitchens lit up. Thanks to the smoke, the fog came, then the clouds.'[14] Such accounts, jotted down while Monet was waiting for the sun to return between cloudy breaks, were repeatedly interrupted because '*voilà mon effet*, I must leave you'.[15]

Fog on water gave Monet mystery, and the occasion for simplification, amplification. London's architectonic motifs allowed him to hold on to actual weather and time of day, while licensing a freer manner. The attraction was also the city itself, its stimulation, action. Thus he complained about 'this damned English Sunday' when the weekday whirl ceased, the smoke diminished because the factories closed, and then there was 'nothing which excites the nerves'.[16]

The London paintings excite the nerves, in contrast to the Japanese Bridge pictures, which soothe them. An industrial powerhouse, hub of world trade, social centre, London was the antidote to secluded Giverny. The bridges, dynamic diagonals, are the organizational basis for most of the Thames canvases; their ancestors are the paintings of Argenteuil's road and rail bridges, but in London Monet destabilized the structures into weightless phantoms. Charing Cross Bridge, a sheer horizontal span on cylindrical piers, geometric, stark, metallic, gleams against the sunlit river, then vanishes, pencil-thin, in the mist. With this modern bridge Monet was daring. *Charing Cross Bridge, Smoke in the Fog, Impression* is lit by plumes of smoke from passing trains; the bridge is a shaky grey line between a rose-violet sky and its reflections, water and air blend in drifts of paint. Waterloo Bridge imposed a subtly altered mood. Its cavernous vaults create dark shadows and undulating patterns, animated by the movement of buses and carriages and smoke unfurling from the south bank, whose strict verticals of chimneys and smokestacks contrast with the arches.

He laid brushstroke on brushstroke, recorded Geffroy, who visited the Savoy with Clemenceau to observe Monet at work,

with a marvellous certainty, knowing exactly to which phenomenon of light each corresponded. From time to time he would stop. 'The sun is no longer there,' he would say. Before us, the Thames rolled its waves, almost invisible in the fog. A boat passed like a ghost. Hardly discernible in that space were the bridges, on which a scarcely perceptible

movement animated the dense haze: trains passing each other on Charing Cross Bridge, buses filing over Waterloo Bridge, the smoke which unrolled into arabesques soon enveloped within the thick and livid vastness. The spectacle was grand, solemn and gloomy, an abyss from which came just the rumour of activity. One would have thought that everything was vanishing, disappearing into a colourless obscurity.

Suddenly Claude Monet snatched his palette and brushes again. 'The sun is back,' he said, but at that moment he was the only one who knew it. However intently we looked, we saw nothing but that muffled grey space, a few uncertain shapes, the bridges as if hanging in the void, the smoke quickly diffused.[17]

In some canvases Monet emphasized the industrial backcloth. When Moscow collector Sergei Shchukin bought one of these, his wife sent it back because she did not like the smoke on the water. In others, especially depictions of the Gothic Houses of Parliament, there is a romantic element, apparitions rise from the water, dark against a flaming sky and its reflection, or veiled in purple mist. Commentators drew attention to the fantastical vein in the Thames pictures. Gustave Kahn wrote that 'these pyrotechnics of gold, of rose-pink, of rose-red ... of gilded or deep blue-green ... seem ... as unreal as the realm of Queen Mab'.

Kahn suggested placing 'certain Monets beside certain Turners ... two moments of impressionism ... two moments in a history of visual sensitivity'.[18] There is a shared dissolution of form in Turner's later works and Monet's London paintings, and Monet had previously spoken to Robinson of his admiration for *Rain, Steam and Speed*. He knew the Turners in the National Gallery, and he was polite to English journalists about them. To Frenchmen he was franker – or more concerned to stake originality to his primary audience. Raymond Koechlin, *Le Figaro*'s London correspondent, who visited Monet at the Savoy, wrote that 'in his private conversations he did not conceal the fact that Turner's work was antipathetic to him because of the exuberant romanticism of his fantasy'.[19] Monet summed up, 'At one time I greatly admired Turner, today I care less for him – he did not draw sufficiently with colour and he put on too much.'[20]

In London Monet drew with colour, conjuring the modern city as

we experience it as a fleeting vista, transforming expansive skies and stretches of water into near abstractions. Nothing is fixed or still. The attention to minute shifting effects, and the grandeur, bear comparisons with the *Cathedrals*, but those elaborate façades belong to the nineteenth century, and the looser London pictures, which are dated 1899–1903, to the shifting ground of twentieth-century art, alert to man's fragile place in his environment. The unceasing traffic pouring across the river in *Waterloo Bridge, Fog Effect*, its fluctuating effects within an iridescent blue alternately opaque and translucent, calls to mind modernist poetry – T. S. Eliot's fragmented ghost city in *The Waste Land* of 1922: 'Unreal City, / Under the brown fog of a winter dawn, / A crowd flowed over London Bridge, so many / I had not thought death had undone so many.'

For death and memory underlie Monet's London too. The series was conceived with Alice distraught at his side and continued, in 1900 and 1901, in a flight from unhappiness at Giverny which was only partly an escape, as letters from the Savoy show: 'I think of your grief, and blame myself for the need to abandon you'; 'I'm tormented to see that you are at the end of your courage, I feel it between the lines, even when you don't say so.'[21] His hope for her was only that 'the hours are more possible'.[22] Whether in her presence or through her letters, Monet lived to the rhythms of his wife's emotions. A sense of the shadowy presence of things in the London paintings has a connection with Alice's tenuous hold on life, even as Monet affirms, against the weight of her mourning, his own joy in the city, its beauty, flow of life, the possibilities of the wide world implied in the sweeping river and big skies. So Monet made the figurative more fugitive than ever, a struggle in which, by the time he left London in April, he had ruined a hundred canvases and run up a huge bill at paint merchant Lechertier-Barbe on Jermyn Street.

He went home via Le Havre where Alice, under strict instructions to control her nerves should the boat be late, was awaiting the return of 'nos enfants d'Amérique'. 'You can feel calm about the crossing, only think of the happiness of being together at last,' Monet consoled, but, 'What a curse to be so sensitive, to be so little master of oneself.'[23] The quartet who disembarked from the transatlantic steamer *Touraine* had, in the absence of the controlling reign of Alice's grief, regrouped

into a new family. Marthe's wedding to Butler took place on 31 October 1900 in Giverny, with Monet, Jean, Jacques and Jean-Pierre as witnesses, signifying Butler's total absorption into Giverny and his wives' family. Twelve years after Alice's hopes for her eldest daughter, Marthe won her American husband – and some peace with Monet, whose wedding present, diligently searched through Durand-Ruel, was Paul Baudry's 1876 Salon portrait of Hoschedé. Swallowing pride and doubts, Monet also helped the couple by asking Durand-Ruel to help Butler, and the dealer duly organized a New York exhibition, which flopped. Butler, mortified, also endured personal misfortune when Courtland, his last surviving sibling, committed suicide in 1903.

So Butler made Giverny his sanctuary, and his children the focus of

The wedding of Marthe Hoschedé and Theodore Butler, 31 October 1900. The newly married couple stand at the top. Monet is next to Marthe. Alice is between her husband and Jean Monet. The three women in white standing on the right are Blanche, Jeanne Sisley, with Lily Butler at her side, and Germaine. Pierre Sisley, whom Germaine hoped to marry, sits at the front next to seven-year-old Jimmy Butler. Abbé Toussaint is seated centre and Paul Durand-Ruel stands at the extreme left.

his life and painting: Jimmy with his hoop, Lily in white fur, or swinging in a hammock, and soon a resplendent dark-haired teenager, resembling her mother, wandering among flowers. Marthe was a devoted step-mother, and her marriage secured the grandchildren for Giverny, to Monet's pleasure too. If to Alice it was initially intolerable to see Suzanne so easily replaced, she was hardly unfamiliar with the story of a widower who falls in love with the woman caring for his children.

Germaine, the sole daughter at home, bore the brunt of Alice's unhappiness. The orphaned Sisley children were frequent visitors, and Germaine's refuge was to fall in love with Pierre Sisley, a painter even less successful than his father. Alice and Monet forbade the match. They considered him a charity case, a bourgeois response incongruously unkind from Monet, who had known Pierre Sisley since he was born in 1867, weeks before his own Jean. Germaine yielded miserably. In 1901 she travelled south to visit friends near Cagnes-sur-Mer where she met Albert Salerou, a wealthy Monégasque lawyer and collector of books and butterflies. She married him the following year and to Alice's distress settled in his home, Les Brighières, in Cagnes, thus becoming a neighbour of Renoir. Her first child Simone, known as 'Sisi', found a playmate in Claude 'Coco' Renoir, born to his parents' surprise at their combined age of 101.

Germaine's proximity was a happy further tie between Monet and his oldest friend. The relationship survived Dreyfus and in 1900 survived Renoir's acceptance of the Légion d'Honneur. Monet disdained and was withering about official recognition. Renoir fretted to Monet, fearful that the piece of ribbon might get in the way of their friendship. Days later he regretted writing. 'I realized today and even before that I'd written you a stupid letter . . . I wonder what it matters to you whether I'm decorated or not . . . You must know me better than I know myself, since I very probably know you better than yourself. So destroy the letter and let's not talk about it any more, and long live love.'[24] 'Ah, que c'est triste,' was Monet's reply.[25] But he went on admiring Renoir, his work and his forbearance in ill health, while Renoir, going his own way, continued to praise Monet's consistency of judgement and behaviour: 'You have for yourself an admirable line of conduct. I have never known the night before what I am going to do the next day.'[26]

Monet was 'not proud', however, to depart for England on his third stint, regretting leaving an Alice 'more and more absorbed in your grief'.[27] He arrived in London on 24 January 1901, two days after Queen Victoria's death. Sargent invited him to watch the funeral from the privileged vantage point of a house opposite Buckingham Palace. His guide was 'an American writer, speaking French admirably ... who was completely charming to me, explaining everything, pointing out all the personalities etc. (he is called Henry James).'[28] This took place close to the second anniversary of Suzanne's death, and Alice's letters 'let through very black thoughts'.[29]

She was making misjudgement after misjudgement over her children. After a minor accident during his military service, 23-year-old Jean-Pierre, was trying to shorten his time in the army; Monet drew on his contacts, sent letters, only for the military doctor to pull up in Giverny on a day that Jean-Pierre had flitted off to enjoy himself in Paris. 'Day of atrocious tortures,' Alice told her diary. 'The major arrived with his ambulance. Jean-Pierre absent. All hope of leave lost and what will Monet say?'[30] Jean-Pierre, though, was cheerful and loyal; like his sister Blanche, he had inherited Hoschedé's optimism and warmth. More troubling was Jacques, resentful, and wild with money like his father: 'He is in a deplorable situation and if we don't help him, it will mean bankruptcy. And still we have to give him a hand. Demands for money, always demands for money. However good Monet is about it, for me it's a cruel torture,' Alice wrote.[31] This lasted years. Monet, clear-eyed about his stepson, paid up and regretted it. 'He is a pitiful being, incapable of directing himself ... and to whom my goodness has been more harmful than useful,' he concluded. 'I gave in often only for my dear Alice, to avoid her being upset ... he has done a lot of harm to his poor mother and to me ... he has abused my kindness.'[32]

Monet's own sons were also acting to type. Jean's dwindling efforts eroded the patience of Léon, who thus lost Monet's last shred of brotherly feeling. When Léon sacked him, Jean diversified into fish-farming, a whimsical scheme which failed, and Monet had to buy him out. Michel, a reluctant new recruit to military service in Rouen, had his own fanciful ideas. For his twenty-third birthday he demanded a mechanized quadricycle, for sale from one of Monet's more exotic

followers in Giverny, Czech painter Vaclav Radimsky. An anxious
Monet sent 200 francs from London and Michel became the owner of
his first registered vehicle, 222Z. His delight in it prompted Monet to
wonder whether a car might be 'a device for lifting Alice out of her
silent desolation' and he ordered a luxurious Panhard-Levassor.[33] It
arrived in Giverny before he did in 1901, with a chauffeur who was
immediately arrested for assault.

Watching Michel hurtling about on his new toy, Clemenceau pre-
dicted that he would smash himself up before long, and Monet himself
became wary of his own rash acquisition: 'I am more frightened than
ever of these engines and totally regret the purchase of the car,' he
decided. The vehicle was 'a waste of time, because you have to be
retired (*rentier*) for that, and not like me absorbed by this passion for
Art'.[34] Alice allowed Monet no illusions about leisure. 'When you
write to me that for you there can never be any distractions any more,
that breaks my heart because I feel your nervous state and your dis-
couragement and that robs me of my courage too,' he answered, and
for the first time he offered to curtail a working trip: 'If you want me
to come back immediately, that would be efforts and sacrifices lost,
but I would prefer that, if I can be useful and can comfort you.'[35] To
this half-hearted offer she said no, but anxiety about his wife, urgency
to return home leading to overwork, and catching cold on the terrace
of St Thomas's landed Monet in bed at the Savoy with pleurisy for
three weeks. Restricting himself first to six oysters and three *sand-
witch*, rising to a filet of merle and cherry compote, then a single lamb
cutlet and spinach as he improved, Monet ignored his canvases,
refused to show them to Sargent when he visited, and, he wrote home,
had 'only one thought, to recover my strength to return to you whom
I love so much'.[36] London proved that 'my life has not stopped being
ardour and enthusiasm followed by disappointment; I had hoped this
time to be happier, but it's the opposite.'[37]

The trip proved that he could not leave Alice alone again. Quickly
and decisively, therefore, once he was in Giverny, he turned his atten-
tion to the garden. In May 1901 he bought land south of the Ru to
enlarge his pond, and was granted permission from the council to
divert the stream further, an extensive project of excavation and
reconstruction. Meanwhile it turned out that 'the car is an excellent

cure!'[38] One summer morning Monet had himself driven to Vétheuil and was so delighted that he returned in the afternoon with Alice and her grandchildren. For several weeks Monet and Alice drove there daily. They rented a small chalet at Lavacourt, with a balcony giving a view across the river of the church and its reflections, which Monet had painted in the year of Camille's dying. Marthe and Butler rowed upstream with the children for picnics, and the drives through familiar countryside, kitting out the little pavilion, and the walks with her husband triggered a remarkable effect on Alice: she rejoiced at a 'little paradise which I no longer want to leave ... it's delicious to stroll along the water again in the same places as twenty years ago.'[39]

Jean-Pierre called these days a return to 'premières amours'.[40] Monet, looking across at the cemetery where Camille was buried, made pink-tinged, weak versions of the motifs which he had rendered so innovatively two decades before. Alice loved the new painted memories, but Monet dismissed them. 'He's already upset with what he's doing and says that he regrets his garden, which is much more beautiful to paint than any Vétheuils.'[41]Alice reported. Knowing these

Monet and Theodore Butler in the Panhard-Levassor motor car, 1900s

Vétheuil pictures to be minor works, Monet allowed the young Bern-
heims to stage a small show, though when the canvases were packed
up, he said he was 'ashamed to send such things'.[42] The exhibition
opened in the winter of 1902 and Alice regretted that ''e doesn't care
about it and he won't go.'[43]

Nonetheless, revisiting the site where he had begun to paint the
world in reflection may have been helpful as he considered both
London mirrored in the Thames and the possibilities of the pond –
nothing in his oeuvre anticipates the water lilies as strangely as
Vétheuil's melting ice floes of 1879–80. Or he was indulging Alice,
for to please her, he renewed the half-year lease on the Vétheuil cha-
let for an extra month. But at the same time, February 1902, he
planted the first water lilies in the enlarged *bassin*. Vétheuil was then
abandoned. It had served its purpose – and shown Alice the pleas-
ures offered by the Panhard. They had themselves chauffeured
around the countryside most Sundays, and without ever learning to
drive himself, Monet soon loved speed as much as Michel did, boast-
ing that, driven at 80 km an hour, he could leave Giverny for Paris
at dawn and be back by noon.

Alice still went to the cemetery daily, and made sure their mother
remained in her grandchildren's minds – her hand is behind the
inscription 'À notre maman chérie / souvenir de notre 1ère commu-
nion / 21 May 1905 / James et Lily', engraved on the Hoschedé tomb.
But Vétheuil was a turning point for her as London had not been. The
Butler children's memories of the extended family in the early 1900s
are happy ones, of indulgent birthdays and gargantuan Christmases
with foie gras in pastry, stuffed capons with chestnuts and truffles,
Christmas pudding and banana ice cream, when they 'would find at
their places those little grey envelopes lined with rose madder,
containing money from La Bonne [short for Bonne Maman, or grand-
mother] and Monet. Next to the napkins, there were mysterious little
packages of sweets and small gifts . . . the large presents were waiting
under the tree which had been installed in the mauve dining room.'[44]
Monet, Jean-Pierre wrote of this period, was at ease and able at last
to 'realize all his fantasies for his house and garden'. On his own
account, he remembered this time, after army service and before 'I left
the house, the family', as 'the most superb of my life'.[45] He married

Geneviève Costadau, daughter of a friend of Alice's from Périgord, in 1903, the fifth and final wedding of Monet's stepchildren to take place in the Giverny studio.

Michel was also back from military service, nearly twenty-five, and without a profession or intention of finding one. In November 1902 he crashed his quadricycle as predicted and for three months Monet nursed him in his studio, unable to work or think about anything except his son: 'I will only be calm when I can see him walk like everyone else.'[46] At the turn of the year he told Geffroy, 'if you knew how sad I am *au fond de moi*.'[47] Affectionately severe, Geffroy answered that Monet was 'ungrateful towards things and beings, towards eternal nature, towards yourself ... You will recover your magnificent equilibrium. You have your art, which is your life prolonged, amplified. You have nature and travel, and the world of ideas.'[48]

All these things are distilled in the London paintings, to which Monet returned seriously in 1903. Cursing that in England's changing weather he had even attempted to go beyond the *pochade* (oil sketch), he had to resign himself to 'doing the real work here, in the studio'.[49] The London paintings were reworked more extensively, and at greater delay and distance from the motif than any series so far. Monet was insistent about the paintings' unity, establishing coherence between them, ensuring they were harmonized and 'assez londonienne', 'sufficiently London-looking' as a group, with 'great big strokes' corresponding to the city's atmosphere.[50] He refused to send Durand-Ruel a single London canvas, because he needed to have them all in front of him as he worked, and 'the view of the series complete will have a much greater importance.'[51] The dealer was eventually promised an exhibition for 1904, for which Monet was fearful. Mirbeau took him in hand: 'Oh you are starting your stupidities again ... you are coming close to the big success of your life, the conquest of a country ... and you sacrifice all that ... Why? for phantoms ... at the moment you are the only one who can't judge your paintings.'[52]

Painting London was Monet's last flourish on a world stage, creating from already iconic sites newly iconic pictures. 'Vues de la Tamise à Londres' opened at Durand-Ruel's in May 1904 to enormous attention and almost universal praise. Monet's timing was smart; there was particular interest in London as the Entente Cordiale between Britain

and France had just been signed, in April. *Le Soleil* reported a steady flow of carriages and cars along the Champs-Élysées to the rue Laffitte every afternoon of the exhibition. Durand-Ruel did fabulously, buying and reselling pictures within hours, and Monet, having earned nothing in 1903, sold altogether 271,000 francs worth of paintings in 1904.

Koechlin said that Monet 'translated' the city: 'today was one of those luminous half-fogs: I stopped ten times on the bridges and embankments thinking of you.'[53] In 1906 Vollard sent the Fauvist André Derain to London to paint the Thames in emulation of Monet. In his screeching hues and blocky forms, Derain's London was youthful and brash, yet demonstrated his debt to Monet's liberated colour and serial method. The city was barely recognizable as the one Monet and Pissarro had painted during their stay as émigrés thirty years before.

Pissarro had still been at work on his views of Paris when he died in November 1903, impoverished as ever and still helped by Monet, who soothed during his friend's last days, 'as for your preoccupation with your old debt, you don't need to have the slightest concern in the world. Look after yourself without worrying.'[54] Pissarro's final works, setting ephemeral effects within grandly architectonic structures, are a tremendous conclusion to the Impressionist cityscape, but Monet's London paintings from the same time move somewhere beyond it. Camille Mauclair, who had complained of colour wandering about in the *Cathedrals*, in his history *L'Impressionnisme* in 1904 called Monet 'a precise visionary, envisaging nature ... never departing from it, and struggling with it from hour to hour ... Monet magnified it in his mind, raised it to the level of a decorative synthesis, amplified it so as to strike from the rock of nature undreamed of emotions and enchantments.'[55]

After the landlocked motifs of haystacks and the cathedral, London returned Monet to his first love, water. The London series ushers into Monet's painting characteristics of late style, shared across history by certain long-lived great painters, including Titian, Rembrandt, Matisse: reflective, emotional, extravagant yet authoritative, controlled, meditations on the abstract character of reality.

Monet's battle with the London pictures was to balance his responses to the observed city with an abstracting freedom. When,

unable to work directly from the motif, he turned the canvases to the wall in frustration in 1903, he told Durand-Ruel that he longed for 'fine weather to come and to be able return to painting in front of nature'. Thus began the second group of works devoted to his pond. These, he said, 'will be my final effort and I will see if I am still good for something.'[56] So, while finishing the city paintings in the studio, Monet brought the grandeur of London's watery reflections back to the Giverny garden, and his Thames compositions with their spectral bridges became his own bridge to the twentieth century – to the abstracted decorative water-lily ensembles which would occupy him for the rest of his life.

21

The Moment of Roses, 1904–8

'The garden is the man,' declared Arsène Alexandre, and 'among his flowers' Monet was 'kindly, unperturbed, enthusiastic ... he glows with benevolence.'[1] The journalist visited in 1901 and 1904, and the second time, after the enlargement of the pond and new planting, he commented that the garden was 'staggeringly expensive': Monet 'is a man who appreciates splendid things, a fact clearly demonstrated by his passion for the most ostentatious flowers'.[2]

To Geffroy this garden was a fairy tale.

> As soon as you push the little entrance gate ... you think you are entering a paradise ... the colourful, perfumed kingdom of flowers. Each month is adorned with its flowers, from the lilacs and irises to the chrysanthemums and nasturtiums. If it is the moment of roses, all the marvels with glorious names surround you ... on bushes, hedges, trellises, climbing walls, hung on pillars and arches ... the rarest and the most ordinary ... All the corollas chime an enchanted hour ... and make you believe in the setting of possible happiness.[3]

It was the era of the bourgeois garden, the escape into leisure and privacy from industrialized, urban existence. Although his garden was unique and expressive of his own sensibility, Monet belonged to a burgeoning middle class of horticultural consumers who followed the latest cross-breeding and exotic imports, made orders from Latour-Marliac's expensive catalogues, patronized nurseries such as Brunoy's, specialist in irises and orchids, and stacked up gardening magazines and botanical volumes. By 1904 he employed six gardeners, led by Félix Breuil, recruited through Mirbeau. One was responsible for the water lilies alone; from a boat, he dusted and washed them, and

cleaned the pond surface. Altogether Monet cultivated some seventy species, experimented with hybrids – a purple-violet iris was named 'Madame Monet'. He spent prodigiously, time as well as money, on his plants, from bamboo plantations around the pond to paying for the public road bordering the water garden to be tarred, to minimize dust on the lilies.

The flower garden and the water garden were separated by the road and little railway branch line running in between, and their atmospheres were distinct. The former was riotous in colour and roughly geometric. Flowerbeds, planted to ensure continuous blooms, were laid out in rows around wide gravelled paths and a central *allée*, overhung with foliage. Alexandre admired 'this profusion, this teeming quality that gives the garden its special quality ... Monet wants as many flowers in his garden as a space can hold.'[4] In contrast, but no less extravagant, the water garden, with its irregularly shaped pond and curvilinear paths, was home to thousands of water lilies, the new Marliac hybrids combining the hardiness of plain yellow and white flowers with the pinks, reds and lilacs of perfumed exotic varieties.

Monet's garden and second studio in a postcard captioned '*Propriété de Maître Claude Monet. Les iris*', 1900s

The mood was calmer, contemplative, and called to mind Japanese models with its little bridge, cherry blossom, bamboo and Japanese tree peonies. The new pond was four times larger than the first, and Monet designed its winding paths, giving fresh vistas at every bend, to look even bigger than it was.

Proust, without visiting, understood the garden as a painter's creation, imagining 'not so much a garden of flowers as of colours and tones . . . land flowers and water flowers, those soft white water lilies that the master has depicted in sublime canvases, of which this garden is the first and living sketch . . . the garden is a real transposition of art rather than a model for a painting.'[5] Alexandre reckoned that 'when one owns such a beautiful garden', criticism is laughable: 'I believe that this is the moral of *Candide*.'[6]

'*Il faut cultiver notre jardin*.' No artist ever encapsulated Voltaire's advice, horticultural quietism underlining values of happiness in nature and work, tolerance, rationality, self-sufficiency, as Monet did in the twentieth century. Photographs taken in the garden in the 1900s show a more affluent, less rustic Monet than in the 1890s: an updated rococo dandy in pleated silk shirts in pastel shades, cuffs flopping over wrists, English tweeds, and smart boots made by a cavalry supplier in Vernon. Wealthy and celebrated, he could afford indulgence and seclusion.

The *Water Lilies* series of 1903–8 [Plate 46] was begun in far happier circumstances than the *Japanese Bridge* group started after Suzanne's death. Encouraged by the success of the London paintings, Monet this time conceived a longer, more complex and experimental project. Although this is the second series, the first paintings simply called *Water Lilies* date from this period, and there are scores of them. They are more abstracted and open, the emphasis falling on the flowers and the water surface, no longer anchored pictorially by the bridge. Making these paintings was, in the first years, an absorbing pleasure. 'What a marvellous summer we've had and what a joy it's been to work,' Monet told Durand-Ruel in 1906.[7] Alice sat with him as he painted: 'we stayed at the pond all day in this beautiful weather, with the azaleas and rhododendrons in full bloom, it's superb.'[8]

With all her children having married and left home, Alice gave her husband her complete attention, and he was grateful that 'you do

Monet, in his trademark pleated silk shirt, by the water lily pond, photographed by Jacques-Ernest Bulloz, 1905

everything to spare me the least concern.'[9] A short trip in October 1904 to Spain, to see the museums in Madrid and Toledo, was in part undertaken in memory of Manet, who had loved Velazquez; otherwise, the couple did not often leave Giverny. 'We are old, my wife and I, *habitués à notre vie*,' Monet told Geffroy in 1906.[10] Nothing was allowed to disturb their routine. Walter Pach, visiting to offer an all-expenses-paid trip to America, left a cosy picture of being received by Monet, Alice and a granddaughter in the studio, and Monet in mellow mood reading aloud the letter of invitation to Alice. It never occurred to him to accept. Once this *Water Lilies* series was seriously under way, travel was restricted to occasional visits to Paris, to see exhibitions, for oysters at Prunier, for the wrestling matches which were Alice's unlikely, violent delight. And one day the Bernheims turned up and offered a 'petit voyage' in their balloon. 'Heavenly to go up in the air like that, two poor old people like us,' Alice wrote.[11] So she and Monet glided more or less comfortably into old age.

Louis Vauxcelles described a day trip to Giverny in summer 1905, greeted by Monet wearing 'a suit made of some tweedy material in a beige check, a blue pleated silk shirt, a hat of tawny suede, and high cut shoes of reddish leather'. After lunch, the genial fop hastened his guest to the pond because 'the water lilies close before five'. Vauxcelles was drowsy with delight.

> The leaves lie flat upon the surface of the water, and from among them blossom the yellow, blue, violet and pink corollas of that lovely water flower ... Weeping willows and poplars abound, and on the banks of the stream he has planted hundreds of flowers – gladioli, irises, rhododendrons, and some rare species of lily ... The whole thing comes together to create a setting that enchants.

The effect was repeated in the studio, housing depictions of water lilies 'at all hours of day: the pale lilac of early morning, the powdery bronze glow of midday, the violet shadows of twilight'. Finally

> evening falls. A butler in full regalia lays the table on the terrace overhung with Virginia creeper, wisteria, Aristolochia. Claude Monet accompanied us to the gate with that lord-of-the-manor courtesy which has always been his. And then he goes off to give instructions to the

gardener, who is out on the pond in a barge removing the dead vegetation from among the water lilies.[12]

The precious flowers, drifting, their movement almost imperceptible, over the liquid blue-green surfaces of the 1904–8 *Water Lilies*, evoke a dreamy contentment, as if the world is in slow motion, or time is stilled altogether. Monet himself drew analogies with poetry and music, mentioning Mallarmé and Debussy, who composed his *Reflets dans l'eau* (Reflections in the Water) in 1905. Nothing like this existed in painting: nature rendered in the cropped, smallest fragment of a landscape, so that the lilies 'appears to be floating in the moist air, fading away and promoting the play of imagination,' wrote Claude Roger-Marx, the most perceptive contemporary witness, and an adventurous young critic, only twenty when he interviewed Monet about the work in 1909.[13] He thought Monet had now 'severed his last ties' with descriptive painting.[14] The paintings were in this sense paradoxical: they pushed Impressionism towards abstraction, but as representations they made a particular place, the Giverny pond, iconic.

In 1904 it was an extreme move to withdraw to sit beneath a big white parasol to depict, with no certainty of the outcome, a slice of water as a mirror of the world, and also as a self-contained contemplative space. 'The basic element of the motif is the mirror of water, whose appearance changes at every instant because of the way bits of the sky are reflected in it, giving it life and movement,' Monet explained to the journalist Thiébault-Sisson.

> The passing cloud, the fresh breeze ... a rainstorm, the sudden fierce gust of wind, the fading or suddenly refulgent light ... create changes in colour and alter the surface of the water. It can be smooth, unruffled, and then, suddenly, there will be a ripple, a movement that breaks up into almost imperceptible wavelets or seems to crease the surface slowly, making it look like a wide piece of watered silk.

It was, he added,

> exceedingly hard work, and yet how seductive it is! To catch the fleeting minute, or at least its feeling, is difficult enough when the play of light and colour is concentrated on a fixed point, a cityscape, a motionless landscape. With water, however, which is such a mobile, constantly

changing subject, there is ... a problem that is extremely appealing, one that each passing moment makes into something new and unexpected. A man could devote his entire life to such work.[15]

For nearly a quarter of a century, Monet did.

A push-pull between control and freedom, of brushstrokes, of the lilies, floating, opening and closing as they liked, characterizes the series, and the garden itself. 'As in his paintings, where everything appears to be spontaneous and haphazard but is not, the garden is planned with a great deal of calculation, experience, and knowledge of the laws of harmony,' Alexandre wrote.[16] Sky and earth mostly disappear, the banks and edges are eliminated, no single point fixes the eye, in these decentralized, water-flooded compositions. Monet played on tensions between the expansive surface, the watery depths and its interpenetrating flowers and tangled foliage, which by turns absorb or reflect light.

Year by year he wrought variations in tone and colour and experimented with different formats, including his only paintings in tondo form, emphasizing ornamentation. In three square canvases in 1905 the Japanese bridge returns, and clusters of lilies with their flat spreading pads seem to roam freely. In 1906 a hazy quality intensifies, like a mirage. Roger-Marx described 'flecks of pale green foam highlighted ... by flashes of topaz, ruby, sapphire, or mother-of-pearl ... under a light veil of silvery mist, the indecisive meets the precise.'[17] The innovation in 1907 was vertical canvases, unusual for landscape pictures, as in *Water Lilies* [Plate 46]. A burst of dazzling light streams down from the top, twists through foliage, and spills out into a broad eddying pool. The effect is bleached out, disorientating as the aggressive spurt energizes the passive motif. These were the most radical pictures so far, and Durand-Ruel had to admit he did not like them or think he could sell them. It was the first time he baulked at Monet's work. Not that buyers were Monet's immediate concern. Of the paintings in 1907, he informed Durand-Ruel, 'I really have too few satisfactory ones to bother the public.' Anyway, 'the whole effect can only be produced by the ensemble.'[18]

To produce a coherent body of work from paintings of barely tangible fluctuations was a challenge that, over time, became exasperating.

On some areas of the canvases he thickly applied up to nine layers of paint, and a vast range of pigments, but 'it's still just sketching and research,' he wrote after four years.[19] Following the heady beginning, he became a prisoner of the interiority, the streaming inwardness of the paintings, where water seems to flow into itself, as the mind circles. He took a self-portrait photograph of his straw-hatted reflection as a silhouette in his pond – Narcissus staring at himself, at what he had created in order to double and recreate again, through the command of his painting. It is a beautiful, troubled, image of an introspective Monet, enthralled but confronting himself, ageing, and his art, as well as his familiar challenges, climate and light. The mythical Narcissus dies from frustration: 'the shadow that you see is the reflection of your image; / It is nothing in itself; it arrived with you and remains with you; / With you it will go away, if at least you are able to go away!'[20] But Monet could not go away from the motif he had created. To stare at the pond was to stare at himself, his photograph suggested.

Over the decades, he had conquered external reality, seas and rivers, cathedrals and cities, 'scenes complete in themselves', as Roger-Marx

Monet's photograph of his own reflection in the water-lily pond, c.1905

put it. Now he extended the omnipotence of his eye by creating his own world of nature. The water garden really was the outdoor studio he had always trumpeted. He dug the pond and altered its contours like a drawing, he diverted rivers, planted trees, sketched out curving paths, strewed lilies across the water like flecks of the brush, and painted it all as a dissolving fragment. Roger-Marx thought that the paintings manifested 'an authority and independence, an egocentric quality.'[21] Observers were struck by the self-indulgence of the process. 'He paints in spurts, working in fits and starts as the fancy takes him. When he feels in the mood to paint, no one is allowed to disturb him – friends, visitors, buyers – no one. And then he will let a week go by without touching his brushes,' Vauxcelles reported.[22]

Alice fretted both when he did too much – 'Monet works like one enraged and to excess, and I torture myself fearing exhaustion for him'[23] – and when he faltered. Three years into the series, in 1906, his spirits were unpredictable. Alice recorded him repeatedly muttering 'what we can't be and have been' and 'that he can no longer do anything good.'[24] On a wet day, 'Monet, furious, watches the pouring rain which ruins everything. He is desolate, he takes it out on everything which surrounds him, which is really upsetting.'[25] His victims tended to be younger men who were not his sons; perhaps they sparked resentment of his fear of failing powers. 'Jean-Pierre was very badly received when he said that with our fine Panhard we should take to the road. It made him furious and he left the table,' Alice recounted, and 'my poor Monet ... threw us all by the way he talked to Butler about Delacroix, but so hard that it was upsetting for me – in spite of his good heart, he is cutting. How sad to be unable to be happy and to spoil the last days of your life like this.'[26]

Alice had her own difficulties. In January 1907 Germaine came to Giverny to give birth to her second daughter, named to her mother's distress Suzanne – 'only my Suzanne can have that name'[27] – and the baby died, buried in the Hoschedé tomb with her namesake. Germaine, returned to Cagnes, missed her mother's support intensely; Alice, enclosed in Giverny with an increasingly reclusive Monet, was lonely. Outwardly, she was equable, but she told her daughter, 'Really, now, the more life goes on, the more Monet wants to live far from *le genre humain*, and it's a bit hard for me!'[28]

Few people could pull him from Giverny. An exception was Renoir. In autumn 1906 Monet spent some days in Paris to allow his friend to sketch his portrait, a pencil drawing of a warm-eyed, bushy-bearded, smiling Monet. Alice reported them 'very happy to see one another, even though Madame Renoir was there'.[29] Arthritic, incapacitated but working consistently, Renoir was held up as an example in Giverny: 'when you see that condition, how unfair it seems of Monet with his good health to be in such a bad mood and not to do anything.'[30]

Renoir and Monet were together when news of Cézanne's death, in Aix on 22 October 1906, reached Paris. The pair were the last surviving 'comrades of the first struggles', and now experienced unexpected shifts in the relative reputations of the group. Cézanne had lived just long enough to see his reputation rise. In 1900 Pissarro had noted that Cézanne was suddenly 'very much in vogue, it is extraordinary'.[31] In the next few years his aim 'to make of Impressionism something solid'[32] resonated with the emerging, analytical generation who reacted against Impressionism, searching for structure and firmness, and concentrating on the figure. Matisse was the barometer. In 1897 Henri Evenepoel wrote, 'My friend Matisse is doing impressionism and thinks only about Claude Monet', and in 1898 he still described Matisse's pictures as 'painted as though by a mad impressionist'. But in December 1899 Matisse bought, paying the modest 12,00 francs by instalments, the small canvas *Three Bathers* by Cézanne, whom he now called the 'god of painting'.[33]

Durand-Ruel refused to touch Cézanne, pronouncing him dull compared to Monet or Renoir. But in 1907 Cézanne's posthumous retrospective at the Salon d'Automne was a sensation. As well as the bathers, Cézanne's portrait of Geffroy, with its tilting books and unusual perspective, fascinated the Cubists. Maurice Denis, who had painted a *Homage to Cézanne*, spread the rumour – whether it is true is not the point – that when Monet's work was going badly, Madame Monet turned the Cézannes in his collection to the wall. 'You have nothing to fear from the proximity of Cézanne,' Joseph Durand-Ruel reassured Monet in 1908.[34] It is the only known reference to Monet's self-doubt vis-à-vis another artist.

It was not a question of rivalry. The relationship with Cézanne had been one of mutual admiration. 'Cézanne used often to tell me that he

thought you were the greatest living painter,' " Joachim Gasquet told Monet,[35] and Monet never lost a chance to praise Cézanne. The conversation between Giverny and Aix ran on. Four days after Cézanne's death Monet bought one of his last landscapes, *Château Noir*, now at the Museum of Modern Art, and *Vase in the Garden*. Another tribute, in early 1907, was to paint a pair of still lifes, his only paintings in four years which were not water lilies. They draw attention to associations of the 1904-8 *Water Lilies* with stable/unstable still lifes: the water surface like a table top, the lilies like bouquets resting on them, and the effect just controlled, sometimes suggesting an irregular grid.

Charles Stuckey argues that 'the pond's moving surface as represented by Monet is the subdued counterpart to the jagged rhythms invented at the same time by the Cubists and Futurists, who were intent on extending the discontinuous spatial indications of Cézanne's works.'[36] It happened that Monet and Picasso were studying El Greco's spatial distortions and elongations at more or less the same moment: Monet visited Toledo in 1904 to view his works, and Picasso encountered *The Opening of the Fifth Seal* when society portraitist Ignacio Zuoloaga purchased it in Paris in 1905; it was decisive for *Les Demoiselles d'Avignon*. The Monet of the *Water Lilies* shared with the Cubists a reconceptualization of pictorial space, mystery, fragmentation, an impetus to abstraction, a hermetic self-contained language. That is not to suggest that Monet saw any connection, or kept abreast of what the younger generation was doing. 'I don't understand it but I'm not saying that it's bad. For I remember those who didn't understand my works and said, "It's bad",' was his comment on the early-twentieth-century avant-garde.[37] The late additions to his collection demonstrate the limits of what he enjoyed; in 1908 he bought a Bonnard and a Vuillard, younger artists whose Impressionist lineage was incontestable. His final purchase, at a wartime charity sale, was a hazy soft grey seascape, *Sailboats, Vesuvius*, of 1909 by Matisse's friend Albert Marquet. He bought it believing it depicted Brittany; when he was told it was a Mediterranean scene, the picture began to irritate him.

Insisting that his eventual *Water Lilies* exhibition be titled not 'Reflets' as Durand-Ruel wanted but 'Série de paysages de l'eau' (Series of Water Landscapes) in allusion to Courbet's seascapes 'Paysages

de mer' (Seascapes) he asserted his link to the French landscape genre, now waning after its long reign. The battleground for Picasso and Matisse, and for young artists for the rest of Monet's lifetime, was the figure, not landscape. Renoir, as well as Cézanne, were therefore of more interest to them than Monet. For the first time in his career, Monet was aware that he was no longer central to the progressive conversation. A protest-too-much letter against the 'paralytic' Matisse ('one cannot believe anything so stupid') from Mirbeau implies that this may have bothered him more than he allowed, though not enormously.[38] He was, as Roger-Marx said, 'pursuing the renewal of his art according to his own vision and his own means'.[39]

Coming to the end of the second *Water Lilies* series, he already looked ahead to building on it to something yet more abstract, imagining an immersive 'grand decoration'. He revealed to Roger-Marx in 1909 the intention, not fulfilled for many years,

> to use water lilies as a sole decorative theme in a room. Along the walls, enveloping them in the singleness of its motif, this theme was to have created the illusion of an endless whole, or water without horizon or shore. Here nerves taut from overwork could have relaxed, lulled by the restful sight of those still waters ... a refuge for peaceful meditation.[40]

For all their differences, around the same time Matisse expressed a similar ideal of an art of balance and serenity as soothing as a good armchair for a tired businessman. In both cases, what looked lucid and pleasurable, the equilibrium and rational delight of French painting made new for modern art, was complex and nerve-wracking to create.

'I am very tough on myself,' Monet admitted in 1907 when he destroyed thirty water-lily paintings, 'to my great satisfaction'.[41] He worked so hard, and became so fraught with the difficulties of this series, that in 1908 he collapsed, soon after he had agreed to display the *Water Lilies* at Durand-Ruel's even though 'from the moment that my new paintings didn't gain your complete approval, it seemed to be difficult for you to do the exhibition.'[42] In a competitive market, with the young Bernheims snapping at his heels, Durand-Ruel, despite his earlier doubts, was keen to present the show, whereas Monet, once he had

committed to it, became more and more reluctant. He suffered from dizziness and blurred vision, his signals of acute stress, and could neither complete nor judge the paintings. Was his reluctance to put new work before the public intensified by the blaze around Cézanne at the end of 1907? All spring Monet was, he complained to Durand-Ruel, 'not well, very tired, vertigo troubles me and I see less and less clearly. I see the moment where I will be forced to stop all work.'[43]

Alice watched as he destroyed painting after painting. On 15 April she wrote, 'Yesterday was bad for him, he destroyed three canvases and alas it's often like this'; the next day, 'He only blames himself, for his age, his powerlessness, he says.'[44] A glimmer of cheer came when the Bernheims visited on the way home from the seaside, bringing fresh shrimps: 'They knew well how to deal with Monet and lift his spirits; I am very grateful to them, provided it lasts.'[45] It did not. On 24 April: 'I have spent terrible days watching his anxiety, his discouragement. I had all the trouble in the world to stop him writing to Durand that he's giving up the exhibition.'[46] On 4 May: 'What a Sunday . . . Monet, already so badly disposed in the morning, refused to come to lunch and stayed shut up all day in spite of our entreaties. How sad it is when one has health, happiness, to make life a hell.'[47] On 5 May Monet cancelled the exhibition: he has 'written to Durand that he has shut his door to the world'.[48]

Monet's exhibition had been so eagerly awaited that its cancellation was world news, suggesting the reach of his global fame thanks to Durand-Ruel's American foray. A 'special cable to *The Washington Post*' on 16 May 1908 reported that Monet had ruined $100,000 worth of pictures just before the exhibition which 'already had been advertised in the French newspapers . . . with a knife and paint brush he destroyed them all.'[49] The London *Evening Standard* claimed superior knowledge, announcing, 'M. Monet has not sold or delivered a picture since 1904' and the new ones were 'overworked, that is, they showed too plainly how long they had stood on the easel. One of M. Monet's friends even went so far as to say that there were four or five different pictures on each canvas.' Having cut a few to shreds, Monet, 'extremely irritable and morose' turned them to the wall and would 'go away for a change and rest'.[50]

It was however now 'impossible even to get Monet to come to

Vernon or take a little walk; he stays in the studio without moving, without talking.'[51] Nothing, Alice said, 'can give you an idea of his sadness, his absolute decline . . . he stays all day without even reading and when I'm not there, he falls asleep.'[52]

Two old men finally jolted him. The first was faithful Mirbeau: '*Vous voilà* demoralized again! A man like you! It is mad and sad. You have done all that a man can do *de grand* . . . there are dreams, beyond life, which a strong soul shouldn't attempt to reach, because they are unrealizable . . . what you feel, what you see, is a domain vast enough, infinite enough for you.' Mirbeau had seen some of the *Water Lilies* at Durand-Ruel's, before the exhibition was cancelled: 'it's simply vertiginously beautiful . . . works already as eternal as masterpieces. I tell you this because it's what I think, it's what everyone thinks, because it's dazzling. You are without doubt the greatest, the most magnificent painter of our times.'[53] This had some effect. 'Fortunately, his authoritative voice succeeded better than us,' Alice said tartly. Monet 'reread this letter with joy and seems less black'.[54]

The second, a shock, was 78-year-old Remy, husband of Alice's imperious sister Cécile. On 6 June 1908 he was stabbed to death in his Paris home by his butler, Monsieur Renard, in the presence of Cécile and Alice's seventeen-year-old nephew Léon Raingo. This too made international news: American papers revelled in a tale of Parisian decadence exemplified by the 'astounding state of affairs in the banker's household'.

Apparently Renard had control 'over the banker's wife to such a point that the keys to her money and jewelry box were always in his possession', while Léon confessed that his relationship with Renard 'had been of a scandalous character'. Poor Remy, therefore, 'often complained of Renard's growing domination in his household, but his wife defended the butler'. Finding 'his nephew and Renard together', Remy finally 'informed his wife that he would no longer endure the situation', would sack Remy and send Léon 'to a disciplinary school . . . Mme Remy refused to believe the stories told her, and in company with her maid, she left the house. That same night . . . M. Remy and Renard quarrelled during the dinner and Renard killed the banker by stabbing him with a dessert knife.'[55] Renard was sentenced to penal servitude for life and transported to Guiana in 1909. Léon's youth

and bourgeois credentials saved him from further investigation. Cécile retired to live comfortably at her property in the Loire.

After Remy's funeral in Paris, Alice reported, 'My dear Monet has got back to work at last, which isn't too soon.'[56] Some eighty *Water Lilies* had survived the culls, and having their motif constantly before him, infinitely open to revision, was a blessing and a curse. Monet told Geffroy in August that 'these water landscapes have become an obsession. They're beyond the strength of an old man, but I want to succeed in rendering what I feel. I've destroyed some, I've started again, and I hope that with so much effort, something will come of it.'[57] Only when the season appeared finished did he yield, with a bad grace, to Alice's insistence on a short trip away. '*Voilà* (and I was waiting for this) Monet very sad . . . to leave, he can't bring himself to give up his pond and his flowers. I've heard this so much that, really, it spoils the pleasure of the journey.'[58] But she booked a night in Paris at the Hôtel Terminus on 29 September, and next day the couple took the train from the Gare de Lyon for what would turn out to be Monet's final painting campaign away from home. Just before their departure, Durand-Ruel received a scribbled note of their destination: 'Palazzo Barbaro, Venise'.

22

Death in Venice, 1908–14

On reaching Venice, Alice found, like Proust, that her dream had become her address. The Palazzo Barbaro on the Grand Canal, which Mary Hunter was renting for a season, was '*le grand luxe* ... where your wishes were realized as you were forming them'. Mrs Hunter 'pays for everything', and gave the couple 'perfect comfort and complete freedom'. They slipped out each morning before eight, 'alone, Monet and me, by gondola'.[1] They became tourists: they saw the Tintorettos at San Rocco, went to the Lido, ventured inside St Mark's and on the piazza had their photograph taken feeding the pigeons, one perched on Monet's head while Alice grimaced cheerfully at the birds flapping around her. She thought Venice 'a perpetual enchantment ... the hours pass as quickly and gently as the canal. The weather is always radiant ... We had to have the dais on the gondola ... the days go past, always in a dream and rapture.'[2]

The Barbaro was full of artistic and literary ghosts. Sargent, a frequent guest, had painted his Royal Academy diploma piece of 1899 here: the palazzo's American owners Daniel and Ariana Curtis in their huge, ornate salon. In the library in 1902, Henry James had written *The Wings of a Dove*, about a young woman dying in this very palazzo. He was in residence there too when his friend Constance Fennimore Woolson jumped to her death from the Palazzo Semitecole opposite. His macabre account of rowing out to the lagoon to drown her dresses which kept billowing back to the water surface like black balloons summed up the city's reputation in the years before the First World War as stunning but deathly.

Monet began painting tentatively, playing down the effort to Durand-Ruel, who immediately offered advances. Outdoing him, the

Monet and Alice in St Mark's Square, Venice, 1908

Bernheims, to Monet's horror, proposed coming themselves to Venice. But where the dealers envisaged a profitable repeat of paintings depicting a famous watery city, Monet saw the dragon of cliché, Venice itself a work of art, impossible to set down on canvas, or at least he was 'too old to paint such beautiful things'.[3] His London paintings had transformed the grimy capital. It was another challenge, looking out from Alice's 'fairy-tale palace' of the Barbaro, to address a city that sold itself as enchanted. But she never doubted. Venice 'is so beautiful and so created to tempt you, but who can render those marvellous effects? I see only my Monet who can do it.'[4]

She detailed the schedule: eight o'clock at San Giorgio facing San

Marco, ten o'clock back on the mainland at San Marco facing San Giorgio; then after lunch Monet worked on the steps of the Palazzo Barbaro, and from three they took a gondola ride, returning at seven after admiring the sunsets. The chief subjects were the Ducal Palace and its liquid reflections as seen across the water, San Giorgio seen in the morning and also in later afternoon light, plus some flaming sunsets, and the close-up views painted from Palazzo Barbaro. These included foregrounds of tall gondola poles rising from the water with the grand, domed Salute church in the distance, such as *Grand Canal, Venice* [Plate 47] and façades of the *palazzi* Contarini, Dario [Plate 48] and Mula, lining the Grand Canal as it curves past the Accademia Bridge and towards the Dogana Spit. 'Disfigured and dishonoured as they are, with the bruises of their marble and the patience of their ruin, there is nothing like them in the world,' Henry James wrote of these palaces.[5]

In 1900 the Princesse de Polignac, the Monet collector, had bought the Contarini, now renamed Palazzo Contarini-Polignac, and the Monets accepted an invitation to her Salon, but this was an exception; otherwise, Alice said, their life was as regular as a sheet of music. Asked how she spent her days, she explained, 'during the sessions at San Giorgio . . . I can sit close to Monet on firm ground; I spend the rest of the time next to him in the gondola, letting ourselves be rocked by the waves of the passing boats: steam ships, etc., and I can't do anything or move while Monet paints. The hours pass in this contemplation.'[6] Her letters were scrawled 'lurking in my corner, while Monet paints . . . in the covered gondola with its black cabin, a real catafalque'.[7]

The funereal reference was pointed. The sense of a late bonus threads through both Alice's letters – 'what joy to be able to add these luminous hours to the end of our lives'[8] – and, more soberly, Monet's: 'what misfortune not to have come here when I was younger, when I had all the boldness. Still . . . I've spent delicious moments here, almost forgetting that I was the old man I am.'[9] The trip had a honeymoon aspect: 'we live like two hermits in our dear and perpetual tete-a-tete', time suspended with the swaying boat.[10]

The paintings follow that rhythm. They are not a series concerned with nuances of time, rather here was purely the atmosphere of sun and haze peculiar to Venice, water everywhere between Monet and the buildings, light darting off their façades, the Salute and San

Giorgio churches shape-shifters vanishing in the shimmer, the Doge's palace a thick buttery fortress mirrored as brilliant yellow interwoven with turquoise. The colours are deep and sometimes – the San Giorgio twilights, the purple-blue Salutes – so fantastic that one wonders if Monet were answering Derain's Fauve Londons of 1906. The buildings, however, have a floating quality which recalls less London than the tilted planes and sloping surfaces of his pond, which Monet had been depicting for years with only the lily pads as an anchor point. But here he was seeking a different working experience: not a long project, but something self-contained, rapidly notated. Alice told Germaine it was a miracle he had left his garden and was painting, '*entre nous*, something else than the eternal water lilies'.[11]

When in mid-October Mrs Hunter vacated the palazzo, Monet and Alice moved to the Hotel Britannia, also on the Grand Canal and chosen for its vista. Alice opened the window and pronounced it all laid out for Monet. She also thought magical the electric lighting, which allowed Monet to see his canvases in the evening; it was duly installed at Giverny in 1909. The more fashionable and peopled Hotel Danieli, favoured by visitors from Ruskin to Zola to Proust, was rejected because the boat stop outside blocked the view.

From the empty, unheated Britannia, Alice chased from shop to shop to find knitwear for Monet, who had refused to anticipate that he would still be here in cold weather. An encounter with the painter Louis Aston Knight wrested from the reverential young man his fur coat, without which Alice thought Monet would have had to go home. Wearing it, he was still painting outside in a frosty December, with cold feet and cracked hands, while Alice piled her clothes on top of each other and said she looked like a 'purée complète'. Monet was entirely absorbed, leaving his correspondence to her. 'He has been completely gripped by Venice,' she told Geffroy. 'I can't tell you enough the joy I feel from seeing him like this . . . What unforgettable days I've spent here, not leaving my husband's side, and following every brushstroke. You'll come to Giverny, won't you, to see these marvels, these wonderful reflections, this pearly water that he alone can render?'[12]

More than ever his painting bound them together and to an unquestioned goal. But as weeks turned to months, Alice missed her children and the cemetery and longed for home. Once so fiery, she now for

Monet's benefit moderated or hid every desire. She cut short a visit to pray at the Salute because Monet insisted on coming with her. The thought of seeing Germaine in Les Brighières in Cagnes en route back was sustaining, but she did not dare invite her daughter to Venice: 'God knows what joy I would have from that, but Monet would then find it useless to go to Les Brighières, saying that I'd seen you. So, I'm keeping this wish buried deep in my heart, letting it out a little only to you.'[13] Monet agreed to break the journey, but for one night only. Alice did not negotiate, she merely hoped that Renoir would be at home, because that would keep Monet there longer.

He was: Renoir, urged on by his wife Aline, was supervising the building of his new Cagnes home, Les Collettes, completed in November 1908. 'This house disappointed him . . . It was too big. It crushed him,' his son Claude recalled. 'My mother had won . . . finally she had a house that suited her', and it was gratifyingly larger than that of her neighbours.[14] 'The doors and windows have the shoddy lozenges of those pseudo-Louis XVI villas thrown up in haste . . . overnight by speculators' was the dealer René Gimpel's snobbish impression, though 'the view of the sea and countryside is beautiful'.[15] Of Aline in the new garden, Renoir sniped, 'to plant at this age doesn't amuse the old man, but amuses my wife more than one would have thought possible.'[16] This was how Alice and Monet found them in what became a four-day stay, its culinary highlight Aline's bouillabaisse, and 'No, I don't loathe Mme R. as much as you think,' Alice told her daughter, 'on the contrary I'm grateful for her kindness to you and think it's also very good for Sisi to see other children, and Claude seems a very nice little playmate'[17] In a photograph dated 12 December 1908, three generations – Alice, Germaine, Simone – stand brightly in a line in the garden at Les Brighières. Monet sits apart, on the grass, one hand stretched to touch Alice. She leans towards him, her hand on his shoulder, pulling him into the family group.

At home in Giverny, the dealers were at the door. On 18 December Monet sold all the Venice paintings to the Bernheims at 12,000 francs each, though none were finished. Bitter for Durand-Ruel, the treachery may imply that Monet thought the Venice canvases lesser works, or he wished to ally them, with their buoyant Fauve colours, to the modernity which the Bernheims were championing. They had held an important first retrospective of Van Gogh in 1901, and signed a

contract with Matisse in 1909. Durand-Ruel did not try to understand Matisse and thought Van Gogh's reputation over-hyped. He was punished for his loyalty, his restraint, and just for being old. The Bernheims had crept into the elderly Monet and Alice's affections through their youth and high spirits. Alice approved the Bernheim deal and enjoyed Monet's sang-froid. 'Yesterday Durand arrived ... saying that the idea of not having something from Venice had made him ill and that, seeing them, he is now more so!' Monet told Durand coolly 'Yes, the Bernheims are cunning to have twisted you like this.' "[18]

But since the 1880s he had distributed his favours, and the bigger prize went to Durand-Ruel when Monet explained to him, 'My trip to Venice has had the advantage of making me see my canvases with a better eye ... you can absolutely count on me, I am ready.'[19] The *Water Lilies* show was fixed for May. So 1909 began full of promise. Geffroy sent a festive gift of guinea fowl. Mirbeau visited on New Year's Day and loved the Venice paintings. A repeat trip in the autumn, via Cagnes, was a certainty, Alice promised Germaine.

She had hardly penned the words before she collapsed in pain and was unable to eat. Monet gobbled the guinea fowl alone and blamed his wife's exhaustion on the exertions of Venice and Cagnes. By February, this was less persuasive. Alice was so weak that she stayed in bed for two months, and Monet, intensely anxious, suffered from vertigo and terrible headaches, which prevented him from painting.

She emerged from her room in time for Durand-Ruel's *Water Lilies* exhibition, which astonished audiences. 'None of the earlier series,' wrote Jean-Louis Vaudoyer,

can compare with these fabulous *Water Landscapes*, which are holding spring captive in the Durand-Ruel Gallery. Water that is pale blue and dark blue, water like liquid gold; treacherous green water reflects the sky and the banks of the pond and among the reflections pale water lilies and bright water lilies open and flourish. Here, more than ever before, painting approaches music and poetry. There is in these paintings an inner beauty, refined and pervasive, the beauty of a play and of a concert.[20]

'Can these even be called paintings?' asked *La Vie parisienne*'s critic. 'As you look at these marvels, you are frightened to speak, to smile, to breathe ... convinced that in the depths of a half-open sky, you have

surprised a garden favoured by the gods.'[21] The inspired young art historian Louis Gillet in *La Revue hebdomadaire* connected the *Water Lilies* to the feathery pleasures of French rococo painting, noting a shared sensibility with Watteau's *Embarkation at Cytherea* – Monet's favourite Old Master: 'What *fête* could be more delicate than this scene without people.'[22] In the twenty-first century, it is the later monumental *Water Lilies* that are iconic, but the 1909 show was the one by which audiences for the rest of Monet's life remembered his water lilies. Among the visitors was Proust, who saw it, his biographer Jean-Yves Tadié points out, 'at the very moment that he was beginning to write about a painter in his exercise books'.[23]

'Great, enormous success for my Monet! What joy for me, what an unforgettable day! A mad, enthusiastic crowd at Durand's,' Alice wrote after the opening on 6 May.[24] The exhibition's triumph, and the birth of her grand-daughter Nitia, for which Germaine came to Giverny in September, were her great pleasures of the year. But in her diary, just before Nitia was born, she wrote, 'Monet sad and discouraged, suffering, not working ... me so weakened. Feeling myself so overcome and hiding it.'[25] A return to Venice was out of the question. Although financially rewarding, with earnings of 227,000 francs, Monet concluded to Geffroy in December that '1909 has been absolutely disastrous, I haven't done anything, not touched a brush.'[26]

1910 opened as badly: 'The year hardly began well here, my wife always suffering ... I no longer think of my work and see everything in black.'[27] This cry to Geffroy recalls one from thirty years before, spoken to Hoschedé about Camille in 1879: 'My wife ill most of the time. I am utterly discouraged and can no longer see or hope for a way ahead.'[28] Nature repeated itself too. The freeze and flood wreaking destruction along the Seine in 1879–80, just after Camille's death, was the worst in living memory until the one of 1910. It threatened to swallow Monet's garden at a time when Alice's decline became harder and harder to explain.

Blockaded into the upper floor of Le Pressoir, she appreciated 'the beauty of all this' as water washed over the snow-clad ground in January. 'C'est le déluge universel,' she told Germaine; 'from Monet's windows, you can see no more than an expanse of water. the poor *bassin* is overflowing, the paths flooded ... only the big brambles

come through; the rhododendrons, the azaleas are under the water. Monet speaks only to groan.'[29] The Seine rose a record eight metres in Paris, causing the most severe flooding since 1648, and in Vernon to seven metres. Giverny, on a hill, fared better but the water came half-way up the central path of Monet's garden, and the village was only passable by boat. Road and rail links were cut, and sixteen-year-old Jim Butler rowed around the streets delivering supplies.

Monet and his head gardener Félix Breuil outdid one another in pessimistic scenarios. 'Monet's discouragement, like the Epte, doesn't subside,' Alice wrote. 'Monet more and more excessive (everything is lost, things will never come back, he must sell the house, the car).'[30] The waters rose again in March, eventually receding to leave the sur-viving plants layered with mud, straw, dead animals and a disgusting stench. Monet admitted to being the 'perfect egoist, I only thought of my garden, my poor flowers'.[31] But that was to keep at bay a greater terror. Alice was becoming spectral. Mirbeau wrote full of concern for 'votre femme souffrante ... I know her well ... and what must be going through her head, and in her heart, full of concern to spare you.'[32]

Monet had to accept, he told Geffroy in April, that Alice was ser-iously ill: 'We're so worried that I can't think straight any more'. Alice had acute myeloid leukemia. Radiotherapy was 'the only thing that could save her', though it could not reverse the disease.[33] X-rays had only been discovered in 1895 and the new treatment had as yet no clear proof of success. Monet held to that 'very faint hope remaining, but it is a hope', and the treatment did bring some improvement.[34] After it, Alice could get up for half an hour a day, then an hour. The Bernheims were pressed into service to source an invalid's chaise longue; it arrived next morning, 14 May, and Alice 'stayed stretched out close to the open window and at last benefited from this rare good day'.[35] Still Monet existed in the 'anxiety which kills little by little' as Renoir wrote in sympathy;[36] Aline Renoir frequently asked for news of Alice from Les Brighières, and was a support to the distraught Germaine.

A remission in June allowed Alice to get as far as the garden. 'It's a true paradise, all the irises in bloom, all the poppies, the azaleas, the roses,' she reassured Germaine. Very slowly, she walked the gravel paths and ventured to the pond which 'has suffered, the rhododen-drons among others hardly flower', but had recovered better than

Monet, Alice and her granddaughter
Lily Butler in the garden, Giverny, July
1910

expected.[37] Monet persuaded himself the same was true of his wife. Her improvement, he insisted to Julie Manet, 'is more than progress, it's a veritable resurrection'.[38] But no one who saw Alice, ashen, white-haired, looking far older than her sixty-six years, bringing all her resources to stand and face the camera, as she appears in photographs on the bridge with her pretty teenage granddaughter Lily in summer 1910, could have thought she would endure much longer. On 27 July she described in her journal 'poor Monet whose desperate look said that death was very close'[39] and on 6 October she said she felt doomed, and suffered for being an obstacle to Monet the painter.

She continued radiotherapy, and Monet continued to believe in his wife as a life force. 'What vitality in spite of everything,' he told Geffroy in December, though 'at times I am so distraught I don't know what I'm doing.'[40] From January 1911 he no longer left her side. Still, Durand-Ruel visited on 26 March and spent 113,000 francs on eight water-lily paintings, and Geffroy remembered that 'until the last days' Alice welcomed Monet's friends 'with the same affection and the same smile' as always.[41] By April there were no more visitors: an invitation to the Bernheims, whose company Alice always enjoyed, was cancelled and on 7 May Monet informed Geffroy, 'My dear wife is lost. It's only a question of hours. I don't know what will become of me. I am annihilated.'[42] Alice, who had insisted on the last rites for Camille, did not

receive them herself. Was she too weak to ask, did the idea not cross Monet's mind, did he fear to frighten her, or had suffering taken away her faith?

On 19 May 1911 a telegram to Durand-Ruel announced, '*dénouement fatal* this morning at 4 o'clock', followed by a note to Geffroy: 'It's over, my adored companion dead ... I am lost.'[43] Alice was buried alongside her first husband and their daughter Suzanne on the morning of 22 May. Among the mourners Geffroy noticed a fumbling, nearly blind old man, long distanced from Monet but come to represent the old group: Degas. Monet relived 'that terrible day' over and over. 'I want to tell you all the good your presence did me ... from the depths of my heart,' he wrote to Geffroy. 'In spite of the children's tender affection, I feel myself floored, demolished by this cruel separation ... Thank you for your encouragement, but this is stronger than I am. I have to mourn my dear companion, and alas, I am mourning her.'[44]

'With Monet, there is nothing to fear, he will certainly take up his brush again, because he has not yet finished expressing himself,' Geffroy assured Jean-Pierre at the funeral.[45] To Monet he insisted that work 'is the only consolation of artists and of men. You still have big and important things to do.'[46] Clemenceau recommended the old Rembrandt as his example. Monet felt all this, but helplessly. 'I have to be able to work to conquer my grief, and I can't do it. I have no taste for anything,' he told Rodin.[47] Durand-Ruel's renewed Sunday lunch visits were a comfort and in August his car brought Renoir and Gabrielle, his model and maid, who reported to Vollard that Monet 'is still crying over his wife's death on the banks of his pond'.[48] Monet greatly appreciated this effort from the emaciated, ancient-looking Renoir, 'always valiant, in spite of his sad condition, while I lose all courage, despite being the healthy one ... I can't get used to my sad existence.'[49]

Every morning Marthe came to supervise the running of the house, and when the Butlers went to Paris, Blanche arrived from Rouen to take her place. The sisters often found Monet buried in Alice's letters, weeping. 'You know how much I loved her and how unhappy I am,' he told Germaine.[50] To Geffroy he said his only comfort was 'to reread all my dear wife's correspondence and to relive almost all our life'.[51]

Paul Durand-Ruel, *c.*1910

Later he burnt Alice's letters – though not the hundreds that he had written to her.*

In October he made a trip thirty kilometres north to Bernouville, the estate of Clemenceau, who had a positive impact. On his return he resolved to finish his Venice pictures, which felt a way of staying close to Alice: 'I do not stop thinking about her while painting. We were both so happy during that stay; she was so proud of my ardour.'[52] But he quickly lost faith, telling Geffroy at Christmas, 'I had got back to work and thought myself saved, but I am no longer good for anything and am disgusted by what I am doing,'[53] though he allowed the Bernheims to schedule the long-delayed Venice show for 1912. He was most open with Blanche: 'All I've done is to completely spoil several Venice canvases. I would have done better to keep them as they were, in memory of such happy days spent with my dear Alice ... I can only say that

* The likely explanation is devotion and protection of Alice's privacy, possibly connected with the irregularities of their early relationship; Jean-Pierre's second wife Elisabeth subsequently burnt parts of Alice's journal, from the period following Camille's death. These obliterating gestures also cast light on the absence of letters to or from Camille. There is no evidence that Alice destroyed them in a fit of jealousy, as has been suggested. Monet's peripatetic, disorganized life with Camille makes it likely that letters would have been lost; nonetheless, the absence of a single word written by or to Camille is extraordinary. If Monet destroyed her letters as he did Alice's, the goal may similarly have been protection.

nothing works, that I no longer sleep, that the days are as long as the evenings and as the nights. Wouldn't I have done better not to write?'[54]

Meanwhile the formal division of Alice's estate dragged on. As the Monets had married according to the system of *séparation de biens*, her property consisted only of furniture and decorations in her bedroom and her personal effects, a meagre inventory of dresses, dressing gowns, petticoats, furs, sets of buttons, fans, jewellery, and a Christ 'embroidery on velvet', to be distributed among her daughters. These paltry possessions demonstrated both how the Hoschedé children owed their material comfort to Monet, and the gulf between what Alice's sons and Monet's sons, brought up together, could expect to inherit. To Jacques, having kept his creditors at bay as he awaited his mother's death, with inflated hopes of his inheritance, and still raging against his father's usurper, this was intolerable.

He went to court to demand the return of Manet's portrait of him at Montgeron, *Child among the Flowers*, which neither Alice nor Hoschedé nor Monet had ever owned; Jacques claimed it had hung in his mother's bedroom before her marriage, and Marthe and Germaine were summoned as witnesses, in a raking over of her personal effects during her pre-marital relationship with Monet which would have mortified Alice. For Jacques, the absent picture symbolized the disappearance of his Montgeron childhood. Then he offered Monet a picture he owned. 'I have tried in vain to propose that my brothers and sisters as well as Monsieur Monet buy a portrait of my mother by Carolus-Duran from me in order to get out of the awful situation in which I find myself. It seems that, like my future, this portrait holds no interest for any of them.'[55] This was Carolus-Duran's 1876 depiction of Alice at Montgeron. Monet wanted it, but not at the cost of doing business with his stepson. He waited until Jacques had sold the portrait to a dealer, then bought it for 350 francs.

He could not forgive the suffering Jacques had caused Alice: 'In spite of the memory of his mother who loved him so much, and perhaps even because of it, I no longer want to hear him mentioned.'[56] The end of his relationship with Jacques was part of a wider recalibration with the Hoschedé children. Following their mother's death, the two who had settled in Giverny moved away: Jean-Pierre to his wife's native

Périgord, and Marthe and Butler, taking the teenage James and Lily, to New York. They lived in America from 1913 to 1921.

Back to Giverny came Jean and Blanche. In poor health, Monet's older son was struggling with his fish farm. He may have had syphilis. Monet believed he became ill after a trip to a chemical factory in Switzerland working for his uncle. He had been taking cures since at least 1907, and was neither strong nor strong-willed. Monet had been concerned about his health for some time, but Jean was not his primary concern until he had a stroke in 1912.

His shock then was comparable to the anxiety caused by Jean's arrival forty-five years before: two weeks after his son's stroke, Monet, terrified, lost the sight of his right eye, just as he had temporarily gone blind while waiting in Sainte-Adresse for Camille to give birth. This time there was a physical basis, for he was diagnosed with cataracts, the result of a lifetime exposing his eyes to bright sunlight. But the uneven development of the symptoms in the next decade suggests stress made his sight worse, and on pessimistic days, he imagined himself blind. He paid to extract Jean from his failed business, and bought the couple a little house in Giverny, the Villa des Pinsons, 'but how sad! . . . my poor child's health gets worse every day.'[57] Some of his son's suffering was mental and emotional. 'At times silent and withdrawn, at others incoherent and rambling, Jean showed little awareness of reality.'[58]

Mirbeau called the Venice pictures, which the Bernheims showed in May 1912, an 'appeasement', a taste of 'the sweetness of your tragic memories'.[59] Monet's *palazzi* paintings especially, their contrasts of sun-warmed pink or yellow stone, deeper purples and dark swirling water, are voluptuously melancholy, with thick slashes filling voids of tomb-like windows – monuments to emptiness, reflected in broad cursive marks in watery foregrounds. Monet had taken Ruskin in his luggage to Venice and the water lapping against shaded stone calls to mind Ruskin's cadences chanting time: 'the fast-gaining waves, that beat, like passing bells, against the STONES OF VENICE'.[60] Begun in joy, when completed Monet's Venice paintings were eloquent of tragedy. They made their public appearance the same year as Thomas Mann's *Death in Venice*, with which they share memories of love and decay, and a balance between precise description and free expression. Charged with his last happy memories of Alice and the sense now that

'age and grief have exhausted my strength',[61] these emotional paintings were Monet's own 'Death in Venice'.

He told Durand-Ruel, 'I know well in advance that you will find my canvases perfect. I know . . . they will have a huge success, but I am indifferent to all that because I know that they are bad, I am certain of it.'[62] Still, he kept a painting of the marble-encrusted Palazzo Dario as a memory, and it was a gold-framed Dario too that Vuillard depicted above the brothers' mantelpiece in his *Portrait of Josse and Gaston Bernheim-Jeune'* in 1912. The Bernheims thus yoked themselves to Monet's Venice just when they were risking wilder ventures – Paris's inaugural 'Futurism' exhibition took place in their gallery just before 'Monet Venise'.

This exhibition, acclaimed as expected, and winning plaudits even from young critics such as Picasso's apologist Guillaume Apollinaire, closed a phase in Monet's career. He never had a solo exhibition in Paris dedicated to new work again, and no solo exhibition there at all between a small display at Durand-Ruel's in 1914 and a retrospective at the Bernheims in 1921. His very first one-man show, at Charpentier's in 1880, and the 1912 'Monet Venise', both planned with and approved by Alice, bracket their life together. For thirty years she urged and supported his ventures in Paris's leading commercial galleries, with increasingly elevated prices. The Bernheims' 1912 show was the coda. After it, Monet's relationship with the market changed, galleries became less important, and his primary concern was no longer easily saleable easel pictures. The stage was cleared for the last act.

When the Venice show closed, there was at first a blank. 'I sacrificed my art for her, to think only about her and to devote myself to care for her better, to save her, in vain, alas! The painter is completely dead, there remains an inconsolable husband,' Monet wrote to Germaine.[63] But although 1912–13 seemed fallow, and just five paintings survive from these two years, they were a preparation for something new, as Monet in mourning reconsidered painting his garden. He felt 'like a beginner having to relearn everything', and, with the two paintings of his house covered by vines, seen across flowers and trees, in 1912 it is clear that he is reacquainting himself with the motif.[64] But the three paintings from 1913, delicate, fluttery depictions of the rose-draped pergolas forming an arch on the edge of the pond, are pivotal. They look back – the floral arcs, repeated as reflections interwoven with

bright lilies, carry echoes of the Japanese bridge pictures, and the soft luminosity and liquid foregrounds are reminiscent of those of Venice. But they also look forward: through this arch Monet's re-entered the world of his water lilies.

He was confident enough of the pergola paintings to allow himself to be photographed while retouching one of them, and there were signs throughout 1913 of reviving spirits. Before the Butlers' departure for America, Michel drove his father in a new car for a farewell holiday with Jim and Lily, to St Moritz. The highlight was seeing the glaciers from the Bernina Express, and Monet admitted the trip was beneficial. In the summer the American opera singer Marguerite Namara came to give a recital at Giverny, and Monet 'asked if I knew the soprano-baritone duet from *Le Nozze di Figaro* of Mozart. Of course, I did, and we went right into it. We sang the entire thing, including the recitative; he knew all the words. His voice was not a very beautiful sound, but it was on pitch and full of vitality and energy just like himself.'[65]

On his visit to Giverny the same summer the actor Sacha Guitry, twenty-eight, photographed Monet in a big panama hat, his eyes sad, but with a hesitant smile (see p. xx). His young friends brought out his vivacity, whereas in Giverny the spectacle of his invalid son sapped it. Monet cuts a determined yet beleaguered figure, alone in the studio-gallery hung with his pictures, in a photograph taken in November 1913 for an interview in the journal *Je Sais Tout*, to which he consented reluctantly, to please Durand-Ruel. Suggesting that the mural project had returned to mind, the prominent images in the photograph are two large water-lily experiments from 1897. grouped with *The Red Cape*, the portrait of his first wife passing like a stranger outside their Argenteuil home in the snow, also occupies a significant place; this ghostly picture of Camille, whom Jean resembled in looks and fragility, may have had a connection to Monet's agony in watching their son deteriorate.

Monet retired to bed with flu on New Year's Day 1914, and stayed there for several weeks. Blanche nursed him as well as her husband. Monet recovered and 'everything would be fine,' he wrote to Guitry's wife Charlotte Lysès on 5 February, 'if, alas, my older son were not *very ill* today. What a torture for me to witness this collapse right here in front of me, oh how hard this has been.'[66] Jean, delusional, was taken to Monet's studio, where he remained, too ill to be moved. He died there in

the evening of 9 February, aged forty-six. 'I knew that my poor son was incurable, but it's no less dreadful for me and for his poor wife. Our consolation is to think that he is no longer suffering, because he was a true martyr.'[67] Jean was the first Monet to be buried in the Hoschedé tomb in the Giverny cemetery. Monet followed the cortège up the hill but did not enter the church for the funeral service. Blanche chose the inscription on the grave for her husband, *Priez pour lui*, 'Pray for him'.

Responding to condolences, Monet thanked his correspondents on behalf of himself, 'my Michel' and 'my poor daughter, so admirably devoted and so courageous. She doesn't want to leave me for the moment, which will be a comfort to us both.'[68] Blanche never did leave him. Le Pressoir became her home for the rest of her life. Her support was called on immediately. Michel needed minor surgery in March, and Blanche stayed at the Hôtel Terminus in Paris with Monet as he awaited news of the operation.

Blanche's effect on Monet was so rapidly beneficial that it seems shocking. 'I am marvellously well and obsessed by the desire to

Monet in his first studio, 1913

paint ... I count on beginning great things,' he wrote to Geffroy in April, two months after Jean's death.[69] 'Thanks to work, the great consolation, all is well,' he followed up to Durand-Ruel in June. 'Up at four, I work hard all day, and by the evening I am completely exhausted', and, most revealing of the transformation of his spirits, 'my sight is fine again'.[70] Durand-Ruel had just lost a daughter, and Monet wrote in solicitude for their shared tragedy, but he was at a different stage in the absorption of grief from his friend's sudden bereavement, which brought to an end the 82-year-old dealer's career – he retired and his two surviving sons (a third had also died) took over the business. By contrast Monet had been mourning his son since 1912, enveloping one sorrow into another after the loss of Alice. In the sense that he had found it unbearable to watch Jean suffer, his death was a relief.

It was also, although there is no reason why Monet would have seen it like that, a sacrifice. If Camille's death in 1879 set Monet free for romance with Alice and new vistas for his work, Jean's death delivered Blanche to Monet, and her cheerful presence, understanding and attention created the conditions for his new project, the *Grandes Décorations*. The ten-year-old who had carried the canvases at Montgeron now, at forty-eight, gave up her own painting, and devoted herself entirely to Monet's, as if it were the only thing she had ever wanted to do. 'She always accompanied Monet to his painting site and, as in the days of old, carried his equipment, changed the canvases on the easel as the light ... changed.'[71] That the cost to her was not negligible is implied by the joyful landscapes to which she returned immediately after Monet's death, but she never uttered a word of regret, and in photographs from 1914 onwards she is always smiling.

'It would be a great pleasure for me to show you the start of the vast work I have begun,' Monet invited Geffroy in July 1914. 'For two months now, I have been working without interruption.'[72] The journalist came, but a repeat visit had to wait. 'If there is a clearing in the black sky of Europe, it goes without saying that I will take the train to Vernon, and Giverny,' he wrote to Monet on 31 July.[73] Geffroy was acquiescent about war: 'we must endure the catastrophe that has befallen us.'[74]

When France mobilized, on 2 August 1914, Monet was seated at the edge of the pond, under the shade of a white parasol, exploring in wide strokes the pattern and colour of water, flowers and the reflections of his

weeping willows. 'Bravo! Monet's large water lilies are marvellous targets for firing practice!' Renoir declared in a fit of patriotic sarcasm.[75]

An American visitor, Mildred Burrage, left a record of Giverny just before the First World War. 'The meadows stretch out to the Seine. Beyond the river the distant hills lie blue and purple in the summer air. The wheat fields beside the road are full of vivid scarlet poppies, with here and there a dash of blue cornflowers. Everywhere there is a stillness, a calm, a perfect peace ... Giverny itself is a little village lying in this happy valley.'[76] Almost overnight in summer 1914, it became desolate.

The young left for the front, and memories of the Franco-Prussian war drove many to flee northern France after Germany invaded Belgium on 3 August. Pouring on to dusty roads were processions of peasants driving their cattle and sheep, the very old and children loaded on carts. Germaine, in Giverny that summer, rushed with her daughters to Aunt Cécile Remy in Blois when her husband was called up. The American artist couple Mary and Frederick MacMonnies set up a makeshift hospital in their Giverny home, for which Monet's kitchen garden supplied the vegetables. From America, Butler and his friend Philip Hale sent donations for the wounded. Monet, indifferent to the Franco-Prussian war, was very patriotic now, but thought 'a mad panic has seized all our country'. Blanche should feel free to go, he told Jean-Pierre's wife Geneviève, but 'half my life is here' and 'I'm staying ... if those savages must kill me, it will be among my canvases, in front of my life's work.'[77] This was, he knew, unlikely – and it was inconceivable Blanche would leave him. She remained in Giverny through the First World War, to care for Monet, and also through the Second, to guard his paintings. Altogether she lived at Le Pressoir for forty-seven years – longer than Monet lived there himself.

'We are as if lost here,' Monet wrote on 8 August to the Bernheims.[78] Michel, declared unfit for military service because of his recent operation, volunteered, and was awaiting call-up when he travelled to bid farewell to his childhood companion, as usual a step ahead of him and already mobilized. Jean-Pierre departed on 10 August to join the transport corps. Michel handed him Monet's farewell letter: 'Don't fail to send us your news, above all be brave and careful and know that our hearts will be with you. Think of us, those who remain are not the least to be pitied.'[79]

Monet photographed by Sacha Guitry, 1915. The inscription
is 'to G. Clemenceau, his old and faithful friend'

23

Blue Angel, 1914–20

Three times in his career Monet began monumental decorative projects, spectacularly beyond the size of an easel; each coincided with a woman entering his life, opening opportunities for his painting, spurring a fresh level of ambition. *Déjeuner sur l'herbe* celebrated, and was made possible by, Camille, his new girlfriend in 1865. The Montgeron panels, inaugurated by the *Turkeys*, were created when he met Alice in 1876. And the *Grandes Décorations*, a group of multi-panel water-lily paintings which by 1920 covered some 170 square metres of canvas, could not have happened without Blanche's return to live with him in 1914.

Blanche broke the spell of what he called 'three years of horribly cruel mourning'.[1] From now on, 'no one could imagine not seeing Blanche at Monet's side, always and everywhere,' Jean-Pierre said.[2] Paul Valéry's daughter Agathe described '*la petite Blanche*, round and reassuring with her apple cheeks and a smile shining gold', waiting to greet visitors at the porch.[3] René Gimpel remembered her appearing with a tray of liqueurs, a shining figure: 'white hair and a youngish face with high colour'.[4] The Duc de Trévise called her 'the good fairy always to be found in the shadow of this magician'.[5] Mostly it was Monet and Blanche alone. By the fringe of the pond or in the studio, her calm and her practical help were the backcloth as Monet painted the water lilies with a new nervous vivacity, violence and elegiac lyricism. They occupied him throughout the war and beyond, and he never stopped thinking about them. To Trévise he explained, 'I paint in the daytime and because I dream about it I paint even at night.'[6]

In an account given to Thiébault-Sisson of beginning the *Grandes Décorations* in 1914, Monet emphasized that the work only became

possible when, after Jean's death and with Blanche in residence, he regained some confidence about his sight. 'A day finally came, a blessed day, when I seemed to feel that my [cataract] malady was provisionally checked,' he said.

> With great joy I found that although I was still insensitive to the finer shades and tonalities of colours seen close up, nevertheless my eyes did not betray me when I stepped back and took in the motif in large masses ... While working on my sketches I said to myself that a series of impressions of the ensemble [of the water-lily pond] done at the times of day when my eyesight was more likely to be precise, would be of some interest. I waited until the idea took shape, until the arrangement and the composition of the motifs became gradually inscribed on my brain, and then when the day came that I felt I had sufficient trumps in my hand to try my luck with some real hopes of success, I made up my mind to act, and I acted.[7]

In its outrageous scale and greater abstraction, the cycle of paintings were thus a negotiation with the condition of Monet's eyesight. The *Grandes Décorations*, and some hundred sketches for them, such as *Water Lilies* [Plate 49] – each today considered a major painting in its own right – made a virtue out of a frailty of old age. They were also about sight and perception, themes present in Impressionism from the beginning. What is direct observation, what is the painted image, what is imagination and memory – motifs 'inscribed upon the brain' – fuse, as broad sweeping brushstrokes, sometimes fluid as water, sometimes agitated swirls and scrawls, loops and trails of pigment, depict the dissolving lilies while also asserting their own force and energy as paint. The water is boundless, the horizon line has gone, there is no vanishing point, the canvases form an endless continuum. The picture plane has become primarily a painted surface rather than a site for representation.

'No more earth, no more sky, no limits now,' Roger-Marx had written of the 1903–8 *Water Lilies*.[8] On experiencing the decorative coherence when those paintings were shown at Durand-Ruel's exhibition in 1909, Monet had already talked of doing a decoration based on the *Water Lilies*. During his tentative return in 1912 to painting his garden after Alice's death, Monet confided to Geffroy that 'to render

what I feel, I totally forget the most basic rules of painting – if they even exist.'[9] The 1912–13 efforts stalled, but in 1914 old-age reckless-ness, allied to instinctive control, bore fruit. With unprecedented graphic and gestural freedom, and a solemn emotional tenor, Monet brought the abstracting impulse of the 1903–8 series to sumptuous fulfilment. He explained, '[I] adapted my working methods to my eyesight ... and laid down the colour haphazardly, on the one hand trusting solely to the labels on my tubes of paint and, on the other, to force of habit.'[10] The degree of abstraction varied: it is more evident in the easel paintings, as Monet worked out his compositions, than in the enormous panels, but everyone noticed an 'altogether new bold-ness of execution', as Thiébault-Sisson said,[11] and greater physicality.

Clemenceau understood an effect between abandon and coherence: close up a canvas appeared a 'storm of madly brushed colours', but from a distance forms are recomposed 'across the inextricable jumble of multi-hued touches' and 'an impressive symphony of tones emerges from the thicket'.[12] Monet wanted an immersive effect, to surround the viewer with a panorama of the pond as experienced during pas-sages between light and darkness in morning and late afternoon and early evening; he did not paint in full sunlight. The flowers and clouds are passive, but the facture can be aggressive. Joseph Durand-Ruel called the *Décorations* brutal. Trévise described 'paint in a whole range of thicknesses, from the lightest comma-like brushstrokes to coils of impasto to the most stubborn mound of paint'.[13] The dreamy, refined water lilies exhibited in 1909 evoke time stilled; in the fiercer *Grandes Décorations*, with their overheated extremes of green, gold, amethyst and rose, dusky violet, flaming orange, the same motifs are choreographed to suggest time passing.

There is continuity between the two groups of works – and the rup-ture of death. 'After the tragedy of my life I stopped painting,' Monet explained flatly. 'It was my old friend Clemenceau who pulled me through my bereavement. I discussed with him a kind of decoration that I had once wanted to do. He said, "That's a superb project! You can still do it – do it!"'[14] In Monet's account, Clemenceau has the starring role as the external element decisive to the *Grandes Décora-tions*. Blanche was taken for granted, absorbed into Monet's working practice as he had absorbed Camille and Alice before her.

What actually happened, when contact between Giverny and the outside world shrank during the war, was a collaboration between the tiny, unassuming, determined woman who had lived all her adult existence quietly in Normandy, and the stocky, relentless politician who had travelled the globe and came and went between Le Pressoir, Paris and the trenches. Clemenceau, nicknamed 'The Tiger' for his ferocity, was president of the army from 1915, a senator, and a thorn in the side of the government for his hectoring against its inadequate war effort. He and Blanche worked as a duo nurturing and encouraging Monet.

Clemenceau was the sole visitor always welcome at Giverny. 'I used to get away from the Front every now and then, without telling anybody where I was off to, and spend a little time at Monet's. War talk was taboo. I went there to rest. Monet would show me his flowers.'[15] His secretary Georges Wormser remembered Clemenceau's 'incomparable friendship with Monet. This friendship was perfect: communion of tastes, ideas, reciprocal admiration, life truly shared.'[16] Geffroy thought Clemenceau got Monet through the war 'by his example and by his visits, where his rough and affectionate words gave hope to the man overwhelmed by public troubles suffered at the same time as his private unhappiness', but he also insisted that it was through Blanche that 'Monet found the courage to survive and live, and the strength to work'.[17]

Calling her Monet's 'blue angel', Clemenceau enjoyed a respectful flirtation with Blanche. With his high spirits and charm he aimed to balance the impact of Monet's manias and depressions. 'Ask the angel from me if she finds herself in hell,' he warned Monet, and, 'Don't make too heavy demands on the angel.'[18] Monet knew he could be ghastly towards Blanche in his bad moods, and that 'it's a sad life I give her in our solitude. For me, she is an admirable consolation.'[19] Clemenceau brought them a backgammon set where they teased out their frustrations in the evenings, or they sat reading together. Blanche described Monet as 'a violent character, very lively, but a good heart'.[20] The cook, Marguerite, warned that Monet's temper would cause her 'wet handkerchiefs', and 'Poor blue angel! She needs blue in her soul to compensate for Claude Monet's bitumen,' said Clemenceau.[21] For him they were 'le vieillard et l'ange', like mythological characters. In a

summer photograph Monet, almost seventy-five, perched on a high chair beneath the parasol, sketches the lilies on a big canvas, and behind Blanche, nearly fifty, in white, hovers, keeping watch.

The image is peaceful, but passing along the road at the end of the garden came a stream of ambulances bringing back the wounded to Giverny, and they could hear the sound of cannon from Beauvais sixty kilometres away. To paint, Monet said to Geffroy in 1914, 'is still the best way not to think too much about the current sadness, even though I should be a bit ashamed to be considering little investigations into forms and colours while so many are suffering and dying for us'.[22] He knew several of them. Clemenceau's son Michel was wounded in August 1914, and soon afterwards Renoir's two older sons. The shock, plus fatigue from crossing the war-torn country to secure care for them, killed Aline Renoir. 'I often think about you, and as I get older, I turn to thinking about our youth. That lifts me a bit in the present,' Renoir wrote to Monet in the first months of the conflict,[23] and later, 'I'm still not very solid. I'm happy you're doing the *Grandes Décorations*, that will be more masterpieces for the future. It's a real joy just to think about eating a cutlet with you, I'm drooling in advance.'[24] This was ironic nostalgia, as Renoir was skeletal and could only eat mashed food through a tube. Gimpel, visiting him during the war, found 'a frightful spectacle' with a sunken head and fleshless hands like chicken claws, in which brushes were placed between his fingers and fastened with string, yet 'the chair-bound cripple with his quivering stumps: it all vanished when you saw those eyes ... what animation and vivacity.'[25] For Monet, Renoir was a model of courage.

'We ... continue to have good news of those absent, but we live all the time in anxiety and apprehension,' Monet wrote to Durand-Ruel in November 1914.[26] These sentiments were repeated for four years. More than 1.3 million French soldiers were killed, the worst casualties per head of all the Allied armies. One of the saddest vignettes of Monet's life is that of the old man returning from a failed journey to bid farewell to his only surviving son about to leave for the front in 1915, departing from Versailles. Monet set off from Giverny 'to kiss my Michel ... useless trip: he had gone a day earlier, so I couldn't kiss him and came back contrite and sad, it's hard at my age,' he told

Monet in his dining room, 1915. The walls, painted yellow, are hung with Japanese prints

Geffroy.[27] 'What does the future hold for me? Many, many families are suffering,' he wrote, and 'I am always trembling for my Michel.'[28]Posing for a photograph alone in his dining room in 1915, Monet stands stoical, dignified, the lined face and bright eyes almost imploring in their suggestion of habitual sorrow. Without diminishing the roles of Blanche or Clemenceau, Geffroy believed that Monet 'survived the most terrible griefs which broke his heart and ravaged his spirit by his inner strength'.[29]

'I haven't painted the war ... But there's no doubt about the war existing in the pictures I did at the time,' Picasso said of 1939–45.[30] The same holds true for Monet's *Grandes Décorations* in relation to the 1914–18 conflict. They were begun in personal sorrow, the ephemeral, drifting lilies and dark, downward coursing willows images of mourning, memorializing Alice and Jean. The war, bringing constant anxiety about Michel, intensified the emotional charge, and gave the context of national grief. The counterbalance is comfort and renewal: a garden growing, nature's enduring rhythms, acceptance of diurnal, seasonal cycles, distilled on to canvases painted a few hours from the

killing fields. The paintings are rapturously melancholic, exuberant in the joy and challenge of returning to painting and the refuge it offered.

The reflective surface of the pond offered both contemplation of infinity and an enclosed space, the haven of shelter – lifelong quests in Monet's painting. Geffroy summed up that 'after running round the world adoring the light that brightens it, he knew that this light came to be reflected with all its splendours and mysteries in the magical hollow surrounded by the foliage of willows and bamboo, irises and roses, through the mirror of water from which burst the strange flowers which seem yet more silent and hermetic than all the others.'[31]

The *Grandes Décorations* have the characteristics of a late style: extreme, abstracting, interior. While the generation following him, Picasso and Matisse, were returning to order, working with drab colours and tight analytical structures, Monet was painting disorder as sombre harmonies, in a tension between formlessness and pattern. 'Everything is everywhere in front of the luminous abyss of Monet's pond,' Geffroy said.[32] Recreating nature as an enveloping decorative scheme, the *Grandes Décorations* are at once the crowning achievement of Impressionism, eloquent paintings of wartime France, the all-over compositions speaking of chaos and dissolution, and pointers to mid-twentieth-century gestural abstraction. 'Vast pure poems,' said Paul Valéry;[33] and 'astonishing painting ... a song without words, pictures where the artist's only subject is himself,' according to Louis Gillet.[34]

Few canvases between 1914 and the end of Monet's life are dated, but accounts suggest that initially the painting proceeded fast. Blanche said he had 'exceptional vigour' and 'covered his canvases in a very short time'.[35] Work 'is the only means not to think too much about current sorrows' he told Raymond Koechlin in January 1915. 'So I am pursuing my idea of a Grande Décoration. It's a very big thing that I've begun, especially at my age, but I don't despair of getting somewhere if I keep my health.'[36] In February the Bernheims were informed that 'I'm using and wasting a lot of paint, but it absorbs me enough not to think too much about this terrible appalling war.'[37] The opulent colour and facture, sheer size and impasto volume, defied wartime privation. Gimpel counted 'some 40 cardboard boxes, each containing a dozen large tubes of paint in the same colour ... laid out very

precisely'. There were more than fifty clean brushes, each 'three-quarters to an inch wide', and palettes 'covered with colours in little spaced-out daubs: cobalt, ultramarine blue, violet, vermilion, ochre, orange, dark green, another very clear green, and lastly a lapis lazuli yellow'.[38]

Happy that 'since I've recovered the taste for work again, I no longer think that I had trouble with my eyes', Monet in 1915 threw himself into building.[39] Overcoming shortages of materials and labour, he had a third studio constructed, at a cost of 50,000 francs. Glassy and gigantic, it was, he thought, hideous. It was completed shortly before his seventy-fifth birthday and although he admitted to Jean-Pierre, 'I am ashamed to have had it built, I who always scream at those who make Giverny ugly', it was a vote of crazy optimism: 'I speak as if I had many [years] ahead of me, which is pure madness . . . yes, this is folly, arch folly.'[40] The new construction, twenty-three by twelve metres, and fifteen metres high beneath a giant skylight, allowed him to display and move around the huge paintings, as panels on casters. A settled schedule returned Monet to the practice adopted for the *Déjeuner* in 1865: summers at work outdoors on easel paintings before the motif; winters reprising these at monumental scale indoors.

Already, in 1915, he was keen to show select visitors what he was doing. Vuillard came with Bonnard and thought that the 'large canvases like the ceiling of [the Sistine Chapel] suggest rhythm and colour, all works linked by a majestic lyricism.'[41] As a homage to Monet, the Académie Goncourt, with Mirbeau and Geffroy at its head, relocated its June meeting from Paris and all ten members descended on Giverny for lunch. 'Monet had returned to work on the water-lilies paintings he had shown before the war . . . but now on a vastly greater scale. He was setting his impressions down upon huge canvases some two metres high and three-to-five metres wide,' the novelist Lucien Descaves recalled. 'We were surrounded by what seemed to be a celebration of water flowers. Mirbeau, who was already ill, suddenly seemed to return to his former self.' Pessimism about the war had withered the pacifist Mirbeau, and when Monet explained the *Grandes Décorations* would take five years, he cried out that surely

two was enough. He knew he would not otherwise survive to see the work finished.

Descaves thought Monet's willows, despite their connotations of loss, 'were bent smiling over the mirroring water' and concluded, 'Claude Monet is like some antique Doge, secure in the serenity of his glory, his kingdom now reduced to his works ... one work, but his own.'[42] That power is in the paintings: the transformation, at the command of Monet's brush, of everything he sees into effects of light and colour, the garden cultivated to his instructions, wildness domesticated, then manipulated again on canvas and re-imagined in the studio. Trévise, watching the process, commented on the self-contained circularity of the project. 'When everything has been put in place, when in the morning his special gardener, working from a small boat, has finished soaking every water lily pad in order to remove the dust, then the owner settles down and is once more pure artist, energetically painting the site he had patiently put together.' Monet asked Trévise, 'Don't you think that I must have been quite mad to paint all this? Of what possible use could it be?'[43]

Monet at work, a still from Sacha Guitry's film *Those of Our Land*, 1915

Monet, Michel on leave
from the front, Blanche
and Jean-Pierre (standing
at the side), 1916

This was rhetorical. Already in summer 1915 the *Water Lilies* was perceived as a patriotic emblem when Sacha Guitry came to Giverny to make his propaganda movie *Ceux de chez nous* (Those of our Land), documenting France's greatest living artists. The film underlines the physical endurance needed for this sort of painting. Monet in white paints by the edge of the water, forceful, graceful – 'like a poet's vision of old age ... majestic ... full of vigour, simplicity, authority,' said Trévise. He considered the painting performative: the studio 'vast as an empty stage ... the cast of characters: reflections of clouds, ripples of water, water-lily petals. The subject: the subtle interplay of air and water under the fiery rays of the sun'. Trévise described Monet as a set designer, eager to display his moveable panels: '"You haven't seen everything yet," he added, and he shifted the fabulous partitions around several times, enclosing me within them.'[44]

The new atelier came into its own in 1916. The first photographs of the new space, showing four continuous panels of lilies and willows, date from this year of heroic work and heartache, when Monet worried about Michel, who was in the trenches at Verdun. In December

he told the Bernheims and the Durand-Ruels, 'I am launched into the transformation of my big canvases, and am not leaving them . . . my *grand travail* takes all my time.'[45] The dealers grew excited; the art market, subdued during the war, received a boost with the sale of twenty-four Monets at the Plaza Hotel, New York, in January 1917, after the death of their owner, American collector James Sutton. A *Water Lilies* from the 1903–8 series caused a sensation, its reflections making it appear that the painting had been hung upside down. Georges Durand-Ruel, in New York, imagined a transatlantic coup for the *Grandes Décorations*: several clients were eager to buy for their city's museums. Monet answered that the work was unfinished, and he refused to consider sales.

Although his massive endeavour gobbled paint and canvas, he could afford to splash out and wait: he earned 40,000 francs a year in interest on savings of around a million francs, and was expensively if reluctantly selling off older works. He gave generously to wartime charitable causes, and did his best to get around economic strictures. He struck up a canny friendship with Étienne Clémentel, art-loving Minister of the Interior and Commerce, which led to dispensations on the transport of canvases and stretchers when civilian rail freight was restricted, and assured supplies of coal and fuel. Clémentel was patriotic, already referring to the *Grandes Décorations* as 'your splendid *oeuvre de guerre*'.[46] Durand sent wine, actress Charlotte Lysès procured cigarettes – tobacco was prioritized for soldiers – but high living at Giverny took a hit. Matisse, who invited himself in 1917, was told to expect a 'déjeuner tout à fait sans façon'.[47] But it was the *Water Lilies* that Matisse devoured: he went home and painted the dark, geometric *Garden at Issy*, overlapping discs of bushes above a silted-up brown pool, where miniature water-lily pads somehow survive.

1917 was a terrible year for France. The army was close to collapse, there were mutinies and anti-war demonstrations at home, prospects of advance on the western front seemed hopeless and the Russian Revolution was ending Germany's battle in the east. At Passchendaele, from July to November, Allied forces moved forward five miles, with over 200,000 casualties on each side. For 'those who remain', daily dread was taking its toll. Monet felt 'annihilated by this terrible war and the anxiety I feel for my son, so often exposed, and whose

letters upset me . . . I feel I'm getting old and regret having undertaken this colossal work, certainly beyond my strength.'[48]

His generation was disappearing. The year 1917 brought the deaths of his estranged brother Léon, unmourned; of Degas, which meant something because of youthful friendship and common battles, and of Rodin, Monet's exact contemporary. Most distressing was Mirbeau's death, on his sixty-ninth birthday, on 16 February. At his funeral Monet was so distraught that he wandered off after the burial, not knowing where he was going, failing to see or talk to his friends there. Georges Lecomte called him 'the old oak of Giverny': 'bareheaded beneath the hazy winter sky, this rough-mannered, very sincere man sobbed. From the depths of his eyes, overcome with grief, tears rolled into the thickets of his long beard, which had now become quite white.'[49] The flowing white beard is the dominant feature in an unfinished self-portrait in 1917 – Monet's only venture in the genre apart from the one in the difficult year 1886. This time he made three attempts at a sketchy head – weathered face, sturdy brow, eyes half-closed, quivering nostrils. He destroyed two and would have slashed the third had Clemenceau not carried it off.

Monet and Blanche took a holiday in Honfleur and Le Havre in October 1917, their first sight of the coast for years, full of memories and invigorating sea walks. He was just back in the studio when Raymond Poincaré, President of France, bowed to the inevitable: 'I see the terrible defects of Clemenceau. His immense pride, his instability, his frivolity. But have I the right to rule him out when I can find no one else who meets the requirements of the situation?'[50] The Tiger became Prime Minister on 15 November 1917, with a single policy, to make war. Clemenceau was dynamic and harsh, impressing soldiers during his visits to the front line, inspiring the public with his firmness. New hope came to Giverny. 'My daughter-in-law asks me to kiss you and tell you how much she admires you. She is not the only one,' Monet told his friend.[51]

Winston Churchill, who toured the front with Clemenceau in March 1918, thought him 'an extraordinary character . . . his spirit and energy are indomitable. 15 hours yesterday over rough roads at high speed in motor cars. I was tired out – & he is 76.'[52] The tide had not yet turned. In Operation Michael, launched on 21 March in

Saint-Quentin and aiming to divide French and British troops, the Germans advanced within 120 kilometres of Paris, and shelled it. A bomb fell on rue Laffitte close to Durand-Ruel's gallery, packed with Degas's paintings for his posthumous sale. The house opposite was reduced to rubble. Eighty-seven-year-old Durand-Ruel sheltered as instructed in his cellar, then emerged to attend his regular 11 o'clock mass at the Saint-Augustin church. He sent regards to Clemenceau on behalf of 'many artists and lovers of art, all of whom are excellent Catholics and patriots as we should all be'.[53]

Monet worked on, refusing a visit on 3 August from the Bernheims because 'I don't have much longer to live and I must devote all my time to painting, with the hope of finally reaching something good.'[54] Their cousin Georges, setting out on spec with René Gimpel, cycling on hired bikes from Vernon station on 19 August, was luckier. 'Ah gentlemen, I don't receive when I'm working, no I don't receive,' Monet opened, almost in self-parody. 'You'll understand, I'm sure, that I'm chasing the merest sliver of colour. It's terrible how the light runs out, taking colour with it. Colour, any colour lasts a second, sometimes three or four minutes at most. It's my own fault, I want to grasp the intangible ... how painting makes me suffer! It tortures me!' Then he let them in and Gimpel left a record of the *Water Lilies* as they looked at the close of the war.

> Bernheim had told me about an immense and mysterious decoration on which the painter was working and which he probably wouldn't show us. I made a frontal attack and won the day; he took us down the paths of his garden to a newly built studio ... Inside there is only one huge room with a glass roof, and there we were confronted by a strange artistic spectacle: a dozen canvases placed one after another in a circle on the ground, all about six feet wide by four feet high: a panorama of water and water lilies, of light and sky. In this infinity, the water and sky had neither beginning nor end ... It was mysterious, poetic, deliciously unreal. The effect was strange: it was at once pleasurable and disturbing to be surrounded by water on all sides and yet untouched by it. 'I work all day on these canvases', Monet told us.

Gimpel had 'never seen a man of that age look so young ... He looks like a young father who, on 25th December, puts on a false white

beard to make his children believe in old Father Christmas. His face is softly coloured and unblotched. His small round chestnut eyes, full of vivacity, add emphasis to whatever he says.'[55] The well-connected Gimpel, smart, witty, as at home on a transatlantic liner with a crate of canvases bound for American millionaires as he was receiving a visit from Proust at midnight or jesting with the crippled Renoir, brought cosmopolitan panache and wit to Giverny over the coming years, and described the elderly Monet in his diary with unsentimental sympathy.

Monet kept his deeper doubts for Geffroy, who was told around the same time as Gimpel's visit, 'I think I will die without having achieved anything I like ... because I am seeking the impossible.[56] But his energy remained prodigious. The summer's work included two significant groups of large easel paintings, continued into 1919: ten *Weeping Willow* canvases, trunks dark and thick, branches writhing, foliage pouring down in rushing strokes, blocking light from the tiny segment of water, and a companion quartet, *Corner of the Pond at Giverny*, whose flowering bushes share the baroque agitation and vertical impulse but are brighter. The tide of the war had turned. 'Good news of those in the army, good health here, all that plus the good news from the front, that is a lot,' Monet wrote in September.[57]

Before dawn on 11 November in a railway carriage at Compiègne, the Allies signed an armistice with Germany, and at 11 o'clock a ceasefire came into effect. Michel, and Jean-Pierre Hoschedé and Albert Salerou, had been spared. One other family soldier came to Giverny: among the American troops waiting to return home was 21-year-old James Butler, whose visit thrilled Blanche, his 'Tante Lanlan', and Monet. Renoir's sons had also survived, Pierre left with a withered arm, Jean with one leg four centimetres shorter than the other, but Renoir considered himself fortunate. Fifty-two per cent of French troops were killed or wounded, and one in twenty French citizens lost their lives. From its total population of 300, Giverny lost twelve men at the front.

On 12 November Monet wrote to 'the father of victory': 'Dear and great friend, I am about to finish two decorative panels that I would like to sign as on the day of victory, and offer to the State

with you as intermediary. It is not much, but it is the only way I have to take part in the victory. I . . . would be happy if they were chosen by you. I admire you and kiss you with all my heart.'[58] It was as close as he came to a statement that the *Grandes Décorations* was war work, and Clemenceau observed, 'The action across this battlefield is life itself, luminously transposed, the elemental competition for successive instants . . . Under the protection of the willows, the bouquet of water lilies keep, for a time, the brilliance of their triumphant blossoms', but then clouds envelop them, night falls, and growing life is 'conquered by the irresistible power of the universal blaze'.[59]

Clemenceau visited Monet on his seventy-eighth birthday, arriving with Geffroy, two cars in case of a breakdown, and four chauffeurs. 'You saved France,' Monet said; 'No, it was the infantry,' Clemenceau replied.[60] Monet thought Clemenceau looked a decade younger. The Tiger was already in pursuit, demanding a donation of not two but twelve panels, to be installed in Paris as a memorial to peace. Monet accepted. In Clemenceau's retelling, 'I said I was glad he was a Frenchman . . . and said, "What is there left to do now?", and Monet answered: "Now we'll get to work on that monument to Cézanne."'[61] If the story is reliable, this was a rapid deflection. For a non-political artist who had always avoided bureaucratic involvement, Monet had delivered himself into alarming association with the state. At a stroke, Clemenceau's demand destroyed the equilibrium which, during the war years sequestered in Giverny with Blanche, allowed Monet to evolve the *Water Lilies* in a spirit of experimentation and freedom. Five days after agreeing to Clemenceau's proposal, he blacked out in his studio.

He cancelled Georges Bernheim and Gimpel on 24 November, then sent a telegram asking them to come after all. He told them, 'When I paint I can always stay on my feet; otherwise I tire quickly', adding that he was not afraid of death. 'And I'm not frightened of it because I'm very unhappy.'[62] Gimpel referred to the *Water Lilies* studio as 'that stable crammed with the immense canvases he painted during the war' as if the project were finished: 'a triple symphony of water, sky and light'.[63] Bernheim tried to buy one. 'Impossible,' replied Monet. 'Each one evokes the others for me, and anyway, 'Why,

Mr Bernheim, should I sell to you?'[64] But before the year was out, the reviving market after the armistice, and a certain depletion of funds, changed his stance. Théodore and Marthe Butler were struggling financially in New York, and Monet made them a long-term monthly allowance of 150 dollars, the cost rising as the exchange rate went against the franc. The panels were sacrosanct, but the first war-time easel paintings left the studio. Josse and Gaston Bernheim acquired two *Weeping Willows*, and two *Corner of the Pond* canvases went to the Durand-Ruel brothers, each for 20,000 francs. All appeared in the Bernheims' exhibition 'Monet Rodin' in January 1919. Monet did not bother to go to Paris, then or for the rest of the year.

Clemenceau was wounded in an assassination attempt on 19 February 1919. He soldiered on at Versailles, reaching a peace settlement in June which, despite enormous German reparations and disarmament, he thought too lenient. His demobbed troops were going home to an altered France. The recalibration of labour was felt at Giverny as elsewhere. Monet noted a dearth of domestic staff and that all his gardeners had left: 'it's a compete disarray ... But all this is nothing, the signing of the Peace treaty is a true relief.'[65]

Michel's return was the greatest relief. Forty and with no profession, Michel led a shadowy life in a wing of Le Pressoir and in the garage, keeping his distance from his father and Blanche. Shy as always, he painted in secret, was indulged – infantilized – with gifts of

Gabrielle Bonaventura

cars, including the new luxury streamlined Voisin, and maintained a discreet relationship with a local model, Gabrielle Bonaventura, a single mother with a daughter, whom Monet did not allow across the threshold. Did he remember his own father closing the door at Sainte-Adresse to the unmarried Camille? Michel would not marry Gabrielle until 1931. He kept quiet, avoided conflict, and was the only person whom Monet loved more than he was loved in return. His occasional interest was treasured – a postcard from a trip to the Midi, 'seeing all these beautiful olive trees I can't help thinking of your canvases'[66] – and Monet enjoyed being chauffeured by him. Gimpel observed some irritation from Blanche: 'She doesn't seem to care very much about Monet's son. He lives there, she said, at the other end of the house, and doesn't work. She gave the impression of being fed up with him. He is very spoiled by his father.'[67]

So the trio of Monet, Blanche and Clemenceau continued, the Tiger visiting more frequently after Versailles. The weather was superb during the first summer of peace and Monet began 'a new series of landscapes which fascinate me . . . I don't dare say too much that I'm content, but I work on them with passion and that's a rest from my *Décorations*.'[68] But towards the end of the year his sight worsened, prompting Clemenceau to recommend a cataract operation. The response was a terrified, 'I prefer to make the most of my poor sight, and even give up painting if necessary, but at least be able to see a little of these things that I love.'[69] Then came news of Renoir's death on 3 December, which aged Monet: 'With him a part of my life disappears . . . I'm forever reliving our youthful years of battles and hopes. It's hard to be the only one left, certainly it won't be for long, I feel older every day.'[70]

He told Gimpel at the beginning of 1920, 'I see much less well. I'm half deaf and blind. I haven't much longer to live. Remember, Renoir is gone.' Without mentioning the proposed donation, he added, of the *Décorations* 'I've begun getting offers, but I don't think I'll sell. I shall work until my death; it helps me get through life.'[71] From Chicago collector Martin Ryerson came a reported $3 million dollar offer for thirty big canvases, and there was interest from the ship-building tycoon Kojiro Matsukata, who was planning to found a museum, the 'Sheer Pleasure Fine Arts Pavilion', in Japan. Monet

declined with the excuse that he did not want the work to leave the country. Towards France, his conditions were firm: '1) to keep my canvases until the end; 2) I won't separate myself from them until I have seen the site where they will placed ... That is my *absolute decision*.'[72]

Clemenceau's real difficulties with the *Water Lilies* were just beginning. He was at Giverny on 17 January 1920 when he heard the results of the presidential elections: he lost, resigned as prime minister, left politics, travelled to Sudan, and returned to retire to a modest house at Saint-Vincent-sur-Jard in Vendée. No contract had yet been signed for the *Grandes Décorations*, but far from the project lapsing, political defeat inflamed Clemenceau's zeal. These paintings destined for the nation, and their creator's struggles, were his mission, and to secure them for Paris would be the peacetime coda to his war victory. He was swept into years of tortuous negotiations. The chasm between the *Grandes Décorations*' self-contained beginnings and their public appropriation made friction inevitable, and though he remained inspirational to his friend, he was now associated with the agreement with the state, and risked being perceived as an adversary to Monet's creative freedom. So he watched Monet in old age again become the rebel, against the institutions of state, and against the ravages of time.

In September *Le Figaro*'s Arsène Alexandre, commissioned by the Bernheims to write a book on Monet, brought Paul Léon, Beaux-Arts director, to Giverny to discuss the donation. He described the *Grandes Décorations* in what everyone except Monet saw as their finished or almost finished condition: the cool *Green Reflections* would face the dark columns of the seventeen-metre high *Three Weeping Willows*, and the airy blue *The Clouds* contrast with the molten gold *Agapanthus*. This anticipates the final installation, although *Agapanthus* would be replaced by other works. Provisionally, Monet and Léon agreed an elliptical pavilion, to be built in the gardens of the Hôtel Biron, since 1919 the Musée Rodin, and formerly the sculptor's studio. Monet demanded the commission for Art Nouveau architect Louis Bonnier – a link to the water lilies' Art Nouveau sinuosities. But then he rejected Bonnier's design and, the oval scheme being judged too expensive, was offered a circular room. He dismissed it as a

'circus ring' and sent an angry message via his eightieth birthday interview with Trévise in *La Revue de l'art*: 'I am bequeathing my four best series to the French government, which will do nothing with them!'[73] The Freudian slip – bequeathing – implied that the *Décorations* would not leave Giverny before his death.

Nonetheless, in October Thiébault-Sisson reported in *Le Temps* that Monet had given the state an ensemble of twelve paintings. *Le Figaro* expanded the story to explain that the state would purchase from Monet *Women in the Garden*, for a record 200,000 francs. It would go to the Musée du Luxembourg, antechamber for masterpieces acquired for France until their creators' deaths promoted them to the Louvre. Monet told Gimpel the purchase balanced his gift of the *Water Lilies* panels. The pure gesture agreed with Clemenceau in the emotion of victory looked rather less pure.

The sale of *Women in the Garden'* was vengeance long awaited, for the Salon rejection of this painting had thrust Monet into poverty in 1867. But the deal trapped him: there was now no escape from delivering the *Grandes Décorations*, and although the Third Republic was not the Second Empire, and sympathetic Paul Léon a zeitgeist away from Napoleon's reactionary arts superintendent Count Nieuwerkerke, Monet's dislike of authority endured. 'I want my tranquillity ... and not to hear talk of this ... all these disturbances compromise my work and I haven't time to lose.'[74]

Jean-Pierre insisted that 'Monet remained indifferent to honours. He always lived simply in an isolation which he had chosen among the splendours he had created.'[75] Yet Monet was bitter when he told Gimpel, 'Three of us, Degas, Renoir and I, have had our revenge ... the others died too young', and there was some score-settling now.[76] Camille, eventually in the Louvre, would join Manet's *Olympia* there as the two seminal figure paintings of the 1860s. Monet was curating his legacy; the following year he complained about the 'complete absence of figures' in Alexandre's book about him.[77] And he had himself photographed with Trévise in 1920 in front of one of the surviving panels of his *Déjeuner sur l'herbe*, with a picture of the Hoschedé sisters in a boat also prominent. *The Red Cape*, Camille in Argenteuil, has been moved to be propped up alongside the large panel.

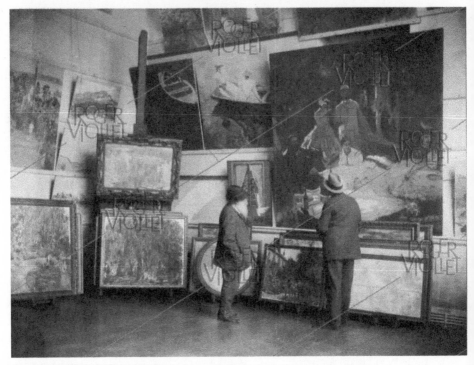

Monet and the Duc de Trévise in his studio, 1920

It is revealing that he bound the fates of *Women in the Garden* and the *Water Lilies* – two versions of the bourgeois garden, private domains vibrant with bright sunlight and shadows, the subject that Monet had made his own, and with which, from the plein-air freedom of the first to the abstraction of the second, he had remade French painting across fifty years. In 1867 Zola, although he had read his friend's canvases so literally, had been struck by the abstract element already present in *Women in the Garden*. 'The sunlight falls directly on [the] brilliant white dresses; the tepid shadow of a tree cuts across the garden paths, across the sunlit dresses, like a big grey tablecloth.'[78] In the *Water Lilies*, the water surface is like a tablecloth dotted with flowers. The pond at Giverny, as well as the suburban garden at Ville d'Avray, appear so much bigger, more expansive, on canvas than the reality, for Monet's *hortus conclusus* encompassed a whole worldview denoting joy in the visible,

interiority, peace, security, all hard won against the pressures and dangers of life outside.

Entering his ninth decade, Monet no longer experimented with easel-size water-lily paintings. Instead, while waiting to proceed with the monumental panels until he knew the exact dimensions and layout of their disputed home in Paris, he plunged into the leafy tangles on his pathways, and the flowers draping the little bridge. None of the paintings made after 1920 would be exhibited or sold in Monet's lifetime. With them he retreated into the secret garden of memory.

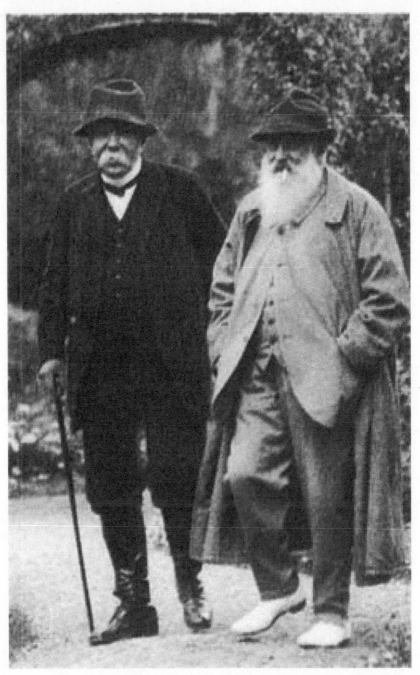

Monet and Clemenceau in the garden at Giverny, *c.*1920

24

'Midnight in Full Sunshine',
1920–26

Survivor of storms and floods, exuberant in its variety of mature plants, a continuous seasonal succession of flowers, Monet's garden was at its zenith in the 1920s when horticulturalist Georges Truffaut came from his nurseries at Versailles to document Giverny for his magazine *Jardinage*. Everything that Monet had cultivated had flourished and ripened to give the impression of glorious but controlled wildness, as in his paintings. Long velvety irises, ferns and rhododendrons edged round the pond. Clematis draped over trellises like lace curtains. Hardy roses reached seven metres and spread clusters of blooms everywhere. Tree peonies sent from Japan happily adjusted to the Norman climate. The willows soared, their branches drooped low. The bamboo planted under Alice's gaze had grown to form a thick protective wood. Colour blazed: striped Rembrandt tulips, vermilion poppies, shrimp-pink North American azaleas, violet aubretias. Truffaut thought the garden, 'Monet's most beautiful work ... the one that has most appealed to his senses for the past forty years and to which he owes his greatest joys'.[1]

Even when painting stalled, the garden never staled for Monet, and as he aged, his pleasure in it became a craving: 'more than anything, I must have flowers, always, always.'[2] He was 'more impatient every year for his flowers', Thadée Natanson noticed. In Natanson's old-age portrait, Monet, sitting trance-like at the edge of the pond, would 'watch the water lilies slowly close', while from his half-smoked cigarette 'scrolls of smoke climbed and renewed themselves around him'. It is the image of a voluptuary. On his paths, Natanson thought Monet cock of the walk, showing off 'his long beard ... like a crop of

Monet in his flower garden, photographed for an article in Georges
Truffaut's magazine *Jardinage* in 1924

plumage, with enough belly and the slender legs of a rooster, his head
held high'.[3]

Natanson was not the only observer in the 1920s to imply an erotic
charge. 'It was in summer that you had to see him, in this famous gar-
den which was his luxury and his glory, and for which he did follies as
a king for a mistress,' said Louis Gillet; 'the *nymphéas* pond was the
master's jewel, the nymph with whom he was in love'.[4] Zola had writ-
ten that 'Monet loves water as one loves a sweetheart.'[5] Monet slept
with a Renoir nude at the head of his bed – *Young Girl Bathing*, sitting
on a rock, auburn hair falling over her shoulders, now at the Metro-
politan Museum of Art – but, never a painter of the nude himself, he
directed his sensual responses to colour, light, atmosphere, seeking
them in what Kirk Varnedoe called 'the harem of nature he had created
in his garden'.[6] In a 1920s photograph in his studio Monet positions
himself, upright, thrusting, grasping a long paintbrush and a huge pal-
ette, alongside his painting of a single dark willow trunk surrounded
by scores of rounded, delicate lilies. Gimpel implied the flowers were
like people: 'they grow to unheard of heights . . . so tall on their stems
that they seem to walk along with us.'[7]

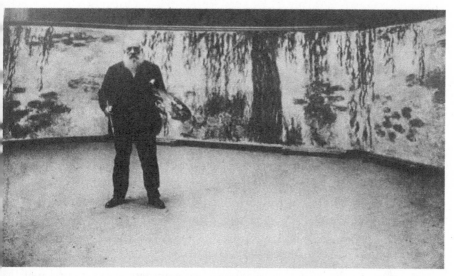

Monet in his third studio, 1920s

Natanson regretted that on Monet's once 'crowded garden paths . . . long after, of all the white dresses which he loved to see . . . there remained only that of his daughter-in-law'.[8] Blanche was approaching sixty, but a new generation of women in white animated the garden. Alice's granddaughters, Lily Butler, back from America with her family in Giverny, and Simone Salerou, adorned the Japanese bridge. The architect Bonnier brought his granddaughter Jacqueline to calm the tempo for discussion of the Hôtel Biron. The writers and painters who beat a path to Monet's door were encouraged to bring their daughters, or young wives. The art critic Henri Ciolkowski came with his new bride Marie-Ange Bouis, to whom Monet gave nasturtium cuttings and talked about his garden, while refusing to talk to the journalists in the party about art. He thanked Gillet for the company of his charming daughters, and confided to Paulette, Helleu's youngest child, that Velázquez made him cry. In seventeen-year-old Agathe Valéry's autograph album he inscribed in shaky handwriting, 'All I can say is that painting is terribly difficult'.[9] These girls with short hair bobbed beneath headbands wore loose, knee-length dresses in jaunty 1920s style, but little else had changed since the Hoschedé sisters were Monet's 'jeunes filles dans la fleur de la jeunesse' in the 1880s or even Camille in the 1860s.

In the easel paintings of 1920–24, Monet returned to his paths and footbridge, chiefly with the groups of works entitled *The Japanese Bridge* and *The Rose Path*. The garden had become denser, richer, older – abundant like the paintings. The bare wooden footbridge of the 1899–1900 series had acquired an arching trellis and was swamped in white and mauve wisteria. The rose path was more copious, suffused, brimming with blossoms. Both became the stage for paintings overflowing with feeling, enacting and expressing Monet's anguish about his struggle with impending blindness. In January 1921 he gave an interview to Marcel Pays for *Excelsior* explaining that he saw 'less and less', and managed to work only as long as 'my paint tubes and brushes aren't mixed up ... I will paint almost blind, as Beethoven composed almost deaf.'[10] He told Arsène Alexandre in May that he noticed his vision 'diminish every day, almost every hour', and Clemenceau a year later that 'my sight is going completely and if you knew what that meant for me' – yet 'the wisteria has never been so lovely.'[11]

He twisted the motifs into overgrown, impassable tunnels, silted up with tufty plants, encrusted and slathered in pigment – images of engulfing darkness. The rose alley is a dead end, not a passage through the garden, the bridge is a barrier rather than a connection. The forms are buried under heavily worked layers, and rough strokes eddy disconcertingly around the surface rather than recede back into space. The rose path, overrun with webs of paint, is muffled beneath drifting curlicues, ragged clumps of colour, as if Monet were already groping his way by touch. He explained to Gimpel, 'I've got used to painting broadly and with big brushes.'[12] The wisteria-laden bridges are barely perceivable shapes, murky opposites of their lucent precursors. Rusty browns and reds rush in to overwhelm remnants of green. In the sunset paintings the bridge is a funnel of fire, flame red, shrill yellow. At other times blue-green screens falling like curtains, suggesting the cataract veil, are pierced by cool silvers and whites, and there are last glimmers of the lilies. 'My poor eyesight makes me see everything in a complete fog,' he wrote to the Bernheims. 'All the same, it's very beautiful, and it's this which I'd love to have been able to convey.'[13] Some of these paintings, such as *The Artist's House Seen from the Rose Garden* [Plate 50], are glorious bursts of colour; knowing the garden by heart, Monet worked by threading recollection and

observation, compensating for reduced eyesight by memory and feeling. To revisit motifs was to revisit time lost, to regain it in paint.

Few people saw these obdurate, complex paintings, fewer could decipher them. None were included in the Bernheims solo show in 1921. Joseph Durand-Ruel in 1922 considered them unsaleable, 'black and sad'.[14] 'Le père Durand' had just died, aged ninety. Monet did not attend the funeral, and visits from the Durand-Ruel sons grew irregular. Returning to Giverny in October 1923, Joseph confirmed, 'The new studio is literally crammed with Monet's last garden series. It is clear that he no longer sees anything and no longer registers colour.'[15]

With hindsight, we see that it was the dealers who were blind. In old age, 'Monet seems to paint what we actually experience in looking, the drifting and gathering of sight itself', thus becoming a modern painter of 'nothing', the artist Bridget Riley has commented.[16] Borders between representation and abstraction become porous for many artists in extreme old age, and if the paintings were accommodations with Monet's changed sight, they were also expressive renderings of his feelings about his sight, achieved through deliberate aesthetic choices. What has survived may not be what his visitors originally encountered. His vision did not straightforwardly decline; there were better and worse phases. Eyedrops in 1922 allowed him for a time to 'see as I haven't for a long time ... I see everything in my garden. I rejoice in all the tones', and he may have used these periods to make adjustments.[17] And throughout these years he was simultaneously attending to his large panels, which maintained clarity, luminosity and legibility. 'Astonishing series of large water lilies. This little man of 84 ... sees only through one eye with a lens, the other is closed. And his tones are more precise and truer than ever,' observed Maurice Denis.[18] Agathe Valéry in 1923 was the 'dazzled prisoner' of 'magic partitions', as tiny Blanche

> who animated this fairyland ... would harness the heavy easels ... and close them around you, drowning you in the pond seen according to the rhythm of the light and the hourly change of the seasons [while] at the centre, in white ... with his beard like God the father's, the creator contemplated and judged his creatures: little cups of green where the

famous water flowers sleep then awake, moiré reflections in resonant
or diaphanous tones.[19]

Clemenceau recounted Monet's work to make the *Décorations* airier,
lighter, how clouds that had looked heavy one day suddenly seemed
weightless, or a pool of water that had seemed solid and pasty became
lustrous, woven with shades of rose. The pink-tinged clouds reflected
in the turquoise waters of the pond in the final twelve-metre *Clouds*
panel are ethereal abstractions, yet painted with vigorous precision.
There was no loss of mastery when Monet was refining these late
paintings. The differences between the two bodies of work is of intent.
As the *Grandes Décorations* drew closer to becoming public property,
the tangle of the garden paintings looped inward.

If Monet was constrained by his failing eyesight, he was literally
cornered by the negotiations for the *Décorations*. In 1921 he was
offered not the promised Hôtel de Biron pavilion, deemed too expen-
sive to construct, but a building in the Jardin des Tuileries, the
Orangerie, whose straight lines and right angles went entirely against
the *mise-en-scène* envisaged for his paintings. His instinct was to
retract his donation, but pushed by Clemenceau, and with a proposal
to enlarge and alter the space to two oval rooms, requiring twenty-
two panels, he accepted. He signed a contract on 12 April 1922 to
deliver the paintings within two years. Only Michel dared speak out:
'as for the new combination for the decorations, I don't think there's
anything good about it, and I find it disgusting that the State now tries
to shirk building a special pavilion.'[20] Blanche, in her mother's foot-
steps, was Monet's intermediary with the world, accommodating and
diplomatic. Michel was his partner *contra mundum*, as Camille had
been.

A month after signing the contract, Monet declared he could no
longer work, and he embarked on a frenzy of slashing paintings. 'All
winter I closed my door to everyone,' he told the novelist Marc Elder
in May. 'I felt that otherwise every day would be diminished, and I
wanted to benefit from what little eyesight remained, to complete
some of my *Décorations*. And I was very wrong. For, at last, I had to
admit that I was ruining them, and I was no longer capable of making
anything beautiful. I destroyed several of my panels. Today I am

almost blind and should give up all work.'[21] Elder visited and glimpsed some of the 'massacred' paintings: on frames leaning against the wall, 'shreds of torn canvas hung on the edges. The trace of the knife is still alive . . . under the table is the pile of canvases that the servants have been ordered to burn.'[22] Clemenceau witnessed Monet 'swearing that his life was a failure, and there was nothing left for him to do except shred all his paintings before he died. Some studies of the highest quality were lost in these fits of rage. Many . . . were saved thanks to Mme Monet's efforts.'[23]

The Tiger pressed for a consultation with an opthamologist and a shaky Monet presented himself at the Paris 'cabinet' of Clemenceau's colleague Dr Charles Coutela. Eminent, assured, charming, Coutela won Monet's confidence by prescribing drops to improve the left eye, with one-tenth vision remaining, and suggested an operation for the cataract almost totally obscuring the right, which could only perceive light. The fate of his eyes and the *Grandes Décorations* were always entwined. Thinking of the inauguration, Monet was in 'terrible agitation' that 'I'll no longer be there for the big day, or will still be here but no longer be able to see at all.'[24] Suffering nightmares – he said flu – he postponed the operation, finally accepting it in the winter when his sight deteriorated very rapidly.

On 10 January 1923 at the Ambroise Paré surgical clinic in Neuilly, Coutela performed an iridectomy under local anaesthetic on a Monet sick with fear, so upset that he vomited. The second part of the operation took place on 31 January, and Monet stayed in the clinic with instructions not to move for three days. Blanche, there throughout, described the first night: 'He was so over-excited and nervous that he moved all the time; he even got up several times and we had a lot of trouble persuading him to stay lying down; he wanted to tear off the bandages, saying that he would prefer to be blind to not moving, etc. Finally he became calmer, but this fit of exasperation has delayed his recovery.'[25]

Monet stayed in the clinic another week. At home too recuperation was slow and he howled that it was 'criminal to have been led into this situation and this fatal operation'.[26] When it turned out that yet another intervention was needed, Monet saw himself permanently blind and refused to leave his bed. The third operation on 18 July was

more painful and took longer. Clemenceau came close to blaming Monet: 'the operation, not without difficulty, was very delicate for a nervous man capable, in spite of himself, of creating complications'.[27] Coutela counted it a success. Near sight was restored, long sight satisfactory, and would improve if the patient consented to wear his glasses.

The doctor had not reckoned on eyes more sensitive to colour nuances than any alive. Monet told Julie Manet that with his bandaged eyes he saw 'a fantastical blue, I've never seen a blue like it'.[28] Afterwards he cried that he saw everything too yellow, then that he was used to seeing thirty-six colours but now only perceived two – blue and another which, he was not sure, was either green or yellow; he decided on yellow. At another moment, that was the colour he missed. Blanche greeted Sacha Guitry with relief: '"I'm glad you are here. Come quickly. He's in such a state!" He was sitting alone in his big studio, his palette before him, with the look of a man overwhelmed by misfortune. I kissed his cheek, and he took my hands and said in a heartbreaking voice, "I can't see the yellow any more."'[29] Tinted spectacles did not help: 'if I always have to see nature as I see it now, I would have preferred to be blind and keep the memories of the beauty that I have always seen.'[30] Clemenceau and Coutela advised a fourth operation, on the better eye. Monet refused, remembering especially the failed cataract surgery of Degas's American friend Mary Cassatt, an exhibitor with the Impressionists in the 1870–80s; still living in Paris, she had been almost completely blind and unable to paint since 1914.

Monet endured many fuzzy months after the third operation when 'nature and even more my canvases look dreadful to me'.[31] The Durand-Ruel brothers visited and agreed about the paintings – 'atrocious, violent'.[32] They purchased nothing less than ten years old. For the dealers, the 1920s garden pictures were the last straw, for they could not even shift the wartime *Water Lilies* easel works, which were too abstract for establishment taste but recherché to an avant-garde conditioned by Cubism. Gimpel in 1926 'had great difficulty in finding two good pictures'.[33]

Monet may anyway have considered many of these to be sketches, or unfinished – if ideas of finishing meant much by now. Jean-Pierre insisted,

I never heard Monet declare of one of his works, even of the most beautiful, that it was 'finished'. For him, the word 'finished' did not exist in painting. Generally he did not sign his canvases in advance, doing so only when they were sold or destined for an exhibition. Then he had to, the buyers often attaching more value to the signature than to the painting itself.[34]

Of more than a hundred 1914–19 water-lily paintings, Monet sold only eleven in his lifetime, and five of these were from the more pictorially conventional *Corner of the Garden* and *Weeping Willow* groups. They attracted only two private buyers: Matsukata and Henri Canonne, a pharmacist who had made a fortune inventing a throat pastille. Monet's market was rooted in history. In the mid-1920s his pre-1914 canvases fetched between 30,000 to 50,000 francs. Matsukata was rumoured to have handed Monet a cheque for one million francs. Gimpel described his 'malicious mocking expression ... the look with which these days he bitterly defends his prices. And why shouldn't he?'[35] He could afford to be out of touch with fashion.

Monet in his garden, 1920s

In the 1920s a new generation came to Giverny: surrealists and Dadaists. The American poet Malcolm Cowley and his artist wife Peggy lived above the blacksmith's shop, 'chez Tellier', in 1922–3 and struck a friendship with Alice's grandson James Butler, who in family tradition had become a painter and a botanist. Louis Aragon and his lover, heiress Nancy Cunard, moved to the village to join them; in his novel *Aurélien* Aragon would describe peering into Monet's garden and imagining the colours of the flowers shifting in the memory of its old blind owner, as if he were repainting it.

Surrounding Monet's still, quiet garden was the din of modernization. The American painter Abel Warshawsky lamented that since the war, 'Giverny had undergone considerable changes ... alas, it was no longer possible to work by the roadside as in former times on account of the steady flow of motor traffic, which sends clouds of dust and sprinkles gravel over the easel.' The place was less rural; many of the inhabitants had ceased to farm and worked in factories in Vernon and Bonnières. Some farms became second residences for Parisians and 'to cater to these new pleasure seekers, and their weekend parties, several swagger hotels had been erected'.[36] The bohemian crowd included Tristan Tzara, André Breton, Michel Leiris and Isadora Duncan. The party house was a former tithe barn, La Dîme, home to children's furniture designer and playboy Roger 'Teddy' Toulgouat, who hosted paying guests until one of them ran off with his wife. At the heart of the scene was Lily Butler, working as an illustrator for *Harper's Bazaar*. In 1926, to Blanche's delight, she married Toulgouat, and they moved into the house next door to her father.

Monet kept apart from all this, as his own pace slowed. He paints 'as if he had eternity before him', Clemenceau complained in January 1924.[37] The Orangerie deadline came and went. Monet's sight wavered between bad and dreadful. 'I'm surrounded by care and affection,' he wrote to Coutela in the spring, but 'life is a torture.'[38]

Not the first old, desperate patient to hope against hope that a different doctor could bring better news, in 1924–5 he put himself in the hands of Dr Jacques Mawas, Maurice Denis's oculist. Geffroy's friend the young painter André Barbier made the introduction, and Mawas came to Giverny in June 1924, where Clemenceau, loyal to Coutela, lay in wait. The Tiger gave him a frosty reception, but Monet was

welcoming, and over lunch laughed at his own recent paintings, explaining he could now only see blue – and he only knew he painted blue because of the label on the tube. Mawas prescribed glasses from the manufacturer Zeiss. Monet declared them perfect, before quickly changing his mind and feeling abandoned by both doctors. Clemenceau that summer reported Blanche in tears and Monet in a stubbornly black mood: at Giverny it was 'midnight in full sunshine'.[39] To Barbier, Monet wrote tartly 'I don't know if I'm doing well or badly, that's my affair, *à moi tout seul.*'[40] Henri Ciolkowski visiting in October, described Monet as 'upright, [with a] steady step and walking without a stick', his appearance unchanged except that 'heavy black glasses completely masked his eyes'.[41] Smoking incessantly, Monet regretted that he had not refused all operations, 'Perhaps I would be totally blind today, but that would be better and I wouldn't damage these paintings which I can't stop myself working on . . . Yes I'm difficult . . . they say of me, Claude Monet is only an eye, but what an eye. It's no longer worth much now, that eye.'[42]

He began 1925 by withdrawing his donation to the French state in a letter to Paul Léon, skirting a hurt and mortified Clemenceau, who told Blanche that he would never see Monet again unless he changed his mind. Clemenceau felt he had broken his word not only to him but to France. 'You have created the situation. I can only accept it with a sadness of which I don't want to speak,' he wrote, assuring Monet a few days later, 'I have never stopped admiring you and loving you as always.'[43]

A note from Monet to Bonnard in mid-January – 'I curse the idea I had of giving to the State. And I am going to have to give them in a deplorable condition which makes me very sad. I make every effort to succeed but without hope' – implies that the retraction was more rhetorical, a cry of despair, than real.[44] And soon afterwards Blanche explained that 'Monet works all day on his *Décorations* for the Tuileries' to visitors from Saint-Étienne seeking to buy a painting.[45]

Clemenceau, despite his threats to keep away, returned within a few weeks, initially restricting the conversation to flowers. He found Monet melancholy but still working. 'When a singer has lost his voice, he retires; the painter operated for cataracts should give up painting; and this is what I haven't been able to do,'[46] Monet wrote to Mawas in March. Bereavements in the spring kept his spirits low.

Sixty-one-year-old Marthe died in May, and Sargent and Lucien Guitry, Monet's actor friend, both also in their sixties, in June, prompting Monet to warn Geffroy, 'At my age we never know if we'll see each other again.'[47] Within the year Geffroy too was dead, at seventy – he died in his sleep, as quiet and stubborn a gesture as he ever made: his death came four days after that of the disabled sister to whom he had dedicated his existence. So the Tiger outlived all Monet's friends, and still relished a fight: 'Let's rub our shabby old pelts against each other, if that gives us back a bit of our lost youth.'[48]

Then, suddenly, it was Monet who was rejuvenated. As a last resort, Mawas suggested covering the unoperated left eye completely. The result was dramatic: 'My sight is totally improved. I work as I always did, am happy with what I do, and if the new glasses are even better, I ask only to live to be hundred.'[49] The unexpected summer of 1925 was, Monet told Marc Elder, 'for me like a second youth'.[50]

The bursts of pink flowers cloaking the house, leaving visible only its grey slate roof tinged violet in the sun, in *The House in the Roses* paintings of Monet's final working summer, are as lavish and bushy as the foliage overwhelming the *Japanese Bridge* and *Rose Path* groups of 1920–24, but the effect is transformed. It is as if a window has been opened; a breeze blows through, lifts the paint that fell like a thick curtain, and the canvas breathes again. The tunnels have gone. Soft brushstrokes caress the house with roses, closing the circle of Giverny as an image of shelter which began with the billowing canopy in 1883. The 1925 season yielded six airy, voluptuous, tremulous paintings, plus the beginnings of another four, *The House seen through the Roses*, which are less firm, and probably unfinished. Throughout the mood is serene, the pink/purple/green tonalities harmonious, and the light floods back. Most crystalline is an eleventh painting, the largest and most resolved: a close-up of a fragment of twirling branches, flutters of little comma strokes of leaves, brilliant dabs of pink and white blossoms against a pellucid azure-mauve sky. *The Roses* is as close to still life as to landscape – the limpid vitality, intense colour, spare composition, recall the translucent flower paintings which Manet made during his last illness.

In October Monet was still working outside: 'I forget everything, so happy am I to have at last recovered my vision of colours. It's a true

resurrection.'[51] There was no further reference to retracting his donation: now he planned to put the last touches to the *Décorations* when he moved back to the studio for the winter, and deliver them in the spring.

Then, around his eighty-fifth birthday in November, his energy waned. Blanche blamed gout and bad weather, and Clemenceau played down a feebleness that overtook Monet, shut up in the big studio lashed by rain, and with a hacking cough. Monet said he was only waiting for the paint to dry before dispatching the first consignment of panels for the Orangerie. The chosen works chart the cycle of light through the day, following the course of the sun: *Morning with Willows, Trees Reflections, The Clouds, Clear Morning with Willows, The Two Willows, Setting Sun, Green Reflections* and *Morning*. As a final, public testament, they record Monet's most acutely tuned perception, pushing his method of observation so far as to demonstrate that light was an abstract phenomenon, that as it changed it cast everything into a condition of flux. They thus threw open the path to twentieth-century abstract and perceptual painting.

For the moment however, the *Grandes Décorations* went nowhere. Clemenceau, who had been ill himself, recovered sufficiently to make the journey to Giverny in April and found that 'the human machine is cracking on all sides ... he is stoic and even cheerful at times. His panels are finished and won't be touched again. But it is beyond his strength to separate himself from them. The best is to let him live from day to day.' He was shocked that 'poor Monet doesn't even have the courage to walk around the garden ... the valiant little woman carries him in outstretched arms. I reminded him of our youth, that cheered him. He was still laughing when I left.'[52] Clemenceau joked with a black humour, 'from our two half-illnesses we could perhaps make one healthy man'.[53]

Blanche reported Monet bored, unhappy, unable to work. Clemenceau came again in June, shut his doctor eyes to Monet's cough, pain and weight loss, and thought he merely needed reassurance. He was indeed more spirited after seeing Clemenceau, and the visit encouraged him to accept others. Arriving in a chauffeur-driven Bentley came New York photographer Nickolas Muray on a European tour for *Vanity Fair*. He gave Monet, posed in the garden, wrapped in a coat already too large for him, sometimes in dark glasses, sometimes

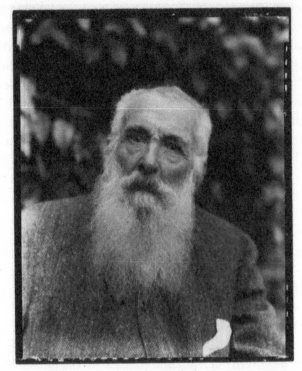

Monet photographed by Nickolas Muray, 1926

with a gaze seeming to look beyond the world, the informal chic of a 1920s celebrity while also conveying his deep withdrawal. The upright pose and furrowed face are self-possessed, dignified, tired, stricken – a tremendous presence.

On 30 June a red Ford convertible driven by the painter Jacques Salomon brought his wife Annette and her uncle Vuillard . They were given a tour of the garden, the studio and the painting collection after a lunch where Monet gulped down white wine, reminisced about Manet and Cézanne, complimented Annette on her ultramarine dress, which offset his yellow walls, and had the *Décorations* shifted to anticipate the Orangerie arrangement. He waved brightly as they left, inviting them to return soon.

In July Gimpel found Monet in the studio rearranging his paintings, having just destroyed scores of them. Blanche was the reluctant collaborator.

It is she who starts by making an incision in the canvas with a knife and detaching a piece of it, then they are burned in their entirety and Monet stays by the fire so that nothing may escape destruction. But although his daughter-in-law approves his gesture in principle, she has moments of reaction when she grows nervous and agitated; Monet notices and the work is postponed to the next day.

It is a touching portrait of a last collusion. Blanche explained that Monet 'no longer has the strength to paint, it drains him.' She took Gimpel aside, 'anxious to know if I thought he looked better . . . She seemed to think he did; she must be right. She keeps track of him every minute . . . Without his daughter-in-law, Monet would live in a seclusion that would kill him; it is she who keeps him alive.'[54]

A sombre undercurrent crept into Clemenceau's letters: 'send your slippers to the stars', 'I'm counting on you for a swansong. Without death with gentle eyes, life would be no more than an error of Providence.'[55] He was trying to protect and prepare his friend. He thought Monet 'was frightened. He was afraid of physical pain, afraid of death . . . he didn't want to think about it.'[56] That is one explanation for the absence of a will, without which Blanche would inherit nothing, Michel everything. Perhaps Monet was arranging matters. Gimpel heard that he gave Blanche considerable amounts of money directly, and it may always have been accepted that, as happened, 'she's the one who will stay on in the house.'[57]

In August the doctor at Bonnières, Jean Rebière, took one look at the spluttering, emaciated Monet and got him to his surgery, where he had an X-ray machine. He communicated his findings to Blanche, Michel and Clemenceau: an incurable lesion and congestion at the bottom of the left lung. The next day Clemenceau organized a medical conference, choosing as lead, for his optimism as well as his expertise, Dr Antoine Florand, 'docteur Tant-Mieux' (doctor Much Better), 'all of whose patients die cured'.[58]

Rebière suspected lung cancer, and Clemenceau referred to a tumour in writing to Blanche, but Monet was not told of it. Florand diagnosed pulmonary sclerosis, which might develop more or less quickly, and reassured Monet. Clemenceau, aware of and playing on Monet's extreme nervousness, told him his case was 'about

reconciling the over-imaginative patient rather than curing the ill-ness'. He outperformed doctor Tant-Mieux, glossing medical reports before they reached Giverny, warning his colleagues not to alarm the patient, normalizing the illness to Monet: 'take care of yourself mod-estly, day to day, to allow the old robustness to come out on top.'[59] Privately he was devastated, while Monet, thanks to the carefully strategized consultation, was equable: Rebière (who had learnt his lines) 'gives me hope for recovery, but the suffering and pains could be long, so I must arm myself'.[60].

Monet, lifelong quick to self-pity and to solicit sympathy, was in the reality of his last illness the opposite. To Georges Durand-Ruel, visiting on 12 September, he claimed he would soon be back at work, which the dealer thought fanciful: 'I don't think he will be able to paint again, although he talks about it all the time; his sight is getting worse and worse.'[61] This made writing difficult, and mostly Monet passed his correspondence to Blanche, but he picked up his pen for Clemenceau on 18 September:

> At last it's me writing to you, happy to be able to tell you that I am bet-ter (although there are moments when I suffer a lot), but I am reasonable and have a taste for food again, and I sleep well enough thanks to the attentions of Rebière and Florand, to the point where I was thinking of getting palette and brushes ready to pick up work again, but the relapse and pains prevented me. But I'm not losing courage and am busy with major changes in my studios and projects to perfect the garden. All that to prove to you that I am doing this with courage.
>
> Can you read this verbiage? I hope so, and that you'll visit soon, which will immediately help me improve. You should know anyway, if my strength doesn't come back enough to do what I want with my panels, that I have decided to give them as they are or at least a part of them. And you, how are you? Better than me, I hope. I kiss you with all my heart, Blanche and Michel join me.[62]

On 4 October Monet wrote to thank Paul Léon, in words suggesting he had made peace with the State: 'your letter touched me very much. I have been quite ill all summer, and couldn't touch a brush; I am bet-ter, but not yet recovered ... in spite of my weakness, I have gone back to work, but in very small doses.'[63]

These are Monet's last two known letters. His farewell to the press followed when news of his illness spurred the journalist Marcel Sauvage to take the train to Giverny. He waited in the garden until suddenly Monet appeared, leaning on Michel's arm, stumbling as he walked, wearing big glasses: 'he seemed to have retreated into the depths of his great white beard.' After painfully climbing the three steps to his house, he turned and waved to Sauvage: '"No." He does not want an interview. He has nothing more to say.'[64]

Of the next two months, the few witnesses all made the same point. Blanche: 'he no longer thought of painting, but spoke only about his flowers and his garden.'[65] Jean-Pierre: 'if he still thought and asked about his plants and his garden, he seemed no longer to think, to have forgotten what he loved more than anything: painting.'[66] Natanson: 'nothing made him forget his flowers. Every day, until the very last, he asked about some new lilies sent from Japan.'[67] There was also poetry: the painter Henry Vidal remembered that in the studio 'a book of poems by Baudelaire [Les Fleurs du Mal] was opened to 'The Stranger' at the page which says:

'Tell me, enigmatical man, whom do you love best? Your father, your
 mother, your sister, or your brother?'
'I have neither father, nor mother, nor sister, nor brother.'
'Your friends, then?'
'Now you use a word whose meaning I have never known.' . . .
'Then what do you love, extraordinary stranger?'
'I love the clouds, the clouds that pass up there, the wonderful clouds.'[68]

Blanche was grateful that Natanson and Bonnard visited in mid-November. After that, only Clemenceau was admitted; he came every Sunday 'to distract him from his pain as much as possible'. To tell the truth, he reported,

[He] did not suffer very much. There were some moments of crisis when Monet suspected that he was ill, but he did not want to stay in bed. Fifteen days before he died, we were still dining together at the table. He had spoken to me about his garden. He had told me that he had just received an entire stock of lily bulbs from Japan, the flower he loved best of all, and he was waiting for two or three cases of very

expensive seeds that would produce beautifully coloured blossoms. 'You will see all of this in the spring,' he told me. 'I will no longer be here.' But one could tell that he did not really believe it and that he was hoping to be there in May to rejoice at the spectacle.[69]

Clemenceau's role was to remain cheerful. Blanche, from whom Monet could hide nothing, said that 'during those last two months he suffered a great deal.'[70] On 2 December Clemenceau was summoned, arriving just after Paul Durand-Ruel's grandson, Pierre, and went straight up to the bedroom. The young Durand-Ruel, not permitted to see Monet, waited downstairs and kept his family informed: 'For four days, Monet has been unable to eat; he suffers greatly and is receiving constant injections to relieve his pain and keep him alive . . . his death is expected at any moment.'[71]

Clemenceau returned to Paris, and Monet asked for him again on Sunday morning, 5 December. 'Feeling his breathing become more and more laboured, I took his hand. "Are you suffering?" I asked him. "No," he replied, in a barely audible voice. A few minutes later, he gasped very feebly, and that was all.'[72] Monet died in his bedroom at one o'clock in the afternoon, with Clemenceau, Blanche, Michel and Jean-Pierre at his side. Jean-Pierre said that at the end he was 'calm and not rebellious'; Blanche reported, 'he had suffered but had a gentle death.'[73] In a card thanking Marc Elder for his condolences, Michel confirmed, 'My poor father's end was gentle. He wasn't aware that he was dying, which was a great consolation to us. But how painful the preceding days were!'; Blanche wrote, 'The soul of the house has gone.'[74]

Théodore Butler went to the *mairie* to declare the death. Someone sent a telegram from Vernon and Monet's death was front-page news in every Paris paper on the Monday. This made the intimacy he had wanted for his funeral impossible. Otherwise his requests were observed: a civil burial, simple, no speeches, no flowers. Flowers belonged to life not death.

The villagers stayed away as asked, but a crowd from Paris lined the streets when, just before eleven o'clock on 8 December, Clemenceau forced his way through to the gate, saw the coffin draped in black, with a single wreath, cried out, 'No black for Monet,' and

grabbed a piece of colourful fabric to replace it.[75] Then the hearse began its journey down the central path which Monet had so often painted; it was fringed by winter roses and chrysanthemums. It was a foggy morning and the painter Henri Vidal thought Monet would have liked the 'mysterious pink, mauve and gold of the unobtrusive poplars and the hazily outlined hills'.[76]

Following rural custom all the men lined up first behind the coffin, but Clemenceau, arm-in-arm with Dr Rebière, hung back to walk with Blanche, Germaine and Lily, in black veils, who led the women. Gradually the old man slipped to the end of the procession and then, suddenly overcome, left it entirely, shaking and in tears. Clemenceau's chauffeur was summoned. The Tiger was therefore waiting at the cemetery when the coffin arrived. It did not enter the church, there were no bells or prayers; instead the focal point was Clemenceau. The mourners formed a semi-circle around his silent, hunched figure as Monet was lowered into the tomb to join Alice beneath the white marble cross erected for her first husband.

On the black square of earth, there were just a few yellow pansies. Over the years foliage has grown to entwine the cross, entirely obscuring Ernest's name at its base and climbing to adorn the tribute to Suzanne, *retournée à Dieu*, in the prominent position above her father. The eight remaining members of the Monet-Hoschedé family sheltered in the same tomb are commemorated only by simple stone plaques lining the base of the grave. The inscription to Monet, *regretté de tous*, lies in the centre, with space left on either side for flowers to spill over, as they still do: an unceasing sequence of different blooms, through spring and summer. Directly below, added in 1947, is the memorial to Blanche, claiming as usual the place nearest to him.

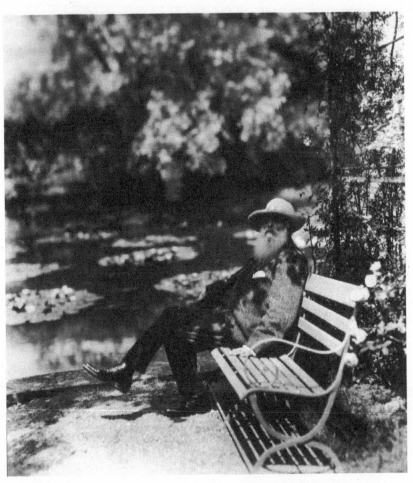

Monet beside the water-lily pond by Nickolas Muray, June 1926

Epilogue: 'The Magic Mirror'

Although he himself fled daylight and worked by night, it was Proust who expressed better than anyone Monet's greatest legacy: that he enlarged the joy of vision.

> To draw out the truth and beauty of a place we must know that they are there to be drawn out. There has to be someone who will say to us, here is what you may love; love it. And then we love. Monet's pictures show us the magic vein in Argenteuil, in Vétheuil, in Epte, in Giverny. The pictures make us adore a field, a sky, a beach, a river . . .
>
> We look closely at the magic mirror, stand back from it, try to empty our minds of all else, strive to grasp the meaning of every colour, each one of which brings to mind memories of past impressions, which arrange themselves in an architecture as immaterial and varied as the colours on the canvas, and build up, in our imagination, a landscape.'[1]

Monet's paintings, says Proust, teach us to look closely at external reality, and also to reshape it by our store of memories into a landscape of our own mind.

Among the contrasting homages paid to Monet soon after his death were those of Clemenceau, who insisted that his friend 'sacrificed everything to expressing *things as they are*', and Louis Gillet, who claimed that Monet, rather than depicting the material world, 'succeeded in fixing the impalpable, in portraying the immaterial', thus painting 'the colour of time'.[2] That both are valid speaks for Monet's vast achievement, and goes some way to explaining the breadth, and also the fitful unfolding and understanding, of his influence.

In 1927 the *Water Lilies* panels went, as planned, to the Orangerie. There they were ignored for two decades, hardly visited or mentioned,

often covered up for other exhibitions to take place in the large space. Clemenceau lamented 'a conspiracy of silence', but the cause was the art historical moment. While Cubism extended its long reach across the first half of the twentieth century, Cézanne's authority reigned. In 1939 Lionel Venturi, editor of Cézanne's first catalogue raisonné, dismissed Monet as the 'victim and gravedigger of Impressionism'.[3] Few defenders who had known him well remained: the closest painter friend to survive him, Helleu, died in 1927, and Clemenceau in 1929.

The water lilies themselves fared better, initially. They were cared for by Blanche, who looked after the house and garden, altered nothing, and began to paint it herself: *The Flowery Lawn* and *On the Bridge*, including one of her nieces in a white dress, are pictures from spring 1927. Blanche's joy and comfort was her work, and the great-nephew whom she helped bring up and taught to paint: Lily's only child, Jean-Marie Toulgouat, born in September 1927, nine months after Monet's death. By then Michel had moved out of Giverny; he bought his own home at Sorel-Moussel, forty kilometres away, where he constructed his own beautiful garden. Gimpel reported in 1927 that Blanche and Michel 'get on very well these days'.[4] Michel, who had no children, was generous to his step-siblings and their families, and gloriously careless with money; Jean-Marie recalled asking for 50,000 francs and being slipped notes totalling 500,000. The teenager was with Blanche in 1944 when Field Marshall Rommel, stationed nearby at La Roche-Guyon, called at Le Pressoir in tribute to Monet; they allowed him in, but both Blanche, nearly eighty, and Jean-Marie, refused to shake his hand. A thousand kilometres away, Gimpel, who had joined the Resistance, was working in a sawmill in Neuengamme concentration camp; spirited to the end, he taught English to his fellow prisoners in expectation of the liberation. He perished there in January 1945.

Following Blanche's death, Le Pressoir was neglected. *Water Lilies* canvases were stacked against crumbling walls in the studio, birds flew in and out of broken windows, and the garden too became a wilderness. It was during this decline that, in 1949, the American abstract painter Barnett Newman declared to Alfred Barr, director of the Museum of Modern Art in New York, 'Don't tell me who my father is, my father is not Cézanne. My father is the late Monet and you

don't have one in the Museum of Modern Art collection.'[5] Newman's colleague Ellsworth Kelly, who lived in Paris in the early 1950s, explained that still then, 'France had not discovered the *Nymphéas*. I had only remembered the *Haystacks*, but then I wrote . . . and asked if I could see the studio. There were all the water lilies.'[6] The next day Kelly painted his first monochrome, *Tableau Vert*, inspired by the grasses in Monet's pond.

Soon afterwards, Monet was anointed precursor to American abstraction. His 'influence is felt', Clement Greenberg pronounced in 1957, 'in some of the most advanced painting now being done in this country', and the *Water Lilies* 'belong more to our time, and its future, than Cézanne's own attempts at summing up statements.'[7] In effect, painting after the Second World War caught World War caught up with what Monet was doing during the First World War, and curators and art historians started to catch up too. MoMA in 1955 acquired its first large-scale *Water Lilies* canvas. Through the 1950s, to fund his passion for safaris in Africa, Michel Monet sold *Water Lilies* to other American museums, and there were exhibitions including them on both sides of the Atlantic before he died in 1966. He bequeathed to the French state a desolate 'Sleeping Beauty Giverny: the roof of the house fallen in, the Japanese bridge rotting in black water, the flower garden overgrown with brambles, many of the trees dead. Not until 1977 did restoration, orchestrated by Gerald van der Kemp and funded by American donors, begin. Giverny opened to the public in 1980.

The same year Robert Hughes, in his history of modern art *The Shock of the New*, connected the all-over skeins of paint on the water-lily canvases to Jackson Pollock's *Lavender Mist* and cast Monet as a presiding spirit for the twentieth century: 'For the pond was as artificial as painting itself. It was flat, as a painting is . . . the pond was a slice of infinity. To seize the indefinite; to fix what is unstable; to give form and location to sights so evanescent and complex that they could hardly be named – these were the basic ambitions of modernism.'seize the indefinite; to fix what is unstable; to give form and location to sights so evanescent and complex that they could hardly be named – these were the basic ambitions of modernism.'[8] In 2020 Adam Gopnik said, 'He is the one French painter who mattered most to the American

abstract painters ... the one who showed that it was possible to paint big to be intimate, and that a picture could envelop as potently as it might narrate.'[9] For the last half-century, it is this later Monet who has captured popular and scholarly interest.

Although Monet hardly spoke of his art, in yoking *Women in the Garden* with the *Water Lilies* in his sale/donation to France, he was surely indicating a continuum within his work. In 2015 the Royal Academy's landmark exhibition 'Painting the Modern Garden' showed how, from the 1860s to the 1920s, Monet wrought the most original effects from this motif of the enclosed 'avant-garden', the subject as well as the manner shaping artists from Van Gogh and Bonnard to Klimt and Matisse. The exhibition sited Monet as father to the irrepressible pleasure-givers of modern art. 'Oh the completeness of the garden dream! The solace, the safety!' T. J. Clark summed up in 2022. 'Monet was a scandal for the serious-minded, then as now, but his was the vision that had made modern painting ... for in him hedonism had taken on a true monumentality.'[10]

To create great art from that lightness of being and nonchalant amplitude, rooted in his own quality of self-indulgence, was a far-reaching gesture. Monet painted the milieu he loved, making it at once thrillingly recognizable and compellingly disconcerting – from the empty space overhung by Camille's black-ribboned hat in the Argenteuil garden in *Luncheon* in 1873, to the tangled grasses surging towards us as Blanche swings her absurdly long oar in *The Pink Skiff* in 1890. In the process, he legitimized the bourgeois idyll as a world-view for painting. Its underlying values remain our own: secular humanism, democratic leisure, pleasure, tolerance, truth to individual experience. For us, as for his first audiences, Monet's painting offers respite from an increasingly technological, urbanized world, while his faith in a cohesion between the human and natural enduringly appeals as our harmony with the environment disintegrates.

Manet, Degas, Cézanne, Renoir were in constant dialogue with art from the past, but Monet scarcely looked back. More than his friends, his biography illuminates his painting because, as Clemenceau put it, he had no agenda except to be himself: 'He was as he was, and never could have imagined being otherwise.'[11] Greenberg said, 'Impressionism was, and expressed, his personal innermost experience.'[12] He

never attempted a historical or religious narrative, nor a nude, a subject where reference to academic tradition was unavoidable. So determining for the future was this modern-life approach that we sometimes forget how revolutionary it was. In 2020 Adrian Ghenie, the most gifted European painter to emerge in the twenty-first century so far, went beyond the late paintings to applaud Monet's earlier 'act of hooliganism'. ' "Impression, soleil levant" [*Impression, Sunrise*] of 1872 is not a sweet sea landscape with a sun rising, but a bomb so powerful that it could put the Greco-Roman canon to rest for good,' he said. 'Putting aside mythology, religion ... hooliganism saved painting by focusing on the medium itself, ignoring the "grand" subject matter and fighting only for the surface.'[13]

Monet's impact has remained seminal and therefore diffuse. He inaugurated the serial method on which Andy Warhol based his career. The immersive installation of the *Water Lilies* is a precursor to the enveloping spaces of Rothko's Chapel – painting's transcendental vein – and the garden in Giverny anticipated land art. The clouds reflected in the surface of its pond are recalled in Anish Kapoor's *Sky Mirror* sculptures. Peter Doig explained that, making his snow paintings in the 1990s, 'I was looking at Monet, where there is this incredibly extreme, apparently exaggerated use of colour.'[14] And in 2018 David Hockney, aged eighty-one, moved to Normandy to record its landscape, season by season, en plein air. Monet, he believes, 'was excited every day of his life and he painted that way'. At Giverny,

> he saw forty springs, forty summers, forty autumns and forty winters. The accumulation of all that must have been magnificent for him in his mind and in the way he'd look at paintings. I know how exciting it must have been ... You're always wondering when will the first day be, the first little shoots, you're looking out for them, it's very exciting ... Monet, chain-smoking Monet, began his *Nymphéas* in his seventies. I'm sure it gave him ten years, it's life-enhancing.[15]

Monet outlived all his Impressionist colleagues, and also the novelists who had portrayed him. But the publication, partly posthumous, of *À la recherche du temps perdu* between 1913 and 1927 coincided almost exactly with the creation of the last *Water Lilies* cycle. Proust had seen the earlier *Water Lilies* exhibitions, and had mused, 'Imagine

today a writer to whom the idea would occur to treat twenty times under different lights the same theme, and who would have the sensation of creating something profound, subtle, powerful, overwhelming, original, startling like the fifty cathedrals or forty water-lily ponds of Monet.'[16] He was foreseeing his novel, equivalent to Monet's series paintings in scale, sense of shifting time, changing perspectives, the whole symphonic in structure yet built on fleeting moments and fragments, on impressionistic method – Monet's gift to literature.

Monet possessed only volume two, *À l'ombre des jeunes filles en fleurs* (1919), whose description of a visit to Elstir in Balbec – the fictional equivalent of Cabourg, across the estuary from Le Havre and close to Trouville – evokes memories of the Norman coast of his childhood, and of his own paintings. Unlike Zola's failed artist Claude Lantier, Proust celebrates Elstir as successful, famous, a genius. In *À l'ombre des jeunes filles en fleurs*, the narrator watches him depicting 'the outline of the setting sun', then wanders about examining his seascapes, by turns turbulent and lyrical: a wave 'angrily crashing its lilac foam on to the sand', and 'at the foot of immense cliffs, the Lilliputian grace of white sails on the blue mirror'. Among them, he says, 'I felt perfectly happy, for ... Elstir's studio appeared to me like a laboratory of a sort of new creation of the world.'[17]

Notes

A Note on the Sources

I have cited dates (where known) and details of writer and recipient for all correspondence to and from Monet, to and from members of the Monet and Hoschedé families, and where material is quoted from a primary source. To avoid overburdening the notes, I have given only page numbers for quotations from secondary sources.

Unless an English source is given, translations from French sources are my own.

Short titles of the principal sources quoted in the notes are:

Archives – Archives Claude Monet, Correspondance d'artiste, Collection Monsieur et Madame Cornebois, Hôtel Dassault (Artcurial), Paris 2006

Arnyvelde – André Arnyvelde, 'At Home with the Painter of Light', *Je Sais Tout*, 15 January 1914

Aubry – G. Jean-Aubry. *Eugène Boudin* (1922), London 1969

Bazille 1992 – Aleth Jourdain and Didier Vatuone (eds), *Frédéric Bazille, Prophet of Impressionism*, Montpellier and New York, 1992 (exh cat)

Bazille 2016 – Michel Hilaire and Paul Perrin (eds), *Frédéric Bazille and the Birth of Impressionism*, Montpellier and Washington, Paris 2016 (exh cat)

Cabot Perry – Lilla Cabot Perry, 'Reminiscences of Claude Monet from 1889 to 1909', *The American Magazine of Art*, March 1927

Clemenceau – Georges Clemenceau, *Claude Monet*, Paris 1928

CR I–V – Daniel Wildenstein, *Claude Monet: Biographie et catalogue raisonné*, vols I–V, Wildenstein Institute, 1974–91

Durand-Ruel – Paul Durand-Ruel, *Memoirs of the First Impressionist Dealer*, Paris 2014

Ehrlich White – Barbara Ehrlich White, *Renoir: An Intimate Biography*, London 2017

Geffroy – Gustave Geffroy, *Claude Monet, sa vie, son œuvre*, Paris 1924

Gimpel – René Gimpel, *Diary of an Art Dealer* (1963), London 1986

Giverny – Jacqueline and Maurice Guillard (eds), *Claude Monet au temps de Giverny*, Paris 1983 (exh cat)

Havre –Géraldine Lefebvre (ed.), *Monet au Havre*, Paris 2016 (exh cat)

Hoschedé – Jean-Pierre Hoschedé, *Claude Monet: Ce Mal Connu* (2 vols), Paris 1960

Journal – Journal begun by Alice Hoschedé in April 1863, formerly in the possession of Claire Joyes, now Archives Philippe Piguet

Julie Manet – Julie Manet, *Growing Up with the Impressionists: The Diary of Julie Manet*, London 1987

Life at Giverny – Claire Joyes, *Claude Monet: Life at Giverny*, London 1985

Mathieu – Marianne Mathieu and Dominique Lobstein (eds), *Monet the Collector*, Paris 2017 (exh cat)

Monet's Table – Claire Joyes, *Monet's Table: The Cooking Journals of Claude Monet*, New York 1989

Pissarro –John Rewald (ed.), *Camille Pissarro: Letters to his Son Lucien* (1950), Boston 2002

Proust – Marcel Proust, *In Search of Lost Time*, vols 1–6, translated by Scott Moncrieff and Terence Kilmartin, London 1996

Renoir – Jean Renoir, *Renoir, My Father*, New York 1962

Retrospective – Charles Stuckey (ed.), *Monet: A Retrospective*, New York 1985

Rewald – John Rewald, *The History of Impressionism*, 4th edition, London 1980

Symposium – John Rewald and Frances Weitzenhoffer (eds), *Aspects of Monet: A Symposium on the Artist's Life and Times*, New York 1984

Thiébault-Sisson 1900 – François Thiébault-Sisson, 'Claude Monet: An Interview', *Le Temps*, 27 November 1900

Thiébault-Sisson 1926 – François Thiébault-Sisson, 'About Claude Monet', *Le Temps*, 29 December 1926

Thiébault-Sisson January 1927 – François Thiébault-Sisson, 'About Claude Monet', *Le Temps,* 8 January 1927

Thiébault-Sisson June 1927 – François Thiébault-Sisson, 'Claude Monet's Water Lilies', *La Revue de l'art ancien et moderne*, June 1927

Tinterow – Gary Tinterow (ed.), *Origins of Impressionism*, New York 1995 (exh cat)

Trévise – Duc de Trévise, 'Pilgrimage to Giverny', *La Revue de l'art ancien et moderne*, January and February 1927

Vauxcelles – Louis Vauxcelles, 'An Afternoon Visit with Claude Monet', *L'Art et les artistes*, December 1905

Venise – Philippe Piguet, *Monet et Venise*, Paris, 2nd edition 2008

PROLOGUE

1. *Clemenceau*, p. 19
2. Alice to Honorine Hoschedé, 12 September 1879, *CR* I, p. 98
3. *Clemenceau*, pp. 19–20
4. Ambroise Vollard, *En écoutant Cézanne, Degas, Renoir* (1938), Paris 2005, p. 85
5. Thadée Natanson, *Peints à leur tour*, Paris 1946, pp. 35, 36
6. Meyer Shapiro, *Impressionism: Reflections and Perceptions*, New York 1997, p. 61
7. Monet to Berthe Morisot, 1 November 1886, *CR* II, p. 286; Monet to Alice, 25 March 1884, ibid., p. 246
8. Monet to Bazille, 26 August 1864, *CR* I, p. 421; Monet to Alice, 20 November 1885, *CR* II, p. 267
9. Monet to Alice, 17 October 1886, *CR* II, p. 281; Monet to Alice, 30 April 1889, *CR* III, p. 247
10. *Clemenceau*, p. 78
11. Monet to Bazille, December 1868, *CR* I, p. 425
12. Monet to Geffroy, 7 October 1890, *CR* III, p. 258
13. *Trévise*, p. 339
14. Émile Zola, 'The Realists at the Salon', *L'Événement*, 1866, and 'The Actualists', *L'Événement*, 1868, in *Retrospective*, pp. 34, 38–9
15. *Proust*, I, pp. 2023
16. *Proust*, II, pp. 556–7

I. THE CITY AND THE SEA, 1850–57

1. Marc Elder, *À Giverny chez Claude Monet*, Paris 1924, p. 35
2. Émile Zola, 'Une exposition: Les peintres impressionnistes', in *Les écrits sur l'art*, Paris, April 1877
3. Fernand Bidaux to Monet, 4 July 1898, *Archives*
4. Monet to Thiébault-Sisson, 19 November 1900, *CR* IV, p. 349
5. *Thiébault-Sisson 1900*, p. 204
6. *Hoschedé*, I, p. 83
7. *Geffroy*, p. 5
8. *Thiébault-Sisson 1900*, p. 204
9. Adolphe Monet to Bazille, 11 April 1867, in Gaston Poulain, *Bazille et ses amis*, Paris 1932, pp. 74–7
10. Ibid.
11. Eugène Guinot, 'Rue Laffitte', in *Les rues de Paris*, Paris 1844, p. 113, in Véronique Chagnon-Burke, 'Rue Laffitte: Looking at and Buying Contemporary

Art in Mid-Nineteenth-Century Paris', *Nineteenth-Century Art Worldwide*, 2:2, Summer 2012

12. Alfred Fierro, *Histoire et dictionnaire de Paris*, Paris 1996, p. 435

13. François Guizot, *Le Moniteur*, Paris, 2 March 1843

14. Jules Janin, *Itinéraire du chemin de fer de Paris au Havre*, Paris 1854, pp. 101–2

15. Jules Janin, *La Normandie*, Paris (undated), p. 534

16. *Courrier du Havre*, 23 February 1848, in Roger Lévy, 'La révolution de 1848 au Havre', in *Revue d'Histoire du XIX siècle*, 191144, p. 127

17. Frédéric de Coninck, *Le Havre, son passé, son avenir*, Le Havre 1869, p. 145

18. *Pissarro dans les Ports*, exhibition catalogue, Le Havre 2013, p. 18

19. Émile Zola, 'The actualists', *L'Événement*, 1868, in *Retrospective*, p. 38'

20. Quoted in Robert Herbert, *Impressionism: Art, Leisure and Parisian Society*, London 1988, p. 292

21. Théophile Beguin-Billecocq, diary 1853, in CR I, p. 3

22. *Thiébault-Sisson 1900*, p. 204

23. Ibid.

24. Ibid., p. 205

25. Ibid., p. 204; *Gimpel*, p. 73

26. Bidaux to Monet, 4 July 1898, *Archives*

27. *Havre*, p. 77

28. Monet to Alice, 30 October 1886, CR II, p. 285

29. *Clemenceau*, p. 16

30. *Geffroy*, p. 5

31. *Aubry*, p. 168

32. Jacques-Émile Blanche, *Propos de peintre: De Gauguin à la Revue Nègre*, 3rd series, Paris 1928, p. 34

33. Joachim Gasquet, *Cézanne: A Memoir with Conversations*, London: 1991, p. 164

34. Hippolyte Billecocq to Ernest Billecocq, 10 August 1857, Collection Billecocq, Musée Marmottan

35. Claude Roger-Marx, 'M. Claude Monet's "Water Lilies"', *Gazette des Beaux-Arts*, June 1909, in *Retrospective*, p. 268

2. TREMBLING LAUGHTER, 1857–9

1. *Thiébault-Sisson 1900*, p. 205

2. Charles Baudelaire, *Curiosités esthétiques*, Paris 1868, II, p. 526

3. Hippolyte Billecocq to Ernest Billecocq, 10 August 1857, Collection Billecocq, Musée Marmottan

4. Adolphe Monet to Bazille, 11 April 1867, in Gaston Poulain, *Bazille et ses amis*, Paris 1932, p. 75
5. *Gimpel*, p. 152
6. *Thiébault-Sisson 1926*, p. 342
7. *Hoschedé*, I, p. 83
8. Monet to Alice, 19 February 1901, CR IV, p. 354
9. Monet to Rodin, 16 July 1911, CR IV p. 382
10. *Geffroy*, pp. 3, 326
11. *Thiébault-Sisson 1900*, p. 205
12. Baudelaire, *Curiosités*, II, pp. 530–31
13. *Aubry*, pp. 21–2
14. *Thiébault-Sisson 1900*, p. 205
15. Philippe Burty, 'The Landscapes of Claude Monet', *La République française*, 27 March 1883, in *Retrospective*, p. 99
16. *Aubry*, pp. 24–7
17. Ibid.
18. Boudin to Monet, 28 July 1992, *Aubry*, p. 118
19. *Thiébault-Sisson 1900*, p. 206
20. *Aubry*, p. 155
21. *Aubry*, p. 30
22. Monet to Boudin, 3 June 1859, CR I, p. 419
23. Monet to Boudin, 28 March 1889, CR III, p. 242
24. *Aubry*, p. 118
25. Ibid., p. 60
26. *Thiébault-Sisson 1900*, p. 206
27. Hippolyte Billecocq to Ernest Billecocq, 1 October 1858, Collection Billecocq, Musée Marmottan
28. René Delange 'Claude Monet', *L'Illustration*, 4374, 15 January 1927
29. *Cabot Perry*, p. 194
30. *Havre*, p. 84
31. *The Unpublished Letters of Elizabeth Barrett Barrett [sic] to Mary Russell Mitford*, New Haven 1954, p. 209
32. *Havre*, p. 148
33. *CR I*, p. 6
34. Monet to Boudin, 20 February 1860, *CR I*, p. 420
35. *Havre*, p. 189
36. *Thiébault-Sisson 1900*, p. 204
37. Ibid., p. 206
38. Monet to Boudin, 19 May 1859, CR I, p. 419
39. Ibid.

3. OSCAR IN PARIS AND ALGIERS, 1859–61

1. Edward King, *My Paris: French Character Sketches*, Boston 1868, p. 1
2. Monet to Boudin, 19 May 1859, CR I, p. 419
3. Alain Plessis, *The Rise and Fall of the Second Empire*, Cambridge 1979, p. 55
4. Frederick Brown, *Zola: A Life*, London 1995, p. 86
5. Ibid., p. 138
6. Valerie Steele, *Paris Fashion: A Cultural History*, New York 1988, p. 128
7. Monet to Boudin, 20 February 1860, CR I, p. 420
8. Quoted in Alex Danchev, *Cézanne: A Life*, London 2012, p. 67
9. *Thiébault-Sisson 1900*, p. 206
10. Carolus-Duran to Monet, 30 May 1911, *Archives*
11. *Thiébault-Sisson 1926*, p. 343
12. Gregor Dallas, *At the Heart of the Tiger: Clemenceau and his World*, London 1993, p. 32
13. *Geffroy*, p. 15
14. Monet to Boudin, 21 April 1860, CR I, p. 420
15. Quoted in Joanna Richardson, *La Vie parisienne*, London 1971, p. 101
16. Stephen Eisenmann and Thomas Crow, *Nineteenth Century Art: A Critical History*, London 2007, p. 206
17. *Tinterow*, p. 7
18. Eisenmann and Crow, *Nineteenth Century Art*, pp. 206–7.
19. Charles Baudelaire, *Art in Paris 1845–1862: Salons and Other Exhibitions*, Oxford 1965, p. 146
20. *Tinterow*, p. 6
21. John Richardson, *Manet*, London 1958, p. 6
22. Danchev, *Cézanne*, p. 69
23. Baudelaire, *Art in Paris*, pp. ix–x
24. Kenneth Clark, *Landscape into Art*, London 1949, p. 164
25. Baudelaire, *Art in Paris*, p. 217
26. *Gimpel*, 9 October 1920, p. 153
27. *Thiébault-Sisson 1926*, p. 342
28. *Geffroy*, p. 22
29. Alex Danchev (ed.), *The Letters of Paul Cézanne*, London 2013, p. 114
30. *Thiébault-Sisson 1900*, p. 206
31. Lewis Piaget Shanks, 'Eugène Fromentin: A Painter in Prose', in *The Open Court*, 1920, 11, p. 664
32. Aimé Césaire, 'Discourse on Colonialism', in *Colonial Discourse and Postcolonial Theory: A Reader*, Patrick Williams and Laura Chrisman (eds), London 1994, p. 176

33. Alexis de Tocqueville, *First Report on Algeria*, Paris 1847, p. 142, in Cheryl Welch, 'Out of Africa: Tocqueville's Imperial Voyages', in *Review of Middle East Studies*, 45:1, pp. 53–61, January 2009

34. *The Times*, 15 July 1845

35. De Tocqueville, *First Report on Algeria*, p. 146

36. Corneille Trumelet, *Bou-Farik*, p. 130, in Paige Gulley, 'French Land, Algerian People', *Voces Novae: Chapman University Historical Review*, 10:1 (2018), p. 8

37. Eugène Bodichon, *Hygiène à suivre en Algérie*, Paris 1851, in ibid., p. 10

38. Pauline de Noirfontaine, *Un Regard écrit: Algérie*, Le Havre 1856, pp. 21, 20, 314

39. *Thiébault-Sisson 1926*, p. 342

40. *Thiébault-Sisson June 1927*, p. 289

41. De Tocqueville, *Notes on the Voyage to Algeria in 1841*, p. 36, in Welch, 'Out of Africa'

42. *Thiébault-Sisson 1900*, p. 206

43. Ibid.

44. *Gimpel*, p. 339

45. *Clemenceau*, p. 18

46. *Thiébault-Sisson 1926*, p. 342

47. Ibid.

48. *Arnyvelde*, p. 270

49. *Thiébault-Sisson 1900*, p. 207

50. *CR* I, p. 19

51. *Thiébault-Sisson 1900*, p. 217

52. *CR* I, p. 19

53. Ibid., p. 24

54. Ibid., p. 19

55. *Hoschedé*, I, p. 166

4. BAZILLE, 1862–5

1. *CR* I, p. 22

2. Ibid., p. 23

3. *Renoir*, p. 94

4. Ehrlich White, p. 99

5. *Renoir*, p. 26

6. *Bazille 1992*, p. 33

7. Ibid., p. 155

8. Monet to Bazille, 16 July 1867, *CR* I, p. 424

9. Monet to Bazille, 15 July 1864, ibid., p. 420

10. *Bazille 1992*, p. 23
11. Ibid.
12. *Rewald*, p. 200
13. *Bazille 2016*, p. 23
14. *Bazille 1992*, p. 58
15. *CR I*, p. 25
16. *Thiébault-Sisson 1900*, p. 208
17. *Renoir*, pp. 99–100
18. *Thiébault-Sisson 1900*, p. 208
19. *CR I*, pp. 23–4
20. *Bazille 2016*, p. 24
21. *Arnyvelde*, p. 272
22. Monet to Gautier, 23 May 1863, *CR I*, p. 42
23. *Rewald*, p. 8
24. *Tinterow*, p. 129
25. *Bazille*, p. 155
26. *Rewald*, p. 84
27. *Rewald*, p. 142
28. Charles Baudelaire, *The Painting of Modern Life* (1863), London 1995, p. 12
29. Jules Claretie, 'Salon de 1875', in *L'Art et les artistes français contemporains* (1876), p. 337
30. Alex Danchev, *Cézanne: A Life*, London 2012, p. 88
31. *Bazille 2016*, p. 28
32. Ibid., p. 27
33. *Bazille 1992*, p. 156
34. *Bazille 2016*, p. 115
35. Monet to Gautier, 7 March 1864, *CR I*, p. 420
36. *Renoir*, p. 99
37. *Bazille 1992*, p. 158
38. *Rewald*, p. 109
39. *Bazille 2016*, p. 115
40. Ibid., p. 222
41. Monet to Bazille, 15 July 1864, *CR I*, p. 420
42. Ibid.
43. Monet to Bazille, 26 August 1864, *CR I*, p. 421
44. Monet to Boudin, October/November 1864, ibid.
45. Monet to Bazille, 16 October 1864, ibid.
46. Adolphe Monet to Bazille, 11 April 1867, inGaston Poulain, *Bazille et ses amis*, Paris 1932p. 75
47. Monet to Bazille, 14 October 1864, *CR I*, p. 421
48. Monet to Bazille, 16 October 1864, ibid.

49. Monet to Bazille, 14 October 1864, ibid.

50. Monet to Bazille, 6 November 1864, ibid., p. 421

51. Monet to Boudin, October/November 1864, ibid.

52. *Bazille 2016*, p. 226

53. Monet to Bazille, winter 1864, *CR* I, p. 422

54. *Bazille 1992*, p. 29

55. *Bazille 2016*, p. 48

56. *Rewald*, p. 123

57. Ibid.

58. Ibid.

59. Monet to Bazille, 4 May 1865, *CR* I, p. 422

60. *Bazille 2016*, p. 64

61. Monet to Bazille, July 1865, *CR* I, p. 422

62. Monet to Bazille, 16 August 1865, ibid.

63. *Bazille 2016*, p. 30

64. Monet to Bazille, July 1865, *CR* I, p. 422

5. CAMILLE, 1865–7

1. Théophile Thoré, 'Salons de W Bürger 1861–68', in *Retrospective*, p. 35

2. Ernest d'Hervilly, in *L'Artiste*, 1866, *CR* I, p. 32

3. Léon Billot, *Journal du Havre*, 31 October 1868, in *Retrospective*, p. 40

4. Émile Zola, 'The Realists at the Salon', in *Retrospective*, p. 34

5. Monet to Gustav Pauli, 7 May 1906, *CR* IV, p. 370

6. *Geffroy*, p. 30

7. Arsène Houssaye, *Man about Paris: The Confessions of Arsène Houssaye*, London 1972, p. 53

8. Gloria Groom (ed.), *Impressionism, Fashion & Modernity*, Chicago 2012, p. 60

9. Charles Baudelaire, *The Painting of Modern Life* (1863), London 1995, p. 12

10. Groom, *Impressionism, Fashion & Modernity*, p. 125

11. Ibid., p. 21

12. Monet to Sacha Guitry, 21 April 1923, *CR* IV, p. 215

13. *Bazille 2016*, p. 64

14. *CR* V, p. 134

15. Baudelaire, *The Painting of Modern Life*, p. 13

16. Monet to Bazille, July 1865, *CR* I, p. 422

17. Monet to Bazille, 14 October 1865, ibid.

18. *CR* I, p. 444

19. *Aubry*, p. 60

20. Monet to Bazille, July 1865, *CR* I, p. 422

21. *Bazille 1992*, p. 38

22. Ibid.

23. *Bazille 2016*, p. 74

24. Ibid., p. 76

25. *CR* I, p. 32

26. *Thiébault-Sisson 1926*, p. 343

27. *Renoir*, p. 102

28. Thoré, 'Salon de W. Bürger', p. 35

29. *CR* I, p. 444

30. Zola, 'The Realists at the Salon', p. 34

31. *Rewald*, p. 200

32. Billot, *Journal du Havre*, p. 40

33. *La Vie parisienne*, 5 May 1866, in *Retrospective*, p. 33

34. *La Lune*, 13 May 1866, ibid.

35. *CR* I, p. 32

36. *Thiébault-Sisson 1900*, p. 217

37. *Trévise*, p. 334

38. Zola, 'The Actualists', *L'Événement*, 1868, in *Retrospective*, p. 39

39. Monet to Courbet, 19 June 1866, *CR* V, p. 188

40. *Bazille 1992*, p. 161

41. Monet to Bazille, 9 July 1867, *CR* I, p. 424

42. Monet to Bazille, 25 June 1867, ibid.

43. Ibid.

44. Monet to Bazille, 16 July 1867, ibid.

45. *Bazille 2016*, p. 104

46. Ehrlich White, p. 99

47. Monet to Bazille, 20 May 1867, *CR* I, p. 423

48. *Bazille 2016*, p. 30

49. *Rewald*, p. 168

50. *Bazille 2016*, p. 36

51. Ibid.

52. *Rewald*, p. 172

53. Adolphe Monet to Bazille, 11 April 1867, in Gaston Poulain, *Bazille et ses amis*, Paris 1932, pp. 74–7

54. Ibid.

55. Monet to Bazille, 25 June 1867, *CR* I, p. 423

56. Ernest Cabadé to Monet, 1 July 1898, *Archives*

57. *Bazille 2016*, p. 36

58. Walter Pach, 'At the Studio of Claude Monet', *Scribner's Magazine,* June 1908, in *Retrospective*, p. 255

59. *Trévise*, p. 334
60. *Rewald*, p. 172
61. Monet to Bazille, 20 May 1867, CR I, p. 423; Monet to Bazille, 25 June 1867, ibid.
62. *Rewald*, p. 171
63. Ibid., p. 198
64. Ibid., p. 200
65. Ibid., p. 460
66. *Tinterow*, p. 131
67. *Thiébault-Sisson 1900*, p. 217
68. *Trévise*, p. 334
69. Émile Zola, *Édouard Manet: Étude biographique et critique*, Paris 1867, in *Tinterow*, p. 125
70. Mallarmé to Monet, June 1888, *Geffroy*, p. 330
71. *Trévise*, p. 335
72. Monet to Arsène Alexandre, 2 February 1921, CR IV, p. 408
73. Monet to Bazille, 25 June 1867, CR I, p. 424
74. Ibid.
75. Monet to Bazille, 9 July 1867, ibid.

6. 'PAINTER ON THE RUN', 1867–9

1. Monet to Bazille, 25 June 1867, CR I, p. 424
2. Monet to Bazille, 9 July 1867, ibid.
3. Monet to Bazille, 3 July 1867, ibid.
4. Monet to Bazille, 9 July 1867, ibid.
5. Monet to Bazille, 16 July 1867, ibid.
6. Monet to Bazille, 12 August 1867, ibid.
7. Cabadé to Monet, 5 April 1878, *Archives*
8. Monet to Bazille, 12 August 1867, CR I, p. 424
9. Ibid.
10. Monet to Bazille, 20 August 1867, ibid.
11. *Bazille 1992*, p. 42
12. Monet to Bazille, 1 January 1868, CR I, p. 425
13. Bazille to Monet, 2 January 1868, ibid., p. 444
14. *Bazille 2016*, p. 136
15. Monet to Bazille, December 1868, CR I, p. 425
16. Ibid., p. 445
17. *Bazille 2016*, p. 38
18. CR I, p. 445

19. *Rewald*, p. 185
20. Zola, 'The Actualists', *L'Événement*, 1868, in *Retrospective*, pp. 38–9
21. Monet to Bazille, 6 August 1868, *CR* I, p. 426
22. *CR* II, p. 293
23. Monet to Bazille, December 1868, *CR* I, p. 426
24. Monet to Bazille, 6 August 1868, ibid.
25. *Aubry*, p. 74
26. *CR* I, p. 445
27. Monet to Bazille, October/November 1868, ibid., p. 425
28. Monet to Bazille, December 1868, ibid.
29. Charles Stuckey, *Claude Monet, 1840–1926*, New York 1995, p. 192
30. Monet to Bazille, December 1868, *CR* I, p. 426
31. Ibid.
32. *Bazille 2016*, p. 143
33. *Bazille 1992*, p. 35

7. LA GRENOUILLÈRE, 1869–70

1. *Aubry*, p. 74
2. Monet to Arsène Houssaye, 2 June 1869, *CR* I, p. 426
3. Monet to Bazille, 9 August 1869, ibid.
4. Monet to Bazille, 17, 23 August 1869, ibid., pp. 426–7
5. *Bazille 1992*, p. 45
6. Monet to Bazille, 25 September 1869, *CR* I, p. 427
7. Walter Pach, 'At the Studio of Claude Monet', *Scribner's Magazine*, June 1908, in *Retrospective*, p. 253
8. Monet to Bazille, 25 September 1869, *CR* I, p. 427
9. Kenneth Clark, *Landscape into Art*, London 1949, p. 173
10. Ehrlich White, p. 32
11. Alex Danchev (ed.), *The Letters of Paul Cézanne*, London 2013, p. 326
12. Michael Doran (ed.), *Conversations avec Cézanne*, Paris 1978, p. 94
13. *Durand-Ruel*, p. 177
14. *Aubry*, p. 79
15. Frederick Brown, *Zola: A Life*, London 1995, p. 180
16. *Hoschedé*, I, p. 83
17. Brown, *Zola*, p. 195
18. Ibid.
19. *Bazille 2016*, p. 195
20. Ibid., p. 198
21. Ibid., p. 42

22. Ibid., p. 195
23. Ibid., p. 196
24. Boudin to Monet, 14 July 1897, CR I, p. 51
25. *Aubry*, p. 80
26. Pierre Assouline, *Discovering Impressionism: The Life of Paul Durand-Ruel*, New York 2004, p. 102
27. Ibid.
28. Ibid., p. 115
29. *Durand-Ruel*, p. vii
30. Assouline, *Discovering Impressionism*, p. 272
31. Ibid., p. 109
32. *Durand-Ruel*, p. 82
33. Ibid., p. ix
34. *Rewald*, p. 261
35. *Bazille 2016*, p. 196
36. Ehrlich White, p. 47
37. *Bazille 2016*, p. 195
38. Ibid., p. 205
39. *Thiébault-Sisson 1900*, p. 208
40. *Bazille 1992*, p 166

8. THE BRIDGE TO ARGENTEUIL, 1871–3

1. *Durand-Ruel*, p. 81
2. Monet to Pissarro, 27 May 1871, CR I, p. 427
3. *Rewald*, p. 260
4. Frederick Brown, *Zola: A Life*, London 1995, p. 222
5. *Durand-Ruel*, p. 82
6. *Aubry*, p. 82
7. Stéphane Mallarmé, 'The Impressionists and Édouard Manet', *Art Monthly and Photographic Portfolio*, London, September 1876
8. *Cabot Perry*, p. 183
9. Théodore Duret, 'Le Peintre Claude Monet, 1880, in *Retrospective*, p. 71
10. John House, *Impressionism Paint and Politics*, London 2004, p. 146
11. Ibid., p. 144
12. *Durand Ruel*, p. 120
13. T. J. Clark, *Heaven on Earth*, London 2018, p. 16
14. *Rewald*, p. 294
15. Ibid., p. 302
16. *Durand Ruel*, p. 101

17. Robert Herbert, *Impressionism: Art, Leisure and Parisian Society*, London 1988, p. 15

9. 'THIS SCHOOL OF THE FUTURE', 1873–6

1. Monet to Pissarro, 22 April 1873, CR I, p. 428
2. Denis Rouart (ed.),*The Correspondence of Berthe Morisot*, London 1986, p. 92
3. Ibid.
4. Monet to Rodin, 4 March 1887, CR III, p. 221
5. *Renoir*, p. 269
6. Monet to Pissarro, 5 December 1873, CR I, p. 429
7. *Rewald*, p. 313
8. Maurice Guillemot, 'Claude Monet', *La Revue illustrée*, 15 March 1898, in *Retrospective*, p. 196
9. *Durand-Ruel*, pp. 116, 117
10. Paul Mantz, *Le Temps*, 22 April 1876
11. Jules Claretie, *L'Indépendant*, 20 April 1874
12. *Le Figaro*, 3 April 1876, in *Retrospective*, p. 60
13. Ernest Chesneau, *Paris-Journal*, 7 May 1874, in *Retrospective*, p. 59
14. Louis Leroy, *Le Charivari*, 25 April 1874, *Rewald*, pp. 320–24
15. Jules Castagnary, *Le Siècle*, 29 April 1874, in *Retrospective*, p. 58
16. Guillemot, p. 196
17. Théodore Duret, 'Le Peintre Claude Monet', 1880, in *Retrospective*, p. 71
18. Stéphane Mallarmé, 'The Impressionists and Édouard Manet', *Art Monthly and Photographic Portfolio*, London, September 1876
19. Kenneth Clark, *Landscape into Art*, London 1949, p. 178
20. *Durand-Ruel*, p. 135
21. Ambroise Vollard, *En écoutant Cézanne, Degas, Renoir* (1938), Paris 2005, p. 252
22. *Rewald*, p. 351
23. *Vauxcelles*, p. 247
24. *Gimpel*, p. 59
25. Mallarmé, 'The Impressionists'
26. Stéphane Mallarmé, *Correspondance: 1862–71*, Paris 1959, p. 137
27. *Rewald*, p. 377
28. *Aubry*, p. 94
29. Monet to Gustave Manet, 7 May 1876, CR I, p. 430
30. *Le Gaulois*, 'Impressions of an Impressionist', 24 January 1880, in *Retrospective*, p. 70

31. Monet to de Bellio, July 1876, *CR* I, p. 431
32. *Rewald*, p. 377a

10. À MONTGERON, CHEZ MONSIEUR HOSCHEDÉ, 1876–8

1. *Hoschedé*, I, p. 159
2. *Mathieu*, p. 218
3. Ibid., p. 230
4. Adolphe Tabarant, *Manet et ses œuvres*, Paris 1947, p. 294
5. *Hoschedé*, I, p. 159
6. Honorine Hoschedé diary, 4 February 1863, *CR* I, p. 81
7. Ibid.
8. *Journal*, 27 August 1870
9. Honorine Hoschedé diary, 29 April and 2 May 1875, in *Symposium*, p. 58
10. *Journal*, September 1875
11. *Journal*, 31 December 1875
12. Honorine Hoschedé diary, 1 December 1875, in *CR* I, p. 82
13. Monet to Alice, 9 February 1884, *CR* II, p. 237
14. Claire Joyes, *Monet's Table: The Cooking Journals of Claude Monet*, New York 1989, p. 94
15. Honorine Hoschedé diary, 15 February 1876, *CR* I, p. 82
16. Ibid., 9 June 1876
17. *Journal*, late August 1876, in Ulf Küster (ed.), *Monet, Light, Shadow and Reflection*, Basel 2017, p. 155
18. *Mathieu*, p. 216
19. Honorine Hoschedé diary, April 1863, *CR* I, p. 81
20. *Journal*, 19 February 1869, 19 February 1872 and 19 February 1874
21. *Journal*, 8 October 1876
22. Honorine Hoschedé diary, April 1863, *CR* I, p. 81
23. Monet to Manet, 1876/77, *CR* I, p. 431
24. Monet to de Bellio, 1876/77, ibid.
25. *Renoir*, p. 163
26. 'Le Jour et la Nuit', *Le Moniteur universel*, 8 April 1877, in *CR* I, p. 84
27. *Rewald*, pp. 393–4
28. Claire Joyes, *Claude Monet: Life at Giverny*, London 1885, p. 17
29. *Journal*, 20 August 1877
30. Monet to unknown recipient, 5 July 1877, *CR* V, p. 188
31. *Cabot Perry*, p. 194
32. Monet to Murer, 11 April 1878, *CR* I, p. 434

33. *Rewald*, p. 412
34. Monet to de Bellio, 1877, *CR* I, p. 432
35. Monet to Murer, 26 January 1878, ibid., p. 433
36. *Renoir*, p. 100
37. Monet to Zola, 1877, *CR* I, p. 432
38. *CR* I, p. 91
39. *Rewald*, p. 387
40. Monet to de Bellio, 15 January 1878, *CR* I, p. 433
41. Monet to Murer, 20 January 1878, ibid.

11. PASTORAL, 1878–9

1. Monet to de Bellio, 26 September 1878, *CR* I, p. 435
2. *Gimpel*, p. 152
3. Meyer Shapiro, *Impressionism: Reflections and Perceptions*, New York 1997, p. 184
4. *Hoschedé*, I, p. 159
5. Monet to Murer, 1 September 1878, *CR* I, p. 34
6. 'Le Salon de 1880', *Gazette des Beaux-Arts*, July 1880, ibid., p. 110
7. Émile Taboureux, 'Claude Monet', *La Vie moderne*, 12 June 1880, in *Retrospective*, p. 89
8. Monet to Murer, 25 March 1879, *CR* I, p. 436
9. Monet to Alice, 5 November 1886, *CR* II, p. 286
10. Marthe to Alice, 1 October 1878, *CR* I, p. 93
11. Monet to Hoschedé, 14 May 1879, ibid., p. 437
12. Monet to de Bellio, 26 September 1878, ibid., p. 435
13. Monet to Muret, 28 November 1878, ibid., p. 435
14. Monet to Charpentier, 13 December 1878, ibid.
15. Monet to de Bellio, 30 December 1878, ibid., p. 436
16. Taboureux, 'Claude Monet', p. 91
17. Monet to Hoschedé, 14 May 1879, *CR* I, p. 437
18. Monet to de Bellio, 10 March 1879, ibid., p. 436
19. Monet to Alice, 30 October 1886, *CR* II, p. 285
20. *Clemenceau*, p. 65
21. *Trévise*, p. 341
22. De Bellio to Monet, 25 August 1879, *CR* I, p. 97
23. Monet to de Bellio, 4 September 1879, ibid., p. 437
24. Caillebotte to Monet. 10 April, 1 May, 13 May 1879, *Archives*
25. 'Chroniques parisiennes: les indépendants' *Le Gaulois*, 18 April 1879, in *CR* I p. 96

26. Monet to Manet, 14 May 1879, ibid., p. 437
27. Monet to Hoschedé, 14 May 1879, ibid.
28. Hoschedé to Honorine Hoschedé, 16 May 1879, ibid., p. 97
29. Ernest Hoschedé to de Bellio, 9 July 1879, Fondation Custodia archive
30. Alice to Hoschedé, July/August 1879, CR I, p. 96
31. Hoschedé to Honorine Hoschedé, 5 September 1879, in Ulf Küster (ed.), *Monet: Light, Shadow and Reflection,* Basel 2017 (exh cat), p. 158
32. Monet to de Bellio, 17 August 1879, CR I, p. 437
33. De Bellio to Monet, 25 August 1879, ibid., p. 98
34. Ehrlich White, p. 75
35. Alice to Honorine Hoschedé, 26 August 1879, CR I, p. 98
36. Hoschedé to Honorine Hoschedé, 1 September 1879, in Küster, *Light, Shadow and Reflection*, pp. 157–8
37. Hoschedé to Honorine Hoschedé, 5 September 1879, CR I, p. 98
38. Alice to Honorine Hoschedé, 12 September 1879, ibid.
39. Monet to de Bellio, 5 September 1879, ibid., p. 437
40. Caillebotte to Monet, 9 September 1879, *Archives*
41. Alice to Honorine Hoschedé, 12 September 1879, CR I, p. 98
42. *Clemenceau*, pp. 19–20
43. *Trévise*, p. 334

12. ALICE, 1879–81

1. Monet to Pissarro, 26 September 1879, CR I, p. 437
2. Monet to de Bellio, October 1879, ibid., p. 438
3. Monet to Boudin, 28 March 1889, CR III, p. 243
4. Renoir to Monet, 1879, *Archives*
5. Marthe to Hoschedé, 20 November 1879, CR I, p. 446
6. Ibid., p. 100
7. Monet to Hoschedé, 16 November 1879, CR V, p. 189
8. Alice to Hoschedé, end November 1897, CR I, p. 100
9. Alice to Hoschedé, mid December 1879, ibid., p. 105
10. Alice to Hoschedé, 6 January 1880, ibid., p. 106
11. *Gimpel*, p. 52
12. Monet to de Bellio, 8 January 1880, CR I, p. 438
13. 'Tout Paris', 'Impressions of an Impressionist', *Le Gaulois*, 24 January 1880, in *Retrospective*, p. 70
14. Monet to Duret, 8 March 1880, CR I, p. 438
15. Alice to Hoschedé, 10 January and 23 June 1880, ibid., p. 446
16. Alice to Hoschedé, 29 March 1880, ibid., p. 110

17. Juliet Wilson-Barreau, *Manet by Himself*, London 1991, p. 178
18. Monet to Hoschedé, 25 July 1880, ibid., p. 441
19. Monet to Duret, 8 March 1880, ibid., p. 438
20. *Rewald*, p. 416
21. Émile Taboureux, 'Claude Monet', *La Vie moderne*, 12 June 1880, in *Retrospective*, pp. 90–92
22. *Rewald*, p. 503
23. Ibid., p. 462
24. Monet to Durand-Ruel, 7 March 1883, CR II, p. 227
25. Monet to Duret, 1 August 1880, CR I, p. 441
26. Alice to Honorine Hoschedé, 12 September 1880, ibid., p. 115
27. Monet to Duret, 13 December 1880, ibid., p. 442
28. Monet to Alice, 14 February 1882, CR II, p. 214
29. Monet to Pissarro, 16 September 1882, ibid., p. 220
30. Monet to Alice, 28 October 1886, ibid., p. 284
31. Monet to Alice, 29 October 1886, ibid., p. 285
32. Monet to Alice, 17 November 1886, ibid., p. 287
33. Alice to Hoschedé, November 1880, CR IV, p. 57
34. Wilson-Barreau, *Manet by Himself*, p. 185
35. Monet to Alice, 17 April 1884, CR II, p. 244
36. Claire Joyes, *Monet's Table: The Cooking Journals of Claude Monet*, New York 1989, p. 20
37. Ibid., p. 28
38. Monet to Alice, 12 November 1886, CR II, p. 288
39. Monet to Alice, 21 February 1884, ibid., p. 240
40. Alice to Germaine, 16 November 1905, *Giverny*, p. 281
41. Monet to Alice, 1 February 1884, CR II, p. 235
42. Monet to Alice, 1 October 1886, ibid., p. 279
43. Alice to Germaine, 7 March 1906, *Giverny*, p. 277
44. Alice to Germaine, 27 January 1910, ibid., p. 275
45. Alice to Hoschedé, June 1881, CR I, p. 119
46. Monet to Alice, 19 November 1885, CR II, p. 267
47. Monet to Alice, 8 February 1884, ibid., p. 237
48. Monet to Alice, 19 February 1888, ibid., p. 230
49. Monet to Alice, 19 March 1882, CR II, p. 217

13. THE PATH TO GIVERNY, 1881–3

1. Monet to Alice, 15 February 1882, CR II, p. 214
2. Geffroy, 'Claude Monet', *La Justice*, 15 March 1883, in *Retrospective*, p. 97

3. Monet to Durand-Ruel, 6 April 1882, *CR*, II, p. 218
4. Monet to Alice, 29 February 1884 and 12 March 1884, ibid., pp. 242, 244
5. Monet to Alice, 20 February 1882, ibid., p. 215
6. Alice to Hoschedé, 1882, ibid., p. 6
7. Monet to Alice, 17 March 1882, ibid., p. 216
8. Monet to Alice, 18 March 1882, ibid., p. 217
9. Monet to Alice, 22 February 1882, ibid., p. 215
10. *Geffroy*, p. 96
11. Monet to Alice, 4 April 1882, CR II, p. 217
12. Ernest Chesneau, 'Groupes sympathiques: les Peintres impressionnistes', *Paris-Journal*, 7 March 1882, in *Retrospective*, p. 5
13. Philippe Burty, 'The Landscapes of Claude Monet', *La République française*, 27 March 1883, in *Retrospective*, p. 98
14. Alice to Germaine, 7 October 1908 and 10 October 1908, *Venise*, pp. 35, 36
15. Blanche to Hoschedé , July 1882, CR II, p. 8
16. Monet to Durand-Ruel, 18 September 1882, ibid., p. 220
17. Durand-Ruel to Monet, 18 September 1882, *Durand-Ruel*, p. 170
18. Monet to Durand-Ruel, 26 September 1882, CR II, p. 220
19. Alice to Hoschedé, September 1882, in Ulf Küster (ed.), *Monet: Light, Shadow and Reflection*, Basel 2017, p. 160
20. Monet to Alice, 12 February 1883, CR II, p. 225
21. Alice to Hoschedé, September 1882, in Küster, *Light, Shadow and Reflection*, p. 160
22. Monet to Hoschedé, 1 January 1883, CR II, p. 222
23. Monet to Alice, 2 February 1883, ibid., p. 223
24. Monet to Alice, 19 February 1883, ibid., p. 227
25. Ibid.
26. Monet to Alice, 20 February 1883, ibid., p. 227
27. Monet to Alice 25 March 1884, ibid., p. 246
28. Alice to Germaine Salerou, 12 November 1908, *Venise*, pp. 57–8
29. Monet to Alice, 22 February 1886, CR II, p. 272
30. Monet to Alice, 31 March 1884, ibid., p. 248
31. Monet to Alice 3 October 1886, CR II, p. 279, and 18 January 1888, CR III, p. 225
32. Monet to Alice, 26 October 1886, CR II, p. 283
33. Monet to Alice, 1 March 1884, ibid., p. 242
34. Monet to Alice, 5 February 1883, ibid., p. 224
35. Claire Joyes, *Claude Monet: Life at Giverny*, London 1885, p. 66
36. Ibid., p. 61.
37. Monet to Alice, 17 November 1886, CR II, p. 289
38. Ehrlich White, p. 151

39. Boudin to Monet, 28 July 1892, *Aubry*, p. 118

40. Alice to Germaine, 19 October 1908, *Venise*, pp. 48–9

41. Monet to Alice, 22 October 1886, *CR II*, p. 283

42. Monet to Alice, 30 January 1888, *CR III*, p. 227

43. Monet to Alice, 7 February 1888 and 27 January 1888, ibid., pp. 228, 226–7

44. Monet to Alice, 19 February 1888 and 5 March 1895, ibid., pp. 230 and 282–3

45. Monet to Alice, 9 November 1885, *CR II*, p. 265

46. Monet to Alice, 30 October 1886, ibid., p. 285

47. Alfred de Lostalot, 'Exhibition of the Works of M. Claude Monet', *Gazette des Beaux-Arts*, April 1883, in *Retrospective*, p. 104

48. Burty, 'The Landscapes of Claude Monet', p. 98

49. *Pissarro*, p. 25

50. Monet to Durand-Ruel, 7 March 1883, *CR II* p. 227

51. Will H. Low, *A Chronicle of Friendships, 1873–1900*, New York, 1908, p. 446

52. *The Selected Correspondence of Kenneth Burke and Malcolm Cowley*, Berkeley 1988, p. 129

53. *Hoschedé*, I, p. 21

54. Monet to Durand-Ruel, 29 April 1883, *CR II*, p. 228

55. Eugène Manet to Monet, 1 May 1883, *Archives*

56. Monet to Durand-Ruel, 1 May 1883, *CR II*, pp. 228–9

57. *Mathieu*, p. 132

58. De Bellio to Monet, 7 June 1883, *Monet's Years at Giverny: Beyond Impressionism* (exhibition catalogue), New York 1978, p. 19

59. Monet to Durand-Ruel, 5 April 1883, *CR*, II, p. 228

60. Alice to Germaine, spring 1883, *Giverny*, p. 276

61. Monet to Durand-Ruel, 10 June 1883, *CR II*, p. 229

62. Ibid.

63. Monet to Durand-Ruel, 5 July 1883, ibid., p. 230

64. Monet to Alice, 28 January 1884, ibid., p. 234

14. HOME AND ABROAD, 1884–6

1. Alice to Germaine, 2 January 1906, *Giverny*, p. 276

2. *Rewald*, p. 486

3. Monet to Durand-Ruel, 1 December 1883, *CR II*, p. 232

4. *Rewald*, p. 464

5. Barbara Ehrlich White, *Impressionists Side by Side*, New York 1996, p. 103

6. Denis Rouart (ed.), *The Correspondence of Berthe Morisot*, London 1986, p. 135

7. Monet to Durand-Ruel, 12 January 1884, *CR II*, p. 232

8. Monet to Durand-Ruel, 17 January 1884, ibid.
9. Monet to Alice, 5 February 1884, ibid., p. 236
10. Monet to Alice, 26 January 1884, ibid., p. 233
11. Monet to Durand-Ruel, 5 February 1884, ibid., pp. 236–7
12. Monet to Alice, 10 March 1884, ibid.
13. Leo Jansen, Hans Luijten, Nienke Bakker (eds), *Van Gogh: The Letters*, London 2009, vol. IV, p. 97
14. Monet to Alice, 27 February and 25 March 1884, *CR* II, pp. 241 and 246
15. Monet to Alice, 27 February 1884, ibid., p. 241
16. Monet to Alice, 25 January 1884, ibid., p. 233
17. Monet to Alice, 28 February 1884, ibid., p. 242
18. Monet to Alice, 19 February 1884, ibid., p. 240
19. Monet to Alice, 21 February 1884, ibid.
20. Monet to Alice, 9 February and March 1884, ibid., pp. 237 and 246
21. Monet to Alice, 10 April 1884, ibid., p. 251
22. Monet to Alice, 18 April 1888, *CR* III, p. 235
23. Monet to Alice, 26 January 1884, *CR* II, p. 233
24. Monet to Durand-Ruel, 27 April 1884, ibid., p. 252
25. Octave Mirbeau, 'Notes sur l'art: Claude Monet', *La France* (21 November 1884), ibid., p. 33
26. De Bellio to Monet, 29 November 1884, ibid., p. 34
27. Monet to Morisot 10 November 1884, *CR II*, p. 256
28. Monet to Alice, 30 October 1886, ibid., p. 285
29. Monet to Alice 19 March 1884, ibid., p. 245
30. *Gimpel*, p. 89
31. *Hoschedé*, I, p79
32. Alice Monet to Germaine, 21 July 1907, *Giverny*, p. 278
33. Claire Joyes, *Monet's Table: The Cooking Journals of Claude Monet*, New York 1989, p. 54
34. *Hoschedé*, I, p. 80
35. Claire Joyes, *Claude Monet: Life at Giverny*, London 1985, p. 49
36. Joyes, *Monet's Table*, pp. 59–60
37. *Gimpel*, p. 89
38. *Hoschedé*, I, p. 88
39. Alice to Germaine, 9 June 1907, *Giverny*, p. 278
40. *Hoschedé*, I, p. 118
41. Germaine to Alice, 6 July 1901, *Giverny*, p. 265
42. *Hoschedé*, I, pp. 37–44
43. Monet to Alice, 26 September 1886, *CR* II, p. 278
44. Joyes, *Claude Monet*, p. 61
45. Ibid., p. 88

46. *Cabot Perry*, p. 182
47. Monet to Alice, 21 October 1886, CR II, pp. 282–3
48. Monet to Alice, 3 October 1886, ibid., p. 279
49. Monet to Alice, 5 April 1893, CR III, p. 273
50. Monet to Alice, 21 October 1886, CR II, pp. 282–3
51. *Hoschedé*, I, p. 81
52. Monet to Blanche, 15 November 1886, CR II, p. 289
53. Ibid.
54. Monet to Blanche and Suzanne, 17 November 1885, ibid., p. 266
55. Guy de Maupassant, 'The Life of a Landscapist', *Le Gil-Blas*, 18 September 1886, in *Retrospective*, pp. 122–3
56. Monet to Alice 27 November 1885, CR II, p. 268
57. Durand-Ruel to Monet, 24 July 1885, *Archives*
58. Monet to Alice 9 November 1885, CR II, p. 265
59. Wilson-Barreau, *Manet by Himself*, London, 1991, p. 184
60. Monet to Alice, 12 November 1885, ibid., p. 266
61. Monet to Alice, 19 November 1886, ibid., p. 290'
62. Monet to Pissarro, December 1885, CR V, p. 190
63. Monet to Alice 20 April 1888, CR III, p. 235

15. BETRAYAL AND LOYALTY, 1886

1. Monet to Alice, 22 February 1886, CR II, p. 272
2. Ibid.
3. Monet to Alice, 20 February 1886, ibid.
4. Ibid.
5. Monet to Alice, 24 February 1886, ibid.
6. *Pissarro*, p. 108
7. Monet to Alice, 26 February 1886, CR II, pp. 272–3
8. Monet to Alice, 24 February 1886, ibid., p. 272
9. Monet to Pissarro, 10 April 1886, ibid., p. 274
10. Monet to Geffroy, 10 December 1895, CR V, p. 207
11. Alex Danchev (ed.l), *The Letters of Paul Cézanne*, London 2013, p. 243
12. Monet to Zola, 5 April 1886, CR II, p. 273
13. *Pissarro*, pp. 67–8
14. Frederick Brown, *Zola: A Life*, London 1995, p. 561
15. Monet to Arsène Alexandre, 6 December 1920, CR IV, p. 408
16. Pierre Assouline, *Discovering Impressionism: The Life of Paul Durand-Ruel*, New York 2004, p. 189
17. Aurélien Scholl, *Le Matin*, 10 April 1886; *Le Français*, 21 May 1886

18. Octave Mirbeau, *Le Figaro*, 9 August 1888
19. *Julie Manet*, p. 134
20. *Aubry*, p. 107
21. *Vauxcelles*, p. 248
22. Sylvie Patry (ed.), *Inventing Impressionism: Paul Durand-Ruel and the Modern Art Market*, London: 2015, p. 44
23. Durand-Ruel to Monet, 2 April 1888, *Archives*
24. Patry, *Inventing Impressionism*, p. 136
25. Monet to Morisot, July/August 1886, CR II, p. 275
26. Denis Rouart (ed.), *The Correspondence of Berthe Morisot*, London 1986, p. 143
27. *Pissarro*, pp. 78, 127
28. Stuckey, p. 213
29. Octave Mirbeau, 'Claude Monet', *L'Art dans les deux mondes*, 7 March 1891, in *Retrospective*, p. 160
30. W. G. C. Byvanck, *Un Hollandais à Paris en 1891*, 1892, ibid., p. 165
31. Monet to Morisot, 1 November 1886, CR II, p. 286
32. William Seitz, 'Monet and Abstract Painting', *College Art Journal*, 1956, in *Retrospective*, p. 369
33. Gustave Geffroy, *Pays d'Ouest*, Paris 1897, in *Retrospective*, p. 128; *L'Enfermé*, Paris 1897, pp. 441–2
34. Gustave Geffroy, 'Salon de 1887 – VI Hors du Salon Claude Monet II, *La Justice*, 2 June 1887, CR III, p. 3
35. Mirbeau, 'Claude Monet', p. 160
36. Félix Fénéon, 'Le Néo-impressionnisme', *L'Art moderne de Bruxelles I*, 1 May 1887, in T. J. Clark, *Farewell to an Idea*, London 1999, p. 110
37. *Pissarro*, p. 148
38. Monet to Geffroy, 20 June 1891, CR V, p. 199
39. Monet to Geffroy, 16 October 1920, ibid., p. 214
40. *CR II*, p. 57
41. Sacha Guitry, *If I Remember Right*, London 1935, pp. 80–81
42. Mirbeau to Monet, 20 March 1900, *Archives*
43. Monet to Alice, 13 November 1886, CR II, p. 288
44. Monet to Alice, 27 November 1886, ibid., p. 291

16. LES DEMOISELLES DE GIVERNY

1. Monet to Duret, 13 August 1887, CR III, p. 223
2. Thadée Natanson, *Peints à leur tour*, Paris 1946, p. 37
3. Monet to Geffroy, 22 June 1890, CR III, p. 257

4. *Gimpel*, p. 312
5. Monet to Alice, 28 January 1888, and Monet to Geffroy, 20 June 1888, *CR* III, pp. 227 and 298
6. Leo Jansen, Hans Luijten, Nienke Bakker (eds), *Van Gogh: The Letters*, vol. IV, p. 76
7. *Geffroy*, p. 283
8. Stéphane Mallarmé, *Collected Poems*, Oxford 2006, pp. 234–6
9. *Trévise*, p. 334
10. Denis Rouart (ed.), *The Correspondence of Berthe Morisot*, London 1986, p.183
11. *Trévise*, p. 334
12. *Gimpel*, pp. 318, 313
13. Mirbeau to Monet, October 1889, *Archives*
14. *Geffroy*, p. 332
15. Claire Joyes, *Monet's Table: The Cooking Journals of Claude Monet*, New York 1989, p. 91
16. *Hoschedé* I p. 76
17. *Vauxcelles*, p. 246
18. *Geffroy*, p. 330
19. Monet to Duret, 10 March 1888, *CR* III, p. 232
20. Monet to Alice, 26 January 1888, ibid., p. 226
21. Monet to Alice, 23 January 1888, ibid.
22. William Gerdts, *Monet's Giverny: An Impressionist Colony*, New York 1993, p. 106
23. Monet to Alice, 29 January 1888, *CR* III, p. 226
24. Monet to Blanche, 5 March 1888, ibid., p.231
25. Monet to Alice, 16 March 1888, ibid., p. 232
26. Gerdts, *Monet's Giverny*, pp. 29–30
27. Walter Pach, 'At the Studio of Claude Monet', *Scribner's Magazine*, June 1908, in *Retrospective*, p. 253
28. Dawson Dawson-Watson Catalogue Raisonné Project, dawsondawson-watson.org
29. Gerdts, *Monet's* Giverny, p. 39
30. Monet to Alice, 10 March 1892, *CR* III, p. 264
31. Monet to Geffroy, 20 June 1888, ibid., p. 298
32. Mirbeau to Monet, 16 February 1899, *Archives*
33. Gerdts, *Monet's Giverny*, p. 212
34. Monet to Geffroy, 25 February 1888, *CR* V, p. 191
35. Félix Fénéon, 'Dix Marines d'Antibes', *La Revue indépendante*, August 1888, in T. J. Clark, *Farewell to an Idea*, p. 112
36. *Pissarro*, p. 127

37. Rouart, *Correspondence of Berthe Morisot*, p. 154
38. *Pissarro*, pp. 126–7
39. Monet to Alice, 9 May 1889, CR III, p. 248
40. Ibid.
41. *Aubry*, p. 116.
42. Mirbeau to Monet, December 1889, *Archives*
43. Renoir to Monet, 11 August 1889, *Geffroy*, p. 245
44. Michael Fried, *Manet's Modernism*, Chicago 1996, p. 6
45. *Boston Transcript*, June 1890
46. Monet to Morisot, 11 July 1890, CR III, p. 257
47. *Clemenceau*, p. 15
48. Mallarmé to Monet, 21 July 1890, in *Geffroy*, p. 330
49. Octave Mirbeau, 'Claude Monet', *L'Art dans les deux mondes*, 7 March 1891, in *Retrospective*, p. 161
50. Hoschedé to Paul Gachet, January 1890, CR III, p. 41
51. Ibid.
52. Ibid.
53. Pierre Assouline, *Discovering Impressionism: The Life of Paul Durand-Ruel*, New York 2004, p. 222
54. Monet to Geffroy, 7 October 1890, CR III, p. 258
55. Monet to Bazille, December 1868, CR I, p. 426
56. *Trévise*, p. 337
57. W. G. C. Byvanck, *Un Hollandais à Paris en 1891*, 1892, in *Retrospective*, p. 165
58. Gustave Geffroy, 'Claude Monet Exhibition', *L'Art dans les deux mondes*, 9 May 1891, in ibid., p. 164
59. *Trévise*, p. 337
60. Geffroy, 'Claude Monet Exhibition', p. 163
61. Mirbeau, 'Claude Monet', p. 160
62. Monet to Durand-Ruel, 23 March 1891, CR III, p. 261

17. 'NOW YOU HAVE HAPPINESS', 1891–2

1. *Pissarro*, p. 159
2. Ibid., p. 161
3. Monet to Pissarro, 7 February 1891, CR III, p. 260
4. Monet to Paul Gallimard, 29 January 1891, CR V, p. 196
5. *Pissarro*, p. 166
6. W. G. C. Byvanck, *Un Hollandais à Paris en 1891*, 1892, in *Retrospective*, p. 165
7. Mallarmé to Monet, 9 July 1891, *Geffroy*, p. 330

8. Durand-Ruel to Monet, 9 May 1891, *Archives*

9. *Durand-Ruel*, p. 158

10. *Thiébault-Sisson 1900*, p. 218

11. Walter Sickert, *The New York Herald*, 16 April 1889

12. Hartwig Fisher and Sean Rainbird (eds), *Kandinsky: The Path to Abstraction*, London 2006, p. 19

13. Theodore Robinson, 'Claude Monet', *The Century Magazine*, September 1892

14. CR III, p. 37

15. Georges Clemenceau, 'The Cathedrals Revolution', *La Justice*, 1895, in *Retrospective*, p. 176

16. G. Gengembre, F. Naugrette and Y. Leclerc (eds), *Impressionnisme et littérature*, Rouen 2012, p. 134

17. Paul Adam, 'Peintres impressionnistes', *La Revue contemporaine*, 4 (April 1886), p. 542

18. Félix Fénéon, *Œuvres récentes de Cl. Monet, Le Chat noir*, May 16 1891, in CR III, p. 42

19. *Pissarro*, p. 166

20. Theodore Robinson Diary, Frick Art Reference Library, New York, 3 June 1892

21. *Cabot Perry*, p. 184

22. Robinson, 'Claude Monet'

23. Georges Lecomte, 'Beaux-Arts: Peupliers de M. Claude Monet', *Art et critique* (5 March 1892), pp. 124—5, in *Symposium*, p. 165

24. Monet to Durand-Ruel, 14 June 1891, CR III, p. 262

25. Monet to Alice, 31 March 1892, ibid., p. 265

26. Monet to Mallarmé, 28 July 1891, ibid., p. 262

27. *Cabot Perry*, p. 181

28. Mirbeau to Monet, August 1890, *Archives*

29. Octave Mirbeau, 'Claude Monet', *L'Art dans les deux mondes*, in *Retrospective*, pp. 157–62

30. J. E. Blanche, 'Cl. Monet', *La Revue de Paris*, 1 February 1927, pp. 563–4, in CR III, p. 56

31. Helleu to Monet, November 1897, *Archives*

32. *Renoir*, p. 278

33. Monet to Geffroy, 6 July and 26 October 1891, CR V, pp. 199–200

34. William Gerdts, *Monet's Giverny: An Impressionist Colony*, New York 1993, p. 106

35. Monet to Alice, 9 March 1892, CR III, p. 264

36. *Julie Manet*, p. 43

37. Monet to Alice, 9 March 1892, CR III, p. 265

38. Ibid., pp. 264–5

39. Claire Joyes, *Claude Monet: Life at Giverny*, London 1985, p. 66

40. Monet to Pissarro, 17 March 1892, CR V, p. 201
41. Monet to Alice, 9 April 1892, CR III, p. 266
42. Monet to Geffroy, 17 July 1892, CR V, p. 202
43. Suzanne to Theodore Butler, 7 June 1892, CR III, p. 47
44. Joyes, *Claude Monet*, p. 66
45. Monet to Geffroy, 17 July 1892, CR V, p. 202
46. Theodore Robinson Diary, 20 July 1892
47. Gerdts, *Monet's Giverny*, p. 125
48. Joyes, *Claude Monet*, p. 60
49. Suzanne to Theodore Butler, 7 June 1892, CR III, p. 47
50. Theodore Robinson Diary, 3 July 1892
51. *Gimpel*, p. 59
52. Paul d'Estournelles de Constant to Monet, July 1892, *Archives*

18. REVOLUTION IN THE CATHEDRAL, 1892–7

1. Monet to Alice, 2 April 1892, CR III, p. 266
2. Monet to Alice, 2 March 1892, ibid., p. 264
3. Wynford Dewhurst, *Impressionist Painting: Its Genesis and Development*, London 1904, in *Retrospective*, p. 230
4. Monet to Alice, 3 April 1892, CR III, p. 266
5. Theodore Robinson Diary, Frick Art Reference Library, New York, 23 May 1892
6. Monet to Alice, 4 April 1893, CR III, p. 273
7. Monet to Alice, 5 April 1893, ibid.
8. *Julie Manet*, p. 43
9. C. Mauclair, 'Choses d'art', *Mercure de France* (June 1895), p. 357, in Joachim Pissarro, *Monet's Cathedral*, London 1990, p. 29
10. Monet to Alice, 3 April 1893, CR III p. 273
11. Monet to Alice, 9 March 1893, ibid., p. 270
12. 'Monet I Norge', *Dagbladet*, 4 April 1895, in CR III, p. 65
13. Monet to the Prefect of the Eure, 7 July 1893, CR III, p. 274
14. *Julie Manet*, p. 43
15. Ehrlich White, p. 177
16. Hayashi to Monet, 16 April 1894, *Archives*
17. Monet to M. Joyant, 7 August 1894, CR III, p. 277
18. Monet to Geffroy, 10 December 1895, CR V, p. 207
19. Alex Danchev (ed.), *The Letters of Paul Cézanne*, London 2003, p. 259
20. Monet to Geffroy, 23 November 1894, CR III, p. 278
21. Danchev, *The Letters of Paul Cézanne*, p. 281
22. *Geffroy*, p. 196

23. Charles Stuckey, *Claude Monet, 1840–1926*, New York 1995, p. 226
24. *Geffroy*, p. 198
25. Ambroise Vollard, *Recollections of a Picture Dealer*, London 1936, pp. 167–8
26. Monet to Alice, 10 March 1895, CR III, p. 283
27. Oscar Reutersward, *Monet*, in *Retrospective*, pp. 171–2
28. Georges Clemenceau, 'The Cathedrals Revolution', *La Justice*, 20 May 1895, in *Retrospective*, pp. 175–9
29. Helleu to Monet, September 1908, *Archives*
30. Richard Thomson (ed.), *Monet and Architecture*, London 2018, p. 165
31. Mauclair, 'Choses d'art', p. 29
32. André Michel, *Notes sur l'art moderne*, Paris 1896, in *Geffroy*, p. 206
33. Monet to Geffroy, 8 June 1895, CR V, p. 206
34. Monet to Geffroy, 17 November 1895, ibid., p. 207
35. Geffroy to Monet, 1896, *Archives*
36. Monet to Geffroy, 5 March 1897, CR V, p. 208
37. Monet to Mallarmé, 8 March 1896, CR III, p. 290
38. *Julie Manet*, 2 March 1896, p. 84
39. Ibid., March 1896, pp. 86–7
40. Monet to Geffroy, 11 May 1896, ibid., p. 207
41. Monet to Durand-Ruel, 17 November 1896, CR III, p. 292
42. Theodore Robinson Diary, 3 June 1892
43. William H. Fuller, *Claude Monet and His Paintings*, 1899, in *Retrospective*, p. 203 19. R[check]

19. RETREAT TO THE GARDEN, 1897–9

1. Monet to Alice, 16 February 1897, CR III, p. 294
2. Monet to Alice, 21 February 1897, ibid.
3. *Cabot Perry*, p. 184
4. Maurice Guillemot, *La Revue illustrée*, 15 March 1898, in *Retrospective*, p. 195
5. *Julie Manet*, p. 134
6. Monet to Paul Gsell, January/February 1893, CR V, p. 201
7. Monet to Geffroy, 6 November 1897, ibid., p. 209
8. Monet to Geffroy, 3 August 1897, ibid.
9. Guillemot, *La Revue illustrée*, p. 200
10. Ibid., p. 201
11. *Pissarro*, p. 332
12. Stephanie Rachum, 'Pissarro's Jewish Identity', *Assaph: Studies in Art History*, B, 5, 2000, p. 12
13. *Geffroy*, pp. 263–4

14. Monet to Zola, 3 December 1897, *CR* III, p. 296
15. Rachum, 'Pissarro's Jewish Identity', p. 24
16. Ibid.
17. Ibid.
18. Frederick Brown, *Zola: A Life*, London 1995, p. 743
19. Ehrlich White, pp. 191, 201
20. Maya Balakirsky Katz (ed.), *Revising Dreyfus*, Boston 2013, p. 305
21. Brown, *Zola*, p. 562
22. Katz, *Revising Dreyfus*, p. 310
23. Rachum, 'Pissarro's Jewish Identity', p. 24
24. Marcel Guérin (ed.), *Lettres de Degas*, Paris 1945, p. 232
25. Monet to Geffroy, 15 December 1899, *CR* IV p. 339
26. *Pissarro*, pp. 332, 338
27. Monet to Geffroy, 22 March 1899, *CR* IV, p. 337
28. Claire Joyes, *Claude Monet: Life at Giverny*, London 1985, p. 75
29. Monet to Geffroy, 7 February 1899, *CR* IV, p. 337
30. Renoir to Monet, 8 February 1899, *Archives*
31. Monet to Durand-Ruel, 22 March 1902, *CR* IV, p. 362
32. Alice to Germaine, 23 November 1908, *Venise*, p. 64
33. Alice to Germaine, 3 November 1908, ibid., p. 51
34. *Journal*, 30 September 1900, in *Mathieu*, p. 220
35. *Journal*, 9 January 1903, *CR* III, p. 301
36. *Julie Manet*, p. 172
37. Alice to Germaine, 10 October 1908, *Venise*, p. 36
38. *Hoschedé*, I, p. 127
39. Monet to Pissarro, 5 January 1900, *CR* V, p. 210
40. Monet to Alice, 19 February 1901, *CR* IV, p. 354
41. *Vauxcelles*, p. 249
42. Cabadé to Monet, 24 August 1898, *Archives*
43. Monet to Geffroy, 5 July 1899, *CR* IV, p. 339
44. Arsène Alexandre, 'Monet's Garden', *Le Figaro*, 9 August 1901, in *Retrospective*, p. 222

20. UNREAL CITY, 1899–1903

1. *Gimpel*, p. 129
2. Wynford Dewhurst, *Impressionist Painting*, 1904, in *Retrospective*, p. 229
3. Henry James, *English Hours* (1905), London 1981, p. 7
4. Quoted in Richard Thompson (ed.), *Monet and Architecture*, London 2018, p. 171

5. Monet to Pissarro, 5 January 1900, *CR* V, p. 210

6. Alice to Germaine, 15 October 1908, *Venise*, p. 38

7. Monet to Alice, 23 February 1900, *CR* IV, p. 343

8. Monet to Alice, 17 February 1900, ibid., p. 342

9. Monet to Germaine, 11 March 1900, ibid., p. 344

10. Monet to Alice, 18 March 1900, ibid., p. 345

11. Ibid.

12. *Trévise*, p. 337

13. Monet to Blanche, 4 March 1900, *CR* IV, p. 344

14. Monet to Alice, 3 February 1901, ibid., p. 351

15. Monet to Alice, 28 February 1900, ibid., p. 343

16. Monet to Alice, 10 March 1901, ibid., p. 356

17. *Geffroy*, p. 309

18. Gustave Kahn, 'The Claude Monet Exhibition', *Gazette des Beaux-Arts*, 1 July 1904, in *Retrospective*, pp. 226–7

19. Katherine Lochnan (ed.), *Turner Whistler Monet*, London 2004, p. 44

20. *Gimpel*, p. 73

21. Monet to Alice, 6 February 1901 and 19 March 1900, *CR* IV, pp. 352, 345

22. Monet to Alice, 14 February 1900, ibid., p. 342

23. Monet to Alice, 31 March 1900, ibid., p. 347

24. Renoir to Monet, 23 August 1900, *Archives*, p. 130

25. Monet to Renoir, August 1900, *CR* IV, p. 348

26. Renoir to Monet, 23 August 1900, *Archives*, p. 130

27. Monet to Alice, 8 February 1901, *CR* IV, p. 352

28. Monet to Alice, 2 February 1901, ibid., p. 351

29. Monet to Blanche, 18 February 1901, ibid., p. 354

30. Journal, 13 March 1901, *CR* IV, p. 24

31. Journal, 6 July 1901, ibid., p. 15

32. Monet to Louise Costadau, 19 July 1912, *CR* IV, p. 385

33. Claire Joyes, *Claude Monet: Life at Giverny*, London 1985, p. 77

34. Monet to Alice, 7 March 1901, ibid., pp. 355–6

35. Monet to Alice, 5 March 1901, ibid., p. 355

36. Monet to Alice, 15 March 1901, ibid., p. 357

37. Monet to Alice, 30 March 1900, ibid., pp. 346–7

38. Mirbeau to Monet, June 1903, *Archives*, p. 102

39. Alice to Germaine, 10 July 1901, *Giverny*, p. 265

40. *Hoschedé*, I, p.126

41. Alice to Germaine, 12 July 1901, *Giverny*, p. 265

42. Alice to Germaine, 31 January 1902, *Giverny*, p. 265

43. Alice to Germaine, 10 February 1902, ibid.

44. Claire Joyes, *Monet's Table: The Cooking Journals of Claude Monet*, New York 1985, p. 79

45. *Hoschedé*, I, p. 127

46. Monet to Durand-Ruel, 22 December 1902, *CR* IV, p. 363

47. Monet to Geffroy, 26 December 1902, ibid.

48. Geffroy to Monet, 11 December 1902, *Archives*

49. Maurice Kahn, 'Claude Monet's Garden', *Le Temps*, 7 June 1904, in *Retrospective*, p. 243

50. Monet to Alice, 25 March 1900, *CR* IV, p. 346

51. Monet to Durand-Ruel, 2 March 1904, ibid., p. 364

52. Mirbeau to Monet, 20 March 1900, *Archives*

53. Raymond Koechlin to Monet, 25 March 1905, ibid.

54. Monet to Pissarro, 9 November 1903, *CR* V, p. 211

55. Camille Mauclair, *L'impressionnisme*, Paris 1904, in J. M. Cocking, *Proust: Collected Essays on the Writer and his Art*, Cambridge 1982, p. 290

56. Monet to Durand-Ruel, 10 May 1903, *CR* IV, p. 363

21. THE MOMENT OF ROSES, 1904–8

1. Arsène Alexandre, 'Monet's Garden', *Le Figaro*, 9 August 1901, in *Retrospective*, pp. 222–3

2. Arsène Alexandre, 'News from our Parisian Correspondents', *Courrier de l'Aisne*, 9 June 1904, in *Retrospective*, p. 225

3. *Geffroy*, p. 328

4. Alexandre, 'Monet's Garden', p. 220

5. Marcel Proust, 'Splendours', *Le Figaro*, 15 June 1907, in *Retrospective*, p. 250

6. Alexandre, 'News from our Parisian Correspondents', p. 225

7. Monet to Durand-Ruel, 28 September 1906, *CR* IV, p. 371

8. Alice to Germaine, 27 May 1906, *Giverny*, p. 278

9. Monet to Alice, 1 April 1900, *CR* IV, p. 347

10. Monet to Geffroy, 10 April 1906, ibid., p. 370

11. Alice to Germaine, 17 April 1908, *Giverny*, p. 271

12. *Vauxcelles*, p. 249

13. Claude Roger-Marx, 'M. Monet's "Water Lilies"', *Gazette des Beaux-Arts*, June 1909, in *Retrospective*, p. 265

14. Ibid., p. 256

15. *Thiébault-Sisson June 1927*, pp. 289–90

16. Alexandre, 'News from our Parisian Correspondents', p. 224

17. Roger-Marx, M. Monet's "Water Lilies"', p. 265

18. Monet to Durand-Ruel, 27 April 1907, *CR IV*, p. 372
19. Monet to Durand-Ruel, 20 September 1907, ibid.
20. Ovid, *Metamorphoses*, 3.434–6, translated in George Shackelford (ed.), *Monet The Late Years*, New Haven, CT, 2019. I am indebted to Emma Cauvin, PhD candidate at Sorbonne University, Paris, for the allusion to Ovid and for her reading of the paintings in her essay in this volume, 'The Late Monet and His Critics: Water Lilies, "Cunning Mirrors on Paradise"'
21. Roger-Marx, 'M. Monet's "Water Lilies"', p. 255
22. *Vauxcelles,* p. 249.
23. Alice to Germaine, 12 August 1907, *Giverny*, p. 278
24. Alice to Germaine, 29 May 1907, ibid.
25. Alice to Germaine, 16 May, 17 May 1906, ibid., p. 277
26. Alice to Germaine, 15 February 1906 and 9 June 1907, ibid., pp. 277 and 278
27. *Journal*, January 1907
28. Alice to Germaine, 8 April 1906, *Giverny*, p. 277
29. Alice to Germaine, 26 October 1906, ibid., p. 281
30. Alice to Germaine, 6 and 7 March 1906, ibid., p. 277
31. Pissarro to Lucien Pissarro, 21 April 1900, *Pissarro*, p. 340
32. Joachim Gasquet, *Cézanne: A Memoir with Conversations*, London 1991, p. 164
33. Jack Flam, *Matisse,* Ithaca 1986, pp. 51, 60, 72
34. Durand-Ruel to Monet, 21 April 1908, *CR IV*, p. 55
35. Joachim Gasquet to Monet, 7 April 1912, *Archives*
36. Charles Stuckey, *Claude Monet, 1860–1926*, New York 1995, p. 10
37. *Gimpel*, p. 314
38. Mirbeau to Monet, February 1910, *Archives*
39. Roger-Marx, 'M. Monet's "Water Lilies"', p. 256
40. Ibid., p. 267
41. Monet to Durand-Ruel, 27 April 1907, *CR IV*, p. 372
42. Monet to Durand-Ruel, 20 March 1908, *CR IV*, p. 373
43. Monet to Durand-Ruel, 7 April 1908, ibid.
44. Alice to Germaine, 16 April 1908, ibid.
45. Alice to Germaine, 17 April 1908, ibid.
46. Alice to Germaine, 24 April 1908, ibid.
47. Alice to Germaine, 4 May 1908, ibid., p. 272
48. Alice to Germaine, 5 May 1908, ibid.
49. *The Washington Post,* 16 May 1908, in *Retrospective*, pp. 250–51
50. *The Standard,* 20 May 1908, ibid., p. 251
51. Alice to Germaine, 8 May 1908, *Giverny*, p. 272
52. Alice to Germaine, 14 May and 7 May 1908, ibid.
53. Mirbeau to Monet, 19 May 1908, *Archives*

54. Alice to Germaine, 21 May 1908, *Giverny*, p. 272
55. 'Butler held for Banker's Murder', *The San Francisco Call*, 27 June 1908
56. Alice to Germaine, 25 June 1908, *Giverny*, p. 272
57. Monet to Geffroy, 11 August 1908, *CR IV*, p. 374
58. Alice to Germaine, 27 September 1908, *Venise*, p. 29

22. DEATH IN VENICE, 1908–14

1. Alice to Germaine, 3 October 1908, *Venise*, p. 33
2. Alice to Germaine 3, 5 and 6 October 1908, ibid., pp. 33, 34
3. Alice to Germaine, 8 October 1908, ibid., pp. 35–6
4. Alice to Germaine, 6 October 1908, ibid., pp. 34–5
5. Henry James, 'The Grand Canal', *Scribner's Magazine*, vol. XII, November 1892
6. Alice to Germaine, 30 October 1908, ibid., p49
7. Alice to Germaine, 25 October 1908, ibid., p. 46
8. Alice to Germaine, 6 October 1908, ibid., pp. 34–5
9. Monet to Geffroy, 7 December 1908, *CR IV*, p. 375
10. Alice to Germaine, 4 November 1908, *Venise*, pp. 52–3
11. Alice to Germaine , 23 October 1908, ibid., p. 44
12. Alice to Geffroy, 16 November 1908, *CR IV*, p. 62
13. Alice to Germaine, 31 October 1908, *Venise*, pp. 49–50
14. Ehrlich White, p. 240
15. *Gimpel*, p. 12
16. Ibid., p. 249
17. Alice to Germaine, 25 November 1908, *Venise*, p. 65
18. Alice to Germaine, 6 February 1909, *Giverny*, p. 272
19. Monet to Durand-Ruel, 28 January 1909, *CR IV*, p. 375
20. Jean-Louis Vaudoyer, *La Chronique des arts et de la curiosité*, 15 May 1909, in Daniel Wildenstein, *Monet's Years at Giverny: Beyond Impressionism*, New York 1978, p. 39
21. Franc-Nohain, 'Les Fleurs sur l'Eau', *La Vie parisienne*, 22 May 1909, in George Shackelford (ed.), *Monet: The Late Years*, Kimbell 2019, p. 66
22. Review collected in Louis Gillet, *Trois variations sur Claude Monet*, Paris 1927, p. 39
23. Jean-Yves Tadié, *Marcel Proust: A Life*, London 2000 (Paris 1996), p. 525
24. Alice to Germaine, 6 and 8 May 1909, *Giverny*, p. 274
25. *Journal*, 6 September 1909
26. Monet to Geffroy, 7 December 1909, *CR IV*, p. 378
27. Monet to Geffroy, 4 January 1910, ibid.

28. Monet to Hoschedé, 14 May 1879, *CR* I, p. 43

29. Alice to Germaine, 25 January 1910, *Giverny*, p. 275

30. Alice to Germaine, 2 and 3 February 1910, ibid., pp. 275–6

31. Monet to Julie Manet-Rouart, 6 February 1910, *CR* IV, p. 378

32. Mirbeau to Monet, February 1910, *Archives*

33. Monet to Geffroy, 19 April 1910, *CR* IV, p. 378

34. Monet to Durand-Ruel, 15 April 1910, ibid.

35. Monet to G. or J. Bernheim-Jeune, 14 May 1910, ibid., p. 379

36. Renoir to Monet, 2 May 1910, *Archives*

37. Alice to Germaine, 2 June 1910, *Giverny*, p. 276

38. Monet to Julie Manet-Rouart, 1 July 1910, *CR* IV, p. 379

39. *Journal*, 27 July 1910

40. Monet to Geffroy, 27 December 1910, *CR* IV, p. 380

41. *Geffroy*, p. 331

42. Monet to Geffroy, 7 May 1911, *CR* IV, p. 381

43. Monet to Durand-Ruel, 19 May 1911; Monet to Geffroy, 19 May 1911, ibid.

44. Monet to Geffroy, 29 May 1911, ibid.

45. *Hoschedé*, I, p. 43

46. Geffroy to Monet, 16 July 1911, *Archives*

47. Monet to Rodin, 16 July 1911, *CR IV*, p. 382

48. Ehrlich White, p. 277

49. Monet to G. or J. Bernheim-Jeune, 28 August 1911, *CR* IV, p. 382

50. Monet to Germaine, 29 September 1911, *CR* V, p. 217

51. Monet to Geffroy, 7 September 1911, *CR IV*, p. 382

52. Monet to Germaine, 19 November 1911, ibid., p. 383

53. Monet to Geffroy, 29 December 1911, ibid.

54. Monet to Blanche, 4 December 1911, ibid.

55. *Mathieu*, p. 222

56. Monet to Louise Costadau, 19 July 1912, *CR* IV, p. 385

57. Monet to Durand-Ruel, 10 April 1913, ibid., p. 387

58. Claire Joyes, *Claude Monet: Life at Giverny*, London 1985, p. 105

59. Mirbeau to Monet, February 1912, *Archives*

60. John Ruskin, *The Stones of Venice*, London 1851, gutenberg.org, pp. 1–2

61. Monet to Durand-Ruel, 10 May 1912, *CR* IV, p. 385

62. Ibid.

63. Monet to Germaine, 17 June 1912, 'Marc Piguet se souvient de son enfance', *La Montagne*, 24 April 2016

64. Monet to Louise Costadau, 19 July 1912, *CR IV*, p. 385

65. Charles Stuckey, *Claude Monet, 1840–1926*, Chicago 1995, p. 245

66. Monet to Charlotte Lysès, 5 February 1914, *CR* IV, p. 389

67. Monet to Durand-Ruel, 16 February 1914, ibid

68. Monet to Geffroy, 16 February 1914, ibid.
69. Monet to Geffroy, 30 April 1914, ibid., p. 390
70. Monet to Durand-Ruel, 29 June 1914, ibid.
71. Joyes, *Claude Monet*, p. 105
72. Monet to Geffroy, 6 July 1914, CR IV, pp. 390–91
73. Geffroy to Monet, 31 July 1914, *Archives*
74. Geffroy to Monet, December 1914, ibid.
75. CR IV, p. 80
76. William Gerdts, *Monet's Giverny: An Impressionist Colony*, New York 1993, p. 213
77. Monet to Geffroy, 1 September 1914, CR IV, p. 391
78. Monet to G. and J. Bernheim-Jeune, 8 August 1914, ibid.
79. Monet to J.-P. Hoschedé, 10 August 1914, ibid.

23 . BLUE ANGEL, 1914–20

1. *Arnyvelde*, p. 270
2. *Hoschedé*, I, p. 92
3. *Giverny*, p. 244
4. *Gimpel*, p. 73
5. *Trévise*, p. 319
6. Ibid., p. 338
7. *Thiébault-Sisson June 1927*, p. 291
8. Claude Roger-Marx, 'M. Claude Monet's Water Lilies', *Gazette des Beaux-Arts*, June 1909, p. 265
9. Monet to Geffroy, 7 June 1912, CR IV, p. 385
10. *Thiébault-Sisson June 1927*, p. 293
11. François Thiébault-Sisson, 'Claude Monet', *Le Temps*, 6 April 1920, in *Retrospective*, p. 299
12. *Clemenceau*, p. 27
13. *Trévise*, p. 339
14. Ibid., p. 338
15. Sacha Guitry, *If I Remember Right*, London 1935, p. 238
16. *Symposium*, p. 202
17. *Geffroy*, pp. 332–3
18. Clemenceau to Monet, 8 October 1924, *Symposium*, pp. 211–12; Clemenceau to Monet, 26 March 1924, CR IV, p. 118
19. Monet to J.-P. Hoschedé, 8 February 1916, ibid., p. 393
20. *Hoschedé*, II, p. 159
21. Clemenceau to Monet, 13 March 1922, *Symposium*, pp. 208–9

22. Monet to Geffroy, 1 December 1914, *CR* IV, p. 391

23. Renoir to Monet, 22 November 1914, *Archives*

24. Renoir to Monet, 24 March 1916, ibid.

25. *Gimpel*, pp. 12–15

26. Monet to Durand-Ruel, 6 November 1914, *CR* IV, p. 391

27. Monet to Geffroy, 30 November 1915, ibid., p. 393

28. Monet to Thérèse Janin, 2 March 1916, ibid., p. 393; Monet to Lucien Pissarro, 21 June 1917, ibid., p. 397

29. *Geffroy*, p. 326

30. Antonina Vallentin, *Picasso*, Paris 1957, p. 355

31. *Geffroy*, p. 336

32. Ibid., p. 335

33. Paul Valéry, *Cahiers*, II, in *CR* IV, p. 129

34. Louis Gillet, *Trois variations sur Claude Monet*, Paris 1927, p. 110

35. *Hoschedé*, II, p. 163

36. Monet to Koechlin, 15 January 1915, *CR* IV, pp. 391–2

37. Monet to G. or J. Bernheim-Jeune, 10 February 1915, ibid., p. 392

38. *Gimpel*, p. 75

39. Monet to Léon Werth, 1 March 1915, *CR* V, p. 213

40. Monet to J.-P. Hoschedé, 19 August 1915, *CR* IV, p. 392

41. Charles Stuckey, *Claude Monet 1840–1926*, Chicago 1995, p. 246

42. Lucien Descaves, 'At Home with Claude Monet', *Paris-Magazine*, 25 August 1920, in *Retrospective*, p. 278

43. *Trévise*, pp. 320, 339

44. Ibid.

45. Monet to G. or J. Bernheim-Jeune, 12 December 1916 and Monet to G. Durand-Ruel, 13 December 1916, *CR* IV, p. 395

46. Clémental to Monet, 7 January 1918, *Archives*

47. Monet to Geffroy, 1 May 1917, *CR* IV, p. 397

48. Monet to Léonce Bénédite, 12 February 1917, *CR* V, p. 213

49. Georges Lecomte, 'Cl. Monet ou le vieux chêne de Giverny'. *La Renaissance de l'art français*, October 1920, p. 408, in ibid., p. 86

50. J. F. V. Keiger, *Raymond Poincaré*, Cambridge 1997, p. 372

51. Monet to Clemenceau, 3 February 1918, *CR* V, p. 214

52. Martin Gilbert, *Winston S. Churchill, 1874–1965*, London 1975, vol. IV, p. 99

53. Pierre Assouline, *Discovering Impressionism: The Life of Paul Durand-Ruel*, New York 2004, p. 274

54. Monet to G. Bernheim-Jeune, 3 August 1918, *CR* IV, p. 400

55. *Gimpel*, p. 58

56. Monet to Geffroy, 10 September 1918, *CR* IV, p. 400

57. Ibid.

58. Monet to Clemenceau, 12 November 1918, *CR* IV, p. 401
59. *Clemenceau*, p. 99
60. *Gimpel*, p. 76
61. Sacha Guitry, *If I Remember Right*, London 1935, p. 239
62. *Gimpel*, pp. 73–4
63. Ibid.
64. Ibid, pp. 74, 75
65. Monet to G. Durand-Ruel, 24 June 1919, *CR* IV, p. 402
66. Michel Monet to Monet, 1922, *Archives*
67. *Gimpel*, p. 315
68. Monet to G. and J. Bernheim-Jeune, 25 August 1919, *CR* IV, p. 403
69. Monet to J. Durand-Ruel, 9 November 1919, ibid.
70. Monet to Geffroy, 8 December 1919 and Monet to Fénéon, mid-December 1919, ibid.
71. *Gimpel*, p. 127
72. Monet to Thiébault-Sisson, 27 June 1920, *CR* IV, p. 406
73. *Trévise*, p. 340
74. Monet to Thiébault-Sisson, 8 July 1920, *CR* IV, p. 406
75. *Hoschedé*, II, p. 154
76. *Gimpel*, p. 152
77. Monet to G Bernheim-Jeune, 20 March 1921, *CR* IV, p. 409
78. Émile Zola, 'The Actualists', *L'Événement*, 1868, in *Retrospective*, p. 39

24. 'MIDNIGHT IN FULL SUNSHINE', 1920–26

1. Georges Truffaut, 'The Garden of a Great Painter', *Jardinage*, November 1924, in *Retrospective*, p. 317
2. *Trévise*, p. 320
3. Thadée Natanson, *Peints à leur tour*, Paris 1946, pp. 32–6
4. Louis Gillet, *Trois variations sur Claude Monet*, Paris 1927, pp. 90–92
5. Émile Zola, 'The Actualists', *L'Événement*, 1868, in *Retrospective*, p. 38
6. Kirk Varnedoe, 'Monet and his Gardens', *The New York Times*, 2 April 1978
7. *Gimpel*, pp. 57, 153
8. Natanson, *Peints à leur tour*, p. 39
9. *Giverny*, p. 244
10. Marcel Pays, 'Une visite à Claude Monet dans son ermitage de Giverny', *Excelsior*, 26 January 1921
11. Monet to Alexandre, 24 May 1921 and Monet to Clemenceau, 4 and 22 May 1922, *CR* IV, p. 411
12. *Gimpel*, p. 127

13. Monet to G. or J. Bernheim-Jeune, 11 August 1922, ibid., p. 415
14. *CR IV*, p. 304
15. Ibid., p. 296
16. Mel Gooding, *The Experience of Painting*, London 1988, p. 121
17. Monet to Coutela, 13 September 1922, *CR IV*, p. 423
18. *CR IV*, p. 118
19. *Giverny*, p. 244
20. Michel Monet to Monet, 1922, *Archives*
21. Monet to Marc Elder, 8 May 1922, *CR IV*, p. 414
22. Marc Elder, *À Giverny, chez Claude Monet*, 1924, in *Retrospective*, p. 305
23. Clemenceau, p. 30
24. Monet to Paul Léon, 17 September 1922, *CR IV*, p. 415
25. *CR IV*, p. 109
26. Monet to Coutela, 22 June 1923, ibid., p. 424
27. Clemenceau to Monet, 29 July 1923, ibid., p. 113
28. *CR IV*, p. 129
29. Sacha Guitry, *If I Remember Right*, London 1935, p. 233
30. Monet to Clemenceau, 30 August 1923, *CR IV*, p. 416
31. Monet to G. or J. Bernheim-Jeune, 6 October 1923, ibid.
32. *CR IV*, p. 116
33. Ibid., p. 340
34. *Hoschedé*, II, p. 113
35. *Gimpel*, p. 221
36. William Gerdts, *Monet's Giverny: An Impressionist Colony*, New York 1993, p. 212
37. Clemenceau to Blanche, 19/20 January 1924, *CR IV*, p. 117
38. Monet to Coutela, 9 April 1924, ibid., p. 425
39. Georges Clemenceau, *Lettres à une amie: 1923–1929*, Paris 1970, p. 16
40. Monet to Barbier, 17 October 1924, ibid., p. 419
41. Henri Ciolkowski, manuscript (in French) for 'Monet at 84, still a Master Painter', *The Art News*, 8 November 1924, in *CR IV*, p. 124
42. *CR IV*, p. 124
43. Clemenceau to Monet, 18, 22 February 1925, *Symposium*, pp. 213–14
44. Monet to Bonnard, 19 January 1925, *CR IV*, p 420
45. J. Le Griel, 'Voyage fait à Giverny (Eure)', in *Les Amitiés foréziennes et vellanes*, April 1925, reporting a visit to Giverny in winter 1925, in *CR IV*, p. 126
46. Monet to Mawas, 25 March 1925, *Symposium*, p. 420
47. Monet to Geffroy, 17 June 1925, *CR IV*, p. 420
48. Clemenceau to Monet, 30 November 1925, ibid., p. 130
49. Monet to Barbier, 17 July 1925, ibid., p. 420
50. Monet to Elder, 16 October 1925, ibid., p. 426

51. Monet to G. Bernheim-Jeune, 6 October 1925, ibid., p. 421
52. Clemenceau, *Lettres*, p. 18
53. Clemenceau to Monet, 10 June 1926, CR IV, p. 134
54. *Gimpel*, pp. 314–15
55. Clemenceau to Monet, 4 July, 10 June 1926, CR IV, pp.136, 134
56. Ibid.
57. *Gimpel*, p. 333
58. Clemenceau, *Lettres*, p. 35
59. Clemenceau to Monet, 31 August 1926, *CR* IV, p. 137
60. Monet to Clemenceau, 31 August 1926, ibid., p. 421
61. *CR* IV, p.138
62. Monet to Clemenceau, 18 September 1926, ibid., p. 426
63. Monet to Paul Léon, 4 August 1926, ibid., p. 421
64. Marcel Sauvage, 'Après la mort de Cl. Monet', *Comoedia*, 7 December 1926, ibid., pp. 138–9
65. *Hoschedé*, II, p. 164
66. Ibid., p. 153
67. Natanson, *Peints à leur tour*, p. 41
68. Henri Vidal, 'Remembering Claude Monet', *France-Marseille*, 19 February 1947, *Retrospective*, p. 349
69. *Thiébault-Sisson January 1927*, pp. 348–9
70. *Hoschedé*, II, p. 153
71. *CR* IV, p. 140
72. *Thiébault-Sisson January 1927*, p. 349
73. *Hoschedé*, II, pp. 153, 164
74. *CR* IV, p. 140; *Hoschedé*, II p. 164
75. Guitry, *If I Remember Right*, p. 234
76. Vidal, 'Remembering Claude Monet', p. 349

EPILOGUE: 'THE MAGIC MIRROR'

1. Marcel Proust, 'Le Peintre. Ombres – Monet', in *Contre Sainte-Beuve/Essais et articles/Pastiches et mélanges*, Paris 1971. Translations are from Sylvia Townsend Warner, *Marcel Proust on Art and Literature*, translated by New York1984, pp. 356–8, and J. M. Cocking, *Proust: Collected Essays on the Writer and his Art*, Cambridge 1982, p. 288
2. *Clemenceau*, p. 109; Louis Gillet, *Trois variations sur Claude Monet*, Paris 1927, p. 94
3. Clement Greenberg, 'Claude Monet: The Later Monet', *Art News*, New York 1957, in *Retrospective*, p. 381

4. *Gimpel*, p. 333

5. 'The Sixties as they Were', *Making it New: Essays, Interviews and Talks*, New York 1994, p. 340

6. Carol Vogel, "Inside Art", *The New York Times* 16 April 2009

7. Greenberg, 'The Later Monet', pp. 375, 381

8. Robert Hughes, *The Shock of the New*, London 1980/1991, pp. 124, 116

9. Adam Gopnik, 'An eye still seeing', in Gloria Groom (ed.), *Monet and Chicago*, Chicago 2020, p. 15

10. T. J. Clark, *If These Apples Should Fall*, London 2022, p. 193

11. *Clemenceau*, p. 111

12. Greenberg, 'The Later Monet', p. 378

13. Adrian Ghenie, *The Hooligans,* New York 2020

14. Adrian Searle, Kitty Scott, Catherine Grenier, *Peter Doig*, London 2007, p. 132

15. Edith Devaney (ed.), *David Hockney: The Arrival of Spring, Normandy, 2020*, London 2021 (unpaginated); Jackie Wullschläger, 'Blue Sky Painting', *Financial Times*, 13 January 2012

16. Proust, 'Sainte-Beuve et Balzac', *Contre Sainte-Beuve*, in Helen Borowitz, 'The Rembrandt and Monet of Marcel Proust', *The Bulletin of the Cleveland Museum of Art*, 70:2, February 1983, p. 93

17. *Proust*, II, pp. 478–83

Select Bibliography

Alexandre, Arsène, *Claude Monet*, Paris 1921

Alphant, Marianne, *Monet: Une vie dans le paysage*, Paris 1993

Assouline, Pierre, *Discovering Impressionism: The Life of Paul Durand-Ruel*, New York 2004

Balakirsky Katz (ed.), Maya, *Revising Dreyfus*, Boston 2013

Baldassari, Anne (ed.), *Icons of Modern Art: The Shchukin Collection*, Paris 2016 (exh cat)

Baudelaire, Charles, *Art in Paris 1845–1862: Salons and Other Exhibitions*, Oxford 1965

—, *Curiosités esthétiques*, Paris 1868

—, *The Painting of Modern Life* (1863), London 1995

Berger, John, *Portraits: John Berger on Artists*, London 2015

Bouillon, Jean-Paul, *Manet to Bracquemond: Newly Discovered Letters to an Artist and Friend*, Paris 2020

Brown, Frederick, *Zola: A Life*, London 1995

Clark, Kenneth, *Landscape into Art*, London 1949

Clark, T. J., *The Painting of Modern Life*, Princeton 1984

—, *Farewell to an Idea*, London 1999

—, *If These Apples Should Fall*, London 2022

Clemenceau, Georges, *Claude Monet*, Paris 1928

Cocking, J. M., *Proust Collected Essays on the Writer and his Art*, Cambridge 1982

Cogeval, Guy et al. (eds), *Claude Monet 1840–1926*, Paris 2010 (exh cat)

Coninck, Frédéric de, *Le Havre: son passé, son avenir*, Le Havre 1869

Conisbee, Philip and Coutagne, Denis (eds), *Cézanne in Provence*, New Haven 2006 (exh cat)

Dallas, Gregor, *At the Heart of the Tiger: Clemenceau and his World*, London 1993

Danchev, Alex, *Cézanne: A Life*, London 2012

—(ed.), *The Letters of Paul Cézanne*, London 2013

Doran, Michael (ed.), *Conversations avec Cézanne*, Paris 1978

Dumas, Ann (ed.), *Painting the Modern Garden: Monet to Matisse*, London 2015 (exh cat)

Durand-Ruel, Paul, *Memoirs of the First Impressionist Dealer*, Paris 2014

Ehrlich White, Barbara, *Impressionists Side by Side*, New York 1996

—, *Renoir: An Intimate Biography*, London 2017

Eisenmann, Stephen and Thomas Crow, Thomas, *Nineteenth Century Art: A Critical History*, London 2007

Elder, Marc, *À Giverny chez Claude Monet*, Paris 1924

Flam, Jack, *Matisse*, Ithaca 1986

Fried, Michael, *Manet's Modernism*, Chicago 1996

Gasquet, Joachim, *Cézanne: A Memoir with Conversations*, London 1991

Geffroy, Gustave, *Claude Monet, sa vie, son œuvre*, Paris 1924

Gerdts, William, *Monet's Giverny: An Impressionist Colony*, New York 1993

Gillet, Louis, *Trois variations sur Claude Monet*, Paris 1927

Gimpel, René, *Diary of an Art Dealer* (1963), London 1986

Gengembre, G., Naugrette, F. and Leclerc, Y. (eds), *Impressionnisme et littérature*, Rouen 2012

Gordon, Robert and Forge, Andrew, *Monet*, New York 1985

Groom, Gloria (ed.), *Impressionism, Fashion & Modernity*, Chicago 2012 (exh cat)

—, *Monet and Chicago*, Chicago 2020 (exh cat)

Guérin, Marcel (ed.), *Lettres de Degas*, Paris 1945

Guillard, Jacqueline and Maurice (eds), *Claude Monet au temps de Giverny*, Paris 1983 (exh cat)

Guitry, Sacha, *If I Remember Right*, London 1935

Herbert, Robert, *Impressionism: Art, Leisure and Parisian Society*, London 1988

—, *Monet on the Normandy Coast*, New Haven and London 1994

Higonnet, Anne, *Berthe Morisot*, Berkeley 1995

Hilaire, Michel, and Perrin, Paul (eds), *Frédéric Bazille and the Birth of Impressionism*, Montpellier and Washington, Paris 2016 (exh cat)

Hoschedé, Jean-Pierre, *Claude Monet: Ce Mal Connu*, Paris 1960

House, John, *Impressionism: Paint and Politics*, London 2004

Houssaye, Arsène, *Man about Paris: The Confessions of Arsène Houssaye*, London 1972

Hughes, Robert, *The Shock of the New*, London 1980/1991

Irvine, Gregory (ed.), *Japonisme and the Rise of the Modern Art Movement*, London 2013 (exh cat)

Janin, Jules, *Itinéraire du chemin de fer de Paris au Havre*, Paris 1854

—, *La Normandie*, Paris (undated)

Jansen, Leo, Luijten, Hans and Bakker, Nienke (eds), *Van Gogh: The Letters*, London 2009

Jean-Aubry, G., *Eugène Boudin* (1922), London 1969

Jourdain, Aleth and Vatuone, Didier (eds), *Frédéric Bazille, Prophet of Impressionism*, Montpellier and New York, 1992 (exh cat)

Joyes, Claire, *Claude Monet: Life at Giverny*, London 1985

—, *Monet's Table: The Cooking Journals of Claude Monet*, New York 1989

Karpeles, Eric, *Paintings in Proust*, London 2008

Kessler Aurisch, Helga and Paul, Tanya (eds), *Monet and the Seine*, New Haven and London 2014 (exh cat)

Küster, Ulf (ed.), *Monet: Light, Shadow and Reflection*, Basel 2017 (exh cat)

Lefebvre, Géraldine (ed.), *Monet au Havre*, Paris 2016 (exh cat)

Lochnan, Katherine (ed.), *Turner Whistler Monet*, London 2004 (exh cat)

Mallarmé, Stéphane, *Collected Poems*, Oxford 2006

—*Correspondance, 1862–71*, Paris 1959

Manet, Julie, *Growing Up with the Impressionists: The Diary of Julie Manet*, London 1987

Mathieu, Marianne (ed.), *Julie Manet: An Impressionist Heritage*, Paris 2021 (exh cat)

—, *Berthe Morisot: Shaping Impressionism*, London 2023 (exh cat)

—and Lobstein, Dominique (eds), *Monet's Impression Sunrise*, Paris, 2014 (exh cat)

—and Lobstein, Dominique (eds), *Monet the Collector*, Paris 2017 (exh cat)

MuMa (Musée d'art moderne André Malraux, Le Havre), *Pissarro dans les Ports*, Le Havre 2013 (exh cat)

Natanson, Thadée, *Peints à leur tour*, Paris 1946

Noirfontaine, Pauline de, *Un Regard écrit: Algérie*, Le Havre 1856

Painter, George, *Marcel Proust: A Biography*, London 1959

Patry, Sylvie (ed.), *Berthe Morisot*, Paris 2019 (exh cat)

—*Inventing Impressionism: Paul Durand-Ruel and the Modern Art Market*, London, 2015 (exh cat)

Piguet, Philippe, *Blanche Hoschedé-Monet, un destin impressionniste*, Bonsecours 2010 (exh cat)

—, *Monet et Venise*, Paris, second edition 2008

Pissarro, Joachim, *Monet's Cathedral*, London 1990

—, *Monet and the Mediterranean*, New York 1997

Plessis, Alain, *The Rise and Fall of the Second Empire*, Cambridge 1979

Poulain, Gaston, *Bazille et ses amis*, Paris 1932

Proust, Marcel, *In Search of Lost Time*, translated by Scott Moncrieff and Terence Kilmartin, London 1996

—, *Marcel Proust on Art and Literature*, transl. Sylvia Townsend Warner, London 1984

Renoir, Jean, *Renoir, My Father*, New York 1962

Rewald, John, *The History of Impressionism*, 4th edition, London 1980

—(ed.), *Camille Pissaro, Letters to his Son Lucien* (1950), Boston 2002

—and Wiitzenhoffer, Frances (eds), *Aspects of Monet: A Symposium on the Artist's Life and Times*, New York 1984

Richardson, Joanna, *La Vie Parisienne*, London 1971

Richardson, John, *Manet*, London 1958

Rouart, Denis (ed.), *The Correspondence of Berthe Morisot*, London 1986

Shackelford, George (ed.), *Monet: The Late Years*, Kimbell 2019,

Shapiro, Meyer, *Impressionism, Reflections and Perceptions,* New York 1997

Steele, Valerie, *Paris Fashion: A Cultural History,* New York 1988

Stuckey, Charles, *Claude Monet 1840–1926,* Chicago 1995 (exh cat)

—(ed.), *Monet: A Retrospective*, New York 1985

Tabarant, Adolphe, *Manet et ses œuvres,* Paris 1947

Tadié, Jean-Yves, *Marcel Proust: A Life,* London 2000

Thomson, Richard (ed.), *Monet and Architecture,* London 2018 (exh cat)

Tinterow, Gary, *Origins of Impressionism*, New York 1995 (exh cat)

Tucker, Paul Hayes, *Monet in the '90s*, New Haven and London 1989 (exh cat)

—, *Claude Monet: Life and Art*, New Haven and London 1997

—, *Monet in the 20th Century*, New Haven and London 1998 (exh cat)

—(ed.), *Claude Monet: Late Work*, New York 2010 (exh cat)

Vollard, Ambroise, *En écoutant Cézanne, Degas, Renoir* (1938), Paris 2005

—, *Recollections of a Picture Dealer*, London 1936

Wildenstein, Daniel, *Claude Monet: Biographie et Catalogue raisonné*, Paris and Lausanne, 1974–91

Wildenstein, Daniel, *Monet: The Triumph of Impressionism*, Cologne 1996

—, *Monet's Years at Giverny: Beyond Impressionism*, New York 1978 (exh cat)

Williams, Patrick and Chrisman, Laura (eds), *Colonial Discourse and Postcolonial Theory: A Reader,* London 1994

Wilson-Barreau, Juliet, *Manet, Monet and the Gare Saint-Lazare*, New Haven and London 1998 (exh cat)

—(ed.), *Manet by Himself*, London 2004

Zola, Émile, *The Kill* [*La Curée*], transl. Brian Nelson, Oxford 2008

—, *The Masterpiece* [*L'Œuvre*], transl. Thomas Walton, Oxford 2008

ARTICLES

* indicates an article originally published in French and cited here in the translation in Charles Stuckey's collection of reviews and essays *Monet: A Retrospective*

Adam, Paul, 'Peintres impressionnistes', *La Revue contemporaine*, 4, April 1886

Alexandre, Arsène, 'Monet's Garden', *Le Figaro*, 9 August 1901*

Alexandre, Arsène, 'News from our Parisian Correspondents', *Courrier de l'Aisne*, 9 June 1904*

Arnyvelde, André, 'At Home with the Painter of Light', *Je Sais Tout*, 15 January 1914*

Blanche, Jacques-Émile, *Propos de peintre: De Gauguin à la Revue Nègre*, 3rd series, Paris 1928

Borowitz, Helen, 'The Rembrandt and Monet of Marcel Proust', *The Bulletin of the Cleveland Museum of Art*, 70:2, February 1983

Burty, Philippe, 'The Landscapes of Claude Monet', *La République française*, 27 March 1883*

Cabot Perry, Lilla, 'Reminiscences of Claude Monet from 1889 to1909', *The American Magazine of Art*, March 1927

Chagnon-Burke, Véronique, 'Rue Laffitte: Looking at and Buying Contemporary Art in Mid-Nineteenth-Century Paris', *Nineteenth-Century Art Worldwide*, 2:2, Summer 2012

Clemenceau, Georges, 'The Cathedrals Revolution', *La Justice*, 1895*

Delange, René, 'Claude Monet', *L'Illustration*, 4374, 15 January 1927

Geffroy, Gustave, 'Claude Monet Exhibition', *L'Art dans les deux mondes*, 9 May 1891*

Greenberg, Clement, 'Claude Monet: The Later Monet', *Art News*, New York 1957

Guillemot, Maurice, 'Claude Monet', *La Revue illustrée*, 15 March 1898*

Gulley, Paige, 'French Land, Algerian People', *Voces Novae: Chapman University Historical Review*, 10:1, 2018

Helleu, Paulette, 'Une visite à Giverny en 1924', *L'Œil*, March 1969

Lévy, Roger, 'La révolution du 1848 au Havre', *Revue d'Histoire du XIXe siècle*, 1911, 44

Lewis, Adrian, 'Death and Convention', *Apollo*, March 2012

Mallarmé, Stéphane, 'The Impressionists and Édouard Manet', *Art Monthly and Photographic Portfolio*, London, September 1876

Mirbeau, Octave, 'Claude Monet', *L'Art dans les deux mondes*, 8 March 1891*

Pays, Marcel, 'Une visite à Claude Monet dans son ermitage de Giverny', *Excelsior*, 26 January 1921

Piguet, Marc, 'Marc Piguet se souvient de son enfance', *La Montagne*, 24 April 2016

Proust, Marcel, 'Splendours', *Le Figaro*, 15 June 1907*

Rachum, Stéphanie, 'Pissarro's Jewish Identity', *Assaph: Studies in Art History*, B, 5, 2000

Robinson, Theodore, 'Claude Monet', *The Century Magazine*, September 1892

Roger-Marx, Claude, 'M. Claude Monet's Water Lilies', *Gazette des Beaux-Arts,* June 1909*

Seitz, William, 'Monet and Abstract Painting', *College Art Journal*, 1956

Taboureux, Émile, 'Claude Monet', *La Vie moderne*, 12 June 1880*

Thiébault-Sisson, François, 'Claude Monet: An Interview', *Le Temps*, 27 November 1900*

—, 'About Claude Monet', *Le Temps*, 29 December 1926*

—, 'About Claude Monet', *Le Temps*, 8 January 1927*

—, 'Claude Monet's Water Lilies', *La Revue de l'art ancien et moderne*, June 1927*

Thoré, Théophile, 'Salons de W. Bürger 1861–68'*

‹Tout Paris', 'Impressions of an Impressionist', *Le Gaulois*, 24 January 1880*

Trévise, duc de, 'Pilgrimage to Giverny', *La Revue de l'art ancien et moderne*, January and February 1927*

Truffaut, Georges, 'The Garden of a Great Painter', *Jardinage*, November 1924*

Varnedoe, Kirk, 'Monet and his Gardens', *The New York Times*, 2 April 1978

Vauxcelles, Louis, 'An Afternoon Visit with Claude Monet', *L'Art et les artistes*, December 1905*

Wagner, Anne M., 'Why Monet Gave Up Figure Painting', *The Art Bulletin*, 6:4, December 1994

Welch, Cheryl, 'Out of Africa: De Tocqueville's Imperial Voyages', *Review of Middle East Studies* 45:1, 53–61, January 2009

Zola, Émile, 'The Actualists', *L'Événement*, 1868*

—, 'The Realists at the Salon', *L'Événement*, 1866*

List of Illustrations

[6pp to come]

Index

[8pp To come]

INDEX

INDEX

INDEX

INDEX